DIGITAL HERITAGE

DIGITAL HERITAGE

APPLYING DIGITAL IMAGING TO CULTURAL HERITAGE

Edited by
Lindsay MacDonald

ELSEVIER

Amsterdam • Boston • Heidelberg • London • New York • Oxford
Paris • San Diego • San Francisco • Singapore • Sydney • Tokyo
Butterworth-Heinemann is an imprint of Elsevier

Butterworth-Heinemann is an imprint of Elsevier

Linacre House, Jordan Hill, Oxford OX2 8DP
30 Corporate Road, Burlington, MA 01803

First Edition 2006

British Library Cataloguing in Publication Data
A catalogue record for this book is available from the British Library

Library of Congress Cataloging in Publication Data
A catalog record for this book is available from the Library of Congress

ISBN 13: 978-0-75-066183-6
ISBN 10: 0-75-066183-6

For information on all Butterworth-Heinemann publications
visit our website at www.books.elsevier.com

Typeset by Cepha Imaging Pvt Ltd, Bangalore, India
Printed and bound in Germany
06 07 08 09 10 9 8 7 6 5 4 3 2 1

Working together to grow
libraries in developing countries

www.elsevier.com | www.bookaid.org | www.sabre.org

ELSEVIER BOOK AID International Sabre Foundation

Dedicated to Dr Robert W.G. Hunt,
who has inspired a whole generation
of colour image scientists.

CONTENTS

PREFACE

This book is about digital photography and digital image processing, and how they are being applied to conservation. Over the past decade, digital photography has developed dramatically from a specialist scientific activity into mainstream consumer electronics. Around the year 2000, the sales of digital cameras overtook sales of film cameras, in terms of the number of units sold, and their growth has continued unabated. Today, every major camera manufacturer offers products for digital photography with all the functionality and optical quality of the traditional film-based models. Although film will not disappear entirely, it seems destined to be relegated to niches, with digital imaging becoming dominant across all sectors.

What makes digital photography so gratifying, in addition to the reduced cost of consumables, is that the image is immediately available for inspection. It can be replicated without degradation and is already in a suitable form to enter the digital workflow for publication or archiving. In the digital domain, all the techniques of digital image processing can be applied, and all today's digital media can be employed for dissemination and display.

The primary motivation for this book was the European research project VITRA (Veridical Imaging for Transmissive and Reflective Artefacts). Ten of the twenty chapters have been written by people directly involved, who explain the significance of the results achieved. The project brought together partners exhibiting the state-of-the-art in digital photography, robotic engineering, image processing, databases, and conservation. This unique inter-disciplinary collaboration resulted not only in the construction of a most innovative imaging system, described in Chapter 14, but also in new insights into the application of digital imaging to decorative surfaces in historic buildings.

Of course, photographic imaging techniques have long been in use for site recording. The public desire to cherish and restore historic buildings, and the activities of heritage organizations to document and conserve them, has produced an architectural fabric across the entire European landscape in which the old and new co-exist. This heritage reaches back at least to medieval times (pre-1500) in all European countries and much further in some cases, notably in Italy and Greece, and is irresistible to visitors from relatively young cultures such as USA and Australia.

Two crucial aspects of managing historic buildings are conserving the fabric and providing access. The materials themselves must at least be protected against decay and damage and, wherever possible, restored to their former state. Decorative surfaces such as painted murals, mosaics, carvings, and mouldings are particularly vulnerable and require close attention from specialist conservators. The need to open buildings for access by the public must always be balanced against issues of safety, security, and deterioration, and frequently physical access is restricted.

Digital imaging can contribute to both conservation of and access to historic buildings. For conservation it can be used to survey the state of existing surfaces, to compare styles and details with other sites, to visualise the effects of proposed cleaning or reconstruction techniques, and to provide a record of appearances before and after restoration. For access, imaging can provide representations of the site, structure, viewpoints, and details of a building, all presented in diverse media such as postcards, guide books, and documentaries. Through digital media and the internet, moreover, digital imaging can provide 'virtual reality' tours of a historical site by combining imagery with annotations, text, and sound through an interactive graphic user interface.

The other ten chapters in this book broaden its scope by dealing with various heritage applications of digital photography. They cover library documents, museum objects, fine-art paintings, vintage photographs, rare books, papyrus manuscripts and polychrome sculpture, and have been contributed by experts at some of the world's leading institutions in their respective fields. A particular focus in Part 1 is how to identify the users, and to elicit and meet their needs. The chapters on technology in Part 2 follow the logical progression from image capture in both visible and infrared wavelengths through image processing, database storage, colour management, image compression, and quality assessment. The applications in Part 3 show how the methods may be applied to various media in practical situations. In all cases, the aim has been to restrict the technical depth to an easy undergraduate level, while making the content relevant and accessible to anyone with an interest in the subject.

I most sincerely thank all the contributors to this book for taking the trouble to present their work in such lucid detail. The expertise and care they demonstrate bodes well for the way the world's heritage will be conserved for future generations.

LINDSAY MACDONALD
Professor of Digital Media
London College of Communication

FOREWORD

'Digital Heritage' is very timely, as its publication coincides with the celebration of the 20th anniversary of the cultural digital imaging 'revolution' heralded at the opening in 1986 of the Musee d'Orsay in Paris, with its bold and inspiring visitor information system. Digital photography and image processing have become vital tools for conservation and restoration, based on a stream of research since the 1970s. As pointed out in the book and reflected in current EC funding policies, much of the R&D work of the past two decades has matured. Opportunities now exist for many practical applications, although there is still no shortage of new technology challenges from the cultural sector, as for example in the area of 3D digitisation. While the 'public face' of cultural image systems now attracts most attention, the need to protect and disseminate the world's cultural heritage is arguably greater than ever before.

This book is clearly aimed at the 'serious reader' and the approach of inviting leading authorities to contribute 20 chapters addressing crucial topics has resulted in a valuable reference work, which shows, in 'reachable depth', the situation in digital heritage at the beginning of the millennium. Each chapter is over three times the average length of a conference paper and thus enables the authors to cover their respective topics in a full, and measured manner. Ideally, it should be on the bookshelf of everyone seriously interested in the state-of-the-art and practice in 'Culture × Technology', or at least a copy should be available in their organization's library. Moreover, it is also intended as a resource for university courses and should stimulate engineers and scientists of the future to develop an interest and capability in this important application field. It will also prove useful to those Arts and Humanities specialists with the courage to face technical issues, although much of the book is in fact 'maths-free' and accessible to people from all disciplines.

In the first of the three parts, the book rightly emphasises user requirements. This is achieved through a series of chapters covering the historical development of digital imaging in several heritage fields: research and general libraries, museums, commercial photographic collections, fine art auction houses, and the built heritage. This enables the reader to obtain a holistic view of the evolving nature of user requirements as the technology has developed and responded over the last 15 years. It is thus more valuable, I believe, than a straightforward

'snapshot' of user requirements at the time of writing, which would inevitably become dated whereas history well written never becomes stale. Another interesting aspect of this section is the choice of different perspectives ranging from the scholarly orientation of the British Library and Victoria & Albert Museum to the business-like Christie's in the commercial art world. In between lie Alinari and Octavo, who, although primarily focused on business, show distinct signs of idealism.

In the second part on Technologies, the seven chapters span well-selected axes of digital heritage: digital cameras, infra-red reflectography, image processing, colour management, image compression and – a neglected Cinderella in the field – image quality. Although a certain amount of mathematics is unavoidable for a serious treatment in several of the chapters, this is provided in digestible form so that even a reader without a full grounding can still benefit. It is certainly accessible for students who have completed their first year undergraduate course in engineering or computer science, for example. Several of the authors, such as Peter Rudolf on digital cameras, provide historical background, as well as technology descriptions. Alfredo Giani's treatment of the 'limits of image processing' is enlightening in its clear description of the complex issues involved. To bring image databases to life, Mike Stapleton provides an intriguing scenario of a museum's applications. The 'black art' of colour management is particularly well elucidated by Phil Green and this sets the scene for the final chapter on image quality by two of the pioneers, Ralph Jacobson and the Editor. Two specific areas on infra-red and image compression are well covered: the former by a Florentine partnership of Duilio Bertani and Luca Consolandi and the latter by Thomas Zellman of Berlin.

The third part on Applications begins by describing leading-edge research in the European VITRA project on monumental buildings, including a long-term interest of the Editor: stained glass windows. These present many challenges in conservation and restoration, for both conventional and digital photography. VITRA team members describe their work ranging from high-quality image capture in very challenging circumstances of important monuments in England and Germany to the visualisation of panoramic images over the web. Pointers to the future are given in the chapters on 3D modelling by Angela Geary and on digital imaging for easel paintings by David Saunders and his colleagues from the National Gallery. The coda to the book is a stimulating chapter by Tom Evans on future R&D, illustrated by a scenario perspectives regarding daily life of a fortunate family living in Dublin in 2010. The author's knowledgeable excursion into policy issues is grounded in a historical review of the European Commission's long-term support for digital heritage, beginning in the Digital Library area in the 1980s and subsequently spreading to many heritage areas. Archaeology, monuments, and museums have arguably provided the most challenging and successful results.

The innovative EC project VITRA, out of which this book grew, can trace its origins back to some of the ideas and membership of the seminal EC project VASARI. It is noteworthy that VITRA capitalised on sophisticated image processing software that was developed originally in VASARI and steadily improved through a series of projects at the National Gallery over almost 15 years. It is thus a pleasure to see the names of my former team colleagues, such as David Saunders, John Cupitt, and Anthony Hamber, among the list of distinguished contributors to this book. It is also gratifying to see many additional important names from across Europe – especially from Italy and Germany – reflecting the strong early wishes for the field to grow by developing pan-European cooperation in 'Culture × Technology'. However, this is not to ignore the positive nature of globalization in this field, and the cooperation across the Atlantic in particular as indicated in the contribution by Czeslaw Jan Grycz.

Lindsay Macdonald was a leading member of the small group of digital cultural imaging pioneers with whom I have had the pleasure and privilege to collaborate, beginning in the late 1980s. His great expertise in the field, strong commitment, and dry, sharp sense of humour have ensured his place as a respected member of the wider image science network. He has contributed regularly to the EVA ('Electronic Imaging and the Visual Arts') Conferences held in London, Paris, Florence, and elsewhere. Now, in his position as Professor of Digital Media at the London College of Communication (LCC), the largest of the constituent colleges of the University of the Arts London, Lindsay and his international colleagues can be confidently expected to continue with their valuable work in Digital Heritage, from research to application, and from education to dissemination.

JAMES HEMSLEY
Founder of the EVA Conferences
August 2005

LIST OF CONTRIBUTORS

Dr. Francesco Aru
Department of Information
 Engineering
Via Gradenigo 6B
35131 Padova
Italy
Tel: +39-049-8277642
Fax: +39-049-8277699

Mr. Nick Beckett
Metric Survey Team
English Heritage
37 Tanner Row
York YO1 6WP
Tel: 01904-601959
Fax: 01904-601999
Email: nick.beckett@
 english-heritage.org.uk

Dr. Duilio Bertani
Art Diagnostic Group
Istituto Nazionale di Ottica
 Applicata
Largo E. Fermi n. 6
50125 Firenze
Italy
Tel: +39-055-23081
Fax: +39-055-2337755
Email: duilio.bertani@mi.infn.it

Mr. Cristiano Bianchi
Keepthinking Ltd.
15 Maiden Lane
London WC2E 7NG
Fax: 0207-240-8015
Email: c.bianchi@keepthinking.it

Mr. Paul Bryan
Head of Photogrammetric Unit
English Heritage
37 Tanner Row
York YO1 6WP
Tel: 01904-601959
Fax: 01904-601999
Email: paul.bryan@
 english-heritage.org.uk

Dr. Luca Consolandi
Istituto di Fisica Generale
 Applicata
Università degli Studi di Milano
Milano, Italy

Prof. Guido Cortelazzo
Department of Information
 Engineering
Via Gradenigo 6B
35131 Padova, Italy
Tel: +39-049-8277642
Fax: +39-049-8277699
Email: corte@dei.unipd.it

Dr. John Cupitt
Scientific Department
The National Gallery
Trafalgar Square
London WC2N 5DN
Tel: 020-7747-2826
Fax: 020-7839-3897
Email: john.cupitt@ng-london.
 org.uk

Mr. Tom Evans
8 Paddock Road
Caversham
Reading RG4 5BY
Tel: 0118-946-2694
Fax: 0118-946-2486
Email: tom.evans@
 wavecrest-systems.com

Mr. Keith Findlater
Colour & Imaging Institute
Kingsway House East
Kingsway
Derby DE22 3HL
Tel: 01332-593114
Fax: 01332-622218
Email: keith@woollyj.freeserve.
 co.uk

Dr. Angela Geary
Research Fellow
Camberwell College of Arts
Peckham Road
London SE5 8UF
Tel: 0207-514-6428
Fax: 0207-514-6310
Email: a.geary@camb.linst.ac.uk

Dr. Alfredo Giani
Research Fellow, Bioengineering
 Group
Department of Information
 Engineering (DEI)
University of Padova
Via Gradenigo 6/A
35131 Padova
Italy
Tel: +39-0498-277742
Email: giani@dei.unipd.it

Dr. Phil Green
School of Printing & Publishing
London College of Communication
Elephant & Castle
London SE1 6SB
Tel: 0207-514-6759
Fax: 0207-514-6772
Email: green@colourspace.
 demon.co.uk

Mr. Czeslaw Jan Grycz
CEO and Publisher
Octavo
134 Linden
Oakland CA 94607-2538
USA
Tel: +1-510-251-6031
Fax: +1-510-588-4670
Email: grycz@octavo.com

Dr. Anthony Hamber
10 Cautley Avenue
London SW4 9HU
United Kingdom
Tel: 0208-772-9585
Fax: 0208-772-9585
Email: anthony.hamber@
 btinternet.com

Prof. Ralph Jacobson
The Old Farm Cottage
Madjeston
Nr. Gillingham
Dorset SP8 5JH
Tel: 01747-822-764
E-mail: ralph@copse12.freeserve.co.uk

Prof. Lindsay MacDonald
School of Printing & Publishing
London College of Communication
Elephant & Castle
London SE1 6SB
Tel: 0207-514-6707
Fax: 0207-514-6772
Email: l.macdonald@lcc.arts.ac.uk

Mr. Sam Minelli
Fratelli Alinari Photo Archives
 and Museum
Largo Fratelli Alinari, 15
50123 Firenze
Italy
Tel: +39-055-2395244
Fax: +39-055-2382857
Email: sam@alinari.it

Mr. Joseph Padfield
Scientific Department
The National Gallery
Trafalgar Square
London WC2N 5DN
Tel: 020-7747-2826
Fax: 020-7839-3897
Email: joseph.padfield@
 ng-london.org.uk

Mr. Andrea de Polo
Fratelli Alinari Photo Archives
 and Museum
Largo Fratelli Alinari, 15
50123 Firenze
Italy
Tel: +39-055-2395201
Fax: +39-055-2382857
Email: andrea@alinari.it

Mr. Peter Rudolf
Leica Camera AG
Oskar-Barnack-Strabe 11
D-35606 Solms
Germany
Tel: +49-(0)6442-208246
Fax: +49-(0)6442-208170
Email: peter.rudolf@
 leica-camera.com

Dr. David Saunders
Department of Conservation,
 Documentation and Science
The British Museum
Great Russell Street
London
WC1|B 3DG
Tel: +44-(0)-20-7323-8669
Fax: +44-(0)-20-7323-8636
Email: dsaunders@
 thebritishmuseum.ac.uk

Ms. Barbara Schick
Restoration Department
Bayerisches Landesamt für
 Denkmalpflege
Hofgraben 4
80076 Munich
Germany
Tel: +49-89-2114-319
Fax: +49-89-2114-300
Email: barbara.schick@blfd.
 bayern.de

Mr. Neil Smith
eIS
The British Library
96 Euston Road
London NW1 2DB
Tel: 0207-412-7043
Fax: 0207-412-7155
Email: neil.smith@bl.uk

Prof. Rolf Snethlage
Head of Restoration
 Department
Bayerisches Landesamt für
 Denkmalpflege
Hofgraben 4
80076 Munich
Germany
Tel: +49-89-2114-321
Fax: +49-89-2114-300
Email: rolf.snethlage@blfd.
 bayern.de

Mr. Richard Tao Song
Colour & Imaging Institute
Kingsway House East
Kingsway
Derby DE22 3HL
Tel: 01332-593114
Fax: 01332-622218
Email: t.song@derby.ac.uk

Mr. Mike Stapleton
System Simulation Ltd.
Bedford Chambers
The Piazza
Covent Garden
London WC2E 8HA
Tel: 0207-836-7406
Fax: 0207-836-7690
Email: mike@ssl.co.uk

Mr. James Stevenson
Photographic Manager
Victoria and Albert Museum
London SW7 2RL
Tel: 0207-942-2545
Fax: 0207-942-2746
Email: j.stevenson@vam.ac.uk

Mr. Shanmugalingam Suganthan
Colour & Imaging Institute
Kingsway House East
Kingsway
Derby DE22 3HL
Tel: 01332-593114
Fax: 01332-622218
Email: s.suganthan@derby.ac.uk

Mr. Pietro Zanuttigh
Department of Information
 Engineering
Via Gradenigo 6B
35131 Padova
Italy
Tel: +39-049-8277642
Fax: +39-049-8277699
Email: pietro.zanuttigh@dei.unipd.it

Dr. Thomas Zellman
AlgoVision LuraTech GmbH
Helmholtzstr. 2-9
D-10587 Berlin
Germany
Tel: +49-30-39-40-50-50
Email: t.zellman@luratech.com

PART 1

USER REQUIREMENTS

Digitising Documents for Public Access

Neil Smith

1.1 The British Library

1.1.1 Mission

The British Library (BL) is the national library of the United Kingdom and serves a wide and inclusive user audience, ranging from the general public to the national and international library and information communities. In providing access to its incomparable collections through digitisation and the web, the BL must reflect the varying requirements of its core user groups and deliver digital services accordingly. This chapter reviews the strategic, policy and management aspects of the Library's digitisation programme, and describes the technical approach to digital capture. It draws on the *Collect Britain* website as a detailed case study.

The BL is an international research library of world renown. It was founded in 1972 by the amalgamation of existing national institutions including the British Museum Library and the National Lending Library for Science and Technology. As a non-departmental public body, the BL receives UK Government funding from the Department for Culture, Media and Sport (DCMS). The overall policy directions of DCMS promote access, learning, social inclusion and creativity.

The BL's mission is '*To help people advance knowledge to enrich lives*'. It achieves this by aiding scientific advances, adding commercial value for businesses, contributing to UK's 'knowledge economy', supporting academic investigation, adding to personal and family history, and generally increasing the nation's cultural well being.

The BL's collections are at its core and have developed over 250 years. They contain more than 150 million individual items, representing every age of written civilisation and every aspect of human thought. Each year, three million items enter the collections of manuscripts, printed materials, sound recordings and digital materials. The BL's collections are available to anyone who needs to use them. They serve all areas of education, business and industry, the medical profession, independent writers and researchers, local and national government and the library and information sector. The Library continues to be innovative in the ways it exploits its collections as a resource for the nation and the world.

1.1.2 Key facts

- The BL delivers a wider range of services than any other library in the world.
- The BL is the UK's national library and its services are used by every university and public library authority in the country.
- As a major international research library, it serves users from 180 countries.
- The BL receives Government funding and also earns £28 million annually, 40 per cent of which is from overseas trade.
- The BL's Document Supply Centre specialises in scientific, business and medical information and supplies over 3 million items each year directly to people in their workplaces.
- The BL is used by 91 per cent of the UK's top 100 research and development companies.
- 75 per cent of all new commercial registrations are from small- and medium-sized businesses.
- Over 400 000 visits are made each year to its reading rooms, and over 3 million scientific and 2 million humanities items are consulted.
- The BL's online catalogues give access to 36 million items and 6.9 million searches were made during 2002.
- 2.6 million items were acquired during 2002.
- 44 metres of publications arrive at the BL every working day and the collection now fills 594 kilometres of shelving.

1.1.3 The Library's collections

The collections of the BL have been amassed over many years and embrace all known languages. The Library traces its formal history to the foundation of the British Museum Library in 1753 in which three existing great collections were brought together: the Cotton Collection (which had been bequeathed to the nation in 1700), the Harley Collection and the Sloane Collection. To these was added to the Royal Collection in 1757, gathered by monarchs of earlier ages. Further addition of many other collections since has produced the quality, breadth and depth of the BL's collection underpinning its position as the national library.

While no library can any longer aspire to being comprehensive in its coverage of the world, the BL nevertheless collects widely and in depth in its areas of traditional strength. These outstanding collections include:

- The UK national published archive of books, serials and newspapers received by legal deposit.
- Rich holdings of books, serials and newspapers from overseas.
- Incomparable holdings of early printing from Britain and overseas.

- The national collection of Western and Oriental manuscripts from the beginning of writing to the present.
- The national archive of maps and other cartographic materials.
- The national archive of printed and manuscript music.
- The archives, library and other materials assembled by the former India Office.
- Internationally important holdings of philatelic material.
- One of the world's largest archives of sound and video recordings.
- Business information in many forms.
- The world's largest collection of patent specifications.
- The world's largest collection of conference proceedings.
- Millions of UK and overseas reports and theses in microform.

Increasingly, many of these categories of materials are now produced primarily – or solely – in digital form, and the Library's digital collections are large and rapidly expanding.

The British Library's collection may be regarded as the world's finest: the range and effectiveness of the services it provides on the basis of these collections are without rival. Every working day, services are offered in twelve reading rooms and study areas. Each year, there are more than half a million visits by readers and approximately five million documents are supplied to remote users. Its catalogues are made available world-wide via the Internet. The BL runs a varied programme of publishing, education and public events, with the exhibition galleries attracting one million visitors annually.

1.1.4 The Library's users

The Library is focused on five audiences:

1. University researchers (HE and FE) through to commercial researchers and life-long learners.
2. Businesses from large high technology corporations through to SMEs.
3. Education from school libraries to students and teachers.
4. Professional librarians from public libraries to HE libraries.
5. The public as visitors to exhibitions and events in St. Pancras.

Figure 1.1 illustrates the audiences and the services offered. This is a huge agenda but technology, particularly digital content and access and delivery over the web, makes it easier to reach more people and offer better services.

The researcher

Most of the Library's money is spent supporting 'the researcher'. Examples include entrepreneurs researching the history of a patent, PhD scholars in

Figure 1.1

Services offered by the British Library.

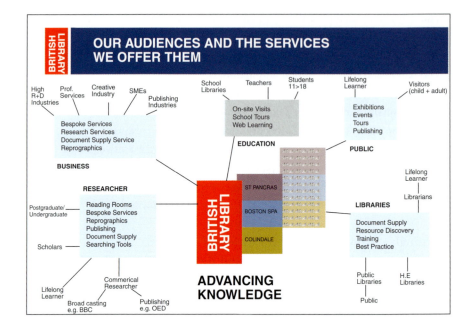

humanities subjects, and scientists in global pharmaceutical companies. The Library supports the researcher through a wide range of services, from reading rooms in all of its sites to remote information access (from scientific documents to high quality images).

Business

The Library has a critical role supporting businesses of all sizes, from individual entrepreneurs to major organisations. It does this across a wide range of services, from offering patent advice to inventors to supplying research information to companies. The BL's extensive science, design and business collections provide businesses with access to the information they need, and its experts help them to find what is most valuable.

The learner

The BL supports education across the whole spectrum from primary schools to Higher Education. An active outreach programme makes extensive use of the web as well as onsite activities.

The library community

The BL plays a key role in supporting the wider UK library and information network by offering a source of reliable guidance, expertise and leadership relating to national and international library and information provision.

It also provides high quality bibliographic services based on national and international standards. The BL's world-class collections and cost-effective services complement local provision.

The general public

As the UK's national library, the BL wants to be recognised by the public at large for the difference it makes to the UK. Services offered to this group include exhibitions and events, tours, online and print communications highlighting the Library's assets, and, increasingly, Web services which provide a digital showcase for the collections.

1.2 The Library's Digitisation Programme

Digitisation forms one aspect of the Library's overall strategy for managing digital resources. The overall strategy includes acquiring the right materials, preserving and archiving digital materials, making materials accessible now and in the future, developing infrastructure to support the digital library, and creating rich digital resources that are accessible now and in the future.

The BL has been engaged in digitisation for over ten years, successfully producing a number of digital resources to showcase the treasures contained within its holdings. The benefits of digitisation have been recognised, leading to an increasing desire to digitise more content in order to serve better the Library's key audiences.

For the BL, digitisation offers an important way to open up its unique heritage collections, and make more widely accessible items of national and international appeal.[1] However, it is only one small piece of the larger puzzle of constructing the digital library. The challenge is how to create a complete digital resource that offers a rich experience for users. The BL sees digitisation as a way to:

- Maximise use of the collections by facilitating a greater volume of networked access, both in the reading room and remotely, and by providing the enhanced functionality intrinsic to the digitised items.
- Reflect national and international priorities for wider access to, and enhanced use of, integrated collections of digitised educational, cultural or scientific materials which have a combined value greater than their component parts.
- Contribute to the conservation of original physical materials for future users by substituting digital surrogates.
- Preserve the collection of analogue sound recordings.
- Generate income from those products with market appeal that can be exploited commercially by a partner, or by the BL itself, consistent with the aim of maximising access to the collection.

Digitisation contributes to the BL's overall strategy in the following broad ways:

Access

Digitisation can make resources more accessible to existing on-site users, at the desktop, rather than having to wait for items to be delivered from the stacks. It can make resources accessible to remote users or those for whom physical access would be difficult, which is especially important to a London-centred service. Improved search and indexing features will add value to the content.

Preservation

Unlike microform, digitisation is not generally accepted at present as a preservation medium; but it can minimise the handling of fragile originals and thus, contribute to their preservation.

Space-saving

Disposal of originals after digitisation will only be an option for institutions without a long-term commitment to retention, and thus will offer no real advantage to the national library. Relegation of material to secondary storage space, especially out of London, however, may make storage more efficient and cheaper.

The digitisation of collection materials offers benefits to our existing users and has the potential to open up new audiences and applications. These benefits of access to digitised collections include:

- Online access to high-demand material by multiple users;
- Flexibility created by access on a 24 × 7 basis;
- Enhanced access through retrieval systems and full text;
- Improved collocation of materials within a collection, or multiple collections;
- Access to materials normally inaccessible for conservation reasons;
- Potential for the establishment of virtual collections through collaboration, e.g. the International Dunhuang Project;
- Opportunity for cultural restitution through digital surrogates;
- Potential for visual enhancement, e.g. by zooming into large objects.

The BL's collections are predominantly composed of printed and manuscript materials, sound recordings, and increasingly (but not relevant here) born-digital items such as electronic journals. This chapter concentrates on the digital capture of what are essentially flat, two-dimensional objects and not on the capture of three-dimensional objects.

The BL's experience of digitisation began with the *Electronic Beowulf* project in 1992.[2] This collaboration with scholars from the USA linked access, scholarship and conservation of the fire-damaged manuscript. Early concentration

on material such as *Beowulf* which was unique, valuable, at risk (in conservation terms), and of high scholarly importance, was typical of the first steps by major libraries in the early 1990s. At this time, almost all digitisation was experimental in some way. For the BL, it was an extension of the long-standing links between conservators and photographers, and the use of digital cameras built on existing skills in capture and material handling.

Initial experience gain in *Beowulf* was built upon and improved through rapid advances in and general availability of technology, for instance:

- Scanning backs for high-end cameras;
- More powerful computers;
- Cheaper mass storage;
- Higher bandwidth for internal and global networks;
- Standard software, particularly *Photoshop*;
- Standard file formats, e.g. TIFF and JPEG.

These developments saw an important shift in the mid- to late 1990s from digitisation as experiment to digitisation as an operational task, but it was still seen as expensive. Specialist staff such as photographers were needed, plus considerable input from conservators in the planning and setup of projects. Also, for some classes of materials, conservators were needed on a continuing basis during the digital capture of, for example, the *Gutenberg Bible*, Shakespeare *Quartos* and the Chaucer *Canterbury Tales*. With funding having to be sought externally for each project, the overall amount of digitisation undertaken remains small in terms of the overall size of the BL's special collections. Digitisation of originals continues, however, in collaborative projects where the material in the BL's collection can form the basis of wider scholarly and interpretative efforts made available on the web.

At the same time, revisions to the BL's digitisation strategy since 2000 have led to more emphasis on building 'critical mass' through large-scale digitisation of textual materials from surrogates. Other factors have reinforced this, such as the strategy for Library buildings and estates and a desire to provide access to a wider selection of material in the St. Pancras building and on the web. In this new strategy, newspapers have grown in importance owing to user demand and the development of new technologies to extract content from digital newspaper pages. The Library has been successful in obtaining funding for two major newspaper digitisation projects. In the first, one million pages of the Burney collection of eighteenth century British newspapers are being digitised with funding from the US National Science Foundation (NSF) via the BL's partner, the Centre for Bibliographic Research at the University of California, Riverside. In the second, two million pages of nineteenth century UK national, regional and local newspapers are being

digitised with funding from the Higher Education Funding Council for England (HEFCE).

1.3 Standards and Guidelines

The Library has adopted standards, preferably open international standards, in its digitisation projects for the following reasons:

- To ensure the long-term viability of the digital images. This is important because the cost of digitisation in terms of money and staff resource is such that it is unlikely that the digitisation could be repeated in the short term. Moreover, some of the BL's material can only be handled carefully and rarely and curators discourage unnecessary contact.
- To ensure maximum re-use of the images across projects and through time.
- To enable the Library to take part in co-operative projects, and to maximise its chances of obtaining external funding.
- To make best use of the skill and expertise of staff. The fewer different standards used, the easier it is for staff to apply their expertise to new projects. The adoption of open international standards enables the BL to make best use of external sources such as advisory bodies, contractors, and consultants.

The use of standards in the BL digitisation programme follows those taken by peers such as the Library of Congress, the National Library of Australia, and large US research libraries such as Harvard, Yale, and Cornell Universities. This accumulated best practice is to [3]:

- Capture an initial high-resolution digitised master file (also referred to as an archival master) as an uncompressed raster (bitmap) image;
- Store in the TIFF file format;
- Use 24-bit sampling (i.e. three channels of 8 bits each) for colour materials such as illuminated manuscripts, maps and photographs;
- Use 8-bit sampling (i.e. single channel greyscale) for printed half-tones and microfilm;
- Use 1-bit sampling (i.e. black-and-white binary) for simple printed texts and optionally for microfilm;
- Derive 'service copies' for web delivery at lower resolution (primarily for screen viewing) from the archival master;
- Store service copies in the JPEG compressed image file format;
- Retain the archival master on suitable media in a secure managed storage environment for future reference and re-use.

Depending on the individual library's preservation policies, the archival master may or may not fulfil the role of a preservation surrogate. It is currently

the BL's policy that digital versions of collection items are only held as preservation surrogates for audio recordings.

The range of materials in the BL's collection is very wide in terms of dimensions, fabric (paper, vellum, photographs etc.) and fragility. The care and safety of the collection is a primary concern in all BL digitisation projects and a full conservation assessment is made of all materials prior to digital capture, in accordance with professional best practice.[4] The Library's digital capture staff have all been trained in the handling of these rare and unique items by the Collection Care department. The application of conservation principles extends to the mounting of items for digital capture using standard techniques – e.g. cushions, Melanex strips, rubber or polystyrene blocks, weight bags and cushioned plastic clips. A sample of an archival master file is shown in Figure 1.2, complete with adjacent ruler and colour target and without any cropping or deskewing.

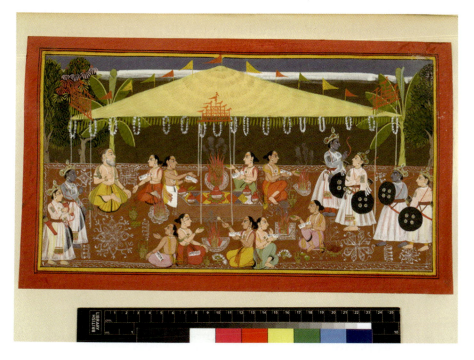

Figure 1.2
RAMAYANA, the great epic poem of Valmiki, in Sanskrit, narrating the exploits of the hero Rama. 3 Vols. Large Folio. [15,295, 15,296, 15,297]

While it is the BL's policy to capture the archival master to the highest standard (resolution and bit-depth) so that re-scanning in the future is not necessary, this must always be done with a conscious and pragmatic view of fitness for purpose and resources available. There may be occasions when it is very clear that the Library will have no need for a high quality archival master, so scanning can be done at lower standards of resolution and bit-depth. At all decision points in the selection process, an audit trail is completed so that future filming and digitisation proposals have an opportunity to review these earlier decisions.

The archival master should reflect as accurately as possible the visual information of the object (original or surrogate). The file format used at this stage should be uncompressed, represent the greatest possible colour/greyscale information, and retain data about the capture device. Currently there are only three viable formats that fulfil these criteria: TIFF, PNG, and SPIFF. Given the relatively poor support for PNG and SPIFF, the library uses TIFF v6 for the archival master. Migration to PNG, SPIFF, or JPEG2000 will be considered when support is adequate and these develop into *de facto* standards.[5]

Service copies of the digitised master in other formats must also be made available in three sizes for delivery to users over the web: (1) thumbnail – GIF, JPEG or PNG; (2) low resolution – JPEG; (3) high resolution – JPEG. They can be produced at the time of image capture and stored in a content management system, or produced on demand at delivery time from a copy of the digitised master file. The choice will reflect the nature of the individual project and delivery requirements.

Because of the philosophy outlined above, the Library implements guidelines for digitisation standards rather than a prescriptive approach. Table 1.1 illustrates the capture of the archival master, either from the original object or from an intermediate medium such as microfilm or Ektachrome.

Table 1.1

Quality guidelines for the capture of the digitised master file.

Original object	Recommended resolution (Minimum resolution) pixels/dpi	Bit depth
Black and white text document	600 (300)	1 or 8 grey
Illustrations, photographs, maps, manuscripts	600 (300)	24 colour
35 mm slide or negative, colour	6000 on longer side (3000)	24 colour
35 mm slide or negative, black and white	6000 on longer side (3000)	8 grey
Large format photograph, transparency, negative	6000 on longer side (3000)	24 colour
Microfilm – black and white	600 300	1 8 grey
Oversized material	600 if possible, but no less than 300	24 colour or 8 grey

Table 1.2 shows the preferred file formats for the various operational versions of the digitised masters – the service copies. See the case study *Collect Britain* below for examples.

Version	Format	Format source details
Archival master	TIFF v.6	http://partners.adobe.com/asn/tech/tiff/specification.jsp
Thumbnail	GIF or PNG	http://www.w3.org/Graphics/GIF/spec-gif89a.txt
		http://www.w3.org/TR/PNG
Low-resolution service copy	JPEG	http://www.w3.org/Graphics/JPEG
High-resolution service copy	JPEG	

Table 1.2

File format guidelines for the service copy versions.

1.4 Digitisation Methods

1.4.1 *Original materials*

The Library's initial experience with the digitisation of collection items was in the *Electronic Beowulf* project, which began in 1993 as part of the Library's Initiatives for Access programme.[6] Digital photography of the fire-damaged *Beowulf* manuscript was performed by a Kontron *ProgRes 3012* digital camera, originally designed for medical imaging as shown in Figure 5.2. Experience with *Beowulf* showed that a high quality digital camera was able to produce the resolution and colour fidelity required to represent materials such as manuscripts, photographs, and maps.

The BL bought further digital scanning backs as better models came onto the market, fitting them onto the existing standard BL studio camera bodies. These scanning backs were also found to be suitable for the on-demand reprographic services. Following competitive tendering, the BL purchased a number of Phase One *PowerPhase* digital scanning backs to be used with the De Vere 480 camera chassis. This scanning back employs three CCD line arrays of 7000 pixels each, enabling the capture of colour images up to 144 MB in size (24-bit RGB per pixel). The later *PowerPhase FX* employs a 10 500 pixel CCD chip that enables images of up to 380 MB to be captured. The camera back is connected to a Mac G4 running Adobe *Photoshop* software.

Sironar lenses were chosen for their greater depth of field with resulting better focus for bound materials. These give conservation benefits for non-planar rare and fragile materials by not requiring them to be mounted with glass plates or clips. Standard fluorescent cold lighting was purchased, again with conservation requirements of the original materials being the driving force. More details are given below, in the *Collect Britain* case study.

1.4.2 *Microfilm scanning*

At the same time as the Library was experimenting with its first digital camera in the *Electronic Beowulf* Project, it was also looking at digitising from surrogates,

particularly microfilm.[7] Part of the impetus was that scanning from micro-film provided conservation benefits for the originals, and also offered the potential to 'industrialise' the process and therefore enable the mass digitisation of collections at an affordable price.

For certain kinds of material such as printed text, digitisation from microfilm offers the BL several advantages over digitising from the original:

- It is considerably cheaper, as the high labour costs associated with originals (retrieval from the store, scanning and reshelving) are not incurred;
- Digitisation from film is considerably faster than from originals;
- There is an established market for microfilm digitisation, enabling outsourcing of the task;
- The Library can easily send microfilm offsite for digitisation whereas it can not send original materials;
- The outsourcing suppliers usually offer and integrate other required processing such as optical character recognition (OCR).

There are issues which need to be considered in microfilm digitisation, however. In most libraries, microfilming tends to have been carried out as a preservation or conservation activity on older material. This can mean that the characteristics of the original material have a more significant impact on costs and quality than the microfilm characteristics. A number of factors need to be considered:

- The polarity of the film – negative yields higher quality;
- Density – medium density is better for image quality and OCR accuracy;
- Reduction ratio – lower is preferred;
- Orientation – 1 page per frame (1-up) is preferred to two pages per frame (2-up);
- Skew – frames need to be de-skewed – particularly to maximise OCR accuracy.

It is unlikely that these factors would make the digitisation impossible from a technical point of view, but any of them could require manual intervention in the scanning which would increase the cost per frame scanned. For these reasons, it is advisable to provide potential suppliers with sample film to illustrate the range of issues inherent in the film and their likelihood of occurrence.

The Digitisation of Microfilm Project began in 1992 to test the efficiency of digitising film and using OCR software to produce searchable text. The Library used its Mekel M400XL microfilm scanner to digitise frames from the Burney collection of seventeenth and eighteenth century UK newspapers – a unique resource comprising material from the very beginning of the newspaper era. The results of the scanning were patchy, largely as a result of the condition of the printed pages when they were microfilmed and the resulting widely varying density of the microfilm. In addition, the inability of OCR software at that time

to deal with the eighteenth century fonts, e.g. the long-S, and the large number of occurrences of illegible characters proved difficult to overcome. It was an experiment ahead of its time and the project was closed during 1995.

From January to July 2001, the Library, the JISC Malibu Project, a collaboration between Olive Software, OCLC and the Oxford Forced Migration Online Project, produced a prototype system for the digitisation, indexing, and presentation of historic newspapers from microfilm using material selected from the British Library Newspaper Library collection.[8] The newspapers selected were the *Daily News*, the *News of the World*, the *Manchester Guardian* and the *Weekly Despatch* and covered some significant dates in recent British history from the years 1851 (Great Exhibition), 1856 (Crimean war), 1886 (the Irish Question), 1900 (centenary year, Boer War) and 1918 (end of the Great War). Olive Software's *Active Paper Archive* product provides OCR of the page images with full-text searching and the processing of the page images in order to recognise and identify individual articles on each page automatically. The results can be seen on the test server at http://www.uk.olivesoftware.com.

Today, scanning microfilm of library materials is commonplace and there is an established market in both the UK/Europe [9] and North America. The presence of this market and the low cost per frame for digitisation make outsourcing the logical choice. This is even more the case now that value-added elements are to be found in the areas of OCR, recognition of the individual articles on the pages, and Web delivery. The film scanning has become a standard service and it is no longer economical to adopt an in-house approach of purchasing expensive film scanners and employing staff to operate them, plus the associated IT and accommodation overheads. Unless volumes are extremely high (and guaranteed), outsourcing is usually preferred. Additionally, film scanning is likely to be done according to requirements that optimise the article recognition and OCR processes while still producing high quality images for display to users.

Reliance on outsourcing for film digitisation places the emphasis for libraries on establishing and specifying the outputs and quality standards from the digitisation and not on the technical issues associated with film scanning. Competitive tender with the requirement for bidders to scan carefully chosen sample films which expose all the characteristics (both good and bad) of the microfilm, puts the technical onus where it belongs – with the supplier.

1.5 Case Study – *Collect Britain*

To illustrate how the BL's strategic objectives, its developing digitisation strategy and its user-centred approach are being put into practice, one of the Library's large digitisation projects is presented here as a case study. This is the *Collect Britain* project (formerly known by its project name of 'In Place') [10] funded as part of the *NOF-digitise* programme.

1.5.1 NOF-Digitise programme

In July 2001, the UK Government's lottery-based New Opportunities Fund (NOF) announced grants totalling £50 million to more than 150 UK national and local organisations under its *NOF-digitise* programme. These awards were for the express purpose of creating a 'communities bank' of Internet learning resources which would document a wealth of UK achievement and heritage in the fields of the sciences, culture and social diversity. The Internet learning resources were to be targeted specifically at 'lifelong learners' – from school children to the retired people. This has been the largest single co-ordinated digitisation funding initiative yet launched in the United Kingdom.

The aim of the *Collect Britain* project (http://www.collectbritain.co.uk) is to digitise approximately 100 000 items from the Library's physical collections spanning the last 1000 years with the digital content being made available on the web. The digitised content is directed towards users of public libraries through the People's Network and schools through the National Grid for Learning. The BL's participation in *NOF-digitise* is in line with its strategic vision to make its collections more widely accessible on everyone's 'virtual bookshelf'. This is the first time that the BL has specifically targeted a project at 'lifelong learners', beyond its core clientèle of academia, business and commerce.

Collect Britain has a deliberate UK-wide geographical focus under the theme of a 'national sense of place'. The philosophy behind the project, agreed by the BL and *NOF-digitise*, was the presentation of a range of unique materials from the Library's collections that would not otherwise be widely available. With the exception of the *Penny Illustrated Paper* (digitised from microfilm), this approach meant recourse to the original items for digitisation. Together with the NOF timetable and the funding allocated, this led to the basic decisions described below with regard to the digitisation processes.

Seventeen individual collections are included, as shown in Table 1.3, each led by one of the Library's specialist curators. The BL's great diversity of collections is featured – illustrated books, newspapers, sheet music, maps, original drawings, prints, photographs, and sound recordings. It will create 98 000 digital images with accompanying metadata and deliver them via a Content Management System to the Web, where they will be available free of charge for a minimum of 6 years.

1.5.2 Technical approach

The digitisation processes selected and implemented for the *Collect Britain* project were determined by several factors:

- The majority of digitisation was to be done from the original materials;
- The collection items to be digitised were all, to various degrees, fragile, valuable, and rare or unique – thus conservation aspects of the original material were paramount;

Collection	Description
Very illuminating	2500 stunning images from the renowned ancient and illuminated manuscript collections.
The way we speak	Regional accents and dialects preserved by the Survey of English Dialects and the Millennium Memory Bank.
Pure magic!	2000 printed items from everyday nineteenth-century life collected by the Victorian conjurer, Evanion.
Svadesh Videsh: home from home	A portrait of the Indian subcontinent in 22 500 images from the former Oriental and India Office.
On the road	Ride into Regency London through 30 coloured drawings from the Kensington Turnpike Trust.
Everything curious	A sketchbook tour of England between 1750 and 1850 featuring drawings by Samuel Grimm.
Sing along!	Illustrated sheet music for piano pieces and songs from the heyday of Victorian Music Hall.
Streets of London	1200 maps from the Crace Collection chart the capital's transformation through three centuries.
Military alert	Original drawings for the Ordnance Survey maps commissioned under threat of French invasion.
Read all about it	The Penny Illustrated Paper chronicles Victorian life through 40 000 pages and 500 000 images.
Time exposure	Images of Victorian Britain captured in 3000 original early photographic book illustrations.
Caribbean views	Contrasting perspectives on plantation life in the colonies during the eighteenth and early nineteenth centuries.
Waxing lyrical	Rare early wax cylinder recordings of song, music, and speech from five continents.
On the waterfront	Deptford plans and drawings uncover history in and around the royal dockyards.
Britain uncovered	Follow the unveiling of the country through maps and views created between 800 and 1600.
Picture the scene	The British landscape in 13 000 engravings and aquatints from nineteenth-century topographical books.
By royal command	Part of George III's collection of prints and maps of the British Isles and former Colonies.

Table 1.3

Collections within the Collect Britain system.

- The funding and timescale constraints of the contract with *NOF-digitise* put a large emphasis on achieving the throughput targets;
- The end result of the digitisation exercise was to produce high quality images for lifelong learners available through the Web;
- Library digitisation policy required the retention of a high quality digital master to enable re-use and re-purposing of the materials in later projects;
- The BL already had considerable experience in digitising similar materials through the use of digital photography.

Accordingly, the BL took the decision that digital photography, rather than flat-bed scanners, would be the primary means of capture. The conversion of a collection storage area into a digitisation studio proved to be a considerable task, involving total refurbishment together with installation of an upgraded environmental monitoring and control system (temperature, relative humidity and UV output from the lighting) to cater for people, cameras, and computers. This work took several months and cost around £200 000 to complete. The new studio gave the BL additional digitisation capacity beyond the end of the *Collect Britain* project.

Having made the decision to use digital cameras with scanning backs, a competitive procurement was undertaken to select and purchase the equipment. The major selection criteria, based on achieving the quality and throughput targets, were:

- Quality of image capture;
- Ease of set-up for different kinds of materials;
- Speed of capture;
- Reliability;
- Cost.

Phase One digital camera backs were selected for the project. Six *PowerPhase* and two *PowerPhase FX* digital camera backs were bought for use with the De Vere 480 camera chassis. Rodenstock *Sironar* digital lenses were chosen for their greater depth of field with resulting better overall focus for bound materials. Conservation requirements of the original materials dictated the choice of fluorescent flicker-free cold lighting, purchased from Photon Beard Ltd. using two banks per camera with daylight colour balance. Each camera back is connected to a Macintosh G4 computer, running Adobe *Photoshop* software. The computers are networked to a server with 7 Terabytes of storage for the retention of the 'raw' digital master files. No colour management software is employed for image capture but colour targets are captured with each image, as shown in Figure 1.2 (see page 11). Consistent images for the Web are produced by applying the Adobe RGB profile to the capture of all master files. A colour

management system could be employed at a later date on the retained master files if the output format (e.g. high quality printing) required it.

The quality of the master files is checked by a small team inspecting images for the following quality attributes:

- A sharp, clean image;
- A colour balance faithful to the original;
- Accurate contrast and brightness;
- Accurate file image data captured in the TIFF header.

Following these QA checks, a cropped master is produced to act as the basis for further processing; this cropping also removes the colour bar and scale from the image as these are not required for the service copies distributed on the Web. Once approved, the images are transferred to a Content Management System for further processing (Figure 1.3).

1.5.3 Examples of Collect Britain items

Figures 1.4–1.6 illustrate some of the variety of the Library's collection materials represented in *Collect Britain*.

As has been described, the primary approach to digital capture in the *Collect Britain* project is the digitisation of the original materials. However, the largest

Figure 1.3

One of the digital cameras in action in the BL Digitisation Studio.

Figure 1.4

An example from the 'Very Illuminating' collection.

Figure 1.5

An example from the 'Time Exposure' collection.

CASCADES ON THE LYN

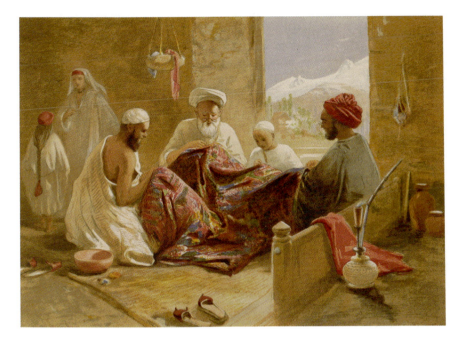

Figure 1.6

An example from the 'Svadesh Videsh' collection.

single collection within the project, 'Read all about it', has been digitised from a surrogate form, in this case microfilm. The Library was keen to include this collection as it holds the only complete run of the *Penny Illustrated Paper* which was published between 1861 and 1913. It provides a valuable and entertaining source of detailed information on everyday life and historical events in Britain and across the Empire.

The digitisation of the *Penny Illustrated* presented challenges in terms of access as well as opportunities to present a rich source of social and political issues to the intended NOF audience. Response to the Newspaper Library pilot project's approach had been extremely positive and Olive was selected to process the *Penny Illustrated* pages using the *Active Paper Archive* software. The results were integrated into the Content Management System and hence into the *Collect Britain* website. The full text of the *Penny Illustrated* articles will be available for searching on the website, fully integrated with the metadata of other items and limited to the *Penny Illustrated's* pages.

1.5.4 Content management

The Content Management System (CMS) controls the website from creation of its database to interactive performance with users. The BL selected System Associates through competitive tender to provide a CMS for *Collect Britain*. The configuration stores all the design elements, code and templates and packages them for delivery to the website, as shown in Figure 1.7. The CMS is

Figure 1.7

Functional architecture
of the content
management system.

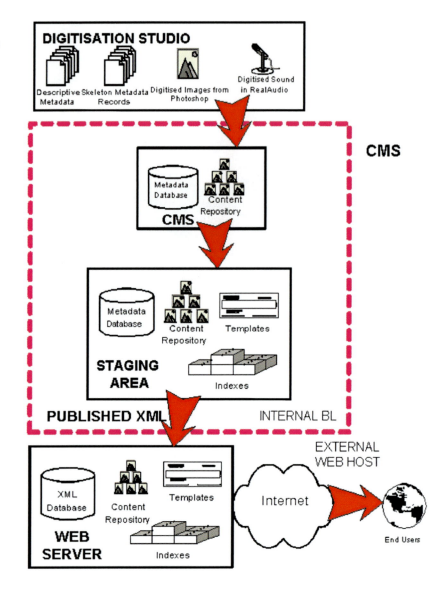

Figure 1.7

Functional architecture of the content management system.

deployed on Compaq servers running Microsoft Windows 2000 Advanced Server and using Macromedia Coldfusion MX as its application server. Metadata is stored in an SQL Server 2000 database and digital objects in a File Store. *Collect Britain* was among the first sites in the UK to use the Adobe Graphic Server to produce and store automatically the three service copies of each image master captured in the digital studio:

Thumbnails illustrate the results of a search as an aid to selection of required images. The maximum size is 96×96 pixels (i.e. if landscape 96 wide and height in proportion; if portrait 96 high and width in proportion). They are in 8-bit GIF file format (256 colours).

Small identification images display on the 'object pages' alongside text describing the image. The maximum size is 250×250 pixels, stored in 24-bit JPEG format (true colour).

Large reference images result from the selection of the 'large image' option on the object pages. The maximum size is 712×712 pixels, stored in 24-bit JPEG format (true colour).

Very large or complex images are delivered with *Zoomify*, a bandwidth-friendly browser which enables users to examine the images in fine detail. Figure 1.7 shows the functional architecture of the processing with the CMS at its centre.

1.5.5 Workflow

In order to deliver the project on time and within budget, the Library has established a production system to manage the complete content production cycle for digitised items, known as Digital Library Objects (DLOs), from selection through digitisation and metadata creation through to return of the original item to its storage location. The essential workflow is as follows (using still images as an example):

a) Selection by curatorial staff;
b) Retrieval of physical item from storage area;
c) Entering object into workflow system;
d) Creation of a unique ID;
e) Matching the unique ID to the object;
f) Mounting ready for image capture;
g) Capture of archival master image;
h) QA of archival master image;
i) Production of service copies of image (automatic process in the CMS);
j) Creation of metadata;
k) Linking images and metadata to object ID (automatic process in the CMS);
l) QA to check metadata against object;
m) Storage of object and metadata;
n) Feed to the web server;
o) Return of physical item to the archive.

This process is complex and the CMS includes features to enable DLOs to be tracked and for exceptions to be flagged and managed. Figure 1.8 illustrates the workflow, beginning with retrieval of physical items from the Library's collections (at upper left) and proceeding to the Studio for digitisation. The master files are cropped and the quality checked and the original archival

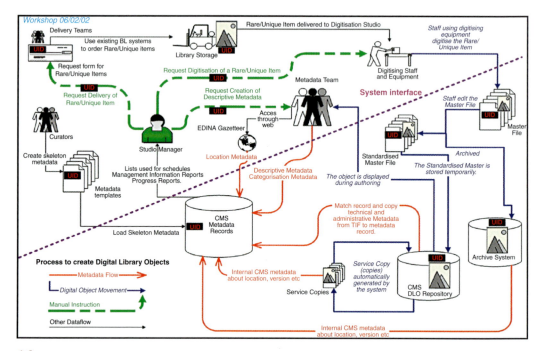

Figure 1.8

Workflow for the creation of a Digital Library Object (DLO).

master is stored. The standardised master is retained for as long as required by the Adobe Graphics Server software in the CMS for automatic generation of the service copies. The other main process – metadata creation – takes place independently of digitisation and can be done before, during or after digitisation (largely depending on whether the digital image or the originals are used by the person who enters the metadata). The key to the integrity of the DLO is to ensure that the same UID (Unique IDentifier) is used by the CMS for both the images (master file and service copies) and the associated metadata record. The CMS repository feeds the *Collect Britain* website with the completed and quality-checked DLOs.

1.6 The Users

Who are the 'Lifelong Learners' of NOF's specific target audience? The term 'lifelong learners' has come into common use without being clearly defined – some now prefer the term 'adult independent learners'. In planning the project and in particular its Website, we have sought to create a variety of content with

as wide an appeal as possible across all ages, levels of learning, and purposes of research. Three types of user are envisaged:

- The general or casual user – the Web-surfer or Net-browser;
- Learners both in and out of formal education – the private researcher, the 'enthusiastic amateur', as well as school children;
- Academic researchers – both university students and faculty.

1.6.1 What do the users want?

The initial submission to *NOF-digitise* proposed three basic approaches for the users to expose the content:

- The ability to browse in the various collections;
- The ability to search by using keywords derived from the metadata;
- Structured learning journeys through particular topics containing material from across the collections.

Prototype web interfaces for these three access paths were developed. Usability tests were carried out with a sample of users against the prototype interfaces (Table 1.4). The purpose was to understand whether there were any serious usability issues in the prototype *Collect Britain* interfaces to be addressed before progressing with full development of the site. Profiles of the users are given in Tables 1.4(a) and (b).

The participants received a short, verbal, scripted introduction and orientation to the test, explaining the objective and information about what was expected. They were assured that the web site was the focus of the evaluation and not themselves, and that they should perform in a comfortable manner typical of their usual browsing. The participants were informed that

(a)

Age range	Number
25–30	2
31–40	2
41–49	0
50–55	1
56–64	2
65–70	1

(b)

Internet experience	Number
2–3 years	2
4 years	2
7 years	2
8–9 years	1
12 years	1

Table 1.4

Profiles of users in usability testing by (a) age and (b) experience.

they would be recorded on both video and audio tape. The performance test consisted of two phases. During the first 15 minutes, there was substantial interaction between the test monitor and participants. Participants had a chance to browse around all sections of the site, and were asked specific questions as well as being encouraged to think aloud. The second phase consisted of a series of tasks that the participants were asked to carry out while being observed and again encouraged to think aloud. Interaction between the test monitor and participants during this phase was minimal.

After all tasks were completed or the time expired, each participant was debriefed by the test monitor, including:

- Filling out a brief preference questionnaire regarding the perceptions of usability and aesthetics of the site;
- Overall comments about participant's performance;
- Responses to probes from the test monitor about specific errors or problems during the test.

The following areas were tested:

Navigation
- By looking at the Home Page, do users get a sense of what kind of site this is and what they can do there?
- By looking at the pages for collections, Virtual Exhibitions and Themed Tours, do users understand what these sections provide and what they can do there?
- Do users understand what lies behind the navigation labels?
- Are users able to move freely from one section to another?
- Can users easily find their way back to the Home Page?

Labelling
- Are the terms used on the website correctly understood prior to usage?
- Identify the amount of learning that takes place during typical usage.

Image manipulation
- Is it obvious to users how to use the zoomable image interface?
- Can users easily get back to the original image after using the zoomable image?

Content search
- Do users find and understand the simple Keyword Search?
- Do users find and understand the Advanced Search?

1.6.2 Fitting the website to the users

The results of the test procedure described above were applied in an iterative design process for the web interface. It was also influenced by new library-wide design guidelines introduced in August 2002 to ensure commonality of branding and look-and-feel across all library sites. It is important that the *Collect Britain* website attracts and re-attracts a wide variety of users under the 'lifelong learner' banner and three main principles have been employed to achieve this:

Look and feel – above all enticing and inspiring – clean and uncluttered – simple, unambiguous, and intuitive.

Tone and voice – sympathetic and encouraging – friendly in tone without being patronising.

Editorial style – vernacular without being vulgar – avoiding an academic writing style – banishing long sentences and jargon.

In the interests of clarity and straightforward navigation, the website has a very simple structure with no more than four levels. To provide access to the material there are three main pathways: Collections, Themed Tours, and Virtual Exhibitions. These are illustrated on the *Collect Britain* Home Page shown in Figure 1.9.

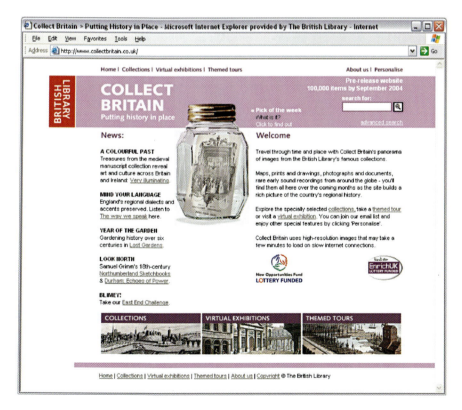

Figure 1.9

Homepage for the Collect Britain website.

The more experienced, motivated or informed user would be expected to travel the Collections pathway and be presented with 'orthodox' search strategies. The more casual learner would probably travel the Themed Tours pathway or the Virtual Exhibitions pathway and be presented with various options designed to stimulate curiosity.

Figure 1.10

Home page for the Illuminated Manuscripts collection, offering the Curator's choice of sample items, a textual introduction to the manuscripts and facilities to browse or search the collection.

Collections Pathway

To provide access to the seventeen different collections represented in *Collect Britain*, there is a Collection Finder page as illustrated in Figure 1.10. For each collection, there is a textual description and a 'Curator's Choice' highlighting five of the curator's favourite objects with appropriate links to the database.

Users can enter a search term from the Collection Finder screen, for example 'travel'. Specific selection from the search results gives a screen with detailed information about the particular item, in this case a piece of sheet music, as shown in Figure 1.11. The information is derived from the metadata record created by BL staff and linked to images in the Content Management System. The user can move easily through the pages of the document and select a larger image for each page, such as the cover of the sheet music shown in Figure 1.12.

Figure 1.11

Screen with detailed information about an item in the collection.

Figure 1.12

Screen showing the large reference image of an item in the collection.

Themed Tours Pathway

Designed to provide a learning 'experience' of a specific theme illustrated through the range of the *Collect Britain* collections, themed tours are intended to be simple and easy to navigate with no more than six pages. As an example, 'The Real East Enders' contains old maps of East London, reports on the murders by Jack The Ripper from the *Penny Illustrated Paper*, Victorian music hall songs, and sound recordings of Cockney accents among others. Other themed tours currently available are 'Lost Gardens' and 'On the Trig'.

1.6.3 How do we reach the users?

The *Collect Britain* website was launched in May 2003. Because the extended schedule for the digitisation and metadata creation activities meant that content creation would not be complete until the summer of 2004, the site was launched as a pilot with access to four collections, namely:

1. An essential guide through the history of London, with some 1200 printed and hand-drawn maps dating from 1570 to 1860, collected by Frederick Crace;
2. The original Ordnance Surveyor's' Drawings made between 1790 and 1840;
3. Selected parts of the *Penny Illustrated Paper*, published from 1861 to 1931;
4. The British Library's Victorian Popular Music Collection.

The pilot site included several personalisation features. Users had the facility to enter an email address to receive updates after the addition of significant new content, encouraging repeat visits to the site. Users were also given the facility to create a 'personal folder' where they could store images and sounds of their own choosing and so build their own local history. Additionally, two Themed Tours were promoted for narrative-led interpretation of selected sources: a major tour called 'The Old East End' and a secondary tour called 'Lost Gardens'. Also offered was one sample Virtual Exhibition, which, like the themed tours, offered an edited version of the source material. 'Literary Landscapes' examined the birthplace localities of well-known writers born in Britain. Following this initial launch, further collections, Themed Tours and Virtual Exhibitions have been regularly added in a programme of updates to the site. The complete site became available in the autumn of 2004.

Collect Britain users are encouraged to register in order to benefit from the site's advanced features, such as email alerts and personal folders where items can be downloaded on the Library's system for later re-use. In addition, users can contact the *Collect Britain* support team with any queries at: supportcollectbritain@bl.uk. Users of the site are also encouraged to access the BL's data protection policy as it relates to the *Collect Britain* site at

http://www.collectbritain.co.uk/personalisation/dataprotection.cfm. Users of this page are also given a link to the Library's Privacy Policy.

1.7 References

1. British Library Digitisation Policy (At http://www.bl.uk/about/policies/digital.html).
2. Prescott, A. (1998). Constructing Electronic Beowulf. In Towards the Digital Library (L.Carpenter, S. Shaw and A. Prescott, eds). The British Library, London.
3. Sitts, M.K. (ed.) (2000). Handbook for Digital Projects. Northeast Document Conservation Center, Andover, Mass (Also at http://www.nedcc.org/digital/dighome.htm).
4. Beagrie, N. and Jones, M. (2001). Preservation Management of Digital Materials: A Handbook. The British Library, London (Also at http://www.dpconline.org/graphics/handbook/).
5. Visual Arts Data Service, Creating Digital Resources for the Visual Arts: Standards and Good Practice (At http://vads.ahds.ac.uk/guides/creating_guide/sect33.html).
6. Carpenter, L., Shaw, S. and Prescott, A. (eds.) (1998). Towards the Digital Library. The British Library, London.
7. Podmore, H. (1998). The digitisation of microfilm. In *Towards the Digital Library* (L. Carpenter, S. Shaw and A. Prescott, eds). London.
8. Deegan, M. Steinvil, S. and King, E. (2002). Digitizing historic newspapers: Progress and prospects. *RLG DigiNews V6 N4 2002* (At http://www.rlg.org/preserv/diginews/diginews6-4.html#feature2).
9. Bremer-Laamanen, M. (2003). Digitisation for access to preserved documents. *Liber Quarterly*, **13**, 137–145.
10. Shaw, G. (2002). "In Place": Making the British Library's Collections "local" as well as "national". *Liber Quarterly*, **12**, 199–207.

1.8 Further Reading

This section provides pointers to relevant information on the Web.

Strategy, policy and management issues
NLA Digitisation Policy 2000–2004
http://www.nla.gov.au/policy/digitisation.html
The NINCH Guide to Good Practice in the Digital Representation and Management of Cultural Heritage Materials
http://www.nyu.edu/its/humanities//ninchguide/

Digitization processes
NOF digitise technical standards and guidelines
http://www.peoplesnetwork.gov.uk/content/technical.asp
Moving theory into practice: Digital imaging tutorial
http://www.library.cornell.edu/preservation/tutorial/contents.html
Digitization 'Good Practices'
http://digitalcooperative.oclc.org/digitize/goodpractice.html

General advice for a digitization project based on cultural heritage materials
http://www.tasi.ac.uk/advice/advice.html
PADI – Preserving access to digital information
(These guidelines on digitisation provide a major source of further reading.)
http://www.nla.gov.au/padi/topics/69.html

User requirements

Usability testing of library websites: Selected resources
http://www.lib.ncsu.edu/dli.ht/usability/library_usability.html
Writing for the Web
http://www.ukoln.ac.uk/nof/support/help/papers/writing-web/

Digitising Rare Books and Manuscripts

Czeslaw Jan Grycz

2.1 Introduction

In the context of digital imaging, digitisation is a term applied to the act of capturing images using a digital camera. In the context of this book, it refers principally to a *process*, applied to the preservation of documents in libraries and other archival institutions. In a library context, digitisation is a technique used to capture and record images of individual book pages, illustration plates, or the entire book itself.

Thus, digitisation is the method of creating a digital image from an original book or manuscript utilising an electronic capture process. A digital camera (one equipped with an electronic light-sensitive device in place of photographic film) captures the optical characteristics of an original. It records the data, not on chemical-based photo-sensitive film but in an electronic file format. The resulting data file can subsequently be enhanced for various desired visual effects, is easily stored in databases, can be reproduced multiple times without generational degradation of quality, and can easily and quickly be transmitted across the Internet to anywhere in the world.

This process is typically initiated at a patron's request but is increasingly undertaken by a library, internally, as a means for creating a 'digital surrogate' of an original work or book in its collection. Having a digital surrogate of the original makes it possible for the library to reduce handling of an original fragile item, and it allows the library to make surrogates available, via the Internet, and other useful images of the original work to patrons and scholars. As an additional advantage, having digital images allows a Library to post those images on the Library's web pages.[1]

The Internet has stimulated a demand for online access to information. Institutions, like museums and libraries, correctly perceive that digital images – at the same time as they reduce the need for direct access to the originals – can be used to provide improved access to those works in their collections that are considered most important (or most 'in demand'). Importantly, such access is location- and time-independent. That is, scholars anywhere in the world can

retrieve or view web pages and electronic images without having to travel to specific (often distant) libraries to view their originals.

Digitisation is considered one of the primary means (currently just behind the more familiar microfilming process) for providing long-term *protection* for valuable rare books and manuscripts by creating a useful substitute for the original. At the same time, digital files can facilitate widespread *access* (with all the flexibility and immediacy made possible by electronic networks).

Those who wish to implement digitisation strategies are, however, confronted by a daunting array of challenges and options, from the process of deciding *which objects* are most suitable for digitisation, to *which equipment* is best suited for a desired end-result.

In this chapter, the author uses the company he directs as a case study, placing digitisation activities in the context of the effort to overcome the myriad technical, management, and financial challenges associated with digital preservation. In doing so, he also gives a comprehensive overview of the issues involved in digital imaging.

2.2 Surrogates

Libraries use digital images as 'surrogates'. By definition, a surrogate can be used in place of the original. If a surrogate is electronic, the same files can be used both internally (to *protect* the original when the surrogate is of sufficient quality and accuracy to stand in place of the original), and externally (to provide wider *access* for those who might otherwise be unable to view or study an original).

Electronic surrogates are superior to previous forms of surrogates (such as photographic prints, microfilm, printed facsimiles) because they can be efficiently and inexpensively delivered via electronic networks to patrons and scholars, wherever in the world they happen to be (Figure 2.1). Surrogates can be used to create a wide variety of physical (printed) reproductions (black and white, colour, in any of various sizes, through cropping, magnification, or reduction).

Surrogates can be generated for specific and quite different purposes. Examples are JPEG files for web display, TIFF files for storage, PDF files for print reproduction, PICT files to be incorporated in word-processing documents, etc. Thumbnails can be mounted on web-sites as reference copies of the originals. Images from different original works (or from different libraries) can be displayed together as newly formed and expandable 'virtual collections'. Images can be enhanced with programming tools for close analysis. Digital files can facilitate internal bibliographic search operations. Increasingly sophisticated linked 'webs of information' combine catalogue data, explanatory texts, original images, and all manner of ephemera and annotations into new robust data repositories.

The availability of an inexhaustible supply of faithful identical copies is an important consequence of digitisation. Identical copies are made whenever

Figure 2.1

Surrogates One characteristic of the contemporary research environment is that individuals are able to access image databases from wherever they may be working. Wireless and broadband communications have accelerated the use of images (in addition to existing text files). Images frequently contain greater density of useful information in a format more easily absorbed and utilised for comparison, analysis, or simple aesthetic pleasure.

electronic files are duplicated, because the duplicates are *clones* of the original. Unlike most other forms of copying, electronic copies suffer no degradation through the duplication process. Having identical reference materials can foster collaboration of various kinds within a scholarly community because each individual within a collaboration can have easy local reference to an image, identical to the one in the possession of his/her colleagues. Central repository databases make the collaborative effort even more reliable.

Employed in the manners listed above, digital images can act as surrogates, protecting the original works from over-circulation or excessive handling. At the same time, they can be widely disseminated and shared (improving access to an item that could otherwise not be shipped outside the archive or collection). Digitisation, using today's digital capture technologies, offers substantial advantages over previous technologies, such as microfilm. When compared to the variability of photographic prints, the inconvenience of microform reproductions, or the expense of printed facsimiles, the advantages of digital images are apparent to most archivists.

But in order to function as intended, digitised surrogates must instil their prospective 'end-users' with the same confidence as (or greater than) earlier forms. This means that the surrogates must prove to be consistently faithful and authentic to the original, having captured details in ways that lend confidence to those who would employ the surrogate as they would an original. The digital capture process must be undistorted and reliable.

2.3 Challenges

There are various challenges facing those who would assemble ideal digital capture system: capital investment and its return, technical know-how and its acquisition, workflow management and its implementation, equipment and technology maintenance, and digital assets management, to enumerate only

the most obvious. While not insurmountable, these challenges can be extremely complicated, and each deserves careful consideration.

2.3.1 Capital investment and return

The capital investment in digitisation equipment suitable for digitising incunabula and other rare and precious volumes is not insignificant. A high-resolution camera alone costs, today, upwards of $50 000. Added to this figure are various peripherals (optics and specialised lenses, lighting fixtures, camera stands and furnishings, and suitable hard disk storage facilities) that can easily double or treble the investment in the digital camera capture system (Figure 2.2).

Such an investment must be weighed against the potential cost-recovery or service-provision benefits. This is not a simple calculation. One elusive way to justify such an investment is to anticipate revenues from the provision of access or the creation and distribution of files and products generated from images of unique and valuable items from a library's collection.

Octavo has experimented with a variety of publication and access models. Some are more sophisticated than others; some are more costly to develop than others. What seems clear is that, as patrons and consumers of digital images and products become more comfortable with digital images, demand increases for improved value-added enhancements of various kinds. While this augurs well for those who are prepared to finance the creation and publication of editorial, navigational, and visual enhancements, it may complicate the allocation of resources within institutions for whom providing *access* is, alone, a greater

Figure 2.2

Capital Investment The camera with its digital photo-sensitive scanning back (seen in the shadow area at the center top of this illustration) is augmented by necessary peripherals: a calibrated camera-stand (the upright column extending from the right of the table upwards), special low-intensity full-spectrum lights (shown at the top left on adjustable stands), a copy table (upon which the book is positioned, cushioned by its hand-made cradle), and a sturdy table. Not shown in this picture is a high-capacity computer, capable of processing large amounts of image data, a high-quality display screen, and the software that provides the imaging professional with proper feedback and viewing conditions for the images being captured.

priority than developing *enhanced product* lines. At that point, *return on investment* [ROI] for achieving consumer satisfaction might come into conflict with institutional resources directed toward more traditional efforts.

This conflict has even become apparent when a distribution of labour takes place. One such example was encountered when Octavo made available for sale various kinds of added-value digital publications that were expensive to produce. At the same time, an originating library posted the same images on its website, fulfilling a correctly perceived mandate to make images of works in their collection 'freely available' to the public. In such cases, if the partner library is not conscious of the significant expenditure involved in the post-imaging publication process, the sale of such added-value publications can be seriously undermined, diminishing any chance for cost recovery. Recovering costs is essential, after all, if the entire process is to be economically sustainable. If the library were conscious of the value-added effort, appreciated the end result, and acted on that knowledge, it could mitigate the negative effects of posting competing images. It could, for example, post medium-resolution images for public consumption (thereby satisfying its mandate), while making it known that higher resolution images and digital publications are also available for purchase (contributing to value-added marketing).

2.3.2 Technical know-how and acquisition

Digital photography is superficially similar to analog studio photography. Visual light rays in both instances are reflected off a target and captured through an optical lens that focuses the light onto a photo-sensitive element. The techniques of staging, cradling and illuminating the original object are quite similar to those used in traditional studio photography. Yet, because of the higher sensitivity of digital capture devices over conventional film, and the altogether different after-capture processing of images and file management, even this approximation to analog photography serves at best as an initial *foundation* for professional digital image capture and management.

Unfortunately, advertising and promotional materials for digital camera equipment, especially at the consumer level, promise 'point-and-click' ease-of-use for various 'megapixel' resolutions. They intentionally suggest that very low-cost cameras can generate startlingly high quality results. Such advertisements obscure the many limitations of consumer-model cameras for professional use.[2]

Even after filtering out the obvious hyperbole and deciphering the actual meaning of advertising jargon (especially as regards resolution and predictable image quality), consumer marketing materials leave an impression that may be entirely misleading. They undervalue the need for professional competence in capturing originals, managing workflow and creating derivatives of digital images. All of these steps are critical where the results are to act as reliable surrogates for original rare and valuable works.

The tasks specifically important for professional library digitisation are: selection, conservation evaluation, handling, staging, lighting, capture, optimisation, storage, retrieval and subsequent management. Their execution is sufficiently different from the analogous tasks in film photography that only a limited amount of expertise transfers easily from one domain to the other. The tasks are, themselves, increasingly complex if advanced digital software manipulation tools are to be used with a view towards creating faithful, authentic, and unadulterated reproduction. A review of various large-scale University Library digitisation projects revealed just how traumatic and difficult has been the transition from analogue to digital mechanisms and the surprising complexity of managing the resulting files and processes.[3] See also Chapter 5.

2.3.3 Workflow management

In a large number of libraries, digital studios have been established as stand-alone facilities, augmenting existing photographic studios. Because conventional analog studios have traditionally been viewed as ancillary service units to the principal library activity, both types of service (digital and film-based) are often only loosely integrated into institutional workflow systems that could make either approach, more efficient.

Increasingly, the *digitisation* activity is understood to be more easily integrated into the conservation and preservation roles. The *access* services are designed to provide new availability of rare materials to researchers. Now that the promise of seamless electronic file transfer among networked computers has begun to prove itself, digital imaging studios (unlike their analog photographic counterparts) can be integrated into the larger cataloguing and customer-service functions of a library. This is another reason digitisation has a greater appeal for systems librarians than conventional photo-duplicating operations.

But the provision of services through networked computers and interrelated bibliographic and customer order files is a relatively new development (at best) for most libraries. Some are still struggling with the implications of automated card cataloguing systems. Integrating an activity that for so long has seemed as peripheral as photography can have a low administrative priority, despite the substantial efficiency and cost-recovery potential. It deserves to be looked at carefully.

2.3.4 Equipment and technology maintenance

Given the rapidity with which technology and equipment change and become obsolete, investments of the magnitude of high-end digitisation cameras (and associated equipment) are hard to justify. Since the advent of consumer-level digital cameras, the proliferation of digital capture and storage technologies

has brought many competing and increasingly attractive products to market (even though many are inappropriate for library needs).

Budget-conscious administrators are justified in reserving judgment and postponing capital investments in equipment that seems to grow obsolete with every passing week, especially when low cost alternatives *appear* to suggest the advent of affordable solutions, *just around the corner.*

2.3.5 Digital asset management

The final broad challenge is to manage what rapidly becomes a *very large* database of diverse digital assets. Under this category come such diverse issues as file-naming conventions, file type management, derivative creation and storage, parent/child metadata sharing and inheritance algorithms, approaches to viewing and magnification of image files, digital data file reliability and refresh [4] procedures, security, and intellectual property protection mechanisms.

2.4 Passionate Commitment

Having laid out a palette of challenges related to digitisation, it may be appropriate to describe what we have learned at Octavo. The experience can be considered a kind of *case study* to review approaches to the identified challenges.

It is not inappropriate to note here that Octavo, as a business entity, was wholly supported during its inception and early beginnings by the individual largesse of Silicon Valley pioneer and entrepreneur Dr. John Warnock (Figure 2.3). Readers will recognise Dr. Warnock's name as the co-founder (along with Charles Geschke) of Adobe Systems Inc., now one of the largest software companies in the world. Both founders enjoy a well-deserved reputation for their engineering creativity and skill; and both have engaged in generous philanthropic support of libraries and related communications technology companies. Both are lovers of rare books. Dr. Warnock, in particular, has amassed an admirable personal collection of rare books, especially in the history of science (Galileo, Copernicus, Newton, Hooke, Harvey, Fuchs, Franklin) as well

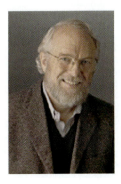

Figure 2.3
Dr. John Warnock, bibliophile and founder of Octavo.

as in the decorative and printing arts (Dürer, Midolle, Chaucer). It is no surprise that an appreciation for the art of the book translates to a mandate to promulgate that art. Dr Warnock would have Octavo conduct an electronic business in a manner that presses forward the tradition of fine bookmaking, rather than intersecting, substituting, or deflecting it in some way.

Octavo recently digitised the special copy of Johannes Gutenberg's *Biblia Latina* (Mainz, c. 1455) held by the Library of Congress.[5] This is the book that revolutionised the dissemination of knowledge in western civilisation by introducing a cost-effective and relatively inexpensive way of reproducing multiple copies of the same text through what has come to be known as the invention of 'moveable type' (Figure 2.4).

It is not an exaggeration to claim (though only time, itself, will prove the point) that the combined inventions and software developed by Adobe Systems under the direction of Warnock and Geschke may have as great an impact on publishing in the Digital Age as Gutenberg's had in the Renaissance. As dramatic as such a claim may seem, it explains the commitment Dr Warnock infused in Octavo to maintain a standard equal to that of the original craftsmen of Gutenberg's age five hundred years ago. The craftsmen in Gutenberg's printing shop harnessed the (then new) technologies of their time, struggling with the infelicities and awkwardness of early prototypes.[6] The result of their efforts was a book form that has not been surpassed for over 500 years.

Even though organisational and reproduction refinements have been introduced over time (tables of contents, page numbers, copyright pages, chapter divisions, increasingly detailed illustrations, improved mechanisation, smoother more calendared paper, high definition colour reproduction), the

Figure 2.4

Johannes Gutenberg The Gutenberg 'Bible' (c. 1455) is the iconic and most historic of printed books, widely recognised as being the first Western printed book from some kind of re-usable type matrices designed to imitate hand calligraphy. This illustration shows the scrupulous economy with which workers in Gutenberg's shop preserved their materials. The diagonal blemish visible in the space between the columns of type is actually a rip in the parchment, discovered just before printing. It was sewn together 500 years ago in Gutenberg's printing shop (so the valuable parchment sheet would not have to be wasted).

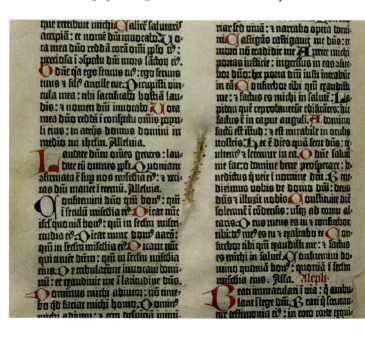

fundamental structure and model of the books printed by Gutenberg and his followers have withstood the test of time. The books they produced (and the explosion of scientific and intellectual ferment they engendered) become, therefore, not only the objects of much of Octavo's specialised digitisation efforts, but also exemplars for Octavo's own activities in both practical and inspirational ways.

Dr Warnock has allowed his passion for the printed book to infuse the 'culture' of Octavo as a company, and he has provided financial support for the experimentation of techniques for excellence. This has enabled Octavo to establish reliable standards for digitisation, digital file management; and processes for the subsequent publication and re-use of image data files. His support of Octavo is thus a contribution of substantial value to the library and bibliophile communities. It is in the context of this generous contribution, that the following observations from experience are offered.

In order to represent an original book adequately and faithfully, a digital surrogate should have a number of characteristics that have become the *sine qua non* of Octavo's digitisation efforts. The resulting digital images of rare and precious books must be faithful, authentic, and comprehensive.

2.5 Faithfulness

To be faithful to the book-making tradition, digital images of rare books should reproduce the time-tested qualities of an original printed work. Octavo accomplishes this in numerous ways. One of the most evident ways is to insist on digitising a book as an open double-page spread, with un-cropped edges, so that the viewer can perceive the book as if it were resting on a desk, or being held in one's lap (Figure 2.5).

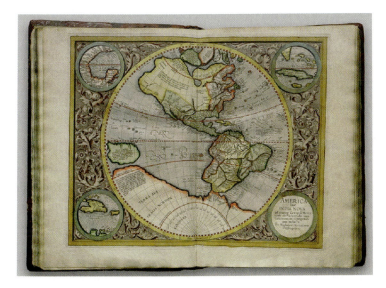

Figure 2.5

Natural Double-Page Spread This rendering of the great *Atlas* published by Gerardus Mercator in 1595 reveals the book as its designer intended it to be viewed. The fact that the edges of the individual pages can be seen without distortion can be useful in identifying plates that may have been separated from the book in its long history, but that clearly belong to it. One's immediate orientation to the context of the book and its texts and images is instinctive when presented in this natural manner. The surrogate is consistent with the way the book was originally published.

Figure 2.6

Expected Technical Innovation If it is important to be true to the tradition of fine bookmaking in the visualisation of digital images of rare and precious books, it is equally important – in presenting them in digital formats – to include such electronic capabilities as one would expect of an excellent digital publication. In Octavo's flagship products 'Octavo Digital Editions' the files are presented in ubiquitous PDF file format, with all the capabilities provided by Acrobat. Navigation is facilitated through hot-linked Tables of Contents, thumbnails, embedded ASCII text to facilitate searching, and similar technical enhancements.

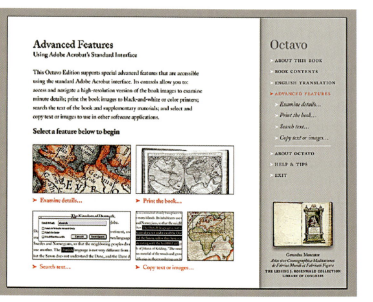

Once an image has been captured in such a natural state, faithful to the way the original book was designed to be viewed and used, any number of detailed close-ups of the text block, illustration or artefact can be generated from the original as was done in Figure 2.4 illustrating the detail on a page of the Gutenberg *Bible*. Too frequently, one sees books of extraordinary value photographed or even digitised with closely cropped edges, revealing only the content of what the photographer or curator thinks is important. But the context of the whole is lost when only the details are made visible.

Digitised books may be distributed in any of a variety of 'published' forms (more properly, 'made available to the public') for use in study, reading, research or simple aesthetic appreciation. Octavo's digital images also incorporate innovative affordances one might expect of a modern electronic text, such as easy navigation, and comprehensive searching. Such functionality aims to be useful and creative, in its own right, in the same tradition as the earlier book-making craft (Figure 2.6). Thus, the digital images include technical metadata [7] as a matter of course, and bibliographic metadata (either embedded or linked to library databases) as a matter of convenience.

2.5.1 Staging and handling

The aspiration to marry the familiar characteristics of the printed book with the innovative capabilities of electronic files has led to the evolution of 'visualisation standards' that Octavo has adopted in the cradling, capture and display of its digital images of printed works. Original books are almost always staged in collaboration with a library's conservation staff. In many cases, the conservator takes advantage of the timing of a book's imminent digitisation to make minor repairs and to subject the book to a modern cleaning. A conservation evaluation

Figure 2.7

Customised Cradles Acid-free foam of various sizes and shapes can be infinitely adjusted during the digitisation process to support the volume in any stage of its openings. The foam, which is very easy to handle, can also be cut and sized not to show out from under the book which it is supporting.

is commissioned at the beginning of digitisation, and compared with a formal 'exit evaluation' after completion of digitisation.

We seek to handle original volumes as gently and as little as possible, relying on the advice of those experts who have the ultimate responsibility and knowledge of the works under their care. We prefer (respecting the book's original design) to show the book lying as flat as is comfortable, viewed as if seen by a scholar or reader on a desk. We have also adopted the convention of imaging an entire two-page spread, with un-cropped edges. It should be possible to inspect the entire digital volume as the original might be viewed.

Although Octavo has experimented with a number of cradling devices, we have found that constructing our own has several advantages:

a) We can be sensitive to the changing weight and shifting balance of a volume as the book pages are turned during digitisation. Over the course of image capture, the weight against the spine typically shifts from the right hand side to the left hand side. We can adjust the cradling incrementally, so that each book is carefully supported throughout the entire digitisation process (Figure 2.7).
b) We can assemble the supports (usually a combination of acid-free foam and paper constructions) so that they are wholly hidden beneath the volume itself.

Careful positioning of the book supports keeps ephemeral materials from unintentionally appearing from beneath the edges of the book in its digitised form. This in turn eliminates the subsequent need for 'erasing' any superfluous areas from the final published digital image through software manipulation, which might distort the edges of a binding or a page. Features such as tears and deckle edging can be of considerable value to certain types of scientific research, and it is important to do nothing that would tend to introduce artificial changes in these critical areas.

2.5.2 Lighting

The goal of proper lighting is to illuminate a book in natural light, revealing all the details of the surface and the mechanics of printing, showing a full-page

Figure 2.8

Illumination There exist numerous lighting solutions when it comes to the actual selection of light sources. Some prefer fluorescent lights, with their broad and uniform light characteristics, even though they require pre-heating to reach a proper lighting brightness. Others prefer point-source lights, which can be generated by a variety of metal elements served by various bulb manufacturers. Still others prefer stroboscopic lighting solutions which are more difficult to work with but actually keep to a minimum, the exposure of lumens and photons on the original. What is essential is that the light reproduce the full visible spectrum, be filtered against harmful ultra-violet rays, be monitored for consistency throughout a digitisation project, and be recorded in both the technical metadata, and in the exposure of a calibrated colour target.

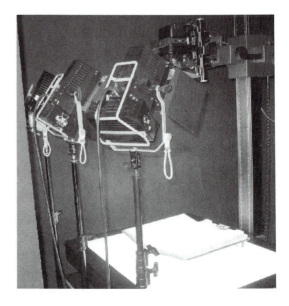

spread, and allowing an unhindered inspection of every point along the naturally curved surface of an open book from its edges to the gutter: in short, all that can be viewed by the naked eye in reference to the original. This is no small task, but is well worth the investment in time and concentration to get it right before digitisation begins (Figure 2.8). Lighting is of critical importance for at least three reasons.

a) A natural, full-spectrum illumination of the original work will tend to render the appearance of the original in the most natural way (aiming again to reproduce the effect one might have when studying the original book). It is extremely easy, however, to illuminate a work in such a way that the surface characteristics of the paper are obscured. Indeed, it would seem, from numerous examples published on various library web sites, that some photographers actually take pains to brighten the background so that the paper surface does *not* show up as visible. This is done, presumably, to improve the contrast between the typography and its natural background. Such techniques generally result in inferior images that are less appealing and less easy-to-view and less useful for conservation.

b) It is well understood that, unless special circumstances warrant their capture, the wavelengths of light outside the visible spectrum (especially the more harmful ultra-violet (UV) wavelengths) should be filtered out during any photography of rare and valuable historical works. The filtering is done at the lighting, rather than at the lens of the camera. The important factor is to protect the original from exposure to the offending light waves, because dyes used 500 years ago are often susceptible to fading in the presence of intense light (the inks are said to be 'fugitive' in the parlance of ink-making). The lighting should also be as 'cool' as possible.[8] This requirement exposes an original work to less heat (infra-red

radiation), which might otherwise affect the relative humidity of the original materials and have a detrimental effect on their suppleness and longevity. These factors influence the selection of appropriate lenses and affect not only the setting of the lens aperture,[9] but also the optimal length of an exposure.

The illumination of a book printed by typographic indentation (frequently referred to as 'letterpress' printing) requires a 'raking light', i.e. light that is cast onto the original surface at an acute angle. Raking light can bring into relief the impression of typographic characters into the surface of the paper, and can enhance the 'dimensionality' of printed books (Figure 2.9). It simulates the almost tactile nature of handling and studying an historical book. Even the waviness of centuries-old paper is useful to study.

Both the practical observation of a book's physical condition and its aesthetic appeal should be preserved when staging and illuminating a book. Not only is the angle of incidence important, but also the direction from which the primary illumination is cast. This direction should be consistent from book to book in a digitisation series, so that the viewer can become accustomed to it and thus be better able to interpret new views consistently. Shadows, especially ones that would obscure any potential information to be found within a gutter, for example, must be avoided.

c) Because they are free-standing, electrical and heated lighting equipment (even when set to very cool parameters) constitute an implicit danger to the original works illuminated by them. Hence, all electrical wires, the stabilising screws and clamps, heated bulbs that might (in the odd infrequent circumstance) break or pop from their mounts, even the very position of the lights with respect to the original works must be carefully deployed. Their location must be kept in mind at all times by the photographer. Accidental bumping or tipping of lights constitutes a danger of the

Figure 2.9

Surface Features Raking light reveals the inherent physicality of books. It instils a subliminal sense of familiarity with the original object. Familiarity is one of the characteristics that contributes to the acceptability of a surrogate. The image on the left is lit in a way that reveals the surface imperfections (the cockling of the paper, and slight foxing on the pages). The image on the right is poorly lit. Its contrast might *appear* to render the typography easier to read, but because it looks artificial, it creates an unconscious barrier to anyone wishing to read Mary Wollstonecraft's (1792) *Vindication of the Rights of Women.*

Figure 2.10

Depth of Field One of the less-appreciated challenges of staging a three-dimensional object (like a book) relates to obtaining sufficient *depth of field*. It is this quality that permits the highest and lowest surfaces of a book to be in sharp focus. Depending on the size and condition of an original, the highest point of the book (typically the fore-edges of its pages), and the lowest point of the book (the portion of the pages tucked into the gutter) might be several inches distant from one another. A combination of aperture, speed, and lighting satisfies the need to achieve sharp focus across this space. But the effort to achieve the proper balance among these variables is anything but simple.

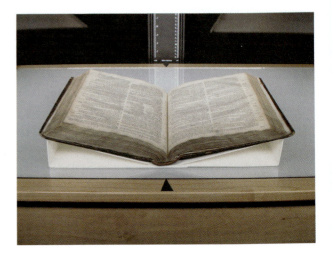

highest magnitude and must be avoided at all costs. Hence taping of electrical cords (which might seem unnecessary or superfluous) is standard practice. The need for constant vigilance by the operator cannot be overestimated.

Proper illumination is thus one of the most important tasks of an imaging specialist (Figure 2.10). It often takes a disproportional amount of time to set up the lights; frequently requiring more effort than the related staging, cradling and handling activities, combined.

2.6 Completeness

A surrogate is of diminished value if there is any information in the original that is not completely and satisfactorily recorded by the digitisation process. Octavo images the binding, fly-leaves, blank pages, and any other artefact or ephemeral item that may be closely associated with the book.

For example, a wonderful volume (c. 1817–1821) of engravings by Pierre Joseph Redouté consists of illustrations of flowers (Figure 2.11). The exemplar we had in the Octavo studio was, apparently, a collection of early press proofs, subsequently bound together with tissue slip-sheets which had been inserted between the sheets to make certain that the ink from the beautiful engravings would not accidentally smudge an opposite facing page. Octavo photographed not only the engraving pages, but each side of each intervening slip sheet. The theory is that in any formal 'publication' of a digital edition, the slip sheets might (or might *not*) be eliminated. The choice would depend on convenience to the reader, coherence of the content, and market preferences.

Conversely, any scholar who wished to use the digital images as a reliable surrogate of the original would be able, with confidence, to inspect the entire book

Figure 2.11

Completeness In order to be
trusted as an authentic and
reliable surrogate, the images
taken from the original work
must be complete, recording
every page, printed or not,
and every artefact associated
with the original (whether or
not integral to the actual
structure of the book.)
Similarly, bindings, covers, end
sheets, and any relevant
accompanying items should be
digitised at the same time as
they were in the case of
this edition of Pierre Joseph
Redouté's *Les Roses* (c. 1817).

(even the slip sheets) with as much scrupulous attention and care as she might
give to the original if the original bound volume was laid out in front of her.

2.7 Authenticity

A digital surrogate seeks to capture sufficient information that would enable a
scholar (say, 300 years from now) to view or reproduce the captured images in
a way that would constitute an authentic representation of what the original
looked like at the time of its capture. This is a lofty ideal. No one, today, would
confidently guarantee such an eventuality. In an effort to work *towards* that
possibility, however, Octavo not only captures all technical metadata information
about the imaging process (camera type, date of capture, aperture setting,
speed of exposure, depth of colour information, resolution parameters, etc.)
but consistently photographs each volume with a dye-impregnated [10] colour
target, an exposure scale, and an inch and metric ruler (Figure 2.12).

We have also gone to the somewhat labor-intensive effort to calibrate all our
equipment, our lights, the translucent copy table, and the reproduction targets.
The calibrations are used to generate an International Color Consortium
(ICC) colour profile for each imaging project we undertake (see Chapter 11).
There are several good texts recently published on the subject of colour calibra-
tion and controls. One of the best deals with the technical issues in a scientific
and careful manner, but places the implications of 'industrial-strength' colour
management in the context of workflow systems.[11] This guarantees consistent
exposure from day-to-day and week-to-week. It allows us to digitise to an overall

Figure 2.12

Gathering Colour Information
The GretagMacbeth colour target is one of the most popular colour devices on the market. It is made of dye-impregnated colour swatches (rather than lithographed ones which depend on translucent inks and are susceptible to discolouration over time). Each project begins with the digitisation of the large target. Subsequently, each page spread is digitised with the accompanying smaller target (seen in the background of this illustration).

ICC colour profile for each volume. The rendering, which is intentionally neutral and flat (similar to shooting a flat halftone for best eventual print reproduction results), is embedded in the original raw digital images captured by Octavo's equipment, and is maintained throughout the life of the file. It is also carried forward to any of the derivatives from the original file.

Although the effort of calibrating equipment and capturing ICC colour profiles has not yet been universally adopted by all digitisation studios (not even by all those established internally within top-ranking library facilities), these profiles constitute the most reliable technological method yet developed for capturing colour information in a standardised manner. Availability of the profiles *might* lead to greater confidence that an image captured today will be viewable and possess colour fidelity generations from now. We can expect that the then-available equipment and processes may be quite different from the ones in use today. But if the new devices also conform to migrated ICC standards, the likelihood of colour accurate viewing and reproduction will be improved. This objective, to be sure, is at the very heart of the International Color Consortium, and is one reason the profiles have won such wide acceptance. The ICC standard is endorsed by manufacturers of camera equipment, reproduction machines, and numerous other devices geared towards authentic colour reproduction.

2.8 Archival File Repositories and Derivatives

At Octavo, we consider the raw images (those initially captured by the camera and immediately stored on disk drives) to be of archival quality. As a matter of policy, Octavo makes available to the originating library one copy of all raw

image data files (along with the relevant technical metadata) that result from the digitisation of a work in its collection.

Although we certainly aspire to the goal that Octavo, the company, will be viable and in existence years hence, we recognise that it is the independently financed library or museum that is – for justifiable reasons – universally identified as the permanent institution to which citizens bestow the responsibility for caring for cultural artifacts. Accordingly, we consider such institutions to be the repository of first choice for keeping archival files over time. Since the initial raw digital files are the highest quality representations of their original works, it is only ethical and reasonable that the library be assured that a copy of the raw files be submitted to them for safekeeping.[12]

Octavo's own copies of the raw images are quickly employed to create derivative files of various kinds. We consider 'publishable' files (ones suitable to distribute to the public) to be ones that have been inspected thoroughly. We embed a copyright notice to accompany the image. We provide the image with a neutral background. We optimise the file for on-screen viewing. These derivative 'working files' are generally compressed to reduce their size.

There exist various methods for compressing files, each of which relies on specific algorithmic rules. The present most advanced algorithms involve techniques known as 'lossless' compression, because they do not use codes to approximate the spatial relationships between pixels, but rather eliminate redundant ones in a manner that allows them to be regenerated exactly (upon decompression). Earlier compression techniques were based on less reliable statistical averages. Compressed files (because they are, indeed, smaller in actual size) can be more easily transferred, subsequently manipulated, and more comfortably handled for editorial purposes. See Chapter 12.

Depending on specific needs or instructions, we promptly create thumbnails suitable for web display, make files that facilitate zooming and online magnification, or derive ones that are specifically intended for print reproduction.

Specific uses may require files to be converted from one file format to another. We make those conversions in house for quality control and comparison. Typically, for example, we compose Octavo's final 'publication quality' digital editions in PDF [13] file-format. PDF affords the purchaser an optimised single file which also conveys the software capabilities built-in to the Adobe *Acrobat* Reader software. This permits, for example, accurate printing on a range of printers from low- to high resolution. It enables searching text blocks, provides a capacity for annotation, and facilitates group collaboration.

The goal of Octavo's digitisation process, in contrast to the goal of software developers, is to remain independent of any proprietary software technologies for viewing, interpreting or manipulating the published image data files (Figure 2.13). We wish our files to be open to *any* third-party software enhancements but not be encumbered by proprietary software that might, itself, become obsolete in time.

Figure 2.13

Resolution The hypothetical question is frequently asked: 'Why is there any need for the time and expense of high resolution imagery when my [pick one]
• printer,
• projector,
• computer monitor,
• other
can only display a low resolution?'
The answer is in the study of details through magnification.

Both images (left) focus on a single detail from the *Great Mainz Bible* (c. 1456). The detail on the left is magnified from a high resolution image, while the one on the right is magnified from a low resolution image. It is when magnified that differences in resolution become apparent. Here, the low resolution is clearly disappointing. The reader is unable to see the enlargement without 'pixelation' (which many laypersons describe as being 'out of focus').

Following this approach helps to guarantee that images of the rare and precious volumes digitised by Octavo can be viewed and interpreted by the greatest number of users on the widest variety of computer platforms and with the greatest number of image-reading software packages. It also enables third-party software developers to create and market useful products to satisfy the needs of different users and researchers.

2.9 Experimentation

To summarise the previous discussion:

■ Digital surrogates are, in various compelling ways, superior to earlier forms such as microform imaging.

■ In order to cement the confidence of those who rely on surrogates for research, study, or enjoyment, reliable digitisation must be consistently faithful, authentic and comprehensive. Standards for assuring such qualities need to be promulgated and widely adopted.

■ These requirements, and the technical complexity of proper handling, staging, lighting and imaging, require professional expertise and substantial capital investment.

■ Similarly, the management of the final digital files (the incorporation of proper technical, bibliographic and descriptive metadata, the careful creation of derivative files, and the management of an expanding image database) is a growing concern for library managers. It is an increasingly important new job for institutions engaging in such efforts.

■ At present, few digitisation studios are fully integrated into the operational workflow procedures of library systems. They would be more efficient if their procedures were to be integrated into the customer-service provisions of automated library systems.

■ Patrons and scholars (perhaps the ultimate 'consumers' of digital images) demand more added value as they come to use and increasingly rely upon digital images for pedagogical, research and communication purposes. These values generally place additional demands on already strained library resources and suggests the need of additional funding for product- or publication-development costs.

What can be learned from these varied conclusions about the proper management of digitisation? What might be concluded about its future role in library preservation and access models? How might the professional activity of digitisation conform to the economic and business realities of institutions? How has Octavo responded to such observations?

One thing that might be said about the digitisation of rare books and manuscripts as described in the personal narrative above is that we are involved in 'early days' of the technology. As with any innovation, initial exploratory efforts in digitisation are frequently viewed as novelties. 'Early adopters' have confronted various difficulties.

2.9.1 History

Some of the early experiments involved full motion video and 'interactivity'.[14] The results suffered greatly from platform dependence and insufficient computer processing power and memory.

Commercially available image databases have sought various searching and database management solutions.[15] Conversion from analog to digital formats of what were known as academic '35 mm slide libraries' also concentrated on finding indexing and retrieval algorithms but solutions were frequently built upon proprietary applications with limited portability. High-end image research laboratories sought solutions to image identification apart from the use of textual or descriptive data.[16] Fortunately, indications today abound that open standards, portability, experience and networking solutions are all contributing to a development environment. This permits us to concentrate on communicating images and ideas rather than (repeatedly) solving technical difficulties and data compatibility failures.

The evolutionary process can be observed in Octavo's own development. Octavo was among the leaders in digitising rare books and manuscripts. It was, perhaps, the first systematically to digitise complete books *in situ* and *in toto*, learning from the earlier work done by microfilm digitisation projects of the last several decades.[17]

Far-sighted leading libraries had, early on, converted analog images to digital. They not only saved considerable storage space and handling of delicate film negatives but were also able to reproduce individual images and details on their web pages and in their image databases. When the British Library released its marvellous 'Turning Pages' exhibit [18] the emphasis was on

movement and simulation, rather than high resolution and inspection. But the immensely popular exhibit had another advantage: it made concrete for much of the public, just what might be imagined and developed, if digital techniques were adopted for providing access to book materials (see also Chapter 1).

All these manifestations helped the ultimate users of digital images to imagine the possibilities of digitisation. In turn, suppliers began to identify characteristics that would prove beneficial and lasting.

2.9.2 Meta-Manager

Recognising that libraries required metadata to ensure retrieval of their images; and required cross-institutional standards for metadata so that they could share their images, Octavo sought to adopt metadata standards for its own digital assets repository (today consisting of a little over four terabytes of data). This proved difficult.

For a review of the challenges faced by digital repositories and their management of diverse metadata standards, it is useful to read the detailed experience of the University of Texas in an excellent and thorough article entitled: *A Metadata Approach to Preservation of Digital Resources: The University of North Texas' Libraries Experience.*[19] This describes various initiatives, standards and approaches to the vexing and complicated issue of uniform metadata standards in the digital resources environment. Additional useful information can be found in Chapter 10 and on the site of the Research Libraries Group.[20]

Though Octavo ultimately adopted a simpler company-specific solution that was open to the importation of other more fully developed metadata structures, the short effort did lead to a facility that some libraries have found useful (Figure 2.14). Octavo has digitised more than a single collection for which a library might only have possessed a catalogue entry known as a 'finding aid'. A finding aid simply identifies the existence of a discrete collection, but does-not necessarily identify, in detail, what is contained in the collection. Working with programmers, and remaining consistent with our existing image capture procedures, we developed a mechanism by which catalogue librarians could access and update pre-established metadata fields through standard browser interfaces. This allowed them to fill in information as the collection was viewed by an increasing number of people, and new identifications or descriptions became available.

2.9.3 Virtual exhibits

Octavo is currently working on a conceptually simple project. We will link a collection of historical and valuable maps we have digitised for a client, to audio explanations of their meaning and importance. Users will be able to view

Figure 2.14

Leveraging off-the-shelf Software Meta-Manager (as it was dubbed within the company) is not a product, but a facility with which one library has experimented. Its a mechanism to easily add detailed catalogue information related to a collection of glass photographic plates for which there existed merely a 'finding aid'. Using the common ubiquitous web browser technology we were able to build a simple interface through which more detailed descriptive data could be entered as it was discovered.

the maps on their computer screens (or, alternatively, on the web itself), and magnify portions of the maps for closer study. By invoking a simple embedded audio track, they will also be able to listen to a mentor's guidance, pointing out what is of particular interest in the beautiful cartographic works on the screen. In effect, this product will be a kind of 'digital virtual exhibit' of a collector's important graphic assemblage. It will also be a compelling way to listen to a passionate expert explaining his excitement and sharing his insights.

2.9.4 High-definition display technology

Similarly, through another partnership, Octavo is licensing some of its book images to a commercial provider of exquisite imagery for display on high-definition plasma screens intended for corporate offices, exclusive hotels, and various public spaces. These are all new venues for delivering the inspirational images of our printed history to new generations of viewers.

2.9.5 End goals

The focus of this period of innovation gradually shifts attention from the *technology of delivery* to the *content of the materials, themselves;* and from the *experimental* to the *practical.* This is precisely the proper emphasis to make in all digitisation projects. The important thing is image *content,* not the vehicle of its expression.

2.10 Identification

Shortly after the author arrived at Octavo, in February 2000, a staff retreat tackled the question of whether Octavo was, at heart, a technology company or a publishing company. This seemingly naïve question has also occurred in library administrative discussions, restated in terms of whether the purpose of digitisation is to *preserve images* or to *provide access to images*. Both questions deal with an important distinction, even if both slightly miss their mark.

If digitisation is a technology effort, its proper management is focused on technology, which is a complex (and – in its own right – a quite fascinating) undertaking. It can be a 'never-ending' undertaking inasmuch as new equipment constantly enters the marketplace, imaging, and metadata standards keep evolving, digital-asset management and security and intellectual-property issues continually occupy center-front attention. With the perspective that the effort is – at heart – technological, technological preoccupations dominate the culture and the business discussions.

If digitisation is an *access* or a *publishing* effort, the focus is rightly placed on the ultimate *uses* and *purposes* for which digitisation is undertaken. Access, to be sure, is different from publishing, but the sensitivity to the material, its importance, and the *content* of the image focuses attention on *what is the message*, to use Marshall McLuhan's felicitous and well-known phrase.[21]

It turns out not to be a simple black and white determination, any longer, to decide to be one or other type of company. This reflects the ambiguity libraries face about the extent to which they should internalise digitisation activities, or sub-contract them out to experts. As in many other domains of the modern digital age, the available software and networking tools give one the capability (even if it is illusory at times to believe one possesses all the requisite *skill sets*) of encompassing all that belongs to the sequence of selection, capture, store, enhance and publish. The result is that companies (and libraries) increasingly experience (at best) an ambivalent bifurcated role, or (at worst), a schizophrenic identity.

2.11 'Consumer' Demands

An exploratory period of creativity and innovation is an important stage in the evolution of any niche industry. Most people find it difficult to 'imagine possibilities' in the absence of practical demonstrations or prototype examples. It is only after they receive and interact with new products and forms that consumers can begin to test their applicability to known circumstances. Only after exposure to the possibilities does the 'novelty' wear off, and practical acceptance begin to influence the development of useful and marketable products and services.

In today's internet-enabled marketplace, however, the dynamics between novelty and practical acceptance takes on a greater urgency as the traditionally capital-bound publishing industry (whether of printed materials, musical CDs,

or motion picture tapes/DVDs) is, itself, undergoing considerable change. The 'old model' was one in which the publisher risked capital on building up an inventory of items that was made available to the marketplace. (In some disciplines this is called *push* marketing.) The 'new model' is popular today as new technologies and strategies make it possible for consumers to define what they want and *pull* such desired products from suppliers, utilising *just in time* and *on demand manufacturing* strategies.

What used to be a *push* marketplace, is increasingly being nudged by consumers into a more individualised and responsive *pull* marketplace.[22] It would be easy to overestimate the impact of the change for the *very* well-established corporations and businesses; but even they, as we read in the business sections of daily newspapers, are vulnerable to changing demands. Evidence is mounting that a change *is* taking place in people's perception and expectations. All businesses will do well to understand these changes, and to recognise the difference between the 'push' and 'pull' strategies. Those that cannot adjust to the changing conditions will be out-paced by those that can. This is true even for different relative value of the products being purchased.

2.12 Strategies

If the business model necessarily undergoes modification; and if the marketplace for goods is continually changing, what are some of the survival strategies that can be exercised to control the evolution of digitisation?

2.12.1 Professional and trusting partnerships

As has been explained above, the effort of professional bibliophilic digitisation is complex. Managing and utilising images for the enjoyment and satisfaction of an increasingly sophisticated public takes constant monitoring.

a) Given an understanding of the task, it is wise to leverage compatible efforts whenever possible.

Octavo enjoys a very close relationship with its provider of camera equipment, optics, and technical information. This relationship is characterised by open two-way communications, through which we learn from the broader customer-base served by our vendor; and our vendor learns from better understanding of the specific application to which we are putting his camera and equipment. In this particular case, it would appear that we are the favoured beneficiary.

The number of high-end digital cameras installed for the kind of work we describe in this chapter is small indeed, compared with the large number of the same cameras installed for the advertising, media, and fashion industries. Octavo benefits by learning about the experiences and solutions that have been developed by companies with far more generous budgets.

b) Another commercial partner is devoted to high-end print reproduction with high colour fidelity and innovative multi-pass colour printing techniques. This is an area of its own specialisation. Unless compelling reasons existed for Octavo to become operationally involved in such efforts, it is far better to partner with such a company, especially one that shares a compatible sense of dedication and commitment to excellence to whom we can confidently delegate specialised printing tasks.

c) Similarly, we maintain cordial relationships with library research organisations and associations, since they are the seed-bed for collaborative efforts in cross-institutional data exchange mechanisms, metadata definitions and retrieval algorithms.

d) Finally, when Octavo describes its library customers as 'partners', we do so with full appreciation of the collaborative effort between our own technical and publishing efforts and the library's front line contact with clients and scholars. This is the best way to maximise information gathering from those whom we hope to serve; and information dissemination to those we hope will appreciate, buy and use our value-added assortment of digital publications. Sometimes, it is true, we are ahead of our partner libraries and pull them forward. Often it is the other way around: our libraries present challenges for us to accomplish something more innovative.

2.12.2 Emphasise capture and reproduction quality

There is a dictum repeated by professionals in the commercial business of marketing: 'Don't fall in love with your product; fall in love, instead, with your audience'. The audience for professional bibliophilic digitisation comprises curators, experts and scholars for whom reproduction quality, fidelity, faithfulness and reliability are constant values. Those same values need to permeate all our activities.

It is clear that the delivery of images in various forms, on different media, and in myriad collections will evolve as the use of digital images becomes a part of mainstream activities. It is also a fact that we will be in a position to *serve* those various needs only if we capture and maintain images to the highest available standards, with their associated metrics and in a form suitable for current and future needs. Our growing collection of images will be valuable in its own right (perhaps will become Octavo's greatest asset and legacy), but only if it can be mined for various future uses.

2.12.3 On-demand manufacturing

One of the highest costs of any publishing business is its investment in inventory. What is known, in accounting terms, as the 'cost of goods sold' is the sum of all those expenses and outlays specifically associated with the individual 'products' offered and sold to the public. Octavo has recently adopted an 'on demand' manufacturing model. We no longer amass an inventory of our

editions or digital 'publications'. Instead, Octavo has acquired the necessary printers, CD-burning towers and label-printing machines. We have developed methods to create small numbers of desired 'products' *on demand*, or *as needed*. This on-demand manufacturing process has three salutary effects:

a) To the extent that Octavo's capital is no longer chained to minimum manufacturing runs resulting in cartons of waiting-to-be-sold jewel-cased CD-ROM editions, the company is able to invest the equivalent capital in other areas of the business.

b) As interest waxes or wanes for any specific digital publication Octavo has available, the company can quickly respond to that need without recourse to outside vendors.

c) If new delivery formats are demanded by customers, the company's investment in *media* does not limit its ability to deliver its *content* in any of the several ways in which people might wish to receive it.

2.12.4 *Investment prioritisation*

Despite what has been written about the complexity of the digital capture process (and it *is* an activity that requires experience and diligence), digital capture will inevitably be commoditised.

a) Cameras fitted out with *area array* photo-sensitive elements are exposed across their whole surface when light is reflected onto it from an object. Such cameras will be inevitably faster than those fitted out with today's, more conventional *linear array* systems which require a moving scanning element to traverse the surface of the photo-sensitive element.

b) Stroboscopic illumination will expose a rare book to fewer lumens and photons of light than even the coolest of steady-state lighting systems.

c) Software and algorithmic programs that interpret the data captured by sensors *offline*, will release a camera more quickly for taking the next exposure, than ones that process data in real time.

d) Even mechanical cradles (eschewed by many in the rare book field), can be predicted to speed the process of turning a page, and focusing a camera lens, making certain that the field plane of the scanning device is precisely parallel to any given page of a book.

No matter what innovation is introduced to the process of capturing images, the costs involved reduces to throughput numbers: 'How many images can successfully be captured in any given period of time?'

What is more significant in terms of quality assurance is the human judgment and attention that is given to evaluating and processing acceptable finished results. This situation becomes paradoxical because the introduction of digital metrics (automatic exposure calculators, light-sensing devices to guarantee

equivalent exposures over time when power or light fluctuations may vary, colour targets and calibration devices to assure consistency and replicability of colour) suggests that the 'science' of digitisation is becoming more mature. Thus human factors should count for less.

Yet, while scientific advances may result in faster, more accurate results, the *judgment* about what is acceptable and publishable still involves a variety of human interventions. It is worthwhile investing in the processes that facilitate the contribution of human judgment and facilitate the evaluative process. Facilitating these contributions is more important than optimising the *technology* of digital capture. For all practical purposes, techniques for optimising human factors will be, in any case, introduced and developed by the vendors of digital equipment.

2.12.5　*Automating repetitive processes*

Octavo has invested in workflow systems that facilitate the operator's reliable and systematic capture of images. For example, after a work has undergone a conservation evaluation, the camera operator needs to create a 'shoot list' which will guide him through the sequential imaging of each and every page spread in a book. This gives him an opportunity to examine the book with attention to any conditions that might need special care as, for example, pages that cannot be easily opened flat, the presence of gatefolds or crossover images, or other physical conditions that need special handling.

Octavo has automated the creation of the initial 'shoot list', and every other stage that can be facilitated through computer-aided procedures, from the control of the camera settings, through the evaluation and acceptance of captured images into our image database. We have provided systematic naming conventions. We have labored to create logical 'taxonomic' structures of derivatives for specific purposes, so that there are no ambiguities about images suitable for cover reproduction, thumbnail use, printing, or viewing under various specific circumstances.

Sufficiently broad experience with all manner of image and content has given us the ability to extrapolate from the sum of those experiences what are common and repetitive requirements. We are subsequently able to optimise a *series* of derivatives (rather than coping with individual one-of-a-kind situations).

2.12.6　*Enabling expandable and scalable workflow solutions*

Octavo – unlike most in-house photo- or digitisation studios – anticipates that it will need to support some given number of external digitisation laboratories at any given point in time. We foresee that number growing. The benefit of our experiences is optimised when imaging specialists located in any of several remote locations can use the same workflow infrastructure.

This capability means that a strategic priority for Octavo has been the development of workflow systems that are expandable, replicable, and scalable. Our workflow systems depend on the speed of the networked infrastructure to transmit files, to mirror them to authorised users, and to enable real-time problem solving when imaging operators confront technical difficulties. Practically speaking, the system works in the following manner:

a) An imaging specialist, using Octavo's selection and configuration of equipment, captures an image *in situ* at a participating library.
b) The image may undergo preliminary interpretive processing locally, before it is quickly and automatically transferred to Octavo's redundant storage facility in California.
c) Upon recognising that a new file has been deposited, Octavo's Image Tank database launches programs that create various derivative files automatically. The files are compressed and stored.
d) One such derivative file is instantaneously made available to the imaging specialist (wherever he/she may be located) via Octavo's Online Capture System (OCS). This lets the operator know the status of an image and also confirms the *stage* of the imaging process within any given project or book.
e) Since the Online Capture System is Internet-enabled and viewable through conventional web browser software, the same system makes it immediately possible for authorised and involved participants in the digitisation process (as well as those who may be interested in an immediate and urgent research potential), to view images *as they are captured.*

Not only does its immediacy suggest a number of scenarios for how the Online Capture System can support future collaborative activities but the OCS also allows the redundant and repetitive tasks of file transfer, derivative creation, security redundancy, and immediate feedback to be accomplished with little – if any – attention from the imaging specialist. Such necessary house-keeping can be accomplished in the background, conferring on the specialist the relative leisure to concentrate on the staging, handling, and imaging of a book. *That*, after all, is (and should be) the specialist's ongoing primary concern. Importantly, Octavo's Online Capture System supports a large number of simultaneous imaging specialist users, without necessitating a modification of the underlying programming code.

2.12.7 Adding values – serving needs

If one agrees that it is the *content* of a library's collection (and its digitised images) that are the essential value that gives purpose to the entire digitisation effort, it follows that the addition of valuable enhancements to the images will be further appreciated by the 'end-users' of digital images. The users must be

comfortable using the 'products' of digitisation as surrogates, as subjects of research, and as sources of pleasure.

2.12.8 Octavo Digital Editions

Examples of serving such expanded needs are Octavo's flagship publishing product, known as Octavo Digital Editions or ODEs (pronounced 'o-dees'). These were developed as proof-of-concept to demonstrate that proper electronic publications would have to achieve an elevated standard for new advanced forms of digital publishing to serve the public well. They also aimed to present the rare books Octavo had digitised in a compelling, attractive and respectable form (Figure 2.15).

ODEs deliver high-resolution images of individual rare books, viewable on any computer screen. The images are further supplemented with explanatory information that make them more valuable. Commissioned essays, written by world-class subject-specialists, place the digitised book images in historical and cultural context. Transcriptions, cleverly sandwiched in a separate graphical layer beneath the digital images, permit a high degree of navigation across an entire book. Search algorithms allow users to find character strings using simple term-matching as well as more advanced Boolean search commands. Hyperlinked tables of contents give users quick access to specific sections of a compound object on the CD-ROM within the relative security of a print convention with which they are already familiar. Linked thumbnails provide a more innovative visual method of navigating to specific sections of a book. Electronic 'bookmarks' allow editors to contribute improved identification of illustrations or materials that might otherwise escape the casual reader.

Figure 2.15

Octavo Digital Editions Setting the standard for what digital publishing should aspire to, ODEs include a set of the full digital images of a given book. In addition, the images are 'enhanced' with explanatory commentary information about the history and provenance of the original work, transcriptions or translations, electronic navigational facilities, and other features that continue the tradition of bookmaking, in that they utilise the capabilities and 'materials' of the present environment to create useful, attractive, and educational digital publications. (These are available for purchase at http://www.octavo.com).

Innovative as they were when first introduced, ODEs have undergone continual change since their introduction, as Octavo's own editorial and technical staff gained facility in the assembly programs we employ. Feedback from purchasers of our products has also helped us adjust to market demands. Originally, ODEs were equipped with self-starting programs. Their purpose was to recognise the host operating system and launch Octavo editions in an appropriate versions for each different computer platform. It eventually became obvious that if we generated our editions in PDF file format, purchasers could download their own reader software. The simpler, more useful files, would work on any computer platform. From the end-user's perspective, this single decision shielded them from many growing concerns about the possible corruption of individualised operator settings by start-up programs like the ones we originally employed. From Octavo's perspective, a lot of troubling attention was saved by not having to anticipate and support all the platforms and every variety of operating system users might choose to employ when viewing our products.

One of our more recent publications, Josiah Dwight Whitney's *The Yosemite Book*, (1868) [23] includes an interactive screen that allows a user to 'click' on a map at the location from which Whitney is thought to have been standing when taking his photographs. The click results in the display of the photograph that was taken from that very spot, over a century ago.

We are anticipating releasing a title of images of a classical composer's handwritten musical notation. Users might reasonably expect (and certainly *desire*) to easily hear the music represented by the notation as they review the creative jumble that so tangibly represents the creative process at work. We are expecting to incorporate such audio files with appropriate interactive elements, to make the experience of studying the images more useful and stimulating.

Octavo has had to be aware of subtly changing possibilities in the use and re-use of digital images. As a practical matter, it is in the re-use of images that one might expect Octavo to recoup some of the very high costs associated with adding the kind of values to images that are represented through the editorial investment and publication of ODEs.

2.12.9 *Octavo Research Facsimiles*

Last year saw the release of a series of 'Octavo Research Facsimiles' (ORFs). These are comprised of *sets* of our very high-resolution images, providing unparalleled opportunities for detailed inspection and study. Octavo's Research Facsimiles typically allow a far greater magnification than that available on the intentionally compressed ODE products. Comparing the two forms of digital editions immediately exposes the trade-off from the viewpoint of the consumer as well as the publisher (Figure 2.16). While ODEs provide (typically) a magnification of (only) approximately 200% of original size, the loading of the image

Figure 2.16

Octavo Research Facsimiles Research facsimiles
simultaneously demonstrate the utility of
compression and the advantages of uncompressed
files. In contrast to Octavo's flagship product, its
original Octavo Digital Editions, the Research
Facsimiles are cumbersome. The illustration here
shows the presentation set of high-resolution
images that was delivered to the Librarian of
Congress on the completion of the digitisation of
the Library of Congress' Gutenberg *Biblia Latina*.
The large, very detailed files occupy no fewer than
22 individual CD-ROMs, whereas the more
compact ODE is delivered on two CD-ROMs. The
difference is in the magnification possible for
close and meticulous study.

files on standard academic or desktop computers is quite quick. Moving from
page to page is conveniently swift. The images sacrifice little in the way of useful
resolution for most purposes.

The ORF editions provide a much higher degree of magnification. In compar-
ison with ODEs, they are somewhat sluggish to load. It is impossible to view the
large-sized images without sufficient computer RAM and without the aid of
special (albeit, off-the-shelf) image-viewing software. Yet, on a suitable computer
platform, these high-resolution images serve another purpose for those to
whom very close scrutiny and very accurate reproduction is more important
than speed or supplementary textual materials.

2.12.10 Octavo collections

Another evidence of change is the increased interest in 'collections'. Having
moved from the period of 'novelty' to 'practicality', Octavo is aware of a growing
interest among scholars, in what might be called a 'critical mass' of primary
source materials, in preference to one-of-a-kind individual works that demon-
strate, however well, the advantages of high resolution imagery. The Shakespeare
Quarto Digitisation Project (SQDP) is an example of this kind of interest in
scholarly collections (Figure 2.17). In collaboration with six international
libraries, and under the overall leadership of the Folger Shakespeare Library in
Washington, DC, Octavo had, by the end of 2004, digitised *all* the primary
resource materials related to William Shakespeare, including each and every
individual Quarto edition of Shakespeare's plays published before 1641. There
are over 300 such extant quarto-sized editions. They are held in the Special
Collections of at least six libraries in the UK and in the US.

Assembling all these primary Shakespeare resources into one single database
will create a central 'virtual' collection. Such a collection exists physically

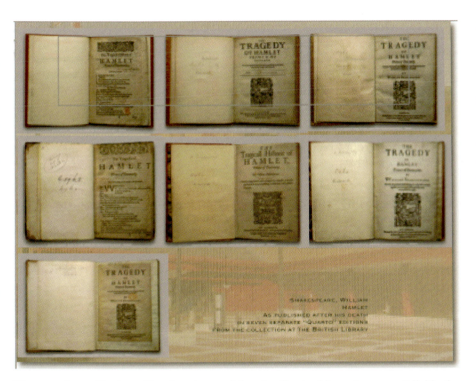

Figure 2.17

Octavo Collections
The illustration at the
left shows the title
pages of the seven
individual original
editions (known as
'Quarto editions'
because of their size)
of William
Shakespeare's play
Hamlet owned by the
British Library. There
are additional (and
variant) Quarto
editions in other
libraries. Octavo has
digitised all the
Quarto editions
of William
Shakespeare's plays
(wherever they exist
in individual library
collections).

The complete collection will only exist as a 'virtual collection' but – because of digitisation – can be assembled and made available anywhere in the world.

nowhere else in the world. The virtual collection will allow scholars to compare variant editions and undertake lexical studies from the comfort of their own 'desktops', wherever they happen to be. Such a massive collection will also challenge designers to provide suitable and easy navigation tools and software for comparing images. Such new resources can be used pedagogically. They might be enhanced for comparative studies. Portions might be licensed to third-party developers who might augment the images with pre-existing collections of scholarly and periodical literature. Individual Quartos can be downloaded and printed locally. Inexpensive print facsimile editions can be created for purchasers interested in the physical manifestation of individual copies.

Virtual collections inspire us to think in new ways. One can enumerate any number of discipline-specific collections that would be useful and attract wide positive attention. Virtual collections can, like SQDP, be assembled from the collections of several participating institutions. Virtual collections of important images can be licensed to third parties and augmented by their incorporating important related textual archives from their own collections. Eventually, virtual collections could include facilities for both student and expert annotations. Image databases could be equipped with infrastructure that would enable distance-education uses.

2.12.11 Octavo facsimile print reproductions

Digitised images of rare books inspire people. It will come as no surprise that some libraries, observing the clarity and fidelity of a digital image, believe that facsimile print reproductions of select images will highlight the impressive works in their collection and may bring it to the attention of a new appreciative audience in a new way. Octavo has partnered with a company to provide such facsimile print reproductions. It is startling to observe how rapidly this segment of the business is growing.

2.12.12 Licensing, sub-contracting, granting permissions for use

As the range of potential uses for high-resolution digital images grows, Octavo is faced with a business conundrum which (again) reflects a similar problem faced by directors and managers of libraries and cultural institutions. It is undeniable that demonstrating modernity and developing applications in response to user's preferences is an important way of drawing attention to more funda-mental and basic activities or products. Commercial marketing professionals call this 'branding' of one's corporate or institutional image.

Expanding activities or explorations into new related directions (like devel-oping new 'products', developing 'virtual exhibits', or making available facsimile print reproductions or innovative licensing contracts for Octavo) can reinforce the fundamental mandate of the company. Providing innovative access to their collections, can similarly enhance recognition of the mission of a library or museum.

The challenge faced, in common, by commercial entities, like Octavo, and non-profit cultural institutions, like Octavo's library partners, is to maintain a balance of the use of resources and to stay focused on primary responsibilities. That this is a difficult challenge is well demonstrated in a study written by Gerry Wall, who analyzed the cost/revenue realities among institutions involved with digitising their collections, aspiring to provide access as well as to generate needed revenues.[24] In this context, the twin strategy to sub-contract specialised work and to leverage the skills of respected partner organisations seems to make the most conservative sense.

2.13 The Future

The immediately preceding discussion emphasises the growing pressure by the end-users of digital images for additional values that make digital images of rare books more than merely a collection of 'pretty pictures'. The added values can be *technical* (improved navigation, susceptibility to alternative computer enhancements, hyper-linking to internally or externally related materials); *editorial* (interpretive essays, detailed caption or bookmark materials,

transcriptions, multi-lingual translations); or purely *commercial* (licensing for integration into textual resource materials, licensing for facsimile print reproduction, permissions for oversize graphic reproduction for exhibits or inspiration).

The values people find satisfying depend on what end-users want. Their desires change with increased confidence in the quality and reliability of digital images to represent reality. Expectations change when the imagination is stimulated. Experiencing new ways in which images of the most inspirational and important books of civilisation and culture are being harnessed for useful and interesting purposes is nothing short of exciting. What is undeniable is that the creation of value is a specific effort that costs human labor and considerable capital in its own right. Some libraries are beginning to question whether it is their responsibility or even within their capacity to engage in providing such enhancements. Following are some alternative conclusions that might be drawn from these considerations:

- Libraries will mutate into yet another form of cultural activity. One can trace the mutations libraries have undergone through the various synonyms that are sometimes used interchangeably to describe the work of libraries: repositories, archives, collections, catalogs, indexes, educators, cultural centers, and community centers. To these one might forseeably add 'digital publishers'.[25]
- Libraries will be wise to sub-contract as much digitisation work as possible. They should establish offices to license out wisely the use of their intellectual property (whether in physical or digital form) to experts who can most effectively generate revenues (some of which would be paid back to the library in the form of royalties) by adding value to the library's properties.
- The investment in digitisation (and the quality assurance that the resulting images are faithful, authentic, and comprehensive) is an activity proper to the cultural responsibilities vested in libraries. Systematic digitisation of their most important collections should be encouraged in place of grant-supported and opportunistic efforts.
- The Library community should encourage multi-institutional creation (or re-assembly) of collections as a high priority.
- All of the above.
- None of the above.

Each of these opportunities implicitly centers around the question: 'What deserves to be digitised'? Of course, *each* of these options *will be* undertaken. Any number of relationships to accomplish the creation of virtual collections *will* be negotiated. Individual passions *will* determine the course of much of what becomes available.

2.14 Conclusion

Perhaps the lasting truth that might be deduced from these reflections is that *content yearns to be seen.*[26] The corollary of this proposition is that if the content images are reliably faithful, authentic, and comprehensive, such images will long be appropriate for several generations of anticipated display technology and communication methods.

If no compromise has been made in the capture and quality assurance of high-resolution images (even at the equipment limitations of today), we can be assured that such images will be appreciated. We can count on their continuing to be as inspirational as the original works themselves. It is unlikely that we will repeatedly be afforded an opportunity to digitise the rare and precious volumes that are under a camera today. What we digitise must be considered to have been digitised for all time.

During and just after World War II many medieval manuscripts and printed works that were shipped out of harm's way from Europe to the United States underwent systematic microfilming. Only the highest quality of microfilm was used because that technology was the best then available. And the motivation for excellence was the clear knowledge of the vulnerability and transience of what were thought to have been secure and solid repositories.

Today, we are similarly confronted with the awful reality that our most secure and stable edifices are, after all, vulnerable and subject to destruction. This realisation should reinforce the opinion that digitisation, whenever it takes place, should employ the highest-quality equipment, be conducted in the safest procedural circumstances, and include the highest standards for image capture and quality controls. Ultimately, it is the *content* that counts, and technology is content's servant.

2.15 References

1. Some research – although not conclusive – suggests that digitization is somewhat counter-productive in that attention is drawn to the availability of an original. This, in turn, creates *greater* demand on the original, rather than *reducing* the demand for viewing and inspecting it. Most of these studies, however, preceded the wider acceptance and increasing familiarity by scholars of the advantages and limitations of digital images.
2. The Library Community experienced a similar exaggeration of claims about fidelity and usability when high-resolution flat-bed scanners were introduced and promulgated among libraries as low-cost solutions to the digitization process.
3. Rieger: *Preserving Digital Assets: Cornell's Digital Image Collection Project* First Monday, volume 5, number 6 (June 2000), URL: http://firstmonday.org/issues/issue5_6/kenney/index.html.
4. It is common, these days, to consider that the preservation of digital data requires a regular systematic process of 'refreshing' the electronic files. Typically, this means

rewriting the files onto new media, with error-checking algorithms employed, to be certain that no change or deterioration has been made from the original to the copied file.

5. http://www.octavo.com/collections/projects/gtnbbl/index.html.

6. See Johns, Adrian: The Nature of the Book, for contending claims about the invention of printing.

7. Metadata is now so widely used that its definition has become considerable stretched to include any textual elements that can be organized into a database and that describe a document in ways that can be made available to specialized search engines. Originally, bibliographic catalogue records were not considered examples of metadata, while the description of the cataloguing system in use was more properly considered metadata ('data about data.') Today, however, the term is much more elastic, since search engines can access full text transcriptions of book images, employing clever algorithms that involve not only character string matching, but analytics about proximity, sentence construction, figure of speech and can identify proper or common nouns as an aid in retrieving a specific idea or related reference.

8. Light is measured, by professional physicists, in a number of different ways, depending on its 'behavior'. Among the most common is the basic unit of thermodynamic temperatures as measured by the scale defined by Lord William Thomson Kelvin.

9. In general, one needs to compromise between the need to open the aperture to allow more cool light to expose the photo-optical elements, and the need to close the aperture to achieve satisfactory focus throughout the imaging process (known as depth-of-field). Once the compromise is reached, the ability to compensate electronically is possible.

10. As opposed to any of several lithographed and pre-printed commercially available targets. Octavo has adopted the GretagMacbeth DC target as the most sophisticated and densely coloured target available.

11. Bruce, F., Murphy, C. and Bunting, F. (2003): *Real World Colour Management.* (ISBN 0-201-77340-6) Peachpit Press.

12. To be sure, not all libraries have yet developed the policies and procedures that guide them in the proper storage and maintenance of such archival files. In the case of works imaged by Octavo's high-resolution equipment, each two-page spread could easily require 350 Mb of storage. A single book could involve half a terabyte or more. In addition, because the files are electronic, they would need to be refreshed to guarantee their ongoing retrieval, according to a schedule set (or still to be set) by the library community itself. These issues constitute an important challenge for policy makers among libraries today, especially those involved with digitization projects.

13. PDF = Portable Document Format. One of the most significant developments to emerge from the Adobe product releases was its Acrobat software that released documents from dependence on application software. If the software were made capable of generating a file in the PDF format, that file could be viewed, printed, and distributed in a platform-independent manner. Since its original release, Acrobat software has grown to include functions of considerable appeal to both the business and academic communities, including annotation, collaboration models, and even legal digital signature mechanisms.

14. Foremost among these might be the various CD-ROM editions produced by 'Voyager' in the 1980s.

15. The Bettman Archives, Academic Publishing's 'Image Database', and Corbis all provided interesting retrieval strategies for their collections.

16. Much of this research is now being conducted under the auspices of, or largely funded by, the Homeland Security Department.

17. Evaluating the accomplishment of the microfilming effort is bittersweet; and brings to focus some of the themes mentioned earlier in this chapter. There is no doubt that microfilming served to preserve and provide access to books and works of exceptional vulnerability and importance. The medium is also very stable. With the exception of some discolouration and fogging on film that was not properly developed, the microfilm medium has proven durable. Still, the technology was limited. Most of the images were captured in black and white. Those who performed the work were not always sensitive to capturing exposure scales and other metric guides with their target objects. And, of course, using microfilm readers does not belong to one of life's more pleasurable activities.

18. Cf.: http://www.bl.uk/collections/treasures/digitisation.html.

19. Alemneh, D., Gelaw, S., Hastings, K. and Hartman, C.N. *A Metadata Approach to Preservation of Digital Resources: The University of North Texas Libraries' Experience.* First Monday, Volume 8, Number 7.

20. Cf.: http://www.rlg.org/longterm/ for information on the long-term preservation of digital data. Cf.: http://www.rlg.org/preserv/diginews/ for an archive of technical and case studies on digitization efforts undertaken by libraries and museums and reported in the Association's excellent newsletter 'RLG DigiNews'.

21. McLuhan, M. *Understanding Media: The Extensions of Man* (Cambridge: The MIT Press, 1994). McLuhan first published his monumental work in 1964 (thirty-years since the current edition continues to be available.) In it, and in the subsequent hundreds of articles and several books be wrote, McLuhan explored the impact of technology on society and pop culture; and in turn, explored the impact on human communities and relationships. The issues raised in this textbook and chapter, insofar as they pose challenges for directions and responsible actions, would doubtless please the Canadian who has become known as the first father of the electronic age.

22. In its simplest terms, a *push* enterprise is one in which the seller creates an inventory of products *in anticipation of* a perceived audience for those products, and then attempts to 'push' the inventory into the marketplace. In an Internet-enhanced marketplace, one of the more successful relationship models is when the audience, itself, makes demands for products, and the seller is sufficiently savvy and nimble about delivering desired materials *on demand*.

23. http://www.octavo.com/collections/projects/wtnyos/index.html.

24. Wall, G. *Business model issues in the development of digital cultural content,* First Monday, Volume 8, Number 5.

25. The British Library's online 'edition' of Leonardo da Vinci's notebook, with its accompanying audio commentary is an example of such publishing activities. Cf.: http://www.bl.uk/collections/treasures/digitisation.html.

26. This trenchant observation was first concisely stated by Doug Rowan, CEO of Imaging Solutions, and former CEO of Corbis.

Digitisation Programmes in the V&A

James Stevenson

3.1 Introduction

This chapter describes the history and rationale behind the digitisation programmes at the Victoria and Albert Museum (V&A), the UK National Museum of Art and Design. The V&A was late to embrace digital technology in any form, and it was not until 1988 that the first computers were purchased to support business tasks. This was echoed in the way that images were captured and managed. Even as recently as 1993, photographs were still being taken with large-format cameras from the 1940s. Negatives were often 10×8 inches in size, wet-processed in dishes, with prints made by contact on photographic paper. Nevertheless the photographers within the museum's Photographic Studio were, and still are, extremely skilled at lighting cultural heritage objects to obtain optimum rendering of their appearance and surface texture. V&A publications have a justifiably high reputation for their image quality and V&A photographs are considered to be amongst the finest in their field. This chapter discusses how rapid changes have occurred in image-making techniques, how the digitisation of images is now managed and how the museum is starting to benefit from the creation of digital media. This is an evolving area within the museum and by no means have all ideas discussed been completely worked out. The chapter is not intended as a manual on how to undertake such a digitisation programme and readers may well find that their own practices suit them better.

The wide remit of the V&A means that the collection is large and extremely varied. There are reckoned to be over 4 million objects in the museum plus the archives. Many objects in the museum, however, consist of multiple parts. For example, a medieval manuscript may have 250 pages, each highly decorated and interesting in its own right. One relatively minor archive of photographs might contain 1.5 million images. Individual pieces within the museum that could be digitised, and would be useful for both visitors and for collections management, could easily be divided into tens of millions of items.

The V&A is home to many individual national collections that range from sculpture and portrait miniatures to photography and theatrical archives.

This diverse collection has always created a question of identity for the V&A. Many potential visitors believe that it only represents some image of Victoriana and are surprised when they visit to find the wealth it contains. Making the museum better known, particularly for these important national collections, is an objective for which digitisation can play a major role. The large number of objects in the collection has dictated the approach we have been forced to take in making images and has determined how we have developed our current programmes to make the objects available in a digital form.

3.2 Photography of the V&A Collection

The museum was founded in 1856 out of the profits of the Great Exhibition of 1851. Its aim was to be a source of inspiration for British design and to assist British manufacturing industries to aspire to high quality. Photography was still in its infancy in 1856, being only 17 years after Fox Talbot's presentation to the Royal Society of the Calotype photographic process. Henry Cole, the first director of the V&A, was a forward-thinking Victorian, who realised that the new technology of photography was the perfect means to fulfil one of the purposes of the new museum, that of disseminating knowledge of the collection to the widest possible audience in the UK and hence, providing a resource for the design and manufacturing industries. He employed Thurston Thompson as the first museum photographer, who in turn employed and trained a staff of twelve royal engineers as photographers. This complement of imaging staff has generally been maintained from that time to the present day.

A major advantage of employing a core imaging staff within the museum has meant that the build-up of image archives by the Photographic Studio has been continuous. There is a comprehensive archive of images from 1856 to the present day, an almost unique record of museum photography. Of course, most of this is in the form of black and white negatives and prints, with the first colour images not being made until 1956, but it allows researchers to see the appearance of objects as they were in the past, up to 150 years ago. There are still many examples where the only image of an object is over 100 years old. Unlike many museums, the fact that all of these images of objects are kept in a central archive means that the digitisation of this back catalogue is a much easier task than if it were dispersed throughout individual curatorial departments. The management of this archive has always been the responsibility of image professionals in the Photographic Studio (rather than librarians or curators), who recognise the value of photographs and the particular care needed to preserve them. This sense of ownership has protected the photographic archives from ill-informed museum managers on many occasions during their history.

The photography of museum objects needs to be kept simple, yet be of high enough quality to depict the object well. At the V&A, we have developed

standards of image making to cater for different project needs, based on three types of image:

1. A *record shot,* usually made by a non-professional image-maker and used for project preparation;
2. A *creative shot,* where the object is placed in a stylish context, used for publicity and promotion;
3. A *descriptive image,* used for digitisation projects as well as for catalogues and museum databases. This picture is considered as being closest to the experience of seeing the actual object without actually being in its presence. V&A photography has exhibited this quality throughout its existence and the underlying principles have remained consistent regardless of the nature of the photographic medium. It is recognised by museum curators as being the image of choice when describing cultural heritage objects.

Images in the collection have a multiplicity of uses by the museum as well as by the Picture Library for its external clients. The museum publishes up to fifteen books a year, most of which are heavily illustrated by the Photographic Studio. The Design Studio produces leaflets, guides, and publicity for the general public as well as specialist booklets for the Education Department. Perhaps the most important aspect of image making is as a complement to collections management. It was only a decade ago that people questioned the value of an image database, and asked why academics would possibly want to see images of objects against the curatorial record. As with most new technologies, now that it has been put in place, users have difficulty in working without it, and the association of a digital image with the record of every museum object is seen almost as a right.

3.3 First Steps Towards Digitisation

The initial driver for a digitisation programme was the commercial imperative of the Picture Library. Since 1856 this has always been the focal point for sales of V&A images to the public, and has operated as a place for picture research and support for academics and members of the public. In 1995 it was decided to update the provision of this service by automating the sales invoicing procedures and by installing a digital image database. The database selected was based on *MUSIMS Index+,* produced by System Simulation Ltd., which was felicitously the same product used for the museum's Collections Management System.

The development of the V&A web site has created a further demand for digital image content that is growing considerably as the museum tries to represent its physical installations by virtual ones. Already new gallery developments

and exhibitions can be seen as *Quick Time* panoramas and a selected few objects as 3D rotational movies. As staff within the museum recognise the potential of these new ways of visualising museum collections, they become enthused to employ this technology for their own museum web projects. Currently, web visitors can search through a database of approximately 15,000 museum objects. It is intended that 50,000 objects will be available on this database by 2007, including a substantial number of both QT and 3D image models.

The adoption of digital cameras and scanners to create digital files within the museum began cautiously, and has only become significant recently as client demand has caught up with the technical capabilities. Typical client demands include the need for images for fast delivery for press and marketing use, for virtual museum projects, for databases within the academic and research areas of the museum, and for collections management and the public galleries.

It is interesting to observe how this client demand is stimulated. The more that internal staff see digital images on museum databases, the more they realise their versatility. External client demand also plays a part; indeed this has been one of the drivers for digitisation needs in the Picture Library. However, for many non-creative staff, it is their personal use of digital cameras and computers that shows them how these technologies can be applied in the work place. It could be that their children's schoolwork illustrates the advantages of working in this way. Whatever the reason, the demand for digital images of the collection and museum events and activities is steadily growing and increases month by month.

In order to finance the production of digital files for the image database in the Picture Library, funds were diverted from the creation of the analogue print archive to digital scanning. At that time, neither the expertise nor the funds were available to undertake a scanning programme in-house, so we decided to purchase scans from an external bureau. A tendering process was undertaken with the requirement that bidders should fulfil several criteria: scans should be of high quality; they should be clean; museum documentation systems should be followed meticulously; and bureaux should prove that the handling of archive material conformed to accepted museum standards. Many candidates were dismissed on their inability to comply with this final condition.

A bureau was finally selected and the decision was taken to make scans in the Kodak PhotoCD format, to a maximum file size of 18 Mb per image. There were several reasons for this decision. PhotoCD was already an established standard for high quality digital image storage. The data encoding allows for representation of 'whiter than white' and 'blacker than black' tones. The format is versatile in that multiple file resolutions are stored within a single 'image pack'. The compression is lossless. The CD-ROM disk is one of the few physical storage media having a measured lifetime and it can be considered a reliable preservation medium. Each disk is manufactured with a unique identity number,

making the medium attractive to the V&A database software developers, because this unique id may be used for structuring image-loading routines.

A file size of 18 Mb rather than the maximum 72 Mb available was selected for reasons of price. With the likelihood of scanning a large volume of images, it was considered that the image detail contained within the 18 Mb format satisfied most of the predicted needs of the museum. If a larger area scan were needed, then later higher resolution scanning of those few originals could be undertaken on a needs basis. Practice to date has proved this to be a realistic approach, as most images are used in multimedia applications where very high resolution is not usually an issue. As digital print reproduction grows in the future, this approach may need to be reconsidered and more images may need to be re-scanned. However, with a collection as large as that of the V&A, the amount of re-scanning will always be a small percentage of the total.

As a leap of faith, we decided to start the scanning programme before the database was in place. This was a risk because we would be without the means to see the images created for some time. However, as there always had been a delay in making photographic prints for the analogue archive, we felt that this should not hinder picture research too much. The result was that we already had over 10 000 scans to load the database when it was eventually installed.

An unforeseen problem with PhotoCD was the fact that it was developed around the 35 mm film format, in which each frame has physical dimensions of 36 by 24 mm, and hence an aspect ratio of 3:2. When scanning formats of an aspect ratio closer to square – such as 5×4 inch transparencies, the major format used at the V&A – a black border occupies the unused area at the left and right of the digital image frame. This requires cropping, with a consequent reduction in file size. Most of the film images, particularly those of 2D subjects, contain Kodak colour calibration targets. One of our quality measures was achieved by measuring selected scans containing these patches and judging the results against known target values in *Photoshop*.

3.4 Image Identification

3.4.1 File-name

The Kodak PhotoCD file name has presented some problems for the future development of digitisation programmes, particularly as we have since moved to creating digital files from scanners and digital cameras internally within the museum Photographic Studio. PhotoCDs have a fifteen-character unique id number attached to each disk. This number is created during the manufacturing process and is in the format:

```
PCD123456781234
```

This number was re-structured by V&A software developers into three sections:

```
PCD             Prefix
123245678       Major id (the first eight characters)
1234            Minor id (last four characters)
```

Each image on the disk is named according to the following scheme:

```
img001.pcd
```

Therefore the complete file name for any single image file in the standard PhotoCD format would be:

```
PCD/12345678/1234/img001.pcd
```

Although this file number structure is simple for database systems to use, it is not intuitive for use by picture researchers or photographers during a digitising programme. Unfortunately, because of the physical arrangement of the digital archive, known as the Image Arena, this structure has to be maintained. In retrospect, it would have been better to assign each digital file a simple numerical id that could have increased without limit as more volume was created. In some ways this approach to creating numbering systems that have in-built meaning is a hangover from analogue cataloguing systems, particularly in museums where quick interpretation of an object's status or provenance could be made from its assigned number.

In order to use this structured numbering system for our own digital image files, from both scanner and camera, we have adapted the Kodak PhotoCD format. The number has now become:

```
Prefix          One of six tags, depending on the
                nature of the creation device:
DCH             Digital camera high resolution
DCM             Digital camera medium resolution
DCL             Digital camera low resolution
SCH             Scan high resolution
SCM             Scan medium resolution
SCL             Scan low resolution

yyymmdd         Major id in date format
                e.g. a file made on 15 June 2004 would
                be 20040615

1234            Minor id. This is a rising numerical
                sequence controlled by an authority
                list within the Photographic Studio.
```

Each image on the disk, now stored in the TIFF format, is named:

```
img001.tif
```

The full file-name for any single image-file then becomes, for example:

```
DCH/yyyymmdd/1234/img001.tif
```

This is still a complex identifier, but one with which a user creating or searching for images can associate some meaning for quality, creation method and creation date.

3.4.2 Object information

The final phase of the digital file creation activity is to relate each image file created to the subject depicted and to the analogue image from which the digital image may have been derived. In a museum context this is often a picture of a museum object, each of which has its own unique id number. For our database, these three identifiers are referred to as:

```
Picture Reference     Number of the analogue image
Image Reference       Number of the digital image file
Museum Number         Unique identity number of the
                      museum object.
```

When preparing a collection of photographs for a scanning session, a file is created which contains these three numbers. This is recorded in a spreadsheet as a comma-separated value file *.csv. The format of this file is shown in Figure 3.1.

This file enables the bureau, internal scanner operator, or photographer to keep accurate control of the images made during a batch or session. The number of lines in a file is limited to the total number of files that can be stored on a CD-ROM. For a PhotoCD, this meant a total of 100 images on a disk. When making TIFF files, thirteen 50 Mb high resolution or seventy 9 Mb low-resolution files can fit onto a standard 650 Mb CD-ROM. The csv files are stored in a secure directory on the museum network and are used to control the database image-loading routines.

3.5 Getting Started With Digitisation

3.5.1 Scanning

We decided that, in order to gain greater control over image standards and to reduce costs, scanning our existing analogue images in-house would be the

Figure 3.1

CSV file structure showing the individual numbers necessary for database management.

preferred option for the future. Due to our involvement in several collaborative projects in the European Commission's Information Society Technologies (IST) programme (see Section 3.7.3), we were able to purchase an industrial quality A3 flatbed scanner for digitising our large-format photographic negatives and transparencies. We also purchased a small-format 35 mm film scanner for our archive of 35 mm slides and negatives. These two scanners enable us to batch-scan volumes of photographs in a single session and to respond more quickly to business demand.

As we were able to dictate the workflow, we decided to use the TIFF standard for image files. Kodak PhotoCD is a proprietary format and its production was originally restricted to expensive proprietary systems. TIFF, being a general format, is much easier to use and universally acceptable. We also decided to increase the file size to 50 Mb in order to cater to a larger variety of demands, and to safeguard the future use of files.

There is still debate on the issue of file size in museums. One view is that file size and creation time are directly related and that, in order to be able to produce a large volume of content, only small files should be created. Others think that even large digital files are unsuitable for reproduction of fine detail and that only analogue photographs are suitable. In the opinion of the author, a 50 Mb file generated by a high-quality scanner will easily permit print reproduction of A4 size in a high quality fine-art publication. More importantly, the time difference between making small or large resolution files is insignificant in the total time involved in an image-making session. Storage volume and the costs of equipment and operation are the most important issues dictating the production of large volumes of digital image files.

The quality standard for scanning has been set by Photographic Studio with little input from other sections in the museum. Because there are potentially many different areas and a wide variety of uses for digital images, a simple base standard has been established. Scans are made at 16 lines per millimetre on the original, which equates to approximately 400 dots per inch (dpi), the largest image dimension being 300 mm. This produces an image file of approximately 50 Mb, which is saved as a TIFF format, in the Adobe 1998 RGB colour space. This satisfies most uses and exceptions are treated as special cases when required.

Material for a scanning session is selected primarily on business demand, dictated by the museum's projects and activities. Once a set of analogue images has been chosen for scanning, they are batched into groups that can be recorded on a single CD-ROM. A csv file is made, usually in Microsoft Excel, recording the three key numbers as previously described.

The production of digital scans is an interesting process for those with a photography background, because the imaging environment is familiar but slightly different. Much of the terminology is the same as in traditional photography and the understanding of analogue imaging sensitometry can usually be directly related to the computer desktop. This often makes scanning a natural process for photographers to adopt. Perhaps the most unexpected thing about scanning for a photographer is that it can be a slower process than black and white photographic printing. This often comes as a surprise and is still not fully understood by museum managers who naturally assume that new technology should always be quicker than older craft technologies.

Cleaning and removing dust and scratches by digital editing methods takes far longer than with photographic enlargers. The manufacturers of scanners could learn a lot from enlarger manufacturers, who over 150 years have almost perfected the craft of holding photographic material. In any scanning session, it is the cleaning task that takes the longest time. Of course, shortcuts and batch routines can aid this task but a policy decision has to be made as to how far to go with cleaning. At the V&A, we have decided that generally cleaning is best done at the scanning stage and is reasonably undertaken at a magnification of 50 per cent. If cleaning is left until the image is re-used, then pressure of deadlines often means that it is neglected. Neither can it ever be assumed that the final user of the images will undertake this task. Indeed it is rare to expect a designer or pre-print producer to undertake any form of critical image preparation on the raw file.

3.5.2 Digital cameras

The Photographic Studio at the V&A comprises a total of 17 staff, of whom 12 are full-time photographers. At a time when photography is evolving from analogue to digital, it is these numbers of staff who determine the proportion

Figure 3.2

Using the Sinar technical camera in the
V&A Photographic Studio.

of the budget that can be spent on the purchase of capital equipment. A national museum like the V&A is a relatively wealthy institution, but even for a museum such as this, large-format digital cameras have to be cost-effective. Care must be taken to obtain best value for money and to match cameras to the tasks required of them.

Photography of cultural objects in the museum is usually undertaken on a still life set. This means that the object is placed on a static background in a studio, and that there is no movement of the object during the photographic session. In order to capture images of the highest possible quality, with sharp focus, rich detail, and accurate recording of the object's shape, the large-format technical camera is an essential tool. At the V&A our standard camera is the Sinar 5×4 studio camera, as shown in Figure 3.2, which can be adapted to take 10×8 film when required. Our analogue photography was traditionally based on the requirements of the fine art publishing industry which typically produces large-format coffee table books with high print production standards as described in Chapter 5. The production of large format colour transparencies ensured that, when reproduced in print, museum objects were illustrated extremely well. It is this large-format high-quality photographic standard that has influenced our approach to the purchase of digital cameras. Sinar have a policy of backward compatibility and now produce several CCD digital camera backs that fit onto our existing analogue cameras. We delayed for several years the adoption of digital cameras because it was difficult to match the quality of large-format transparency film.

For the photography of museum objects, two aspects have always been considered: quality of image and time to make images. Because of the large collection of objects and the speed needed to turn over images, we dismissed the use of scanning digital backs. Even though this type of camera back is capable of achieving extremely large and high quality scans, they are too slow for the working practices at the V&A. Many have a scanning time of at least four minutes, resulting in substantial 'down time' for the photographer during a photographic session.

Fortunately, single-capture digital camera backs can now match our standard of between 35 and 50 Mb per image. We currently use the Sinar 54 digital camera back, which contains a 24 million pixel CCD that records images in 16 bits per colour channel. Though four exposures are needed to capture an image, this poses no problems as almost all of our photography is of static subjects. The cameras can be effortlessly linked to electronic flash so that the whole sequence of four images can be synchronised from the computer desktop. The photographic session then becomes similar to that for analogue photography. This has the advantage that the photographers can concentrate their efforts on the major tasks of lighting the subject and the creative process.

For the photography of public relations events and for specialist multimedia uses for the museum website, we have adopted the Canon 1DS, a portable 35 mm style digital camera. This has a CCD array with 11 million pixels, which produces a sufficiently large file for print and web designers to use details of images from the full frame without any appreciable loss of quality. Our decision to use Canon digital was made purely because we have a large collection of analogue Canon lenses and attachments that are equally useful with the digital equipment. These smaller cameras have also been found to be extremely useful for the production of QuickTime object movies and panoramas and for general purpose photography around the museum's estate.

3.5.3 British galleries case study

Between 1997 and 2001, the V&A undertook a major lottery-funded project to renovate a large number of galleries in the museum. These were themed around the history of British interior decoration from the Tudors to the Victorians. Twelve galleries were involved, containing up to five thousand objects. It was anticipated that 3500 objects would be displayed in the new galleries. A development in these galleries would be the museum's first major

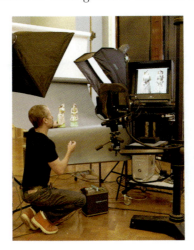

Figure 3.3

Using the large format digital camera in a museum gallery.

use of multimedia and would include a database and interactive displays that would describe various features of the gallery's story and be available for all visitors. At this stage, there were no digital cameras in the Photographic Studio, so we decided that all the analogue images captured would be scanned and processed for potential digital use. Scans had to be obtained externally, as our capacity to scan in-house was limited at that time. Because we could guarantee a high volume of images over the set period, we were able to obtain a competitive price for this work.

Before photography commenced, a quality-checking programme was undertaken to check all existing analogue material. Notes were made on the project database as to which objects had suitable existing images and which needed new photography. Project meetings were undertaken to classify the range of objects and their different workflows from removing them from display through temporary storage, conservation, photography to final re-display. In the photographic cycle, objects were moved from storage into the Photographic Studio, which underwent creative work, and then were removed back to storage. The analogue images were collated, catalogued on the image database, prepared for scanning with a csv file, and then sent to the scanning bureau. On receipt, they were processed initially for the internal image database and then for use on the gallery interactive displays and public database.

This project was an excellent testbed to prove that we could manage a digitisation programme of this size. It involved not only photographers and image managers, but also a team from all disciplines across the museum. The quality was found to be high and all deadlines were efficiently met. Subsequent public approval of the galleries (see Figures 3.4 and 3.5) and the multimedia presentations has been positive and has helped to create a confident approach to other such projects within the museum in the future.

Figure 3.4

Searching the object database in the British Galleries.

Figure 3.5
Interactive area in the British Galleries.

3.5.4 Collection services

Recent reorganisation in the museum has resulted in the formation of a Collections Services Department, which brings together several service departments under a single management structure. For the first time the Photographic Studio, Conservation, object technicians and movers, and the Records section now work together. This department has developed a series of so-called 'Gateway' projects, based on relocation of objects in museum galleries and stores undertaking because of building and re-development work. The Collections Services Department has taken the opportunity to catalogue the collections in detail and to create an image of each object involved. Some galleries being re-displayed involve the processing of over 3000 objects at a time.

It has become clear that, to be successful, digitisation projects need to be co-ordinated and multi-disciplinary. In order to achieve the degree of scale to make these projects efficient and representative enough of the collections to tell an effective story, tasks such as object movement are crucial. There needs to be an unobstructed flow between getting the object from its permanent location, moving it to the photography site, undertaking the photography, capturing catalogue information, and removal of the object to its final location. Scheduling these tasks is critical and the shorter the distance between the sites, the better. We have placed the photography, whenever possible, at the same site as the objects, either during their removal from a gallery or store, or next to their final gallery or store. During the planning phase, objects of similar size and format are identified and whenever possible grouped together, in order to maintain the photographic activity as consistently as possible without re-arranging the set-up.

3.6 Image Management

Image management is a new discipline being developed in the Photographic Studio at the V&A. In reality this has always taken place but somehow in the analogue environment, the task was seen as an extension of routine clerical tasks. Suddenly within a digital environment, the issues have become more complex. A wide range of computer skills is needed, many of which can be specialist skills at command-line level. Because the volume of data is potentially large and, unlike analogue photographs, images cannot be immediately spread out and sorted on a physical light box, the task becomes a virtual one where images are replaced by lists in a file structure. It is also more difficult to manage the process of creating and storing digital images, so meticulous record-keeping is essential to keep control of the whole workflow. Cross-checking of data has to be built into the process so that errors are automatically displayed.

3.6.1 Backup and image arena

At the V&A, we have introduced simple clerical systems to help keep track of the image management process. At the end of any session, either scanning or photography, the photographer creates a CD-ROM of the cleaned and finished master image files in a sequence that relates to their csv file identifiers. The workflow from this point involves recording the volume of images for general management information, and production of files for museum databases. Currently only the master image files are stored on CD-ROM, from which JPEG images are derived for display.

Raw file digital images are stored on CD-ROM in metal filing cabinets on the main museum site. When these raw files can be stored on-line on network servers, then the disks will be removed to the museum's off-site depository for greater security. We currently store only one copy of each CD-ROM which seems contrary to sound preservation advice. This indeed is true but the same risk applies with analogue photographs. Negatives are unique and glass plates, which we have by the thousand, are particularly fragile. The major disadvantage of having master files stored only on CD-ROM is the time taken to re-purpose files. Those clients who need access to large files have to rely on a service provided by the Photographic Studio for copies of images.

The museum databases are supplied with small format JPEG versions of the master image files. These are created in batch-routines and stored on-line in the Image Arena, held on a Solaris UNIX server in a flat file directory structure. Each record simply includes a reference to the image file and if it matches, the image is displayed on the record. The Image Arena stands alone and separate from the databases so that if more databases are created, enhanced, or modified, then the images can still be shown on their records. It also has the advantage that the digital image can be changed in the Image Arena without having to

make any changes in the database record. This separation of the images from their records endows the database with a degree of independence, enables image managers to enhance the services to clients and gives them the freedom to make changes when necessary.

Databases and the Image Arena are backed up on magnetic tape drives independent of one another on a daily basis when activity is quiet, usually in the late evening. Due to the growing size of the Image Arena, it is backed up incrementally so that only new or changed content is added to the previous back-up.

3.6.2 Image cataloguing

Images are catalogued on the image database. This involves assigning a unique Picture Reference number to each image record, adding keywords and caption information and collating technical metadata regarding the creation of the image. The quality of this information is critical when it comes to retrieving images from the database (Figure 3.6). Searching for images is an intensely subjective activity and each picture researcher brings his or her own expectations to this task. The richer, fuller and more accurate the catalogue information, the greater the satisfaction of the researcher with the results.

Recently, the Collections Management and image databases have been linked together so that some curatorial authored fields can now be shared. This reduces redundancy of information and increases the potential for establishing authority lists of common terms. Linking the two databases has been one of those small technological changes that allows for substantial improvements to

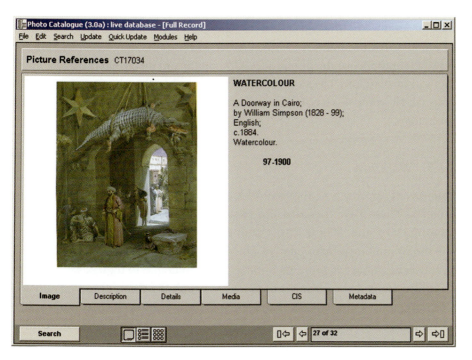

Figure 3.6

Front page of image record from the image database.

Figure 3.7

Ikat pattern textile.

work practice. Although outside the scope of this chapter, it will radically change some of the workflow issues encountered in the image-making process.

The V&A has been a partner in two EU-funded projects in the Information Society Technologies (IST) programme: ARTISTE and SCULPTEUR. These projects aimed to develop improved methods for searching image databases with a combination of text terms and image content. The algorithms allow searches to be made by similar colour, similar texture, by a primitive rendering of the image such as a fax, and by a detail of the image. In ARTISTE, this was achieved across multiple distributed databases over the web. It is our intention to add content-based searching to our image database and subsequently to the museum website.

Many objects in the V&A collection depict abstract patterns that are difficult to index and classify beyond the most simple object description terms. There may be several hundred images of a single object type such as Ikat textiles, all of a similar texture pattern (see Figure 3.7), where text descriptions alone are insufficient to record the differences. Opening up an image database to a novel method of searching based on image content rather than by text alone is still unusual. However, this has the potential to develop new markets and applications for images.

3.6.3 Workflow

Our recent approach to digitisation has been dictated by museum-approved projects. These have included the New Opportunities Fund (NOF) projects 'Moving Here' and 'People Play', the museum web-based 'Collections On Line', and the continuing development of gallery-accessible databases. Thus in addition to converting image capture technology from analogue to digital, we have also radically changed the workflow of images through the Photographic Studio.

Photographers now have to take a greater responsibility for accurate record-keeping than before. In an entirely analogue world, the catalogue data can be

interpreted according to the context and conventions of the museum. For example, the syntax for museum object numbers is critical for computers but not so for human beings. The absence of dots, slashes, and colons in an object number generally does not prevent a curator from understanding it. For a computer, however, the lack of a single dot may render the identifier meaningless. This change in the required level of accuracy is new to the photographer, and indeed to the curator who, during the digitisation process, must ensure that quality standards are maintained.

The previous sections have described in detail how digitising programmes have evolved in the V&A and are managed today. The flow diagram in Figure 3.8 illustrates the care taken throughout the process. Each stage is designed to keep careful management control, and to ensure that errors are found, checked and corrected.

3.6.4 Colour management

For reassurance of control over the digitisation process, we have installed the Macbeth Eye One system for calibrating digital equipment and profiling colour spaces. As we have created more digital content, the users of these images have become more critical of quality and their expectations have been raised for embedded colour profiles. Though the basics are relatively simple, the task of actually controlling colour in monitors, cameras and scanners is in practice quite difficult. Making the calibration software behave correctly with the different types of software, and when necessary, overriding each manufacturer's default profile, is actually quite frustrating and difficult. The effort of implementing this into the normal production cycle is worthwhile, however, as the benefits can quickly be seen. Printing, in particular, becomes a much easier task with less waste and more accurate results.

In order to assist the colour management process, all photographs of 2D objects and some 3D objects have a colour target included in the subject scene. Traditionally for many years, this was the Kodak colour patch, but this has been superseded by the Macbeth Color Checker chart. In order to make best use of the chart, which is too large for many V&A objects, we have made our own small customised charts from patches cut from the Macbeth chart. These contain a 6-step grey scale, the six primary and secondary colours (R,G,B,C,M,Y), the V&A logo to check image orientation, an arrow to point to the top of an object, and a 5 cm dimensional scale, as shown in Figure 3.9. These features assist in the reproduction of abstract objects, of which there are many in the museum.

The first step for successful colour management is correct calibration of the monitor. All monitors in the studio are calibrated to a white of 6500K and a gamma of 2.2 for PC and 1.8 for Mac. This task is undertaken weekly for

Figure 3.8

Workflow in the V&A
Photographic Studio.

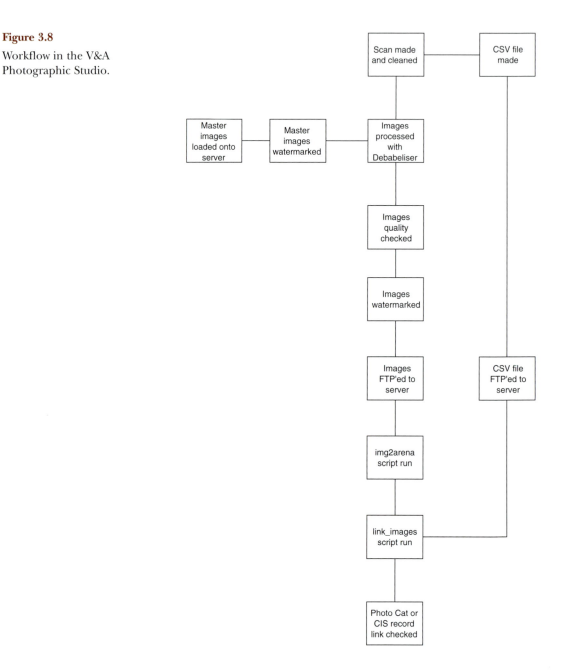

each monitor. The profile based on this calibration is stored within the computer
and is overwritten after each routine calibration.

The active publishing programme at the V&A produces twelve to fifteen new
books per year. As we undertake some of the production of these books entirely
digitally, it is necessary to have accurate control of the colour profiling so that
the printer has confidence in his final output from his press. Print houses at
many locations around the world produce these books, so the actual print

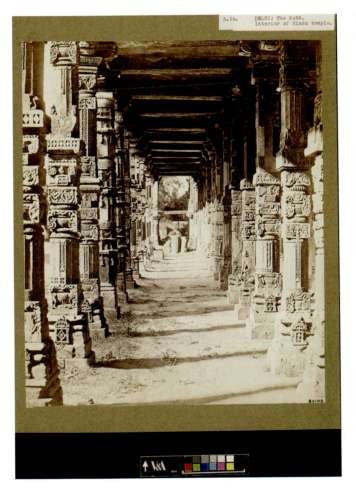

Figure 3.9

Image containing the V&A colour target (bottom) for colour calibration. The vintage photographic sepia print shows the interior of a Hindu temple in Delhi.

colour profiling has to be undertaken by the print houses themselves. In order to assist them in printing these images correctly, we supply all of our digital images encoded in the Adobe 1998 RGB colour space, which have been assessed on our calibrated monitors. These files are accompanied by a set of proof prints made on our own profiled ink-jet printer, which again are assessed against our calibrated monitors. Prints are viewed in a standard viewing booth under D50 illumination.

3.7 Imaging Applications

3.7.1 Printing

A large volume of black and white negatives has traditionally been printed and supplied as analogue photographic prints. Throughout its history, the V&A Photographic Studio has employed a member of staff solely to undertake

this work, and until recently this was the only practical way of supplying images from these negatives. On the retirement of the most recent holder of this post, it was decided that it was an inefficient way to continue with this service, so a new approach is to be taken. Any request for a print from an analogue image in the archive will henceforth be processed by entirely digital means. Each negative will be scanned, the file stored and processed for the museum databases, and digital prints will be made on a photographic quality inkjet printer. The rendering of these printers is now so good that their prints can barely be distinguished from analogue prints for most uses. Of course exhibition quality fine art prints will still need to be made in the traditional way for some time, but this type of work will become a craft skill in a way similar to the way that silkscreen printing has become to the print trade.

There is a great deal of time saved by this approach. After scanning, the image printing can take place unsupervised as a batch process during down time, such as overnight, and more importantly the file can be re-used for further printing at a later date. With traditional analogue photography, once a print had been made and handed over to a client, it was gone. For a repeat order, the whole process had to be undertaken again from start to finish. For digital files, however, subsequent prints take only a short time to produce.

3.7.2 Multimedia content

A benefit of digitisation projects is the ability to use digital photography to show museum objects in novel ways through multimedia techniques. At the V&A, we have been making *QuickTime VR* object movies of museum objects and 360° panoramas of museum galleries. In order to make these panoramas, we use a 35 mm type of digital camera. It is placed on a tripod with a panoramic mount, which enables an accurate, and perfectly level series of images to be made in a sequence of one full rotation of 360°. Typically we take 36 images at 10° intervals, which are stitched together into one long image using VR Worx software. This panoramic image, as shown in Figure 3.10, is then virtually wrapped into a cylindrical shape. Using Apple's *QuickTime* movie player, the viewer is then placed at the centre of the cylinder and can interactively 'look around' at the panorama. See Chapter 17 for a more detailed discussion of panoramic imaging.

Figure 3.10

Panoramic image showing a 360° view of the Sculpture Gallery.

Rotating 3D objects are made in a similar way with the same software. Objects are placed on a motorised turntable and a series of images is taken with a static camera as the object is rotated through 360°. When the images are stitched together into a .mov file, they can be viewed by a *QuickTime* player so that the viewer can turn around the virtual object at will.

These capabilities enable museum visitors to the museum website to see objects in the round. When coupled with structured text about the object, they allow a better developed story to be told, which hopefully enhances the viewer's understanding of the object.

We have also been experimenting with the production of 3D image models of cultural objects. Our work in this field is still in its early stages and there are many issues to resolve, particularly with the production of large volumes of 3D images. A series of images is captured in a similar way to that for rotational movies of objects. In our case, we have used GET ENST software to convert these images into wire mesh 3D models. JPEG images of the object's surface are then wrapped as texture maps onto the wire mesh to create the 3D effect. The viewer can see and move the virtual 3D model through all its facets using the Cortona VRML viewer. Such virtual models enable a deeper understanding of an object, because they contain information about its structure as well as its appearance.

3.7.3 Research

The more that digital images are seen, the more demand there is to re-use them for other projects. During the last few years, our digitisation efforts have been quite successful and at the time of writing our image database illustrates 85 000 objects. This database is available on-line to all staff in the museum from their desktop computers. It is now routinely used on most museum projects such as exhibition and publication preparation and by curators for preparing talks and lectures. This familiarity with using images for research purposes has stimulated projects where digital images are used in their own right. The museum website is an obvious showcase for the collection and recently we have re-processed over 15 000 digital images for this purpose. We are also contributors to the educational resource providers AMICO and SCRAN. In addition, we routinely supply V&A Picture Library clients with image files.

The V&A Photographic Studio was one of the first in a UK museum to participate in externally funded research projects. The V&A has been a partner in several EU funded Information Society Projects; ARTISTE, ARCO and SCULPTEUR. Working with technical partners from Southampton University and Sussex University, NCR and the French École National Supérieure Telecommunications (ENST) has enabled the photographers at the V&A to develop new methods of managing multimedia. These projects have all been

based on developing systems to create, distribute and manage multimedia assets created in cultural heritage institutions.

ARTISTE and SCULPTEUR were concerned with the development of image and general multimedia databases to include content-based searching. SCULPTEUR attempted to apply these features to 3D virtual image models. ARCO took 3D image models of cultural objects along with their associated metadata, and used them as features in user-defined virtual environments such as virtual galleries. Involvement with ARCO and SCULPTEUR has enabled the V&A image makers to develop new techniques of image modelling, which will be increasingly used in the future.

The role of the V&A Photographic Studio in these projects was to provide content for the technical partners, to create visionary scenarios and to test the prototype virtual environments. The results of these projects were very encouraging and indicate that within a few years web users will be able to interact with museum objects in new and exciting ways.

3.8 Future Plans

This chapter has shown that a lot of effort and investment has been spent in bringing the V&A into the twenty-first century in terms of advanced digital imaging technology. Over the past few years, the museum has made a great deal of progress in undertaking digitisation of its image collections. This has resulted in a large body of work, which is now starting to be seen in the gallery displays and on the museum website.

Because of the nature of the V&A collection, which has images of many abstract patterned objects such as textiles, wallpapers and designs, content-based image searching will be applied to the museum's multimedia databases. These features will provide a unique way of classifying and accessing images of cultural heritage objects.

There are two classes of user of digital content in the museum, the general academic researcher who needs to visualise objects, and the creative professional who needs to develop presentations from this content. Both of these classes, as well as external users, would benefit immensely from a Digital Asset Management (DAM) system. As the volume of images created and used by the museum grows, the installation of a digital asset management system is seen as the next important technological step forward. The potentially vast quantity of digital images and multimedia content that could be generated at the V&A can only be successfully managed with a DAM.

Client-controlled access to content would then become possible, speeding up delivery and user satisfaction, and transaction control would be more efficient, freeing up considerable management time. In general, digital asset management appears to be essential for the success of digitisation projects in the cultural

heritage sector. In a knowledge economy, museums could become the 'content coalmines' of the future, supplying large amounts of structured information to creative users. To do so, they must use the most effective tools for data delivery and DAMs offer a way to achieve this.

Cataloguing, storing, and searching for 3D multimedia content present new challenges. As these types of multimedia are often constructed from a series of still images, the linking of each separate element to the parent image must be precise. A versatile DAM system will assist with this, as the current Image Arena is limited to showing and storing JPEG images only. To link these other forms of multimedia content to image records will require enhancements to our current databases.

The V&A Photographic Studio employs twelve photographers, one of the largest complements of such staff in a UK museum. To supply all of these photographers with digital cameras of sufficiently high quality to match V&A imaging demands is a high capital expense. The cameras we have selected, to allow us to make high quality images, in a fast productive way, cost in the region of 35 000 Euro each. To supply all of the staff with this equipment would cost the museum perhaps another quarter of a million Euro. In order to do this, the V&A will continue to bid for external funding for digitisation projects in order to support the purchase of capital equipment. Until all image capture can be undertaken digitally, the Photographic Studio will continue to undertake analogue photography on large-format colour transparency, and then scan the images to add to the digital archives.

Digital capture enables photographers to shorten the time for the image-process cycle. The next few months will see considerable management time devoted to developing process routines so that the whole workflow from commission, through image capture to archiving and linking to database will take place entirely from the photographer's desktop. The objective is to reduce the length of time from commissioning to image delivery, thereby satisfying client demand for an efficient service. No doubt the result will be an increased demand for this fast service which will in turn spawn new types of image services, as yet impossible to imagine. Part of this evolution will be the fully digital development of reprographics, with a seamless transition between image production and press printing.

All of these ideas and developments will enable two-dimensional and three-dimensional virtual image models of the museum's collection to be presented to an ever more sophisticated and disparate audience. This is critical to the mission of the V&A and is part of the agreement that all government-funded museums have undertaken as part of their budget contract with the Department of Culture Media and Sport (DCMS). The museum website allows the collection to be seen in a comprehensive way, not only in the UK but from anywhere in the world. The museum visitor of the future is expected to become

increasingly a virtual visitor to a virtual collection. Digitisation of the collection is the key to achieving this goal.

3.9 References

John Physick (1975). Photography at the South Kensington Museums. HMSO.

ARTISTE Cultivate paper http://www.cultivate-int.org/issue7/artiste/

Digicult DAM http://www.digicult.info/downloads/
thematic_issue_2_021204.pdf

V&A website www.vam.ac.uk

People Play www.peopleplayuk.org

Moving Here www.movinghere.org.uk

ARCO www.arco-web.org

SCULPTEUR www.sculpteurweb.org

Baxes, G. A. (1994). *Digital Image Processing: Principles and Applications.* John Wiley & Sons.

Giorgianni, E. J. and Madden, T. E. (1998). *Digital Colour Management.* Addison-Wesley.

Evening, M. (1998). *Adobe Photoshop 5 for Photographers.* Focal Press.

Stevenson, J. (2000). Image metadata and quality modifiers. *Journal of the Association for Historical and Fine Art Photography.*

4

Digital Access to a Photographic Collection

Andrea de Polo and Sam Minelli

4.1 Introduction

Today, the world is filled with images. Thanks to technological innovations in the communication sector, television, broadcast programmes, satellite connections, pay-per-view technologies, and fibre optic communications, images are becoming less expensive and ever more widely adopted. In addition, with the spread of the Internet, data and multimedia content such as clip art, movies, still pictures, soundtracks, etc. have become much more accessible.

In the world, there are both profit-based commercial enterprises, and non-profit educational institutions. Especially on the Internet, many users have focused their work to create and use content provided on-line by those enterprises and educational institutions. For commercial companies, lawyers, end users, and Internet providers alike, it has therefore become quite difficult to define, manage and verify the intellectual property rights of what they can find on-line. Moreover, since the Internet covers the entire world, very often the regulations and rules of some countries might be in conflict with others. Therefore, it is becoming very complicated to manage and clear copyright over the Internet, because through the functions of web mirrors, servers, remailers, anonymisers, and strong encryption keys, to say nothing of hackers and spam, it is difficult to identify the end user or track down his/her routing.

This case study describes the main issues for the Alinari Photo Archive and similar commercial companies in seeking to digitise their content and provide it on-line for educational and business usage.

4.1.1 Company background

In 1852, Leopoldo Alinari, with his brothers Giuseppe and Romualdo, established the photographic workshop in Florence, which is at the heart of the firm still bearing his name. It was the beginning of a unique visual experience which, focusing on the themes of photographic portraiture and views of works of art and historical monuments, immediately met with outstanding national and international success.

Fratelli Alinari is now the world's oldest firm operating in the field of photography, in the fundamental sector of images and visual communication. It is structured into several departments and activities:

- Museum of photography
- Picture library
- Art printwork
- Publishing house
- Restoration/conservation laboratory
- Exhibition space
- Digital and multimedia department
- Library of history of photography
- Showroom/bookshop.

The Archive preserves over 3.5 million vintage images from all over the world. The history of Alinari coincides with the very history of photography. The creative activity of its dynasty of photographers is at the heart of the great heritage housed in the present archives. It is a heritage which is growing ever larger and which, thanks to a sensible policy of new acquisitions and new photographic campaigns, ranges from daguerreotypes to modern colour photographs. Alinari is today the leader in traditional and multimedia photographic publishing and is synonymous with the highest quality in the production of artistic prints. The company represents an irreplaceable landmark for preserving, cataloguing, disseminating and handing down Italian and European history, society, art, and culture through the medium of photography. Stock agency partners include: Bridgeman, Courtauld Institute, Giraudon, RMN, Roger Viollet, Interfoto, Ansaldo, Touring Club Italiano, The Italian Ministry of Culture, Istituto Luce and Corbis.

An integral part of the Alinari Museum is the Library of History of Photography, from the origins to the present day. Open to the general public and to scholars, it houses all the company's publications, the major historical and artistic reviews on photography published in Italy, and all those very famous and much sought-after treatises and handbooks which, for years, have taught photographers 'their art'.

Alinari is currently in the process of providing the historical archive online, through the 'Save our Memory' project. The aims of the project are to catalogue, restore, digitise and retrieve images via the Internet, through a powerful but easy-to-use English – Italian database together with a large portion of the photographic collection. A first corpus of 250.0 images is already online and 300 images are added on a daily basis. Alinari has preserved the atmosphere, the soul, the spirit of the 1800s and today, it has to make major technological changes in order to fit into this competitive business.

4.1.2 European project activities

Alinari has participated in and contributed to several European research and development projects. These include: IMPRIMATUR (a project investigating

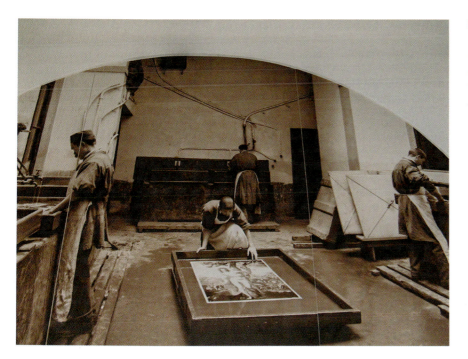

Figure 4.1
Nineteenth-century
system for reproducing
the older artisan way.
Copyright Fratilli
Alinari, Italy.

early adoption of e-commerce and watermarking technology across Europe);
AQUARELLE (a large European network of content providers and technological
suppliers using SGML protocol for sharing complex multilingual databases);
RAMA (a network of prestigious archives and galleries connected through
a common interface), MIGRATOR2000 (a JPEG-2000 image compression devel-
opment project); VICTOR (a solution for sharing quality content in remote
Greek islands); REGNET (a network of European photographic archives);
ORPHEUS (an e-learning, multilingual solution photo repository for European
high schools and universities); 2KAN (a benchmarking and validation project
regarding JPEG-2000); Today TNT (a secured network to spread out e-commerce
offers for photographic archives); ECMADE (a market validation architectural
portal of virtual exhibitions); SCHEMA (a content-based retrieval analysis bench-
marking study); a Network of Excellence project which aims to create a new
online solution for content-based retrieval); ERMIONE and EURIDICE (two
eTEN market validation projects focused on e-learning); eCHASE (a research
project for improving access of digital libraries using advanced searching tools
and AceMedia (an in-depth study about ontology, semantic web, JPEG-2000
and wireless solutions for home usage). Alinari is playing a vital role in these
projects by providing know-how, e-commerce capability, Intellectual Property
Right management, and has been involved in the MINERVA initiative, with the
scope to provide best practice in the field of IPR and DRMS image protection.

4.2 The Alinari Photo Archive

4.2.1 Objectives

The Alinari photographic archive aims to make available a range of services targeted at the educational institutions and professional business sector through the entire web. Thanks to a sophisticated system of copyright management (watermarking on the fly) and the enlargement of images in real-time (XL Image technology), the Alinari online system provides advanced and efficient services for students.

The photo archive is based on an innovative idea, especially as it concerns services covering the critical and problematic digital content sector. Content enables digital products and services for the 'new economy' to stand out, and therefore it is a significant factor for the added value of those digital services and products. A competitive and dynamic digital content sector in Europe and abroad is a major prerequisite for success in the new economy.

4.2.2 Description of services

The online service has a registration/subscription approach so that users can preview low-resolution images, enlarge the details, and print. It supports the introduction of new forms of co-operation between different stakeholders (cultural institutions, universities, archives, professional translators, etc.) by setting up a technical infrastructure and organisational framework to permit visits to virtual archives and remote interaction services with the database. Cultural stakeholders are institutions holding valuable content such as a photographic collection or a museum/gallery preserving an important corpus of objects/artefacts.

In order to define the database architecture, we first need to define services and target users. The service offered consists of making available through the web, photographic images from both historic and contemporary archives, captured from all over the world during more than 150 years of activity. Images were specifically selected for the educational and business sectors. Besides Alinari resources, other digital archives have been contacted to verify their interest in accessibility through the same website. For this reason, the database platform must be as standard as possible: both from the point of view of both professional users (engineers, developers, catalogue experts, …), and end users.

Users are able to search for, examine, select, and download images in which they are interested simply by means of the Internet connection to the website. The on-line application, featuring high quality variable-resolution image capabilities, is accessible by a subscription, according to the type of user and the use of services. From the main Alinari database, the user has the possibility to navigate through low-resolution images and print photographs. A short string

of text is normally associated with each delivered image describing its content, title or other cultural references. The localisation of the textual part of the archives in several languages (Italian, English, French, German, Spanish, etc.) allows the fast promotion and dissemination of services.

The existing Alinari search system allows navigation and search by:

- Field (author, subject, site depicted, date, photographic technique);
- List (artists and photographers, personalities, events, photographic movements);
- Boolean (and/or/not) and other operators;
- A variety of thesauri (iconographic, geographic, period and style, type of work).

The distinctive features of the new service are as follows:

- Consultation of the digital database requires entry of the username/password.
- The registered user may then browse with access to images via the XLImage tool for zooming large size images.
- All pictures carry an invisible and unique ID along with a visible hallmark identifying the ownership. For the 480×480 pixel images, a dynamic signature is applied at the bottom of each file, constructed in real-time, with the date, time, picture ID, user ID and IP address of the end user. This information is also recorded at the same time in the main server tracking system. Alinari believes that using the 'watermarking on the fly' technology is a very good way to discourage illegal use of the images.
- The pictures may be used for educational (non-profit) or business (profit) purposes.
- The navigation process is fast and efficient, thanks to a dedicated high speed Internet connection, a 'lightweight' website design and a very reliable and stable image retrieval system. A very complex search with multiple words usually takes no more than a few seconds, and the overall system is written in a standard programming language for easy porting and integration.
- The language selection is performed through a common entry page. The main site has two directions; the entrance to the main picture archive database (through a login process) and a virtual tour which also explains the objective of the system. Most attention is paid to assisting the user during navigation and system interrogation; the help tools work like a virtual agent to provide instant advice and suggestions.
- Access to the web site is guaranteed by a couple of keys (username and password) stored in the user's database table. The keys are generated by the administrator.

Protection of the valuable content is assured by the ImageBridge Pro solution provided by Digimarc Corporation. All Alinari images are statically water-marked during the digitisation process (a code identifying the ownership is spread invisibly all over the digital file). Moreover, the high resolution photographs are also protected, but in this case with a dynamic watermark, applied on-the-fly. This means that the original file can be stored on the server without

any digital protection. When the user makes a request, the server applies the watermark automatically to the image before downloading it. The advantages of this solution are: (a) the image is always protected with the latest version of the software available; and (b) the server tracks in real time the usage of the images (web spider), and statistics of the most requested images are generated (mainly for marketing and business reasons) very precisely and easily.

The Alinari repository is offered to two different kinds of user groups:

1. Professional and for profit business users such as: stock agencies, photographers, webmasters, designers, journalists, editors, publishers, profit organisations;
2. Educational users such as: students, professors, scholars, researchers, museums, historians.

Images can be used for different purposes: personal usage, internal decoration, articles, studies, workshop, business, public location (for example to decorate the façade of a building), website, and so on. The user must clear the copyright by defining with the Alinari licensing office the exact usage of each specific image (this operation can now be carried out easily online). Once the user enters the site (either education or business web server), he must agree with the terms of copyright usage posted online before downloading any image from the Alinari server.

4.3 Architecture of the Database System

The database (DB) architecture must take into account different functionalities and processes:

- Image selection and storage
- Digitising process
- Quality management
- Cataloguing: populating the database
- Revision activities
- Search engines modes
- Testing and monitoring.

The system has a client/server architecture with a web interface for all stakeholders (internal developers, external personnel and end users). Images are selected by the professional team and picture curator from the archive. All digital files carry out their unique ID number, associated with the correlated exit, metadata and ontology information and the appropriate Apple ICC ColorSync profile.

4.3.1 Digitising process

Before digitising the images for online photographic services (education and business), the Alinari team carefully selects the best images that meet the

requirements for the professional and e-learning sectors. The selection of the images is based on criteria such as:

- Originality of the photograph
- Artistic importance of the work captured
- Quality and conservation status of the medium
- Importance of the overall content for the market needs
- Genre and topic addressed by the photograph.

Once the images have been selected from the large photographic repository, they are classified in terms of the importance of the photograph for the end user, and its conservation status. Badly damaged photographs are first carefully restored. All media are treated with care, for example by using special cotton gloves and storage in acid-free boxes. When being digitised, the approved images are first assigned a unique collection and picture ID number (which identify the photographer's name and collection corpus). After the digitisation is completed, the image is properly classified using the extensive Alinari iconographic and professional thesaurus tree.

The images are acquired in digital form using the Kodak (Creo) EverSmart Supreme scanner (maximum of 4.3, with 5400×14000 dpi all over the scanning area) for slides and large images, and with a Leaf Valeo 22 megapixel digital camera back for oversize prints and projects that require high overall flexibility and fast delivery time. The Creo scanner is used for images that have a high dynamic range, mainly negatives and transparency slides, while the digital camera back is used to reproduce delicate vintage photographic albums or 3D objects such as images mounted in oversize frames.

Once the images have been digitised, they are stored in one host computer for quality control:

- Check if digital restoration is needed (clean scratches, remove dust, holes, resizing ...).
- Check colour quality.
- Direct comparison of the digital print with the original.

The photographic retouching is done mainly in Adobe Photoshop, using well-trained operators. In the market, there are several tools to retouch the files automatically (ASF Digital ROC, Extensis's Intellihance, Grain Surgery, Image Doctor, ...), but in the company's daily workflow, the 'old way' of using mainly the advanced Photoshop tools is still preferred, at least for cases of post-processing. Photoshop provides the best defined manual settings to control the results properly after the restoration has been done. Performing automatic operations can sometimes create unwanted results (unsharp images, 'non realistic' photographs, etc.).

The whole environment has been adapted to meet the most severe require-ments in terms of calibration and consistency of the workflow. The walls have been painted with grey of 18 per cent reflectance and the fluorescent room lights have a calibrated colour temperature. Atmospheric dust is reduced to the mini-mum and each Apple Macintosh workstation uses a 5000K calibrated display to check the colour accuracy of images. Last, but not least, the whole digital work-flow is monitored by a supervisor who ensures the maximum accuracy and consis-tency of the digital data. The digital files are optimised on different workstations for colour accuracy, cropping, image enhancement, gamma characterisation. All digital files are compared with the vintage (original) photograph. It is important to explain that certain images may require double-checking of colour and hence, on request, certain critical files are printed for colour proofing.

The proper ICC colour profile is embedded in each image file, to create stand-alone files that can be printed anywhere and provide the same colour rendering. The colour profile chosen is Adobe RGB-1998 because it is a popular and well-known colour space used by many photographers, laboratories, and agencies around the world. This colour profile is verified during the monthly colour calibration operation, with the aid of a spectrophotometer and the Gretag calibration software and IT8.7 calibration targets for the various devices (scanner, monitor and printer). The system is deemed to be calibrated only after each device has met the colour tolerance figures and a calibrated colour chart has been printed and double checked.

Each image file is finally saved in TIFF format of average dimension 4000×6000 pixels, which can cover an A3-size page printed at photographic quality. The resolution of 305 pixels/inch (12 pixels/mm) is used because it is considered in the desktop publishing and photographic fields to be sufficient for good quality results. In fact, a higher resolution in most cases would not produce a better image quality, but a lower figure might show up some defects or image degradation.

A colour image therefore requires 30–80 Mb (depending on the size of the original) for an uncompressed TIFF file, around 10 Mb for a JPEG file (with the least compression/best quality) and around 5 Mb for a JPEG-2000 file (lossless, no image degradation). The large amount of memory necessitates very expensive storage systems. Because storage space is still expensive (and time consuming to be moved around), Alinari is currently converting all its digital content into the JPEG-2000 lossless file format. Thereby, images can finally be compressed with benefits to the content provider (and end user) such as:

- Small file size (JPEG-2000 can save around 35 per cent more space than JPEG at the same compression level);
- Much better image quality when restored after compression;

- Error resilience (the file can still be opened/displayed even if damaged during transmission)
- 3D volumetric support;
- ROI (Region of Interest) selection of part(s) of the image that can be zoomed at higher resolution.

The proofing is done using GMG RIP software, which gives consistent proofs and high quality colour matching prints. The results of printing a given image on different printing devices or substrate can also be simulated. The image files are finally saved into two data storage media: a Pioneer DVD-R 4.7 Gb disk and on 650 Mb CD-ROMs. The DVDs are kept at Alinari offices (off-line), in a 720 juke-box rack, while the CD-ROMs are sent to a building outside the city, for disaster recovery purposes.

The whole system as shown schematically in Figure 4.1, has been used for over three years with extremely consistent results. Being able to print virtually any kind of image in different countries, with accurate reproduction of the finest hue and tonal variations, is indeed a great professional achievement for the Alinari team, where colour accuracy and consistency are two key objectives of the everyday work. When files are sent out to remote clients from around the world, a simple but effective description of the steps to open and print the file(s) properly is always provided. This assures the same consistent results with any kind of printer, paper output or ink.

The system is calibrated weekly using an X-rite spectrophotometer and Gretag software. The images are colour corrected and approved on an HP 5500ps 42-inch DesignJet colour printer and an HP DesignJet 10ps (ICC profiled). UV-curing inks are used in order to ensure a longer lifespan of the image (rated as up to 70 years under normal lighting and temperature conditions). UV ink has a slightly smaller colour gamut, compared to dye-based inks, but the difference is not noticeable for typical prints. Every month, the overall system is verified for quality standards by an external consultant company.

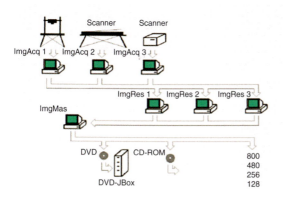

Figure 4.2

Digitising system architecture.

The overall lesson from this development is that technology should always be used in the best and most appropriate manner. Expensive solutions do not necessarily mean better results. What is critical is to be able to work with a team of people who are properly skilled and well trained. Moreover, it is important to keep the overall workflow constantly calibrated to a common standard (the whole digitisation chain, from input to output). Only careful usage of technology can produce consistent and reliable results over time.

4.4 Cataloguing: Populating the Database

The images are catalogued and indexed according to the current iconographic thesaurus. This is an index tree that has been built *ad hoc* by the Alinari team, in collaboration with international experts in the field of photographic indexing, like the MoMa (New York), the Italian Ministry of Indexing (ICCD) and the Getty Center. It consists of controlled terms and vocabularies that categorise the images contained in the photographic repository. The words are linked through a tree allowing the end user effectively to find the most appropriate terms with only a few clicks (within the online database).

The process of cataloguing can be done both with the original images and/or with digital copies. All images can be divided in two great categories: reproductions of works of art and generic photography. The input forms to be used are different for these two categories and are generated offline, then integrated and automatically imported into the database. In the early phase, the inputs are rough information such as Author, Title, Place, Date, Subject. Only later, in the second phase, does the cataloguer insert links from the image to the thesaurus. The third phase is the revision activity. Figure 4.5 shows the overall process schematically.

What metadata is needed to populate the database? The structure must be flexible. At an early stage, there must be the naming of objects, place, date and author of capture, as well as author of the work of art (if known). Some information is easily and immediately associated with pictures belonged to the archive, but most information needs some research. A picture of an old man sitting on a chair, for example, has a different cultural value if one knows that the person portrayed is Théophile Gautier (a famous French author).

4.4.1 Definition of input forms

PH-form: Each image catalogued has a PH-form filled or partially filled. The archivist inserts information referring to the photographic image: Author, Material (film, paper print, vintage print, …), Size, Content Description.
FA-form: The image is a reproduction of some work of fine art. In this case, the previously filled PH-form must be linked to one or more FA-forms containing

PH-form	
Inventory Number	CAL-F-010304-0000
Photographer	Tatge George, for Alinari
Date	2002
Place	Europe – Italy – Sicily – Ragusa
Technique	Colour Process
ObjectType	Film positive
Subject	
Description	The Piazza del Duomo of Ragusa Ibla
Events	None
Keywords	Landscape – Landscape with Road View – View of the City – Street Scene Architecture – Structure – Urban – Road–Avenue Transportation – Scene and Method of Transportation – By Land – On the Road – Automobile Vegetation – Tree – Palm Architecture – Structure – Housing – Building Architecture – Building Elements, Decoration and Sections – Balcony Architecture – Building Elements, Decoration and Sections – Window

FA-form	
Inventory Number	CAL-F-003253-0000
Object Type	Film positive
Artist	Michelangelo
Date	1997
Technique	Colour process
Placement	Europe – France
Description	Male figure (copied from Giotto), drawing by Michelangelo, housed in the Louvre Museum, Paris
Place repres.	None
Keywords	Drawing and Graphics – Drawing

Table 4.1

Examples of two input forms used for image cataloguing. Copyright for Imprint Fratilli Alinari, Italy.

Figure 4.3

Relationship between the image database and the textual database referring to reproductions of works of art (FA) and generic photography (PH).

information on the work of art itself: Author of the work of art, Place, Date of the work of art, ...).

It is clear that for each photographic image, there must exist only one PH-form, but maybe many FA-forms (when in the same photo many works of art are represented) logically related as shown in Figure 4.2. The two forms shown in Table 4.1 as examples have only a few fields: the real forms have many other fields for both content information (size of the print, ...) and administration (who inserted data, who made corrections, who made the translations, ...).

4.4.2 Revision process

To perform the populating process some common operations are needed (Figure 4.3):

- Login.
- Search the image to be catalogued.
- Review and change data (correction of data).
- Update the thesaurus.
- Inform the administrator in case of dysfunctions (image missing, DB locked, ...).
- Perform administrative functions for both cataloguers and reviewers.

After the first data has been input by the cataloguers or translators, starts the long and delicate phase of validating the fragments generated. The

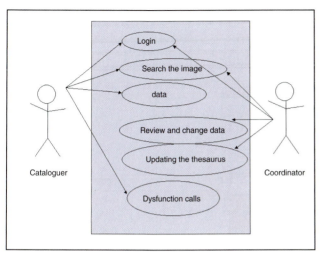

Figure 4.4

Use Case of Catalogue and Revision personnel.

revision activity needs the support of professionals to correct texts and information associated with the image files. The access of each person to the database has a specific level of authority. Input and change of data stored must be monitored in records linked to the data itself (but held in a separate database).

4.4.3 Testing and monitoring the DB

Log files for the evaluation (test and validation) processes are created. The main parameters recorded are:

- Number of agreements reached with institutions belonging to the education and training sector. The number of universities, schools and research centres involved in the Alinari service is tracked to ensure the appropriate usage of the service.
- Number of hits: number of users entering the web site and so the number of registered users.
- Number of queries processed.
- Number of images downloaded: this number represents the rate of successful searches.
- Query time response.

It is monitored which images are most often visited and also which keywords are most often used for searching. Evaluation of the search engine response is necessary to compare the results with other market products.

Figure 4.5

Overall Flow Diagram.
The main steps of
populating the database
are represented.

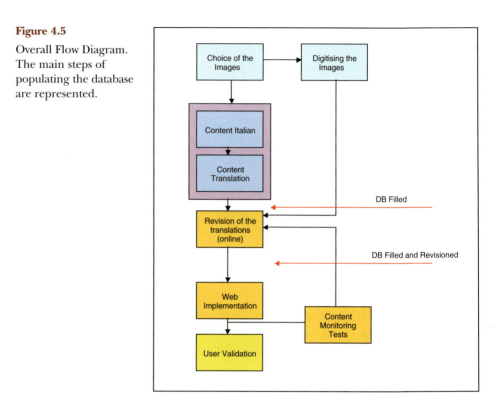

4.5 Search Engine Modes

4.5.1 Organisation of the thesauri

Iconographic Thesaurus: a dictionary of selected terms which allows a search via subject, ordered in 61 iconographic classes from Agriculture to Zoology.

Geographical Thesaurus: functional in the search for sites. For Italy, the thesaurus allows interrogation by region, province and municipality. For other countries, the search can be by nation.

Thesaurus of Periods and Styles: allows for interrogation of pictures of art a search by art style and/or historical period.

Thesaurus Type of Work of Art: offers a subdivision of subjects of artistic and historical-artistic importance and therefore allows for a search by type of object and/or architectural complex.

4.5.2 Free text search

This function enables the user to query the system by means of one or more key terms, which can be combined using Boolean operators (and, or, …).

4.5.3 Analytic search

The analytic search is divided into two sections: (1) works of art (in which crossed searches can be carried out regarding the subjects depicted in art); (2) photographs (in which crossed searches can be carried out for 'real' subjects depicted photographically. In addition, the search can be conducted via photographic techniques.

4.5.4 Advanced (Fine arts search)

The user can make any advanced cross-search referring to subjects represented in works of art. Specific image searches can be carried out by crossing more than one parameter, directly typing in the terms in various fields, or selecting subject headings from the lists.

The results of interrogation of the 'advanced search for works of art' provides only subjects shown in art. For subjects regarding architecture, the 'Type of Work' field is used instead of the 'Key word' field. For example, terms such as capital, dome, column … may be sought via the Type of Work field, a list which helps the user to formulate the query.

4.5.5 Advanced (Photography)

The user can make any advanced cross-search referring to real subjects represented in works of photography. Specific searches can also be carried out, crossing more than one parameter, by directly inserting terms into the various fields or selecting headings from the lists. The results of interrogation of the advanced photographic search provide only 'real' subjects as photographed, including subjects relating to architecture. The search can also be carried out via photographic techniques.

4.5.6 Content-based retrieval (Visual image search and pattern matching)

Thanks to long research and validation work, today Alinari is capable of providing an innnovative solution based on the European NoE project SCHEMA for search and retrieval of images based on colour and shape similarity. Visual retrieval, including relevance feedback, is not a dream anymore!

4.6 Software System

4.6.1 Software index

- Operating system of the web servers is Windows SQL Server 2005 with MS Internet Information Server mounted.

- DB platform is Microsoft SQL2005 managed by Stored Procedure and VIEW in order to optimise the queries with full-text engine for all free searches.
- Zooming software for the images (without the need of any plug-in) is XL-Image (http://www.xlimage.it), which enables Internet users to view images of high resolution quickly and interactively by choosing the portion of a large image to be viewed. This achieves high image quality with best speed performance from any remote user browser.
- The watermarking and image protection is managed with Image Bridge Pro by Digimarc (http://www.digimarc.com).
- Programming languages used to manage the image files are Perl, MS Access, ASP, C/C++, PhP.

4.6.2 Interoperability

The Alinari online system uses open source code and well-known standards, such as the Microsoft programming languages and pure HTML coding for the website. Linking of the system to other content providers will be investigated during the project, even though no technical obstacles are expected.

A firewall FreeBSD manages the security rules of the TCP/IP connections to the DB server. The online system is based on a direct CDN T-1 (2MBs) full internet connection provided by Telecom Italy. The backup recovery line is an ISDN (128KBs).

4.6.3 SQL Server

A comprehensive database and analysis solution, SQL Server 2005 delivers the performance, scalability, and reliability that demanding Web and enterprise environments require. New XML and HTTP support simplify data access and interchange, while powerful analysis capabilities enhance data value. Features include maximised uptime, advanced management functions to automate routine tasks, and improved programming tools.

The SQL Server enables users to query, analyse, and manipulate data over the web. It simplifies the integration of back-end systems and data transfer across firewalls using rich XML functionality and support for other Internet standards, such as XPath, XSL, and XSLT. Web developers can access data without relational database programming, while database administrators can easily manipulate data in XML format using Transact-SQL and stored procedures. Use of secure HTTP database connectivity ensures that data can be queried, even by novice developers, through intuitive user interfaces to a specified URL.

4.7 XL-Image Software

The common way to deliver (or rather squeeze) an image file through a standard Internet connection is to compress it. By doing so, a compromise in image quality is inevitably made, because of the image deterioration due to compression. The end user's experience will invariably not be enriched due to the low quality of such images.

Some commercial solutions involve the encoding of image files into proprietary formats, with all the problems that proprietary formats entail, such as lack of technical support and the difficulty of migrating to another system once the technology is obsolete or the company which designed it ceases to exist. The best technologies currently on the market, some of which do not require special client software, are rather crude tools that only allow limited functionalities such as zooming. The XL-Image software has the system architecture shown in Figure 4.6, which offers:

Client side:

- No plug-in is required, and the user is given a choice of a HTML viewer enabling basic functions such as zooming and panning, or a Java viewer with advanced functionalities. Either viewer is supported by all existing Internet browsers in their standard configuration. The user can choose the size of the viewing window according to the speed of the available Internet connection, with the image in a larger viewing window requiring longer time to load.
- No special hardware requirements. XL-Image viewers are compatible with most installed hardware and operating systems, including older browser versions and slower CPUs.

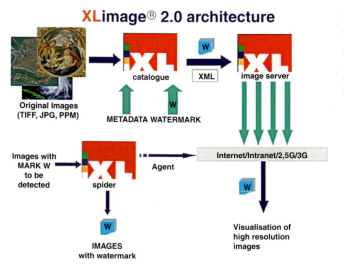

Figure 4.6

Web server scheme for XL-Image image management and watermarking workflow.

- No special Internet connection is necessary.
- No specific computer platform necessary is required, as the viewer will work on all Windows, Macintosh, Unix and Linux platforms, running the most popular Internet browsers.
- The image is inherently protected from copying, because only the content of the viewing window can be copied (and this only by image-grab of the computer screen).

Server side:

- XL-Image can be downloaded and installed within a few minutes. The software is accompanied by a good handbook, allowing high-resolution images to be put online quickly.
- The software fits easily into existing website architecture with no re-design necessary. All that is needed is to provide new hyperlinks from the existing website to high resolution images. Each will open in a separate window which will also display all the navigation tools.
- It is already available for WindowsNT/2000, Solaris and Linux server platforms.
- Multi-format design allows ready uploading of most common image file formats, such as TIFF, BMP, PICT, JPEG, etc.

Figure 4.7

XL-Image pyramid visualisation of the multi-resolution image file.

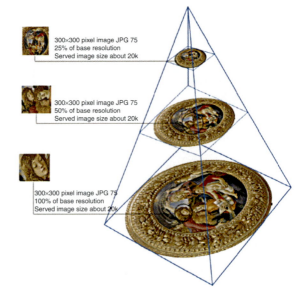

300×300 pixel image JPG 75
25% of base resolution
Served image size about 20k

300×300 pixel image JPG 75
50% of base resolution
Served image size about 20k

300×300 pixel image JPG 75
100% of base resolution
Served image size about 20k

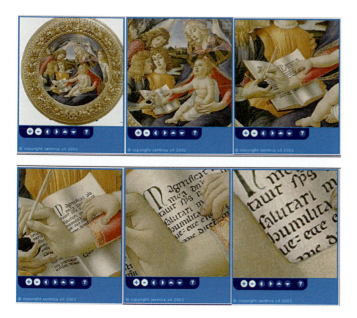

Figure 4.8

Image zooming is interactive without special software plug-ins, enabling very fast access to large images (even 10 000 × 10 000 pixels).

The XL system converts JPEG, TIFF, PPM or BMP images into the IMGF proprietary pyramidal format used by the XL-Image server, as shown in Figure 4.7. The pyramidal format aims to optimise access time, support colour profile management (ICC colour profiles), and provide good security.

The images are stored as IMGF file format using the television colour space YC_bC_r (CCIR-601 standard), in order to optimise the JPEG compression and improve the access to the file. The files are first saved in the web server as IMGF pyramid multi-resolution files and then are converted, on the fly, to the different file sizes according to user requests (or administrator granted privileges). The whole encoding and decoding is done without any noticeable time delay. The final images are provided as standard JPEG file format, so that no dedicated software plug-in is required.

4.8 Image Compression

4.8.1 JPEG2000

JPEG2000 image compression technology has been continuously tested in the Alinari laboratory since the year 2000. Alinari was also the test leader of the JPEG2000 Advanced Networks (2KAN) project, which was devised as an R&D project to address the new Parts 9 to 12 of the JPEG 2000 Standard, with the aim of maintaining European know-how in a leading position. Indeed, the new parts were introduced thanks to the active involvement of the European

delegates to the ISO/JPEG meetings, who argued that market considerations should lead to a strong applications focus in the following areas:

- *Part 9: Wireless,* where one of the main issues is the robustness to bit errors while distributing the JPEG2000 image data. Examples of application cover communication domains such as 2.5G (GPRS), 3G (UMTS), DRM (Digital Radio Mondiale), wireless LAN and others. Data loss when the traffic is congested may have a severe impact on image quality and even on the ability to decode content at all.
- *Part 10: Security* is a new concern for image owners as the value of the content becomes higher thanks to quality enhancement. Moreover the embedding of metadata gives the image file a status of complete "object", able to feed databases with coherent content and easy to find with an appropriate search engine.
- *Part 11: Interactivity* is one of the most demanded features as applications become more and more sophisticated. Interoperability, meaning the ability to exchange contents between applications and platforms, is also expected.
- *Part 12: Volumetric images* are needed in many an application, such as medical representations (e.g. CT, computer tomography), biology, geology, and artwork representation (sculptures, objects).

The Open Standard concept addresses those requirements in terms of application-oriented recommendations. 2KAN is structured to process each new part of JPEG2000, establishing for each a set of specifications, tests and evaluation, concluding with important contributions to the Standard. The 2KAN consortium featured three universities involved in algorithmic research, three industrial partners willing to offer their customers a wider range of applications, and two representatives of end-users, including an Author Society.

JPEG2000 has good chances of being universally adopted in future as a standard image processing component, but at the time of writing, it does not yet have the high performance required by XL-Image in terms of speed, colour quality (ICC client-server profiles), security, and adaptability to Alinari's configuration. One most important problems is that JPEG2000 cannot be directly integrated into the Alinari system architecture connecting it to the image database. The absence of a client-server architecture reduces the level of interaction for the user. A new project targeting this interactivity will be soon undertaken by the 2KAN consortium. JPEG2000 is described in greater detail in Chapter 12.

4.8.2 MPEG-7

MPEG-7 is referred to as the 'Multimedia Content Description Interface'. It is a standard for describing the data of multimedia content (music, graphics, images, video, …) that supports some degree of interpretation of the information's meaning by attaching metadata. Descriptions and Description Schemes are associated with the content in order to ensure a fast and efficient search

for material. The main elements of MPEG-7 may be grouped as:

- Description Tools: Descriptors and Schemes for Audio, Visual and Multimedia content.
- Description Definition Language.
- System Tools.
- Reference Software XM

The MPEG-7 standard includes different types of information referring the content:

- Form – The coding format used, for example JPEG, MPEG-2, or the overall data size. This information helps to determine whether the material can be 'read' by the user's receiver.
- Conditions for accessing the material – Links to a registry with intellectual property rights information and price.
- Links to other relevant material – May help the user to speed up the search.
- Context – In the case of recorded non-fiction content, it is very important to know the occasion of the recording (e.g. Olympic Games 1996, final of 200 m hurdles, men).

The general characteristics of MPEG-7 would be adaptability to combine lots of different content types such as music, video, text, etc. The standard will be of good interest in a second phase, after validation of the Alinari system by end users when the system will be stable and the database fully populated. At the current state of the art it would require a risky amount of effort to study and start applying the MPEG-7 standard to the architecture here described. It must be pointed out, however, that in an eventual second phase it will still be possible to migrate to a different standard. As the MPEG-7 description must be associated with the content itself, it should be possible to generate the MPEG-7-archive by automatic agents.

4.9 Conclusions

Technology can be a veritable 'beast', difficult to handle properly and expensive to keep. The Alinari archive team has learned and developed since 1995 strong skills, background and understanding of content-based retrieval, watermarking, web semantic, picture management and e-commerce. Today the company remains in its original nineteenth century building but is running state-of-the-art computer technology. This combination of an ancient environment with high technology is indeed creating a unique and very special enterprise.

The overall message from this case study is that technology can be very useful and powerful in support of institutional needs. However, technology must be used correctly, otherwise it can be very complex and time-consuming to manage.

The decisions about which tools and solutions to employ must be taken carefully by skilled people with good understanding and know-how.

4.10 References

1. Jack, K. (March 1997). YCbCr to RGB Considerations – AN9717.
2. A.A.V.V. (June 2002). User Centred Product Creation, Technology Enhanced Communication Laboratory, Università della Svizzera Italiana.
3. Costabile, M. F., Garzotto, F., Matera, M. and Paolini, P. (January 2002). The SUE Inspection: A Systematic and Effective Method for Usability Evaluation of Hypermedia. IEEE Transactions on Systems, Man, and Cybernetics, Vol. 32, No. 1.
4. ISO TC 42N 4968 (September 2002). Photography – Electronic still picture imaging – Terminology.
5. Paolini, P., di Blas, N., Guermandi, M. P. and Orsini, C. (June 2002). *Evaluating the features of museum Websites (the Bologna report).* Università della Svizzera Italiana.
6. Felix, D. and Muller, C. (June 2002). *User Testing. User Centred Product Creation Workshop.* Università della Svizzera Italiana.
7. Martínez, J. M. (July 2002). (UPM-GTI, ES), *MPEG-7 Overview (version 8)-ISO/IEC JTC1/SC29/WG11N4980,* Klangenfurt.
8. Day, N. (March 2002) *MPEG-7 Applications, ISO/IEC JTC1/SC29/WG11 N4676.*
9. Minelli, S. H. (July 2002). *Progetto di analisi dell'utenza web Alinari e principi di usabilità.* Alinari internal report.
10. Forte, F. and Vernier, E. (June 2002). *Bello ed Accessibile,* PC World.
11. Handbook, *XL catalogue* 2.0, Centrica Srl, 2002.
12. Assfalg, J. and Pala, P. (January 2002). *Analisi del sistema informativo ondine Alinari.* http://luratech.com; http://www.hp.com; http://www.alinari.com and http://www.apple.com

4.11 Web References

1. http://www.i3a.org: I3A is the leading global association for the electronic imaging industry.
2. http://www.w3.org/: The World Wide Web Consortium's official web site created to lead the World Wide Web to its full potential by developing common protocols that promote its evolution and ensure its interoperability.
3. http://www.pima.net/standards.htm: International Organization for Standardization Technical Committee 42 (Digital Photography)
4. http://jpeg.it: The Italian official JPEG web site.
5. http://www.mpeg-industry.com/: The MPEG-7 official web site.
6. http://mpeg.telecomitalialab.com/: The MPEG home web site.
7. http://www.ibc-secure.org/2002/conf/cnfntc_mpeg7.html
8. http://www.2kan.org: The JPEG-2000 Advanced Networks official web site.
9. http://www.celartem.com/home.html: VFZoom official web site.
10. http://www.intel.com/support/performancetools/libraries/ijl/ycbcr.htm: Intel JPEG Library for encoding and decoding a YC_bC_r 422 JPEG file.
11. http://www.vnet5.org
12. http://www.useit.com: Usability and Use Cases. Jakob Nielsen site.a

5

Digitisation in the Commercial Art World

Anthony Hamber

5.1 Introduction

T he commercial art world has relied on photography since the earliest days of the medium's existence and one of the core components of the commercial art world is the auction house. By at least the 1850s, auction houses had adopted photography as a 'business getting' tool and a medium through which to create sale catalogue illustrations in the form of manually pasted in original albumen prints, in some instances, hand-coloured.[1] This latter application to catalogue illustration remained largely under-utilised, however, and black-and-white photomechanical illustration did not become an integral part of auction house sale catalogues until the 1970s and only in the 1980s did more and more colour photomechanical illustrations appear. By the beginning of the 1990s, full colour illustration of every lot in high value auctions such as Old Master and Impressionist paintings, furniture and jewellery was rapidly becoming the norm for the major auction houses and with it significantly increased production costs.

In the early 1990s, advances in digital imaging technologies – largely driven by the advent of studio-quality digital cameras – began to offer a number of significant business opportunities to those commercial sectors involved in photomechanically illustrated catalogue production. These benefits were primarily considered to be savings on film, film process and scanning costs, increased productivity within photographic studios and catalogue production. There was also possible competitive advantage in that the deadline by which items needed to be consigned for auction could be moved closer to the auction date itself.

Fine art objects have posed a number of challenges to the world of reprographics – and latterly photography – for centuries. Anomalous reflections and out-of-gamut colours are major considerations. Gold and silver objects have proved to be difficult to reproduce, particularly using the conventional four-colour printing process.[2] The limitations of optics, such as the angle of view, pose other problems. Controlling the distortion of perspective introduced through the lenses used to photograph 3D objects such as pieces of sculpture or furniture has resulted in most photography in the studios of major auction house being undertaken on large-format (plate) cameras.

These characteristics have led to much 'black art' in the craft skills behind the photography, pre-press and printing of illustrations in fine art books and auction catalogues. Prior to the project discussed in this chapter, however, very significant advances had been made in digital scanning, digital image processing and digital colour management, particularly from the mid-1980s. These technologies formed core components of the digital process workflow into which digital photography could be inserted.

The advent of 'studio quality' digital cameras in the early 1990s – some 150 years after the advent of photography in 1839 – coincided with the introduction of digital contract proofing devices and 'digital printing presses'. Together these offered a number of business opportunities for various parts of the commercial art world including cost savings, speed, productivity and increased quality and consistency.

Some of the earliest adopters of studio-quality digital photography included the world's major art auction houses, Christie's and Sotheby's. The scale of catalogue production largely drove the potential for application of this new technology. Christie's was publishing annually some 800 auction catalogues worldwide by the early 1990s and these included tens of thousands of photomechanical illustrations, many in colour.

With a complex process flow, idiosyncratic business logic and high image quality standards, the implementation of a fully digital workflow from digital photography to catalogues printed by new digital services posed a variety of issues and challenges. However, some organisations such as Christie's had a number of existing advantages. The company had its own photographers and photo studios. It owned a reprographics company and also owned a printer. This already gave a very significant platform on which to build a 'fully digital' image chain to exploit the potential of digital photography.

This chapter examines the rollout of digital photography, automated catalogue production and new digital and analogue systems and services within one of the world's leading auction houses. It covers the full process of planning and implementing an image digitisation programme:

- User requirements and process flow analysis;
- Business models;
- Digital camera selection;
- Change management;
- Digital colour management;
- Digital contract proofing;
- Digital printing.

Although this project commenced in 1993, more than a decade ago, many of the methodologies and approaches remain valid today. With a plethora of

high-end studio-quality digital cameras, the narrowing of the gap between these devices and the 'prosumer' range of digital cameras, and the wide range of desktop digital film scanners available on the market, there is a potentially bewildering choice of options to generate digital images. Similarly, desktop digital printing devices manufactured by companies such as Epson, Hewlett Packard and Canon have become mainstream consumer goods. 1993 also saw the introduction of high-speed electrophotographic 'digital printing presses' such as the Indigo *E-Print* 1000 and the Agfa *ChromaPress*, based on the Xeikon print engine. Thus, in principle at least, it had become technically possible to create a fully digital image chain from image origination to output as toner on paper.

The chapter concludes with an overview of the current state of digital photography within the commercial art world and some pointers towards future trends.

5.2 Stakeholders and User Requirements

The objective of the project at Christie's was to employ digital photography as the image origination process to create digital images of oil paintings for use as catalogue illustrations in an auction catalogue. Initially, the brief had been considered as merely supplying a handful of digitally photographed images as the basis of a limited number of black-and-white illustrations in a single auction catalogue and then to examine the possibility of creating all the black-and-white illustrations for a single catalogue.

Prior to the project, tests had been carried out with a Kodak DCS-200 35 mm SLR digital camera and sample black-and-white catalogue illustrations were created. The tests were limited to a proof of concept, as no images were included in commercially available catalogues and the contract proofs produced did not test the capability of the digital file from the 1524×1012-pixel images captured by the camera, in terms of the maximum size of printed illustration (based on a 150-lpi screen) achievable from 'raw' and interpolated digital image files.

Analysis of the existing process flow underpinning the production of auction catalogues formed a key part of user requirements. It highlighted what continue to be key issues influencing the successful implementation of a fully digital workflow. Technical, procedural and political matters coupled to human resource challenges all had to be successfully addressed. This involved fundamental business transformation and change management.

Many of the stakeholders involved in the existing catalogue production chain had a limited, often almost non-existent, understanding of the various reprographic processes used to create illustrated catalogues, or of the existing digital technologies involved and the potential benefits of digital photography. These included the art experts, the photographers, and the marketing and press officers.

Indeed, many had only the most limited understanding of the characteristics and limitations of photography and four-colour printing.

Perhaps one of the most important outcomes of the project was the appreciation that there was a need to educate all stakeholders about the components in the new digital production chain as well as to explain the potential benefits, both individually and collectively. Even today, the level of necessary understanding of the components of the digital image chain remains a challenge. While there may be no specific business benefit in all stakeholders having a detailed knowledge of the complete process flow, there are significant benefits to each group of stakeholders in understanding their position within the process flow and the various related dependencies.

Resistance to change was apparent from the outset. First there was the fear, uncertainty and doubt that the technology would work. This ranged over the entire image chain from the art specialists themselves and photographers, through the reprographics departments to the printer. There was some basis for this concern, since a number of early tests using digital photography had failed to match existing quality, a benchmark that was quickly identified as a key criterion for acceptance. The photographic colour transparency had an installed base of familiarity with the auction house world that had been developed over a period of some decades. Large format transparencies were portable and comparatively functional. When placed on light boxes, 10×8 inch transparencies had proved to be impressive marketing tools that were accepted throughout the trade as a *de facto* standard. Changing this standard was a major disruption, particularly to the art specialists.

While these failures in printed image quality from initial tests with digital photography were in fact partially a result of the lack of adequate and effective calibration and image processing, they did establish an unfortunate prejudice. One of the major struggles through the project was to achieve and sustain a fully calibrated image chain that enabled digital colour management initiated in digital photo studios to be passed through a series of digital 'handshakes' down to the printing press.

Another key aspect was the identification of existing bottlenecks in the 'analogue' process flow and understanding of how a digital workflow would remove or displace these bottlenecks or create new ones. Thus issues related to matching existing productivity and flexibility became key factors of success.

In 1993, most of the in-house photographers were far from computer-literate, and none had sufficient knowledge to use studio digital cameras to create reprographic-quality digital images. In addition they were sceptical, given the high quality that was being achieved using large-format transparency material and graphic arts drum scanners, coupled to their expertise in photographing works of fine and decorative art. There were also usability issues that posed

potential barriers. Would digital cameras be as functional and usable as conventional large-format plate cameras?

The art department staff posed other challenges. Art experts understood little about the processes used to create their primary marketing tools, the sales catalogues, and (significantly) the large-format transparencies that might be sent to their top clients. The subjectivity of their analysis of image quality, as will be highlighted below, proved to be a challenge since the 'buy-in' of the art experts was key to the successful introduction of digital photography. They formed the direct interface with clients – both vendors and buyers – and they needed to be able to continue to supply appropriate image services to clients. The existing image services were almost exclusively based around photographic colour transparencies.

Almost all art experts at the time were working on text-based core business IT systems. Many were still using old VT-100 visual display terminals for access to property and cataloguing systems running on a proprietary mini-computer. While IBM-PC compatible computers were being introduced across the company, these did not yet have 24-bit graphics as standard and the World Wide Web was still very much in the future. Digital image database solutions were little known or understood within a business context. A key question was how art departments would be able to 'view' digital images if their primary business tool – the photographic colour transparency – were to disappear with the advent of digital photography? The idea of appending digital images to items in the property system was one long-term goal. It was postulated that warehouse porters might use consumer digital cameras to capture thumbnail digital images as objects were consigned.

For the pre-press stakeholders, digital photography represented a highly disruptive technology and was perceived as posing a significant business threat. Core parts of the pre-press revenue stream would either disappear, notably the scanning of transparencies, or be displaced, such as contract proofing of images. Image quality was a key concern. Digital imaging scanning and process-ing technology had made very significant progress in terms of quality and productivity from the late 1970s, largely due to technological innovations from companies such as Crosfield, Scitex and Linotype-Hell. By the early 1990s, the market could be considered relatively mature. However, in 1990, Optronics had introduced a desktop photomultiplier (PMT) drum scanner and this emerging market was then rapidly targeted by other companies such as Screen, Howtek and ScanView and began to erode the market share of the high end manufacturers of drum scanners. As charge-coupled device (CCD) technology became viable for low-cost desktop scanners in the mid-1990s, the economics of scanning was revolutionised.

Thus there was scepticism that digital photography could match the image quality benchmark of large-format photographic transparency and

high-end scanning. In addition to the threat to scanning from competitively priced desktop drum scanners, the persistence of analogue proofing processes such as DuPont *Cromalin* and 3M *Matchprint* was beginning to come under increasing pressure through the advent of digital mass-storage devices – notably in the form of magneto-optical disks – coupled to digital contract proofing devices.

For the printer, there were concerns regarding the quality and consistency of what would be a new stream of colour image data from the pre-press bureau, to be recorded onto film separations for plate making and thence to the printing press. The colour transparency was the primary intermediary by which image quality was evaluated. The printer also had vested business interests in the close relationship with the pre-press suppliers involved in scanning, film separation, contract proofing and plate making. Printers generally considered that the stewardship of colour management lay on the printing press and that it was manual control of the press that added value to the printer's role. Herein lay perhaps the most fundamental change of the entire project.

5.3 Process Flow

The process flow at Christie's at the start of the project was as shown in Figure 5.1. The existing studio procedure included the taking of multiple (usually three) large-format (5×4 inch) photographic colour transparencies, almost exclusively by 'flash' light. These would include 'bracketed' shots – perhaps one $1/2$ f-stop over and one $1/2$ f-stop under the estimated camera exposure time. There was

Figure 5.1

Initial process flow based on photographic transparencies.

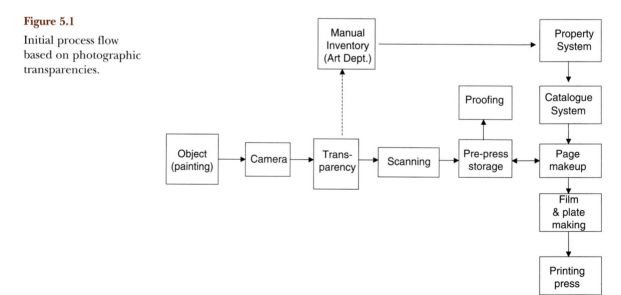

variation in the types and manufacturers of film used, depending on the subject matter of individual art departments, such as paintings, furniture or jewellery. While a Kodak Color Control target was frequently placed adjacent to a painting being photographed, rarely was a grey scale included.

Framing of subject matter was comparatively loose in large-format transparencies. This aided studio productivity in that 'filling the frame' was not a prerequisite for the photographer. In addition, when shooting furniture, it was common practice to place the piece onto an 'infinity cove' giving significant areas of background around the object. This enabled the transparency to be scanned for either 'landscape' or 'portrait' aspect ratio for the final catalogue illustration or for marketing material.

Following photography and processing, two levels of quality assurance took place. First the photographer would check the transparencies (in some instances against the actual paintings depicted) as they returned from processing and then would hand them onto the art department for whom the transparency had been taken. After checking by staff in the art department – to determine which transparency would act as the 'Master' for scanning – the photographic transparencies were marked up with hand-written annotations as to what size of catalogue illustration should created (i.e. $1/4$ page, $1/2$ page, full page, etc.). Then these transparencies were supplied to the printer who would hand them on to the pre-press department for scanning and reprographics. Subsequently art departments would be shown contract proofs of individual images (but not necessarily of entire pages including text). Page proofs for text would be supplied for proof-reading as black and white laser prints. In 1993, desktop publishing had not yet been introduced within Christie's and this was to form a parallel, but integrated, part of the overall project to automate catalogue production.

Analysis of the traditional process flow indicated that the pre-press staff rarely had direct contact and input to the art department staff, except for the most valuable lots. It was a catalogue production representative from the printer who would meet with art departments to discuss photographic transparencies, contract proofs and any suggested colour corrections. One of the weaknesses of this process flow was the non-standardisation of systems and procedures to evaluate reflective originals (such as oil paintings), transmissive copies (photographic colour transparencies) and reflective contract proofs. There were no calibrated viewing booths or standard illumination sources to compare transparencies with proofs within the auction house. Comparisons between transparencies and the original paintings were carried out using light boxes alongside the paintings illuminated by the tungsten modelling lights of studio flashlights. There could be wide mismatches between the spectral power distributions (SPDs) of the illuminants used, and the general viewing conditions were far from ideal. Transparencies were frequently held up by hand and

viewed in the art departments against any available form of ambient lighting, such as daylight through windows, overhead tungsten lamps or fluorescent tubes, desk lamps etc.

For some high value objects, moreover, multiple duplicate transparencies might be made for general distribution, including to clients. Procedures for recording and subsequently identifying which transparencies were originals and which were duplicates were not well embedded within the art departments, resulting in some instances where a copy (rather than an original) transparency ended up generating the catalogue illustration.

Once a photographic colour transparency had been selected by the art department, it was scanned on a high-end drum scanner – such as a Crosfield Magnascan – set up and calibrated to specific printing targets by the manufacturer's installation engineers. The digital process flow in pre-press involved the creation of digital CMYK files rather than RGB files. These high-end scanners exploited dedicated RGB-CMYK transformations, embodied in look-up tables (LUTs) and based on a representative sample of transparencies of auction house subject matter. The settings loaded into the dedicated scanner software included functions such as unsharp masking (USM), for instance, set at a high level of 300 per cent for images of jewellery. One of the key issues was that the art specialists and marketing department wished to produce pleasing images, sometimes at the expense of fidelity to the original object. Thus both jewellery and Impressionist paintings were invariably over-sharpened. This often introduced artefacts, such as the appearance of sharp 'texture' that was actually film grain and not a feature of the original. In some instances the high levels of USM even caused significant changes to areas of colour.

The pre-press operators had a good understanding of the digital values of CMYK files and their relationship to the halftone dot sizes produced on the film separations and subsequently – via printing plates – how these would appear on the printed page. By 1993 pre-press image retouchers had begun to move away from high-end workstations and were undertaking retouching and correction of CMYK files via Adobe *Photoshop* on Apple *Quadra* and *Power Mac* desktop computers. In 1993, *Colorsync* had only just been conceived by Apple, however, and *Photoshop* did not yet have an embedded Colour Management System (CMS). Colour management was largely carried out by examining the on-screen CMYK percentage values and linking these to knowledge of press characteristics such as dot gain.

Change was also afoot in the development of quality CCD-based flatbed scanners interfaced to Apple Macintosh computers. These began to appear in the early 1990s, and manufacturers such as Linotype-Hell with its *Topaz* and Scitex with its *Smart* scanners began the move away from drum scanners based on PMT technology.

At the start of the project, the CMYK files scanned from colour transparencies were temporarily stored on magnetic-optical disks and then output to an image setter, the films from these were used to make analogue proofs using DuPont *Cromalin*. These proofs were examined by the art experts and annotated with corrections. Their vocabulary was highly subjective ('too blue', 'darker green' etc.) and no colour reference standard, such as some form of colour chart or Pantone, was used.

In the early 1990s, the high cost of mass storage on magnetic hard disks of large numbers of digital images resulted in magneto-optical disks managed by jukeboxes becoming the standard within many pre-press environments. This was used only as a temporary production storage area and image files were not stored for archival purposes, it being considered more cost effective for the transparency to be rescanned. Indeed, the film separations that led to the printing plates for each auction catalogue were stored in large card envelopes at the printer's site, even though the likelihood of their ever being reused was negligible.

At the start of the project, much 'stripping in' of film was carried out at the printers by the traditional craft technique. The four image film separations (CMYK) would be output separately from the text (just the black or 'K' channel) and the two layers manually assembled to create the master flats for the plate-making stage. In parallel with the advent of digital photography was the introduction of desktop publishing in the form of Quark *XPress*. Those working for the printer on page layout, pagination and output to film were to be retrained as Quark operators. Quark page templates were developed to reflect the standard catalogue page layouts. This enabled page creation to be speeded up. Standard fonts were generated. Routines were developed to stream text data out from the proprietary cataloguing system run on a mini-computer into the appropriate *XPress* fields. This export/import function included the link to the relevant digital image file for the illustration. Extensive use was made of bar-coding for the creation of digital image file names and integration of this metadata into existing legacy systems. This is discussed in more detail in Section 5.5.

5.4 Digital Camera Selection

5.4.1 Requirements analysis

The requirements for evaluation of the digital cameras emerged from a detailed analysis of the sizes of illustrations from an entire year of auction catalogues. This confirmed that the vast majority of catalogue illustrations (over 80 per cent) were below A4 format, indeed most being smaller than A5 format. It was therefore determined that the digital camera must be able to produce a digital file sufficiently large enough to create a full-bleed A4 illustration with a screen of 150 lpi.

The image file created from the digital camera also had to match the quality of a digital file produced from scanning a large-or medium-format photographic transparency, and produce a printed image quality equivalent to the existing benchmark.[3]

A set of key parameters was taken as the basis for the return on investment (ROI) criteria by which a digital camera would be selected. Most photographic studios were equipped with large-format cameras and electronic flash lighting. Most photography was taken on 5 × 4 inch colour transparency material, with 10 × 8 inch colour transparencies only for the most valuable lots for sale. This was not because of reprographic considerations but because 10 × 8 inch transparencies were used as primary marketing tools to show works to prospective clients. Comparatively little medium-format photography and almost no 35 mm format work was undertaken.

Together with the full costs of photographic processing, digital scanning, output of film separations and proofing it was possible to build a 'cost per auction lot' model where core components could be easily individually identified. The overarching consideration was the cost and implications of re-equipping the entire photographic studio, potentially a large capital expenditure. The benefits of such an expenditure needed to be clearly articulated within the return on investment (ROI) model.

The productivity of photographers provided one key benchmark. A specialist auction house photographer could take up to eighty paintings a day using large-format cameras and conventional photographic materials. A more usual average was fifty paintings a day and this was taken as the ultimate target for a digital photo studio. However, a key area for debate was what activities a digital photographer would be expected to undertake. How many of the pre-press functions could be displaced upstream into the photo studio without significantly reducing either productivity or quality?

5.4.2 Early digital cameras

In 1993, the market for studio-quality digital cameras was very much in its infancy. Three different configurations of CCD sensors existed: linear arrays, area arrays and moveable area arrays. During the 1980s, CCD technology had been exploited to create a relatively large installed base of cameras for the machine inspection, scientific and military imaging sectors, though the array area devices used were of comparatively low pixel resolution, up to 1024 × 1024 pixels by the end of the 1980s. In addition, these devices had none of the controls and ergonomic features of 'proper' cameras, and were disparaged by professional photographers as 'bricks with a lens on'. While they might be considered suitable for copy stand work and had been successfully used in cartographic applications, they had distinct limitations in terms of their usability within a

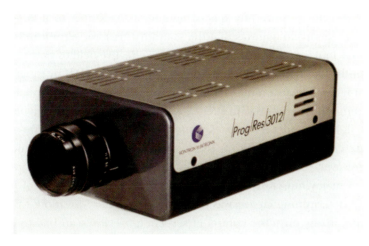

Figure 5.2
The ProgRes 3012 digital
camera developed around 1990
by the Lenz brothers and
marketed by Kontron.

professional photo studio. Such 'brick' CCD cameras had poor functionality
in terms of focusing and framing the image, there being no viewfinder or
'live-video' preview.

CCD cameras had their origins in the machine inspection and scientific
sectors. Their development is described in detail in Chapter 7. The Kontron
ProgRes 3012 had a comparatively low resolution sensor (512 × 387 pixel) that
could be shifted in both X and Y directions in the image plane by two piezo
crystal actuators, to capture a series of images from which a high resolution
composite image of 3072 × 2048 pixels was generated. This camera had evolved
from CCTV and surveillance technology and fell into the 'brick with a lens'
category, as is clear from Figure 5.2. Because it was completely self-contained, it
could not easily be attached to a medium-or large-format camera and it could
not be used with studio electronic flash lighting, the *de facto* standard in almost
all photo studios. Instead it required high-intensity continuous illumination,
such as tungsten–halogen photoflood lamps, over its full exposure period of
1 minute. Thus while the *ProgRes* could acquire large digital image files that
could more than exceed a full bleed A4 150 lpi printed image, it had limita-
tions from both usability and productivity perspectives. In addition, little atten-
tion had been paid to processing the RGB images captured by the digital
camera through to print. For instance, there was no reprographic quality RGB-
CMYK colour separation software provided with the *ProgRes*, because Kontron's
background was in monochrome imaging for specialised industrial inspection
and medical applications rather than printing and publishing.

Line scanning CCD camera backs were also examined in some detail. In late
1993, PhaseOne launched its *PhotoPhase* FC70 line scanning CCD camera back
that could produce an image of up to 5000 × 7000 pixels using a 5000-element
linear CCD array. The device could be attached to the back of a conventional
studio plate camera in the position of the film dark slide. The PhaseOne

therefore did not require any special adapter to mount it to a large-format camera. One disadvantage was that the scanning area was significantly smaller than the 5 × 4 inch area available, reducing the effective field of view of the lens.

New continuous lighting (high frequency fluorescent, HMI or tungsten) was needed for the line scanning digital camera back, and the potential costs of re-equipping photo studios with such lighting was high. The heat generated by tungsten lighting and the long exposure time necessary with line scanning backs were considered significant issues, particularly for very high value works of art. However, scanning camera backs have been successfully adopted by a number of major museums and galleries around the world. One of the most significant determining factors was the speed of image acquisition. In order to get a digital image onto the computer screen, a preview scan had to be made first, followed by the full resolution scan. For the *ProgRes* this could take well over a minute, whereas the Leaf could generate its image in under 30 seconds.

5.4.3 *Leaf DCB-I digital camera*

A milestone in the introduction of studio-quality digital photography took place at the Photokina exhibition in Cologne in 1992 when Leaf Systems Inc. exhibited its DCB-I (Digital Camera Back). This device used a large CCD array sensor and could be attached to a Hasselblad medium-format professional camera. At its heart was a 2048 × 2048 pixel Peltier-cooled Loral CCD chip. Three Wratten gelatin filters (Red, Green and Blue) were mounted into a rotating 'filter wheel' attached onto the screw thread on the front of the camera lens. Three separate exposures – one for each of the colour filters – were taken to create an *RGB* image. The Leaf camera back could be used with either electronic flash or continuous lighting. However, the gelatin filters held in a somewhat primitive 'filter wheel' were susceptible to damage and fingerprints, and could give rise to flare on the image from unwanted light. Because of the need for three shots to be taken, it became imperative that the digital camera was held rigidly in place in order to obtain accurate registration of the three separate images. A software function to 'register' the three images was included in the Leaf DCB-I camera software and was a mandatory step in the process flow. It was found that sufficient time was needed between camera exposures for the photographic flash light to recharge fully. If the intervals were too short, then the flash illumination was variable and the images of the three channels needed to be calibrated for relative brightness.

Although the Leaf DCB-I did not produce images of the highest pixel resolution of all the cameras evaluated, it had the strongest mixture of image quality, usability, functionality and productivity. Most importantly, it was liked by all the photographers who tested it. Leaf Systems understood the reprographics market well and had previously produced a successful desktop scanner, the *Leafscan* 45.

Additionally, the developers seemed to have benefited from the detailed involvement of a local professional photographer working near the company's headquarters in Massachusetts. In terms of technical evaluation, the digital images created were clean (although there was some 'noise' in the blue channel), sharp and the colours were saturated. The software was functional and photographers found it comparatively easy to use. The high dynamic range (HDR) 14-bit files created by the Leaf DCB-I camera gave the ability to capture a greater tonal range (more *f*-stops) and a wider colour gamut than film. Three-shot digital photography could also reduce the problems of colour aliasing in fine detail that often occurred with single-shot chips with mosaic colour filter arrays.

One critical test of the Leaf DCB-I was carried out at Christie's in-house reprographic department with the company's in-house printer in attendance. A particularly problematic original – a watercolour by British artist Helen Allingham (1848–1926) – was selected as the subject. The artist had used a combination of pigments to produce a colour that appeared to the eye as light purple but was invariably recorded on photographic emulsions as light blue. The three-shot Leaf DCB-I camera produced on screen a digital image in which the light purple of the original was well matched (both visually and as CMYK percentage values) on screen. This proved to be a definitive test for both the head of reprographics and the printer – although the challenge would now be to take this image accurately all the way to print. Similarly successful tests were carried out on a very high value lot, a painted riverscape by Claude Monet (1840–1926), which had a particularly vibrant green pigment that colour transparency film could not accurately render.

Other single-shot digital cameras and camera backs were also examined. The 35 mm SLR format, notably the Kodak DCS range, was discounted primarily because of limited image quality. The interpolation algorithms used to generate RGB data for each pixel produced numerous artefacts, especially for patterned originals, and the general technical quality of the digital image files did not meet the requirements for high-end catalogue illustration. In addition, there were geometrical issues related to the lack of movements (so-called 'swing and tilt') in a 35 mm SLR camera to enable correction of distorted perspective.

In 1994, Leaf Systems launched its *Catchlight* single-shot digital camera back, based on a CCD sensor of 2048 × 2048 pixels with an integral colour filter array. There were two primary limitations with this digital camera back. Firstly, each image captured in single shot could take several minutes to interpolate and then render onto screen. Secondly, the digital image quality was significantly lower than the three-shot digital cameras such as the Leaf DCB-I.

The following year Dicomed announced its *BigShot* which used a Loral 4096 × 4096 pixel CCD and was available in monochrome, three-shot colour and one-shot colour versions. Prices were US$35 000, US$39 000 and US$55 000

respectively, making this an extremely expensive option, particularly since the *BigShot* required a computer with over 300 Mb of RAM in order to work efficiently and RAM at this time was extremely expensive. None of the Dicomed cameras, moreover, could match the image quality, functionality and usability of the three-shot Leaf DCB-I, or its replacement the DCB-II launched in 1995 (Figure 5.3), which enabled live video preview of the scene.

Figure 5.3

Brochure for the Leaf DCB-II, showing the digital back attached to a studio camera, with the filter wheel in front.

5.4.4 Selection of the camera

The camera finally selected in the late summer of 1993 for the initial tests was the Leaf DCB-I, because its digital image proved more than able to generate a printed image of the benchmark quality. It achieved this quality even though its CCD chip had a square aspect ratio and captured a maximum file size of 12 Mb in 24-bit RGB that invariably needed to be cropped to form a 'landscape' or 'portrait' aspect ratio. The degree to which the digital image files could be interpolated (or 'scaled') without loss of image quality surprised many. This was attributed primarily to the fact that each pixel was generated directly from the object rather than through the intermediary of a photographic emulsion and the inherent 'noise' introduced by the granular dye layers of the colour transparency material.

Additional factors influenced the decision to select the DCB-I. In 1992, Leaf had already been purchased by Scitex, one of the large high-end reprographics manufacturers, which also owned Iris Graphics, manufacturers of large-format digital inkjet proofing printers. It was considered that this powerful combination of a single manufacturer's resources and knowledge base could be co-ordinated to establish a fully digital photographic studio quickly and thus obtain some competitive commercial advantage. The knowledge of digital colour management was seen as a critical capability that this combination of suppliers could bring to the project.

When launched, the Leaf DCB-I could only be attached to a Hasselblad medium-format studio camera. This was unsurprising because Hasselblad was the market leader, and even today more than 70 per cent of all digital camera backs are still designed to be attached to it. Although it was functional, allowing the photographer to 'fill the frame' and focus through the viewfinder, the camera lacked the geometric movements of a large-format camera, which are critical in 'squaring up' an image and correcting any distorted perspective, even with a two-dimensional object such as a painting. A sliding adapter became available, enabling the Leaf DCB-I to be mounted onto large-format cameras, but it was considered to be 'clumsy' and unsuitable for the productivity required in the photo studio. The eventual 'best fit' was to mount the digital camera back onto a Fuji GX-680 medium-format camera (Figure 5.4). This camera had its lens plate mounted on a movable element that enabled it to be swung, tilted and shifted, thus giving the necessary degree of control over perspective. For this reason the Fuji GX-680 has remained popular with photographers using digital camera backs.

One significant consideration was the type of computer to which studio-quality digital camera backs could be interfaced. Almost all required an Apple Macintosh, the prevailing standard in the graphic arts. But in 1993 only one person in the Christie's I.T. department had a reasonable understanding of IBM-PC technology,

Figure 5.4

The Fuji GX-680 medium-format camera, showing the lens assembly and camera body separately mounted on a base rail, enabling correction of perspective by lens movements.

the remainder being dedicated to the development or support of the proprietary text-based mini-computer core business system. Thus the issue of technical support for the Apple Macintosh when placed into the photo studios had to be addressed. In the event, it was decided to outsource this technical support, but to this day it remains a vexed issue of how best to provide technical support for Apple Macintosh computers within I.T. departments that do not have reprographics as a major priority.

5.5 Modifying Existing Workflows

Analysis of existing process flows was essential to determine what should be altered and what new procedures and practices might need to be introduced. This included the transition from a hybrid process flow consisting of both

analogue (photography) and digital (scanning) to a fully digital process flow through to the printing press.

One major decision made early in the project was that the digital photo studio would contain a digital contract proofing device. The intention was that in the digital photo studio, each painting would be digitally photographed, processed into CMYK (with direct comparison against the original painting), output to a digital contract proofing device (with further direct evaluation against the original) before the final sign-off of the image. This process flow would also reduce the movement of the paintings in and out of the studio and warehouse, and thus reduce the opportunity for damage. This was seen as a significant benefit by the Christie's insurance department. As mentioned previously, the throughput target was for 50 paintings to be digitally photographed and proofed per day.

Specialist HMI lighting equipment was constructed to illuminate paintings for comparison against the original paintings, both onscreen at the point of RGB–CMYK separation and also after proofing. Another viewing cabinet was acquired to enable direct evaluation of photographic colour transparencies and contract proofs against the paintings.

At the start of the project, it was considered infeasible for a digital photographer to carry out image processing (modification of tone curves, RGB–CMYK separation, USM sharpening, etc.) because of the high throughput required. Furthermore it was considered unlikely that a photographer could be trained up to the necessary level of proficiency in pre-press operations. The target was to train the existing 'analogue' photographers to be proficient in capturing high quality digital images in a productive and consistent manner. Nevertheless, there was also an identified concern that once fully trained, digital photographers might be headhunted.

Early analysis indicated that the digital image file naming conventions used in the existing catalogue production process flow were insufficient for a fully digital workflow and that new digital file naming conventions were required to act as unique and persistent identifiers. These needed to accommodate the possibility of multiple images for a single lot in a sale (for example, a set of lithographs). The digital file names also had to link to the existing proprietary software system that handled property and the creation of catalogues. An extra field was created in these systems. The digital image file names would be exported out of these systems and imported into the legacy page layout software that was to be replaced by Quark *XPress*.

A barcode identifier system was developed that linked both manual and digital systems through the contract proofing device. Triplicate sets of barcodes were issued to the art departments. Of the three identical barcodes, one could be attached to the work of art itself, one was placed in the art department's own manual inventory book and a third was available for other purposes, including

Figure 5.5

The modified workflow enabled by the use of barcodes.

use as a label for a photographic transparency, since the aim of the project was to run parallel digital and conventional photography within the new automated catalogue production system. Digital image file names were created by using a barcode reader attached to the computer hosting the digital camera. The barcode could also be read into the property system through the use of another barcode reader attached to any VT100 terminal (or PC). From there it could be passed to the cataloguing system and then exported as the image identifier in the Quark *XPress* page template illustration box. The introduction of barcodes led to a modified workflow as shown in Figure 5.5.

5.6 Colour Image Processing

5.6.1 *Digital colour management*

To enable repeatable quality tests on a set of representative target objects (rather than using standard photographic colour checkers, Macbeth charts or IT8 targets) a set of four small oil paintings (each less than A4 format) was acquired. Two of the paintings are shown in Figure 5.6. These pictures were chosen for the following characteristics.

- Small and portable;
- Could be easily transported from site to site and stored;
- Could be placed in viewing booths next to contract proofs for direct comparison;
- Could be carried for purposes of demonstration to art departments;

Figure 5.6
Two small oil paintings used as colour test targets.

- Could be hung at the end of the press for direct comparison with sheets from the press;
- Wide gamut of colour;
- Wide tonal range (including dark 'Old Master' style, landscape with high variation of green mid tones, etc.).

While the ability to capture an image of a painting through digital photography and display it accurately onto a computer screen proved to be comparatively simple, reproducing this image in print proved to be somewhat more complicated. In essence, the issues and challenges centred on the creation of a set of appropriate digital colour management procedures in a unified digital image chain.

Digital colour management through the use of International Color Consortium (ICC) profiles is now an accepted part of digital imaging and colour reprographics. However, the project at Christie's commenced in the same year (1993) that the ICC was first established by eight industry vendors for the purpose of 'creating, promoting and encouraging the standardisation and evolution of an open, vendor-neutral, cross-platform color management system architecture and components'. The creation of profiles by means of densitometry and spectrophotometry was reasonably well understood by the early 1990s and formed the basis of the creation of a colour management solution for the fully digital workflow to be put into place.

From a practical viewpoint, however, creating a colour profile for the Leaf DCB-I digital camera was a challenge. There was a high degree of variation is lighting, lens aperture, bellows extension and physical characteristics of the subject matter. The most appropriate starting point was to print out a test colour patch target on a calibrated contract proofing device. This image would then be shot with the digital camera. The image would be made neutral through a camera software function reading from a spectrally neutral mid-grey tile (supplied with the camera), placed within each scene being photographed. The file was then separated into CMYK, digitally proofed, separation films and plates made and finally printed.

This test highlighted several problems. Firstly, it was common practice for the in-house printer to send out the job to another printer without the client knowing. This exposed the fact that a significant number of presses being used at different printing sites were not accurately calibrated and had excessively high dot gain. Printers were traditionally used to adjusting the press manually to achieve the best results. But this ran directly counter to the premise that a press should always be set to a known operating state, with a known dot gain, using the same paper and set of inks. Only in this state could it be characterised and trusted to print images digitally calibrated through the press 'fingerprint' via profiles generated from spectrophotometric measurement.

Indeed the mission to get dot gain under control at the film separation, platemaking and printing press stages proved to be a long and arduous journey that led to a number of confrontational meetings. Eventually, the digital contract proofing device in the photo studio, the digital contract proofing device in the reprographics department, the DuPont *Cromalin* system together with the film setter in the same department, the platemaker and the in-house printing press were all calibrated under a unified set of colour management procedures. Other printers also involved in printing the catalogues had their printing presses similarly calibrated and profiled.

5.6.2 Colour separation software

In terms of workflow, the first major challenge faced was taking the proprietary 14-bit high dynamic range (HDR) digital image files from the Leaf camera in RGB colour space and separating them into CMYK format. It was considered that the HDR-RGB image files should be archived as 'raw' files for later reprocessing. CD-ROM was selected as the archival storage medium. Backup copies would be created and kept off-site. This was a cheaper option when compared against either a magneto-optical jukebox storage system or magnetic tape backup. But it was still expensive: CD-ROM writers were retailing for over £2000 each in 1993 and blank CDs cost £25 each. Writing to blank CD-ROM was comparatively slow, taking up to 20 minutes per disk and the early CD-ROM writers were prone to 'hanging' or creating corrupted data.

Production CMYK files would also be saved onto CD-ROM since it was considered a more robust medium than removable magneto-optical disks for transfer to the pre-press house. The supply of a dedicated high-bandwidth telecoms link, such as ISDN, between the digital photo studio and the pre-press house proved, in 1993, to be prohibitively expensive.

The colour separation of 14-bit HDR-RGB digital files captured by the Leaf DCB-I initially posed a significant challenge. The dedicated Leaf RGB-CMYK separation software, *ColorShop,* was not available at the time of the original release of the digital camera back. One option for the RGB-CMYK conversion stage of the process flow was the use of a Scitex *ResoLut* PS card. The software associated with this image processing card had batch processing functionality that appeared to address a bottleneck. However, the card would not accept the 14-bit HDR file format, so again exported 24-bit TIFF files had to be used, creating another (albeit temporary) intermediary version of the digital image file. Unfortunately, the tests proved inconclusive and it seemed that the separation Look-Up-Table (LUT) was not appropriate for the characteristics of the 24-bit files exported from the Leaf HDR files. At one point, it was suggested that the RGB files could be separated into CMYK through the use of a high-end Scitex *Whisper* reprographics workstation. However tests revealed that the existing

RGB-CMYK separation tables had been constructed to separate RGB scans from colour photographic materials. No consideration was given to the colour gamut achievable from the Leaf DCB nor to the general characteristics of an image captured via three shots using a CCD in a digital camera back.

Because of these inconclusive tests with alternative RGB-CMYK process flows, the production of the first auction catalogue proceeded with illustrations created entirely from digital camera files, and the RGB to CMYK colour separations were undertaken in Adobe *Photoshop* 3.0, with the tables 'tuned' by a consultant to be as good as possible. For this purpose the Leaf HDR images were exported

Figure 5.7

Cover of the first art auction catalogue ever to be produced by entirely digital means.

and saved as 24-bit TIFF files. The resulting catalogue for an auction of paintings held in London in November 1993 was a milestone, in that it was the first auction house catalogue ever to be entirely illustrated with digital photography, including the front cover (Figure 5.7).

This catalogue demonstrated a number of issues. It was clear that Adobe *Photoshop* 3.0 could not produce – without enormous amounts of manual retouching – the same quality of CMYK separation files created from direct scanning of a transparency. It did not have an embedded colour management engine and the necessary control of tone curves and sharpness were also issues. The tone curve only permitted three points for adjustment while a minimum of at least five was necessary. Nevertheless, the production of the first fully digital illustrated catalogue was considered successful, and the outcome was an agreement to create a dedicated digital photo studio with full calibration of the digital image chain and digital colour management.

On the release of Leaf's *ColorShop* separation software, which ran on the Apple Power Mac's main CPU rather than through a dedicated image processing card, it became clear that the process flow to create the best quality CMYK files from the Leaf HDR-RGB files would be to process images individually through this application, there being no batch processing capability. Thus a project to build a set of appropriate LUTs was commenced using the set of target paintings described above. The hope that a small number of separation tables could be made was only partially realised, since numerous subject-specific separation tables proved to be necessary to obtain the required quality. Coupled to this was the creation of a set of tone curves and USM settings that could be associated with each separation table.

5.6.3 Colour proofing

Digital contract proofing within the digital photo studio was carried out through the Iris *SmartJet* A3 format printer. While this device could be profiled relatively easily (albeit slowly) through the use of spectrophotometric measurement, there were questions about which ink sets and paper stock to standardise and how these related not only to the characteristics of Cromalin contract proofing but also to the paper and inks used on the printing press. In addition, it was decided to run the Iris printer through a dual-processor PC rather than an Apple Macintosh through the photo studio network. The Iris *SmartJet* was initially somewhat unreliable – probably due to the high levels of heat and humidity in the photo studio. Paper feed problems were frequent and the ink-jet head tended to clog on a comparatively regular basis. These problems were successfully addressed and the Iris eventually proved to be a high quality contract proofing device with good accuracy and repeatability. It was also adopted by the in-house pre-press company.

One major limitation on the productivity of the Iris *SmartJet* was that the standard software would only print one image at a time. This would be too slow to create the 50 contracts proofs a day set as the target. Creating multiple images as an A3-size Adobe *Photoshop* page proved to be impractical and slow due the amounts of RAM memory required on the PC or Apple PowerMac running *Photoshop*. Thus a bespoke software application programme named 'Scatter' was written for the PC server. This application would automatically scatter as many images (at same size) as could be placed across the A3 sheet. It would rotate the images as necessary, add the file names (a numeric string) and their equivalent as a barcode graphic beneath each image. It would print the time and date at multiple places on each sheet, with additional control strips and text annotations at the sheet edge as required.

One issue relating to human visual perception became apparent at this stage of digital proofing. If the A3 sheet was completely covered with small-sized images – each comparable to a 35 mm contact proof – it was difficult to evaluate the accuracy of the Iris print image with the original painting. The solution was to print images at least A6 or A5 format in size, with sufficient white border to enable easier visual comparison with the original.

The Iris *SmartJet* A3 sheets that were printed out from the 'Scatter' application enabled art specialists to import the image file name field from the property system through reading of the barcode beneath the relevant image. This technology also enabled the art specialists to identify the object in any such bar-coded Iris proof they found, simply by carrying out an image search on the file name field of the property system by using the barcode reader. Bar-coding added value, as described in Section 5.5, through its association with the file naming system for digital images created from transparencies and enabled prepress and catalogue make-up to find high-resolution images more easily.

One variation to the 'analogue' workflow was that art departments were asked to decide what size illustration was required for each painting prior to its digital photography rather than at the time that the catalogue was being put together. While technically it would have been possible to shoot and process all images to a standard size and then allow the imagesetter's Raster Image Processor (RIP) to change the image size at the film output stage, there were legitimate concerns that the RIP would be significantly slowed by the need to sub-sample large image files for the resized illustrations. A number of compromises were created as work-arounds, including manual reprocessing of HDR 'raw' digital image files at the time of catalogue make-up or batch processing them into standardised sizes, e.g. $1/2$ page, $1/4$ page, etc.

5.7 Workflow from Photography to Print

The various process flows that were encountered on the project are summarised in Table 5.1. The process flow found at the start of the project is illustrated in Figure 5.1. and that introduced during the project with the use of bar-codes is illustrated in Figure 5.5. The final configuration of the dedicated digital photographic studio is illustrated in Figure 5.8. It included working areas for a digital photographer, an image processing person in charge of RGB-CMYK

Original analogue	Semi-digital	Fully digital
■ Photography (some use of *Polaroid*™ and then three bracketed shots on 5 × 4 inch transparency)	■ Digital photography	■ Digital photography
	■ Compare digital image on screen against original painting	■ Archive RGB files
		■ RGB to CMYK separation in photo studio
■ Process	■ Save as RGB files	
■ Check transparency against original panting	■ Separate to CMYK at pre-press stage	■ Digital contract proofing in studio
■ Scan to CMYK, output films and create *Cromalin*™/ *MatchPrint*™ (or wet proof off press) for high-value works	■ Output films and create *Cromalin*™/ *MatchPrint*™ for high-value works	■ Compare digital contract proof with original painting
	■ Create plates	■ Send CMYK file to pre-press
	■ Print catalogue	
■ Check *Cromalin*™/ *MatchPrint*™ /press proof against original painting		■ Page make-up in Quark *Xpress*
■ Scan transparency to printed size, and output films		■ Digital contract proof of page layout
		■ Computer-to-plate
■ Page make-up (images and text)		■ Print catalogue
■ Output films		
■ Create *Cromalin*™/ *MatchPrint*™ of page layout for plate and for press proofing		
■ Make plates		
■ Print catalogue		

Table 5.1

Comparision of three process flows: analogue, semi-digital and fully digital.

Figure 5.8

Layout of the digital photo studio, showing separate working areas for photography and image processing/proofing.

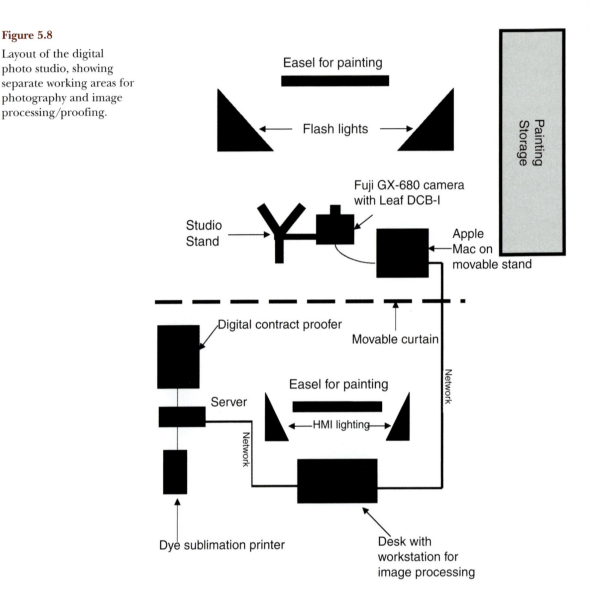

separation and output to the Iris *SmartJet* proofer, and (perhaps most significantly) a dedicated warehouse man to organise the smooth flow of paintings to and from the warehouse.

5.8 Developments over the Past Decade

5.8.1 Studio digital cameras

In the late 1990s there was a move, largely driven by Philips and Kodak, to produce rectangular area array CCDs for digital cameras. The 3:2 format

more closely matches the aspect ratio of the 35 mm photographic film format. More recently the largest area array CCD chips have moved more towards a 5:4 aspect ratio, mimicking the 5 × 4 inch large transparency format.

Digital camera backs in conjunction with high quality optics can now produce digital images of high enough quality to satisfy almost all print requirements. CCD linear array line-scanning cameras are becoming less readily available as single-shot CCD area array cameras predominate. Many of the latter have the capability to capture an image in both one-shot and multi-shot modes, creating colour RGB files from separate red, green and blue channel data rather than through interpolation.

The largest digital image file sizes are still produced by line-scanning cameras such as the BetterLight Super 10K-2, which offers images of 10 200 × 13 800 pixels creating massive 24-bit RGB files of 402 Mb. The Sinarback 54 with its large area CCD offers images of 5440 × 4080 pixels, and can be used in one-shot, four-shot or sixteen-shot modes to generate 24-bit RGB files from 65 to 255 Mb in size. It is interesting to note that these still employ the same principle of piezo micro-actuation of the CCD sensor that was pioneered in the Kontron *ProgRes* camera (see Section 5.3).[4]

Portable studio quality digital camera backs that operate in single-shot mode only are also increasingly available, such as the Sinar 54m (Figure 5.9). The Leaf *Valeo* 22 with a CCD of 5356 × 4056 pixels is another example. Wireless *Bluetooth*® technology is also being adopted to provide a preview image on portable PDA-type display devices. Given that the vast majority of photomechanical illustrations remain below A4 in size, however, it is unclear what value a commercial photographer may derive from generating such large digital image files from a digital camera.

Conversely, consumer and 'prosumer' cameras continue to incorporate ever larger image sensors and the algorithms to produce RGB data for each active pixel of a single-shot colour mosaic sensor have improved very significantly. One-shot cameras with 6-Megapixel sensors, predominantly in single-lens reflex (SLR) style, are now proliferating with over twenty different models available as of the summer of 2004. The effort of the studio-quality digital camera manu-facturers has been directed towards making their equipment more portable.

Convergence of digital image technology is perhaps the most significant development. The chip-maker Qualcomm announced its 6 Megapixel camera chips for mobile phones in Spring 2004. This chip also offers full-motion camcorder recording, coupled to Wideband Code Division Multiple Access (W-CDMA) which is the emerging standard for third-generation wireless networks. This points to the convergence of digital still and video imaging across broadband wireless networks.

Dedicated studio cameras on which to mount professional digital camera backs have also been produced, including the Sinar P3 (Figure 5.10) and the Linhof M679. These cameras are significantly more compact that their

Figure 5.9

The Sinar 54m digital studio camera back, showing the large 22 Megapixel CCD sensor of dimensions 49 × 36.7 mm (4:3 aspect ratio), which fills most of the image plane of a 645 medium-format camera.

large-format film-based predecessors and have benefited from the introduction of 'live' video previewing for framing and focusing the image remotely via the computer screen rather than by using the controls on the camera itself. A wide range of 'digital' lenses is now available from manufacturers including Schneider Kreuznach and Rodenstock.

The vast majority of digital cameras provide software to enable images to be imported directly into Adobe *Photoshop*, which has become a *de facto* standard for all reprographics image processing. With the inclusion of an ICC profile, *Photoshop* can perform RGB-CMYK colour separation of a quality satisfactory for most purposes. A number of digital camera manufacturers continue to offer proprietary RGB-CMYK separation software as an add-on to the digital camera software, such as Sinar *CeMagYK* and Leaf *ColorShop*. Whether these manufacturers can differentiate these products from Adobe *Photoshop* is uncertain.

CMOS (complementary metal oxide semiconductor) sensors for digital cameras have great potential, and both Canon and Kodak have exploited the

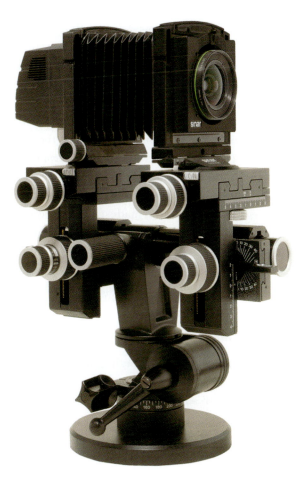

Figure 5.10
The Sinar P3 studio camera, designed especially for use with a digital back rather than film.

technology for a range of professional '35 mm SLR' cameras using sensors with more than 5 Megapixels. The Kodak DCS 14n launched in late 2002 uses a full frame (36 × 24 mm) CMOS chip with 14 million pixels (4536 × 3024). It has been recently replaced by the Kodak DCS Pro SLR/n (using Nikon lenses) and SLR/c (using Canon lenses) although it uses the same CMOS sensor. As with the evolution of CCD sensors during the 1980s, the development of high resolution CMOS image sensor technology is now being driven by the military and scientific sectors, such as surveillance and astronomy. The manufacturers of studio-quality digital cameras, however, have largely stuck to CCD technology for their leading edge products.

One significant recent development is a sensor technology that aims to remove the need for colour interpolation required by existing single-shot mosaic arrays. Foveon X3 CMOS sensors have the colour channels stacked in three layers, just as colour photographic materials have three layers of chemical emulsion. Foveon's layers are embedded in silicon to take advantage of the fact

that red, green and blue wavelengths of light penetrate silicon to different depths. This enables the construction of an image sensor that captures full colour at every pixel site (Figure 7.23). At present the CMOS Foveon image sensor is being exploited by consumer and 'prosumer' camera manufacturers such as the Sigma SD-9 with a 2263×1512 pixel sensor.

Digital colour management is now mainstream for digital cameras. GretagMacbeth have produced the ColorChecker DC and SE charts for creation of ICC profiles for digital cameras, which supplement the standard Macbeth ColorChecker and ANSI IT8 targets produced by film manufacturers such as Kodak and Fuji. Digital cameras are now invariably shipped with ICC profiles, although these tend to be generic and better results in a studio environment can usually be achieved with a custom-made profile (see Chapter 11). The majority of low-end consumer digital cameras produce images encoded directly in the sRGB colour space. A major issue for digital photographers is that repeatability is frequently not feasible. There are too many variables: camera angle, lens, aperture, camera exposure, and especially lighting.

5.8.2 *Digital printing and publishing*

Experiments in 1994 with Kodak *PhotoCD* highlighted that colour management remained a significant issue and that high image quality was hard to achieve. This mirrored the findings of some major publishers, notably IPC Magazines who had undertaken a major project with Wace, its reprographic company, to ascertain whether *PhotoCD* could be used for both digital archiving and production.

Although the Internet was already in existence, the impending impact of the World Wide Web (WWW) was still completely unanticipated in early 1993. Publishing on CD-ROM was evaluated but at the time, the installed hardware base requirement for adequate 24-bit computer graphics capabilities proved to be a barrier to entry. Neither CD-ROM nor DVD has played a significant role as a medium for auction house catalogues. Today, most auction houses offer illustrated online catalogues as well as printed versions. Christie's recently introduced a technology by Zino that mimics the turning of pages in a digital version of the printed auction catalogue. Some art experts who specialise in small-scale objects (such as collectables) and who are technically competent photographers are creating their own digital images for illustrations to their auction catalogues using 'prosumer' digital cameras. These tend to be smaller size illustrations, typically $1/8$th or $1/16$th of a catalogue page.

Experiments at Christie's to use digital printing presses for additional print runs of out-of-stock catalogues proved that there were problems with both quality and cost. Short runs and print-on-demand proved to be economically unviable. While variable digital data seemed to be the logical market for the

early manufacturers of digital printing presses – such as Indigo and Xeikon – the market remained a comparatively niche activity. In 2000, Agfa transferred its *ChromaPress* digital printing division to Xeikon but by January 2002 this company faced liquidation. In 2001, Indigo NV was acquired by Hewlett Packard. A number of factors lie behind these transactions. Traditional printers reacted aggressively in terms of price to counter digital printing services and the image quality gap between good offset lithography and digital print was never satisfactorily closed.

All auction houses run their own commercial picture libraries, repurposing the photographic images taken for the auction sale catalogues. Colour transparencies in 5×4 inch format were then – and to a large extent remain today – the *de facto* standard for use in professional pre-press. Yet downloading of high-resolution image files for print remains in its infancy. Many clients, particularly in the publishing sectors, do not have a fully digital infrastructure and process flow, and do not have a compelling need for the speed of delivery that digital imaging enables. The full impact of digital photography on picture libraries, and clients they supply through licensing agreements, remains a grey area. The future of this business area will become clearer as auction houses develop a more comprehensive digital knowledge management strategy and the markets for digital content mature.

The worldwide impact of ebay.com presents a major challenge for the major auction houses and this Web site has seen an ever-increasing use of digital photography to illustrate the items offered. To date, none of the auction houses has exploited digital image 'streaming' technologies to enable online zooming of very high resolution still images, or considered the application of digital 3D visualisation of objects.

5.9 Conclusion

The R&D phase of the project at Christie's proved that digital photography could speed up the process flow, improve quality, reduce costs and create extra services such as the supply of digital prints for clients. Digital photography and dye sublimation prints proved a successful 'just in time' solution that was suitable for condition reports when works of art were consigned by vendors and when 'photographic quality' colour prints were supplied to key clients. While the Iris inkjet contract proofs were more colour-accurate than dye sublimation prints, they proved to be less robust and unsuitable for repeated handling.

It was shown that digital photography could be used successfully to originate the digital images from which the photomechanical illustrations in auction catalogues were reproduced. Image quality, particularly in terms of colour accuracy and dynamic range, were significantly improved over the previous film-based process. Better colour consistency in terms of neutral backgrounds

was achieved. A more appropriate control over sharpness was achieved, as regards the level of USM applied. In all of these aspects, the judgement of the fine art specialists and business managers was paramount, for whom subjectively 'pleasing' rather than strictly accurate picture reproduction tended to be more important.

By 1996, both the London and New York offices of Christie's were running digital photographic studios and a major rollout of digital camera backs to equip all the other photo studios of the auction house was commenced. Digital photography is now embedded within the core systems of all fine art auction houses, although it took Christie's nearly a decade to come to terms with effective integration of a fully digital process flow feeding an increasing number of digital services. High-end studio-quality digital cameras aimed at catalogue illustration for high value sales continue to be used and the majority of manufacturers active in 1993 still survive. However cheaper 'prosumer' digital cameras are increasingly being used to create the illustrations for lower valued auctions, such as those of the collectors market. Consumer digital cameras are regularly used to provide illustrations for Web sites.

Two areas of auction house core business required analogue photography to be retained during the 1990s. Advertising and marketing requirements could not be met by the digital image file size of the Leaf DCB-I since these were not sufficiently large to create high quality posters or double-page magazine spreads. In these instances, a conventional large-format photographic transparency of the work of art was still required, and indeed continues to survive in the world of the auction house.

In reality, in this study the return on investment model was shown to depend on a complex matrix of interrelated factors including culture, training, leadership and a number of technical and business issues. It has taken over a decade for the full cost benefits of digital photography to be realised. This has occurred as a result of the convergence of various information technologies, and represents a significant watershed for the fine art auction houses. How this industry adopts and adapts to the digital broadband world, enabled by the Web and searched by the 'Google generation', remains to be seen. Whatever be the future directions, digital photography and digital imaging technology will play an increasingly important role in the commercial operations of the art world.

5.10 References

1. Hamber, A. (1996). *A Higher Branch of the Art Photographing the Fine Arts in England 1839–1880*. Gordon and Breach, Amsterdam.
2. Hamber, A. (1999). Communicating Colour: Advances in Reprographic Technology 1840–1967. In *Visual Resources*, Volume XV, Number 3, pp. 355–370.
3. For an outline of the considerations and methodology used see Anthony Hamber and Phil Green, *Digital Photography*, Pira/BPIF Publishing, Leatherhead, 1999.

Although published reviews of comparisons between studio quality digital cameras were examined – such as *Digital Cameras for Studio Photography. The 1995 Seybold Shootout*, Seybold Publications, Media, 1995 – none was found to be sufficiently comprehensive nor did any cover the specific issues and challenges of a fine art photographer.

4. This technology is derived from a patented invention by the brothers Reimar and Udo Lenz, based in Munich, who have continually developed and refined the method over the past 20 years, working with most of the major manufacturers of digital cameras. See European Patent WO9005424 'Optoelectronic Colour Image Sensor' (1990), and US Patent 5,877,807 'Optoelectronic Colored Image Converter' (1999).

6

User Requirements for Metric Survey

Paul Bryan

6.1 Introduction

It is not possible to care for the historic environment and direct resources effectively unless we understand more about its condition and how it is changing.[1] This understanding in turn allows judgements to be made on the significance of a site through understanding why it is there, how it may have been constructed and used over time and what may have been lost. To aid the informing process, Clark introduces the term 'CoBRA – **C**onservation **B**ased **R**esearch and **A**nalysis'.[2] This defines the research, analysis, survey and investigation necessary to understand the significance of a building and its landscape and thus to inform decisions about repair, alteration, use and management. It is now a recognised fact that, within any heritage conservation project, survey data of an appropriate level will always be needed.

Understanding a site can range from a rapid overview using existing maps and photographs right through to the detailed survey and analysis of fabric, drawing upon all of the recording technology and expertise currently available. Within the UK, the term 'recording' has been used to encompass both the collection of the base survey data for the project and its subsequent thematic enhancement. However with the application of modern large-scale data capture techniques to the conservation process, a new internationally recognised term *Metric Survey* has evolved for the data collection element. This is defined as:

> *'The measurement and pictorial presentation of land and buildings to a specified standard, supplying reliable and repeatable base data without specific thematic input.'[3]*

The definition is an attempt to explain the process of measuring a site, building or feature using known, repeatable survey methods leading to the presentation of the recorded information in a scalable form. To minimise subjectivity this should be tackled with the minimum of analytical input, although it is recognised that the interplay between thematic observation and measurement process is often complex and difficult to separate.

The term 'Metric Survey' encompasses the full range of survey techniques currently available, which may be successfully applied within a conservation

project, either separately or in combination. Even though emerging technology such as laser scanning may currently be difficult to classify, metric survey techniques can usefully be divided into two separate groupings:

- Non-image-based (direct), such as hand survey and theodolite measurements;
- Image-based (indirect), such as rectified photography, photogrammetry, orthophotography and panoramic imaging.

6.2 Non-Image-Based Survey Techniques

These survey techniques typically involve some level of contact with the object being surveyed. As well as being particularly suited to confined spaces or areas where other techniques cannot reasonably be deployed, the interplay between observation and measurement allows a greater degree of sensitivity to be introduced into the survey process. Being principally designed for two-dimensional measurements, however, they generate 'traditional' data presentable as either a point or a line. Because they rely on representing what is effectively the surface of an object as a series of lines, they inevitably introduce an element of subjectivity into the process. Therefore to apply them appropriately to complex three-dimensional objects requires a lot of skill, patience and time, together with a prior knowledge of both the systems capabilities and its specific application within the heritage field.

6.2.1 Hand survey

These techniques include hand measurements, which are typically recorded onto a sketch using a tape, spirit level or plumb line to generate the basic measurement framework (Figure 6.1).

The application of modern, low cost, portable distance-measuring devices, such as the 'Disto' from Leica Geosystems, are becoming ever more commonplace and helping to speed up data capture on site. The resultant two-dimensional sketch can then either be annotated and used in its own right, redraughted or even digitised into CAD (Computer Aided Drafting) software to generate the final drawing. Due to the necessary physical interaction with the surveyed object, the resolving power of the technique is very high – typically millimetric – and is limited only by the visual acuity of the surveyor.

6.2.2 Theodolite measurement

The Total Station Theodolite (TST) is used to generate both angle and distance measurements simultaneously. Angular measurement and readout is now characteristically electronic, rather than optical. Also distances are typically

Figure 6.1
Hand surveying on site.

observed using EDM (Electro-magnetic Distance Measurement), whereby a beam of infra-red light is reflected off a small glass prism to provide distance measurements down to millimetric accuracy. When combined together, these observations can generate three-dimensional data that with care and patience is capable of representing very detailed objects, as typically encountered in heritage applications.

This sector of the survey industry has in recent years seen dramatic developments culminating in the general application of REDM (Reflectorless Electro-magnetic Distance Measurement) technology. This is a non-contact method of observing distances, again using infra-red light, but without the need for a separate reflector relying instead on the natural reflectivity of the surface to complete the measurement process. These TSTs have indeed revolutionised the way distances are now observed in the field by allowing an operator on site simply to trace around a feature and produce three-dimensional digital drawings in real time. When combined with a pen-based computer and graphical drawing interface, such as TheoLT, they provide an economical alternative to some of the more sophisticated and expensive measurement techniques. As remote observations are made, the resolving power is limited by both the optical quality of the TST's telescope and the visual acuity of the surveyor (Figure 6.2). Even though millimetric observations are possible, the resolution is often limited by the level of detail actually required within each individual project.

Figure 6.2

Leica TCRM 1103 total station theodolite, equipped with REDM.

6.2.3 GPS measurement

The term Global Positioning System (GPS) is now a familiar phrase to many who need to know their position in relation to a map or chart.[3] The system is based around a constellation of 24 satellites, whose precise position in both space and time is already known. These satellites continually orbit the earth approximately once every 12 hours, broadcasting navigation signals from an altitude of 20 200 km. In its simplest form, GPS works by simultaneously measuring the distance between the user's receiver and a minimum of four orbiting satellites. This enables the unknown position of the receiver to be calculated through the process of trilateration.

By using a hand-held GPS receiver costing no more than £300 it is possible to locate a position anywhere on the earth's surface to an accuracy of around 10 m. Even though these devices have obvious appeal to sailors, walkers, pilots, vehicle drivers or indeed anyone who needs to navigate from one place to another, they have limited use as surveying instruments. This is principally due to their use of the coarse part of the satellite signal which provides limited horizontal and vertical accuracy – the latter being notoriously bad. At the other extreme, the modern crop of survey-grade GPS equipment, costing around £20 000, uses simultaneous collection of the precise satellite signal from at least two positions. Known as differential GPS, this allows detailed corrections to be made to the computed satellite-receiver ranges based on the signal path through the earth's atmosphere. The resulting data has centimetric accuracy, referenced to any local or national co-ordinate network, and is widely used for many mapping applications.

Figure 6.3
GPS equipment being used for photo-control and archaeological field survey.

When combined with a hand-held computer running CAD for the real-time 'kinematic' computation of 3D position, differential GPS provides an excellent tool for specialised application, such as archaeological field survey. By acquiring sufficient satellite data, it is even possible to achieve data of millimetric accuracy, which is ideal for monitoring applications or co-ordinating fixed control points located anywhere on the ground. Being based on a direct line of sight between receiver and satellite, however, GPS is currently restricted to external application only (Figure 6.3).

6.3 Image-Based Survey Techniques

This category typically describes the survey processes of rectified photography, photogrammetry, orthophotography and panoramic photography. Here, the data source is the visual image itself, in either its traditional film-based photographic or digital-based form. When combined with a dimensional scale they can be used to provide valuable metric survey data in either a line or scaled image form.

6.3.1 Rectified photography

In comparison with other more sophisticated survey technologies, the rectified photography process is very simple, significantly cheaper to produce and hence is already widely used in the heritage sector. Being image-based, it is ideal for graphically recording large predominantly flat objects and so has proved a popular choice within many conservation projects where objective metric

survey data is required. Because it is a two-dimensional technique based on a single image, however, it does have some practical limitations:

- It can only be used reliably on objects that are flat or have minimal three-dimensional relief;
- Photography needs to be taken in the 'traditional' manner, with the optical axis normal to the main plane of the object;
- The film and lens planes of the camera need to be aligned with both the assumed vertical and horizontal planes of the object. This is usually achieved by placing and aligning a level bubble along the top edge of the camera.

In its simplest form, the process relies on assumptions by the user about the object being surveyed, such as the verticality of an elevation or, in the case of a floor, its correspondence to a horizontal plane. Together, these affect the consistency of scaling across the object and the achievable accuracy of the resultant metric survey data. The technique relies on indirect remote measurements extracted from the images of the object rather than from direct observation of the object itself. Therefore, the technique's resolving power is limited by a combination of optical quality and angular coverage of the camera lens, scale of image acquired, speed rating/grain size of film or pixel/CCD resolution of digital image. If these factors are considered prior to application, it is possible to achieve an effective result, typically centimetre accurate, that is more than just simple photography with a scale. When remote observations are made, the resolving power of rectified photography is limited by both the optical quality of the TST's telescope and the visual acuity of the surveyor. Even though millimetric observations are possible, this is often limited by the level of detail actually required within each individual project.

6.3.2 Digital rectified photography

The use of digital photography within the heritage sector is becoming increasingly accepted as an alternative to traditional film-based methods. Even though it presents new archiving and file management challenges, within metric survey operations the availability of digital cameras with sufficiently high sensor resolution coupled with the widespread acceptance of photo-manipulation software, such as Photoshop and CorelDraw, and dedicated photo-rectification packages such as RolleiMetric's MSR, Siscam-Galileo's Archis and kubit's PhoToPlan, means that it is no longer necessary to take precisely square-on photography for the production of a rectified image (Figure 6.4). A digital camera of sufficient resolution (or digitisation by a flat-bed scanner, if film-based photography has been employed) can today provide the primary digital imagery to enable digital rectification directly on a standard desktop computer.

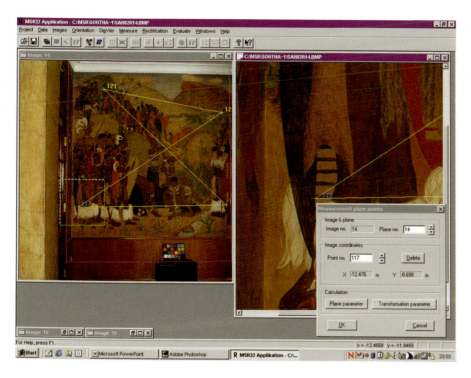

Figure 6.4

Digital rectification using Rolleimetric's MSR software, as carried out within the survey of murals contained within the Zulu Room of South Africa House, London.

This can be carried out using known control points, each with two-dimensional co-ordinates obtained either through direct theodolite observation or indirectly via measured distances, as well as digitising the visible horizontal and vertical perspective in the primary image. Important corrections such as colour balance, contrast and brightness can easily be determined prior to digital montaging and the result printed to scale via a standard ink-jet or laser printer. If a line-based drawing is required, then each rectified image, or the complete photo-montage, may be imported into a standard CAD package such as AutoCAD or Microstation and digitised directly on screen – often referred to as 'heads-up' digitising. Alternatively, a hard copy print can be placed on a digitising tablet and the required linework manually entered into CAD.

Case study – South Africa House

South Africa House is located on the eastern side of Trafalgar Square, in the Westminster district of central London. This grade II* listed building contains some outstanding murals by Eleanor Esmonde-White and Le Roux Smith Le Roux dating from the 1930s, located in its Zulu Room. Detailed survey was required as part of a pre-restoration record prior to condition survey by an external conservator alongside some remedial repairs. Rectified photography was deemed the most appropriate technique of providing the primary survey record. Twelve 'traditional' rectified images were acquired on colour film using a 5×4 inch film-based Toyo monorail camera with artificial illumination

Figure 6.5

Kodak DCS Pro Back fitted to a
Mamiya RZ67 medium-format camera.

provided by a Bowens Traveller flash system. Scale was determined by REDM observations to points of detail located on each mural rather than fixed targets which might have damaged the painted surface.

In addition, a duplicate set of digital imagery was acquired using a Kodak DCS Pro Digital Back (equipped with a 16 Mega-pixel resolution CCD) fitted to a Mamiya RZ67 medium-format camera with 90 mm lens (Figure 6.5). This was used to investigate how best to achieve better colour rendition as well as to test the application of high-resolution 'born digital' imagery for metric survey purposes. Scaled photo-montages were created directly from the digital images, using the MSR rectification software by Rolleimetric, which were output as both unscaled A4 prints and 1:20 scale plots on paper, formatted within AutoCAD.

As well as providing the necessary metric survey output, in both traditional hard copy and digital formats, the application of digital photography within a complete digital workflow successfully delivered a product with greatly enhanced colour accuracy. The context of the murals was also captured through the use of panoramic photography, digitally stitched together to produce a number of panoramic 'movies' of the Zulu Room (Figure 6.6).

6.3.3 Photogrammetry

Even though the principal application for photogrammetry is still within aerial mapping, close-range examples of industrial, medical and cultural heritage have all developed over recent years. Within the UK, the conservation application has principally involved the generation of detailed line drawings of architectural elevations. However the provision of stereo photography and its subsequent photogrammetric processing, particularly as an orthophotograph, is finding

Figure 6.6
Digitally generated
rectified photographic
montage of the Zulu
room mural.

increasing application in both architectural and archaeological projects. Traditionally, all photogrammetric applications have relied upon the acquisition of 'stereo photography' – an overlapping pair of photographs also referred to as a 'stereo-pair', or 'stereo-model' – using a dedicated, film-based 'metric camera'.

The technique provides an indirect method of analysing the surface and shape of an object, based on the original stereo image pair from which all further measurements are taken. Once again the technique's resolving power is limited by the optical quality and angular coverage of the survey camera lens, scale of image acquired, speed rating/grain size of film or pixel/CCD resolution of digital image. From viewing the two images of the stereo-pair, each containing a slightly different perspective of the overlapping detail, the human observer is able to perceive a three-dimensional view. To ensure that the two images provide a suitable basis for photogrammetric stereo analysis, the following image geometry is suggested:

- A camera separation (base) to object (distance) ratio no greater than 1:4;
- Overlap between adjacent image pairs of at least 60 per cent;
- Alignment of each image with the principal plane of the object to within ±3 degrees of parallelism;
- A maximum camera tilt, either upwards or downwards, of 15 degrees;
- A variation in the scale between adjacent images of no greater than 5 per cent.

The other crucial element is the acquisition of a scale for each stereo-pair. Even though this may be provided by simply measuring the distance between two recognisable points or placing a measuring rod in each image, it is traditionally obtained by taking precise angle and distance measurements to pre-marked points using a total station theodolite. As well as allowing these 'scale-less' images to be calibrated to the desired scale, these control targets, and their three-dimensional co-ordinates, also enable the accurate registration of adjacent stereo-pairs. Through indirect determination of both the camera location and lens orientation at the moment of capture, the use of observed targets enables the accurate extraction of horizontal sections, vertical profiles or even production of photo-montage. In addition, they allow re-survey of the same object area to be performed, such as within the monitoring

Figure 6.7

Stereo-pair of Clifford's Tower, York, taken with a Wild P31 metric camera equipped with 300 mm focal length lens. Note the survey control targets circled and numbered.

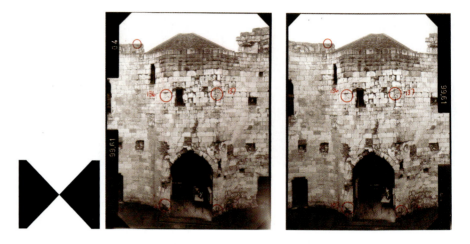

application, without the need to reoccupy the same camera locations precisely. If, after the initial survey is complete, targets are removed, then any subsequent imagery will need to be re-referenced through either repeat survey observation to common detail points or linkage to an existing site co-ordinate system.

Photogrammetric control points typically take the form of a small black-and-white 'butterfly' design printed onto thin, plastic sheets, ranging in width from a few millimetres to several centimetres, as shown in Figure 6.7. These are temporarily fixed to the object, prior to the photography being taken, using some form of conservation-compliant adhesive. Within each stereo-pair, a minimum of three points are required, to facilitate later measurement, although four of more are recommended to provide a redundancy of observation and some degree of error checking during the subsequent processing stages. A total station theodolite is typically used to generate the three-dimensional co-ordinates for each target using either the angle-intersection or angle and distance (polar) measurement technique. The widespread usage of total station theodolites equipped with REDM technology has enabled more rapid survey control observation on site by allowing simultaneous angle and distance observations directly to the surface of the control point.

Acquisition of a photogrammetric package of stereo photography and survey control data, conforming to recognised survey standards such as the Metric Survey Specifications for English heritage,[4] will produce an excellent, three-dimensional, archival record of a heritage site or feature. This increasingly digital colour record complements the traditional film-based record, and can be processed immediately to produce detailed line drawings as shown in Figure 6.8. Alternatively the survey data package can be archived away for some future application. The use of stereo, rather than single-image-based, photography will ensure a greater range of future processing options including two or three-dimensional line-based drawings, two-dimensional rectified imagery and orthophotography.

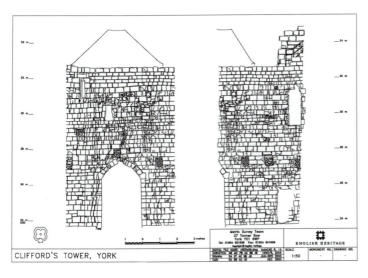

Figure 6.8
Photogrammetric line drawing of
Clifford's Tower, York plotted
at 1:20 scale from the stereo
photography (right).

Case study – St. Mary's Church, Studley Royal

St. Mary's church was designed by William Burges in 1870 for the Marchioness
of Ripon, as a memorial to her brother who was murdered by bandits in
Greece. Located west of Ripon in North Yorkshire, within the grounds of the
Studley Royal estate, it was built in the Gothic style and hence contains a highly
detailed exterior and interior finish, particularly in the chancel which is lavishly
decorated in coloured marbles, tiles, carvings and wall paintings. To aid the
conservation of the monument, currently in the care of English Heritage,
detailed photogrammetric drawings have been produced (Figure 6.9).

As well as supplementing the existing building documentation and site archive,
these drawings were primarily used by the architects planning conservation
work within the chancel. Here the delicate nature of the interior fabric prohibited

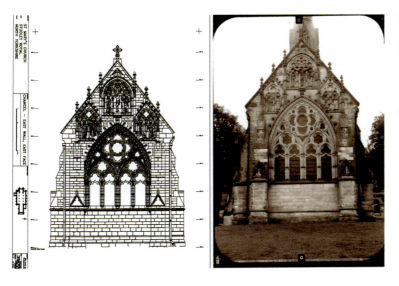

Figure 6.9
St. Mary's Church, Studley
Royal. Photogrammetric
drawing (left) of the east
exterior face of the chancel,
originally plotted at 1:20 scale
from the rectified photograph
(right).

Figure 6.10

3D reconstruction of the internal roof space of the chancel of St. Mary's church, based on photogrammetric, hand and REDM, survey data.

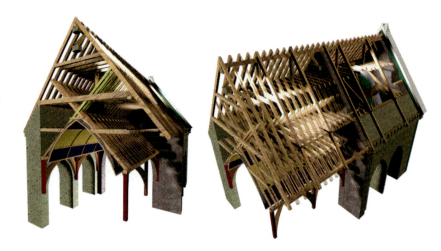

the use of physical survey targets, but the decoration itself provided many points of detail which could instead be used. In order to obtain the required stereo photography at a sufficiently large scale level, a fixed scaffold tower was erected inside the church. To achieve correct exposure a portable, professional flash system was also employed.

As well as stereo photography of the chancel interior elevations, rectified photographs were also taken of all the wall paintings and mosaiced floor tiles, together with survey of the internal roof space. Very often roof spaces of historic buildings remain unsurveyed, due principally to the difficulties of achieving suitable access. However in the case of fire or other possible 'disasters', they are often among the first parts of a building to be lost. Therefore whilst the internal ceiling structure of the chancel of St. Mary's was fully exposed, during repair work to the roof, the opportunity was taken to survey the space fully using a combination of hand and REDM survey. Two simulated cut-away views of the timbers in the structure are shown in Figure 6.10.

6.3.4 Orthophotography

On initial inspection, an orthophotograph appears to be similar to a standard, rectified photograph. However rather than applying a simple, two-dimensional scale correction, the image is differentially rectified to remove the effects of both camera tilt and object relief i.e. it is converted from an image with perspective projection to one with an orthographic projection. Although they are not new, orthophotographs are principally a product of digital photogrammetry where the growing popularity and use of image processing technology has contributed to their growing acceptance as objective, metric survey data. Even though a laser scanner, equipped with either an on-board imaging device or a separate digital camera, can now produce orthophotographic images, generation of a 'true' orthophotograph requires both a fully controlled stereo-pair photograph and

Figure 6.11
Leica Geosystems Helava Digital Photogrammetric Workstation in use at English Heritage offices, running the Socet Set processing software. The stereo image on the left monitor is viewed through the polarised 3D glasses.

the use of modern digital photogrammetric software as typically found on a Digital Photogrammetric Workstation (DPW), as shown in Figure 6.11.

As the majority of close range photogrammetric images are still captured on film, orthophotographic processing on a DPW initially requires scanning of the original negative or transparency to provide the primary digital files. To ensure their geometric accuracy, dedicated photogrammetric scanners are typically used rather than cheaper desktop scanners. The digital images are imported into the workstation and viewed using either 'passive' polarised glasses (as seen in Figure 6.11) or 'active' liquid crystal 3D glasses.

After orientating the 3D view, through identification of common points and digitisation of any control points visible in the image, the operator is able to view the 3D imagery directly on the monitor screen. As well as facilitating the production of traditional line-based drawings, the use of a DPW enables the automated production of a Digital Elevation Model (DEM) which gives the detailed height/depth information required for differential, ortho-rectification of imagery. This is typically generated using a process known as 'image corre-lation', in which a software algorithm analyses the corresponding pixels in each digital image. Where a match is found, a three-dimensional elevation co-ordinate is generated. These are subsequently combined together on a gridded basis to form the detailed, surface model. The original imagery can then be adjusted to fit this DEM, thus removing the scaling errors caused by relief displacement, prior to splicing of adjacent images to form the complete digital, orthophotographic montage. See the example in Figure 6.12.

6.3.5 Panoramic imaging

Panoramic images are traditionally based around the QuickTime VR technology developed by Apple Computer. By acquiring a series of separate, overlapping images, using either a film-based camera (requiring additional scanning) or a

Figure 6.12

Digital orthophotographic montage of the Chapter House floor in Westminster Abbey, with a detail showing one constituent image (inset). Note the slight colour variations introduced by incorrect colour balancing of the primary film negatives during photogrammetric scanning.

digital camera with appropriate resolution, and appropriate software tools on a standard personal computer, the user is able to digitally 'stitch' the images together to form one continuous 360° view. For an example see Figure 3.10. A full account of the technique is given in Chapter 17.

Depending on the geometric projection, either cylindrical or spherical/cubic, panoramic imaging typically allows the user to virtually explore, examine and interact with an extended photographic view of the object (Figure 6.13). The development of digital panoramic cameras has further refined the acquisition process by removing the need to digitally stitch together separate,

Figure 6.13

Cubic panorama of Belsay Hall, Northumberland. Produced by Bob Smith from the Collections Management team, English Heritage.

overlapping images. Instead, one continuous digital image is acquired using a motorised camera that slowly rotates in a full circle around the central point.

Unlike other virtual reality systems, panoramic imaging does not require any sophisticated imaging devices to view the images. The consumer simply uses a standard computer keyboard or mouse to control the direction of view and the image magnification, using freely available viewing software such as Apple's QuickTime player. Even though the term 'movie' is often used to describe such images it is important to recognise that this technology is not actually time-based and so is not the same as video capture.

Panoramic imaging is currently used principally within the multimedia industry, for the presentation of objects and sites accessed either over the Internet or within stand-alone virtual tours. The introduction of an element of scale within the imaging process, however, could provide the potential for metric survey data extraction. Specific developments for the survey market have occurred, such as the Hazmap (HAZard MAPping) survey system developed by As-Built Solutions Ltd., and more recently the measurement application provided by Spheron VR for use with their range of high-resolution digital panoramic cameras. Even though both show promise for survey application, neither is yet used regularly by the commercial suppliers of metric survey data. This is principally due to the increased time required to digitise manually the required level of detail visible in each panorama as required within the heritage application.

Case study – Richmond Castle Cell Block

Panoramic imagery is a great aid to popular presentation of historical sites. An example is the virtual tour of the Cell Block at Richmond Castle in North Yorkshire. Here, there has been a long-term conservation problem, surrounding the historical graffiti which date back to prisoners held during the First World War and which appear on most of the internal cell walls. Due to its poor condition, closure of the building to the public was necessary. In an attempt to restore limited public access, a virtual tour has been created by English Heritage based around panoramic images, the existing rectified photography of the elevations processed using Rollei's MSR software, and the three-dimensional planimetric survey of the cell block. From these has been produced a presentation on a web site which is eminently applicable to all areas of conservation, not only for metric survey (Figure 6.14).

6.4 3D Laser Scanning

Laser scanners are already being applied to a wide variety of metric survey applications at different scales. These can range from the large-scale visualisation of an entire historic landscape using aerial LiDAR, down to the detailed, sub-millimetric analysis of an archaeological artefact using a close-range

Figure 6.14

Front page of 'the Writing on the Wall' virtual tour of the Cell Block at Richmond Castle, North Yorkshire.

triangulation scanner.[6] Regardless of technology, the primary product is often a dense grid of 3D survey points commonly referred to as a 'point cloud' or 'data cloud'. Once captured, this mass of 3D data requires post-processing to convert it into a form useable by the client. Scanners are effectively 3D surface mappers and hence are best applied to the capture of surface topography rather than edge information.

Laser scanners fall into two distinct categories, discussed in the following sections:

- Systems based on optical triangulation or 'structured light';
- Systems based on LiDAR (Light Detection and Ranging) principles.

6.4.1 Optical triangulation or 'structured light' scanners

Structured light scanners have been available for several years, and have been used principally within laboratory environments for the capture and replication of historical artefacts. They work by projecting a laser line across the object's surface, the reflection of which is picked up by a CCD sensor mounted rigidly within the scanning head.[5]

By knowing the fixed distance between the laser source and CCD sensor, it is possible to compute the precise XYZ coordinates of each point along this line, using triangulation (Figure 6.15). By observing points along a series of

Figure 6.15

Principle of Optical Triangulation scanning

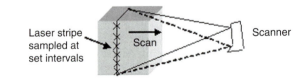

Figure 6.16
Minolta VI-910 close-range laser scanner.

laser lines, scanned many times per second, it is possible to build up a detailed 3D representation of the object surface. These systems offer sub-millimetre accuracy and concentrated data capture, although often at the expense of range and portability. The accuracy is achieved as a result of strictly controlled conditions, such as the fixed distance from laser source to CCD, which often restricts the object-to-sensor distance to less than two metres. Hence, close-range scanners were initially installed within laboratories where all variables could be calibrated, requiring the object to be brought to the scanner. However a number of portable scanners are now available that allow scanning directly in the field. An example is the VI-900 range manufactured by Minolta, shown in Figure 6.16, which is capable of scanning in less than 3 seconds an artefact of up to $1 \text{ m} \times 1 \text{ m}$ in area to a resolution of 0.2 mm.

One factor that limits the scan quality is the reflectivity of the object's surface. If the surface is shiny, e.g. gilded, or marbled, it will cause problems by creating false specular reflections of the laser line and hence incorrect XYZ data. This may sometimes be overcome by 'dusting' the surface with a fine, white, removable powder to reduce such reflections. However, such an invasive approach should be avoided unless the surface is already due to be cleaned and conserved. False reflections may also occur if the surface is wet, so outside scanning during or after rain is also to be avoided wherever possible, together with exposure to bright sunlight, which can cause problems for some optical triangulation scanners.

6.4.2 LiDAR scanners

Pulse-based laser, often referred to as LiDAR (Light Detection And Ranging), scanners work on measuring the time of travel of a pulse of laser light to and

Figure 6.17

Leica Geosystems Cyrax 2500 laser scanner in operation at Clifford's Tower, York. The observed 'data-cloud' can be seen on the screen of the portable computer.

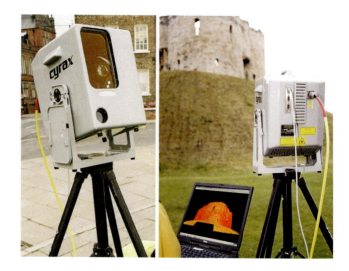

from an object. By recording the range and direction to the object, a 3D point measurement can be derived.

These terrestrial scanning systems offer increased portability and much greater object-to-sensor range, enabling the efficient scanning of larger objects, often up to ranges in excess of 500 m, whilst maintaining point accuracies of around ±5 mm. They suffer problems similar to their close-range counter-parts in that some materials reflect the laser pulse better than others. For instance, shiny objects can cause too much of the energy to be returned whilst black or transparent objects reflect too little. As they do not rely on daylight or artificial illumination, however, they can be operated just as effectively at night as during the day.

Even though this technology cannot easily be categorised as either image-based or non-image-based, it has great potential for metric survey (Figure 6.17). The recent introduction of high-resolution digital imaging technology, either fitted internally within the scanner or mounted separately on an offset camera, together with the application of processing software based on photogrammetric principles, is a definite merger of the approaches. The data generated is currently difficult to interpret and translate into the 'traditional' line drawing format, which is often still required by heritage agencies, without significant additional manual digitising work. Also, the large number of 3D points observed, typically running into millions for any one structure, makes the data unsuitable for processing in standard computer drafting packages, such as AutoCAD or Microstation. Compared with existing survey technology the hard-ware is also expensive, typically costing upwards of £50 000. Yet laser scanners have one overwhelming advantage, which currently set them apart from all other metric survey technology, namely their rapidity of observation with data capture rates typically exceeding thousands of 3D points every second. With the on-going rapid development of the technology, coupled with its inevitable coalition with

other image-based techniques such as photogrammetry, there is no doubt that it will become an important surveying tool of the future.

Case study – Grimes Graves, Norfolk

The site of Grime's Graves, located near Thetford in Norfolk, is the earliest major industrial site in Europe where there still exists the remains of flint mines worked between c.2300–1800 BC. There are about 400 shafts across the six-hectare site, many of which are shallow hollows although some have been deeply excavated and may be descended by ladder. One of these is Greenwell's Pit, which was first excavated in 1868–70. and has recently been the subject of a major survey by English Heritage utilising laser-scanning technology to record the many radiating shafts and galleries dug by the Neolithic miners (Figure 6.18).

Conventional ground surveys of the mine have been tackled before, especially by the British Museum in the 1970s who used specialist mining engineers to survey their plans. However, these were produced in two rather than three dimensions, which limited their accurate referencing with the modern, digital terrain model of the above-ground surface. For the new 3D survey, traditional methods were deemed inappropriate due principally to the difficult subterranean working environment and restrictions on access. Therefore, the rapid observation rates and high level of data capture offered by laser scanning contributed to its choice as the preferred survey methodology.

In order to record both the three dimensional geometry of the structure and the high degree of archaeological evidence still visible on many of the mine surfaces, a combination of terrestrial and close-range scanning technology was employed. This survey has resulted in a massive data archive, comprising numerous separate scans each yielding many millions of individual 3D points, from which for the first time, detailed study of the extent and scale of the mine

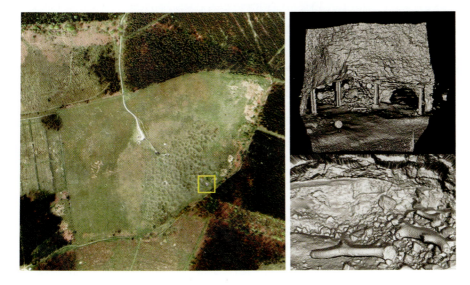

Figure 6.18

Grimes Graves, Norfolk, where laser-scanning technology has recently been used to survey the underground mine workings within Greenwell's Pit (highlighted by yellow square). The aerial image is an extract from The Millennium Map™ © getmapping.com plc. Both screenshots courtesy of Archaeoptics Ltd., Glasgow.

will be possible with accurate quantification of the volume of chalk and flint extracted from the pit. The scans will be invaluable as a management tool to monitor any evidence of future movement or collapses in the mine, as well as facilitating the creation of remote virtual access to a site that is sadly too fragile to admit visitors.

6.5 Comparison of Techniques

The wide variety of metric survey technology available nowadays for heritage applications means there is often more than one appropriate solution to a project. Before selection of technique and prior to commencing a survey considerable thought must therefore be given to:

- The purpose of the survey;
- The content and level of detail required;
- The application by other users involved in the project;
- Which techniques are most appropriate;
- How they can best be applied within any financial constraints.

Table 6.1 highlights some of the advantages and disadvantages for each of the techniques mentioned.

Table 6.1

Comparision of advantages and disadvantages of digital survey techniques.

Technique	Advantages	Disadvantages
Rectified photography	Quick, simple and objective – the image is 'the product'	Applicable on surfaces that are flat or have minimal relief
	Does not require sophisticated equipment – 'DIY' is possible	Requires camera lenses that display minimal distortion and some 'setting-out' to minimise error propagation
	At around £5 per sqm, for production of scaled montages, it is 'cheap' in comparison to other techniques	Typically centimetric rather than millimetric accuracy
Digital rectified photography	Resolution of modern professional digital cameras is now equivalent to film	Requires use of appropriate digital camera or scanning of film-based Imagery
	Does not require darkroom processing – all functions performed on computer desktop	Requires appropriate computer hardware and software tools

Continued

Technique	Advantages	Disadvantages
	Enhanced tonal and colorimetric manipulation of imagery	To retain correct colour balance requires careful control of image exposure
	Correction for lens distortion is possible	Requires separate analysis of lens distortion and input of characteristics into software
	Greater flexibility in product use – raster and vector data can be combined in CAD	Digital data requires careful file management and archiving
Photogrammetry	Requires little or no contact with the object	Requires survey control targets to be temporarily affixed to the object
	Applicable on all 2D and 3-D surfaces	Requires stereo photography, with sophisticated camera and processing equipment
	Resultant stereo photography is an excellent archival record	Obstructions may hinder photographic coverage
	Can provide millimetric accurate 3D data suitable for immediate import into CAD platforms	Accurate and appropriate information requires experienced operators
	Requires minimal access by equipment, often achieved from a remote location	Ideal coverage requires 'setting-out' and restriction of acceptable camera angles
	Low-cost PC-based solutions are now available	Line-based data is often viewed as being subjective
	Modern digital photogrammetric systems provide not only drawings but also orthophotographs, perspective views and animations	At around £13 per sqm, for producing detailed line drawings, the process is often regarded as 'expensive and needlessly accurate'
Orthophotography	Scaled image corrected for both planimetric and height variation	Requires sophisticated software for true orthophotographic production
	Automated tools available for colour matching of adjacent imagery	Requires careful control of scanning process if using film-based imagery
	Greater flexibility in product use – raster and vector data can be combined in CAD	Requires detailed consideration of output – can lead to large file sizes being generated

Continued

Technique	Advantages	Disadvantages
	Digital survey cameras – both terrestrial and aerial – are now available	High price of technology – particularly aerial
	Objective data	Can provide too much information!
Panoramic imaging	Quick, simple and objective.	Requires processing software to stitch accurately the overlapping digital images
	Can use standard film and digital cameras, as well as specifically designed panoramic cameras	Requires dedicated camera bracket to provide accurate angular coverage
	Can provide scaleable product	Provision of dimensional scale is difficult in 'DIY' case
	'DIY' is possible	Ideal coverage of site requires some pre-planning
	Cheap – uses freely available viewing software	Internal and re-entrant spaces are difficult to illuminate
	Very effective visualisation!	Poor-man's virtual reality?
3D laser scanning	Applicable to all 2D and 3D surfaces	Some systems do not work in direct sun or wet conditions
	Rapid 3D data collection in near 'real-time' – requires substantially less site time	Large data sets require extensive post-processing to produce a usable output
	Very effective 'surface-mappers', due to the large volumes of data collected at a predictable precision	Difficulty in extracting edges from indistinct 'data clouds, that characterise heritage examples'
	Ideal for 3D modelling and visualisation purposes	Vector output requires manual digitisation to satisfy heritage recording standards
	Both 3D position and surface reflectance typically generated which, when processed, can be viewed together as an 'image'	Does not currently generate an image of comparable resolution to other techniques
		Close range – up to 0.2 mm accuracy
		Terrestrial – typically 5 mm accuracy

Continued

Technique	Advantages	Disadvantages
	Extensive marketing by manufacturers and exposure to technology by clients, through conferences	No common data exchange format, such as DXF, currently in use to allow ease of processing and archiving by third parties
	Rapidly developing survey technology	Difficult for clients and end-users to remain 'up-to-date'
	Extensive world-wide research and development currently being undertaken on both hardware and software tools	With hardware still expensive and sophisticated software required to process data, cost is currently prohibitive for many heritage projects
	The 'wow' factor – impressive to see in operation	Clients need to understand limitations when considering applicable techniques and required outputs

6.6 Summary

There is now a vast array of survey technology that can be applied within a heritage context, ranging from the humble tape measure right up to sophisticated 3D laser scanners. Along with the general availability of low-cost computer hardware, it is the modern day acceptance of digital rather than analogue data that has had the greatest impact on technical development and has contributed greatly towards the acceptance of digital techniques within the surveyors 'toolkit'. Currently, laser scanners offer an excellent technology for rapidly recording the details of a surface. However their ability to precisely define the edges of features is currently limited by the specialist software required to process the large, three dimensional 'point-clouds'. This will undoubtedly restrict their implementation within projects where there is still a demand for the traditional two-dimensional line-based drawing. It is expected that laser scanning will be incorporated within conservation practice as a method of recording alongside other recognised techniques such as total station survey, rectified photography and photogrammetry. This hybrid approach may provide the most appropriate solution to the graphic recording needs of heritage projects.

6.7 Acknowledgements

The author would like to thank his colleagues in the Metric Survey Team of English Heritage; Cathy Tuck and Pete Topping from the Archaeological Investigation Team of English Heritage for assistance with the Grimes Graves project; Bob Smith from the Collections Management team of English Heritage for use of his

panoramic imagery; Susie Barson from the Building and Landscape Survey Team of English Heritage regarding the South Africa House project; Jon Mills/David Barber from the School of Civil Engineering and Geosciences at Newcastle University for their input with regard to 3D laser scanning.

Except where noted all images used as illustrations in this article were taken by English Heritage.

Disto is a registered trademark of Leica Geosystems Ltd.

TheoLt is a registered trademark of English Heritage.

AutoCAD is a registered trademark of Autodesk, Inc.

Microstation is a registered trademark of Bentley Systems Inc.

Socet Set is a registered trademark of BAE Systems.

Photoshop is a registered trademark of Adobe Systems Incorporated.

CorelDraw is a registered trademark of Corel Corporation Limited.

Quick Time VR is a registered trademark of Apple Computer Inc.

Hazmap is a registered trademark of As-Built Solutions Ltd.

Spheron is a registered trademark of Spheron VR.

MSR is a registered trademark of Rolleimetric.

Archis is a registered trademark of Siscam Galileo.

PhoToPlan is a registered trademark of kubit GmbH.

6.8 References

1. Power of Place – The future of the historic environment, English Heritage, 2000.
2. Clark, K. (2001). Informed Conservation – Understanding historic buildings and their landscapes for conservation, English Heritage.
3. Measured and Drawn, English Heritage, 2003.
4. Metric Survey Specifications for English Heritage, English Heritage, 2000. Product code XH20155, ISBN 1873592574.
5. Barber, D. (2001). Laser Scanning for Heritage Applications – Scanning systems and example projects, Departmental report. Department of Geomatics, University of Newcastle Upon Tyne.
6. Bryan, P. (2004). 3D Laser Scanning – New techniques of observation, Conservation Bulletin, English Heritage.
7. Atkinson, K. B. (1996). Close Range Photogrammetry and Machine Vision, Whittles Publishing.
8. Where on Earth are We? – The Global Positioning System (GPS) in archaeological field survey, English Heritage, 2003. Product code 50788.

6.9 Web links

English Heritage – www.english-heritage.org.uk

TheoLt – www.theolt.com

Kubit – www.kubit.de

Leica Geosystems/LPS – www.gis.leica-geosystems.com/products/lps/

BAE Systems/Socet Set – www.socetset.com

Rolleimetric/MSR – www.photarc.co.uk/rollei/rollei.html

Siscam Galileo – www.siscam.it

AutoCAD – www.autodesk.co.uk

Microstation – www.bentley.com

Apple Quick Time VR – www.apple.com/quicktime/qtvr

Minolta – www.minolta-3d.com

SpheronVR – www.spheron.com

Links to all 3D laser scanning systems – http://scanning.fh-mainz.de

Remote Sensing and Photogrammetry Society for UK (RSPSoc) – www.rspsoc.org

6.10 Glossary

Photogrammetry	The science and art of determining the size and shape of objects by analysing images recorded on film or electronic media.
Ortho-rectification	The adjustment process undertaken in producing an orthophotograph, through fitting an image to a three-dimensional digital elevation model.
Orthophotograph	A true-to-scale image from which the scaling errors caused by the effects of camera tilt and variations in depth have been digitally removed.
Metric Survey	The measurement and pictorial presentation of land and buildings to a specified standard, supplying reliable and repeatable base data without specific thematic input.
CAD	Computer Aided Drafting
DEM	Digital Elevation Model
DPW	Digital Photogrammetric Workstation
EDM	Electromagnetic Distance Measurement
LiDAR	Light Detection And Ranging
REDM	Reflectorless Electromagnetic Distance Measurement
TST	Total Station Theodolite

PART 2

TECHNOLOGY

Principles and Evolution of Digital Cameras

Peter Rudolf

7.1 Introduction

The first ideas of electronic cameras are now nearly 100 years old, only 70 years younger than the first Daguerreotype film camera. Some of the basic working principles and the general assembly have remained the same all this time. Improvements and progress in many technical areas, however, have been required to obtain modern digital cameras. This chapter aims to explain the principles of digital cameras and to evaluate the current state of their development.

Today, information is flowing everywhere in digital format. Digital means that the information is encoded in a discrete, i.e. numerically quantifiable, form. Within electronic information transfer there are numbers, characters, signs, images and symbols, all represented through the binary system of numbers. This system derives the 1–0 numerical state directly from the on–off physical state of simple electronic switches. The advantage of digital processing is that distortion of digital signals through external interference during signal processing, does not, within limits, change the content of the encoded information. Digital information is thus quite robust against distortions.

By contrast, during the processing of analogue information, physical quantities like electrical voltage levels, pressure or movement are used to represent information. The advantage is that a theoretically infinite number of intermediate values exists but on the other side, there is a high sensitivity towards interference. A good example for analogue information processing is provided by the sensor of digital cameras. The incident light is converted into a voltage, whose level is proportional to the energy of the incident light.

When is a device called digital? From the user's point of view, the following definition seems to be applicable: *Digital devices are able to create, process or present digital information to the outside world.* The manner in which the information is represented and flows internally is not relevant to this definition.

According to this definition, digital cameras are electronic cameras that provide image information to the user in digital form. Conversely, analogue cameras such as older TV cameras provide the information as a continuously

Figure 7.1

General components of a digital camera.

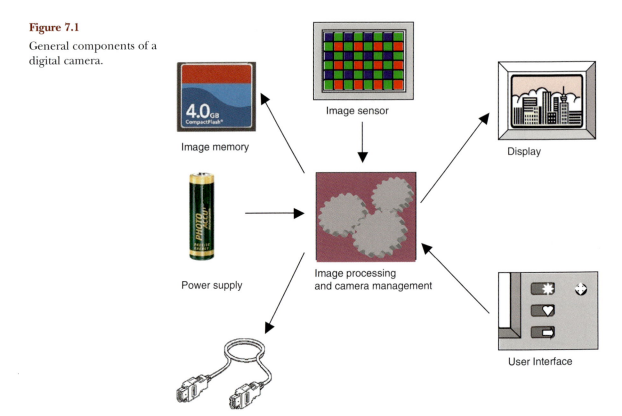

Image memory

Image sensor

Display

Power supply

Image processing and camera management

User Interface

Camera Interface

variable electronic signal, whose amplitude varies in proportion to the intensity of light falling on the image sensor of the camera. Such a sensor can be an electronic valve (vidicon), a CCD or a CMOS sensor. In the following text, only CCD and CMOS image sensors are considered, with a particular emphasis on CCD sensors. Figure 7.1 shows the basic functional elements of a digital camera.

7.2 Components of a Digital Camera

7.2.1 Image sensor

At the beginning of the processing chain, there is an image sensor as the light sensitive device. Two kinds of image sensors are used in today's digital cameras: CCD and CMOS sensors. Both have the same general functionality, namely sensing light, converting it into electrical signals and transporting it to the sensor output.

Therefore according to a beguiling designer's motto – form follows function – both must be constructed in a similar way. The photosensitive elements convert the incoming photons into electrical signals, whose amplitudes are

directly proportional to the intensity at each position of the incident light and to the time the sensor is exposed to light. Expressed more physically, the amplitude is directly proportional to the energy of the incident light. This phase of collecting light is called the integration phase, since the electrical signal is integrated over the exposure time. After the integration period is finished each pixel has to be readout, i.e. the electrical signal of each pixel has to be transferred to the output(s) of the sensor.

CCD is the abbreviation of Charge-Coupled-Device. Part of large CCD image sensor is shown in Figure 7.2. The device can be described as a series of closely spaced capacitors fabricated from metal-oxide–silicon (MOS) technology, each capable of holding a charge. If a bias voltage is applied to such a capacitor via the gate, a local potential well below the gate is created. Incoming photons generate electron–hole pairs, which are separated by the applied voltage. Splitting the gate of the MOS-capacitor into several gates and applying voltages to them in a sequential order (switching them on and off), the charge packet within this capacitor can be moved to the next one and so on. This mechanism provides a simple shift register, allowing signal charges to be propagated through the entire CCD array. By adding several shift registers in parallel and applying the voltages to them synchronously, a two-dimensional area CCD is created. The shift registers are separated from each other by so-called channel stops.

These 'vertical' or 'column' shift registers lead into a 'horizontal' shift register. All the charges of one 'horizontal row' or line of the CCD area are loaded in parallel into the capacitors of the horizontal shift register. Then the content of the register is moved to the output using the same transport mechanism as for the vertical shift register. After all capacitors have been moved to the output and emptied, the next line of the CCD area is loaded into the horizontal shift register. The procedure is repeated until all the signals of the CCD array have been completely read out. The voltages applied to move the charges vertically

Figure 7.2
Photomicrograph of the surface of a large CCD image sensor.

Figure 7.3

Block diagram of a
CCD image sensor of
the full-frame type.

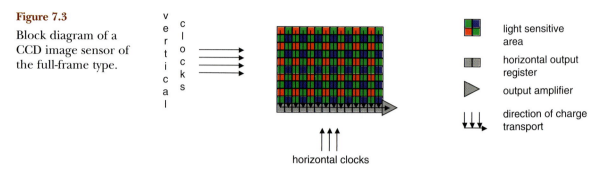

horizontal clocks

through the CCD are called 'vertical clocks'; the voltages applied to move the
charges horizontally are called 'horizontal clocks'.

Whereas each *pic*ture *el*ement (=pixel) of a CCD consists of a MOS-capacitor,
each pixel of a CMOS sensor consists of a photosensitive element and a MOS
transistor, working as a switch, as shown in Figure 7.4. A CMOS imager is a
two-dimensional array of CMOS cells, which can be addressed one row at a time
by switching on the MOS transistor. The output of the pixels of the row is
connected to an analogue-to-digital converter (ADC), where a column address
logic controls which pixel of the row is switched to the ADC.

Pixels as described here are called passive pixels. Due to a large fixed pattern
noise and a very low readout speed, designers found it necessary to add an
amplifier per pixel, and thus the active pixel sensor (APS) was born. All of
today's CMOS sensors are of the APS type.

Figure 7.4

Block diagram of a typical
CMOS image sensor.

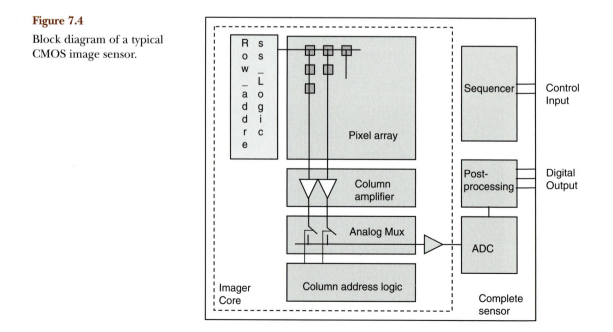

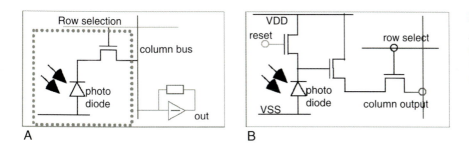

7.2.2 LCD display

The display is the component that most endows superiority to a digital camera over a film camera. Besides control of camera settings and status, it allows immediate visualisation of the captured image. It should therefore be matched in its performance to the image sensor and the optical system.

Current digital cameras are mostly equipped with liquid crystal displays (LCDs). Figure 7.6 shows the working principle of a cell in which liquid crystal fluid is sandwiched between two glass substrates. Liquid crystal molecules of twisted nematic (TN) type are normally loosely arranged with their long axes parallel to one another. In contact with a surface with fine grooves, the alignment layer, the molecules next to the surface align themselves with the grooves. Electrodes between the glass and the alignment layer allow the passage of light through single cells to be controlled, with the aid of two polarisation filters, one on each side of the cell, twisted by 90° against one another.

With no voltage applied, the liquid crystal molecules between the glass plates build a 90° twisted structure from one plate to the other, so forcing the polarised light to follow the twist and thereby pass through the second polarisation filter. A voltage applied between a row and a column electrode, however, generates at

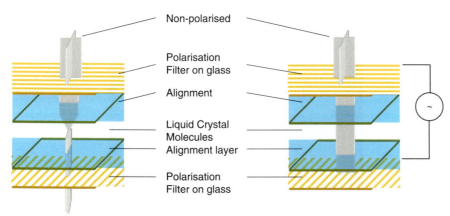

Non-polarised

Polarisation Filter on glass

Alignment

Liquid Crystal Molecules
Alignment layer

Polarisation Filter on glass

Light passing No light

Figure 7.6

Working principle of one cell of a liquid crystal display (LCD).

the cross-point an electrical field, which causes the molecules to become aligned in direction of the field. Light passing the first polarisation filter can now pass the liquid crystal layer untwisted, and since the polarisation plane of the light is not aligned with the second filter, the light is blocked.

This kind of display is called a passive LCD. The pixels are switched on and off from control circuits outside the display. Large distances of the electrodes and the necessary voltages cause passive displays to be slow, lacking in contrast and susceptible to crosstalk between neighbouring electrodes. Most modern LCDs are instead of the active-matrix type, in which a transistor is directly printed on the glass substrate at the cross-point of each row and column. This kind of technology gives the display its name – Thin Film Transistor (TFT) LCD. As the voltages needed to switch the transistors on and off are very low, cross-talk is minimised and the transistors can be switched rapidly.

Colour displays have an additional RGB colour mask, where each pixel is covered with a red, green or blue colour filter, so three neighbouring pixels are needed to provide the three colour channels. Displays used for digital cameras have a diagonal size of up to two inches, a colour resolution of 6 to 8 bits per channel and a spatial resolution of up to $500 \times 500 = 250\,000$ pixels.

All LCD technologies have one disadvantage: they do not emit light, they only modulate light provided by external sources, either a high-intensity backlight for luminous displays or ambient light for reflective displays. New technologies, such as Organic Light Emitting Diodes (OLEDs) will overcome this disadvantage, because they use a kind of polymer which emits light directly when an electrical field is applied. Different colours can be generated using different kinds of polymers. The first commercial OLED displays are being used in high-end consumer and semi-professional digital cameras.

Figure 7.7

Micrograph of the surface of an active-matrix TFT LC-display, showing the transistor in each cell at the cross-point of the row and column electrodes.

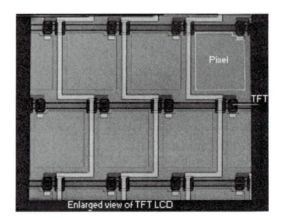

7.2.3 Memory

Mobile digital cameras need some kind of mass storage to store the images in a durable way. Current standards are small-sized hard disks and flash memory. The latter are solid state devices, meaning that there are no moving parts. Flash memory is a type of Electrical Erasable Programmable Read Only Memory (EEPROM). Formerly, PROMS were used in computers to store non-volatile program code, such as the Basic Internal Operating System (BIOS). Whereas PROMs can be programmed only once, EEPROMs can be programmed multiple times by applying a higher voltage to the chip, but it is a slow procedure. Further improvement of the EEPROM technology was necessary to evolve to the current flash memory, which is ideal for digital cameras. It is light in weight, small in size, noiseless, robust because of no moving parts, and fast and economical in power consumption. But compared to hard disk drives, the cost per megabyte is much higher and the storage capacity is more limited.

Flash memory is used in all modern removable solid state storage devices. A variety of different formats is available for digital cameras, some are widely used while others are only available in proprietary formats. Most common as 'electronic film' are: (a) the so-called Solid State Floppy Disk, better known as SmartMedia, with size of a credit card and a storage capacity of up to 1 GB; (b) the SD card, with the size of a stamp and a capacity of up to 1 GB; and (c) the lipstick-sized CompactFlash Card with capacities of up to 8 GB. The Sony Memory Stick is an example of a proprietary removable solid state disk.

Both SmartMedia and CompactFlash, as well as Type I and Type II memory cards, adhere to standards developed by the Personal Computer Memory Card International Association (PCMCIA). This makes it easy to access these cards with an adapter through standard floppy disk drives, USB ports or PCMCIA card slots.

Mobility requires a reliable, small-sized energy storage of high capacity. Modern batteries, such as Lithium Photobatteries, rechargeable Lithium-Ion batteries or rechargeable Nickel-Metal hydride batteries provide high power-to-weight ratios.

7.2.4 Image processor and camera controller

Before the final image is stored on disk or displayed on the built-in monitor, a lot of image processing is required. This job starts with correction of defective sensor pixels, continues with colour interpolation, white balance, colour conversion, and terminates perhaps with noise suppression. Additionally camera management functions must be fulfilled, such as memory and power management and control of the lens, display and user interface. All these functions require a powerful processing unit with most peripheral functions, such as

display and memory controller, USB- or IEEE1394-interface, JPEG encoder, integrated on the chip in order to minimise the required space. It needs to be fast, but with very low power consumption. Due to the large variety of functions, these embedded controllers are often designated as a system-on-a-chip, using application-specific integrated circuit (ASIC) technology.

Looking at all these functions and components inside a digital camera, one can imagine what technical progress was required to make modern digital cameras possible. In the next section, the history of development of CCDs and digital cameras is reviewed.

7.3 History of Digital Cameras

7.3.1 The CCD

In 1969, Willard Boyle and George Smith, working at the Bell Laboratories (USA), invented the Charge-Coupled-Device, the CCD. It is said that in the space of an hour on 8 September, 1969, they sketched out the basic structure of the CCD, defined its principles of operation, and outlined applications including imaging as well as memory.

The invention was inspired by several projects at that time, in which the Bell Labs were more or less involved. One was the work on magnetic bubble memory, a kind of a shift register, where the presence or absence of magnetic dipoles represented the binary 0s and 1s, which were moved along by a rotating external magnetic field. A second project was the work on the silicon diode array camera tube, which was intended to be used in the Picturephone, a telephone combined with a small TV-display and this camera tube. The camera tube was an array of thousands of diodes fabricated on a single chip, which were accessed by an electron beam. Additionally at that time, the MOS-Transistor was in the early stages of development for electronic circuit applications and the MOS-capacitor had just been understood.

Figure 7.8
W. Boyle and G. Smith, inventors of the CCD.

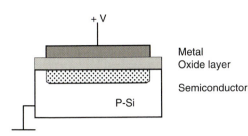

Figure 7.9

The basic structure of a MOS-capacitor.

It can be seen that a CCD combines all these ideas: it consists of an array of light sensitive MOS-capacitors placed closely together thus working as analogue shift registers, as shown in Figure 7.3. All these cells are integrated on a single chip, showing from the beginning all the advantages of a CCD over the vidicon tub in: size, weight, linearity, dynamic range, broad spectral response, power consumption, reliability and durability. Of course in the beginning, there were also several disadvantages which took several years to be removed, or at least to be minimised, namely image quality, cost, frame rate and format.

One main factor limiting the performance and therefore the size of the first CCDs was the poor charge transfer efficiency (CTE). This is defined as the percentage of charges transferred successfully from one pixel to the next. According to Figure 7.3 the charge of a pixel at row i and column j on the matrix of a CCD must be transported through $i+j$ pixels until it reaches the output. The CTE of early sensors was around 99.5 per cent, meaning that the charge of the last pixel of a sensor with $m \times n$ pixels was reduced to $100 \times (CTE/100)^{m+n}$ per cent. For an early sensor with 100×100 pixels, only 37 per cent of the original charge of the last pixel thus arrived at the output. Although a CTE of 99.5 per cent sounds good, it is clear that it is not sufficient to build large sensor arrays with several millions of pixels. To aggravate the situation, the missing charge is not really lost. During transport, it is 'smeared' into other pixels lying on the way to the output, causing the resulting images to appear severely blurred. Accurate coloured images would be impossible. The underlying effects, which can be explained by semiconductor theory, additionally cause a high noise floor. So, most of the development efforts in the following years were turned to improve the CTE. Modern sensors have a CTE of 99.99995 per cent which is an improvement factor of 10 000. The last pixel of a modern high-quality CCD with 4000×4000 pixels thus loses only 0.4 per cent of its charge on its way to the output.

7.3.2 First digital cameras

From the beginning, the technology of digital cameras was driven by both scientific and consumer requirements. Astronomers appreciated the large dynamic range and the excellent linearity, compared with film. In the consumer

sector the size, weight and cost were priorities. The success of CCDs started as soon as they were commercially available. This happened in 1973 when Fairchild offered the first CCD array with 100×100 pixels. The first digital camera was developed by the inventors of the CCD themselves and contained a CCD with a resolution of 250 lines and all the video circuitry to demonstrate its suitability for the Picturephone, although this camera was not intended to be a commercial product, and took its first image of an astronomical object in 1974. The first electronic still image camera using this CCD was developed by Kodak in 1975, and stored the images on a cassette tape.

All these electronic cameras using a CCD were still analogue apparatus, either providing a video signal directly to a television monitor or storing single video images in TV format on magnetic tape. This was best demonstrated by the Sony Mavica, presented to the consumer market in 1981. It was a still video camera, designed as a single lens reflex (SLR) camera with interchangeable lenses, using a 570×490 pixel CCD working in video mode, but capable of writing single video images on two floppy-disks. These images could later be displayed on TV.

The CCD used for the Mavica was of a new type. In contrast to former full-frame sensors, it was an interline transfer (IT) sensor, as shown in Figure 7.10. Each pixel is split vertically into two halves, where one part is light-sensitive and the other one is shielded from light. Both parts are connected together, such that the charge collected within the light-sensitive part could be transferred by an electrical signal to the shielded part, from where it could be read-out in the same way as for full-frame sensors. This characteristic allows the camera to work without a mechanical shutter, but a significant disadvantage is that the light-sensitive area of a pixel is reduced to 50 per cent of its total area, thus limiting light sensitivity and dynamic range. The first factor can be improved by setting micro lenses on each pixel in order to gather all the incident light onto the sensitive part of the pixel.

Additionally, the complete CCD is divided into two frames, consisting of all even-numbered, and all odd-numbered lines respectively. While one frame is exposed to light, the other can be read out and vice versa, a method called

Figure 7.10

Basic structure of an interline transfer sensor.

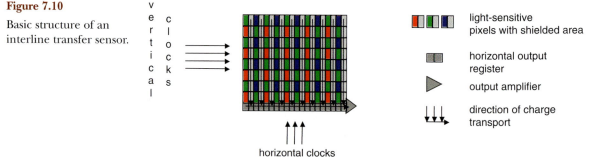

interlaced. Within a receiver, the final image must be reassembled from both frames. Together with an appropriate timing signal, this feature allows easy synchronisation to TV-monitors. For still cameras, this type of sensor is less suitable, because moving objects appear blurred within images.

7.3.3 Consumer products

IT-CCDs were the sensors of choice for the growing market of Video Camera Recorders (VCR and Camcorder). In 1985, Sony introduced the first CCD-based Camcorder, called Video8, which contained a 250.000 pixel CCD. Over the following ten years the number of pixels increased to 410.000, while the size of the chips decreased from $2/3''$ to $1/4''$ diagonal. This was done in order to make the camera as small, light-weight and cheap as possible. In 1992, Sharp was the first to replace the conventional eyepiece viewfinder by a large LCD display showing the 'live' image. In 1995, Sony introduced the first digital camcorder to the market.

While the first cameras for both scientific and commercial purposes used the same CCDs, the situation today is completely different. As mentioned above, an important criterion for commercial use is the price of the sensor. According to Theuwissen,[1] the price of a sensor depends primarily on two factors, namely the price of the processed silicon wafer and the number of defects allowed. Defects can be assumed to be randomly distributed over the wafers, so the probability of getting defect-free CCDs is primarily determined by the yield of chips, i.e. the percentage of chips with defect count below the threshold of acceptability. The price of a single chip therefore depends on the number of chips obtained per wafer which is inversely proportional to the chip area. Increasing the chip dimension by a factor of two can lead easily to a decrease in yield by a factor of five. In comparison to these factors, the number of pixels is of less importance. Making CCDs cheaply therefore means reducing the chip size and, in order to keep the number of pixels constant, also means reducing the pixel size at the expense of dynamic range and sensitivity.

Today's digital consumer cameras come fully equipped with optics, image-processing unit, display, memory and batteries. Something similar is now required for the digital camera backs used for professional applications such as high-end studio photography or cultural heritage. At the time of writing this chapter, 22-Mpixel CCDs with active area of 48×36 mm are available, and 33-Mpixel will be available within the next year. The image data will be digitised with 14 bits, providing 66 MB of raw image data. The frame rate will be unchanged at a minimum of one image per second, meaning that this volume of raw data must be digitised and written to non-volatile memory within one second. Additionally some basic image processing must be performed to show the image on the built-in display. The integrated batteries should allow

an operating time of at least one hour until they must be recharged. All that must be mounted in a housing not larger than current film cassettes. Power consumption must be as low as possible to avoid heating up the CCD thus decreasing image quality. Finally with some adaptations, the camera back should conform to the mechanical and electrical interfaces of the camera bodies of the most important manufacturers. Those are, in a few words, the requirements for digital camera backs within the near future.

7.3.4 The VITRA camera system

Medium-format cameras are traditionally used for documentation in cultural heritage, as described in Chapter 14. In the VITRA project, a medium-format (MF) camera together with a digital camera back was selected. An additional demand of the VITRA project was a reliable Autofocus (AF) mode, since normally the camera is operating high above ground far from the possibility of intervention by the operator. To guarantee correct operation, even under difficult light conditions, the camera should additionally allow the focus to be set manually by remote control. Of course, all other camera parameters such as aperture and exposure time should be controlled remotely also. All these demands, together with the availability of high quality AF-lenses, made the Rollei 6008AF a good choice for the project. This is a 6×6 cm autofocus studio camera which can be completely controlled from remote via a serial interface. For the project, it was used with a standard 80 mm and a wide-angle 35 mm fixed-focus lens. For mobile use, on site in photography of buildings, the Rollei 6008AF was equipped with a battery pack.

The *eyelike* M16 is a digital camera back especially developed by Jenoptik for the VITRA project. It is fitted to the Rollei camera body instead of a film cassette. The *eyelike* M16 is equipped with a 4080×4080 pixel colour CCD from Kodak (Table 7.1), with a light-sensitive area of 36×36 mm, the largest commercially available sensor in 2002 when the project began. The characteristics of this sensor will be used throughout the remainder of this chapter to exemplify the current state of the art in CCD digital cameras.

Figure 7.11.

The Rollei 6008AF camera body together with the *eyelike* M16 digital back.

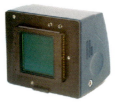

Name:	KAF16802CE
Type:	Full frame
Active pixels:	$4080 \times 4080 = 16.6$ Mpixels
Colour mask:	RGB, Bayer pattern
Pixel size:	9×9 µm
Dynamic range:	72 db, approximately 12 f-stops
Quantum efficiency R, G, B:	23%, 19%, 17%

Table 7.1

Characteristics of the Kodak CCD sensor used in the VITRA digital camera back.

The smaller format of the CCD gives in relation to the 6×6 cm image plane format of the Rollei a focal-length extension factor of 1.7, i.e. with a 35 mm lens the CCD of the *eyelike* covers the same object area as 6×6 film does with a 60 mm lens. This is sometimes a handicap if close-ups of large objects or surface areas are required in restricted space.

To guarantee optimum performance of the CCD, a two-stage cooling system is implemented. The first stage consists of a Peltier element, directly mounted on the rear of the chip. The heat generated by the Peltier element is removed from the back with a small fan. Since the power transfer capability of the IEEE-1394 interface is limited, the cooling system was designed to compensate for the self-generated heat of the electronics, keeping the CCD at approximately the ambient temperature of the camera system.

Within the *eyelike* M16, the 16.6 Mpixels of the CCD are read out at 12.5 MHz, giving a frame rate of 0.6 frames/s. The image data are digitised within the *eyelike* with 14 bits per cell and transferred via IEEE-1394 to the remote computer. All the image processing is done on the remote computer, as explained further in Section 7.8.

7.4 Film Camera versus Digital Camera

According to the Photoindustrie-Verband, Germany, in 2003 more than 100 million cameras were sold worldwide, of which approximately 46 per cent were digital and 54 per cent were analogue models. In Germany in 2003 nearly 7 million cameras were sold, of which more than 70 per cent were digital. These numbers indicate that for most users, both amateurs and professionals, digital cameras had reached a level of performance where they could be substituted for classical analogue film cameras. Concerning technical parameters, usability, robustness, dimensions and weight, they show comparable or nearly comparable performance. If there is a weakness in technical performance, it is compensated by the typical advantages of digital cameras: immediate feedback through the display or the attached computer, high flexibility insofar as individual preferences can be selected per image not only per film, but also there is easier processing, copying and circulating of the digital images.

There are some basic technological differences between film and sensors, which lead to different behavior. Film is based on chemical materials while

image sensors are electronic devices. Comparing the light-sensitive components, film versus image sensor, which characterise the medium, it must be stated that film has some inherent advantages against digital images: positives can be read very easily – simply by holding the film against a light source – whereas reading digital data requires special equipment. Directly related to this is the further advantage that film can easily be archived. A thoroughly developed film will endure for more than 100 years if stored in a cool, dry and dark environment. Current digital media do not exceed this period, and, to make matters worse, after 100 years the devices necessary to read these media are almost certainly no longer available. In a functional digital archive, therefore, the digital image data must be copied to new media at regular intervals of time, e.g. every 10 years.

7.4.1 Exposure

Under the influence of light, silver halide decomposes into metallic silver and the corresponding halogen (usually chlorine or bromine). Expressed in a different way, a photon of suitable frequency impinging on a crystal of silver halide is able to produce a silver atom Ag and a halogen atom X.

$$AgX + h\nu \rightarrow Ag\cdot + X$$

(Note that the formula above is not in the correct chemical notation, but is only to illustrate the process.)

In order to generate a latent image on the crystal of silver halide, a silver cluster must be able to grow large enough not to decompose after a certain storage time and then be able to catalyse the development of the image on film. The minimum size of the cluster necessary to fulfil these requirements is supposed to be four silver atoms, therefore requiring at least four photons. The modification of the crystal surface caused by the exposure is normally not visible as an image until after the subsequent development process, which continues the process of growth of metallic silver selectively at those locations where during the previous exposure, silver 'seeds' were planted.

The process of image generation inside the pixels of an imaging sensor is completely different. Incident light causes electrons to be released from their locations in the crystal lattice of silicon. The number of electrons released depends on the energy of the incident photons, the characteristics of silicon and (in case of a colour sensor) of the colour mask, the design of the sensor and the glass filter in front of the image sensor. The results are described through the so-called quantum efficiency (QE) curve, an example of which for a professional high-end colour image sensor is shown in Figure 7.12. The probability that an electron is generated inside a pixel by one photon is plotted against wavelength.

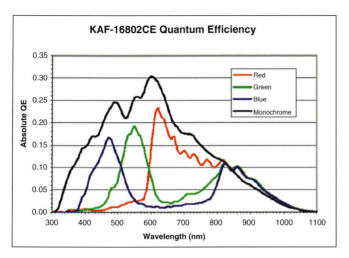

Figure 7.12
Quantum efficiency curve of a high end professional image sensor from Kodak.

The difference between image sensor and film can now be clearly defined: Film is a threshold device, i.e. image information is generated only if the light intensity is larger than a minimum threshold, so that seeds of metallic silver are established for later development. By contrast, an image sensor is a near-perfect analogue transducer, which responds linearly to the smallest quantities of light, which is why astronomers like image sensors so much.

7.4.2 Dynamic Range

The term 'dynamic range' (DR) is normally not used for film, although the definition is applicable. DR describes the capability of a medium to capture both highlights and shadows within a scene. It is defined as the ratio of the maximum non-saturated response to the minimum response capable of detecting information.

For film, the exposure range describes the range between the maximum and minimum levels of light which during development produce distinguishable grey levels on the film. These grey levels are measured by the transmittance of light through the film, which is defined as the ratio of incident light to transmitted light. It is expressed as a density D where:

$$D = -\log_{10}(\text{transmittance})$$

For example, a density of 3 means that the most transmissive area allows $10^3 = 1000$ times more light to pass than the darkest area. The relationship between exposure range and density of grey levels may be represented by a gradation curve, as shown in Figure 7.13.

The minimum exposure is defined by the amount of light necessary to provide a just detectable image in the darkest tones. Positive film, used for transparency slides, is most dense (darkest) where there is no exposure to light

Figure 7.13

Gradation curve shows relationship between exposure and positive film density.

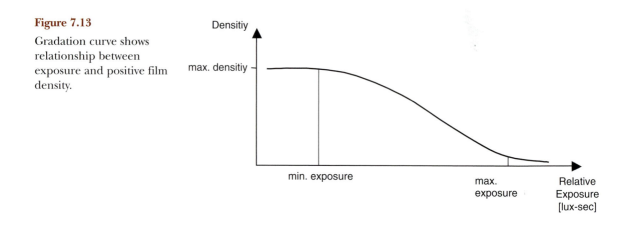

and least dense (lightest) where there is high exposure. The maximum exposure is defined by the amount of light that causes a density level just detectably different from the clear film stock. Since the maximum density of film is fixed, the range between maximum and minimum exposure can be influenced by changing the gradation curve through the development process. A steeper curve causes the maximum exposure to move to the left, therefore reducing the exposure range. Slide film achieves a maximum density of more than 3, and special high-contrast films up to 4. For negative film, the curve is reversed left-to-right and its slope is lower across a wider exposure range.

For comparison, the definition of the DR of an image sensor is given below. It is defined as the ratio of the maximum output voltage V_{out} to the threshold voltage V_{nd} generated by noise S_{nd} in the dark.

$$DR = V_{out}/V_{nd}$$

The higher the DR, the better is the tone resolution of the resulting images. The maximum output voltage range is the difference between the saturation level S_{sat} and the black level generated by dark current S_{dc}

$$V_{out} = S_{sat} - S_{dc}$$

The saturation level S_{sat} is an important parameter of the data sheet of a CCD. It relates directly to the maximum number of electrons Q_{max} that can be stored in a cell without losing them into the substrate or spilling into neighbour pixels by blooming. Q_{max} increases linearly with the light-sensitive area of the pixel and is given in kilo-electrons (ke-). The missing link between S_{sat} and Q_{max} is the conversion factor (μV/e-), which describes the ability of the output circuit to measure the number of electrons stored in a cell and convert it into a voltage. Knowing this factor, it is easy to express cell voltages in electrons and vice versa.

The saturation level and conversion factor depend on sensor design and sensor technology. For example, the data sheet of the Kodak sensor used in the VITRA camera gives a (linear) saturation level of typically 94 000 electrons (= 94ke-) and a conversion factor of 17,5μV/e-. The maximum output voltage of the chip is therefore 1.65 V.

Blooming occurs only at saturation, i.e. at maximum exposure of a pixel. If the amount of light falling on the pixel is so high, and accordingly the number of generated electrons so large, that the storage capacity of the pixel is exceeded before the end of the integration period, all further electrons spill over into neighbouring pixels in the vertical direction inside the columns of the CCD. Blooming typically causes visual artefacts below and above the highlighted area, as shown in Figure 7.14. The KAF16802 chip uses an anti-blooming drain, which extracts the spilling electrons to a location where they are harmless.

Dark current is generated continuously by thermal processes within the silicon substrate. If a pixel is considered as a bucket in which to collect and measure the amount of rain (electrons), dark current can be imagined as water which gets into the bucket through a leak, thereby falsifying the measurement. It is specified as an output voltage after a given integration time, or as a current density (given in A/cm^2) or it can be calculated as the number of electrons per (pixel-) area per second. The number of charges generated by dark current increases linearly with integration and readout time, and additionally doubles with every 7 to 8 degrees of temperature (Figure 7.15).

For example, the datasheet of the KAF16802CE specifies a dark level, i.e. an output voltage level generated by dark current, of 2.7 mV at 20°C. The integration time, according to the data sheet, is 250 ms, and the readout time is 1928 ms. With a conversion factor of typically 17.5V/e-, this value corresponds to 155e- generated by dark current. Assuming that the given dark level is a mean value over the total sensor, and knowing that dark current increases linearly with time, we can further assume that this value corresponds to a level provided

Figure 7.14
Vertical spread of highlights caused by blooming.

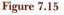

Figure 7.15

Dark current versus temperature.

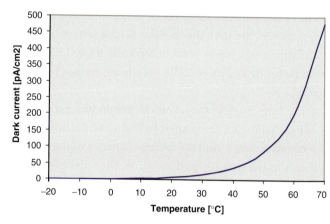

by pixels from the centre of the sensor. These pixels are read out after approximately half the total readout time, namely 964 ms. The sum of integration time and half the readout time is then 1214 ms, which leads to a dark current generation rate of 128e- per pixel per second at 20°C. It is interesting to see that, with this dark current rate and with the sensor set into integration mode and shielded against incident light, each pixel is completely filled with electrons after 94000/128 s = 12.24 min. Reading out the sensor after this time will provide a bright, fully exposed image, even though the sensor is shielded against light.

The second part of the definition of dynamic range requires quantification of the noise floor. There are several sources of noise inside a CCD, three of which are most important for the calculation of dynamic range. One source of noise is the dark current and, since the generation of dark current is a random process, the resulting noise is called *dark current shot noise*. It can be easily calculated as the square root of the number of electrons generated by dark current.

$$N_{\mathrm{r}} = \sqrt{(S_{\mathrm{dc}})}$$

where N_{r} is the dark current shot noise and S_{dc} is the number of electrons generated by dark current after a given integration time. This can be now rewritten as:

$$N_{\mathrm{r}} = \sqrt{(q \ I_{\mathrm{dark}} \ t_{\mathrm{Int}})}$$

where q is the elementary charge, I_{dark} is the dark current in A/pixel/s and t_{Int} is the integration time. It likewise has a strong dependence on temperature, as shown in Figure 7.16.

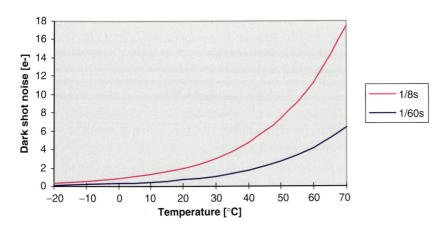

Figure 7.16

Dark current shot noise versus temperature.

For example the KAF16802CE chip shows a dark current of 155e- per pixel at the given integration and readout time. The dark current shot noise per pixel of an image captured under these conditions is 12.5e-. The generation of dark current and therefore dark current shot noise is largely determined by the technology used.

Another source of noise within a CCD is its output amplifier. More precisely, there are several noise sources within the output stage of the CCD, all summarised within the term *readout noise*. The amount of noise generated depends on temperature and readout speed, the latter being largely influenced by the design of the output amplifier of the sensor. With these definitions the dynamic range, DR of a CCD can be calculated as

$$DR = (S_{Sat} - S_d) \: / \: \sqrt{(N_d^2 + N_r^2)}$$

Or, after some rearrangement of terms, as:

$$DR = (Q_{max} - I_{dark} \quad t_{Int}) / \sqrt{(N_r^2 + q \quad I_{dark} \quad t_{Int})}$$

As a result, there is a strong dependence of CCD-image sensors and also of CMOS-sensors on integration time. Since cooling is not possible for mobile cameras, it can be improved only by finding a better technology or by increasing the size of the pixels since Q_{max} depends linearly on the light-sensitive pixel area.

For example, the dynamic range of the KAF16802 is specified as 73 db. According to the formula:

$$DR[db] = 20 \: \log_{10}DR = 20 \: \log_{10}(V_{out}/V_{nd})$$

the dynamic range of this image sensor is 4460:1 at an integration time of 250 ms, a readout speed of 10 MHz and a temperature of 20°C. To resolve this dynamic range, an analogue-to-digital converter (ADC) is required with:

$$n = \log_2(V_{out}/V_{nd}) \text{ bits.}$$

With the given DR, n can be calculated as 12.1 bits, which is rounded to 14 bits, since ADCs with 13 bits do not exist.

For film, in a comparable temperature range, this dependence of dynamic range on integration time is unknown, although some self-development does take place. But the available exposure range of film does not suffer from this effect to the same degree as an image sensor suffers from thermally generated electrons.

7.4.3 Spatial resolution

The light-sensitive layers of film contain halide crystals with large flat surfaces, to minimise reflections between the crystals and to increase the probability that enough photons hit the surface of the crystal to develop seeds of metallic silver. Because of the large crystals, a high sensitivity film looks more grainy than a film of lower sensitivity. It must be noted that the grain structure is not only caused by the size of the crystals itself , but by larger clusters of crystals resulting from the manufacturing process. They appear as random variations of the density of the material, comparable to the noise of electrical signals.

As for an image sensor, the resolution of a film is characterised by its Modulation Transfer Function (MTF). Because of the random distribution of the crystals and their varying size, it cannot be calculated but must be measured. This is done by exposing the film with a raster of alternating black and white lines modulated with a fixed amplitude but increasing spatial frequency. The spatial frequency is defined as the reciprocal of the width of one line pair. After development of the film, the resulting modulation of the raster image on the film is measured for all spatial frequencies using a micro-densitometer. The MTF curve is then calculated as a ratio of the measured to the original amplitude for each spatial frequency, as shown in Figure 7.17.

As mentioned above, the basic modulation transfer function of an achromatic image sensor with a rectangular matrix of pixels can be calculated using the formula:

$$\text{MTF}(u) = \sin (\pi \ a \ u) \ / \ \pi \ a \ u$$

where:

MTF(u) is the modulation or contrast ratio in %,

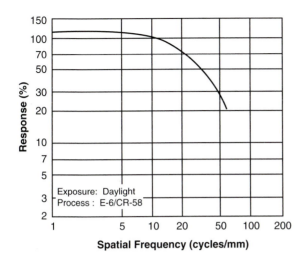

Figure 7.17

MTF curve of a colour slide film (Fuji Sensia II), showing that it resolves spatial detail well up to a frequency of approximately 20 cycles/mm. Due to some sharpening, inherent in the film development process, the resolution of low spatial frequencies, up to 10 line pairs per mm, appears better than the original.

u is the spatial frequency in lines per mm, and

a is the aperture of the sensor pixels.

The Nyquist frequency is defined as the half of the maximum sampling frequency or

$$u_N = u_{max} / 2 = 1 / (2 \ d_{Pixel})$$

where d_{Pixel} is the pitch between two neighbouring pixels.

Normalising u by u_N the formula of the modulation transfer function can be rewritten as

$$\text{MTF}(u) = \sin (\pi \ a \ u / 2 \ d_{Pixel} \ u_N) / (\pi \ a \ u / 2 \ d_{Pixel} \ u_N)$$

As an example, the MTF calculated for the KAF16802 is shown in Figure 7.18. Note that the spatial frequency is given in lines per mm. To get line pairs (or cycles) per mm, the frequency must be divided by two. According to the formulae above, the Nyquist frequency of the chip is $1/2 \ d_{Pixel} = 55.6$ pixel (or lines) per mm, which is equivalent to 27.8 line pairs (lp) per mm. All higher frequencies appear mirrored at the Nyquist frequency, causing aliasing effects. The resulting frequencies may lead to visual artefacts known as 'Moiré patterns' (see also Chapter 9).

The relationship given above is valid only for a black-and-white sensor and only for vertically and horizontally orientated lines. For colour sensors with an RGB filter array in the Bayer pattern, the relationship is more complicated, because only one of each group of four pixels is sensitive to red and blue light and two pixels are sensitive to green light. But because the green channel also

Figure 7.18

Modulation transfer function of the KAF16802 chip from Kodak.

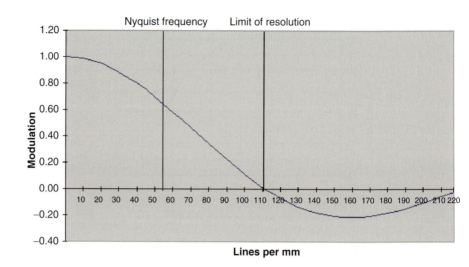

provides the majority of the brightness information (covering the wavelengths of greatest sensitivity of the human eye), it can be deduced that the spatial resolution of grey shades and of green detail is better than that of red and blue. In practice, the pixel structure has the effect of reducing the resolution of the green channel by about 15 per cent and of the red and blue channels by about 30 per cent below that of an unfiltered sensor. The Nyquist frequency of the green channel therefore decreases to approximately 23 lp/mm and of the red and blue channels to approximately 19 lp/mm. Compared with the MTF curve of a colour slide film, as shown in Figure 7.17, the overall resolution seems to be in the same range, but there is evidently space for improvement in future sensors.

All colour image sensors in which each pixel at a given location on the sensor is sensitive to only one colour suffer from another aliasing effect, known as colour Moiré. The 'missing' colours are assumed by the interpolation algorithm to be some kind of mean value of the neighbouring pixels. That is a reasonable approximation so long as the colour information does not change noticeably from one pixel to the next. But on sharp edges like hair, the high local spatial frequencies may lead to a large colour error. Later image processing is able to smooth such edges, but if there is a fine regular colour pattern with a spatial frequency higher than the Nyquist frequency of the image sensor, then colour Moiré occurs, which is difficult to separate from real image structures. Colour Moiré is completely unknown to film, due to its stacked colour dye layers and the random crystalline structure.

7.4.4 Dynamic range versus resolution

There is a contradiction between a large dynamic range and a high spatial resolution. A large dynamic range requires each pixel to be large enough to

collect high numbers of photons and maximise the signal-to-noise ratio, thus lessening the spatial resolution. But, while there is no other way to achieve a high spatial resolution than to make the pixels smaller, there are some possibilities for increasing the dynamic range without increasing the pixel size. Improved technologies minimise dark current and dark current shot noise within the pixels. The quantum efficiency can be improved by optimising the top layers on a CCD, through which light has to pass until it reaches the potential well of the pixel. Especially the gates can be improved by using transparent materials. Improvements of the output amplifiers provide better conversion factors, thus minimising readout noise. Improving the speed of the amplifiers enables higher frame rates and minimises the generation of dark current during readout. So-called micro lenses on each pixel collect and concentrate all the incoming light onto the photosensitive area of the pixel. In this way, the lost light falling on shields between pixels or on other non-sensitive areas of the pixel is minimised. This is especially of interest for some kind of CCDs and for all CMOS sensors, in which parts of the pixel area are reserved for transport channels and amplifiers. As a result, it can be expected that the next generation of imaging sensors will have higher spatial resolution with dynamic range at least the same as today.

7.4.5 CMOS or CCD sensor

As mentioned in Section 7.2.1, modern CMOS imagers are APS devices using at least three transistors per pixel. These transistors need space inside a pixel, thus reducing the area remaining for the photosensitive element. The fill factor is defined as a ratio of the photosensitive area to the total area of a pixel. Besides the number of transistors per pixel, also the CMOS-process used for manufacturing the imager influences this ratio. The larger the structures to realise the transistors on the chip, the smaller the resulting fill factor. Therefore designers aim to minimise these structures in order to maximise the fill factor. However, there is a lower limit of about 0.25 μm, below which silicon becomes more and more transparent. Light passes the pixels without generating electrons. New technologies are required to solve the problem.

 This problem is also relevant to CCD sensors, especially those of the interline transfer type. As explained in Section 7.5, full-frame sensors use the light-sensitive area to move the charges vertically, while interline sensors allocate half of the pixel area for a light shielded sub-pixel, which is used only for transport of charges. That is why full-frame sensors have the largest fill factors of all imagers but require a shutter to shield the cell charges against light during transport. In contrast, interline sensors have a much lower fill factor but do not need a shutter. CCD sensors of the interline-transfer type are mostly equipped with microlenses to overcome the problem.

 One major problem of CMOS sensors is the large fixed pattern noise, caused by the separate amplifier on each pixel. They show slightly different characteristics

(offset and gain), so that even if illuminated with the same light, the results differ from pixel to pixel. This problem is unknown for CCDs since all the charges pass to the same output amplifier.

The ability to integrate many of the camera functions onto the sensor chip is considered the most important advantage of CMOS sensors over CCDs. The implementation of functions like timing control, clock drivers, correlated-double-sampling, pixel addressing and analogue-to-digital conversion increases the overall system performance and also leads to a reduction of system cost, provided that a standard CMOS fabrication process can be used.

CCD sensors are used in a variety of applications for consumer, commercial, medical, scientific and military markets. In the consumer market, the line started with camcorders and is now continued with digital still cameras. The commercial market encompasses high end professional digital still cameras for journalists and photo studios, and also mobile phones and traffic monitoring. Medical imaging includes cameras for microscopy, endoscopy, mammography, and X-ray detection. High resolution, low noise cameras for astronomers are an example of scientific applications. Detection and target tracking are typical for cameras in military applications. With their low power consumption, high level of integration and low production cost CMOS sensors are ideal for cost-sensitive applications such as multimedia applications, video conferencing, machine vision, games, security, automotive, mobile phone etc. The more that CMOS-technology is improved, the wider the range of potential applications for these cameras will be.

7.5 Image Processing

As described in the previous section, current sensors differ widely in structure and capability from the human eye. To present an image to the human eye, which will be perceived as 'natural', a lot of corrections and adaptations to the image provided by an image sensor must be made. Further reasons arise from modern communication requirements. Images will be generated at different locations, transported by modern communication networks all over the world, examined on different displays, printed on different printers, and stored on different devices. In every case, the user wants to see the same image reproduced in a consistent and predictable manner. This requires methods of colour management and data compression.

Image-processing comprises several steps, typically as follows:

- Image capture and digitisation;
- Black-and-white shading correction;
- Blemish correction;
- Grey balance;

- 1-shot interpolation;
- Transformation of raw RGB to a device independent colour space;
- Noise suppression;
- Data compression.

7.5.1 Image capture

After the analogue image signal is output from the image sensor, a low-pass filter is applied which removes undesirable noise. The cause of this noise component is the reset signal in the output circuitry of the image sensor, which empties the output capacitor after its charge content has been converted into a voltage and transferred to the output. The most common method of removing this noise is by correlated-double-sampling (CDS), the working principle of which is shown in Figure 7.19.

The waveform of the CCD signal is divided into three sections: The first peak is caused by the reset signal, which must be removed because it indicates the noise part on the signal. The following flat region identifies the black level of the sensor signal, representing the minimum signal level. The third part of the signal, looking like a valley, is variable in its amplitude and represents the exposure of the pixel: the deeper the valley, the higher the exposure.

CDS now samples the black level of the CCD signal with the S/H pulse 1 and stores the measured voltage level in a capacitor C_{SH1}; a short time later, it samples the video part of the CCD signal and stores the measured value in C_{SH2}.

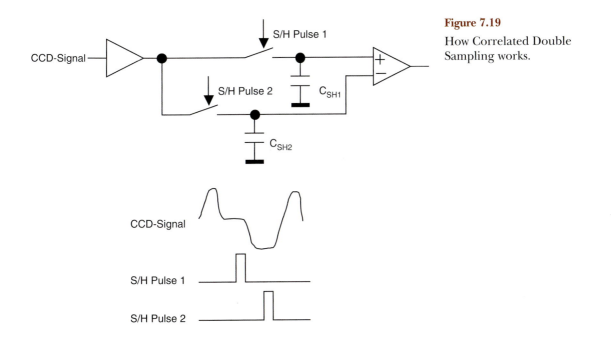

Figure 7.19

How Correlated Double Sampling works.

The following amplifier subtracts the stored signals from one another thus providing the correct exposure amplitude with a noise level reduced by a factor of √2 relative to the original noise.

After the CDS stage, the resulting image signal is normally amplified and fed into an analogue-to-digital converter (ADC). There the signal is digitised with up to 14 bits depending on the dynamic range of the sensor. All further image processing is now done digitally.

7.5.2 Black shading

If the lens cap is placed over the lens so that no light can fall onto the sensor, one would expect that the image would be perfectly black, i.e. would have pixel values of zero throughout. In fact, a black raw image is characterised by three effects:

a) a general non-uniformity of pixel values due to small variations in the basic silicon material of the image sensor;

b) a varying brightness, depending on exposure time and temperature. The reason is the pixel-dependent dark current generation;

c) temporal noise, also due to dark current generation and likewise depending on integration time and dark current.

With a black shading correction, both the first and second effects, which are time invariant, can be compensated, simply by multiplying the image with the shading coefficient on a pixel-by-pixel basis. The result is an equalised black image.

The black shading correction is shown in Figure 7.20(a) and can be represented by the formula:

$$P_{res}(i,j) = c_b(i,j) \ \ P_{raw}(i,j)$$

where:

i, j are line, column indices,

$P_{res}(i,j)$ is the resulting value of the pixel i,j after correction,

$P_{raw}(i,j)$ is the value of the pixel i,j of the raw image,

$c_b(i,j)$ are the black shading coefficients, calculated from a calibration image according to the formula

$$c_b(i,j) = l_{bmin}/P_{cal}(i,j)$$

where:

$$c_b(i,j) \leq 1,$$

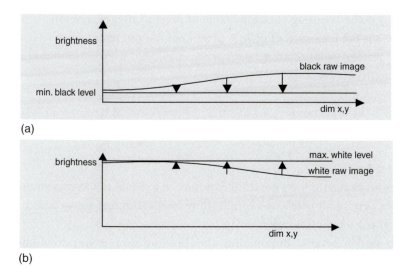

Figure 7.20
Correction of non-uniformity across image area:
(a) Black shading;
(b) White shading.

l_{bmin} is a specified minimum black level, e.g. lower than 99 per cent of all pixels of a black image, but larger than zero,

$P_{cal}(i,j)$ is a black calibration image, taken with the same integration time as the later image to be corrected.

The application software can update the black shading coefficients automatically after each image when the integration time has changed and the shutter is closed again. The above algorithm shows only the basic working principle. Of course, more comfortable algorithms can be imagined, for example avoiding the need to recalculate the black level coefficients whenever the exposure time changes.

7.5.3 White shading

Whereas black shading corrects for pixel non-uniformity in the dark, white shading is intended to correct the non-uniformity of the sensor under illumination, caused by small differences in the sensitivity of individual pixels which show different levels of exposure under the same illumination. Additionally, macroscopic artefacts such as vignetting of lenses and non-uniformity of light sources can be corrected. The last two points are of particular interest for reproduction purposes, especially film scanning.

The white shading correction is shown in Figure 7.20(b) and done according to a formula of same type as for black shading:

$$P_{res}(i,j) = c_w(i,j)\, P_{raw}(i,j)$$

where:

i, j are line, column indices,

$P_{res}(i,j)$ is the resulting exposure value of pixel i,j after correction,

$P_{raw}(i,j)$ is the exposure value of a pixel i,j of the raw image,

$c_w(i,j)$ are the white shading coefficients, calculated from a calibration image according to the formula

$$c_w(i,j) = l_{wmax}/P_{cal}(i,j)$$

where:

$c_w(i,j) \leq 1$,

l_{wmax} is an exposure level near full exposure, e.g. equal to the maximum level of 99 per cent of all pixels of a bright white image, but not overexposed,

$P_{cal}(i,j)$ is a white calibration image.

Since under bright illumination the photon shot noise dominates by far the noise behaviour of the sensor, it makes no sense to consider dark current effects. So, it is sufficient to do the white shading once, thus correcting the time-invariant artefacts related to the image sensor under illumination.

7.5.4 Grey balance

Grey balance at this point can be useful for preparation of 1-shot interpolation. Its intention is to minimise coloured artefacts on black-and-white edges, for example in line drawings. The information about white can be derived from a standard target such as the Macbeth ColorChecker chart, which is later used for colour calibration.

The balance is provided by three multiplication factors, one per colour channel, which are derived during colour calibration from the 6-step grey scale of the Macbeth ColorChecker. It can be described by two equations:

$$R_{new} = c_r\,R_{CC}; \quad G_{new} = c_g\,G_{CC}; \quad B_{new} = c_b\,B_{CC}$$

and

$$R_{new} = G_{new} = B_{new} = \max(R_{CC};\,G_{CC};\,B_{CC}),$$

where:

R_{CC}, G_{CC}, B_{CC} are the RGB input values of the white image area of the Macbeth chart,

c_r, c_g, c_b are the resulting multiplication factors,

R_{new}, G_{new}, B_{new} are the identical R=G=B values of the white image area of the Macbeth chart after the grey balance.

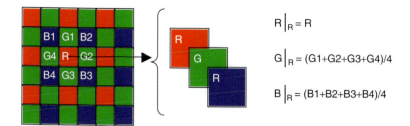

$$R\big|_R = R$$

$$G\big|_R = (G1+G2+G3+G4)/4$$

$$B\big|_R = (B1+B2+B3+B4)/4$$

Figure 7.21
Working principle of interpolation. Green and Blue values must be interpolated from neighbours at the location of the marked red (R) pixel.

7.5.5 1-shot interpolation

When the CCD is exposed to light, each pixel accumulates only that colour information to which it is sensitive. Since the complete RGB colour information at the location of the pixel is not available, it has to be reconstructed as well as possible from the neighbouring pixels. This is done by the 1-shot interpolation, which carries out a weighted interpolation between neighbouring pixels to provide the full RGB-colour information per pixel.

7.5.6 *Colour transformation*

Each type of image sensor has its own characteristics concerning spectral sensitivity, resulting in slightly different input colour spaces. Image output devices, such as monitors and printers, also have the same problem. Even if the same colour information is sent, they would produce different results. To avoid the problem that each input device would need to be calibrated to each output device, device independent colour spaces were created as standards to which every input and output device can be calibrated. Image data provided from a device calibrated to such a standard colour space can then be processed, i.e. displayed or printed, correctly. Correct means that images made with different cameras, i.e. different image sensors, under the same illumination should provide the same results.

There are several device independent colour spaces available. Which one is selected depends on the device characteristics and the field of application. For digital photography the so-called CIE-XYZ colour space has been established. It has a very large colour gamut, containing all of the colours to which the human visual perception is sensitive. See Chapter 11 for further explanation.

The conversion function is based on a polynomial approximation with terms of both linear and higher orders. As an example, a polynomial of second order is given:

$$X_{\mathrm{CIE}} = c_1\,R + c_2\,G + c_3\,B + c_4\,R^2 + c_5\,G^2 + c_6\,B^2 + c_7\,RG + c_8\,RB + c_9\,GB$$

$$Y_{\mathrm{CIE}} = c_{10}\,R + c_{11}\,G + c_{12}\,B + c_{13}\,R^2 + c_{14}\,G^2 + \cdots + c_{18}\,GB$$

$$Z_{\mathrm{CIE}} = c_{19}\,R + c_{20}\,G + c_{12}\,B + \cdots + c_{27}\,GB$$

The coefficients are determined during colour calibration using a calibrated Macbeth ColorChecker chart. Calibrated means that the X,Y,Z values of each colour patch in the chart are known. Illumination with a colour temperature similar to daylight (i.e. range 5000–7000 K) should be used. The calibration can be done as follows: An image is captured from the Macbeth chart providing a set of RGB-data for each colour field. These RGB-data are converted into the CIE–XYZ colour space using the given set of equations with a typical set of coefficients. Comparison of the resulting values with the known values of the Macbeth colour chart allows the colour error ΔE^* to be calculated. Finding the least mean square error solution of the equations provides in an iterative procedure the final set of coefficients. This calibration should be done for all illumination sources with a colour temperature different from daylight. Small deviations can be corrected using the white balance.

7.5.7 ICC input profiles

Instead of using a set of equations, hard-coded into the software, ICC input profiles can be used (see Chapter 11). An input profile describes the colour characteristics of an input device, such as a digital camera or a scanner. A profile can be imagined as a set of parameters added to an image, which tells other processing units how to convert this image into another colour space. Therefore, an ICC input profile describes how to convert an image to a standardised colour space, such as CIE–XYZ. The conversion may be derived from the colour polynomials as above. Thus the digital camera embeds its input profile into the image so that colours on the printed photograph may later be interpreted to look as the user expects.

7.5.8 Noise suppression

There are several sources of noise inside a final image, as exhibited in Figure 7.22, in addition to the dark current shot noise of the image sensor as explained above. A second source, visible in bright areas of an image, arises from the colour sensitivity of the sensor. Looking at the QE diagram in Figure 7.12, it can be seen that within the visible spectrum of 400–700 nm the blue and green channels cover a smaller range and have a lower amplitude than the red channel. Both blue and green seem to be less sensitive than red. To provide a white image, therefore, both channels must be amplified more than the red. Since the green channel exists twice for every four pixels in the Bayer filter mask, they are often averaged together, thus reducing noise by a factor of $\sqrt{2}$. Therefore the noise of the blue channel is often higher than for the other channels. This can often be observed within digital images showing a blue sky.

(a)

Figure 7.22

Types of image noise: (a) in a dark raw image, after some amplification to make it visible. Noise sources are fixed pattern noise, dark shot noise and readout noise; (b) in a processed image at long exposure times. While in dark areas the dark shot noise is dominant, in bright areas photon shot noise becomes dominant causing some colour noise.

(b)

Another reason for noise in bright areas is a feature offered by modern digital consumer cameras, namely the option of selecting a high ISO sensitivity regardless of the dynamic range of the image sensor. A high dynamic range allows the colour information to be compressed to match the colour depth of an output device. There is more information available than can be displayed, and this compression keeps visible noise low. The higher the dynamic range, the more the output data can be compressed in terms of colour depth, and the less visible is the noise.

The problem of noise suppression by algorithms is the decision of what is noise and what is a fine structure. Most noise filters act as low pass filters, removing detail information from the image. To minimise these losses, the image must be analysed in a larger context, to decide what are uniform areas and what are structured areas. Additionally some knowledge about the scene helps to select the correct amount of noise suppression.

7.6 Conclusion

Solid state image sensors have made tremendous progress in the last twenty years. New technologies will further improve the behaviour of both CMOS and CCD sensors. A good example is the three layer image sensor of Foveon, where the colour-sensitive layers are stacked like film. This technique has the potential to improve the spatial resolution of the sensor and minimise aliasing effects.

So, it is only a question of time until image sensors will completely replace film in most applications. This process can already be observed easily in the consumer market of digital still cameras, whereas in other fields it is more hidden but no less inexorable.

Figure 7.23

Principle of the Foveon sensor, showing how different wavelengths of light penetrate to different depths of the silicon material.

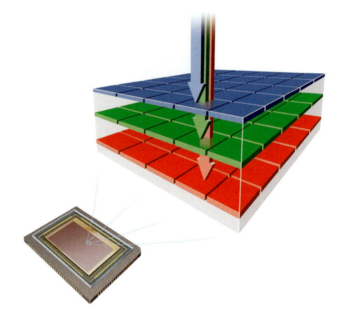

7.7 References

1. Theuwissen, A. J. P. (1995). Solid-State Imaging with Charge-Coupled Devices. Kluwer Academic Publishers.

2. Theuwissen, A. J. P. (1997). *Dynamic Range: Buyers Need Comparable Specification.* Photonics Spectra, November.

3. Theuwissen, A. J. P. *CCD or CMOS Sensors for Consumer Digital Still Photography?* Presentation.

4. Janesick, J. R. (2001). *Scientific Charge-Coupled Devices.* Vol. PM83, SPIE Press, Washington.

5. Verhoeff, P. and Gondoin, P. (1992). MTF measurements of a frame transfer CCD operating in TDI mode. High-Resolution Sensors and Hybrid Systems, *Proc SPIE,* Vol. 1656.

6. Tim Tsai, Y., Kung, T. M. and Larsen, J. (1998) *SPIE,* Vol. 3422, pp. 70–80, July.

7. Smith, G. E. The invention of the CCD. Selected Papers on CCD and CMOS Imagers, *SPIE Milestone Series,* Vol. MS177, pp. 14–18.

8. Fossum, E. R. CMOS active pixel image sensors. Selected Papers on CCD and CMOS Imagers, *SPIE Milestone Series,* Vol. MS177, pp. 73–77.

9. Fossum, E. R. (1993). Active Pixel Sensors: Are CCDs Dinosaurs? *Proc. SPIE,* Vol. 1900, pp. 2–13.

10. Dillon, P. L. P., Lewis, D. M. and Kaspar, F. G. Color imaging system using a single CCD area array. Selected Papers on CCD and CMOS Imagers, *SPIE Milestone Series,* Vol. MS177, pp. 349–354.

11. Felber, P. (2002). *Charge-Coupled Devices – A Literature Study as a Project for ECE575.* Illinois Institute of Technology, May.

12. Dierickx, B. (2000). *CMOS Image sensors: Concepts.* Photonics West 2000 – Short Course, Fillfactory.

13. Malinovich, Y. Koltin, E. Cohen, D. Shkury, M. and Ben-Simon, M. (1999). Fabrication of CMOS Image Sensors, *Proc. SPIE,* Vol. 3649, pp. 212–218.

14. Maternowski, L. Farbmanagement in der Digitalfotografie. Diplomarbeit Technische Fachhochschule Berlin, Fachbereich VI, WS2003/2004.

15. Blankenbach, K. (1999). *Multimedia Displays – Von der Physik zur Technik.* Physikalische Blätter 55, Nr. 5.

16. Marchesi, J. J. (1995). *Handbuch der Fotografie Bd 1-3.* Verlag Photographie.

17. Data sheet of the KODAK KAF16802CE (January 2003).

18. KODAK Application Note MTD/PS-0233: CCD Image Sensor Noise Sources; Rev. 2 (2003).

19. Data sheet of the colour slide film FUJI SENSIA II 100.

20. http://www.colour.org

21. http://www.lci.kent.edu/lc_history.html

22. http://www.netbored.com/classroom/what_is_tft_lcd.htm

23. http://www.sony.net/Fun/SH/1-22/h1.html

24. http://www.internetvideomag.com/articles2002/historyofcamcorders.htm

High Resolution Imaging in the Near Infrared

Duilio Bertani and Luca Consolandi

8.1 Introduction

Infrared (IR) reflectography is a non-destructive imaging technique used in the field of cultural heritage analysis mainly to examine ancient paintings and manuscripts on papyrus. In the first case, it is used to make visible the under-drawing under the paint layer and to store a precise map of previous restorations. In the second case, it is used to improve the readability of those texts in which the support has remarkably darkened or is carbonised.

The technique consists of acquiring and storing images in the infrared spectral region between 1 and 2 micron wavelength. Earlier, this was done with a special photographic film, but nowadays it is more commonly performed with sophisticated electronic devices. Infrared radiation can pass through the paint layers of ancient paintings and reach the preparatory gypsum layer underneath, from which it is reflected except where a drawing was sketched with a material partly or totally absorbing infrared such as charcoal. In a few and simplified words, this is why the underdrawing is made visible by infrared reflectography. The physical phenomenon is described by the Kubelka–Munk theory and is discussed in [1]. The transparency of paint layers depends on their composition, thickness, granularity, index of refraction of pigments and media, etc., and may affect the legibility of the under-drawing in some areas. On the other hand, this non-uniform behaviour yields information about the material used, discriminates colours identical to the naked eye, and allows restorations to be precisely planned. For papyri, the ink is usually a carbon-based material in an organic medium, i.e. a good infrared radiation absorber, therefore the poor readability of the text in the visible spectrum is improved in infrared images because the local contrast between text and background is not affected by colour alterations of the papyrus.

Although researchers, scholars and restorers are very interested in these types of analyses, there is not a market large enough to justify the costs of research and the development of special sensors designed *ad hoc* for these applications. Therefore the more recent prototypes for infrared reflectography are usually designed using sensors originally designed for civil or military applications.

The aim of our research was to design transportable systems for high resolution imaging of both paintings and papyri. This rather demanding objective required a totally different design from normal laboratory apparatus from the point of view of the mechanics. These systems allow working in situ, with the ability to display and control the results immediately and to examine items in a way that would previously have been infeasible. We expect that in a very short-term, it will be possible to capture and store a large number of high-resolution images. The design therefore includes a special digital image archive and dedicated data base, connected to professional printing facilities. The peculiarity of the objects investigated implies that the whole process of shooting-processing-printing should be made under the direct control of the same research centre, in order to update this process at any level should a new device be designed and to maintain a high-quality standard of the final results. This is one of the main points of our research philosophy.

8.2 Infrared Reflectography of Ancient Paintings

In the field of examination of ancient paintings many methods are based on imaging techniques such as infrared reflectography, X-ray radiography, UV fluorescence, pseudo-colouring with infrared colour slide film, multispectral imaging, raking light, etc. Each of these yields specific information on the composition of pigments, the painting technique, the panel or frame structure or the state of conservation. Among all these techniques, complementary and equally important for a complete understanding of the work of art, infrared reflectography is somehow an exception because, thanks to its capability to visualise the under-drawing, it has become an independent research field so important for art historians that a specific congress is periodically held on the subject.[2]

Information on the underdrawing is used by experts to identify the materials and implements used for sketching and to study the evolution of the drawing technique throughout the centuries. Reflectograms may be compared, for example, with the descriptions of technique in classic texts on the subject such as the famous *Libro dell'Arte* by Cennino Cennini. Studying the authors of a specific period, technical differences between various contemporary 'schools' can be revealed and when a single artist is considered, one can follow the evolution of his technique from his early period to his last, point out which was the influence of his masters and of the contemporary artists he met, etc.

In a reflectogram, the underdrawing may show many differences, called pentimenti, with respect to the final painted version we see. These can be small variations from the first version, such as a little repositioning of part of a figure due to aesthetic considerations – a head slightly turned or fingers redrawn in a different position – or very large displacements of entire figures.[3] Sometimes

sketches have been revealed that had nothing to do with the subject finally painted [4] and even signatures unknown before have been made clearly visible.[5] In some lucky circumstances the sketch can be compared with rare cartoons still available, as was the case of the face of the third woman in the *Sposalizio della Vergine* by Raffaello in the Brera Gallery in Milan and its study cartoon at the Ashmolean Museum in Oxford. All this justifies the particular interest of scholars for infrared reflectography, the congresses and publications dedicated to it and the continuous research for new and more and more sophisticated devices.

As mentioned above, infrared reflectography was originally a photographic technique because a special infrared sensitive photographic film was used until the 1960s. Though the first film of this type was invented in Germany about 1870 by adding a special dye to the film gelatin, its scientific application to the examination of cultural heritage started at the beginning of the twentieth century [6] and the technique was routinely used for the examination of paintings once the Kodak IR High Speed, a commercial infrared film, became available on the market. The main limits of this film are its limited spectral sensitivity, shown in Figure 8.1, its relatively large graininess, and the difficulty in determining the correct exposure time and focal position. Nevertheless, it was dominant until Van Asperen de Boer introduced his prototype [7] infrared camera by modifying a Barnes thermal camera with a lead-sulphide detector with a peak response at about 2 microns. We can consider that moment as the start of the transition of reflectography from a photographic to an electronic technique. What really led to the demise of infrared film was the introduction into the market of commercial television cameras equipped with infrared sensitive PbS vidicon tubes. Their main advantages were a more extended spectral

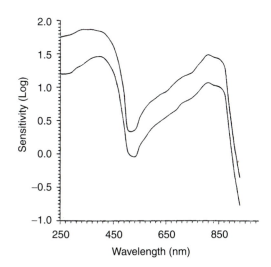

Figure 8.1

Spectral sensitivity of INFRARED High Speed Kodak photographic film.

Figure 8.2

Spectral sensitivity of PbS Vidicon tube N214.

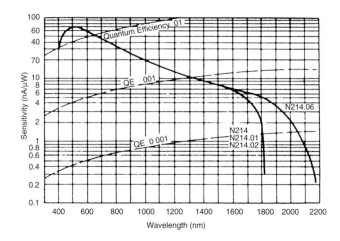

sensitivity in the infrared as shown in Figure 8.2, the immediate visualisation of the reflectogram on a monitor and easy transportability.

The very first PbS vidicon tubes had some drawbacks, negligible at that time but intolerable today if one looks for a high quality result. They had rather poor spatial resolution and signal dynamics and showed a remarkably reduced sensitivity at the image boundary. The consequence was that in order to make a reflectogram of a whole painting, a large number of close-up images had to be taken in order to record the drawing details. In practice, only the central part of a monitor screen with a long radius of curvature was photographed, where the image was good enough. The camera was then moved and a new picture was taken, allowing a large overlap with the previous one. All these images were printed in the dark room, then cut and pasted to obtain the mosaic of the whole painting: a difficult and time consuming task. Mosaics made in this way can be seen in the first published volumes.[2]

The availability of personal computers equipped with frame-grabber boards and image processing software marked another milestone. The infrared vidicon cameras could be attached to a PC to grab their output, and the cut-and-paste procedure to assemble the sub-images of reflectograms could be made through the graphic user interface to the computer. This was much easier if rails were used to translate the camera in front of the painting to avoid any rotations. Precise movement was necessary to record easily juxtaposable images, because even a small rotation would complicate the mosaic procedure. The legibility of the overall reflectogram could be improved with commercial image processing software. The necessary equipment could be used by personnel with a minimum training and a lot of small private restoration and diagnostic firms could afford it, enabling a wide spread of infrared reflectography. The main technical limits of these systems were the poor signal dynamic and spatial resolution of the TV infrared cameras: the first meant a poor rendition of grey tones and the latter

necessitated the capture and assembly of a huge number of close-up images to visualise a detailed under-drawing. The more the quality of reflectograms was improved, the more restorers and art historians demanded better results. It soon became clear that the technique could not be substantially improved any further because the real bottleneck was the sensor, i.e. the vidicon camera itself and the TV standard of its signal which had been designed for commercial broadcasting for home entertainment rather than for scientific applications.

A new system therefore had to be designed, based on a different non-TV technique. At the end of the 1980s, a market survey was undertaken to find which infrared sensors were best for reflectography. InGaAs photodiodes had been introduced for data transmission through optical fibres and were easily available at a very reasonable cost. These little point sensors were more than fast enough, had a spectral sensitivity extending up to 1.7 micron (Figure 8.3), sufficient sensitivity and a linear response. All these characteristics suggested their possible use for a single-sensor optical head. A Fujitsu infrared FID13R13WX detector [8] was donated by a telecommunication company and a first prototype assembled with off-the-shelf instrumentation to demonstrate the feasibility of a new system: infrared reflectography had become a totally digital technique.[9]

The main components of this first makeshift device were a small X–Y translation system with an attached optical head made of a single glass lens. The infrared photodiode was placed in the focal plane along the optical axis of the lens, i.e. in the centre of the image. A small infrared filter and a pin-hole aperture were held close to the glass window of the detector, so that an area of the painting of diameter 0.2 mm was imaged upon it. The head was moved up and down in front of the painting sampling its surface, the detector output was digitised and visualised as a black and white image: the first digital high-resolution non-TV reflectogram. Even the very first result, though a relatively small area of a painting about 10×5 cm, because of the limited run of the translation system, appeared on the monitor to be of a quality far superior to anything previously seen. Thus the feasibility of an infrared scanner for reflectography of paintings was demonstrated and the design of a large-scale prototype could

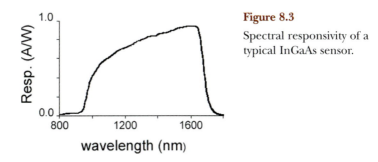

Figure 8.3

Spectral responsivity of a typical InGaAs sensor.

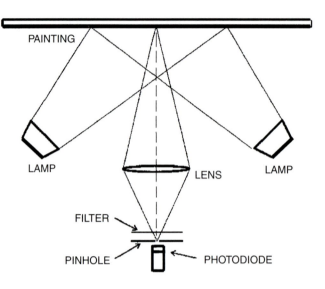

be undertaken. The optical head was designed on the same principle described above, with the addition of two small lamps and electronics to amplify the detector signal, as indicated in Figure 8.4. The traverse of the scanning system could be as long as 110 cm for each axis, as in the prototype of Figure 8.5, to record a reflectogram of a painting of 1×1 m. With the addition of an aluminium bar 2 m long, attached to the vertical translation stage with the optical head positioned in its centre or at its lower or upper end, it proved possible to record three reflectograms in a row. These were perfectly juxtaposable one above the other, examining a total area of about 1×3 m without repositioning the scanner in front of a large painting. The mechanics had to be rather robust and heavy to be self-supporting and dampen any vibrations that would dramatically affect the image quality. This somehow limited the transportability of the system, which was used mainly in galleries and restoration centres.

The good sensitivity of the detector, the linearity of its output signal and the high signal-to-noise ratio allowed the signal to be amplified and digitised at 16 bits in order to record and reproduce a sufficient range of grey tones. It was soon found that it was sufficient to sample the detector signal each 0.25 mm, which meant that the painting was sampled with a spatial resolution of 4 points per linear mm, i.e. 16 points per square mm. This resolves the paint craquelure and any type of hand-made drawing, etching, incision or preparatory shadowing as shown in Figure 8.6. Without going into technicalities, it must be pointed out that high spatial resolution and large signal dynamics are both necessary for a high resolution reflectogram: high spatial resolution alone is not enough.

Although it may seem an odd way to record a reflectogram, to use a single detector drawn up and down along a bustrofedic path in front of a painting, one can see that the method is surely an excellent method to record a high quality

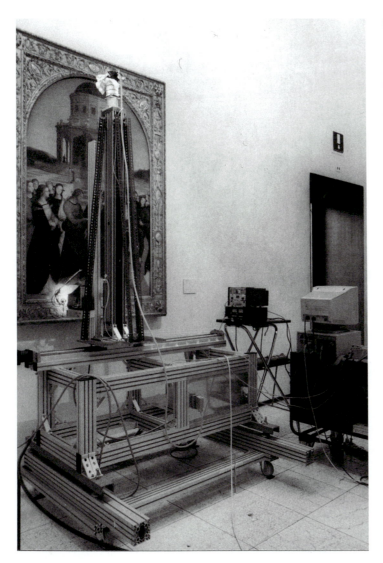

Figure 8.5
Single sensor infrared scanner prototype. The sensing head can traverse in both vertical and horizontal directions, enabling an area of approximately 1 m wide by 3 m high to be scanned.

image with the only disadvantage of being time consuming. In fact, each point of the surface is examined by the same detector, its signal is amplified and digitised by a single electronic circuit, the mechanical movement is perfectly linear and free of play so that no geometrical distortion was ever detected, illumination is exactly the same for each point because the lamps move as part of the head and only a small area around the sampled spot is illuminated while the rest of the surface is not, in compliance with conservation guidelines. The optics and its aberrations were no problem because the detector is very small and placed at the centre of the image: a simple inexpensive lens of 50 mm focal length was used. The prototype performance proved to be so good that it has continued in service until recently, its reflectograms could be printed in real size

Figure 8.6
Detail of a reflectogram
of the *Flagellazione* by
Luca Signorelli,
Pinacoteca di Brera,
Milan. The high spatial
resolution and grey
tones rendition
capabilities of the single
sensor system are
demonstrated by this
detail in which the
preparatory shadowing
and hatching are
perfectly reproduced.

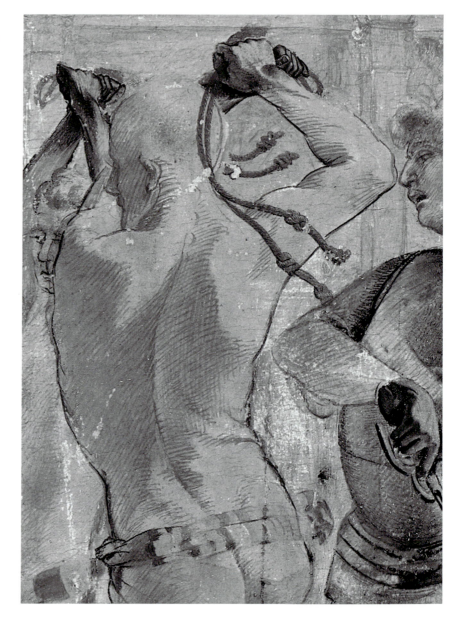

and are still used as a quality standard. The only drawbacks were its large size
and weight and the time it took to record a reflectogram: a few hours were
needed to examine a surface of 1 square metre.

The technology of infrared detectors evolved very rapidly, and, in an attempt
to minimise the size and slowness of the first prototype, a second prototype was
designed as soon as a 256-element InGaAs linear array was obtained. In practice,
this device was a row of small square detectors, 50 micron side, spaced centre-
to-centre by the same distance so that it seemed an easy job to upgrade the

existing prototype by simply replacing the single photodiode with the new array to digitise a swathe of width 256 pixels instead of a line of single pixel width. Unfortunately, things are not always so easy as they seem at first glance: a few inevitable optical problems, beyond the scope of this chapter to discuss, and above all, the fact that the size of the system would not be reduced, meant that this approach was not successful.

8.3 Developments with CCD Technology

A third prototype was based on the principle of image-plane-scanning. This meant that a photographic lens with long fixed focal length could be used to obtain a reduced image of the area to be examined. The 256-element CCD array was moved across the image plane with an X–Y translation system, which in this case could have a much smaller size and weight. For example, with a translation system of only 10 cm traverse for each axis one could scan an area of 10×10 cm at a magnification of 1:4 producing a reflectogram of an area of 40×40 cm of the painting surface. In doing this, some of the formidable advantages of the single detector system were lost: an illumination as uniform as possible had to be obtained over the whole area to be imaged, the scanned image plane area had to be smaller than the corrected image circle of the lens, where optical distortions are negligible, and the array output must be well corrected. The output signal from the infrared array was far from uniform and without correction the reflectograms would have been illegible. Also a non-negligible fixed-pattern-noise (FPN) had to be taken into account along with the array signal fluctuations due to the intensity fluctuations of the lamps, caused by the 50 Hz frequency of the power supply. In the following discussion, these two latter points will be clarified with the aid of a few images rather than theory to visualise their dramatic effects on reflectograms.

The FPN is the non-uniformity of response of the CCD at dark level, which remains constant throughout the signal range, i.e. at different illumination intensities. Figures 8.7(a) and (b) show the FPN of the array before and after correction. The single spike that still remains in (b) is due to a 'bad' pixel, i.e. an ill-functioning element that cannot be corrected. Its effect on the reflectogram must be compensated *a posteriori*, e.g. by replacing all the pixel values in the column it generates with the average of the neighbours. Under uniform illumination of the array the effect of FPN is that of generating a periodic pattern of vertical stripes of different intensity because the image is recorded by moving the array up and down. The sensitivity of the array and the timing of the grab-and-displace technique used to store the image were such that under uniform illumination a second pattern of sinusoidal stripes was recorded because of the aforementioned fluctuations of the illumination intensity at a frequency of 50 Hz. The combined effect of these two problems is shown in Figure 8.8. The first was eliminated by

Figure 8.7

(a) Linear array output signal showing the sensor fixed-pattern noise. The spike is due to an ill-functioning element; (b) Array output signal after correction. The noise is reduced to a level that cannot be detected in the final reflectogram.

(a)

(b)

Figure 8.8

Typical pattern generated by the combined effect of fixed-pattern noise and illumination periodic oscillation due to 50 Hz frequency of the power supply.

correcting each line before storage and the second, by using a stabilised DC power supply for the lamps. A small home-made test panel was devised, where a charcoal sketch was hidden by painted patches of different colour; the small house in the following figures was drawn under a yellow patch. Figure 8.9(a) shows an uncorrected reflectogram to point out the effect of FPN and illumination fluctuations, Figure 8.9(b) shows the corrected reflectogram of the same area.

(a)

(b)

Figure 8.9
(a) The effect of fixed-pattern noise makes a reflectogram barely legible; (b) the same reflectogram corrected.

The mechanics also deserved particular attention in both the choice of components and their assembly. Given the dimensions of the sensor elements, one can easily understand that the array must be drawn up and down along columns perfectly parallel to each other, therefore the two mechanical axes need to be mounted perfectly perpendicular in a plane parallel to the image plane. The camera attachment to the Y axis stage must be such as to make sure the array is parallel to the X axis and lies in the image plane. In addition, the whole system must be so robust that the alignment of its mechanical components is not affected during transport: this is a job for a fine mechanics workshop hardly possible in a traditional laboratory.

Although not exhaustive, the discussion above is meant to pinpoint some of the problems one has to face when designing a new prototype based on a multi-element sensor in place of a single photodiode. But the reduction of size, weight and time required to store a reflectogram justified the effort for building a new prototype. No figures are shown of reflectograms recorded with this system because they are practically indistinguishable from those recorded with the single detector device.

The latest version of the system, shown in Figure 8.10, was first developed by replacing the linear array with a so-called focal plane array (FPA), a rectangular matrix of 320×240 InGaAs elements mounted on the same mechanics for which industrial mechanical components and mounting solutions had been chosen for the reasons mentioned above. The principle is always the same, i.e. that of image plane scanning, but the advantages of using a rectangular

Figure 8.10

Transportable prototype of infrared reflectography device in the Academia Carrara, Bergamo. Robust industrial components have been used to ensure that the mechanical calibration of the system is not altered during its transport.

area array are remarkable: the time necessary to store a reflectogram is very much reduced and focusing is here much easier because an image, though only a small portion of the area to be inspected, is immediately visible on the screen. The system has proved so fast that one can rapidly find the appropriate magnification to match the type of under-drawing by simply controlling the image on the screen in real time while adjusting the distance from the painting and accordingly the focus. A high resolution reflectogram can now be recorded examining an area of about 45×45 cm at a time and that only about 40 min are required to record a reflectogram of an area that needed a whole day with the single sensor device, at the same spatial resolution.

These FPAs, like the linear arrays, are affected by fixed pattern noise and most times, also the gain of each element is different from one to another so that each image must be corrected before storing. In some instances this anomaly is not too evident and should one use the system only for inspection purposes it might be ignored, but this is never the case when a mosaic of images is to be assembled because even a small non-uniformity shows dramatically. Figures 8.11(a) and (b) show the difference between a non-corrected and a

(a)

(b)

Figure 8.11

(a) Detail of a reflectogram where the non-uniformity of the focal plane array is not corrected; (b) The same detail after correction.

Figure 8.12

Output of an hypothetical
3-element array where each
element has a different gain.

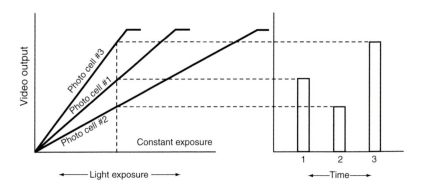

corrected mosaic of 4×4 images. In simple words, this means that in illuminating the FPA uniformly, the output from each element deviates a certain percentage plus or minus from the expected value according to the slope of its conversion transfer function. The non-uniformity in the overall output image is due to this different slope for each element, in other words to their different gain.

To make clear this point, the performance of only three neighbouring sensors in a line of a FPA is shown in Figure 8.12. At a certain illumination intensity, each of the three elements outputs a different value which is rendered as a different grey tone in the reflectogram. For sake of simplicity, the intercept points in Figure 8.12 were ignored: in practice they are a measure of each element's offset level with no illumination, i.e. the FPN mentioned above. Figure 8.13 shows qualitatively the pattern generated by the FPN and Figure 8.14

Figure 8.13

Dark level image showing
the pattern generated by
the FPN.

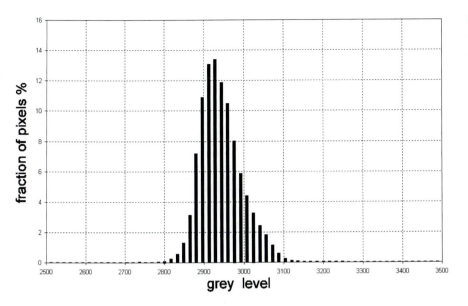

Figure 8.14
Histogram of the image of Figure 8.13.

its histogram. Figure 8.15 shows the histograms of images captured by uniformly illuminating the FPA at different radiation intensities: the variation of the shape of the histogram indicates that each element has a different gain. The response of this type of sensor can be considered quite linear for the central 80 percent of its dynamic range and, provided one can operate in this range, the small deviations from a perfect linear trend can easily be corrected. Many correction techniques are used by the sensor producers, either analogue or digital, the latter being nowadays more commonly used. In practice, the gain and offset of each sensor element have to be measured to construct a file with the gain and offset

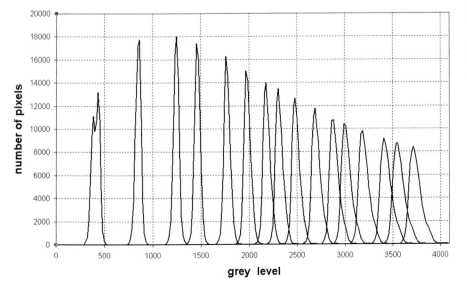

Figure 8.15
Histograms of images stored with the FPA evenly illuminated at different radiation intensities.

corrections for each element. The corrected image pixel values are then calculated as follows:

$$PC_{ij} = G_{ij} * P_{ij} + O_{ij}$$

where P_{ij} is the value of pixel ij before correction, G_{ij} and O_{ij} are values that make gains and offsets uniform across the image and PC_{ij} is the final corrected value of pixel ij. Calibration data to correct a reflectogram are different for each FPA element and could be determined in the laboratory, but this is such a difficult task to perform with sufficient precision that it is better left to the manufacturer. It has also been observed that the electronics associated with these FPAs is rather delicate, e.g. a Peltier cooler is used to keep the sensor at a constant temperature, and a little ill-functioning of the heat dispersion system may cause an over heating of the electronics to the point that the correction parameters are no longer valid. This problem can dramatically affect a final reflectogram mosaic: in the upper part of the image, the first recorded, the joints of the sub-images are not visible meaning that the correction parameters perfectly compensate the local non-uniformities in the FPA response. The quality of the reflectogram typically gets worse towards the lower part where the joints become more evident as the device electronics heat up and the correction fails.

When capturing reflectograms of ancient paintings, one has to comply with certain safety rules and shooting parameters, according to which the illumination intensity must be as low as possible and the lens aperture be stopped down to $f22$ in order to obtain a depth of field of a few centimetres necessary for a perfect focus all over warped wood panel paintings. These conditions and the fact that the material used for the under-drawing and some pigments are rather infrared absorbing, are the reasons why in most cases, one can only exploit half or less of the sensor dynamic range. Here, the FPA response cannot be efficiently corrected as described above and disturbing joints in the overall reflectogram mosaic are made visible. This effect, along with the inevitable luminosity fall-off from the centre to the periphery of the image due to the lens, combine to affect the reflectogram to a certain extent. Fortunately, this degradation can easily be compensated taking into account a reference image of a uniform grey panel captured under the same shooting conditions as the painting, i.e. distance of the painting, lamps position, lens aperture, exposure time. In this way, any imbalance of the light sources may also be taken into account. Figures 8.16(a) and (b) show the reflectogram before and after correction and Figure 8.17, the image of the uniform grey panel.

The importance for art-historians of high resolution in both spatial structure and grey tones is demonstrated by the detail in Figure 8.18 where the underdrawing is characterised by hatching sketched with a small pencil and

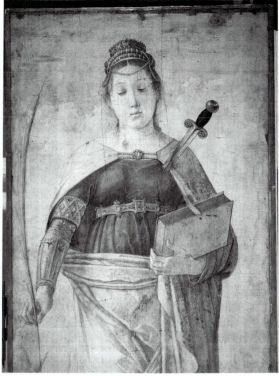

(a)

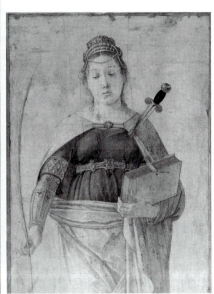

(b)

Figure 8.16
(a) Part of the reflectogram of *S. Giustina de' Borromei* by Giovanni Bellini, Museo Bagatti Valsecchi, Milan, before correction; (b) the same reflectogram corrected using the image of Figure 8.17.

Figure 8.17
Image of a uniform grey panel used for the correction procedure.

Figure 8.18

Detail of a reflectogram of the *Pietà* by Giovanni Bellini, Pinacoteca di Brera, Milan. The fact that even small droplets of ink at the end of the pencil strokes are clearly visible proves the excellent performance of the prototype that compares to that of the single sensor device.

liquid ink. It is clearly legible to the point that even the typical ink droplets at the end of some strokes are well rendered.

The reliability, speed and versatility of the revised prototype was demonstrated by the fact that large paintings could now be examined, such as the *Madonna in gloria col Bambino, angeli e i santi Pietro, Domenico, Paolo e Gerolamo* by Savoldo in the Brera Gallery in Milan, 4.75 m high and 3.07 m wide. Its reflectogram was printed at life size and placed in its frame that was hanging empty on the wall during the panel restoration. Figure 8.19 shows the panel in the transparent box made specially for its restoration: the elevation platform was also used to position the device for the reflectographic inspection. The assembling of the reflectogram is shown in Figure 8.20.

High-resolution reflectography is still rather expensive and a matter for specialised laboratories. Several important galleries have therefore decided to cooperate in a research programme circulating a single piece of equipment for high-resolution reflectography. In this way, a large number of paintings may be

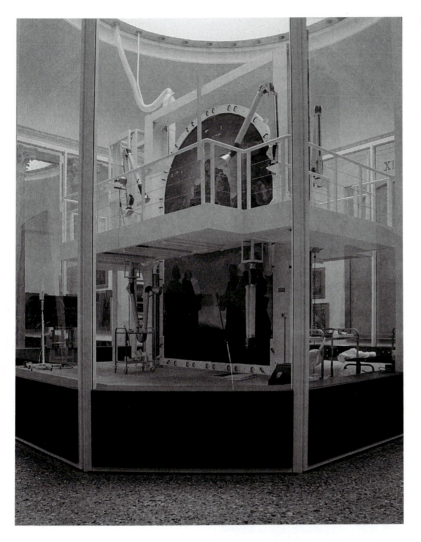

Figure 8.19

Box and elevation platform for the restoration of the *Madonna in gloria col Bambino angeli e i santi Pietro, Domenico, Paolo e Gerolamo* by Savoldo in the Brera Gallery in Milan.

examined by experts of different institutions and the design can be further modified according to their suggestions.

8.4 Infrared Examination of Papyri

Most of the papyri examined in our laboratory are 'Greek', i.e. written in Greek, therefore in the following discussion, the word papyrus will mean Greek papyrus. The reproduction for study and documentation purposes of these papyri has been a problem ever since the first examples were found in Ercolano in the eighteenth century. The most common techniques used since then are described in a paper by C. Gallazzi.[10] Because papyri are mainly written with a carbon-based ink, a material that strongly absorbs infrared radiation, one may think that capturing reflectograms would be an easy task and indeed infrared

Figure 8.20

Assembly of the
reflectogram of the panel of
Figure 8.19.

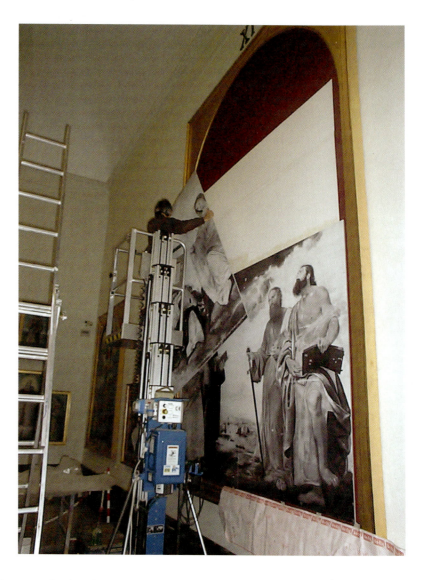

photography has been the tool most used for their examination. This is a
common conviction mainly because the beautiful specimens one can admire in
museums as a tourist are obviously the very best preserved. The state of conser-
vation of most papyri, however, is much worse. Although papyrus is an incredibly
robust material which has survived for so many centuries because of the
specially dry environmental conditions of Egypt, it has become so brittle that it
must be handled with great care. The colour also may vary a lot, from pale straw
to dark brown, often showing remarkable differences from one area to another
of the same papyrus. In the worst cases, the darkening of the surface may be
so severe that the text is practically unreadable by the naked eye. In addition,
specimens are often found in pieces with frayed edges, holes of all dimensions
present all over the surface, and affected by irreversible deformations, as shown

in Figure 8.21. Traditional restoration techniques are ineffective for assembling the mosaic, which is only possible with image processing techniques operating on high resolution images.

Though it may seem beyond the scope of this chapter, it is worthwhile to spend a few words about papyri from 'cartonnage' or carbonised papyri, to give an idea of why the state of conservation varies to such a large extent. There was a period in Egypt when sarcophagi were made with a method like 'papier maché', by which layers of paper were glued one on top of the other and covered with a final layer of gypsum that was eventually decorated. These cartonnages are today real gold mines for papyrologists because the papers used were papyri, at that time considered to be of no more use, but now precious manuscripts. To fit the form of the sarcophagus, papyri were torn or cut and even a careful disassembling of the cartonnage would yield pieces far from intact. One of the problems is that in separating two layers, part of the text on one layer happens to remain attached to the other. Remains of gypsum must then be removed with mechanical tools such as a small goldsmith drill with a rotating brush or a dentist ultra-sound point that requires experience and sensitivity because even a slight excess of pressure would pierce the papyrus. The recovery and documentation of one of the most important finds of this type, a collection of epigrams by the poet Posidippo di Pella, is described in [11].

Figure 8.21

Detail of a papyrus from the collection of the Istituto di Papirologia, Università di Milano.

Carbonised papyri are an extreme case because they have been turned into very fragile carbon black sheets, where the text appears as matt on a glossy background and becomes readable to the naked eye only when holding the papyrus at an acute angle relative to a light source, e.g. a window, such that it is illuminated by raking light. On the basis of research carried out in other laboratories, it is usually taken for granted that capturing infrared images is the best investigative tool for the difficult types of papyri mentioned above. It had also been demonstrated that red-extended photographic film performed better than traditional infrared film,[12] although papyrologists were aware that photographic film would yield results far below the quality they were looking for. The linearity and spectral sensitivity of modern commercial CCDs, typified by Figure 8.22, suggested these devices would be optimum especially if high resolution imaging were deemed necessary. At first, the point was that nobody could precisely define in quantitative terms the high resolution everyone was wanting, an important problem from a technical point of view and even more so from that of costs. Consumer digital cameras had become quite common and reasonably cheap, but when it came to professional devices, prices were well beyond what most researchers in this field could afford.

It was thus necessary to sit for some time with papyrologists and to examine a certain number of papyri to become acquainted with their working methods before formulating an exact idea of what they needed. To decipher a manuscript, it was important to be able to visualise even the smallest and faintest traces of ink because they are sufficient to the expert papyrologist's eye to recognise a letter. This implied that resolution had to be remarkably high from the point of view of both spatial resolution and signal dynamics, i.e. the system had to be capable both to detect small details and to digitise and render a large number of grey tones. Papyri can be very long, even many metres, but fortunately they are not very wide, typically less than 30 cm. Greek papyri in particular are mostly written in columns so the first requirement to be fulfilled was that an area of no less than 30×20 cm, i.e. one column, was to be recorded by the

Figure 8.22

Spectral responsivity of a commercial silicon CCD.

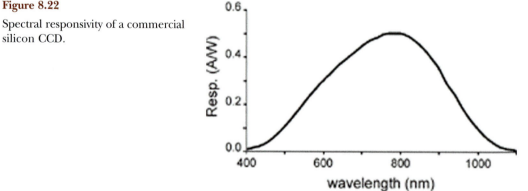

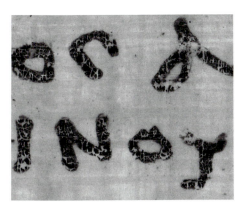

Figure 8.23
Enlarged detail of Figure 8.21.

system in a single capture operation. A practical rule was eventually found concerning spatial resolution, namely that the text should be magnified 10 to 15 times with the ink cracks still appearing sharp on the PC monitor, as shown in Figure 8.23. This requirement corresponds to a resolution of about 40 pixels/mm. The capability to render a large number of grey tones was no problem because the sensitivity and linearity of the modern CCD enabled a 16-bit digitisation of the signal, corresponding to thousands of grey levels.

The system was set up as shown in Figure 8.24 and consisted of a robust aluminium bench with illumination from both above and below, independently adjustable, and a professional photographic camera with a large-format lens

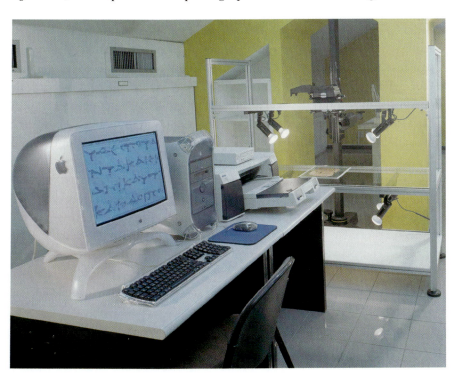

Figure 8.24
The high resolution system for the examination of papyri in the Istituto di Papirologia, Università di Milano.

and bellows. A linear 10500 element CCD was selected, which could scan across the image plane an area of about 8×10 cm to record an image of $10\,500 \times 12\,500$ pixels in both the visible and the infrared, changing filters. Because a good correction of geometrical aberrations was required rather than a large depth of field, a large format darkroom enlarging lens proved most appropriate. The CCD scanning system was attached to the camera in place of the normal photographic plate holder and controlled by a PC.

Papyri are thin with irregular borders and typically contain numerous holes of various dimensions, so the best images are obtained by holding them flat between two glass plates. Any paper backing sheet should be removed whenever possible because the illumination from above, at an angle of about 45°, would project disturbing shadows all along the edges that are rendered in the infrared images as rims as dark as the text and the smallest holes are inevitably reproduced as black speckles. A second image should therefore be recorded with illumination from below, to be used as a black-and-white mask to process the first image to render its background, holes included, as white. This procedure, which is very simple in principle, requires a lot of experience because the thickness of a papyrus can vary greatly to the extent that in some places, it may be so thin as to be transparent. Illumination and exposure time must therefore be determined very accurately for each exposure, because a wrong setting, e.g. an under- or over-exposure, would not make white all the holes or would burn the thinnest areas creating false holes. The illumination from above must also be finely calibrated to be uniform all over the area examined, so that the papyrus fibres are reproduced with a contrast that does not reduce the readability of the text.

An important advantage of high resolution images is that they allow the 'virtual restoration' of a papyrus, i.e. the assembling of its various pieces and the correction of geometrical distortions. These operations cannot be done automatically by software but need much skill and experience. They can only be carried out precisely with the maximum resolution available, because the papyrus fibres and what remains of a damaged text with letters a few millimetres high must be sharply visualised on a monitor. Figures 8.25(a) and (b) show a column of a Greek text and its processed digital infrared image as an example of the performance of the system set up in Milan. Such a system works very well in a laboratory but is not designed to operate in a less controlled environment.

A second portable system was therefore assembled for *in situ* imaging campaigns. The principle is still the same, that of exploring an image plane. In this design a $4K \times 4K$ element CCD was used, the protection filter of which was modified to operate in the infrared. The array is automatically moved across the image plane to store four contiguous images, which are then assembled to obtain a final image mosaic of $6K \times 6K$ pixels. The size of this image does not equal the theoretical size of $8K \times 8K$ pixels one would get by abutting the four sub-images because the 'stitching' software requires a rather large overlapping

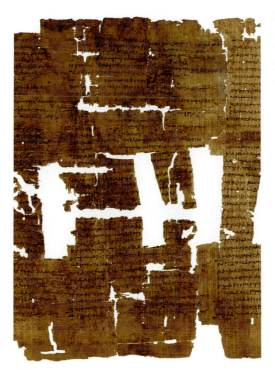

(a)

(b)

Figure 8.25

(a) Visible image of Column IV of the P. Mil. Vogl. VIII 309, Epigrams by Posidippo di Pella; (b) Infrared image of the same column.

Figure 8.26

The author with the transportable system in the Archaeological Museum of Cairo.

of the sub-images to establish their correspondences. Despite this limit, the resolution is sufficient in most cases and some characteristics of the two-dimensional matrix array compared with those of the linear array made us favour the former for a transportable apparatus. Their spectral sensitivity is comparable but the time required by the matrix system to acquire an image is only one tenth and a notebook PC can be used to drive the sensor and its mechanical movement so the device is compact and easy to use, as shown in Figure 8.26. Flash illumination can be used whenever perfect mechanical stability is not assured. The portable system was successfully deployed to examine carbonised papyri also, as shown by the example in Figure 8.27. Illumination here is the real problem, because the papyrus surface is rough and disturbing reflections are difficult to eliminate. Tests are being carried out to improve the technique by placing the papyrus under half-domes of light-diffusing material, in order to obtain a non-directional illumination. Preliminary results are encouraging.

8.5 Conclusion

In conclusion we can say that imaging in different infrared spectral regions has proved a powerful investigative tool for the examination of ancient paintings and papyri. Recent technological developments have made available sensors that can be used to store high resolution digital images of such a quality that the use of photographic film has been practically abandoned. Results can immediately be visualised on the spot and the recording parameters rapidly

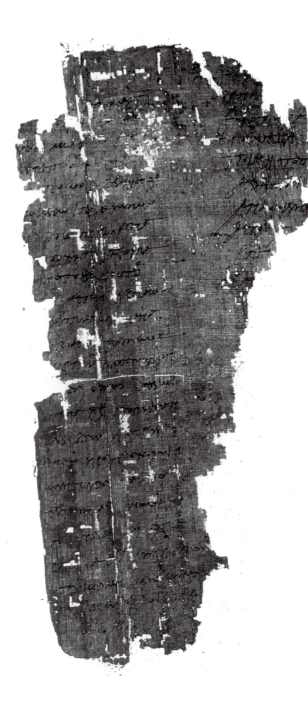

Figure 8.27

Infrared image of a carbonised papyrus of the collection of the Istituto Papirologico G. Vitelli, Firenze. The dark halos around the holes are caused by the glue used to paste the papyrus onto a cardboard backing sheet.

optimised, assuring a high-quality standard and a remarkable reduction of the time and costs of a campaign of measurement *in situ*. It is also worth mentioning that high resolution images can now be reproduced with modern printers on photographic paper with the excellent quality they deserve: darkrooms are becoming obsolete very rapidly.

8.6 Acknowledgements

We gratefully acknowledge the support of the Progetto Finalizzato Beni Culturali of the Consiglio Nazionale delle Ricerche and the Art & Science Programme of Hewlett Packard.

8.7 References

1. van Asperen de Boer, J. R. J. (1970). *Infrared reflectography, a contribution to the examination of earlier European paintings.* Central Research Laboratory for Objects of Art and Science, Amsterdam.
2. *Le dessin sous-jacent dans la peinture,* Colloques, Louvain-La-Neuve, Belgium
3. Olivari, M. (2001). *Tecnica pittorica e disegno preparatorio in Giovanni Bellini e Mario Basaiti,* Oltre il visibile, indagini riflettografiche, Università degli Studi di Milano.
4. Lucco, M. (1989). *'Le tre età dell'uomo' della Galleria Palatina.* Centro Di.
5. Natali, A. Private communication.
6. Gibson, H. L. (1978). *Photography by infrared, its principles and applications.* John Wiley & Sons.
7. van Asperen de Boer, J. R. J. (1968). Infrared reflectography: a method for the examination of paintings, *Applied Optics, **7**,* 1711–1714.
8. Bertani, D., Cetica, M., Poggi, P., Puccioni, G., Buzzegoli, E., Kunzelman, D., Cecchi, S., (1990). A scanning device for infrared reflectography, *Studies in Conservation,* **35**, 113–116.
9. The production of this detector was discontinued but similar devices are still produced with different diameters of the sensitive area, e.g. 300 micron, and spectral range sensitivity. For an uptodate description of the characteristics of these infrared detectors one can look at the *Epitaxx infrared photodiodes data sheets.*
10. Gallazzi, C. (2001). *Papiri e riflettografia, Oltre il visibile, indagini riflettografiche.* Università degli Studi di Milano.
11. Gallazzi, C. (2001). *Papiri dell'Università degli Studi di Milano – VIII: Posidippo di Pella Epigrammi (P. Mil. Vogl. VIII 309).* Il Filarete, Milano.
12. Andorlini, I., Menci, G., Bertani, D., Cetica, M., Poggi, P. (1993). Use of CCD cameras and redextended photographic film for inspection and recording of dark papyri, *Science and Technology for Cultural Heritage,* **2**, 115–122.

Image Resizing – the Limits of Image Processing

Alfredo Giani

9.1 Introduction

A little more than 10 years ago, digital image processing (IP) was the art of a restricted circle of initiates. Special effects software houses used expensive state-of-the-art computer workstations to meet the IP needs of their customers, while the personal computer was still growing out of its infancy and capable of little more than few basic image processing functions. Computers generally were limited not only by the difficulty of meeting the computational demands of IP, but also by the limited memory capacity of the mass storage devices available.

Nowadays, the same laptop computer used to write this chapter has a computational power and storage capacity superior to those of many former mainframe machines, in a fraction of their space, weight and especially price. Furthermore, the outstanding technological progress in the science of image compression enables images to be stored in a fraction of the space required previously. The consequence is that IP has become available to a much broader community of users, with software packages that allow sophisticated editing of pictures and video sequences. This in turn has raised general expectations of what is achievable by IP. However what can and cannot be done with IP is not only a problem of sheer computational power and storage capacity. The goal of this chapter is to demonstrate that some of the problems involved in IP that do not depend on the current technology available, but rather on the inherent nature of digital images.

One of the most common IP tasks is image resizing. Digital cameras, for example, may produce large image files which cannot easily be viewed on the Internet because they require impractically large downloading times. Image compression helps in reducing the memory size of these images, but in many circumstances the only way to obtain a reasonable download efficiency is by reducing the size of the image. Conversely, image enlargement may be required when an initially small image must be shown on a larger scale. Both these operations are likely to produce a result that is qualitatively inferior to the original. Image reduction leads to loss of detail, to an extent that sometimes is not

acceptable, whereas image enlargement leads to blurring and smoothing effects that are perceived as if the original picture was out of focus.

In order to get a thorough insight of the reasons why these problems occur, it is important to understand something of the theory of digital IP. The limitations experienced in image resizing are directly related to a series of mathematical properties of images. In this chapter, the use of mathematical formulations is limited to the simplest level possible, and examples and figures provide more effective explanations. In Section 9.2 a simple mathematical model (the continuous image model) is given to describe 'ideal' images. The following sections tackle the problem of resizing directly in the digital world. A powerful analysis tool, the Discrete Cosine Transform (DCT), is used to explain the problems encountered in resizing. The final section links the continuous image model and the concepts illustrated in Sections 9.3–9.5, which gives a more general scope to the discussion on digital images.

9.2 The Continuous Image Model

What is an image? In the case of human vision, an image is simply what we see with our eyes. Since prehistoric times, mankind has been obsessed with fixing images on a great variety of media, so as to preserve and communicate the visual experience beyond the limitations of the individual memory. For millennia, images existed only in the form of man-made artefacts, such as paintings, engravings and sculptures, until the invention of photography brought a completely revolutionary ability to capture the essence of an image by 'recording' the light emanating from the scene. Photographic cameras mimic the 'mechanics' of the human eye, insofar as their basic components include an iris, variable-focus optics and a light sensitive area. Digital technology introduced a new dimension to the art of imaging, enabling digital images to be represented as numbers instead of chemical reactions in the photographic film.

So, what is an image in mathematical terms? We can start by identifying a model for the 'real' image, i.e. the pattern of light and dark we seek to capture. The simplest way of defining such an image is as a two-dimensional function:

$$v = \begin{cases} I(x, y) & x, y \in [-0.5, 0.5] \\ 0 & elsewhere \end{cases} \tag{9.1}$$

where x and y are two spatial co-ordinates and v is the corresponding value (intensity). Note that in this definition, the image has null value outside the interval $[-0.5, 0.5]$. Real images have always a finite extent and a mathematical model must take this into account. By choosing such an interval, we have normalised the dimensions of the image itself, enabling the comparison of images with different widths and/or heights. Note that the image model in Eq. (9.1) is centred in the origin of the co-ordinate system (Figure 9.1).

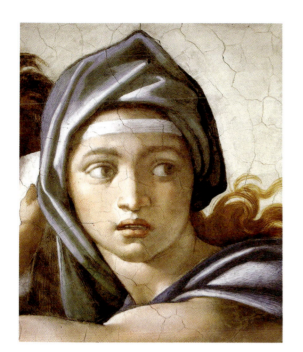

Figure 9.1

(Top) Delphic Sibyl, detail from a fresco on the ceiling of the Sistine Chapel in the Vatican, Rome, by Michelangelo Buonarroti, c.1509; (Bottom left) Extracted luminance component as a monochrome image; (Bottom right) Its representation as a function of the spatial coordinates x and y.

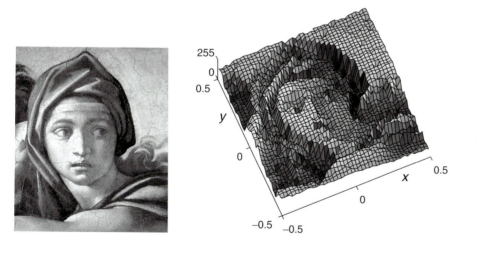

Colour images comprise three visual stimuli commonly denominated as colour channels. Therefore, in order to model colour images, three functions as in Eq. (9.1) are required, one for each colour channel, so that it is more appropriate to describe a colour image as:

$$r = I_r(x,y), \quad g = I_g(x,y), \quad b = I_b(x,y) \qquad (9.2)$$

where r, g, b are the three colour channels red, green and blue. There are many other possibilities, such as the CIE XYZ model or the Hue-Saturation-Value system. In any case, it is possible to describe an image as three separate

functions of the spatial co-ordinates. Hereinafter we will consider only the single generic function, which can be considered as a greyscale image.

The model described in Eq. (9.1) is known as the continuous image model, meaning that the image is defined for any value of the spatial co-ordinates x and y. Is this assumption realistic? To answer this question, we have to introduce the concept of resolution, which can be considered in a broad sense as the dimension of the smallest detail that can be represented in an image. The continuous model has infinite resolution, since there is no lower bound for the smallest dimension. If a detail has extension Δx on the image plane, it is always possible to discriminate the values $I(x, y)$ and $I(x + \Delta x, y)$. The human eye has a finite resolution set by the number and spacing of photoreceptors (cones and rods) in the retina. It is a common experience that as one moves far away from an object, the ability to discriminate the details decreases. Scientists have invented a series of instruments to overcome these problems, such as the telescope and the microscope, which extend our visual resolution over large and small distances respectively.

A theoretical limit to resolution can be conjectured from the laws of quantum physics. Vision operates within a small range of wavelengths of electromagnetic radiation between 700 nm (corresponding to red) and 400 nm (corresponding to violet). However, there is a limit to the size that an electromagnetic wave (and in general any wave) can discriminate. This limit is approximately ten times the wavelength of the radiation used, and it is due to diffraction phenomena. In simple words, if radiation is projected onto an object of dimensions much larger than the wavelength of the radiation used, a shadow will be produced on a screen that represents the image of the object itself. However if the dimension of the object is similar to the wavelength, the light will dodge around the object and a complex wave pattern will be produced instead of a well-formed shadow. Therefore, a theoretical limit for the minimum size of an object that can be resolved by visible light is in the range 4–7 μm.

In fact, the determining factor for the maximum resolution is neither the human eye nor the wavelength composition of the illumination, but rather the medium used to record and reproduce the image. It is commonly known among photographers that as the speed of the film increases, the image becomes more 'grainy'. This is because in order to collect more light in a shorter time, high-speed films use larger photosensitive particles. Since each individual particle yields a single density value once developed, the result is that the spatial resolution is reduced. In digital cameras, the current silicon microchip technology limits the resolution of the CCD sensors employed.

9.2.1 Sampling of the continuous image

Unlike film, where the photosensitive grains are spread over the cellulose substrate in a random way (although with uniform average density), a digital

image has its light-capturing elements arranged in very regular and predictable patterns. A digital (discrete) image is described by the function:

$$I(n,m), \quad n = 0,1,\ldots,N-1, \quad m = 0,1,\ldots,M-1 \qquad (9.3)$$

where N and M are respectively the horizontal and vertical dimensions of the image. The variables n and m are therefore the horizontal and vertical co-ordinates. Unlike the continuous variables x and y, n and m can only assume discrete (integer) values, corresponding to the row and column addresses of pixels in the image.

It is possible to relate the actual (digital) image to the ideal, continuous model in Eq. (9.1) by means of the sampling operation:

$$I(n,m) = I(x,y)\delta(x - n\Delta_x, y - m\Delta_y) \qquad (9.4)$$

where Δ_x and Δ_y are respectively the horizontal and vertical sampling intervals. If the sampled image has N samples (pixels) in the horizontal direction, and M samples in the vertical direction, we have $\Delta_x = 1/2N$ and $\Delta_y = 1/2M$.

The sampling function $\delta(x,y)$ is known as the Dirac delta function, and is defined as:

$$I(x,y)\delta(x - n\Delta_x, y - m\Delta_y) = \begin{cases} I(x,y) & x = n\Delta_x, y = m\Delta_y \\ 0 & elsewhere \end{cases} \qquad (9.5)$$

Note that in Eq. (9.5) the digital image and the continuous image are represented by the same symbol I in order to simplify the notation. It is clear that the digital image has finite resolution. Any detail in the continuous image that has dimensions lower than the sampling steps will be rendered within the space of a single pixel and therefore, lost. For instance, two parallel vertical lines with spacing smaller than Δ_x will be rendered as a single line.

The consequences of sampling can be modelled in a rigorous way by using Fourier Transform (FT) analysis. FT is a mathematical tool that translates the spatial details in an image to the relative power at each spatial frequency. In order to achieve a better understanding of the FT in image analysis, we will use an alternative approach, based on another transform, which is a derivation of the FT for discrete (i.e. digital) images. Using this framework, we will investigate the problems related to image resizing, by successively re-introducing the continuous image model in terms of its FT, to see how continuous and digital images are related.

9.3 The Discrete Cosine Transform

The Discrete Cosine Transform (DCT) provides a powerful description of digital images and it forms the basis of many compression techniques, the most

famous of which is the Joint Picture Expert Group (JPEG) compression format. The DCT of a discrete image $I(n,m)$ with $N \times M$ pixels is defined as:

$$\tilde{I}(f_n, f_m) = DCT[I(n,m)] = \sum_{n=0}^{N-1} \sum_{m=0}^{M-1} I(n,m) \cos \frac{\pi f_n (2n+1)}{2N} \cos \frac{\pi f_n (2m+1)}{2M}$$

(9.6)

Equation (9.6) defines a set of $N \times M$ functions called basis images:

$$B(n,m,f_n,f_m) = \cos \frac{\pi f_n (2n+1)}{2N} \cos \frac{\pi f_n (2m+1)}{2M}$$

(9.7)

Equation (9.7) describes the basis image of frequencies f_n, f_m. It is possible to demonstrate that the image can be completely described in terms of a weighted sum of these basis images, where the weights are provided by the DCT $\tilde{I}(f_n, f_m)$ itself:

$$I(n,m) = DCT^{-1}[\tilde{I}(f_n, f_m)]$$

$$= \sum_{f_n=0}^{N-1} \sum_{f_m=0}^{M-1} \tilde{I}(f_n, f_m) \cos \frac{\pi f_n (2n+1)}{2N} \cos \frac{\pi f_n (2m+1)}{2M}$$

(9.8)

Equation (9.8) represents the inverse of the DCT in Eq. (9.6) and therefore is called the inverse DCT. What do the basis images B look like? Figure 9.2 shows some of these 'building blocks'. Although an individual basis image B can hardly resemble any real image, Figure 9.3 shows that, by adding together the basis images each multiplied by the corresponding DCT coefficient $\tilde{I}(f_n, f_m)$, we can build a 'real' image.

Note that, as the summation of basis images progresses (by increasing the frequencies f_n, f_m), more fine detail is added and the less 'wavy' the image looks. The fact that the visual quality of the reconstruction increases as more high-frequency components are added is not accidental. Higher frequencies account for details, while lower frequencies account for broader features in the image. An example is provided in Figure 9.3 where the lower frequencies have been removed. One can see that although the details are preserved, the quasi-uniform features of the image are incorrectly represented.

Figure 9.2

Basis cosine images with increasing horizontal and vertical frequencies.

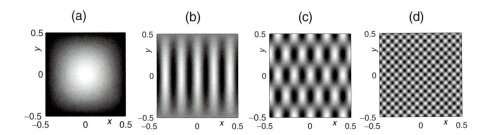

(a)

(b)

Figure 9.3

(a), (b) and (c) – Progressive reconstruction of an image from its lower frequency components; (d) by removing the lower frequency content of an image, only the details are left.

(c)

(d)

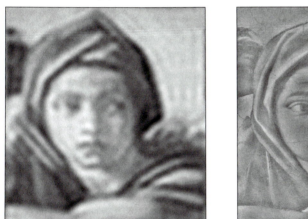

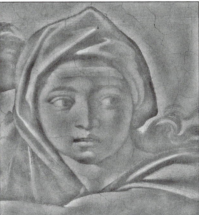

It is therefore common to define as 'low-pass' images those pictures with a little content in detail (higher frequencies). Conversely, by removing the low-pass component from an image we can obtain the 'high-pass' image.

9.3.1 Image spectrum: a graphic representation of the DCT

Any image can be fully represented by its DCT coefficients. It is possible to plot a graphical representation in two dimensions, where the x and y axes represent respectively the f_n, f_m spatial frequencies, and the z axis represents the magnitude of the coefficients $\tilde{I}(f_n, f_m)$. Such a representation is called the DCT spectrum of the image $I(n, m)$. Since the cosine is an odd function,

Figure 9.4

Monolateral (left) and bilateral spectrum (right). For any real signal, the bilateral spectrum is a symmetric replication of the monolateral spectrum around the origin.

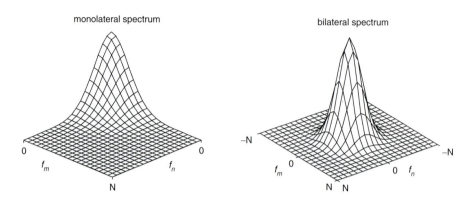

monolateral spectrum

bilateral spectrum

i.e. $\cos(x) = \cos(-x)$, we can modify Eq. (9.6) in order to introduce negative frequencies as follows:

$$\tilde{I}(f_n, f_m) = DCT[I(n,m)]$$

$$= \frac{1}{2} \sum_{n=-N}^{N-1} \sum_{m=-M}^{M-1} I(n,m) \cos \frac{\pi f_n (2n+1)}{2N} \cos \frac{\pi f_n (2m+1)}{2M} \qquad (9.8)$$

This equation leads to a representation of the bilateral spectrum as shown in Figure 9.4. Note however that the standard definition of the DCT is given by Eq. (9.6). One should keep in mind that the bilateral spectrum is redundant, since the spectrum in the first quadrant (i.e. for $f_n, f_m > 0$) is the same for the other three quadrants.

9.4 Image Spectra and Aliasing

By observing the spectrum in Figure 9.4, one can see that f_n, f_m are limited within the respective ranges of $[0\ N]$ and $[0\ M]$. A question naturally arises regarding this limitation and it deserves a thorough explanation, because it is motivated by aliasing, the nemesis of IP design. Aliasing is a problem that engineers must tackle in any digital signal processing application and can be regarded as a limitation in the available frequency space (although the 'real thing' is more complicated).

To explain why the frequencies are limited, let us consider a one-dimensional basis image $B(n, m, f_n, f_m)$ when the horizontal spatial frequency is increased. For the sake of simplicity, we consider $f_m = 0$, and $f_n = 0$, $N/4$, $N/2$, N, $3N/4$, $3N/2$, $2N$. The resulting basis images $\cos \pi f_n (2n+1)/2N$ are shown in Figure 9.5. As f_n increases from 0 to N, so increases the 'rapidity' by which the cosine oscillates (i.e. the spacing between dark and bright lines decreases, and more lines are added). However, as the frequency increases above N, this effect ceases. In fact, it seems that as the frequency increases further, the variability goes 'backwards', i.e. the distance between the lines increases. This is particularly

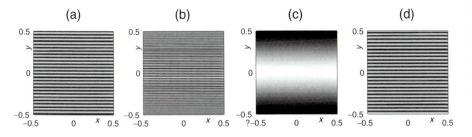

Figure 9.5

Progression of basis functions with $f_n = N/4$ (a), $N/2$ (b), N (c) $3N/4$ (d). As $f_n > N/2$, the visual frequency seems to go 'backwards'.

dramatic for $f_n = 2N$, since the image looks identical to that resulting from $f_n = 0$. This can be explained by considering that for $f_n > N$, there are not enough pixels to account for the variability of the cosine basis function, i.e. the resolution of the image is not high enough, as shown in Figure 9.6.

In fact a cosine with $f_n = N$ spans exactly two pixels for its period (the period T of a cosine is the distance between two peaks of the wave and is the inverse of frequency). This is the maximum variation that the image can exhibit. A shorter period ($f_n > N$) cannot be properly represented, as it would require intermediate positions between two adjacent pixels. This effect is called aliasing: frequencies above the limit of $f_n = N$ ($f_m = M$ for the vertical axis) are 'folded back' into the range $[0\ N]$. The frequency $f_n = 2N$ is called the Nyquist frequency f_{nyq} and aliasing will occur for any frequency greater than $f_{nyq}/2$.

We can imagine any digital image as arising from the sampling of a 'real' image (the relationship between continuous and digital images will be better explained in Section 9.6). It has been shown how the continuous image has 'infinite resolution'. In order to capture the smallest details of the real image, we must make sure that that there are enough pixels to represent these details, i.e. that an appropriately high sampling frequency is used. The consequence of under-sampling the image (i.e. not using enough resolution in terms of pixels) is that these details are incorrectly represented if not completely lost. Unfortunately, high sampling frequencies come with the cost of a larger image, since more pixels must be stored. Therefore, the choice of f_{nyq} is a compromise between memory allocation and resolution, and aliasing must be taken

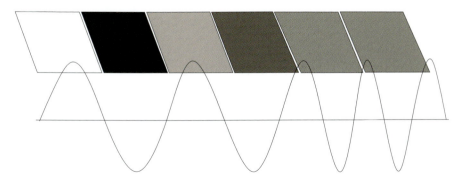

Figure 9.6

At least 2 pixels are needed to represent a cosine function. As the frequency increases, the peaks of the cosine get closer and the resulting contrast decreases.

Figure 9.7

Aliases in the spectrum. The real spectrum of a discrete image is an infinite replication in both frequency dimensions of the base spectrum shaded in grey. Image processing operations affect both shape and position of the aliases as well as the base spectrum.

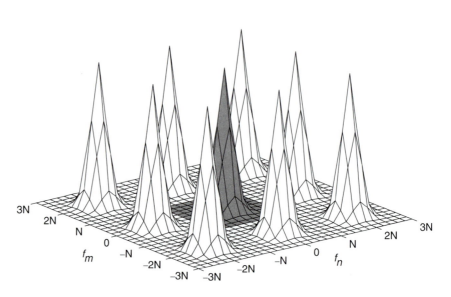

into account. The Nyquist frequency, equal to double the frequency of the 'smallest' detail in the image, represents the minimum sampling frequency to be used in order to preserve detail.

In the case of an image captured by a digital camera, the sampling of the image is determined by the optical projection of the scene onto the CCD sensor array. The Nyquist frequency is fixed by the sampling of the array, but how this translates to spatial frequencies in the scene depends on the magnification of the lens.

We have seen how a frequency above $f_{nyq}/2$ is folded back into the range $[0 \, N]$. Bearing in mind that the cosine is an odd function, it follows that any frequency below $-f_{nyq}/2$ is folded back into the range $[-N \, 0]$, which explains aliasing for the bilateral spectrum. Conversely, the frequency content of an image for frequencies outside the range $[-N \, N]$ is equal to a corresponding frequency in the range $[-N \, N]$. In fact, the DCT provides a 'compact' representation of the spectrum. The complete spectrum of a digital image is a replication ('aliasing') of the bilateral DCT spectrum with spacing equal to the Nyquist frequency (Figure 9.7), which provides the required correspondence. Section 9.6 will provide a more complete explanation of this behaviour.

9.4.1 Normalised frequency representation

The DCT spectrum is defined from frequencies in the ranges $[-N \, N]$, $[-M \, M]$ for the bilateral spectrum. This links the frequency content of an image to the size (dimension in pixels) of the image itself. In order to compare images with different sizes, it is useful to have a representation of the spectrum that is independent from N and M. It is common practice to divide (normalise) the

aforementioned ranges by the Nyquist frequencies $f_{nyq}^{(x)} = 2N$ and $f_{nyq}^{(y)} = 2M$. Therefore the normalised spectrum will extend across the range $[-0.5\ 0.5]$ for both axes.

9.5 Image Resizing

Image resizing is one of the most common image processing tasks encountered in practice. Many practical situations require an amount of resizing, either to enlarge or to reduce the image. Users may want to place their high quality pictures on a web site, and require significant reduction to bring the size in Kb of each picture to a practical value. As the reduction factor increases, however, more and more details are lost, and therefore the reduction factor must be a compromise between the memory target and the degradation of image quality. Conversely, one may want to enlarge a small image, e.g. to produce a large print. Unfortunately as the enlargement proceeds, the image becomes increasingly blurred.

Resizing, either enlargement or reduction, is a real challenge for IP algorithm designers. The goal is to achieve the desired size while keeping the visual quality of the picture (sharpness, detail) as close as possible to the original. Such problems are well known to professional photographers using conventional film. The speed of the film (proportional to the average size of the photosensitive particles in the photographic emulsion) is a critical parameter with respect to the quality of the details. This is particularly important whenever the photographer wants to produce enlargements of the pictures. High speed films (e.g. 400ASA) yield a 'grainy' result when the print is very large. The IP problems are of a different nature, but nevertheless critical for the final result. This section exploits the concepts of the previous section to provide a simple explanation of the problems involved. A more rigorous explanation is provided in Section 9.6.

9.5.1 *Image enlargement*

The first step of an image enlargement algorithm is to place the existing pixels apart. For example, if the image needs to be enlarged two times, a group of four adjacent pixels in a square will be placed at one pixel distance from each other (Figure 9.8). If the image is enlarged to 4 times the original size, then these pixels will be spaced by three intermediate pixels, etc. In order to produce a proper image, it is necessary to 'fill the gaps' created between adjacent pixels. It is the goal of the IP algorithm to fulfil this task.

In general, given an arbitrary enlargement factor, it is required to assign values to new pixels. It is rather intuitive to assume that these will depend on the neighbouring known values (i.e. the known pixels of the original image), and will be more similar to whichever pixel is closer. This provides the rationale to

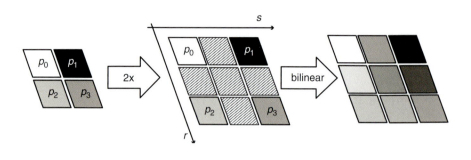

one of the simplest and most popular image enlargement techniques, the bilinear interpolation algorithm. If we assume that the target pixel p (i.e. the value one seeks to estimate) has co-ordinates r and s in a local reference system (with $0 \leq r, s \leq 1$) as depicted in Figure 9.8, then bilinear interpolation determines the value of p as:

$$p = (1-r)(1-s)p_0 + s(1-r)p_1 + r(1-s)p_2 + rsp_3 \qquad (9.9)$$

Equation (9.9) expresses the value p as a weighted sum (weighted average) of its four neighbouring pixels. The weights are determined by the relative distances, and it is easy to see that as p moves closer to one of these pixels, its value will get closer to the latter. For instance if $r = s = 0$, p will be coincident with p_0. In this case, Eq. (9.9) leads to $p = p_0$. Even simpler is the 'nearest neighbour' interpolation technique. This uses the closest pixel as the value for p. If p is exactly in the centre of the neighbourhood, then its value is randomly selected from the four neighbours.

A more complex approach is the bicubic interpolation technique, which uses a larger neighbourhood (4×4 pixels). Functions are fitted through two pixels on either side of the pixel being constructed in order to model the tonal gradient better. In principle, an even larger neighbourhood could be devised, but this challenges the intuitive consideration that p depends primarily on its neighbours. For instance, there may be little obvious correlation between the value of p and a pixel that is 100 pixels distant.

Regardless of the particular technique adopted, the usual result is that the enlarged image appears blurred. Edges that appeared sharp on the original image, now appear smooth in the enlarged image. This may seem not immediately easy to understand, since, after all, the information is still there. Therefore, the 'sharpness' information somehow gets lost in the process. The DCT technique provides a simple and exhaustive explanation.

The bilinear algorithm defined by Eq. (9.9) is a linear operation. This means that if the operation is applied to a sum of elements, the result will be equal to that obtained by applying the algorithm individually to the elements, and then adding up the outcomes. This implies that the enlarged image can be obtained

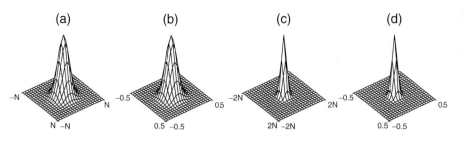

Figure 9.9

Image zooming and spectra. Original spectrum (a) and its normalised representation in $[-0.5, 0.5]$. In the spectrum of the enlarged image (2x zoom) (c) the enlargement corresponds to a doubling of the sampling frequency. The effect is that the normalised representation (d) is shrunk compared to (b).

by adding the enlarged basis images. A more rigorous way to show this is to put $2N$ in place of N (and $2M$ in place of M) in Eq. (9.6). This is equivalent to doubling the sampling frequency (i.e. the resolution), as one can easily understand by considering for example that an element previously described by 5 pixels is now described by 10 pixels. Therefore the aliases in Figure 9.7 will be spaced by $4N$ rather than $2N$. However, the components $\tilde{I}(f_n, f_m)$ have remained unchanged; therefore the shape of the aliases remains unchanged. If the representation chosen is the normalised one, it is clear that the frequency spectrum is more compact, because the frequency components will be divided by $4N$ rather than $2N$. The effect is illustrated in Figure 9.9.

9.5.2 Image reduction

Basic image reduction can be achieved by using a technique equivalent to bilinear interpolation. However this time (for a 2x reduction) the four neighbouring pixels will 'collapse' into the same point (Figure 9.11). Therefore, the question is what value should arise from these four collapsing pixels. Again there is a self-suggesting solution: the resulting pixel will be the average of the four pixels:

$$p = (p_0 + p_1 + p_2 + p_3)/4 \qquad (9.10)$$

It is possible to devise more complex reduction algorithms, but the scheme expressed by Eq. (9.9) is the 'foundation stone' for the whole class of linear reduction schemes. Unlike the enlargement case, this time it is possible to observe a new phenomenon, namely that some of the details in the original picture disappear. For instance, this effect is particularly dramatic in Figure 9.10 for the craquelure pattern, which has a texture rich in fine details.

The higher frequencies of the image (details) will most likely trespass on the 'Nyquist barrier', and therefore will generate aliasing. However, Eq. (9.10) has a 'natural' anti-alias property, so that the higher frequencies will be removed prior to the reduction. This is not the case for instance for the nearest-neighbour reduction algorithm, where the output value is randomly selected

Figure 9.10

Image reduction: the top row of this figure is the 'dual' of Figure 9.8. Here, 4 pixels (left) must be represented by a single pixel (right). This necessarily leads to a loss of information. The result is that details are lost, as evident in the pictures in the bottom row.

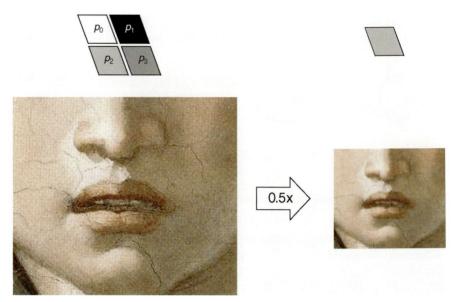

0.5x

from one of the neighbouring four pixels and there is no built-in anti-alias filter. Figure 9.11 shows the differences between nearest-neighbour and bilinear interpolation on a sample image.

9.5.3 Anti-alias filtering

The consequence of image reduction is that the spectrum and its aliases are 'stretched' in frequency. Therefore an image that had a low amount of high frequency becomes suddenly rich in higher frequencies as a consequence of the reduction. If these new frequencies fall outside the normalised range $[-0.5\ 0.5]$ then they will generate aliasing, i.e. the relative distribution of frequencies will be altered.

In order to avoid this, one should ensure that the resized image has negligible content of frequencies greater than $f_{nyq}/2$. If that is not possible, such frequencies must be removed before proceeding with the reduction. Anti-alias or

Figure 9.11

(a) original image; (b) nearest neighbour interpolation: one can see the 'fringes' given by the poor aliasing rejection properties of nearest-neighbour; bilinear interpolation (c) is clearly more robust.

(a) (b) (c)

low-pass filters perform this task, literally removing the high frequencies that may cause aliasing. We have already seen that bi-linear interpolation has a natural anti-alias filtering property produced by the averaging operation (it is, in fact, a very simple low-pass filter). Nearest-neighbour selection does not have such a property and therefore, the result is affected by aliasing.

9.6 The Fourier Transform of the Continuous Image

In Section 9.2, the concept of the continuous image model was introduced. This model represents the 'real thing' we wish to capture, or (more correctly) it corresponds to the visual experience of the human observer. We have seen that in fact any picture (analogue or digital) presents a degree of spatial quantisation. The continuous image model is an ideal representation of reality. The most noticeable difference is that $I(x, y)$ has infinite resolution, whereas any realistic imaging system (included the human eye) must have finite resolution and so is more appropriately represented by the discrete model $I(n, m)$. This model can be related to the ideal image $I(x, y)$ by the sampling intervals Δ_x and Δ_y and Eq. (9.4).

We have introduced a very powerful tool to analyse the discrete image: the DCT is related to the detail present in the image and, more importantly, it changes when an image is resized. The DCT has been used to explain the typical problems and artefacts experienced when one attempts to resize an image.

However, the DCT lives in the digital (discrete) world and never departs from it. Is it possible to provide a similar representation for the continuous image? The answer is 'yes' and the following discussion will not only provide a representation of the continuous image in terms of harmonic (i.e. cosine) functions, but also shed a broader light on the topics previously discussed. The DCT is a special case (for digital images) of a more general mathematical tool called the Fourier Transform (FT), which applies to continuous as well as digital images. Instead of discrete summations, the FT uses continuous integration, and is defined as:

$$\tilde{I}(f_x, f_y) = FT[I(x, y)] = \int_{-\infty}^{+\infty} \int_{-\infty}^{+\infty} I(x, y) e^{-i2\pi(f_x x + f_y y)} dx dy \qquad (9.11)$$

Its inverse function (the inverse FT) is defined as:

$$I(x, y) = FT^{-1}\left[\tilde{I}(f_x, f_y)\right] = \int_{-\infty}^{+\infty} \int_{-\infty}^{+\infty} \tilde{I}(f_x, f_y) e^{i2\pi(f_x x + f_y y)} df_x df_y \qquad (9.12)$$

There are substantial analogies, but also differences, between the FT couple i.e. Eqs. (9.11) and (9.12) and the DCT couple i.e. Eqs. (9.6) and (9.7). A summary is provided in Table 9.1.

Table 9.1

Comparison of the characteristics of the Discrete Cosine Transform (DCT) and Fourier Transform (FT).

DCT	FT
$\tilde{I}(f_n, f_m)$ real-valued function	$\tilde{I}(f_x, f_y)$ complex-valued function
f_n, f_m integer values extend from -0.5 to $+0.5$ (normalised bilateral spectrum)	f_x, f_y real values extend from $-\infty$ to $+\infty$
Real-valued basis functions $$\cos \frac{\pi f_n(2n+1)}{2N} \cos \frac{\pi f_n(2m+1)}{2M}$$	Complex-valued basis functions $$e^{-i2\pi(f_x x + f_y y)}$$

The first thing to notice is that, unlike the DCT, the FT is a complex function (containing i the imaginary unit). Furthermore, the basis functions of the FT are also complex-valued. This complex nature requires a discussion that goes well beyond the scope of this chapter. It betrays the fact that within FT there is phase information to be accounted for. We can imagine the phase information by considering cosinusoidal curves that shift along the x and y axes (Figure 9.12). For a discrete representation, like the DCT, this extra information is not necessary but for continuous images, it is an intrinsic part of the representation.

Another important difference is that the FT frequencies extend from $-\infty$ to $+\infty$. This expresses the fact that the continuous image has infinite resolution and therefore infinite detail at each scale, so that variation can occur at any rate without the upper bounds of the Nyquist frequency. Such differences make the continuous image spectrum far more complex. A simple way to provide a

Figure 9.12

Plot of cosinusoids with increasing phase value.

Figure 9.13
Magnitude (left) and phase (right) of the FT. The phase spectrum has information content as rich as the magnitude spectrum.

graphic representation of the spectrum is to plot the real part $\text{Re}[\tilde{I}(f_x,f_y)]$ and the imaginary part $\text{Im}[\tilde{I}(f_x,f_y)]$ of the spectrum in two different plots. An alternative is the absolute value/phase plot (Figure 9.13). The absolute value is defined as:

$$\left|\tilde{I}\left(f_x,f_y\right)\right| = \sqrt{\text{Re}\left[\tilde{I}\left(f_x,f_y\right)\right]^2 + \text{Im}\left[\tilde{I}\left(f_x,f_y\right)\right]^2} \tag{9.13}$$

while the phase is defined as:

$$\angle\tilde{I}\left(f_x,f_y\right) = \tan^{-1}\left\{\frac{\text{Im}\left[\tilde{I}\left(f_x,f_y\right)\right]}{\text{Re}\left[\tilde{I}\left(f_x,f_y\right)\right]}\right\} \tag{9.14}$$

From Figure 9.13, it is clear that the absolute value plot is similar to the spectrum plot in Figure 9.4 and justifies the choice of this representation rather than the real/imaginary scheme. In fact, the absolute plot usually shows the most important features of an image, like the relative amount of detail at each spatial frequency. However, both absolute value and phase information are required to recover the image from its FT.

The characteristic of the FT most directly related to the re-scaling problem is the scaling property. For the continuous image, re-sizing is defined as:

$$I^{(a,b)}\left(x,y\right) = I\left(ax,by\right) \tag{9.15}$$

where $a,b > 1$ indicates an enlargement, and $0 < a,b < 1$ indicates a reduction (Figure 9.14). The spectrum $\tilde{I}^{(a,b)}(f_x,f_y)$ of the scaled image is related to the original spectrum by the relation:

$$\tilde{I}^{(a,b)}\left(f_x,f_y\right) = \frac{1}{ab}\,\tilde{I}\left(\frac{f_x}{a},\frac{f_y}{b}\right) \tag{9.16}$$

This result shows that if the image is enlarged, the spectrum shrinks, whereas if the image is reduced, the spectrum expands. This has a clear connection to the DCT analysis in Section 9.3, where we have seen for the discrete image that

Figure 9.14

Image resizing and FT.
(a) original spectrum
(b) spectrum of the
enlarged image: one
can see how the higher
frequencies are reduced.
Conversely on the
reduced image (c) the
high-frequency compo-
nents are magnified,
especially on the axes of
the frequency space.

(a)　　　　　　　(b)　　　　　　　(c)

resizing implies that the spectral aliases expand (for image reduction) and
shrink (for image enlargement).

This inverse correspondence is not a coincidence and can be explained by
transforming the relationship between the continuous image and the discrete
(sampled) image. The Fourier transform of Eq. (9.4) is:

$$\tilde{I}(f_x, f_y) = \sum_{n=-\infty}^{n=+\infty} \sum_{m=-\infty}^{m=+\infty} \tilde{I}(f_x, f_y)\delta\left(f_x - \frac{n}{\Delta_x}, f_y - \frac{m}{\Delta_y}\right)$$

$$= \sum_{n=-\infty}^{n=+\infty} \sum_{m=-\infty}^{m=+\infty} \tilde{I}\left(f_x - \frac{n}{\Delta_x}, f_y - \frac{m}{\Delta_y}\right) \tag{9.17}$$

Equation (9.17) is the link between the continuous spectrum and the
periodic discrete spectrum. The spectrum of the sampled signal $\tilde{I}(f_n, f_m)$ is
evidently made up of an infinite replication (aliases) of the continuous spec-
trum. The spacing of these aliases is equal to Δ_x, Δ_y. In order avoid aliasing,
therefore, the image should have no detail smaller than $\Delta_x/2$ in the horizontal
direction and $\Delta_y/2$ in the vertical direction. These criteria in turn set the
Nyquist frequencies respectively equal to $f_{nyq}^{(x)} = 2N$ and $f_{nyq}^{(y)} = 2M$.

9.7　Conclusion

This chapter has discussed, with the aid of a little unavoidable mathematics, the
basis of digital image resizing. It has been shown how the choices made when
sampling the original image into a finite set of pixels impose limits on the
range of spatial frequencies that can be accurately represented. Analysis by
the DCT indicated how the frequency spectrum of an image is related to the
sampling interval, and how it changes when an image is enlarged or reduced
in scale. Visual artefacts may appear in an image due to unwanted alias frequen-
cies being included within the spectrum. The conclusions are that the sampling
of the original image must be suited to the fineness of its inherent spatial detail,
and that subsequent rescaling of the digital image must be undertaken with
care in order to preserve its representation of the original.

9.8 Bibliography

For a good introduction to spatial transforms in digital image processing, the following texts are recommended:

Gonzalez, R. C. and Woods, R. E. (2001). *Digital Image Processing*, 2nd Edition. Prentice Hall.

Holst, G. C. (1998). *Sampling, Aliasing and Data Fidelity*. SPIE Press.

Pratt, W. K. (2001). *Digital Image Processing*, 3rd Edition. John Wiley & Sons.

Vollmerhausen, R. H. and Driggers, R. G. (2000). *Analysis of Sampled Imaging Systems*, Tutorial Text Volume TT39, SPIE Press.

Wolberg, G. (1992). *Digital Image Warping*. IEEE Computer Society Press.

Image Databases and Access

Mike Stapleton

10.1 Image Databases

10.1.1 Role

Technological changes such as the decrease in cost of on-line storage and the development of low-cost workstations, high-quality scanners and digital cameras have made it possible to create and manage large collections of digital images online. The advent of the Web has created new opportunities for the use of digital imagery. This combination of technological capability and user demand has led to a need for systems which are adept at handling large collections of digital images.

The traditional approach is for each application to manage its images in an application-specific manner, often using proprietary formats, sometimes linked to particular hardware. However, collections of digital images with appropriate metadata have come to be recognised as significant resources which can be exploited to different ends. Image databases have emerged as the key to realising this potential. They are digital asset management systems whose primary function is to manage digital still images rather than time-based media such as moving images and audio.

An image database is a software component that provides image-related services for applications. Its role in a system architecture is to separate the functions needed for managing images from any application-specific functionality that needs to make use of them. In broad terms, the functions of an image database are:

- Image ingestion
- Image storage and management
- Image search and retrieval
- Image delivery

Image database applications are built on image databases and fall broadly into two types with differing information requirements:

- Image catalogues focus on the cataloguing of the image as an image.
 The subject depicted in the image may be described in some detail but

the application is unlikely to include a comprehensive model of all possible subjects.

■ Documentation systems place the emphasis on the thing, object or site, being documented. The images serve to illustrate aspects of the object and act as surrogates for the object. The system will incorporate a model of the documentation of the object or site which will be the primary means of finding images.

A documentation system may be built in conjunction with an image catalogue, offering different patterns of access to the same set of images.

10.1.2 Metadata

An image database can be characterised by the information about the image, the metadata, it supports. A generic system architecture has to take into account the different interests in, and applications for, these different types of metadata. It must provide the appropriate interfaces to allow the image metadata to be accessed and maintained.

We can distinguish between the technical metadata, concerned with the image as a digital asset and the content description describing the subject depicted in the image. Where the image is of a creative work such as a painting, the content metadata may also describe the subject of the work itself. It is here where the difference in emphasis between a catalogue of images and a documentation system with illustrations becomes apparent. There are many different traditions for documenting works and their subject matter and it is not, in general, possible for the image database to provide these in an application independent manner. An image database will concentrate on the metadata associated with the image and let any application-specific documentation be managed by an appropriate application. The image database system may provide means for an application to store application-specific data in the same database as that used for the image metadata.

10.1.3 Functions

Image ingestion

An image database system has to provide facilities for loading images and metadata. Images may arrive continuously, for instance via a news feed or from a scanning department. They are processed and loaded into the database as they arrive. Images may also be loaded interactively by a user, either as individual images or batches of images, for instance as a download from a digital camera or the contents of a PhotoCD.

As a side effect of loading the images the image database system may be configured to produce a working set of images in the different sizes and formats needed to support a range of known applications supported by a particular installation.

Image storage

Different image database system architectures may store the images in the database or in a separately managed area of the file system. Image file formats allow some metadata to be stored with the image itself but in the current state of the art, it is more common to store some or all of the metadata separately in the database.

Search and retrieval

Image databases need to offer services for image search and retrieval including:

Retrieval by unique identifier. If the application knows a unique identifier for an image it requires, it can request it directly using this id.

Content-Based Image Retrieval (CBIR). Techniques exist for automatically characterising images in terms of their visual attributes – colour, shapes, texture, etc. Such signatures can be used as the basis for retrieving images sharing visual attributes with a reference query image.

Retrieval by searching metadata. By far the most common approach in current practice is to search the image metadata to identify images for retrieval. The metadata held by the system will be determined by the uses the database is to be put to.

Image delivery

Once the required image has been identified, an application can retrieve a copy of the image together with the metadata to serve the current purpose. Different channels, such as delivery on the Internet, local area networks or to standalone systems, require different techniques so an image database needs to be able to support a range of protocols for delivering images. Images can be very large, so bandwidth is frequently an issue.

Digital images can exist in different formats. These are a combination of the image size in pixels, any compression that may be applied and the encoding by which the image file is created. An image database may offer services to supply images in different formats, either selected from a stored set of encodings or generated on demand from a reference image.

Database management

As well as the image-specific functions described above, image databases need to support the normal range of database management facilities such as user

authentication and authorisation, day-to-day operation, backup, disaster recovery and data archiving. Here, image databases differ little from other, non-image, database systems except that the storage capacity required can be unusually large and dominated by the storage of the images themselves rather than the associated metadata. This characteristic may be reflected in the backup and recovery strategies.

10.1.4 Images in a museum – scenario

Let us consider the requirements for management and use of images in a hypothetical modern museum as an illustration of the central role an image database system can play in developing the uses of images as digital assets. The museum has a large library of print and transparency photography which it has been digitising using outside agencies. It also has a small in-house scanning capability for urgent work. It carries out some film-based photography but increasingly, all photography is digital.

The Picture Library has several roles. It is responsible for photography for the museum and also licenses images on a commercial basis. It wants to develop an on-line service to support this commercial activity. The Picture Library maintains a Photo Catalogue with metadata based on the Visual Resource Association Core Categories [VRA2002]. It is also responsible for the care of prints and transparencies other than those of historical interest.

Much of the photography is of the items in the museum collections but the photographers also take photographs of exhibitions and events at the museum. Photographs of objects will be used for a variety of purposes from a simple record of the object, images whose purpose is to provide as accurate as possible a rendition of the object, and creative images where the photographer uses composition and illumination to present the object to artistic effect.

The museum in our scenario has a New Media team who make use of images from the collection to create multi-media works for in-house use and the web. They use a variety of graphic applications, including Adobe PhotoShop, Macromedia Flash and Director. The New Media team wants to be able to access the image assets freely and to store the new images and multi-media works they create in the image database. Other museum staff make use of the images for creating publications and presentations.

One undesirable consequence of these activities is a tendency for museum staff members to keep copies of images that they have used and maintain their own informal catalogues of images. The Picture Library needs to be able to trace any and every use of images to ensure that intellectual property rights are respected. The proliferation of copies of the images makes this task more difficult.

The museum documents its collection with a Collection Management System that supports cataloguing to the Spectrum standard.[1] The museum Library has an Online Public Access Catalogue (OPAC), in which the museum archives are catalogued using Machine-Readable Cataloguing (MARC) data formats conforming to the ISAD(G) standard.[2] These three systems need to display images in the various user interfaces they support.

The museum operates a substantial website, providing public access to its collection catalogues. As well as the website, the museum wishes to make selections of images available to various other on-line agencies and portals.

10.2 How Images are Stored and Retrieved

10.2.1 Essence and metadata

Digital images exist as encodings of bit-streams that can be transmitted over networks and stored in file systems. The encoded data may be a combination of the data making up the image itself, sometimes referred to as the essence, and additional information, metadata, about the image.

An image database associates metadata with the image and provides services to search this metadata to identify images for retrieval. A generic system architecture has to take into account the different interests in and applications for different types of metadata and provide the appropriate interfaces to allow it to be accessed and maintained.

An image database has to import, store and export images and metadata to carry out its generic functions:

Import. An image database needs to be able to import metadata. This may be supplied by a digital camera or other input device or be the result of interactive data entry. The metadata schema of such sources will determine the metadata that is available to be stored in the image database.

Export. An image database needs to be able to export metadata along with images. Different users will have different metadata requirements. Clearly the image database cannot deliver data that it does not hold and so the role of metadata schema in specifying the information a user wants to receive also places a requirement on the metadata to be stored in the database.

Storage. An image database has to be able to import and export data in the supported metadata schema. However it does not have to store the data in any particular standard schema. As long as the image database can map between the schema used internally for storage and those used for import and export and can meet the requirements. For instance, one schema may call the photographer the 'photographer' another call the photographer the 'creator'. As long as these refer to the same concept, they only need to be represented by a single element in the internal storage schema. This schema defines the information storage capability of the database.

The Digital Imaging Group [3] classifies metadata as follows:

Basic. This is generic information independent of any use of the image, such as the image size, format, compression, colour model etc. This can be expected to be provided automatically by the digitising device and may well be encoded with the image.

Creation. This gives information about the creation of the image. Some technical details may be provided automatically by the digital camera or scanning device. Others such as the photographer or lighting details may have to be provided manually. This information is persistent and remains associated with the image throughout the workflow. This can include information about the equipment and software involved with the creation of the image.

History. The history information describes any manipulations the image has undergone in deriving it from one or more source images. To be useful, such information has to be maintained by the application carrying out the manipulations. Image processing applications generally use proprietary formats for recording history information in a quantitative fashion that allows them to implement an 'undo' function. Current open standards do not attempt to record a complete quantitative history.

The interface to support image processing should be able to export and import such qualitative and quantitative history information as is supplied by the image processing applications that make use of it.

Intellectual Property Rights and Exploitation. This information describes the intellectual property rights (IPR) associated with an image. These include both the moral rights associated with the creation of the image which belong to the creator of the work and the copyright which may be repeatedly transferred to different owners.

Content description. This information describes the subject depicted in the image. Where the image is of a creative work such as a painting, it may also describe the subject of the work itself. The details of what is recorded varies widely according to the use to which the images are to be put. It is here where the difference in emphasis between an image catalogue and a documentation system becomes apparent. An image database will typically support a minimal set of content description metadata and may also provide a means for managing more detailed application-dependent content description metadata or interoperating with a system that does.

So far, so good, but content metadata, the description of the subject of the image, has shown itself to be a slippery concept that depends on the cataloguer's point of reference. It is useful to distinguish between the information that is created when the image is taken, from any description of the subject that could exist before the image was taken. Ignoring the effects of the act of image capture on the subject, any description of the subject is unaltered by the taking of the picture. This tells us which information belongs to the description of the image

and which to the description of the subject: 'did it exist before the image was created?' If so, it is part of the description of the subject and not of the image itself.

Basic, creation and history metadata are sometimes referred to collectively as 'technical metadata'. Various metadata standards are described in a later section of this chapter.

10.2.2 Relating images to one another

An image database provides various means of associating images with one another. The association may be implicit in common metadata or by explicit links. Either approach allows associated images to be retrieved together.

Images sharing content metadata

Images that share the same content metadata have a relationship with one another in that, in some sense, they depict the same sort of subject. These relationships are often made use of in user interfaces that allow the user to browse the image collection in terms of the metadata or link to other images sharing common metadata.

Images grouped by use

Many works (publications; presentations; composite images), make use of multiple images. The image database needs to be able to track such use in order to manage the associated rights. Furthermore, a reader or viewer of the new work may wish to find the original images used. The image database needs to be able to link images by virtue of their having been used together.

Images with common geometry

A set of images may be made such that they are geometrically related to one another. This will usually be done by means of a camera mount with different positions or a robotic camera positioning device. Examples include:

- Set of images forming a panorama taken by rotating the camera;
- A stereoscopic pair of images;
- Set of images taken by moving the camera by a series of fixed steps to photograph a large object or scene as a series of images. This technique is used for photometric and aerial photographic surveys. The VITRA robotic camera,[4] is an example of a system designed to take such series of images.
- A single image may be cropped to make a series of separate images.

Appropriate metadata can link such sets of images and ease the task of managing them for further processing.

Images with the same origin and extent are a special case of images with common geometry. They may be created with a camera when a series of images are taken with the same camera position and lens but with different exposure parameters such as aperture, shutter speed or filtration. Alternatively they may be derived from a common image by the application of digital filters.

There is little support for establishing relationships based on common geometry in the current metadata standards. Image databases that wish to support such relationships, for instance, to support the VITRA camera, have to use additional metadata elements designed for the purpose.

Derived images

Images can be produced from other images, filtering, cropping or combining them to create new images. Metadata can describe how one image is derived from another. This is another area that is not well served by the current standards. The DIG35 Specification, Metadata for Digital Images [3] and NISO Z39.87,[5] allow a history of changes to be recorded but not in a way that is amenable to automatic processing either to repeat or undo the manipulations. Image processing applications such as Adobe Photoshop store a history of manipulations applied to an image in order to support the 'undo' functionality but they do it in a proprietary manner.

The ISO/IEC 12087 family of standards for Image Processing and Interchange,[6] offer a formalism that could be adopted by an image database that wanted to record change history information. This open standard could provide a mechanism that would allow change history to be processed automatically.

10.2.3 Image encoding: lossy and lossless compression

In order that they can be stored or transmitted by digital means, images have to be encoded as a sequence of bits. Many encoding formats have been developed as the technology has matured and it can be expected that there will continue to be developments, particularly in the areas of compression and formats for handling the very large images it is now possible to create with commonly available technology.

The simplest way of encoding image data is as a series of groups of bits each representing a single pixel of the image. This is likely to be how the image is held in a digitising or display device. Some image formats simply encode the image data itself, together with the basic metadata needed to decode the image. Others allow additional descriptive metadata to be stored in the same digital package.

Most encoding formats can apply some form of compression to reduce the size of the bit-stream encoding the image. There are many types of compression

but they fall into two camps: lossless and lossy. An image encoded with a loss-less compression method can be decompressed to produce the original bit-stream before compression. Lossy compression techniques, on the other hand, modify the image to enable it to be encoded more compactly. They are designed to minimise the visual impact of the loss of image quality and can achieve very significant reductions in image storage size. This has made them popular for the delivery of images over the Web where the JPEG [7] format has become the *de facto* standard. The trade-off between compression and loss of quality can be tuned for a specific application.

The most recent development in the JPEG family of standards is JPEG2000. As well as offering greater compression for the same image quality (or better quality for a given level of compression), JPEG2000 supports a lossless compression within the same encoding. This makes it a strong candidate for a wide range of uses. Until JPEG2000 support is a standard facility in all web browsers, however, the older JPEG standards will continue to be the preferred format for delivery to the web. This topic is covered in more depth in Chapter 12.

The TIFF image file format [8] is an industry standard, for storing and exchanging image data. It is supported by many image applications. It provides a standard digital package which can hold a wide range of image encodings including uncompressed and lossless and lossy compression encodings. The most recent revision supports a range of colour models including CMYK, YC_bC_r and CIE $L^*a^*b^*$ (see Chapter 11), JPEG compression and tiled images.

10.3 Searching

10.3.1 Searching metadata

All image databases offer a means for searching the image metadata in order to identify images of interest. We have already looked at the different types of metadata from the perspective of cataloguing and classification. It is also worth considering how these can be searched. Image databases can be characterised by the capabilities of the query languages they use for searching the metadata.

Much of the metadata is structured, either quantified as numbers or dates or as selections from sets of keywords and other controlled vocabularies. There may also be free-text descriptions. Searching the numerical and date information is no different from any other database application. Searching controlled vocabularies and textual descriptions borrows from the information retrieval database model.

A controlled vocabulary may be a simple list of keywords or may be terms organised in a hierarchy to form a thesaurus. A thesaurus expresses relationships between terms. A set of terms may be grouped together as synonyms.

Terms may be linked as expressing a broader or narrower concept than another term. For instance, barley can be seen as a narrower term than cereal. The advantage for searching is that the researcher does not have to use the same term as the cataloguer, the thesaurus will allow the query to match any of a set of synonyms. Cataloguers can apply the most specific terms they can but researchers can use broader terms, relying on the thesaurus to expand their query to include the narrower terms.

Free-text descriptions present different challenges. Query languages for searching text usually include the ability to match part words, specified using 'wild cards' as well as complete words. The text searching facilities may also include the ability to match words with a common root (e.g. garden, gardens, gardener); words which sound alike; and mis-spelt words to afford greater recall.

As well as searching for a single word in the text, query languages for text may offer matches for multiple words or phrases, possible within a certain proximity to one another.

Free-text searching may be a capability of the image database itself or may be supplied by an external search engine. The former approach is likely to support a more integrated user interface.

The query language for an image database needs to be able to combine queries into the numerical information with those for controlled vocabularies and textual descriptions in a seamless fashion.

10.3.2 Content-based searching

An image database may support the ability to search into the image data itself, rather than the metadata. The technologies used are referred to as CBIR (Content-Based Image Retrieval). They offer the ability to identify images which are similar to a reference image. At the user interface, the user can select an image and ask for 'more like this'.

It is fair to say that current CBIR implementations do not offer the magic solution some of their protagonists had hoped for. There have been real successes in image recognition for specialist applications such as counting cells on an image of a microscope slide or looking for anomalies in sets of similar structures. However, it is proving difficult to extend these to general purpose image retrieval. In spite of the limitations of the technology at present, CBIR can be a useful addition to the capabilities of an image database. It is attractive because of the potential to search without the costly process of cataloguing to create the metadata.

Making effective use of CBIR is an interesting challenge. It could be used to help cataloguing by identifying sets of similar images, allowing a human cataloguer to deal with them as a group. The cataloguers make the judgement as to how the images are catalogued but the CBIR facilities assist them in finding applicable images.

Typical CBIR systems measure similarity between images in terms of parameters such as texture, form and colour. At the user interface, it is common for the CBIR facility to allow the user to weight the importance of the different parameters used for analysing the images to tune the retrieval. For instance, they could say that similarity of form is more important than texture. A more sophisticated approach allows the user to select images that are, or are not, of interest from an initial set.

The CBIR system can make use of all the information available from analysing the images to produce a new set of images. Further feedback from the user in the same fashion will improve the quality of the search.

10.3.3 Protocols for search and retrieval

An image database is likely to provide an interactive user interface for searching the database. In addition it needs to be able to support protocols for searching across a network so that the image facilities can be integrated in other applications or systems such as portals. Systems for accessing metadata can be divided into those that query dynamically and those that harvest.

Dynamic systems query the image database in real time. They don't hold metadata except to service the immediate query. The image database responds with a selection of metadata from the images matching the query. This metadata will include Universal Resource Identifiers (URIs) for the images. The URIs can be used subsequently to retrieve the images themselves. There are many protocols an image database can use to support dynamic access including Z39.50,[9] SOAP,[10] CORBA [11] as well as proprietary protocols from Microsoft.[12] These may be applied in an application-specific manner, or according to standard profiles such as the CIMI Profile,[13] which provides a standard for searching cultural heritage information.

A harvesting system, on the other hand, keeps a copy of all the metadata it needs to satisfy the user's queries. It uses its local database to respond to the user rather than send the query across the network. A harvesting system will poll the image database at designated intervals to maintain its local copy of the metadata. Again, this metadata will include the image URIs for retrieving the images. Harvesting systems can be built with any of the protocols used for dynamic access but one protocol, the Open Archives Initiative Protocol for Metadata Harvesting (OAIPMH),[14] has been designed for the purpose and is becoming increasingly widely used.

10.4 Delivery of Images

10.4.1 An image server

Once the images have been identified, they need to be delivered to the interested party. This may be another computer system such as a web portal or a human

user operating some application. Image databases need to be able to deliver images and associated metadata in a manner that is appropriate for the target system. Different techniques and encoding formats are used for different purposes. Images can be very large, so network bandwidth is frequently an issue.

An image database can offer a series of services for image delivery, manifest as an image server component. Given the identifier of an image, the image server will deliver a copy of the image in the format requested by the requesting system.

Different image databases will offer different image delivery services. These generally include features such as the ability to request:

- A specific image size or resolution;
- Whether any compression is required and, if so, how much;
- The format the image should be encoded in;
- Any metadata to be supplied with the image (if the chosen image encoding supports embedded metadata);
- Any watermarking to be applied to the image (see Section 10.4.3).

10.4.2 Delivering to applications

Delivering images to interactive applications places additional requirements on the image database delivery mechanism in order to support a fluent user experience. Some applications simply want to display the image, others want to acquire a copy of the image for purposes such as image manipulation or publishing.

Applications that can display an image from a Web server over HTTP can access the image server directly to display the image. Proprietary protocols can also be used. Where the application needs a copy of the image, it may allow the user to select the resolution and format. The image database in its turn may request some statement of the intended use of the image to be recorded for rights management. A variety of techniques are available to support such dialogues.

Where the image database provides an interactive user interface, it will typically use the services of the workstation window manager to provide a 'drag-and-drop' facility to allow the user to load images into their application.

Some applications support *plugins*, standard ways of adding to their capability. An image database could provide plugins for applications that would provide all the search and retrieval functionality of the image database embedded in the application itself. Plugins are proprietary, although the dominant suppliers may establish *de facto* standards. It is attractive to look for open standards to provide such functionality. If the application can embed a browser, it can make use of the WSRP (Web Services for Remote Portlets) [15] protocol for embedding *portlets* in a web page. This allows the image database to provide not just the image but some interactive functionality as well. For instance,

the image could be supplied to the application as a Web page together with controls giving the user the ability to request a download of the image in different formats.

10.4.3 Image watermarking

Images delivered by the image database may be watermarked in two ways:

A *visible watermark* such as a logo or a textual message, can be applied to an image. It defaces the image sufficiently to prevent exploitation but leaves it recognisable enough to evaluate or use in make-up proofs. As an example, Figure 10.1 shows an image as displayed on the Corbis Web-site with the watermark embossed prominently across the centre. Only when the appropriate fee has been paid does the agency provide a high-resolution version of the image without the watermark.

Invisible watermarks, on the other hand, are embedded in the image by subtly changing the pixel values in such a fashion to encode a short message into the image. The technology, referred to as digital steganography, makes use of the

Figure 10.1

Image of Alfred Hitchcock holding a magnifying glass, from the Bettman/Corbis digital image library. The corporate watermark is clearly visible across the centre of the image. The photograph was taken on the set of his television show 'Alfred Hitchcock Presents' in Hollywood on 7 May, 1956.

characteristics of human perception to hide the modifications throughout the image. The hidden message can be recovered from as little as 10 per cent of the original image and is usually resistant to various forms of image manipulation, such as resizing and rotation. An image database can embed a transaction number that identifies the person or organisation to whom the image was delivered. Subsequent uses of the image can then be traced back to this original delivery.

10.4.4 Protocols

Any protocol suitable for the transfer of files can be used for the delivery of images. The File Transfer Protocol (FTP) [16] has traditionally been used but the ubiquitous protocol of the web, the Hypertext Transfer Protocol (HTTP),[17] has become dominant.

Network bandwidth, determining how rapidly an image can be viewed, has always been an issue for interactive applications. Although the advent of broadband has made network access faster for many users, this has had the effect of increasing the demand for larger, higher resolution images. Techniques have been developed to improve the user's experience when displaying large images.

Progressive encoding allows the image to be displayed rapidly at low resolution and to be overwritten with versions of the image at higher resolution as the rest of the image data arrives. Two or three levels may be used, giving an effect of bringing the image into focus.

Tiling breaks the image up into a grid of tiles which can be delivered separately and assembled together by the application to display the image. Only the tiles needed to fill the screen are delivered at anyone time. As this is dependent on the size of the screen, or viewing area, rather than the image size, a reasonable delivery time can be maintained regardless of the size of the image. As the viewer pans around the image, additional tiles are loaded as necessary.

Pyramidal encoding techniques apply the ideas of progressive encoding to larger images holding the image as multiple layers of tiles at different resolutions. The application selects the resolution and the image area it wants to display and the appropriate tiles are delivered.

Progressive encoding delivery can be combined with pyramidal encoding techniques to good effect. In its simplest form, a viewer embedded in a web page allows the user to pan and zoom round large images encoded as a series of tiles. Delivering the tiles using progressive encoding produces the attractive visual effect of increasing by sharp focus.

10.5 Metadata Standards

This section describes a selection of metadata standards currently used for cataloguing images arising from different traditions and requirements.

10.5.1 DIG35 Specification, Metadata for Digital Images

DIG35 Specification, Metadata for Digital Images,[3] is a comprehensive metadata standard developed by an industry group. It covers all the categories of metadata described in the previous section. The content description metadata is quite simple although it has a framework which can be extended.

DIG35 meet most requirements for a general purpose image library but the specialist requirements, particularly for content description, require additional support.

10.5.2 NISO Z39.87-2002 Data Dictionary-Technical Metadata for Digital Still Images

NISO Z39.87-2002 Data Dictionary – Technical Metadata for Digital Still Images,[5] focuses on technical metadata only, having no support for content description or IPR. It acknowledges the contribution of DIG35 to the specification of technical metadata.

The approach encourages a clear division between those properties which are intrinsic to the image – the technical metadata – and the content description metadata.

10.5.3 IPTC-NAA Information Interchange Model (IIM)

The IPTC-NAA Information Interchange Model,[18] is a metadata standard developed for and by the newspaper and press industry. It has many features designed to support the transmission and use of images within the industry. It was developed in 1990 and, as the first such standard developed, has influenced subsequent work in the field. Its development was frozen in 1997 in favour of XML-based developments. However, since Adobe added to its product Photoshop a proprietary mechanism to insert IPTC metadata, often referred to as the 'IPTC headers', and other metadata into JPEG and TIFF files it has become common for Picture Libraries to deliver images encoded with IPTC metadata.

10.5.4 Dublin Core Metadata Element Set (DCMES)

Dublin Core Metadata Element Set,[19] is a general purpose schema for the exchange of information about 'document-like objects'. In its simple form, it defines fifteen elements (Title, Creator, Subject, Description, Publisher, Contributor, Date, Type, Format, Identifier, Source, Language, Relation, Coverage and Rights) to support simple cross-domain resource discovery. These elements can be further refined by the use of qualifiers. It is not designed for the comprehensive description of photographic metadata although it could be extended in this direction by the use of qualifiers.

The recent UK government-funded digitising programme in the UK, NOF Digitise,[20] mandated the use of simple DCMES descriptions as the minimum level of description for resources digitised under the programme.

The Open Archives Initiative Protocol for Metadata Harvesting Protocol,[14] uses a simple DCMES record as the default information that must always be supplied.

The DC.Culture initiative was developed under the MINERVA project,[21] to define metadata based on the DCMES profiled to be suitable for the description of museum objects when displayed as a union catalogue. The rationale and the resulting schema are described in 24 Hour Museum Metasearch Project: schemas: Version 1.[22] This proposes a mapping to high-level elements encapsulating the concepts of 'who', 'what', 'where' and 'when' as search entry points and also providing some more descriptive data elements primarily for display purposes.

DC.Culture allows the content owner to be more precise as to how their data is searched and presented in the context of a public access union catalogue website. It allows the different content owners, rather than the central service, to be responsible for the presentation of their information to the public within the overall data model supported by the website.

10.5.5 VRA Core Categories Version 3.0

In the VRA Core Categories Version 3.0, [VRA2002], the Visual Resources Association (VRA) describes the use of the DCMES with qualifiers to describe visual works. They are designed to provide a baseline to build on for describing 'works of visual culture as well as the images that document them'. It is quite generic and does not attempt to define any facilities for describing particular types of works. The use of qualifiers to allow more precise documentation is recommended.

The approach adopted by the VRA introduces the distinction between the original work and an image of the work. Separate linked records are created for the description of the work and any images of it. This approach offers a good model for integrating application-specific metadata.

10.5.6 SEPIA Data Element Set

The SEPIA Working Group, funded under the Culture 2000 Programme of the European Union, reviewed the currently used models for describing images and the best practices for managing photographic collections. They refined these to produce the SEPIA Data Element Set (SEPIADES) and proposed combining these elements with the ISAD(G) multi-level model used by archivists.[2]

Their report,[23] published in 2003, describes the outcomes. The approach is academic and provides a model that goes beyond the description of images to address the entire scope of operating an archival Picture Library. The intention is that any particular implementation would select the elements that are appropriate for their purposes. The report also addresses the issues involved with mapping information about photographic images to the DCMES.

10.6 An Image Database in Practice

We now revisit our hypothetical Museum, introduced in Section 10.1.4, to see how image database technology can be implemented in practice to manage the museum's image assets. The Museum has reorganised its image-related activities round a central image database that manages all the Museum's image assets, as shown in Figure 10.2. It provides an intranet website that presents a

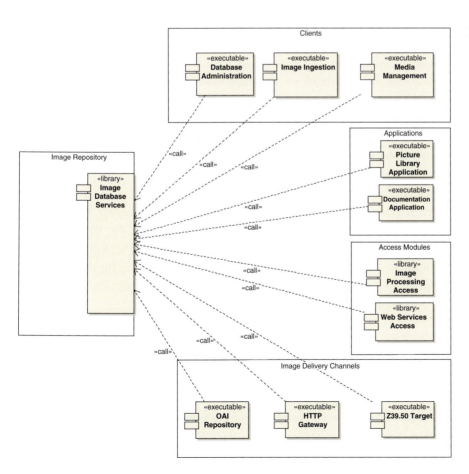

Figure 10.2

Database system architecture for the Museum is designed around a central image repository.

common interface to the museum's collections. The website is populated with images from the image database and provides the most popular way to access the images. The images are also accessible from the specialised applications used by different groups of museum staff. Presentations, publications and other works incorporating museum images are stored as digital assets in association with the images they use.

10.6.1 Image ingestion and archiving

The image essence and metadata are held in a central Repository accessed via the image database services. This is managed by the Museum Information Systems department in a similar fashion to the network, mass storage and other database facilities.

An Image Ingestion service provides the means by which all image assets are loaded into the image database repository. This supports the Picture Library scanning activity as well as allowing individual members of staff to load images.

A wide range of image encodings is supported, any embedded metadata is extracted and loaded into the appropriate image record on ingestion. Images from digital cameras or removable media can be loaded as batches. As well as individual image files, the system can load assets containing images such as publications and presentations. The images are extracted and associated with the metadata describing the parent asset.

The image database can deliver images to a specific resolution and encoding on demand. However, the image database supports a range of known applications which require specific image formats. The system can be configured to prepare these formats on ingestion.

Once the image asset has been successfully ingested, it is archived. The Museum has traditionally used removable media, principally CD-ROM, for archiving. A Media Management module keeps track of the locations of the removable media. The Museum is planning to move to a mass storage system which will provide its own archiving capability. This will keep the archive images on-line or near-line, allowing the image database to access them without operator intervention if they are needed.

10.6.2 Museum, library and archive documentation

The Museum's Collection, Library and Archive documentation systems have been modified to display images in the various interfaces they support. Images are supplied by the image database by a variety of techniques.

The Collection Management System (CMS) links object descriptions to representative images of the object from the image database. It also has a facility to associate images with many of the Spectrum [1] fields. For instance, the

Inscription field can have an associated image of the inscription. Both types of link use the image database URI to identify the image. The CMS application uses embedded portlets to display the images. This allows the image database to provide functionality such as the ability to download an image in a specific format embedded in the CMS application.

The Museum Library operates a MARC-based online public access catalogue (OPAC). The image database contains images of some of the books as well as images of pages and plates from the books. The URIs for these images are stored using the appropriate MARC data elements. The OPAC has been configured to retrieve and display images over HTTP. These are supplied by the image database Image Server component.

Currently, the Museum Archive is housed in a separate building from the rest of the Museum and has a lower bandwidth network connection to the main facilities. A proxy image database has been installed in the Archive building to support local access to the archive database. This harvests copies of images of interest to the archive in the preferred format for the archive documentation application. A daily check is made automatically for new images using the OAI-PMH protocol and serviced by the image database OAI Repository module.

10.6.3 Image use

The Picture Library continues to operate its Photo Catalogue based on the VRA Core Categories. This has been linked to the image database which provides the images and technical metadata for the Photo Catalogue application. The Photo Catalogue has also been revised to inter-operate with the museums collection, library and archive documentation systems to provide additional information about works that are the subject of the image. The Picture Library continues to use the Photo Catalogue to manage the original transparencies and prints where these exist. It also adds content metadata describing the images as images to make them more accessible to general picture researchers.

General access to the image assets is afforded by the Museum intranet. This allows images to be searched for using any of the associated metadata. A 'quick search' facility searches all the textual metadata, an 'advanced search' allows more precise searching. Access to the images may be restricted on the basis of the available rights or the quality of the image.

Users can save images in personal light-boxes or light-boxes shared between staff working on a project. If they wish to download images, they have to fill in an online form describing the purpose, the images are then made available for download in the requested format. The Museum has decided not to apply watermarks to images downloaded via the intranet.

Images can also be supplied for use directly to any application that can embed a portlet as described above. The key requirement is that a dialogue can be entered in to determine the user and the use for rights management purposes. Some applications allow plugins to extend the functionality of the user interface. The Museum has deployed plugins for their most popular applications to allow them to access the image database directly. Completed works, incorporating images, can be submitted for ingestion as described above. A link is maintained between the parent work and the images used.

10.6.4 Selling images

The public website supports the sale of images, either as prints or as images for licenced use. Print orders are fulfilled by a third-party printing service. Once the website visitor has selected the images they want to buy as prints, they are passed on to the site operated by the printing service. This confirms the order details such as delivery and delivery address and completes an electronic credit transaction for payment. The Museum does not want the printing service to hold the image data, so the service has to request the image data from the Museum's Image Database to print the images. This is done using an automated secure FTP request. For security, each image is invisibly watermarked identifying it as delivered to the printing service. The printing service then completes the order by printing and despatching the prints. Once a month, the printing service credits the Museum with the revenue from the sales less its service charge.

Images for licenced use are handled by the Picture Library. The website visitor is asked to fill in a form describing the use he or she wishes to make of the image. If the request requires the intervention of one of the Picture Library staff the form is emailed to the library, who then contact the buyer and complete the negotiation. The library used to email images to customers but has found that, increasingly, organisations restrict the size of email messages and their attachments and is preventing delivery by this mechanism. Accordingly, to deliver the images, the image database e-fulfilment module creates a temporary secure website containing the images. These copies of the images carry an invisible watermark that identifies the transaction that they were created for. They also have the requested metadata embedded in the image file using the IPTC-NAA Information Interchange Model.[18]

This delivery website includes the licence for use and provides a convenient package of the licenced images for downloading. The URL for the images is emailed to the buyer who can then access and download the images at their leisure. The buyer's visit to the temporary website and any subsequent download is tracked for security reasons.

Simple requests are handled automatically. The website uses an electronic credit service to take the payment and delivers the image to the purchaser using the secure delivery website as above.

10.6.5 Image delivery channels

The Museum's public website provides similar facilities to those offered on the museum intranet, however a more restricted range of images and metadata is made available. Where larger size images are presented, they are watermarked with a visible watermark. If a web site visitor wishes to download a large unwatermarked image they have to licence it as described below.

By managing the images in a systematic way, the image database has enabled low-cost ways of producing content for gallery kiosks for public access. The New Media staff have developed a range of standard web templates which access the image server and the documentation systems to deliver the information to the public. By this means, the Museum is able to invest its effort in the organisation and presentation of the content, not the mechanics of assembling the digital assets.

In addition to the public website, the Museum makes its images and metadata available on the web via various web portals and commercial picture libraries, including SCRAN <http://www.scran.ac.uk>; Pixus <http://pixus.scran.ac.uk>; 24HourMuseum <http://www.24hourmuseum.org.uk> and AMICO <http://www.amico.org>. Different systems talk different protocols, so the Museum provides servers for a range of standard Internet protocols implemented using the image database delivery channels. These support the relevant protocols and offer read-only access. They include:

OAI Image repository implements the Open Archives Initiative Protocol for Metadata Harvesting,[14] to provide an OAI Repository for harvesting the image metadata by portals and other similar web-based facilities.

HTTP Gateway and Image server provides access to the Image Database Search and Retrieval Services over HTTP using server-side scripting.

Z39.50 target implements the Z39.50 protocol,[9] to provide a Z39.50 Target for dynamic search and retrieval access to the image metadata by Z39.50 clients.

Web Services The Image Database Web Services bind the Image Database API to the Simple Object Access Protocol (SOAP),[10] to provide a Web Services presentation of the Image Database services.

10.6.6 Changing the way the Museum works

As the system has been rolled out, it has produced improvements in the Museum staff's working practices. The staff no longer feel the need to keep copies of images around, they can retrieve them more quickly from the image database and they have access to the complete set of images rather than the selection they may have come across and saved previously.

The image database 'digital light-boxes' allow staff to share a selection of images, allowing greater cooperation without proliferating duplicates of the images. Storing publications and presentations incorporating images in the database

provides secure storage for these, often large, assets and the publications themselves provide another way of accessing the images.

The system has proved so popular that a new application for exhibition planning has been implemented around the image database. This has necessitated holding images owned by other museums in the database, with an added emphasis on tracking the use of images to ensure that IPR is respected.

10.7 Image Database Architecture

10.7.1 Overview

The basic functionality of an image database is straightforward. It needs to be able to store images securely and allow users to search for and retrieve them. The complexity arises from:

- The different formats in which images can exist, and the different capabilities of those formats in representing both the image and metadata;
- The wide range of metadata that may be associated with an image;
- Integration with application-specific functionality.

This section describes a model architecture for an Image Database (IDb). It presents a simple application programmer's interface (API) which allows applications to apply the metadata schema of their choice rather than be restricted to a specific built-in metadata schema. Multiple different schema can be applied simultaneously to the same data set. Using this architecture, the IDb can be configured to have certain capabilities by defining a set of resources. The API is kept simple by allowing applications to refer to these resources by name rather than needing the knowledge to specify them in detail. Thus the specialist knowledge about metadata schema, image manipulations and encodings is held centrally in the IDb rather than being repeated in different applications.

The IDb provides a set of services for applications, as shown in Figure 10.3. These IDb Services are built on the IDb API which provides access to the Image Database functionality. In addition to the repository, the IDb is composed of a number of internal components, the image encoder, transformer and mapper, which interact with one another to implement the API. These are described in the following sections.

10.7.2 Image database components

Image encoder
The Image Encoder transforms images and their metadata between their representations in their external formats and their internal representations. It is

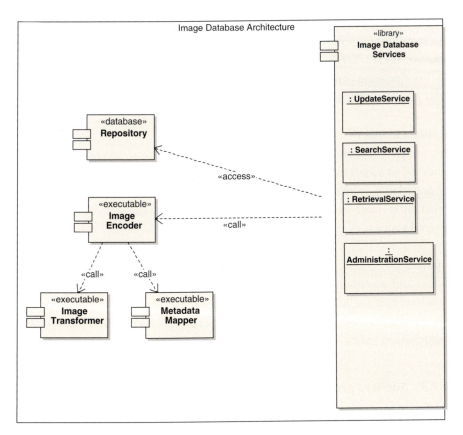

Figure 10.3

Structure and services of an image database.

used by all the IDb Services to encode and decode image and metadata to allow them to present the user's required view of the underlying data. It can handle cases where the image and metadata are encoded separately as well as when there is a single encoded image containing both image and metadata.

Because all image formats incorporate metadata to some degree, the Image Encoder must deal with both image and metadata in carrying out its functions:

- When importing an image it deconstructs the image format to extract the image data and metadata;
- When exporting an image it constructs the appropriate image format from the available image and metadata.

The Image Encoder makes use of the lower level *Image Transformer* and *Metadata Mapper* components to process the image data and metadata respectively.

Image transformer

This component generates versions of image data to meet retrieval and storage requests. It can carry out a range of image processing operations such as scaling, compression/decompression and watermarking on the stored image in order to create the requested image data.

Metadata mapper

This maps between different metadata schemas when image metadata is imported or exported. When metadata is imported, it is mapped to the internal metadata schema. When metadata is exported, a selection of the available metadata is made and mapped to the metadata schema appropriate for the retrieval request.

Repository

Images and metadata are stored in the IDb *Repository*. This provides long-term persistent storage of images and associated metadata. It implements the data model for image metadata and enforces the user authentication and authorisation policy.

10.7.3 Services presented by the image database

To be useful, the image database must provide a number of services to users. These are implemented as procedure calls, with pointers to the appropriate images or data structures. The primary services are shown in Figure 10.4 and are described below.

Update

The Update Service provides mechanisms for importing images and metadata into the image database and updating the details of images already in the database. It can:

- Load new images and metadata;
- Amend the metadata of images already in the database;
- Delete images from the database.

Images can be supplied in any supported format. Metadata can be embedded in the encoded image data where the image format supports it. Metadata can also be supplied as separate documents. The metadata is read from the encoded image and associated metadata documents and stored in the IDb Repository together with the image essence.

The *create* function returns an `Image Id` which can be used to refer to the image subsequently.

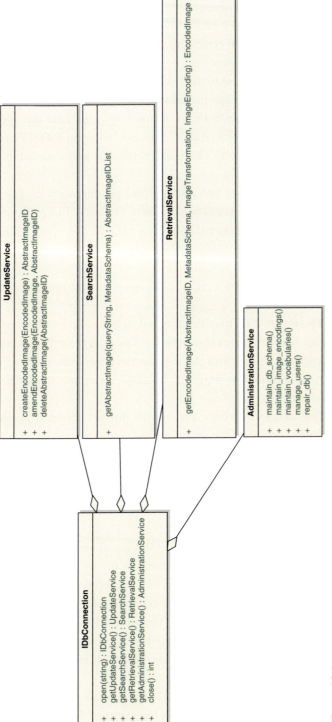

Figure 10.4
ImageRepository UML class diagram, showing image database connection and services.

The *amend* and *delete* functions have to be supplied with the `Image Id` of the image they are to operate on.

Search

The Search Service returns the `Image Ids` of one or more images matching a search request. These can be used in conjunction with the other services to obtain more information about the images, retrieve the images and metadata and modify the image metadata.

The IDb Search Services support queries into the metadata. The query language is a boolean query language based on ISO8777 *Commands for interactive text searching.* [24] This is extended so that the metadata schema is specified as part of the query.

The IDb architecture allows developments such as queries into the image data content itself, known as Content Based Image Retrieval (CBIR), to be incorporated at a later stage.

Retrieval

The Retrieval Service supplies image data and metadata relating to a specific `Image Id`.

The image data may be supplied in any supported format and the metadata to any supported metadata schema. The image may be encoded in any supported encoding together with the metadata as appropriate. Where the image encoding cannot include the required metadata, it can be supplied separately as an XML document.

The Retrieval Service can supply just an encoded image, just metadata or both by specifying the appropriate formats.

Database administration

The Database Administration Service provides facilities for managing the IDb resources, as well as more conventional database administration tasks. These include:

User account management. The IDb provides facilities for user authentication and authorisation to control access to the services offered by the database.

Database schema maintenance. This is used to maintain the data model underpinning the services offered by the database.

Image encoding maintenance. This is used to maintain the image encodings, image transformations and metadata mappings available to the image database.

Controlled vocabularies. Thesauri and term lists used to validate metadata and to support the search facilities.

Disaster recovery. Facilities such as database integrity checking, rollback and repair, to help with recovery in the event of database corruption.

10.8 The Image Database API

10.8.1 Overview

The IDb Application Programming Interface (API) models a set of images with metadata. It is expressed in terms of information retrieval, separating search and retrieve requests. Although there is necessarily an underlying schema for the IDb, application writers and other users need not know this in detail. Users interact with the IDb Services through their preferred metadata schemas and image encodings. The IDb implements this with its set of supported image encodings, transformations and metadata mappings.

The IDb API aims to simplify applications which use it by providing a small number of clearly defined object classes and methods. The API has two object types or classes to represent an image. The AbstractImage class represents the image and its metadata in abstract as managed by the database, independent of any particular encoding of that image. The EncodedImage class represents a particular encoding of an image together with a particular selection of metadata. The database models AbstractImages which can be passed in and out as EncodedImages. This approach enables the behaviour of the database to be described without having to deal with the detail of the image encodings and the choice of metadata.

Other objects, including those representing resources, are:

- Controlled vocabularies;
- User accounts;
- Metadata schema;
- Image transformation and encoding specifications.

These are managed through the Database Administration Service, implemented as an interactive application. A method is provided for enquiring which resources are available in a particular IDb configuration.

Methods are proposed below to provide a framework for managing application-specific data. The diagrams in Figure 10.4 employ the Unified Modelling Language (UML) [25] to show the relationships between entities.

The ImageRepository class embodies a connection to the Image Database API. The API provides methods for opening and closing a connection to the IDb:

```
Open(DataBase) → Status
Close() → Status
```

Opening this connection should be the first procedure in using the API and closing it the last.

When the API is invoked over a stateless protocol such as HTTP, the connection may be dropped from the server side if no activity is seen over a specifiable timeout interval.

10.8.2 EncodedImage

An EncodedImage represents an image and its associated metadata made by encoding an AbstractImage. The metadata is specified by the MetadataSchema. The image data is transformed according to the ImageTransformation.

The EncodedImage class has the following attributes (Figure 10.5):

AbstractImage. The identifier for the image in the database, see below.

ImageEncoding. The ImageEncoding class represents the image encodings the image database can import or export.

The possible values of ImageEncoding types are controlled by a terminology authority. Example values could include 'TIFF6 Baseline', 'JFIF', 'Raw'.

ImageTransformation. The ImageTransformation class represents a complete sequence of image processing operations. These are separately defined as TransformationElements. The TransformationElements class represents the image processing operations that the image database can perform when importing and exporting images.

The possible values of TransformationElements are controlled by a terminology authority. Example values could include 'size to rectangle', 'crop to rectangle', 'watermark'.

MetadataSchema. The MetadataSchema class represents the different metadata schema that the image database can import or export.

Figure 10.5

EncodedImage UML class diagram, showing the hierarchical relationship of image transformation and elements

The API provides methods for importing and exporting images and their metadata:

```
CreateEncodedImage (EncodedImage) -> AbstractImage,
    Status
AmendEncodedImage (EncodedImage, ImageId) -> Status
```

`CreateEncodedImage` imports an image into the database as an AbstractImage. It abstracts the functionality of analysing and deconstructing the different supported formats of encoded images. AmendEncodedImage amends the information associated with an image already in the IDb.

```
GetEncodedImage (ImageId, MetadataSchema,
    ImageTransformation, ImageEncoding) -> Status
```

`GetEncodedImage` exports a image in a given format from the IDb, it retrieves an abstract image, selects the appropriate metadata, applies the image transformations and encodes the image and metadata in the chosen format.
`Status` reports the success or otherwise of the method invocation.

10.8.3 AbstractImage

The AbstractImage class represents the image and associated metadata independently from any specific image encoding or specific metadata schema (Figure 10.6).
The AbstractImage Class has the following attributes:

ImageData
BasicMetadata
CreationMetadata
ContentMetadata
HistoryMetadata
RightsMetadata

The API provides methods for searching for images and for deleting them from the database:

```
GetAbstractImage (Query, MetadataSchema)
    -> list of ImageId, Status
DeleteAbstractImage (ImageId) -> Status
```

`GetAbstractImage` searches for images specified by a query. The query is expressed in terms of the particular metadata schema. It can return one or more abstract image identifiers. These image identifiers can then be used as parameters to `GetEncodedImage` to obtain image and metadata in the

Figure 10.6

AbstractImage UML class diagram, showing the separation of image data from various classes of metadata.

required format. Note, `GetAbstractImage` and `GetEncodedImage` can use different metadata schema. This means, for instance, that a query can be made in terms of a simple content-oriented metadata schema while the image itself can be retrieved with full technical metadata.

`DeleteAbstractImage` deletes an image from the IDb.

10.8.4 *ImageGroup, ImageEnsemble, ImagePackage*

`ImageGroup`, `ImageEnsemble` and `ImagePackage` are different groupings of `AbstractImages` with different attributes in common.

The images in an `ImageEnsemble` have a common `ReferenceFrame`. Those in an `ImagePackage` also share a common origin and geometric extent.

An `ImageGroup` is a less rigorously defined set of images with some user-defined attributes in common.

`ImageEnsemble` and `ImagePackage` groupings emerge directly from the spatial metadata associated with the images. They are created as the result of invoking `GetAbstractImage` with the appropriate spatial metadata values specified in the query.

Some users may wish to split geometrically related images into one or more named subgroups. This can be represented by introducing the ability to name image packages and ensembles, adding appropriate elements to the metadata schema to label images as belonging to a particular `ImageEnsemble` or `ImagePackage`. The API provides methods such as:

```
AddAbstractImageToPackage (ImageId, Package) -> Status
RemoveAbstractImageFromPackage (ImageId, Package)
   -> Status
```

10.8.5 Resources

An application may be built with knowledge of the IDb resources available to it. Alternatively the API provides methods whereby the application can query this information from the IDb.

```
GetMetadataSchemas() -> list of MetadataSchema
GetImageTransformations() -> list of
   ImageTransformation
GetImageEncodings() -> list of ImageEncoding
```

Methods could be provided for maintaining these resources via the API. However, in a multi-user system, an application should not have to deal with the problems of resources changing while it is running. When the application and the IDb are communicating over a stateless protocol such as HTTP it can be difficult to know which resources are in use. The ability for an application to provide a private metadata schema mapping may prove an exception and offer useful functionality. It moves away from the API design principle that applications should not need to know about how metadata schema are mapped, however it does this in a well defined and limited area. A method such as

```
PutMetadataSchema(MetadataSchema, MetadataMapping)
   -> Status
```

could be provided for this purpose.

10.8.6 Application data

An IDb supporting this API can interoperate with another system managing application-specific data. It can supply images and metadata into such a system using the API features discussed above.

The following methods provide a framework which allows the IDb itself to be extended to manage application-specific data internally. They follow the same IR database model as is used to handle the image data and metadata.

```
PutApplicationData (ApplicationSchema,
   ApplicationData) -> Status
GetApplicationRecords (ApplicationSchema, Query)
   -> list of ApplicationRecordId, Status
GetApplicationData (ApplicationSchema,
   ApplicationRecordId) -> ApplicationData, Status
```

10.9 References

1. Spectrum: The UK Museum Documentation Standard; MDA, 2005, ISBN 1-900642-14X, Version 3, http://www.mda.org.uk/spectrum.htm
2. ISAD(G): General International Standard Archival Description, 2nd Edition, 1999; International Council on Archives; http://www.ica.org/
3. DIG35 Specification, Metadata for Digital Images, DIG35 Working Group, Draft 2.0 Beta June 2000
4. http://www.vitra.org/content.php?lang=en&page=technology
5. NISO Z39.87-2002 Data Dictionary - Technical Metadata for Digital Still Images; http://www.niso.org/standards/dsftu.html
6. Image Processing and Interchange (IPI) Functional specification ISO/IEC 12087, Parts 1-5. 1994-1998.
7. Digital Compression and Coding of Continuous-tone Still Images; ISO 10918; International Organization for Standardization, 1994
8. TIFF, Revision 6.0, Adobe Developers Association, June 1991, http://partners.adobe.com/asn/developer/pdfs/tn/TIFF6.pdf
9. Information Retrieval(Z39.50-1995): Application Service Definition and Protocol Specification; http://lcweb.loc.gov/z3950/agency/document.html
10. SOAP Version 1.2; http://www.w3.org/TR/soap12-part1/
11. CORBA Specifications, Object Management Group; http://www.omg.org/technology/documents/corba_spec_catalog.htm
12. Data Access; http://msdn.microsoft.com/library/default.asp?url/library/enus/dnanchor/html/anch_dataaccess.asp
13. The CIMI Profile, Release 1.0H, A Z39.50 Profile for Cultural Heritage Information; http://www.cimi.org/public_docs/HarmonizedProfile/HarmonProfile1.htm
14. The Open Archives Initiative Protocol for Metadata Harvesting Protocol Version 2.0; http://www.openarchives.org/OAI/openarchivesprotocol.html

15. Web Services for Remote Portlets Specification, wsrpspecification-1.0, http://www.oasis-open.org/committees/wsrp

16. RFC 959 File Transfer Protocol (FTP); http://www.rfceditor.org/rfc/rfc959.txt

17. HTTP - Hypertext Transfer Protocol; W3C; http://www.w3.org/Protocols

18. IPTC-NAA Information Interchange Model, Version 4, International Press Telecommunications Council, http://www.iptc.org/IIM/

19. Dublin Core Metadata Element Set, Version 1.1: Reference Description (2003-06-02), Dublin Core Metadata Initiative; http://dublincore.org/documents/2003/06/02/dces/

20. NOF-digitise Technical Standards and Guidelines, v4, March 2002; http://www.peoplesnetwork.gov.uk/content/technicalstandardsv4.pdf

21. http://www.minervaeurope.org/

22. 24 Hour Museum Metasearch Project: schemas: Version 1.0; System Simulation Ltd. http://www.minervaeurope.org/DC.Culture.htm

23. SEPIADES. Recommendations for cataloguing photographic collections; Aasbo, K., Ortega Garcia, I., Isomursu, A., Johansson, T., Klijn, E., Klijn, E.(ed); 2003; http://www.knaw.nl/ecpa/sepia/workinggroups/wp5/sepiadestool/sepiades.pdf

24. Commands for interactive text searching; ISO 8777; International Organization for Standardization, 1993

25. http://www.uml.org/#UML2.0

Colour Management in Heritage Photography

Phil Green

11.1 Introduction

Colour management offers a means of controlling colour from a source medium when reproduced on some other medium. It consists of a set of tools and procedures for the unambiguous exchange of colour information between imaging devices, based on the preservation of colour appearance. The basis of the exchange is a mathematical model of the relationship between device data and visual colour stimulus, and this model is expressed as a colour profile for each device or medium. The goals of colour management may be summed up as interoperability, consistency, and pleasing colour reproduction. The architecture of colour management permits a choice for the user as to whether accuracy or pleasantness is to be emphasised in a given application.

Colour management techniques were originally developed for the reproduction of photographic originals (transparencies or prints) on displays and printers. They have been very successful in this context, but for heritage photography and other media, a number of considerations arise which this chapter attempts to address. First, we must define the viewing conditions of both the original and the desired reproductions, including colour and intensity of illumination, and the background against which the objects are viewed. Secondly, we must consider the methods of measurement and ensure that these correlate well with the perception of colour under the conditions of viewing. Finally we must ensure that the goals of the reproduction are clearly defined, and that the colour transformation workflow is designed to meet these goals.

In order to appreciate fully the application of colour management to heritage photography, and its limitations, it is necessary first to consider colour vision, colorimetry and device characterisation.

11.2 Colorimetry and Colour Vision

11.2.1 Colour vision

The human eye superficially resembles a digital camera, in that it has focusing optics, pigmented layers that filter visible light into three different spectral regions, photosensitive cells that detect the arrival of light quanta, some post-receptoral processing of the raw information, and a pathway for transmission of visual information to other parts of the system. This 'computational model' of vision is over-simplified and obscures the most important features of human vision. The visual image is not formed passively by the simultaneous response of a uniform array of photosensors, but is actively constructed through a succession of saccades (brief jumps of eye position). In other words, consciousness drives the formation of the visual image, rather than the other way around.

Colour sensations in the observer arise from radiant energy in the portion of the electromagnetic spectrum usually referred to as the visible spectrum, which comprises a single octave of wavelengths between approximately 380 and 760 nanometres (nm). Radiant energy below this range, in the ultraviolet region, can contribute indirectly to visual response through the phenomenon of fluorescence.

Retinal photoreceptor cells respond to light energy according to the photopigment with which each type of cell is equipped, and the response is extremely low at each end of the visible spectrum. Photoreceptors are of two fundamental kinds: *rods* which operate only at low levels of illumination, and have a peak sensitivity at approximately 510 nm; and *cones*, which operate at higher levels of illumination and have peak sensitivities at approximately 440, 540 and 580 nm, as shown in Figure 11.1. The existence of three types of cones, each with different spectral sensitivity, is the basis of trichromatic colour vision.

The three cone types can be classified as short, medium and long wavelength (often abbreviated to S, M and L) receptors. Short and medium receptors are known in most vertebrates, but the long wavelength receptors seem to be more recent in evolutionary terms and within mammals are found only in a small number of primates including humans.[1] A large proportion of colour-deficient observers have inherited an alternate L cone with a spectral sensitivity very close to the M cone, or no L cone at all. Cones are distributed unevenly in the retina, and are highly concentrated in the central region called the fovea. As a result, the greatest response occurs in a field that subtends an angle of approximately two degrees to the eye.

The overall retinal response under photopic conditions is given by the $V(\lambda)$ function, as shown in Figure 11.1. The form of the $V(\lambda)$ function, with a peak in the yellow-green region and low response in the blue and red, is a consequence of the absolute sensitivity of the L, M and S cones, and their frequency of distribution in the retina. S cones are particularly sparse in the foveal region

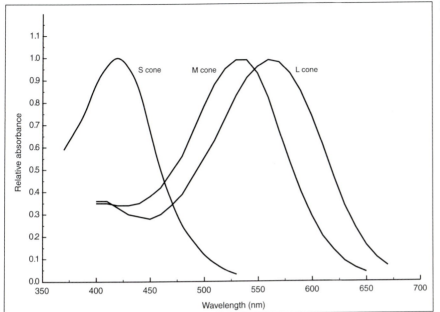

Figure 11.1
Relative sensitivity of the L, M, S photoreceptors and the photopic luminous efficiency function $V(\lambda)$.

relative to the M and L cones, and as a result the S cone makes little contribution to spatial discrimination.[2]

It can be seen that the contributions made by the three cone types to colour vision are very different. The S cones appear to have very low sensitivity, and there is a considerable degree of overlap between the responses of the three cone types, particularly the M and L cones. This degree of overlap makes it almost impossible to stimulate the cones independently, except in a small region at either end of the visible spectrum, so that for most wavelengths two cone types are stimulated simultaneously. The sensation of a particular hue therefore arises from the ratio in which the cone types are excited. In the case of a monochromatic red stimulus at a wavelength of 630 nm, for example, Figure 11.1 shows that both L and M cones would be stimulated, but by different amounts. The ratio of the responses generates the sensation of redness.

The cone responses are pooled by ganglion cells in the retina to produce signals along three opponent dimensions: red-green (corresponding to the relative L to M cone responses), blue-yellow (relative $L+M$ to S) and achromatic (the excitation level of $L+M$). These signals are output from the retina to the perception-processing regions of the visual cortex.

11.2.2 *Perceptual attributes of colour*

The perceptual attributes of colour can be divided into two groups: absolute and relative. Absolute perceptual attributes include brightness, hue and colourfulness. These are absolute because there is no need to relate them to the

attributes of other stimuli such as a reference white. They are defined [3] as follows:

Brightness: attribute of a visual sensation according to which an area appears to exhibit more or less light;

Hue: attribute of a visual sensation according to which an area appears to be similar to one, or to proportions of two, of the perceived colours red, yellow, green, and blue;

Colourfulness: attribute of a visual sensation according to which an area appears to exhibit more or less of its hue.

Relative attributes of colour include lightness, chroma and saturation, which are defined thus:

Lightness: the brightness of an area judged relative to the brightness of a similarly illuminated area that appears to be white or highly transmitting;

Chroma: the colourfulness of an area judged in proportion to the brightness of a similarly illuminated area that appears to be white or highly transmitting;

Saturation: the colourfulness of an area judged in proportion to its brightness.

Predictors for these perceptual attributes are incorporated in models of colour appearance.

11.3 Colour Appearance

The colour sensation that arises on viewing an object is dependent on three components: the reflection of the object itself, the properties of the light by which it is viewed, and the colour vision of the observer. But the situation is more complicated because the human visual system is highly adaptive, and does not produce the same sensation from a given stimulus under all conditions. In particular, it varies according to two properties of the viewing environment: the conditions of illumination and the spatial configuration of the visual field.

11.3.1 *Factors affecting appearance*

Features of colour vision that are known to influence the perceived appearance of a colour surface include the following:

Chromatic adaptation

The human visual system has evolved the ability to adapt to the intensity and colour of ambient light under which an object is viewed. This enables recognition of objects in a wide range of conditions by maintaining the perceived colour appearance approximately constant.

Illumination levels can vary over many orders of magnitude, with a range of correlated colour temperature 3000K for tungsten lighting to 7500K for north

sky light. Despite these variations, we normally judge the most highly transmitting surface in the field of view as a completely achromatic 'white' when our eyes are fully adapted after several minutes.

Simultaneous contrast

The appearance of a coloured area is influenced by colours adjacent, in such a way that the difference between the coloured area and the adjacent field are exaggerated. The apparent lightness, hue and colourfulness may all be affected. The consequence of simultaneous contrast is to make the appearance of any colour element within a complex field strongly dependent on the other elements within the field. As Mollon puts it: 'We judge colours by the company they keep.'[1] Simultaneous contrast can in practice be modelled as local chromatic adaptation, since its effect is similar to subtracting the chromaticity of the perceived illuminant.

Stevens and Hunt effects

Stevens and Stevens observed that perceived brightness contrast increases with increased luminance.[4] Hunt made a related observation, that colourfulness also increases with luminance.[5] These effects are significant in many viewing environments for heritage objects, owing to the wide variation in illuminance levels that occur for viewing the original objects and their reproductions.

Spatio-chromatic interactions

Spatial and chromatic characteristics are processed in different visual centres within the brain, but are by no means independent. Colour appearance at a location in a scene depends on local image contrast, i.e. the relationship between local cone absorptions and mean image luminance.[6] Spatial resolution is highest in the light-to-dark dimension, followed by red-green and blue-yellow.[7] The low spatial sensitivity is a consequence of the relative sparseness and low sensitivity of S cones in the retina.[6] Hence the perception of sharpness depends largely on spatial modulation of the light–dark component, rather than opponent colours.

11.3.2 Viewing conditions

The viewing conditions for an object in a museum or gallery are usually determined by its curator with regard to factors such as permissible intensity level and UV content of the illumination. Many objects are viewed by the public in relatively dim conditions, by lighting that may include incandescent or fluorescent sources, possibly in addition to natural daylight. Rarely will an object be uniformly lit, and this will give rise to shading effects on any photograph of the object. If natural daylight is present, the illumination will also change in direction, intensity and colour temperature as the day progresses (Table 11.1).

Table 11.1

Typical levels of
illuminance or
luminance (white)
under different
viewing conditions.

Application	Typical luminance or illuminance
Dimly-lit room	60 lux
Normal room light	400 lux
Viewing booth for critical colour judgement	2000 lux
Natural daylight	10 000 lux
Display for normal viewing	80 cd/m²
Display for critical colour judgement	180 cd/m²

The properties of illumination which affect colour appearance are its intensity and its colour. Illuminance refers to the amount of light falling on a surface, measured in lux; while luminance refers to the amount of light energy emanating from a surface, whether by reflection (e.g. a painting lit by a room light), transmission (e.g. stained glass illuminated from behind by the sun) or by emission (e.g. a display). Although illuminance and luminance are different quantities, they are related: a perfectly diffusing white reflective surface illuminated by I lux has a luminance of I/π candelas per square metre.

The colour of light is determined by the distribution of its energy at the different wavelengths in the visible spectrum. The spectral power distribution of three typical sources that are found in galleries are shown in Figure 11.2. Tungsten light (as is the case generally for incandescent sources) is characterised by a smooth spectral power distribution with most of the power in the

Figure 11.2

Spectral power distributions of
tungsten, fluorescent, and
daylight sources.

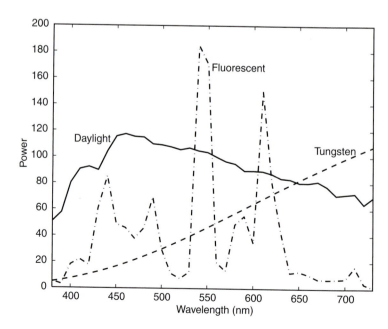

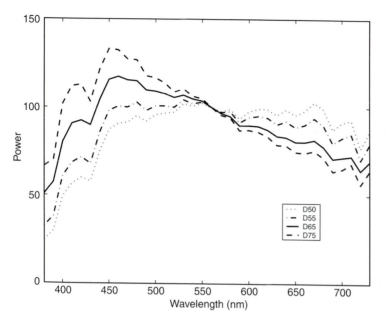

Figure 11.3
CIE daylight illuminants, normalised at 555 nm. The correlated colour temperature of the light depends on the relative proportions of direct sunlight (stronger at long wavelengths) and reflected sky light (stronger at short wavelengths).

red region; light from fluorescent discharge tubes has a very 'spiky' emission, with power concentrated in a few narrow spectral regions; and daylight has a broad distribution across the spectrum.

The colour of daylight varies considerably according to factors such as the angle of the sun above the horizon and the degree of veiling cloud or atmospheric haze. In order to simplify methods of defining colour stimuli, a number of standard spectral power distributions corresponding to phases of daylight have been defined, a selection of which are shown in Figure 11.3. By convention, each standard illuminant is normalised to a value of 100 at 555 nm, the peak of the human visual response.

Although spectral power distribution is the fundamental property that determines the colour of light, it is also convenient to use other ways of characterising the colour of a given light source. These include the chromaticity coordinates of a perfectly reflecting diffuser viewed under the source; and its correlated colour temperature (CCT), specified as the temperature in Kelvin of a theoretical black-body radiator whose colour matches that of the source. Examples of CCTs and chromaticity coordinates for a range of sources are given in Table 11.2.

In lighting a given object, a curator may employ a mixture of different sources of illumination, including general room lighting, typically using warm or cool white fluorescent tubes; directional lighting, usually incandescent; and natural daylight. Efforts are often made to modify the properties of daylight in order to enhance the viewing condition or to reduce the damage caused to artefacts, including particularly colour changes and fading. At the National Gallery in London, for example, some galleries have light sources with blue and

Table 11.2

Correlated colour
temperatures and
chromaticity
coordinates for a range
of light sources.

Source	CCT (Kelvin)	Chromaticity (x, y)
Candle	1800	0.540 0.411
Tungsten	2800	0.447 0.407
Warm white fluorescent	3300	0.417 0.396
Cool white fluorescent	4000	0.380 0.377
Daylight 50	5000	0.346 0.358
Daylight 65	6500	0.313 0.329

orange filters with their intensities adjusted to maintain the colour temperature of illumination in the gallery. It is common practice to use absorption filters to minimise the damage from the ultraviolet component of daylight, for example the transparent structures which shield the outdoor mosaics at Piazza Armerina, Sicily, in order to reduce overall incident light intensity and eliminate UV. [12]

In general, the cumulative illumination on a particular surface can be defined by summing the energies at each wavelength of the separate sources incident on the surface. Visual adaptation to the different sources is more complex, because it is likely that an observer will be partially adapted to each of the principal sources incident on the surface and on the surround, and the degree of adaptation is likely to be greater for sources closer to daylight in their spectral power distribution. With digital photography, an analogous process takes place when the camera is 'white balanced' to a neutral reflector placed in the field of view. For film photography, the 'white balance' is determined by the film type, with films being commonly balanced to a CCT of either 5400K for daylight or 3300K for incandescent sources.

11.4 Colour Measurement

Colour may be measured numerically by an instrument that records the physical attributes of a coloured surface, and then transforms the physical data to appropriate correlates of visual perception. First, the reflectance (or transmittance, for an object viewed by transmitted light, such as stained glass) at each wavelength is integrated with the illumination power and CIE colour matching functions to give 'tristimulus values' for the colour, denoted X, Y, Z. The values represent the relative amounts of three theoretical primaries which would produce the same colour sensation when seen by a standard human observer. They can be further transformed to the CIELAB system, which is a more perceptually uniform colour space based in Cartesian coordinates. The dimensions L^*, a^*, and b^* represent the relative lightness, redness-greenness and blueness-yellowness respectively, as shown in Figure 11.4.

Figure 11.4

CIELAB colour space showing
the three opponent dimensions
of white-black, red-green, and
yellow-blue.

Several choices need to be made when measuring a physical sample and then transforming the data to perceptual correlates. The most significant are the geometry of measurement and the choice of illuminant. The aim is always to measure the colour in the same mode in which it is viewed, while conforming to appropriate standards, so that the resulting data specifies the colour stimulus precisely.

11.4.1 Instrument geometry

To make a measurement, the object must be first illuminated by a source of light. In the majority of instruments, the source is a built-in lamp, but the scene illumination may be used in some situations. The light reflected or transmitted by the object first passes through filters or a diffraction grating, so that only a selected range of wavelengths is presented to the detector. An instrument for measuring reflectance can be designed to record either the diffuse reflectance from the surface of the sample, or the reflectance at a specified angle. One common practice is to measure the reflectance from a planar surface at 45 degrees to the angle of the incident illumination, thus avoiding the specular component from a glossy surface.

The three types of instrument most appropriate to the measurement of colour in heritage objects are:

1. 0:45 reflectance spectrophotometer for planar reflective surfaces.
2. 0:d transmittance spectrophotometer for translucent materials.

Figure 11.5

Instrument geometries for colour measurement [37].

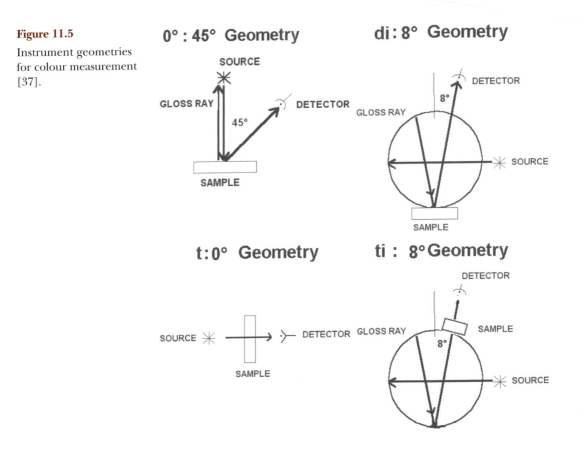

Figure 11.5

Instrument geometries for colour measurement [37].

3. Telespectroradiometer for curved or fragile surfaces or where it is desirable to measure the reflection without physical contact under ambient lighting conditions.

These geometries are shown in Figure 11.5.

There is an additional consideration for measurement of objects normally viewed by reflection but not completely opaque, since the material behind a translucent sample will influence the resulting values. As with all colour measurement, the aim should be to measure the object in the same way as it is viewed by an observer. Thus a fabric displayed against a white wall should ideally be measured on a white backing material.

11.4.2 Digital cameras as colorimeters

The spectrophotometers discussed above use solid-state detectors to record light intensity in narrow wavebands throughout the visible spectrum. A digital camera also records light intensity, although in broader wavebands. Camera sensor

signals cannot be used to compute colorimetric values in the same way as the data from a spectrophotometer, but a digital camera can nevertheless be used to approximate the scene colorimetry through a mathematical transformation of sensor data to estimated tristimulus values. The two most common approaches to this are: (1) to characterise (or model) the relationship between the camera data and known tristimulus values; and (2) to estimate the spectral response of the camera channels so that the tristimulus values can be computed in the usual way.

11.4.3 RGB colorimetry

If the tristimulus values of the set of red, green and blue primaries (the equivalent colours of the three filters) in a camera are known, their XYZ tristimulus values may be computed by a multiplication by a 3×3 matrix. For a perfectly additive system, a direct and lossless linear transformation between RGB and XYZ is possible. If the camera response to luminance is non-linear, following a tone reproduction curve or gamma function for example, an inverse function may be applied to 'linearise' the response before the matrix multiplication.

The principle of the 3×3 transform to XYZ is valid for any set of RGB primaries, whether or not they correspond to real primaries or even to physically realisable colours. In selecting a set of RGB primaries, the aim is to avoid excluding wanted colours from the colour gamut, while maximising the utilisation of the encoding space. An inefficient encoding would be one where many of the possible code values were never used, and the actual colours in the scene occupied only a small percentage of the possible codes. In the xy chromaticity diagram, the colour gamut of a 'colorimetric RGB' encoding can be represented as the triangle connecting the tristimulus values of the primaries. Some examples are shown in Figure 11.11. It must be remembered, however, that a colour gamut is actually three-dimensional.

11.4.4 Fluorescence and metamerism

Two phenomena which can confound the methods of colorimetry are fluorescence and metamerism. Fluorescence occurs when light energy undergoes modification by certain pigments, so that it is re-emitted at wavelengths different from the incident radiation. Many modern materials, particularly paints and papers, contain fluorescent brighteners to enhance the perception of whiteness. Because colour measuring instruments usually have light sources containing very little energy beyond the blue region of the spectrum, they do not report the degree of fluorescence which might be perceived by an observer. The presence of fluorescent pigments can be indicated by comparing measurements

made with and without an ultra-violet cut-off filter. For some applications, it is necessary to exclude all UV from the illuminating source.

Metamerism is the phenomenon whereby two colours which appear to match under one light source appear different under another. One consequence of human trichromatic colour vision is that a given colour sensation (and hence a set of tristimulus values) may arise from many different spectral reflectances. Since any colour sensation is dependent on the spectral properties of the illumination and the object and the observer, there is the possibility that two different spectral reflectances will produce the same trichromatic response under one source of illumination, but different responses under a second source.

Metamerism is generally not significant in the reproduction of photographic originals by conventional printing processes, where the dyes and pigments of both media are similar in their spectral reflectances and transmittances. However, original artefacts contain a much wider range of colorants, with the result that metamerism is more likely. Associated problems can be minimised by careful selection of colorants whose primaries have similar spectral reflectances; by ensuring that wherever possible the illuminant used in computing colorimetric values has the same spectral power distribution as the source under which the reproduction will be viewed; or by using a multi-spectral printing process to produce a closer spectral reconstruction of the original.[8]

11.5 Goals of Colour Encoding and Reproduction

A photographic image provides information about colours in the original scene. Reproductions of heritage photographs may have various requirements, including the need to convey a recognisable impression of the original which is aesthetically pleasing, or to define precisely the appearance of the original subject.

The requirement for colour fidelity of the reproduction with respect to the original subject varies widely according to the application. Fidelity requirements can be broadly classified as follows:

- Recognisable reproduction;
- Aesthetically pleasing reproduction;
- Accurate reproduction of original object under reference viewing conditions;
- Accurate reproduction of original, under the viewing conditions of the original;
- Photogrammetric reproduction for purposes not limited to visual interpretation, including analysis of the structure, composition or condition of the object's surfaces, together with information about its surroundings and viewing context.

Once an image has been recorded as a set of *RGB* device signals, with no supporting information, the possibility of an accurate reconstruction of the original has been lost. Although this can be partially corrected by supplying an

interpretation of the *RGB* values (for example, by means of a colour profile), this will not guarantee fidelity to the original but merely estimate the colorimetry of the original scene. The accuracy will depend on the variability of the illumination conditions, the stability of the original surfaces themselves, and variability in the sensor values recorded by the camera.

Hence the aim should be to record sufficient information from the scene for the degree of fidelity required. Where the applications of a given image are not known in advance, a digitisation procedure should aim to capture the maximum possible amount of information. Digitisation projects are often inherently costly, if they involve recording large numbers of original artefacts or substantial investment in engineering or infrastructure. The cost of acquiring more information from the original should be balanced against the cost of having to repeat the digitisation procedure in the future in order to support a different application.

The requirements that distinguish colour management for heritage photography from other sectors such as the graphic arts industry, arise from the needs of users of heritage images. While it is not the role of this chapter to provide a definitive analysis of these needs, for the purpose of discussion, four broad classes of users are considered:

1. Professional users, such as curators, restorers and researchers, for whom the image may stand for the original object. Investigations may include detailed comparisons with other objects or with other reproductions of the same object. Requirements of the reproduction include the highest possible facsimile accuracy, calibrated against some objective reference. An example is the use of images generated by the Vasari scanner at the National Gallery in London to monitor how paintings change over time.[9,10]

2. Educational users, who access the images as part of an existing corpus of knowledge about cultural heritage. Often with the guidance of an educational agent (such as a teacher, lecturer or librarian), students will make judgements from observation of the attributes of the artefact represented by the image. For example, the student of allegory and symbolism in medieval painting needs to have sufficient confidence in the accuracy of a particular rendering to decide whether the colour of a painted garment supports the notion of it being associated with, say, the emperor of the time.[11]

3. Casual users, who view an image largely in isolation and without being overly concerned about the veracity of the reproduction. An important aim is to make the salient features of the reproduction readily accessible. As an example, numerous reproductions of the mosaics at the Roman villa of Piazza Armerina, have been substantially altered to enhance the colour saturation in order to achieve a 'more pleasing' reproduction. Given that the original colours of the tesserae in any case have faded over the years,[12] such artifice is not to be deprecated too heavily, if all that is wanted is a memorable souvenir or a postcard for the folks back home.

4. 'Machine vision' applications, which apply predetermined algorithms to an image in order to extract information. In cultural heritage imaging, the most common such applications lie in the field of photogrammetry, where geometric precision is paramount but colour fidelity may not be important (see Chapter 6). A preliminary normalisation of the scene content is a feature of some applications of this type, such as histogram equalisation or exposure balancing across the colour channels, which can radically alter the colour appearance of the image.

11.6 Properties of Coloured Media

11.6.1 Surface interactions

Light obeys a number of simple physical laws which determine how it is reflected from, or transmitted through, a surface. Such laws are generally expressions of the conservation of energy. Light is always reflected from a surface at an angle equal to the angle of incidence. If the surface is perfectly smooth, all of the light is reflected at this specular angle to the plane of the surface. At the microscopic scale, most materials are not smooth and the surface can be considered as being made up of facets with different orientations, and each facet reflects light at its own specular angle. If the facets are randomly orientated, the overall (macroscopic) reflection is diffuse; whereas if the facets have a structure the overall reflection tends to have directional properties. Similarly, texture affects the appearance of a surface by providing locally directional reflection. Materials such as textiles that have regularly structured texture can exhibit strongly directional effects when viewed.

In all real materials, some fraction of incident light is not reflected back from the surface, but enters the body of the material where it encounters flakes of pigment or other colorants, which have the property of refracting or absorbing certain wavelengths. The light reflected back through the surface towards the observer now appears to be coloured relative to the incident illumination. As for surface reflection, if the pigment flakes are randomly orientated, the coloured reflection is diffuse, whereas if the flakes are regularly oriented the colour has a directional quality and may appear (for example) glossy, metallic or pearlescent.

Although colour reproduction systems are largely limited to surface colorants (for objects viewed by reflection) and light emitting materials such as phosphors (for displays), the natural world contains a wider range of chromatic materials and structures.[13] Examples include colour produced by fluorescence, iridescence, luminescence, phosphorescence and diffraction. Many of these phenomena have been exploited in colorants used in the creation of heritage artefacts.[14]

Surface effects influence the apparent colour gamut of a medium. A more glossy surface (produced, for example, by varnishing) increases the proportion

of first surface reflection and, by reducing the proportion of light available to be reflected at non-specular angles, has the effect of extending the contrast of the medium. Where pigment is applied in a varnish layer on an absorbent surface, a larger fraction of the colorant is bound within the varnish at the surface rather than entering the material, and the resulting colours appear to be more vivid. More textured surfaces have a more diffuse reflection and thus tend to have a smaller apparent colour gamut and lower density range.

11.6.2 Heritage media

Colour management provides a means of rendering source images from an input medium to reproductions on one or more output media. Every medium has its own specific characteristics of colour balance, dynamic range and colour gamut. Specifications of the media most often involved are needed to understand the requirements for colour management of heritage photography. Common heritage media include natural scenes, painted surfaces, glass, metal, wood, stone, etc.

Metals and *minerals* have a crystalline structure which has local structure. The directional effects of such materials are more evident when they are highly polished. Metallic surfaces can be difficult to measure or record by photography because the reflection is strongly directional and the amount of light detected by the sensor may be less than is apparent to an observer, making the measurement or photograph too dark. *Stone* is usually a composite of a number of minerals, and as a result, any directional effects are usually weak.

In *stained glass* (discussed in more detail in Chapter 15), the colorant acts as a filter to exclude certain wavelengths of transmitted light. Older hand-made stained glass predates the 'float glass' method of production, and as a result is neither flat nor homogeneous, instead refracting light at a range of different angles.

Wood is formed mainly from cellulose fibres, combined with other materials which provide colour. In its natural form, the diverse form of its constituent fibres results in wood having a mainly diffuse reflection, although the varnish usually applied in decorative uses of wood results in a darker and glossier surface.

Paper from any source is also comprised of cellulose fibres, which although nominally aligned in the direction of the paper-making machine and much smaller than in natural wood, are also diverse in form and thus give the surface a diffuse reflection. For commercial use many papers are coated with a layer that enhances smoothness and is engineered to give a particular degree of gloss. Coloured dyes may be added to the wet pulp before it is formed into sheets or reels and dried.

Paints are a dispersion of colorants in a liquid vehicle, the latter being either water or oil based in most decorative materials. The vehicle often has a significant

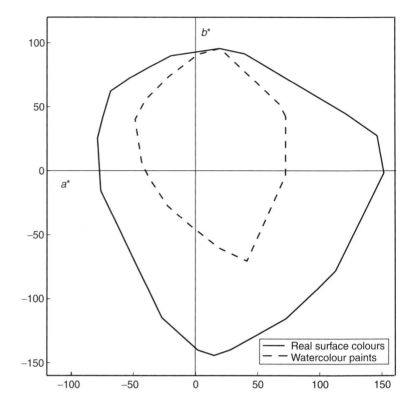

effect on the appearance of the medium, and may be composed, for example, of resins to enhance gloss or add a protective layer.

Textiles are woven materials of natural or synthetic origin, and are commonly coloured by dyeing or printing. The weave of textile materials creates a textured surface which is highly structured, and care needs to be taken in capture to avoid unwanted patterns arising from interference with the sampling array of the scanner or camera.

Heritage media can be recorded in digital form by a number of means, the most common of which is photography (followed, in the case of analogue photography, by scanning of the photographic media). Other means include direct flat-bed scanning of 2D surfaces, and laser scanning of 3D objects.

The colour gamut of real surfaces, based on measurements of both natural and artificial colorants, was described by Pointer [14] and is shown in the CIELAB *a*-b** projection in Figure 11.6, together with the gamut of modern watercolour paints.

11.6.3 *Photographic input media*

Heritage photography input media have until recently been hard copy photo-graphic materials – photographic negatives and prints, together with slides and

cut-sheet transparencies. Prints are viewed by reflection, while transparencies and negatives are viewed by transmitted light. Such media require a separate digitisation step in order to turn images into digital data.

Digital still cameras exchange picture information by means of data rather than a physical intermediate. Digital photography is therefore an input medium which is unrestricted by the properties of a photographic intermediate, and can potentially yield a higher degree of fidelity to the original scene. See also Chapter 7.

Both digital cameras and scanners should be considered as types of digitiser, and for two-dimensional originals, such as documents, either type can be used subject to satisfactory illumination.

11.6.4 Hard copy output media

Output media for cultural heritage are far more varied, and their specific characteristics are often unknown at the point when the input is selected. Output media may be broadly classified into hard copy media, such as prints, and soft copy media, which are essentially displays of different types.

Hard copy media are traditionally controlled in terms of colorant amounts, whether through printing ink on paper, or varying the density of photographic output. There is some use of heritage photography for non-paper substrates such as ceramics, textiles and decorative products, but it is probably true to say that paper (in items such as periodicals, newspapers, catalogues, brochures and so on) forms the largest category of hard copy output.

With some very specialist exceptions, most hard copy reproduction of colour images is based on trichromatic colour reproduction. The required colours are formed by varying the relative amounts of three process primaries (cyan, magenta and yellow), together with black as needed to extend the density range. Because the human visual system has three different classes of colour receptors, as described in 11.2, such trichromatic reproduction is sufficient to match any original colour provided two conditions are met: first, that the reproduction medium has a large enough colour gamut, and second that the viewing conditions are sufficiently similar between original and reproduction. Where the latter condition does not hold, alternative methods of reproduction can be considered, such as multi-spectral techniques (see Chapter 19) and corrections for the viewing conditions through an appearance model.

Colour gamuts for a range of hard copy media are shown in three dimensions in the CIELAB colour space in Figure 11.7.

11.6.5 Display output media

Emissive display media include both the traditional cathode ray tube (CRT) and flat panel displays, connected to a signal source which may be pre-recorded,

Figure 11.7

Colour gamut of hard copy media: transparency (wire frame) and offset print on gloss-coated paper (solid).

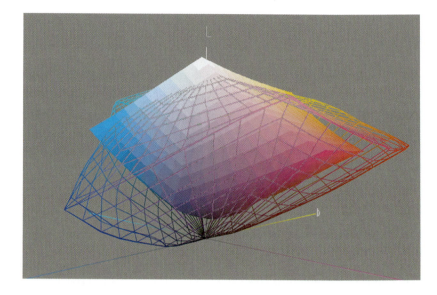

such as video or DVD, or a computer-based application. Displays have a wide range of heritage applications, particularly as interactive displays in gallery or museum exhibits. Images may also be displayed on web browsers, and on a growing list of other devices such as portable digital assistants (PDAs), mobile phones, and outdoor public displays.

Unlike the other output media described above, displays use additive mixing of the light generated by three primaries (red, green and blue) to produce the range of colours. CRT displays use phosphors stimulated by a modulated electron beam, while flat panel displays such as liquid crystal displays (LCDs) modulate the amount of an intense backlight independently through each cell. In the latter case, the colour primaries are differentiated by an array of red, green and blue transmission filters.

The colour gamut of a typical CRT in the CIELAB colour space is shown in Figure 11.8. The appearance of a display is always strongly affected by the ambient illumination, and the perceived colour gamut is reduced by increasing levels of illumination incident on the screen. For this reason, displays are often viewed in dim or dark surround conditions, and this should be a requirement when tonal and colour rendering of the display are of critical importance.

11.7 Characterisation

Given the two separate methods of encoding colour information – device values and colorimetric values – it is essential to have a means of translating colours from one colour space to the other. A characterisation is a mathematical model of the relationship between the two colour spaces, which can be used for this translation. The model can subsequently be incorporated into a device profile (discussed in more detail below) to enable efficient transformation of images.

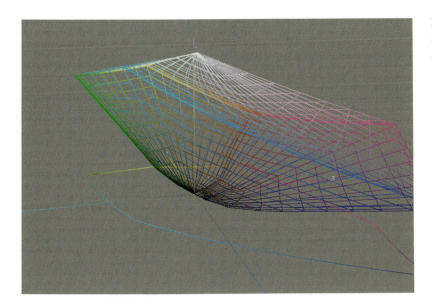

Figure 11.8
Colour gamut of a typical CRT display.

11.7.1 Transformations

In the simplest case, the triplet of colour values in one space is multiplied by a matrix of nine coefficients. There may additionally be a single-channel function, often expressed as a tone-linearisation connection. This is the basis of RGB colorimetry. Equation 11.1 shows an example of a transform from *RGB* to *XYZ* values using a 3×3 matrix and exponential gamma function, which might characterise a display.

$$
\begin{bmatrix} X \\ Y \\ Z \end{bmatrix} = \begin{bmatrix} 0.412 & 0.358 & 0.181 \\ 0.213 & 0.716 & 0.072 \\ 0.019 & 0.119 & 0.951 \end{bmatrix} \begin{bmatrix} (R/255)^{2.4} \\ (G/255)^{2.4} \\ (B/255)^{2.4} \end{bmatrix}
\tag{11.1}
$$

Although this approach works well when there is a simple linear relationship between the device encoding and CIE colorimetry, for most input devices, a more complex model is required. A number of methods exist, including multi-linear regression, basis functions, and look-up tables. More detail can be found in texts by Johnson,[16] Kang,[17] and Green.[18,19]

The transformation of complete images between the two colour spaces is usually implemented by means of a look-up table, which consists of a set of addresses in one signal domain, and the corresponding values in the other, calculated by the chosen model. Most colours will not correspond exactly to the limited number of entries in the table, and interpolation is used to estimate an output value between the nearest entries. The colour management engine finds a number of entries (typically between four and eight) that surround the colour of interest, and calculates an output value using the distance from

each of the known entries as a weight. If the table is well-constructed and the number of entries is sufficient, the errors arising from the interpolation are small enough to be not visually significant.

For conventional photography, the CIE coordinates are those of the photographic media used for input. An input target (as illustrated in Figure 11.9) on the same format (i.e. 35 mm, photographic print or cut-sheet transparency) and photographic material (e.g. Ektachrome, Agfachrome etc.) as the original is scanned. The vendor of the target provides a file containing the measurement values for each patch on the target. Thus a characterisation can be computed from the measured CIE values and the scanned RGB values.

The characterisation produced by this means enables accurate reproduction of the photograph, although not of the original scene of which the photograph is a record. Hence it can be considered an 'input-referred' characterisation, and the resulting colorimetric encoding can be considered as input-referred colorimetry.

Because most images are destined for reproduction on some device (whether display or hard copy), it is usual for the encoded colorimetry to be 'output-referred'. In other words, the characterisation relates the encoded values to the colours to be produced on a specified output device. Examples of output-referred encodings include CMYK for hard copy prints, and RGB for display.

While both input-referred and output-referred encodings have a role to play in heritage photography, the goal of accurate recording of the original can only

Figure 11.9

ISO 12641 test target for characterising input media.

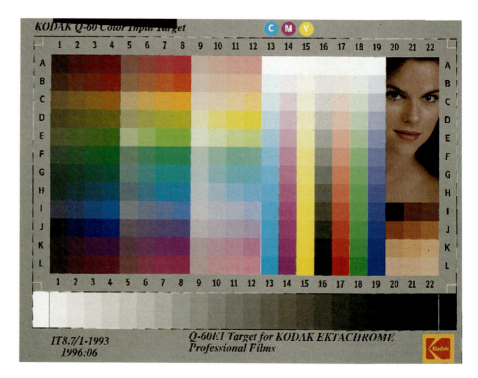

be met by a characterisation which relates the device values to the colours of the original object or scene itself. This is known as scene-referred colorimetry.

11.7.2 Camera characterisation

For most purposes, it is sufficient to make one profile for each device in the colour management workflow, as described in Section 11.8. As an example of the methods which could be used, the characterisation of a digital camera is considered here in more detail.

Two recommended methods of characterising digital cameras are based on the use of a test target and on the spectral sensitivity of the camera.[20]

Colour target characterisation

A reflective target containing a number of uniform colour patches is photographed under the same illumination conditions as the scene to be captured. The relationship between the target measurements and the *RGB* camera data is then determined as described above. A reflective ISO 12641 target (as shown in Figure 11.9) can be used for this purpose, although the photographic dyes used as colorants in this target may not be very representative of the spectral reflectances of objects in the scene. Alternatives are the Macbeth ColorChecker and GretagMacbeth DC charts, which, although they have smaller numbers of colour patches, are more suited to camera characterisation for scene photography than the ISO 12641 target (Figure 11.10).

When it is not practical to shoot the test chart under the illumination conditions used for scene capture (in outdoor photography, for example), information about the colour of the source illuminant is obtained (by direct measurement or by estimation from the scene content) and used to correct the transformation.[21]

Figure 11.10

GretagMacbeth DC colour chart for characterising digital cameras.

Spectral sensitivity characterisation

This method is beyond the resources of most digital camera users, but may be performed by camera manufacturers and by laboratories, and is particularly useful when the scene illumination is unknown or may vary.[22] A brief summary of the procedure is given here:

- Illuminate a diffuse reflector with monochromatic light at regular wavelength intervals through the visible spectrum, and capture the target at each;
- Average the camera signal over a number of pixels in an area to reduce noise;
- Determine the camera spectral response by multiplying the camera raw response for each channel at each wavelength by the illuminant spectral power distribution divided by the reflectance factor of the target;
- Using regression techniques, calculate the best-fitting coefficients to transform the camera spectral response to a set of *XYZ* colour matching functions;
- Images from the camera can then be transformed from raw *RGB* to colorimetric *XYZ* values by first linearising the signals and then applying the matrix.

The performance of a digital camera can also be characterised in the following terms:

Uniformity. A surface known to be smooth and invariant in colour is captured and the resulting image pixel values indicate the degree of non-uniformity resulting from variations in individual cell sensitivity and sensor noise. Where non-uniformity is a problem, taking multiple shots and averaging them often produces a better result.

Tonal reproduction. A grey scale of known density or lightness values is captured, and the relationship between the original and camera *R, G* and *B* signals can be plotted. Ideally the resulting curve should be smooth and monotonic.

Dark current. If the camera controls will allow, an image is taken with the lens completely covered. Since there is no light falling on the sensor during this operation the output should be zero, and the magnitude of the resulting *RGB* values indicates the level of dark current noise present.

Repeatability. An image (usually of a test target) is repeated under identical conditions, both short and long term, and the results compared.

Spatial resolution. Sharpness is a desirable property of images but is difficult to measure. More commonly, the modulation transfer function (MTF) of the camera is determined by photographing a suitable target and analysing the image.[23]

The issues involved in digital camera characterisation have been discussed by MacDonald and Ji [24] and MacDonald, et al.[25] See also Chapter 7.

11.8 Colour Management Using ICC Profiles

The International Color Consortium (ICC) has specified a method for managing colour image reproduction in digital systems. The key elements is the

profile – a data structure that contains the colour device characteristics. Profiles are linked through a profile connection space (PCS) which defines the colorimetry. There are two requirements for using ICC profiles in the colour imaging workflow: first, the set of profiles corresponding to each of the input and output devices in the imaging chain; and, second, an ICC-aware application which calls a colour matching module (CMM) to perform each of the colour transformations.

11.8.1 Types of profile

Profiles are supplied by the manufacturers of a wide range of colour imaging devices, for both input devices (cameras and scanners) and output devices (displays and printers). A number of other, more generic, profiles are also usually available in the profiles folder of the host computer, which may have been installed as part of the operating system or by a colour management-aware application such as Adobe *Photoshop*. These include:

- CIELAB profiles;
- RGB 'working space' profiles;
- RGB monitor profiles for typical display devices;
- Generic profiles for different output media, including 'SWOP' and 'Euroscale' standards for offset litho printing.

Since a profile is required at both ends of a colour transformation, the available profiles – including both device-specific and generic profiles – define the colour transformations that can be carried out. If the profile available for a given device is not adequate (either because it lacks colorimetric accuracy or because the perceptual rendering intent is not sufficiently pleasing), a new profile can be created or edited with a commercial profiling software, such as GretagMacbeth *ProfileMaker*.

To create a profile, the user identifies data for both source and destination. This normally involves selecting a test target and locating the device data and corresponding measurements. For an input profile, the source data consists of the measured values of each patch of the test target, and is usually provided by the target vendor. The destination data consists of the scanner or camera *RGB* values recorded when the target was captured. In the case of an output profile, source data consists of the *RGB* or *CMYK* values for each patch of the test target, while the destination data consists of the corresponding measurements from the display or print. The profiling software then models the relationship between the two sets of data and embodies this in a set of look-up tables.

11.8.2 Rendering intents

The process for making a profile described above is repeated for each of the rendering intents encoded in the profile. Four different rendering intents are

defined by the ICC. The choice of rendering intent for a given application depends on the reproduction objectives (see Section 11.5):

Absolute Colorimetric reproduces the CIE coordinates of the original exactly, with no allowance for the effect of different media. It is used when the aim is to reproduce the colours of the original as accurately as possible, regardless of any changes in appearance that arise from differences between the media or viewing conditions. This intent might be used when matching a spot colour, such as a corporate logo. If the specified colour lies outside the gamut of the reproduction media it is clipped to the nearest colour on the gamut boundary. In the case of image proofs, some clipping may also occur, although in practice any gamut mapping has normally been done already at a previous stage in the workflow.

Relative Colorimetric reproduces the CIE chromaticities of the original, normalising the white point of the reproduction to that of the original. For input profiles, this means that the white point of the photographic medium digitised by the scanner, or the scene white recorded by the camera, is mapped to the CIELAB white point of the Profile Connection Space (PCS). For output profiles, the PCS white point is mapped to that of the output medium, normally unprinted paper for a printer profile, or the monitor white on a display (i.e. the colour corresponding to $R = G = B = 255$).

Perceptual reproduces the CIE coordinates of the original, in a way intended to achieve a more pleasing reproduction. For an output profile, this is used when colour images are printed on a hard copy system, and is designed to give a pleasing rendering when differences in colour gamut and viewing set-up between the original and reproduction media are taken into account.

Saturation adjusts the colours of the original to maximise their colourfulness. It is used mainly for graphics rather than images, where there is no requirement to retain the relative differences between colours but a highly-saturated reproduction is desirable.

Many heritage objects have colour gamuts substantially smaller than those of the available reproduction media. The choice in such situations is between Relative Colorimetric, if the full dynamic range of the original is to be mapped to that of the reproduction, or Absolute Colorimetric, if it is desired to reproduce exactly the white point of the original. A colorimetric rendering intent will generally give better results, by avoiding unnecessary gamut compression and producing a good match between original and reproduction.

For input profiles, the profile making software usually provides some choices in the type of mapping and size of profile. The mapping defines a tone reproduction curve which determines how the tones of the original are mapped to those of the reproduction. Profile size can affect the accuracy of the resulting transformations (a larger profile implies more entries in the look-up tables and potentially smaller interpolation errors), but if the device is reasonably consistent in its response, the profile size will have little effect.

For output print profiles, there are additional choices in the method of generating the black component of the colour separation. These choices can be very important for offset printing processes, and users are advised to review the literature on this topic (e.g. [16,26,27]) before creating profiles for commercial use.

The profiling software obtains the media white point from the measurement data file, and prompts for additional descriptive information such as the device model, the substrate, and the type of profile. All these data are recorded in the corresponding tag fields. After the profile has been made, it should be evaluated by transforming a small number of test images (representative of the kind of work being done), and inspecting them carefully to confirm whether the reproduction goals have been met. In some cases, a given profiling software package may make inferior profiles for a particular medium, and it will be necessary to try re-making the profile with another package.

The quality of a profile can be determined objectively by a combination of two approaches: the relative colorimetric accuracy of the transform, and the quality of the resulting images viewed by human observers (preferably users of the images). Colorimetric accuracy is determined by comparing values predicted by the profile with those measured from the actual output. In the case of printer profiles, it is often desirable to print and measure a further test target in order to obtain a true picture of the profile's performance. Testing visual appearance usually involves transforming a number of natural and synthetic images with the profile and examining the resulting outputs. Artefacts may be readily identified by a single observer, but the effectiveness of colour mapping with the perceptual rendering intent is more a matter of judgement and should be evaluated by a number of observers so that the results can be expressed with a degree of confidence. See also Chapter 13 for a discussion of image quality assessment.

11.9 Using Profiles in a Colour Reproduction Workflow

Profiles can be embedded in many common image file formats such as TIFF, EPS and JPEG. When an application encounters an image with an embedded profile, whether it applies the profile to the image data depends on whether the application is capable of doing this and whether the user has configured it to apply any embedded profiles or to ignore them.

In a workflow where a large proportion of images shares a small number of profiles, the embedding of profiles may be undesirable, particularly where file size restrictions apply (for example where files are transmitted over networks with restricted bandwidth). In such cases, a metadata field identifying the profile by name is preferable.

11.9.1 Conversion to standard RGB encoding

It is common for users to open an image in an image editing application (principally Adobe *Photoshop*) and make any adjustments required before saving it again. The image is often converted to an *RGB* editing space (usually based on the *RGB* colorimetry discussed above, and often referred to as the 'Working space'). When the image is saved, the profile corresponding to this working space is embedded.

Conversion to the working space makes further image exchange straightforward, because the original input profile is no longer required for the image to be correctly viewed or transformed to other colour spaces. Since a working space profile is a compact matrix-shaper type of profile (see Section 11.7.1), it does not add significantly to file size. The drawbacks of working space encoding are that in some cases, the colour gamut of the working space may be smaller than those of the input media and of the reproduction, leading to a possible loss of colourfulness in some regions of colour space. Conversely, if the gamut of the working space is significantly larger than required, there is a danger of contouring unless 16-bit data encoding is adopted.

A number of standard RGB encodings exist, and are discussed in detail in Susstrunk et al.[28] Examples are *sRGB* (particularly for images destined to be viewed on displays), Adobe *RGB* (1998), ROMM *RGB* (for print applications) and RIMM *RGB* (for large-gamut encoding of scene colorimetry). The primaries and colour gamuts of these encodings are shown in Figure 11.11.

Many imaging devices including cameras, displays and printers (especially at the consumer level) are designed to work with standard RGB colour spaces, often using the *sRGB* encoding which is based on the primaries of a typical CRT display.[29] For displays, conversion using the *sRGB* transform gives a good approximation of the *XYZ* tristimulus of the displayed colours, and is a reasonable assumption as a default colour space when the image has no embedded profile, whereas for other devices, some further transformation may be required.

11.9.2 Workflows and profile transformations

In Section 11.5, applications of colour images in a heritage context were summarised. Colour reproduction workflows and profile transformations corresponding to these applications are shown in Figure 11.12.

For *display*, the transformation from reference *RGB* to display *RGB*, using the profile for the display device, is relatively straightforward. Display characterisation for CRTs has been described by Berns and Katoh [30], and for liquid crystal displays by Kwak and MacDonald.[31]

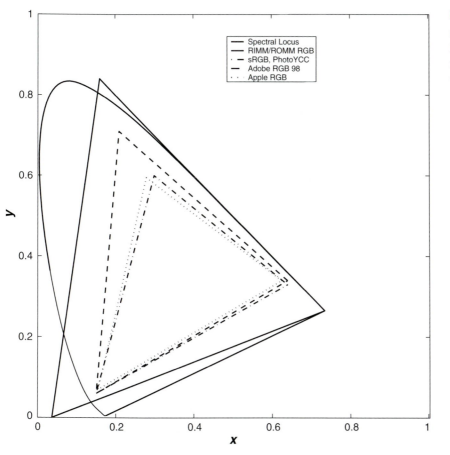

Figure 11.11

Colour gamuts of several RGB spaces.[28] plotted in CIE *x-y* chromaticity diagram.

For *print*, the destination profile is that of the printer or printing process concerned. For commercial printing, reference profiles have wider application than individual press profiles.[32]

For a *proof*, i.e. a preview of a print, the image can be transformed directly from the reference *RGB* space. However, since the proof is usually intended to match the reproduction on another process, a better method is to transform the image first to the print colour space, applying any gamut mapping required by using the perceptual or relative colorimetric rendering intents, and then transforming it to the proof colour space using the absolute colorimetric intent. Since the proof media, whether display or paper based, will almost invariably have a larger colour gamut than the destination printing process, no additional gamut mapping is applied at this second stage.

To retrieve the original *scene colorimetry*, the reference *RGB* image is transformed to the device-independent CIELAB colour space. If any processing was carried out on the scene-referred data to generate the reference image, this processing must be undone in order to arrive at the correct scene colorimetry.

Figure 11.12

Colour reproduction workflows and profile transformations. The existence of a reference colour space (RGB) enables the image to be transformed to the appropriate output colour space (display, print or proof) or back to the original scene colorimetry.

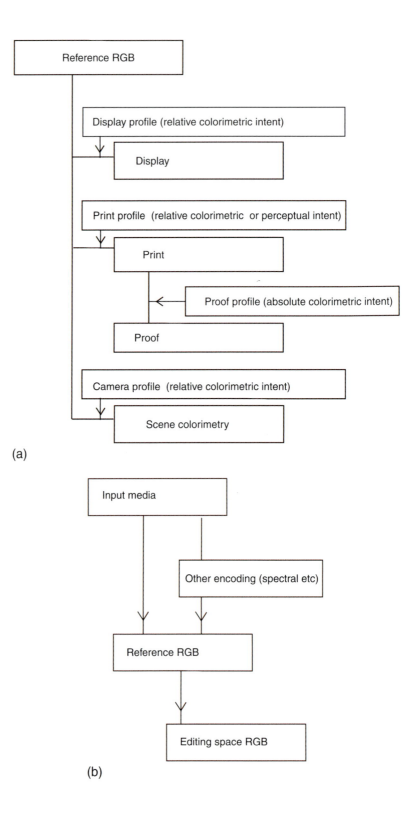

(a)

(b)

11.10 Colour Management Issues for Heritage Photography

Colour management is applicable to the reproduction of colour on all the media discussed in Section 11.6. Although the methods of characterisation that give the best results vary according to the media, the principles remain the same. The key issue that arises is to ensure that the measurement procedures for both original and reproduction media, which form the basis of the characterisation, are appropriate for the viewing geometry. As an example, ISO graphic arts standards specify very clearly the measurement procedures to use for reflective prints and transparencies, but there are many situations where the procedures described may not be applicable. If in the typical viewing arrangement, there is a specular component arising from surface gloss, or the substrate is partially translucent, or the reproduction is viewed under a dim tungsten light, then significant errors will arise from the use of standard graphic arts measurement procedures.

Colour management has been shown to be satisfactory in those sectors for which it was originally developed, particularly in commercial graphic arts colour reproduction. To apply the concepts and tools of colour management to heritage photography, various issues relating to media and viewing conditions must be addressed. Amongst these, the most significant are gamut mapping and colour appearance.

11.10.1 Gamut mapping

The colour gamut of a device or medium is the full range of colours that can be reproduced, represented in a suitable colour space. As can be seen from Figures 11.7 and 11.8, the reproduction medium will in most cases have a colour gamut different from that of the original medium. If the reproduction gamut is smaller than the original gamut, some or all of the colours of the original must be mapped in some way to the gamut of the output medium.[33]

For a stable colour reproduction device, in which the same signals invariably produce the same colour stimulus, it is possible to achieve colorimetric accuracy within quite small tolerances. The extent to which the original and reproduction media have different gamuts is then a major determinant of the degree of visual mismatch, alongside other properties such as surface texture and gloss. For this reason, the method by which the one gamut is mapped onto the other plays a highly significant role in determining the perceived quality of the reproduction, and this illustrates the importance of gamut mapping in the overall colour reproduction workflow.

For a pleasing reproduction, it is usually considered desirable to map the full dynamic range of the original to that of the reproduction medium. This implies

that the image highlight is reproduced as white, regardless of whether the reproduction medium is lighter or darker than the white highlight of the original scene. Similarly, the image black is reproduced as the darkest colour that can be obtained on the reproduction medium.

To compensate for differences in chroma, the usual goal is to preserve the relative differences between colours in the original, while maximising the overall colourfulness of the reproduction. In most graphic arts contexts, this entails a compression in chroma from original to reproduction. However, many heritage subjects such as paintings and artefacts have relatively small colour gamuts, and the question arises as to whether the gamut should be expanded to fill the reproduction medium. An objective of pleasing reproduction might indeed attempt to increase the chroma of the image, but this is inevitably at the expense of accuracy and may lead to the criticism of producing 'garish' reproductions.

11.10.2 Colour appearance

It is generally accepted that CIE colorimetry can only predict an appearance match between two colour stimuli where the viewing conditions for both are identical and the media have similar physical characteristics. The appearance of a pixel within a colour image will therefore be affected by the luminance and chromaticity of all areas within the field of view, including:

- the colour of the pixel itself;
- other pixels in the same image;
- the surround or border of the image;
- the medium's white point (e.g. unprinted substrate or clear transparency);
- other elements in the proximity of the image;
- the background against which the image is viewed;
- the light source;
- the remainder of the field of view.

Simultaneous contrast effects arising from nearby pixels in the image have a considerable effect on appearance. However, such effects will tend to be similar in both the original and reproduction, unless there are large differences in spatial dimensions or colour gamuts between the two media. Given standard viewing conditions, the lightness and chromaticity of the medium and the image border produce the strongest effects, particularly in the case of a display or transparency original with a black border reproduced as a print on paper with a white border.

A colour appearance model extends CIE colorimetry by taking into account the conditions under which a colour stimulus is viewed. In a colour reproduction

workflow, this makes it possible to predict and compensate for the change in appearance arising from a change in viewing condition.

A number of colour appearance models have been developed, derived from an understanding of colour vision and the results of experiments in which observers make judgements of colour appearance under controlled viewing conditions. Some models have as their objective a comprehensive model of appearance phenomena, while others are designed to be more computationally efficient. The CIE recently considered a number of different appearance models and agreed a model that combines their best elements. Following tests of an interim model known as CIECAM97s, the CIECAM02 model [34] has now been adopted for further evaluation.

A colour appearance model may provide the required adjustment to the CIE coordinates for an image so that it appears correct (i.e. its appearance is preserved) when the image is transferred from one viewing condition to another. For example, a cut-sheet transparency is intended to be viewed against a dark surround, which has the effect of making the image appear lighter. When the image is to be reproduced on paper, the white surround has the effect of making the image appear darker. A correction for the different surround can be made by incorporating a colour appearance model into the colour management workflow.

Colour appearance models have been tested in experimental situations that simulate the particular viewing environments, such as graphic arts colour reproduction, offices and workplaces, and product inspection within colorant industries such as textile and paint manufacture. A limited amount of research has investigated the application of colour appearance models in cultural heritage contexts.

11.11 Conclusions

The use of CIE tristimulus colorimetry as a basis for colour transformations between different media, has, in today's colour reproduction workflows, become known as colour management. This is best illustrated by the five-stage transform [35] shown in Figure 11.13.

The five-stage transform starts with the code values which are the result of the image sampling process. The relationship between such code values and tristimulus colorimetry is defined by the process of characterisation, expressed in the device model. For a given device or medium the device model is often embedded into a colour profile, in the format specified by ICC (2001).[36]

The effects of the conditions under which the original is viewed and reproduced are predicted by a colour appearance model. The particular viewing conditions, such as the colour attributes of the incident illumination and the luminance of the surround and background, are input parameters of the appearance model.

Figure 11.13

Five-stage transform in which the original image is converted first to tristimulus coordinates by the device model, then to appearance coordinates for the viewing condition, and from there to tristimulus co-ordinates for the reproduction viewing condition.

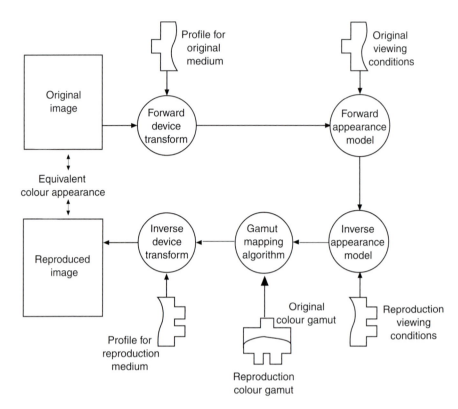

Once the device models for the original and the reproduction media have been defined, and the appropriate appearance model and viewing parameters selected, the original code values can be transformed to tristimulus coordinates for the source viewing condition, then to the corresponding, appearance coordinates, and from there to the appearance coordinates and tristimulus coordinates for the reproduction media. Finally code values for the reproduction device or medium are computed using the device model.

The mapping of colours in the gamut of the original to those in the reproduction medium can be carried out at different stages within the workflow implied by the five-stage transform. Mapping is best performed on appearance coordinates, but can also be performed on colorimetric coordinates, provided that any mismatch between the viewing conditions of the media gamuts is corrected by the use of the appearance model.

11.12 References

1. Mollon, J. (1995). Seeing colour. In *Colour: Art and Science* (T. Lamb and J. Bourriau, eds.), pp. 127–150, CUP, Cambridge.
2. Kaiser, P. K. and Boynton, R. M. (1996). *Human Color Vision*, 2nd Edition. Holt, Rinehart and Winston.
3. CIE (1987). *International Lighting Vocabulary*. CIE Pub. No. 17.4, Vienna.

4. Stevens, J. C. and Stevens, S. S. (1963). Brightness functions: effects of adaptation. *J. Opt. Soc. Am.*, **53**, 375–385.

5. Hunt, R. W. G. (1952). Light and dark adaptation and the perception of colour. *J. Opt. Soc. Am.*, **40**, 362–371.

6. Wandell, B. A. (1995). *Foundations of Vision*. Sinauer Associates, Sunderland, MA.

7. Mullen, K. (1985). The sensitivity of human colour vision to red-green and blue-yellow chromatic gratings, *J. Physiol.*, **359**, 381–400.

8. Tzeng, D.-Y. and Berns, R. S. (2002). Spectral-based six-colour separation minimizing metamerism, *Proc. IS&T/SID 8th Color Imaging Conference*, pp. 342–347.

9. Saunders, D. and Cupitt, J. (1993). Image processing at the National Gallery: the Vasari project, *National Gallery technical bulletin*, **14**, 72–86.

10. Thoma, J., Cupitt, J. and Saunders, D. (2000). An investigation of the potential use of visible-region multispectral imaging for pigment identification in paintings, *Proc Conf. Colour Image Science 2000*, University of Derby Colour and Imaging Institute, pp. 95–106.

11. Gage, J. (1993). *Colour and culture*. Thames and Hudson.

12. Minissi, F. (1961). *Protection of the Mosaic Pavements of the Roman villa at Piazza Armerina (Sicily)*. Museum, **14**.

13. Nassau, K. (2001). *The Physics and Chemistry of Colour*, New York, NY, Wiley.

14. Johnston-Feller, R. (2001). *Color Science in the Examination of Museum Objects – Non-Destructive Procedures*. Getty Conservation Institute, Los Angeles, CA.

15. Pointer, M. R. (1980). The gamut of real surface colours, *Col. Res. Appl.*, **5**, 145–155.

16. Johnson, A. J. (1995). *Colour Management in Graphic Srts and publishing*. Pira International, Leatherhead.

17. Kang, H. R. (1996). *Color technology for electronic imaging devices*. SPIE Press, Bellingham, WA.

18. Green, P. J. (2002a). Overview of characterisation methods. In *Colour Engineering* (P. J. Green and L. W. MacDonald, eds.), pp. 127–142, Wiley, Chichester, UK.

19. Green, P. J. (2002b). Characterizing hard copy printers. In *Colour Engineering* (P. J. Green and L. W. MacDonald, eds.), pp. 221–246, Wiley, Chichester, UK.

20. ISO 12641:1997. *Graphic technology – Prepress digital data exchange - colour targets for input scanner calibration*. ISO, Geneva.

21. Hubel, P. M., Holm, J. and Finlayson, G. D. (1998). Illuminant estimation and color correction, *Proc. Colour Imaging in Multimedia – CIM98*, Derby, UK, pp. 97–105

22. Holm, J. (1997). Issues relating to the transformation of sensor data into standard color spaces, *Proc IS&T/SID 5th Color Imaging Conference*, pp. 290–295.

23. Holst, G. (1998). *Sampling, Aliasing and Data Fidelity*. SPIE Press, Bellingham, WA.

24. MacDonald, L. W. and Ji, W. (2002). Colour characterisation of a high-resolution digital camera, *Proc. Conf. Colour in Graphics, Imaging and Vision (CGIV)*, Poitiers, France.

25. MacDonald, L. W., Ji, W., Bouzit, S. and Findlater, K. (2002). Characterisation of a digital camera for heritage photography, *Proceedings of the International Congress on Image Science (ICIS)*, Tokyo.

26. Green, P. J. (1999). *Understanding Digital Color*. GATF Press, Sewickley, PA.

27. Fraser, B., Bunting, F. and Murphy, C. (2003). *Colour Management: Industrial Strength Production Techniques*. Peachpit, Berkley, CA.

28. Susstrunk, S., Buckley, R. and Swen, S. (1999). Standard RGB color spaces, *Proc. IS&T/SID 7th Color Imaging Conference*, pp. 127–134.

29. IEC 61966-2-1 (1999): *Multimedia systems and equipment – Colour measurement and management – Part 2-1: Colour management – Default RGB colour space – sRGB.*

30. Berns, R. and Katoh, N. (2002). *Methods for characterising displays.* In *Colour Engineering* (P. J. Green and L. W. MacDonald, eds.), pp. 143–164, Wiley, Chichester, UK.

31. Kwak, Y. and MacDonald, L. W. (2001). Controlling color of liquid-crystal displays, *Proc. IS&T/SID 9th Color Imaging Conference,* Scottsdale, Arizona, pp. 355–359.

32. Green, P. J. (2006). Accuracy of colour transforms, *SPIE 6058,* pp. 11–20.

33. Morovic, J. (2002). Colour gamut mapping. In *Colour Engineering* (P. J. Green and L. W. MacDonald, eds.), pp. 297–318, Wiley, Chichester, UK.

34. Moroney, N., Fairchild, M. D., Hunt, R. W. G., Li, C., Luo, M. R. and Newman, T. (2002). The CAM02 Color appearance model, *Proc. IS&T/SID 10th Color Imaging Conference,* pp. 23–28.

35. MacDonald, L. W. (1993). Gamut mapping in perceptual color space, *Proc. IS&T/SID 1st Color Imaging Conference,* pp. 193–197.

36. ICC (2001). *File format for colour profiles.* ICC.1:2001-04 (Version 4.0.0), International Color Consortium (www.color.org).

37. Rich, D. (2002). Instruments and methods for colour measurement. In *Colour Engineering* (P. J. Green and L. W. MacDonald, eds.), pp. 19-48, Wiley, Chichester, UK.

Image Compression and JPEG2000

Thomas Zellmann

12.1 Introduction

Many techniques currently exist for the compression of images in either greyscale or colour. One of the most common is 'Standard JPEG' [1] from the Joint Pictures Expert Group, which takes 8×8 pixel blocks and compresses them using the Discrete Cosine Transform (DCT). However, JPEG is over 15 years old and has fallen behind the state of the art in image compression.

One of the main disadvantages of current image compression techniques is that they are not particularly suitable for documents containing both text and image or graphic regions. As compression rate increases, the text rapidly becomes distorted and illegible.[5] A common solution is first to convert mixed text and image documents to black and white (bitonal) and then to compress them using the CCITT compression standards 'Fax Group 3' or 'Fax Group 4'. This approach enables a high compression rate to be achieved and preserves text legibility, but of course requires that greyscale and all colour information is lost.

JPEG2000 [2] is the new standard ISO 15444-x for still image compression. It is organised in 12 parts: the first defines the core decoder; and the remaining 11 parts are intended for special applications, compliance tests and reference software. Parts 1, 3, 4 and 6 have already been published and can be obtained from www.iso.ch. Parts 2 and 5 will be published shortly, while Parts 8–12 are still under development.

This chapter describes Parts 1 and 6 of the JPEG2000 standard in some detail. Part 2 extends the core Part 1 decoder by introducing a range of new features including extended file format support and improved compression efficiency using more complex algorithms. Part 3 addresses video coding, where every single frame is encoded in compliance to Part 1. Part 4 describes how the compliance of a Part 1 decoder can be tested. It includes a series of test sequences designed to test all the options offered by the standard. The reference software in Part 5 consists of a Java and a C implementation of a Part 1 coder and decoder. They are designed to assist software developers when writing and testing their software.

Parts 8–11 are so-called *new work items*. As can be seen from the titles, they address additional aspects related to still image compression, including server–client communication, transmission over error-prone and wireless channels, security aspects, and three-dimensional extensions. These Parts are in a very early stage of the standardisation process. Part 12 is a common activity with the motion pictures MPEG group towards a unique file format with MP4 (ISO/IEC 14496-12).

12.1.1 JPEG2000 part 1

The first part of JPEG2000, the core coding system, is used in many other parts of the standard, and can be extended by the addition of one or more features from Part 2. In addition to the pure code stream description, Part 1 contains a small, lightweight file format, which meets the needs of most (but not all) standard applications. The idea was to define a simple file format to ensure interoperability even for implementations using Part 1 only, without introducing a high implementation or performance overhead. Part 2 defines a number of extension to the Part 1 file format. This includes more definitions of metadata and colour profiles.

12.1.2 JPEG2000 part 6

Many important document handling applications, including archiving and printing, involve documents with composition of different image types, such as magazine articles with natural image photos and text, or scanned invoices containing text, logos, stamps, etc.

JPEG2000 Part 1 [2,4] does not perform well in such cases. (Incidentally the same is true for JPEG.) In particular, the performance on text or on simple drawings is far from optimal. For this reason the new standard was supplemented with Part 6: a compound image file format for document imaging, for pre-press and fax-like applications, and for medical imaging, etc. It allows the advantages of the different compression standards to be combined by applying them only to particular image types in a document, for example JPEG2000 for natural coloured image regions and FAX G4 or JBIG2 for regions of black and white text.

12.2 Image Compression Steps

Image compression [6] using the JPEG2000 wavelet-based algorithms is one of the most powerful methods available at present. It provides a better performance trade-off between image quality and file size than DCT-based algorithms

(e.g. JPEG-Standard ITU T.81). In addition, it is significantly faster than fractal-based image compression at comparable rates and offers lossless compression as an option. JPEG2000 also generates a progressive data stream whereby a full-sized image may be reconstructed using only a fraction of the complete data stream. Image compression using JPEG2000 has the following distinct steps:

Image preparation
Images to be compressed using JPEG2000 may be encoded in a range of colour spaces and use various numbers of bits to represent pixel values. All images are initially converted into a standard format, including colour space transformation from RGB to YUV if appropriate, before the wavelet transformation is applied.

Two-dimensional discrete wavelet transformation (DWT)
The DWT performs the decorrelation of the individual pixels. Information originally distributed over the whole image will be concentrated in a small number of coefficients.

Quantisation and encoding
The amount of data required to represent the image is reduced by using a combination of quantisation, block-based coding and arithmetic entropy coding.

Data organisation and file format preparation
Coded image data is organised according to importance and the requested style of image delivery. Progressive image improvement may be based on image quality, resolution, channel or position. A JPEG2000 code stream is created with the coded image data and, optionally, placed in a JPEG2000 format file together with any additional information, e.g. metadata, colour profiles or resolution details.

12.2.1 *Two-dimensional discrete wavelet transformation*

The Wavelet Transformation, in a similar way to the Fourier Transformation, analyses the distribution of frequencies within a signal (see Section 9.6). In contrast to the Fourier Transformation, it uses spatially localised functions, *wavelets* and *scaling functions*, to analyse the signal. The property of these functions (*compact support*) which allows the analysis of signals without the windowing effects that result from the application of infinite analysis functions to finite signals.

Images may be viewed as two-dimensional signals, and may be transformed by a Discrete Wavelet Transformation (DWT). The two-dimensional DWT is achieved

Figure 12.1

Regions of an image after a two-step, two-dimensional Discrete Wavelet Transformation. The low-pass information is in the region marked A-02 (upper left).

by applying a one-dimensional DWT first to the columns of the image and then to the rows of the resulting image. A two-dimensional DWT splits the image into four new images: one contains the low-pass (i.e. low frequency) information; the others contain the high frequency information in the horizontal, vertical and diagonal directions (Figure 12.1). The two-dimensional DWT may then be repeatedly applied to the low frequency image until the low-pass component contains only a single pixel. Typical practical implementations for image compression will use 4–6 DWT steps. JPEG2000 uses a very fast version of the DWT, with special handling of rounding errors to ensure the exact reversibility of the transformation, enabling the lossless compression of image data.

12.2.2 Quantisation and encoding

Quantisation and encoding generate the encoded data to be placed in the final data stream. Other compression techniques perform the quantisation and encoding separately, first rejecting information perceived to be unimportant and passing the remaining information to the encoder. JPEG2000 uses the newer bit-plane coding technique, however, which combines both tasks and enables the exact adjustment of compression rate.

The task of the quantisation stage is a reduction in the precision of the transformed image data. Encoding the resulting reduced precision values requires fewer bits and introduces only a small error (Figure 12.2).

The number of quantisation steps can be determined during bitplane coding. Every value will initially be quantised coarsely; if there is enough 'space' left in the output stream, then the quantisation intervals will be split further, becoming successively finer and finer until the quantisation error reaches zero and the transmission is lossless.

Figure 12.2
Example of signal quantisation.

12.3 Advantages of JPEG2000

12.3.1 Lossless to lossy compression

The JPEG2000 compression parameters allow a fully reversible, or lossless, compression to be performed, or the use of quantisation to compress lossily. The transformation and coding techniques for both lossless and lossy coding are achieved by a single compression algorithm.

12.3.2 Superior image quality

The Discrete Wavelet Transformation is able to decorrelate image information more effectively in comparison to the Discrete Cosine Transformation used

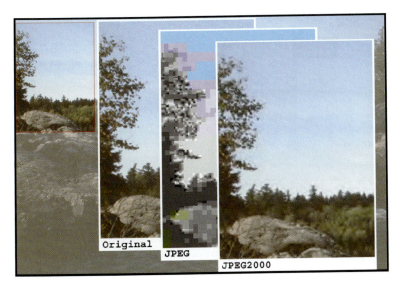

Figure 12.3
Comparison of JPEG and JPEG2000 image quality at the very high compression factor of 192:1.

by JPEG. This results in a superior image quality for wavelet compressed images, particularly at high compression rates.

Quantisation artefacts of the JPEG2000 compressed image are visible as smoothed image regions and the blurring of edges, which are generally preferable to the common JPEG artefacts of blockiness and colour distortion (Figure 12.3).

12.3.3 Progressive image decoding

A JPEG2000 compressed image can be reconstructed using only a fraction of the data in the compressed file. The manner in which the reconstructed image improves as more data is processed is determined by the ordering of the compressed data. The following four progression orders are defined:

Progressive improvement of image resolution

Resolution progressive order places all the compressed data for a particular image resolution before compressed data for any higher resolutions. The initial data of a JPEG2000 file contains a small-scale version of the image with subsequent data increasing the resolution progressively until the full resolution image has been decoded.

Progressive improvement of image quality

When the compressed data is ordered using quality progression then the reconstructed image will become more and more detailed as more data is decoded (Figure 12.4). Quality progressive decoding may be useful in low-bandwidth

Figure 12.4

Resolution progressive decoding, showing a doubling of resolution at each successive stage.

Figure 12.5
Quality progressive decoding.

environments whereby the transfer of compressed data can be halted once a satisfactory image quality has been reached (Figure 12.5).

Progressive improvement by position

Position progressive encoding organises the compressed data in a JPEG2000 file according to position, with all the data for the top-left image region at the beginning of the file and for the bottom-right image region at the end (Figure 12.6). This progression style is similar to that used by many standard image formats such

Figure 12.6
Position progressive decoding.

Figure 12.7

Difference in image quality between a region of interest and the surrounding area.

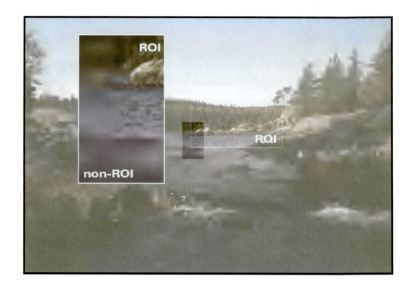

as TIFF or GIF. The receiver reconstructs the image in the conventional order from left to right and top to bottom.

Region of interest coding

JPEG2000 offers the ability to define regions of interest in an image. These regions will be compressed with a higher quality than the surrounding regions and will appear early on in any progressive decoding of the image (Figure 12.7). JPEG2000 allows up to 16 rectangular regions of interest to be defined together with the increased quality factor for these regions.

12.4 Document Compression

JPEG2000 Part 6 [3] is a document compression procedure which preserves text legibility together with high visual and colour quality. The basis of the procedure is the analysis and segmentation of documents. Mixed documents are segmented to generate the following three images:

- a binary image containing text,
- a foreground image preserving the text colour, and
- a background image with the text removed.

The three images are then individually compressed using the most efficient technique for each. The compressed image is composed of the three parts. That is why JPEG2000/Part6 compressed images remain readable at extremely high compression rates. The technique is particularly suited to documents scanned at a resolution of 300 dpi or higher, containing large image regions together with text.

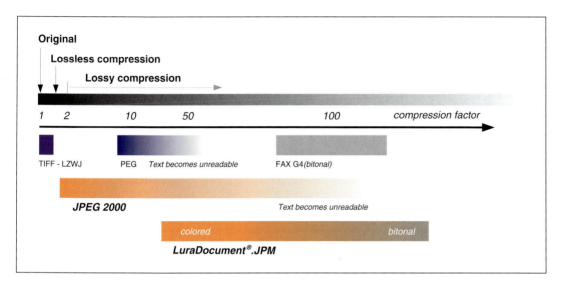

JPEG2000 Part 6 offers the following features:

- Scaleable high-quality compression of colour document images
- Standard file format (JPM)
- Significant savings in disk and network resources
- Significantly higher image quality in comparison to standard compression techniques
- Automatic partitioning between text and image regions
- Bitonal compression of text regions
- Colour or greyscale wavelet compression of image regions
- Supported by standard web browsers using plug-ins
- Thumbnail preview images
- Multi-page format.

The following sections describe the encoding and decoding stages in detail.[7]

12.4.1 Quantisation

Quantisation is the conversion from a coloured or greyscale image to a black-and-white (binary) image. This binary image is the input for the text detection (or segmentation) procedure which generates the text layer. JPEG2000 Part 6 offers two different quantisation methods: either fixed threshold quantisation or adaptive quantisation. The adaptive method adapts locally to changing image statistics and determines locally changing thresholds.

12.4.2 Segmentation

The segmentation stage classifies areas of the document as either text or image regions. One significant advantage of the JPEG2000 Part 6 segmentation algorithm is that a classification between text and image is made for each pixel rather than for rectangular blocks of pixels, as is the case with many alternative segmentation algorithms.

12.4.3 Separation and coding

The separation stage uses the results of segmentation to separate the document into three images of different resolutions:

- The text is removed from the original document to generate a colour or greyscale image containing the image regions and text background. This image is compressed using the core image compression procedures (JPEG2000 Parts 1 and 2). The removal of text regions – extremely difficult structures for image coders to compress – enables a significantly higher compression performance to be achieved.
- The removal of image regions from the bitonal text image makes high compression rates possible. The bitonal text image is compressed using the CCITT Fax Group 4 coder.
- A third image, containing colour for text regions, is generated and compressed using the JPEG2000 core image compression procedures (Parts 1 and 2).

The bitonal text image is compressed at the original document resolution while the background and text colour images are encoded with a reduced resolution.

12.4.4 Decoding

The bitonal text image, the text colour image and the background image are independently decoded. The three decoded images are combined to generate the decoded document, which can then be viewed using a supporting viewer, or converted to a standard image format. Decoding can be seen as a superposition of the coloured text layer and the background layer.

12.5 Market Acceptance and Products

12.5.1 Images

The wavelet-based JPEG2000 is best suited to the compression of natural images, as opposed to drawings with only a few colours, and one of the most important application areas for JPEG2000 is digital photography. While currently almost all consumer digital still cameras currently use JPEG for image compression,

there is a lot of interest among the manufacturers to switch to JPEG2000. The reasons are better compression efficiency, and the ability to generate a lower resolution version of the image easily from the compressed data for use on the camera display.

On the other hand, JPEG2000 is much more complex than JPEG, so there is the need for high performance hardware implementations within such camera devices. There are currently a couple of JPEG2000 chips available on the market, and the author believes that it is just a question of time before the first JPEG2000 consumer cameras become available.

By the end of 2003, there were already more digital cameras embedded within mobile phones than existed as dedicated camera devices. This has opened up a new area of digital photography for consumers. These images have lower resolution and quality in comparison with images produced by a conventional digital still camera, and they are mostly ephemeral, just taken, transferred, viewed and deleted. As the resolution and quality of these devices increases, however, the wireless transmission will require the type of high compression performance that can be easily achieved using JPEG2000.

Another important application area is the field of image archiving and retrieval. More and more image archives nowadays have digital counterparts to the original images stored in their repositories. Typically these images will be presented on websites, or will be sold as digital copies at printable resolution. Here JPEG2000 fits very well, with the ability to store an image at different resolutions within a single file (or database entry) without additional overhead. Another aspect of digital image archiving is the preservation and dissemination of cultural heritage. Normally a museum has only a small percentage of its paintings shown in exhibitions. Publicly available image archives on the Web cannot replace such exhibitions, but they can make many more images available to many more people.

There is a wide range of additional application areas for JPEG2000: publishing, document imaging, colour facsimile, printing and scanning, medical and scientific applications, remote sensing, surveillance and many more. Anywhere that high compression is needed for image storage or transmission, JPEG2000 is a potential candidate.

12.5.2 Documents

Many documents can only be found easily if they are reproduced in colour. This is so even in cases where one might not expect it: different types of bank deposit slips, for example, differ often by their substrate colour and are recognised in that way. Colour often contains extremely important information.

Generally applications of JPEG2000 Part 6 are in the area of document management systems dealing with images of mixed content, where good quality is needed, yet little storage or transmission time can be afforded. Such situations

arise in the archiving of images, in accounting, in land registers, in medical imagery, in colour and grey scanners, and in publishing companies to name just a few.

Today, most document archiving applications use the TIFF image file format, and to a certain extent PDF format, for storing documents of mixed raster content. Applied to colour scans, both of these formats produce, in many cases, file sizes so large that they are difficult to handle. Most document archiving is therefore currently done in greyscale or even black-and-white (using Fax G4 compression within the TIFF format). JPEG2000 Part 6 typically produces a file size much smaller than the corresponding TIFF file and considerably smaller than a PDF file, making archiving in colour possible.

Application areas for JPEG2000 Part 6 are document archiving by public authorities, property registers, libraries, hospitals (for their patient records), or in general within industrial business archives. Typical applications include Document Management Systems (DMS), Digital Asset Management (DAM), and Geographic Information Systems (GIS). Even high-end, high-volume scanners sometimes use document compression for storage and transmission efficiency.

Other potential scenarios can be found in the field of document search and retrieval. Imagine a search engine that looks for documents in the Web. The search result is not just a list of links to the found documents, it is an automatically generated new JPEG2000 Part 6 file, which contains only the table of contents as local pages. All other found pages are arranged as remote objects, just containing links to certain pages of other JPEG2000 documents. No downloading of these pages is necessary at this moment. Only when the user has selected a page from the content will this page be downloaded, and replace the remote page by a local copy. At the end of the browsing session, all interesting pages will be collected automatically and stored on the user's local disk as a JPEG2000 Part 6 file containing only local page content.

12.6 Application at Alinari Photographic Archive

JPEG2000 is ideal for imaging in cultural heritage applications, because it enables an optimal compression to be achieved for scanned historic documents and for images captured directly on site. The Part 1 software for image compression has been tested on a set of selected photographic images owned by Alinari (Italy), the oldest photo stock agency in the world (see Chapter 4), and has been found to produce very good results in all cases.

The criteria for choosing a new image compression format must address the needs of both users and the archive database. There are several reasons why a digital archive might wish to explore and test this new JPEG2000 image file format. Users need to be able to look for images quickly and easily. They also

need images with different resolutions and qualities, some of which could be of a very high resolution, e.g. an image of 5000×3000 pixels could have a file size of 90 MB. For the archive database, both storage and management requirements are important.

Moreover, new consumer imaging appliances (mobile phones, MMS technology, 3G, etc.) and new communication applications, require a revision of the archiving file format. Images are expected to have metadata and IPR information encapsulated in the same file. Other requirements are: guaranteed security and protection from unauthorised usage of the images as well as the ability to specify the colour space of an image with an ICC profile.

LuraWave.jp2 compression is a new format fully compliant with JPEG2000 Part 1 (now an International Standard). It analyses the complete image to enable optimal compression by using a Discrete Wavelet Transformation (DWT) algorithm instead of the Discrete Cosine Transformation (DCT) which helps to minimise visible block artefacts. Even at high compression rates, JPEG2000 compresses images making them appear smooth but without any significant loss of information. At low compression rates, up to around 1:10, JPEG2000 Part 1 suppresses image details that are not perceptible to the human eye. By removing only the 'visual irrelevances', the image compression is practically lossless. The DWT algorithm decorrelates the image information more effectively than the DCT algorithm. This results in superior image quality for wavelet compressed images, particularly at high compression rates. The block artefacts and colour distortion associated with JPEG are avoided by JPEG2000, which smoothes image regions and blurs the edges.

For a digital image archive, the content can be divided into different categories: internal knowledge base, external data, exchange data, log data, ... but the most memory consuming contents are the images. Often the system grows exponentially with the consequence that it is very difficult to customise later on. A good management policy must be united with a good storage policy. Alinari has concluded that JPEG2000 successfully meets most of the digital image archive requirements: from improving compression quality (excellent), to assuring security and enabling colour management plus integrating metadata.

12.6.1 Lossless compression

Colour images with different pattern distribution (i.e. natural landscapes, art subjects, etc.) were selected for the tests. The selected images initially have a very high resolution (2000×3000 pixels, 305 dpi, ICC colour profile: Adobe 1998).

Lossless compression is a feature of JPEG2000, which retains each pixel's original information but still delivers maximum compression. It also enables exact reconstruction of the image. All images are initially converted into a

Figure 12.8

The image has been compressed from 54 MB down to 27.3 MB without losses (compression rate 2).

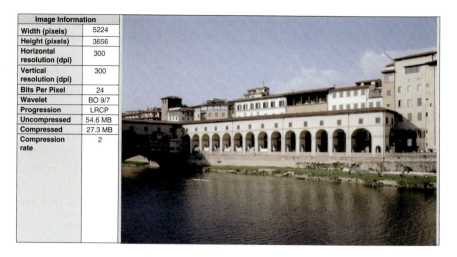

Image Information	
Width (pixels)	5224
Height (pixels)	3656
Horizontal resolution (dpi)	300
Vertical resolution (dpi)	300
Bits Per Pixel	24
Wavelet	BO 9/7
Progression	LRCP
Uncompressed	54.6 MB
Compressed	27.3 MB
Compression rate	2

standard format, including the colour space transformation from RGB to YUV if appropriate, before the wavelet transformation is carried out.

12.6.2 Lossy compression and image quality

At high compression rates compressed images appear smoothed but without any significant loss of information. JPEG2000 was used on several images, as shown in the Figures 12.9–12.12, with different characteristics. Very small files were obtained with almost the same visual quality of the original high resolution files. When comparing an image file compressed with JPEG and then the same file compressed with JPEG2000 at high compression rates, the output is quite different: The JPEG2000 file has no block artefacts nor colour distortion. This means that the user will be able to access images of high

Figure 12.9

Images used for the compression quality tests, from the Alinari library.

Image	File	Image information	
	DAL-F-000250-0000	Detail from a TIFF file: DAL-F-000250-0000 (2960 ×1983 pixel, 300 dpi)	
		Uncompressed file size: 16.8 MB	
		Compression: none	
	AGC-F-000199-0000	Detail from a TIFF file: DAL-F-000250-0000 (2521 ×1993 pixel, 72 dpi)	
		Uncompressed file size: 14.4 MB	
		Compression: none	

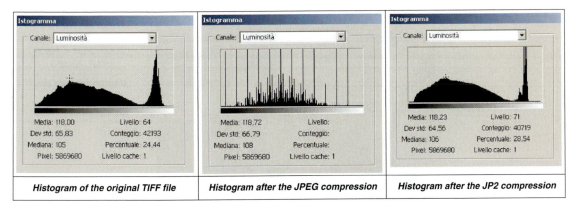

Figure 12.10

Histograms of the DAL-F-000250-0000 original TIFF file and the compressed JPEG and JPEG2000 files. Note the spikiness of the JPEG histogram (centre), indicating uneven distribution of tonal values.

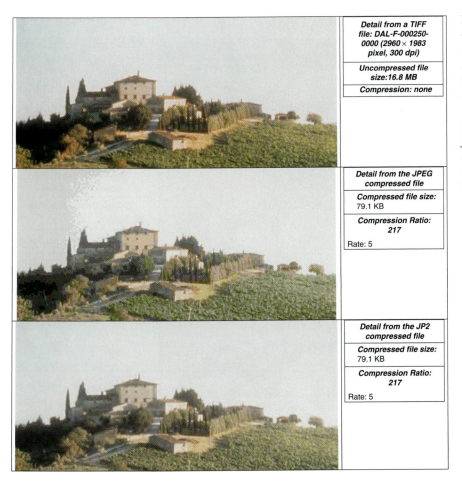

Figure 12.11

The original image file (top) is highly compressed by a factor of 217 by both JPEG (centre) and JPEG2000 (bottom) methods. The image quality of the JPEG2000 version is clearly superior to that of the JPEG version, which has visible block artefacts.

Figure 12.12

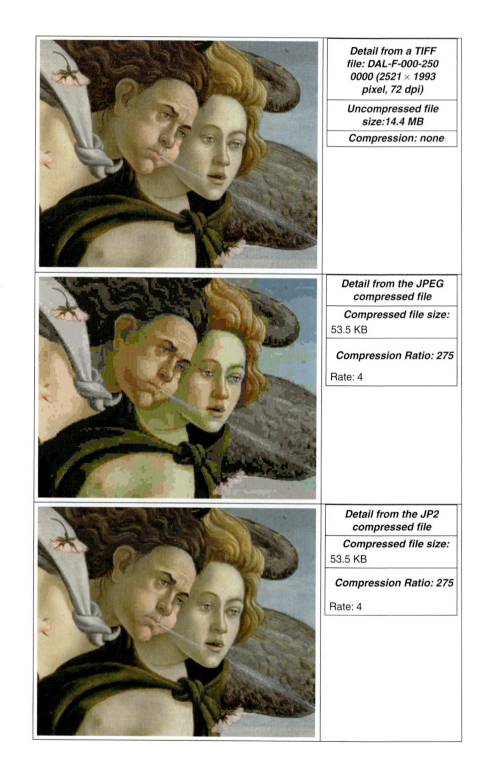

Detail from a TIFF file: DAL-F-000-250 0000 (2521 × 1993 pixel, 72 dpi)

Uncompressed file size:14.4 MB

Compression: none

Detail from the JPEG compressed file

Compressed file size: 53.5 KB

Compression Ratio: 275
Rate: 4

Detail from the JP2 compressed file

Compressed file size: 53.5 KB

Compression Ratio: 275
Rate: 4

quality and large size very quickly, even when there is a reduced connection bandwidth.

12.6.3 Size and quality scalability

A digital image archive accessible *via* the Internet is usually needed to offer different resolutions and sizes of an image. Usually, the results of a search are delivered to the user as a list of thumbnail images, which can then be enlarged by selecting a higher resolution or larger size of file. JPEG2000 improves the situation by enabling a single image file to be viewed at different sizes and resolutions. Requiring just one image file to deliver different resolutions and sizes fundamentally improves the management and speed of the archive and reduces storage space. As a result, the user can flexibly adjust the image quality and the desired image size without having to generate and load separate images (Figure 12.13).

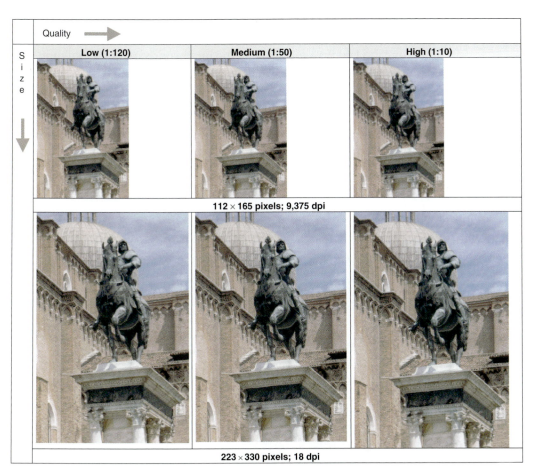

Figure 12.13

Scalability of JPEG2000, enabling a single file to be viewed at different sizes and resolutions. This improves storage, management and bandwidth usage.

12.7 Application at the German Resistance Memorial Centre

In co-operation with the Berlin-based company Minuskel, a multimedia information system has been developed over the past few years for the Gedenkstätte Deutscher Widerstand (GDW), the German Resistance Memorial Centre. This innovative system will one day encompass GDW's complete range of stored data. JPEG2000 Part 6 has been successfully integrated into the digital archiving and knowledge management system. With its optimal compression results, the system is a key factor in the successful realisation of this ambitious project.

The GDW is a memorial to resistance against National Socialism. During the night of the 20 to 21 July 1944, in the courtyard of the former General Army Office, four officers with Claus Schenk Graf von Stauffenberg involved in an attempted coup were executed by firing squad. Stauffenberg, then Chief of Staff of the General Army Office, had masterminded the failed assassination attempt on Adolf Hitler's life at his headquarters in Rastenburg, East Prussia.

In 1953, upon the initiative of the surviving members of families, the foundation stone was laid for a memorial in the inner courtyard of the building. But it was only three decades later that the memorial centre could be officially opened with the exhibition 'Resistance Against National Socialism'. Since then, the central task of the institution has been to promote critical discussion of this infamous segment in German history through exhibitions, publications, educational events and research projects.

The collection also includes relevant data and images connected to this time period. As recently as two years ago, no professional digital solution had been

Figure 12.14

The Court of Honour of the German Resistance Memorial Centre in Berlin © Nikolaus Koliusis/GDW.

utilised for the more than 50 000 documents and photographs in the collection. The employees who kept up the inventory only maintained an overview through the sheer power of memory. This resulted in outside queries first having to undergo a lengthy research process.

12.7.1 The search for a comprehensive information system

The GDW required a database solution in which all images and documents could be systematically entered and registered while being linked to a wide range of other media. This was a special requirement of the project, as the GDW staff was faced with the seemingly insurmountable task of preserving their collection for posterity. As is well known, the quality of paper and photographs reduces steadily over time. Yet, one of the main tasks of the GDW is to use existing documents and reproductions as an historical source for their work. This made unimpaired and lag-free access to information, images and documents vitally important for both researchers and visitors to the exhibition.

DARWIM, the digital archival and knowledge management system designed by Minuskel, was extensively enhanced in collaboration with Algo Vision LuraTech into a multimedia information system to meet these requirements. The employees of GDW have already entered over 18 000 data records into the 'Informationssystem Widerstand' (ISW: Resistance Information System) for storage. This time-consuming data entry process will span several years. In an initial step, the documents and images are conventionally scanned, systematically registered and controlled. Via an automated process, the ISW system then merges the documents with existing data and stores them in compressed mixed raster content format. Only the uncompressed 'digital original' is saved on CD – already 1 Terabyte of data has been saved in this way and there is not yet an end in sight. If this volume of data had been saved in the system, the enormous loading times alone would prevent effective research. The early decision for image data compression software has already proved a success.

Dr. Johannes Tuchel, Director of the GDW, describes their concept as follows: "In Germany, we possess a unique collection on the subject of resistance against National Socialism which includes innumerable images and documents. In order to save these for posterity while maintaining an overview of our collection for modern archiving purposes, we decided to digitise it. Then we can enter it into our digital information system. In this way, the collection is not only available to us internally, but can be viewed by visitors to the memorial centre in presentational form. For this reason, it is particularly important that the photos and texts are reproduced in top-notch quality; at the same time, the data transfer and system loading times must function quickly. Eventually, from the digital documents in the database, high-grade reproductions will be produced."

Figure 12.15

Multi-layer document compression technique.

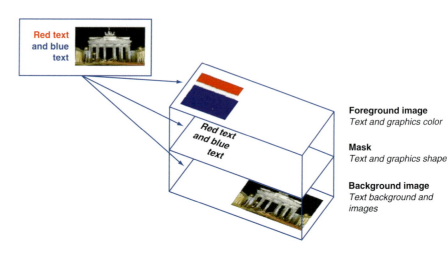

Foreground image
Text and graphics color

Mask
Text and graphics shape

Background image
Text background and images

12.7.2 Digitisation procedure

Via the multi-layer compression technique,[7] text, image and background components are segmented and compressed separately, each with the optimal algorithms. In this process, the total data volume is decisively reduced for high-definition scanning, guaranteeing first class reproduction quality of documents and images in formats up to A3 size (Figure 12.15).

A further major advantage is that with multi-resolution compression (MRC) software, as compared to other compression procedures, hardly any artefacts (errors in the compressed image) are generated. Moreover, this JPEG2000 software solution allows the division of bitonal elements. In this way, for example, a completely faded case file, barely decipherable in original, can be compressed with MRC software in such a way that the background is masked. Just the black and white elements remain, making the document fully legible, as shown in Figure 12.15. With the help of the viewer zoom function, individual images and document sections which are difficult to read in the originals can be enlarged significantly.

12.7.3 Knowledge management versus data maintenance

The archiving of documents alone does not deliver scientific information. Knowledge about people and historical events is only gained when an interrelationship can be established between data – a feature which a simple database simply cannot offer. With the Resistance Information System, the GDW has developed an effective solution for collecting and locating information on individuals, documents, subjects and events in contemporary history. Data and single items of information to be recorded and archived so that essential information can be transmitted to visitors through intelligent cross-links. In this way,

Figure 12.16

Resistance Information System; (top) faded original document on Claus von Stauffenberg (bottom) improved legibility after multi-resolution compression with JPEG2000.

Figure 12.17

Examples of images from the Resistance Information System. Top: Illustrierter Beobachter 1939, Series 48, Page 1707; Bottom: Sectional zoom with LuraDoc Viewer.

individual pieces of information become contextual knowledge, regardless of whether this encompasses texts, catalogued objects, scientific literature, personal data or photos, audio tapes, image files and videos (Figure 12.17).

12.7.4 User interface

The Resistance Information System's user-friendly interface offers two different approaches for the acquisition of information. The menu bar on the upper edge of the screen (Figure 12.18) enables access to the various categories (individuals, documents, subjects, case files, literature, exhibitions and media). If the user is interested in a particular individual, he or she will immediately find an overview of the most important information in a clearly-structured 'index card'. This includes biographical data (short biography, career history, nationality, affiliations, etc.), as well as political activities and milestones from the person's resume.

In the folder 'Documents/Photos', all images and documents connected to the individual can be viewed. By clicking on 'Media', the visitor will find all linked video and audio files. In the 'Texts' area, a wide range of written material on the subject at hand is made available by the system to both staff and visitors.

A second navigation along the context block on the right-hand side of the screen enables the user to call up further information. This is also contextually

Figure 12.18
Resistance Information
System; Claus Schenk
Graf von Stauffenberg
subject window (start
page).

linked to the search topic and assigned to the same categories as in the menu
bar. In addition, a 'Subject' folder has been integrated. Here, the user will find
publications or memos to superordinate themes, e.g. 'Die Weiße Rose', the 'Rote
Kapelle' (both Nazi resistance groups), or the 'Attempted coup of July 20, 1944' –
which in turn can also be linked to the data of other individuals.

In this way, whoever uses the system can gain new insights while viewing a
wide range of contents – even if one does not possess an historical background
on the subject at hand.

12.7.5 Future plans of GDW

To date, eight terminals have been set up at the GDW for public use, through
which individual documents and images from the Resistance Information System
can be conveniently perused. Since autumn 2002, visitors to the Plötzensee
Memorial Centre have also had access through one public terminal. The digital
information system 'Plötzensee Book of the Dead' contains existing biographies,
documents and portraits of the 2891 prisoners murdered at the Plötzensee
prison, Berlin. As soon as new information has been entered into the Resistance
Information System, it becomes available in Plötzensee as well through a
convenient update function. GDW employees are also able to store audio files
in the system, which in turn can be played by visitors.

The successful use of JPEG2000 Part 6 software in the system for the German
Resistance Memorial Centre is a forward-looking solution for integrating a

powerful image and document compression application into a complex knowl-edge management system. It represents an outstanding resource for companies, public foundations and private institutions for the archiving and contextual cross-linking of larger volumes of image and text data.

12.8 References

1. ISO/IEC IS 10918-1, www.jpeg.org
2. ISO/IEC 15444-1:2000, Information technology – JPEG 2000 image coding system – Part 1: Core coding system, www.iso.ch
3. ISO/IEC 15444-6:2003, Information technology – JPEG 2000 image coding system – Part 6: Compound image file format, www.iso.ch
4. Chinen, T. and Chien, A. (2000) Visual evaluation of JPEG2000 color image compres-sion performance, ISO/IEC JTC 1/SC 29/WG 1 N1583, March 2000, Tokyo, Japan.
5. Santa-Cruz, D., Ebrahimi, T., Askelof, J., Larsson, M., and Christopoulos, C. (2002) JPEG2000 still image coding versus other standards, *SPIE's 45th annual meeting*, San Diego, August 2000, vol. 4115, pp. 446–454.
6. Algo Vision LuraTech GmbH, LuraWave.jp2 C-SDK manual, JPEG2000 – High Performance Image Compression.
7. Algo Vision LuraTech GmbH, LuraDocument.jpm C-SDK manual, High quality colour document compression with JPEG2000/Part6.

Assessing Image Quality

Lindsay MacDonald and Ralph Jacobson

13.1 Introduction

The *Shorter Oxford English Dictionary* includes the following definition of the word *quality:* 'The nature, kind or character of something; hence the degree or grade of excellence possessed by a thing.' In popular use, the word suggests a level of luxury or expense, an item with a specification higher than average. To understand how an image can be assessed in terms of its quality, it is worth considering the meaning of quality for any artefact, product or service.

For industrial products, the definition of quality often includes the idea of *fitness for purpose.* Thus a car should provide all the necessary functions for safe transportation, while being reliable, economical and comfortable. For manufacturing purposes, quality means *conformance to specification*, ensuring through measurement and testing that a product's dimensions are within tolerance of the intended values. Within a company, quality means *to make things right*

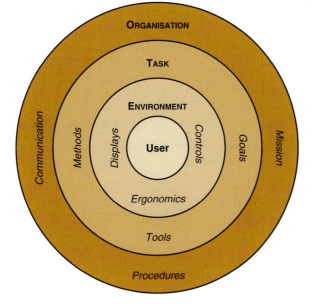

Figure 13.1
User-Centred Design.

first time, thus minimising waste, cutting the cost of inventory holdings and maximising productivity. In market-orientated organisations, quality means a *guarantee of customer satisfaction*, i.e. ensuring that customers are happy with all aspects of the product, including the support and service from the supplier throughout the product's lifetime. The international standard ISO 9000 defines quality as: '*Achievement of all those features of a product or service which are required by the customer.*'

In consumer product design, quality arises largely from a *user-centred design* process, placing *user needs* as the central focus, as shown in Figure 13.1. Ideally all the objectives, characteristics, context and operating environment of a product should be derived from the viewpoint of the user, as well as all tasks that the product supports.[1] This falls within the realm of *human factors engineering*, the practice of designing products so that users can perform the required functions, operations, service and supportive tasks with a minimum of stress and a maximum of efficiency. A good quality product achieves good usability by 'making the design fit the user' rather than the reverse. This principle has important implications for the design of imaging products.

13.2 Quality in Image Reproduction

13.2.1 Media communication

Consider images in terms of their role in media communication, as shown in Figure 13.2. The creator of the image has the purpose of communicating it through a suitable channel to one or more observers. Every element of the chain from creator to receiver affects the quality of the image, and hence the effectiveness of the communication process. Noise in the channel, however, may degrade the transmission, and the characteristics of both the origination medium and reproduction medium limit the overall ability of the system to render the image (size, density range, colour gamut, etc.). Viewing conditions in each case affect the perception of the person viewing the image.

This generalised model can be applied to many practical examples of image communication:

Artist/gallery. The artist paints a picture, which is then installed in an art gallery for exhibition to the public. In this case, the origination and reproduction media

Figure 13.2

A model of cross-media communication.[2]

are identical (namely the painting itself), but the viewing conditions may be different (lighting, distance, surround, etc.). Whereas the artist may have seen the original at close quarters in his studio under north-facing daylight, the gallery visitor looks at the final painting under gallery lighting. Noise processes could include the damage caused by age and transportation (cracks, varnish layers, fading, etc.).

Photographer/magazine. The photographer takes an image on film and makes a print with the desired rendering (cropping, tone curve, contrast, etc.). The print is digitised and incorporated into a layout for a magazine or catalogue, then output to film or directly to a printing plate to be printed with a certain paper and ink set. Soft proofs are viewed on a calibrated computer screen and press proofs are viewed under D50 simulated daylight in a standard lighting booth. The publication is mass distributed by post to consumers, who might typically browse it at home under tungsten lighting. Sources of noise could include variations in the printing process, arising from changes in paper, ink and press settings.

Director/television. The director guides the studio camera in the capture and editing of a programme sequence, which is then broadcast via terrestrial, satellite or cable channel to a network of receivers. Pictures are viewed in the studio on monitors calibrated to D65 reference. Each receiving television might be slightly different in its picture rendering, and be viewed under different conditions. Noise arises from encoding/decoding losses, transmission interference and cross-talk between channels.

The essential point of the above model is that the message passes between the originator and the receiver, i.e. person to person, even though each person engages in an interaction with his or her own medium. The meaning of the communication, and the criteria by which its quality should be judged, can only be understood in the context of the intentions of the originator and the needs of the receiver. These may include purposes as diverse as entertainment, advertising, information, education, politics, etc.

13.2.2 *User task requirements*

User-centred design and media communication provide a context in which to consider the dimensions of image quality, because interpreting the image is a key visual task of the user. To understand what is important in an image conveyed through some medium, one must understand the image reproduction objectives, which in turn depend on the needs of the user for the task being undertaken. Common visual tasks and corresponding image quality criteria, each related to usability of the displayed image, are set out in Table 13.1.

We distinguish four levels in the visual presentation of an image (Table 13.2). The *viewing environment* determines the state of adaptation of the observer,

Table 13.1

Principal usability criteria for different user tasks.

Task	Criterion
Reading text	Legibility
Information displays	Discriminability
Monitoring systems	Conspicuity
Visualisation	Believability
Human computer interface	Consistency
Catalogues	Predictability
Proofing	Accuracy
Advertising	Attention grabbing
Photo-journalism	Depiction
Fine art	Fidelity

Table 13.2.

Four levels of visual presentation of an image.

Content	Stylistic treatment Composition Subject
Image characteristics	Tone, contrast, colour Sharpness, detail and edges Noise, defects
Medium/device	Colorants, gamut Transfer function, white, D_{max} Resolution
Viewing environment	Observer adaptation state Ambient light Viewing geometry, surround

including the geometry, surround and ambient light. Next is the *medium or device* on which the image is presented, e.g. a photographic print or graphic display. Third are the inherent *image characteristics*, the visible features detected by the observer. Finally, the *content* includes composition and pictorial subject matter, interpreted for meaning, rendering and grace.

13.2.3 The FUN model

Yendrikhovskij [3] has proposed a general model of image quality in which the three dimensions are Fidelity, Usefulness and Naturalness (FUN):

Fidelity is the degree of match between a reproduced image and the original image or an external reference. Fidelity may also be considered as a measure of an image's faithfulness to the appearance of the original scene. Many different

reproductions of a given image may be possible, with varying degrees of pleas-antness, but the judgement of acceptability depends on the user. This dimension is important for making facsimiles of existing pictures.

Usefulness is the degree of suitability of a reproduced image to satisfy the user's task. Different tasks place different demands on a person viewing an image, and therefore have different quality criteria. For example, when reading text on a display screen, the most important criterion is legibility. But for a monitoring system, such as the panel instruments of a car, rapid interpretation of the operating state depends on how conspicuous the instrument displays are.

Naturalness is the degree of perceived match between a reproduced image and an observer's internal reference, such as a memory prototype, based on experience of natural scenes. This attribute is important when the viewer has no immediate access to the original scene, as when looking at photographs or watching television. It is even more important when the original does not exist in the real world, for example images from computer games or virtual reality simulations.

The overall image quality can be evaluated as a single-number metric from a weighted sum of its three FUN values. The location of an image in the FUN coordinate system gives an indication of its type, and for particular applications images may be clustered in regions of FUN space, as shown in Figure 13.3. For example, NASA images of the planet Mars might have good fidelity and be useful for analysis, but could not be considered as natural. Medical X-rays might be high in usefulness but low in naturalness, whereas the opposite might be true for virtual reality games. Fine art reproductions must have a high fidelity, whereas holiday pictures aim to be 'pleasing' with a suitable balance of naturalness and fidelity.

13.2.4 Quality of service

Unlike the *closed* architecture of broadcast television systems, in which the characteristics of the receiver are well specified, multimedia systems have an *open architecture* because they integrate many different devices and media types.

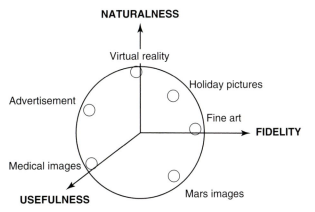

NATURALNESS

Virtual reality

Advertisement

Holiday pictures

Fine art

FIDELITY

Medical images

USEFULNESS

Mars images

Figure 13.3

The FUN model of image quality.[3]

Therefore, quality assessment for multimedia must consider not only the quality of individual components (monomedia) but also the level of integration and how well they collectively meet the interactive needs of the user. Because image quality is only one of many aspects of the overall quality of a multimedia system, it must be balanced against other factors in the trade-offs necessitated by restrictions on processing speed, storage capacity and channel bandwidth.

It is usually not possible to specify 'one quality' for a specific image or video stream, because library images and media channels may be reconfigured and reused with different objectives. Depending on the application, many levels of quality may have to be offered. Because it is generally not practical to store content in multiple formats, resolutions and quality levels, effective multimedia servers have to adjust content 'on the fly' to fulfil the specific needs of each application and/or user.

In telecommunications, *quality of service (QoS)* is defined as 'the collective effect of service performance which determines the degree of satisfaction of a user of the service'. Typical QoS parameters for video-conferencing applications are: good picture, clear sound, fast response (minimum latency), and absence of transmission problems (jitter, noise and data loss). What 'good' actually means depends on the characteristics of human perception and also on what is acceptable in the particular application.[4] The concept of QoS can be extended to multimedia systems:

> *'The quality of a multimedia presentation is the degree to which the communications goal is achieved, considering the information perceived by the human observer in relation to the total information provided.'*

Based on this definition, the following factors determine the quality of every presentation:

- Human observer (perception, memory, experience)
- Information to be encoded
- Goal of the communication
- Application area
- Presentation design (layout, graphics, metaphors)
- Interaction devices and controls.

A multimedia performance metric must take into account all parameters needed to meet the user's performance objectives.[5] For example, in an internet-based virtual gallery, if the three critical parameters are taken to be responsiveness, ease of navigation and image rendering quality, the procedure for assessment of system quality would have to compare their actual (achieved) values with the user-specified (target) thresholds of acceptability.

13.3 Image Quality Assessment

Questions of quality may arise whenever an image is presented for viewing. One might ask: 'Does it look good?'; 'Is it how I remember the original scene?'; 'Can I see the detail clearly?'; 'Is it a good match to another image?'; 'Are the colours correct?'; 'Does it convey the message effectively?'; 'Does it allow me to judge the condition of the depicted object?'; and so on. The appropriate questions, and means of deciding the answers, depend on the task and objectives of the viewer. What may be a perfectly good image for one purpose may be quite unsuitable for another.

In general, image quality may be assessed either for a single image in isolation or for a test image in comparison with a reference image, in three different ways:

1. *Observation,* by using psychophysical experiments to gather the judgements of human observers. A variant may assess image quality indirectly by measuring a user's performance in a visual task such as pattern matching or target following;
2. *Measurement,* by using instruments to determine values for the various quality attributes from a rendered (printed or displayed) version of the image;
3. *Computation,* by applying an algorithm directly to the digital image pixel values.

Metrics are measures or predictors of image quality, which may be expressed as single numbers or sets of numbers. They may be computed from experimental results or from measurement data or from the digital image itself.

13.3.1 Assessment of single images

Suppose that one looks at the image of Figure 13.4 in isolation, and asks 'Is this a good image?'. The response might be both 'yes', on the basis of its style or evocation of the human condition or associations with the fame of the artist, and 'no' on the basis of its quality of reproduction. But it is difficult to say how good or how bad the image really is without a reference by which to judge. For a single image, the observer is forced to make judgements on the basis of memory, experience and cultural expectations. This is always the situation when viewing an original picture in an art gallery.

More commonly, an image is seen as a reproduction generated by an imaging system and display device such as a printer, television, computer monitor or projector. A single image when rendered on a given device may be assessed for its quality characteristics by an observer, as shown in Figure 13.5. The observer must make a judgement under the prevailing viewing conditions, according to his or her visual acuity, experience and preferences. Single colours or regions within an image can be judged for their naturalness, or perceived closeness to

Figure 13.4

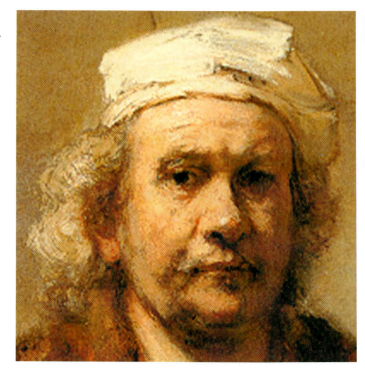

Rembrandt van Rijn, Self-portrait.
1661. Oil on canvas. (Detail)
English Heritage, Kenwood
House, London, UK.

well-known memory colours, or absence of defects. The image overall can be assessed in terms of its pleasantness or suitability for a given task.

A digital image is visually meaningless until it has been rendered on a particular imaging medium, such as a display or printer. The characteristics of the medium (device, colorants and substrate) determine how the digital values associated with each pixel are realised physically. For example, on a colour display the three signals (red, green and blue components) for each pixel generate relative light intensities of the three primaries at the corresponding position on the screen. The colour produced depends on the spectral power distribution of each primary and their combined white balance, and can be measured directly

Figure 13.5

Observer judgement
applied to a single image.

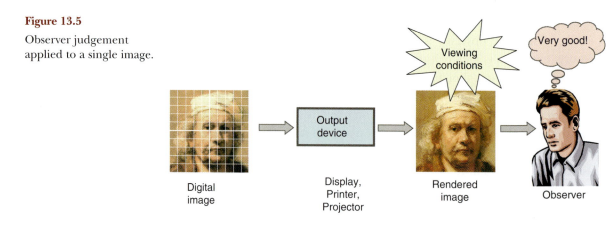

Digital image Output device Display, Printer, Projector Viewing conditions Rendered image Very good! Observer

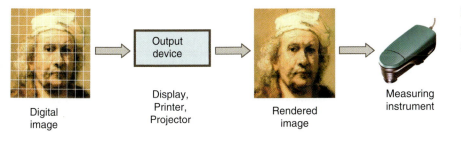

Figure 13.6

Measurement applied to a single image.

Digital image → Output device (Display, Printer, Projector) → Rendered image → Measuring instrument

from the screen using an instrument such as a tricolorimeter or spectroradiometer, as shown in Figure 13.6. For a print, the reflected colour can be measured with a spectrophotometer.

From a computational point of view, it is desirable to predict the quality of an image by calculating statistical measures directly from the pixel data, as shown in Figure 13.7. Suitable measures could be single numbers such as mean, variance, entropy, skewness, etc, or distributions such as histograms in each of the colour channels (Figure 13.8). By embedding knowledge of device characteristics or human visual response in the algorithm, for example by converting the pixel data to a colour appearance space such as CIECAM02, it is possible to achieve a better prediction of how observers might judge the image.

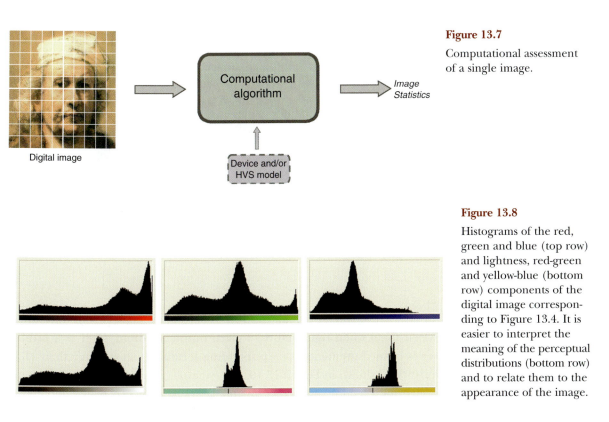

Figure 13.7

Computational assessment of a single image.

Digital image → Computational algorithm → Image Statistics

Device and/or HVS model

Figure 13.8

Histograms of the red, green and blue (top row) and lightness, red-green and yellow-blue (bottom row) components of the digital image corresponding to Figure 13.4. It is easier to interpret the meaning of the perceptual distributions (bottom row) and to relate them to the appearance of the image.

13.3.2 Comparison of two images

In many situations one image, the reference, is adopted as the standard against which another image, the test, is compared. The test image may be a derivative of the same subject which has been modified by some algorithm or rendering technique. This is a common scenario for quality control of an image reproduction process. For example in a digital video system, an original image frame or a moving image sequence may be encoded for storage or transmission using one of the MPEG standards. The decoded image is compared with the original to determine what information has been lost, or what visual artefacts have been introduced, thereby causing some impairment.

Ultimately, a human observer must make the visual judgement of whether an image is of acceptable quality, by comparing the test image with the reference image, as shown in Figure 13.9. By conducting psychophysical experiments in which a series of observers look at pairs of images under controlled viewing conditions, quality scales and acceptability thresholds can be determined for each of the image attributes. Experiments can be conducted by various methods, presenting the images sequentially or simultaneously for monocular or binocular viewing. With multiple image variants, techniques such as rank ordering and magnitude estimation can establish an image quality scale.

Figure 13.9

Observer judgement applied to two images. The test image is compared directly with the reference image.

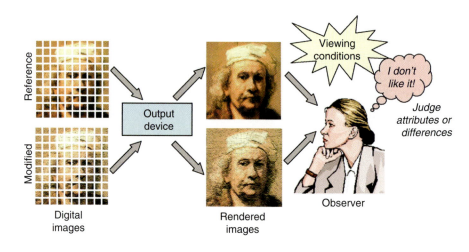

An alternative way of comparing two images is to measure the differences between them when rendered on a given output medium, such as a printer. A series of measurements at corresponding locations can quantify their characteristics, as shown in Figure 13.10. For example, a spectrophotometer could measure the spectral reflectance of the same area on two prints and hence

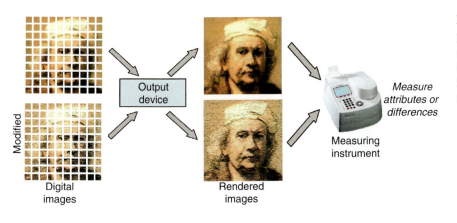

Figure 13.10

Measurement applied
to two images.
Corresponding locations
in the two images are
measured.

determine colour differences between the two images. The spatial resolution is limited by the aperture size of the instrument.

The easiest way to compare two digital images is by computation on the corresponding pixel data, as shown in Figure 13.11. By means of a suitable formula or algorithm, such as calculation of the root-mean-square average of pixel-by-pixel differences, a 'single number' prediction of the (dis-)similarity between the two images may be obtained. Ideally this should correspond to one of the image quality attributes seen by a human observer. The CIELAB 'delta E' formula for colour difference is an example. The procedure may also generate a pixel map containing a difference value for every pixel in the image. A histogram of the absolute differences between corresponding pixels indicates the relative distribution of the magnitude of the errors, as shown in Figure 13.12.

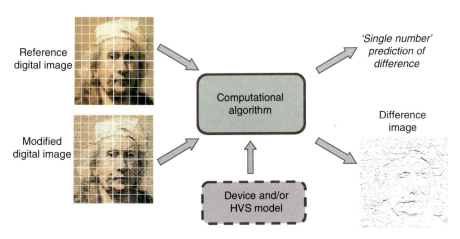

Figure 13.11

Computational procedure
applied to two images.

Figure 13.12

Probability density function (histogram) of differences between corresponding pixels of the reference and test images. Although most differences are small, the long 'tail' indicates that some errors are larger.

Pixel difference

13.4 Dimensions of Image Quality

13.4.1 Tone

Tone is the most important dimension of image quality because the achromatic channel of human vision carries the majority of the information seen in an image, as evidenced in Figure 13.13. Many visual tasks can be performed very well with monochrome images, including line drawings, half-tones, photographs and television. Art photographers frequently prefer to work in black-and-white, because it produces results of greater expressive power than would be achievable in colour. Perhaps in the mind of the observer, a stronger effect is created by interpolation of the absent dimension than if the colour were explicit, in the same way that radio is often said to produce more vivid mental images than television.

The *tonal range* of the image is created by modulation between the white and black limits of the display medium or device. For a reflective medium, such as ink printed on paper, these are determined respectively by the minimum density (D_{\min}) of the substrate alone and the maximum density (D_{\max}) of the substrate plus colorant. For an emissive medium, such as a CRT display, the limits are determined by the maximum luminance level of the device (white) and the ambient luminance level (black). The tonal range is classified in terms of the *highlight, midtone* and *shadow* regions of the image. Images in which the overall average tone is light are said to be *high-key*, whereas images in which the average tone is dark are *low-key*. These different image types may be characterised by the tonal distribution of their histograms (see Figure 13.8).

Figure 13.13

Achromatic (L^*) and chromatic (a^*, b^*) components of the image in Figure 13.4. The majority of the information content is carried in the achromatic channel (left).

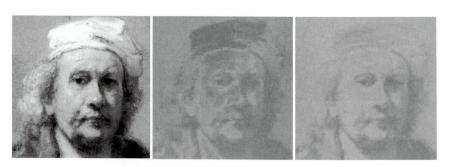

Contrast is defined as the relative tonal variation between two or more parts of an image, typically in terms of a scene luminance ratio or a print density ratio. A distinction can be made between *local contrast* and *global contrast*. Local contrast determines the rendering of details within a particular part of the tonal range, for example in the highlights. High-contrast images generally appear to have more depth than low-contrast images, which are often described as 'flat'.

13.4.2 Sharpness

Sharpness is related to the gradient of contrast at the edges of tonal regions. Sharpness can be considered at multiple scales, as a function of spatial frequency. In particular, the *edge sharpness* of objects and lines can be separated from the *fine detail sharpness* of texture and fine structure within an image.[6] High sharpness, like high contrast, leads to more pronounced depth perception, whereas low sharpness tends to make all parts of the image seem to approach the surface of the display medium (e.g. paper), as illustrated in Figure 13.14. Changes in sharpness may also change the apparent tone and colour characteristics of an image.

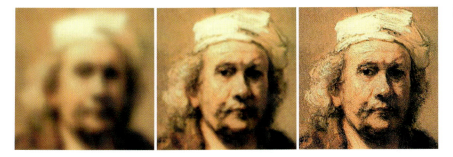

Figure 13.14
Three levels of sharpness. The sharpest version of the image (right) has more power in the high spatial frequencies than the least sharp version (left).

The sharpness of an image is a product of the image formation and capture process (camera optics, film grain, sensor geometry, etc.) and of the reproduction process (display pixels, ink half-tone dots, etc.). The device construction always sets the limit to the maximum sharpness that may be achieved in an image, characterised by the *modulation transfer function* (MTF) of the device. In photographic science, the term *acutance* is used for the edge sharpness of images formed on light-sensitive materials. In multi-layer film materials, the sharpness of the image formed on successive dye layers decreases with depth due to the scattering of the light. In displays based on cathode ray tube (CRT) technology, the sharpness of the image depends on the dimensions of the electron beams, holes in the shadow mask, phosphor dots, and raster scan structure. In liquid crystal displays the image sharpness depends on the LC cell dimensions and colour filter array structure. In television systems generally, both the inherent sharpness of the originating image and bandwidth/cross-talk of the transmission channel significantly affect the final result.

A single image may frequently contain a range of sharpness, resulting for example from the limited depth of field produced by a camera lens of large aperture. Soft-focus lenses generate images that are deliberately unsharp in order to create a certain mood. Sharpness can also be manipulated electronically through sharpening and blurring filters, although the degree of sharpening possible is dependent upon the level of noise in the image.[7]

13.4.3 Colour

Strictly speaking, colour (separated from tone or lightness) consists of two perceptual dimensions, namely *hue* and *colourfulness*. In many images the range of colours is restricted because of the subject matter, thus a landscape of grass and sky contains predominantly green and blue hues and a sunset over water contains predominantly yellow and orange hues. Colourfulness ranges from zero (monochrome greyscale image) through low (pastel image) and medium (normal image) to vivid (saturated image, taken in bright sunlight). The distribution of colours in an image is frequently represented by a scatter plot on a two-dimensional plane (such as CIE $u'\text{-}v'$ or $a^*\text{-}b^*$) or by means of a 2D histogram with a suitable number of bins along each dimension (*x-y* or polar co-ordinates $r\text{-}\theta$).

An image may also be characterised in terms of its *colour gamut*, i.e. the boundary enclosing all colours contained in the image. This is normally represented in 3D, including tone as well as colour. It is important in image reproduction to distinguish the colour gamut of a digital image from the colour gamut of a reproduction device. Often an image gamut will exceed the device gamut, necessitating some sort of gamut mapping procedure to achieve a good result.[8]

For colour image reproduction, Hunt [9] distinguishes six levels of colour fidelity, related to different reproduction objectives. These range from spectrally identical (highest fidelity) through a colorimetric match to an appearance match and finally to 'preferred reproduction' (lowest fidelity). In the last case there may be significant changes to some hues and to the rendering of colourfulness, thereby enhancing the perceived quality of the image for the user who wants a pleasing picture. Image fidelity is not necessarily the same thing as image quality.[10]

One important aspect of colour accuracy is paradoxically the ability to reproduce the grey scale as a true neutral (achromatic) throughout the tonal range from white to black. Colour errors in the successive steps of a grey test scale (typically 10 to 20 steps) can be measured in terms of CIE ΔE^*_{ab}. Care is required with the *grey balance* of a colour reproduction device to ensure that all the primaries (e.g. the **RGB** channels in a display or the **CMY** inks in a printer) track correctly throughout the full signal range.

13.4.4 Noise and graininess

Noise in images arises from many sources and appears in different forms. In the photoelectric detector of a scanner or digital camera, such as a photo-multiplier tube (PMT) or charge-coupled device (CCD), noise arises from thermal motion of the electrons and sets the threshold limit on the minimum light levels that can be detected, as described in Chapter 7. This limit is significant because it determines the minimum unit of information in relation to the maximum signal range, quantified as the *signal-to-noise ratio* (SNR) of the device.

In film, the extent to which the granular structure of the silver halide crystals is apparent in an image is called *graininess*. The physical property, related to measurable grain size, is called *granularity*. Graininess is usually objectionable in images because it results in uniform areas being reproduced with spurious texture and in fine detail being fragmented or obscured. In printed images, similar visual effects may arise from stochastic (random dot) screening techniques. Noise is characterised in terms of its *noise power spectrum* plotted against spatial frequency in cycles/mm.

The opposite of graininess is *smoothness*, which is a desirable characteristic in image highlights, especially in skin tones and gently graduated pastels such as the curved surfaces of porcelain or silver. Photographers will nevertheless sometimes emphasise the grain through unnatural chemical development or darkroom printing techniques in order to obtain artistic effects in an image. Because all real surfaces are textured, pictures need to contain some graininess or irregularity to look realistic – perfectly uniform areas in a computer-generated image look as unnatural as a skin graft on a face.

In television systems, noise may be introduced into the transmission channel from various sources such as limiting of bandwidth, cross-talk between the luma and chroma components, reflections, and bursts of electromagnetic interference. Digital and analogue channels suffer different forms of noise, which affect images in different ways depending on how they have been encoded or compressed.

13.4.5 Defects

A perfect image would be free from all visible blemishes. Real images are usually less than perfect, with various sources producing defects that manifest themselves in different ways. In some cases they arise from the digitisation process.[11] In other cases they are products of the specific imaging device technology:

Blocking. Pixellation caused by excessive image compression (see Figure 13.15).

Contouring. Visible step changes in tone or colour caused by quantising of signal values.

Figure 13.15

Blocking artefacts in a detail of the image in Figure 13.4. The image had been heavily compressed by the JPEG algorithm, and reconstruction errors in the 8×8 pixel-blocks are clearly visible.

Flare. Halation around bright regions in the image from scattering of light in the optics or sensor array of a scanner or camera.

Moiré. Patterns caused by interference between image structure and sampling geometry, particularly seen in printing with half-tone screens.

Streaking. Caused by drag across an image, e.g. a faulty sensor in a scanner's CCD line array or a faulty cell in the print head of an inkjet printer.

Vignetting. Reduction in brightness towards the edges and corners of an image, resulting from optical losses in the camera lens.

13.5 Image Quality Metrics

13.5.1 *Psychophysical measures of image quality*

Psychophysics is the science that deals with quantitative relationships between stimuli and human responses. It is possible to measure perceived image quality as well as image fidelity using the tools of psychometrics. Experimental methods depend on whether observers are asked to judge thresholds or to make suprathreshold assessments. For example, in the determination of just noticeable differences (JNDs), observers are presented with two images (paired comparison method) differing in some attribute and asked to select one of the images (two-alternative forced choice) based on a defined criterion. A 75 percent response level corresponds to one JND, equivalent to a 50 percent probability of perceiving a difference between the two images. This is a relatively easy task for observers and permits numerical evaluation. In a complete experiment, all $n(n-1)/2$ pair-wise combinations are presented, where n is the number of images. It is a

convenient means of evaluating image quality for displays and can accommo-
date variations in screen luminance by randomising the left/right position on
the display. The pair-comparison data can be transformed to interval and ratio
scales by the application of *Z-deviates*.[12]

Three methods are commonly employed in the psychophysical assessment of
images:

1. The *rating scale method*, in which observers assign numbers to their estimations
 of quality, for example on a scale from zero for the least pleasant to 100 for the
 most pleasant. Alternatively the observer may mark on a line between 'worst'
 and 'best' the position representing the perceived value of the attribute. The
 information provided by such scales is not the magnitude of the attribute but
 the observer's estimate of the proportion of the difference between what is being
 rated and the end of the scale. Many potential problems are associated with
 rating-scale methods and magnitude estimates, because people use numbers in
 different ways.

2. The *rank-order method*, in which observers place images in sequence according to
 an aspect of their perceived quality, is commonly employed for printed images.
 It is a simple task for observers to place images in order, but in practice the
 number is limited to about 16. The ordinal scale produced is itself of limited
 value but can be transformed to more useful interval scales, provided that the
 stimuli are distributed uniformly throughout the attribute range. The method is
 rather impractical for assessing displayed images because most display screens
 are not large enough to present all images at a reasonable size and may also be
 subject to spatial non-uniformity.

3. The *category judgement method*, in which observers sort stimuli into a number of
 defined categories, finds application in psychometric scaling. Zwick [13] has
 shown that a 9 point scale, given in Table 13.3, can be used successfully for
 defining distinct categories that are approximately equally distributed.
 Although this 9 point category scale gives equally spaced results, there is no
 universal agreement about the terms and their number for application to
 category scaling.

In some circumstances, especially when dealing with consumer imaging
products such as television or public displays, it may be difficult for non-expert
observers to make fine judgements about image quality. If one assumes that the
original image is good and that a perfect channel would not degrade the image
in any way, then it may be sufficient to assess the amount of degradation
produced by the actual channel. A useful method is to ask observers to grade the
image using a suitable impairment scale. The CCIR (International Consultative
Committee for Broadcasting, 1982) has recommended the simple 5 point cate-
gory scale for assessment of quality of television pictures given in Table 13.4.

Table 13.3

Nine 'equal interval' terms for category scaling.[13]

No	Term
1	Lowest Imaginable
2	Very low
3	Moderately low
4	Mildly low
5	Medium
6	Mildly high
7	Moderately high
8	Very high
9	Highest Imaginable

The International Standards Organisation Technical Committee 42 has recently drafted a standard for psychophysical experimental methods to estimate image quality.[14] It includes a useful table comparing the three main psychophysical experimental methods in terms of their scalability, stability and stress levels for observers as a guide to selecting the most appropriate method. It also proposes a triplet comparison method claimed to reduce assessment time by about one-third when compared with the normal pair comparison method.

Table 13.4

CCIR 5-point impairment scale (1982).

Quality	Impairment
Excellent	Imperceptible
Good	Perceptible but not annoying
Fair	Slightly annoying
Poor	Annoying
Bad	Very annoying

13.5.2 Visual image quality metrics

A visual image quality metric (VIQM) is a single number or figure of merit derived from physical measurements of a system, which relate to perceptions of image quality.[15–17] It may include properties of both the human visual system and imaging device(s) in the imaging chain, as shown in Figure 13.16.

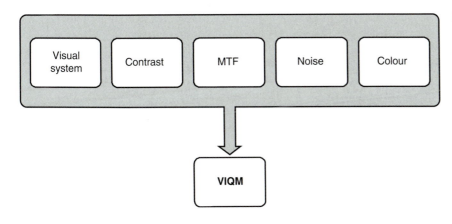

Figure 13.16

Example of a visual image quality metric (VIQM).

The wide variety of VIQMs differ in the number and type of physical measures used and how they are combined with parameters of the human eye. They may be tested for a series of images by correlation between the metric values and the subjective judgements of observers using psychophysical methods.

In reality, there is no unique measure of image quality, because of its multi-dimensional nature.[18] The VIQM approach to image quality assessment, although successful, has a number of limitations that restrict its usefulness as a means of measuring quality. The metrics tend to lack robustness, universality and transferability, and thus are rarely used outside the laboratories in which they were originally developed. Testing generally requires evaluation of statistical correlation between the calculated VIQM and perceived quality. In some cases, these correlations could be regarded as sophisticated curve fits over a limited range of data values, where a straight line might give an equally good fit. There are also fundamental problems relating to visual thresholds, because the contrast sensitivity function (CSF) for the eye is determined at threshold whereas in normal viewing situations images are viewed at higher levels of contrast and brightness, i.e. suprathreshold. Problems of scene-dependency may result from the nature and variety of scenes considered in any evaluation.[19]

13.5.3 *Colour visual image quality metrics*

Metrics in colour appearance spaces have been used for evaluation of image quality. The first true colour VIQM was proposed by Pointer [20], which he termed a colour reproduction index (CRI) as shown in Figure 13.17. It is based on the Hunt model for colour vision, which enables prediction of colour appearance under specified viewing conditions. Determination of Pointer's CRI involves the following steps:

- Define reference and test situation;
- Transform to colour appearance space via the Hunt model;

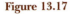

Figure 13.17

Colour Reproduction
Index.[20]

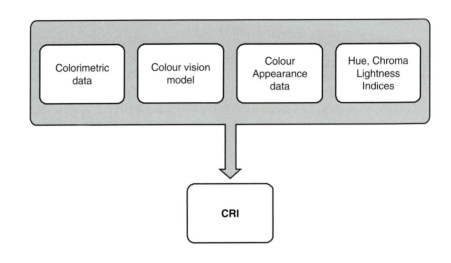

- Compute the weights according to amounts of visual R, Y, G, B components in each sample of reference chart;
- Compute the Hue, Lightness and Chroma indices;
- Scale and combine the indices to give a single index value.

 This process reduces a large amount of data for an array of colours to a single number, which has given good correlations with perceptions of colour in a variety of imaging systems.[21] In recent years it has been superseded by metrics based on CIE colour appearance and difference recommendations, such as RLAB,[22] CIECAM97s,[23] and CIEDE2000.[24]

13.5.4 *Spatial and colour visual image quality metrics*

Because the eye responds to the spatial frequencies of images as well as their colour, VIQMs should also include both aspects. Zhang and Wandell [26] developed a visibility metric for half-tone texture as a spatial extension to CIELAB, which applies three pre-processing stages before computation of the modified colour difference metric ΔE_S, as shown in Figure 13.18. In the first stage, the input image is converted from the device-dependent signals (typically *RGB* for a display) into a device-independent opponent colour space consisting of one luminance and two chrominance (*R-G* and *B-Y*) components. In the second stage each component image is convolved with a kernel that simulates the spatial sensitivity of the human visual system for that component. The calculation is pattern-colour separable because the colour transformation does not depend on the image's spatial pattern, and conversely the spatial convolution does not depend on the image's colour. In the third stage the filtered components are transformed into CIE tristimulus values *XYZ*, from which the ΔE^* colour difference metric can be calculated in the usual way.

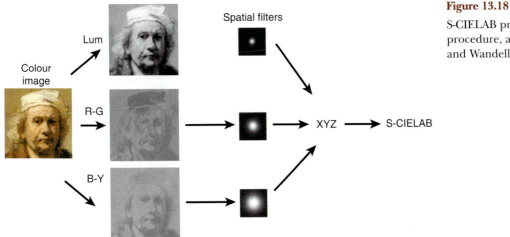

Figure 13.18

S-CIELAB processing procedure, after Zhang and Wandell.[26]

The S-CIELAB metric is compatible with standard CIELAB because for uniform targets of sufficient size (2° diameter) the values are equal. For textured regions, however, the metrics give different predictions that conform more closely to perceived differences in appearance. Experiments on images compressed with the standard JPEG-DCT algorithm showed that for pixel-by-pixel differences between the original and decompressed images the CIELAB distribution had a longer 'tail' with 36 percent of pixel differences exceeding 5 ΔE^*_{ab} units and 10 percent exceeding 10 units, whereas in S-CIELAB only 5 percent exceeded 5 ΔE_S units and 0.2 percent exceeded 10 ΔE_S units. These statistics were consistent with the visual similarity between the two versions of the images.

Farrell [25] used the S-CIELAB metric to investigate trade-offs between addressability (number of dots per inch) and grey-scale resolution (number of grey levels) on an ink-jet printer. She plotted contours of equal ΔE_S error between the original and printed test pattern, based on the assumption that a standard observer viewed the images from a distance of 12 inches. Her conclusions were that: (1) spacing grey levels uniformly in L^* is better than spacing them uniformly in luminance; and (2) half-tone quality improves little with more than 16 grey levels or addressability higher than 600 dpi.

The combination of spatial attributes with colour also occurs in the visual difference predictor [27] and its extended versions.[28–29] These metrics employ more sophisticated models of the human visual system to predict the visibility of differences between images. Johnson and Fairchild [30] have proposed a new metric as a spatial extension to the CIE colour difference metric CIEDE2000, which is similar in some respects to the S-CIELAB metric. These and other spatial/colour metrics are continuing to evolve through active research, and are providing new insights and understanding of visual perception and the measurement of image quality.

13.6 References

1. Rubin, J. (1994). *Handbook of Usability Testing.* John Wiley, pp. 10–23.

2. MacDonald, L. W. (1999). Colour Image Engineering for Multimedia Systems. In *Colour Imaging: Vision and Technology* (L. W. MacDonald and M. R. Luo, eds.), pp. 191–214, John Wiley, Chichester, UK.

3. Yendrikhovskij, S. (2002). *Image quality and colour categorisation.* In *Colour Image Science: Exploiting Digital Media* (L. W. MacDonald and M. R. Luo, eds.), pp. 393–419, John Wiley, Chichester, UK.

4. Yuyama, I., et al. (1998). Objective measurement of compressed digital television picture quality. *SMPTE Journal,* **107**, 6, 348–352.

5. Claypool, M. and Riedl, J. (1998). End-to-end quality in multimedia applications. In *Handbook of Multimedia Computing* (B. Fuhrt, ed.), pp. 875–889, CRC Press, Boca Raton, FL.

6. Nelson, C. N. (1973). Image sharpness criteria. *J. Opt. Soc. Amer.,* **63**, 1289.

7. Bartleson, C. J. (1982). The combined influence of sharpness and graininess on the quality of color prints. *J. Photogr. Sci.,* **30**, 33–38.

8. Morovic, J. (1999). Developing algorithms for universal colour gamut mapping. In *Colour Imaging: Vision and Technology* (L. W. MacDonald and M. R. Luo, eds.), pp. 253–282, John Wiley, Chichester, UK.

9. Hunt, R. W. G. (1995). *The Reproduction of Colour,* 5th edn., pp. 222–240, Fountain Press.

10. Silverstein, D. A. and Farrell, J. E. (1996). The relationship between image fidelity and image quality, *Proc. ICIP-96,* **1**, pp. 881–884.

11. Maclennan-Brown, K and Jacobson, R. E. (2001). Visual significance of digital artefacts, *Proc. IS&T PICS Conf.,* Montreal, Canada, pp. 119–123.

12. Malone, D. (1973). In *SPSE Handbook of Photographic Science and Engineering* (W. Thomas, ed.), pp. 1113–1132, John Wiley and Sons, New York, USA.

13. Zwick, D. M. (1982). Psychometric scaling of terms used in category scales of image quality attributes, *Proc. Royal Photographic Society Symposium on Photographic and Electronic Image Quality* (A. Saunders, ed.), Cambridge, September 1982, pp. 46–55.

14. ISO 20462 (2005). *Psychophysical Experimental Methods to Estimate Image Quality,* International Organization for Standardization, Geneva.

15. Eskioglu, A. M. and Fisher, P. S. (1995). Image quality measures and their performance, *IEEE Trans. Commun.,* **43**, 2959–2965.

16. Jacobson, R. E. (1995). An evaluation of image quality metrics. *J. Photogr. Sci.,* **43**, 7–16.

17. Gerfelder, N. and Müller, W. (1999). Objective quality estimation for digital images in multimedia environments. In *Colour Imaging: Vision and Technology* (L. W. MacDonald and M. R. Luo, eds.), pp. 339–361, John Wiley.

18. Ahumada, A. J. and Hull. C. N. (1993). Image quality: a multidimensional problem. In *Digital Images and Human Vision* (A. B. Watson, ed.), pp. 141–148, MIT Press, Cambridge MA, USA.

19. Jacobson, R. and Triantaphillidou, S. (2002). Metric approaches to image quality. In *Colour Image Science: Exploiting Digital Media* (L. W. MacDonald and M. R. Luo, eds.), pp. 371–392, John Wiley, Chichester, UK.

20. Pointer, M. R. (1986). Measuring colour reproduction, *J. Photogr. Sci.,* **34**, 81–90.

21. Pointer, M. R., Attridge, G. G. and Jacobson, R. E. (2001). Application of a colour reproduction index to digital camera characterization. *Imaging Sci. J.,* **49**, 91–100.

22. Fairchild, M. D. and Berns, R. S. (1993). Image colour-appearance specification through extension of CIELAB. *Color Research and Application,* **18**, 178–189.

23. Hunt, R. W. G. (1998). *Measuring Colour*, 3rd edn., pp. 208–241, Fountain Press Kingston-upon-Thames, UK.

24. Luo, M. R., Cui, G., and Rigg, B. (2001). The development of the CIE 2000 colour-difference formula: CIEDE2000. *Color Research & Application*, 26(5), 340–350.

25. Farrell, J. E. (1999). Image Quality Evaluation. In *Colour Imaging: Vision and Technology* (L. W. MacDonald and M. R. Luo, eds.), pp. 285–313, John Wiley, Chichester, UK.

26. Zhang, X. M. and Wandell, B. A. (1996). A spatial extension to CIELAB for digital color image reproduction, *SID Symposium Digest*, pp. 731–734.

27. Daly, S. (1993). The Visible differences predictor: An algorithm for the assessment of image fidelity. In *Digital Images and Human Vision* (A. B. Watson, ed.), pp. 179–206, MIT Press, Cambridge, MA.

28. Feng, X., Spiegle, J. and Morimoto, A. (2002). Halftone quality evaluation using colour vision models, *Proc. IS&T PICS 2002 Conf.*, Portland, Oregon, USA, pp. 5–10.

29. Lian, M.-S., Yu, Q. and Couwenhoven, D. W. (2002). Visibility of ink dots as related to dot size and visual density, *Proc. IS&T PICS 2002 Conf.*, Portland, Oregon, USA, pp. 11–17.

30. Johnson, G. M. and Fairchild, M. D. (2002). On contrast sensitivity in an image difference model, *Proc. IS&T PICS 2002 Conf.*, Portland, Oregon, USA, pp. 18–23.

13.7 Bibliography

Baird, J. C. and Elliot, N. (1978). *Fundamentals of Scaling and Psychophysics*. John Wiley and Sons, New York, USA.

Barten, P. G. J. (1999). *Contrast sensitivity of the human eye and its effects on image quality*. SPIE Optical Engineering Press Bellingham, WA, USA.

Engeldrum, P. G. (2000). *Psychometric Scaling: A Toolkit for Imaging Systems Development*. Imcotek Press, Winchester, MA, USA.

Fairchild, M. D. (1998). *Color Appearance Models*. Addison-Wesley, Reading MA, USA.

Jacobson, R. E., Ray, S. F., Attridge, G. G. A. and Axford, N. R.(2000). *The Manual of Photography, Photographic and Digital Imaging*, 9th edn., Focal Press, Oxford, England.

Janssen, R. (2001). *Computational image quality*. SPIE Press Bellingham, WA, USA (2001).

Keelan, B. W. (2002). *Image Quality Models – Characterization and Prediction*. Marcel Dekker Inc., New York, USA.

MacDonald, L. W. and .Luo, M. R. (2002). *Colour Imaging Science*. John Wiley, Chichester, England.

MacDonald, L. W. and .Luo, M. R. (1999). *Colour Imaging: Vision and Technology*. John Wiley, Chichester, England.

Watson, A. B. (1993). *Digital Images and Human Vision*. MIT Press, Cambridge MA, USA.

PART 3

APPLICATIONS

Imaging Historical Architectural Sites for Conservation

Nick Beckett, Barbara Schick and Keith Findlater

14.1 Introduction

Photography is the primary medium for documenting a historical site at a defined time and for preserving this information for future generations. Producing and archiving this information is vital for future use by restorers, historians, architects, and the public. Sometimes the detailed early photographs from the nineteenth century may be the only information we can rely on. It is important to consider, when dealing with cultural objects, that the images produced are often made for the national archive, therefore they should always be taken to the highest possible quality. At present the national archives require black-and-white negative material along with colour negative and/or transparency film. The integration of digital images is a new task.

For conservation records, a good image is a true representation that shows the required information. Image-based recording for conservation has to be thought of as a process for producing a true and accurate document without anything added to or taken away from the subject (see also Chapter 6). The principles are equally applicable to both conventional (film-based) and digital photography.

This chapter gives a brief outline of the techniques used in site photography for conservation and documentation. It is intended as an introduction to the various practices and procedures commonly employed by heritage organisations. Case studies demonstrate some of these practices.

14.2 Photographic Techniques

User requirements have to be considered in order to select the appropriate photographic technique. The level of recording will depend on the subject characteristics. With many different types of equipment now available to the photographer, it is usually possible (subject to budget) to produce the image as a documentary piece exactly as the conservator desires.

Pictorial photography gives additional information of the surroundings and the pervading spirit of the objects of interest. This helps with general orientation and can serve a purpose for the historian by showing the condition of the whole location and not just a small portion that could mislead the viewer into thinking the site is in perfect condition because he sees only the single perfectly lit artefact. Panoramic imagery is especially useful in presenting this evidence.

Documentary photography shows not just a single artefact or condition but several elements of the location. The images give a visual record of how buildings and sites have changed. The fabric of buildings can vary enormously, ranging from domestic dwellings to industrial sites, municipal buildings to ecclesiastical architecture, factories, mills, mines, pubs, prisons, sports stadium, country houses, gardens and more. This form of photography is important when planning consent is given to redevelop or demolish buildings, when it is necessary to record the site quickly before alteration. This has been valuable in recording industrial architecture such as the English coal mines, when they closed down in the early 1990s.

Panoramic photography. Panoramas of scenes can be made by taking an incremental series of photographs around a full 360° rotation. The number of increments depends on the angle of view of the lens and the overlap required between each image. The panoramas can be integrated into a site plan to produce a virtual reality walkthrough, where at each predefined location the user can turn to see the scene at any angle (for a more complete account, see Chapter 17). This imaging process, which enables interactive viewing from a computer display, is a pictorial form of heritage imaging and has scope for atmospheric and creative photography. Figure 14.1 shows the 'unwrapped' cylindrical panoramic image representing the interior of a room in the National Bavarian Museum in Munich.

Record photography can be summarised into three types (see also Chapter 6): (a) metric photography; (b) rectified photography; and (c) conservation photography. Conservation photography is not a technique *per se*, but characterises a special application of the images captured by the methods of record photography.

Metric photography. Stereoscopic images may be adapted for photogrammetry, by the use of a medium format camera with image format of 60×60 mm or larger. Glass plates, vacuum back or pressure plates ensure that the film is flat

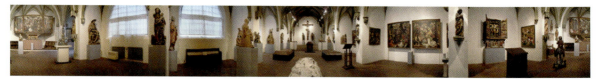

Figure 14.1
Panoramic view of the Church Room, National Bavarian Museum.

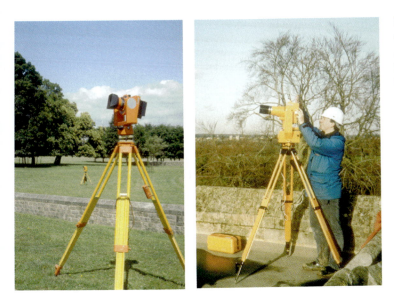

Figure 14.2

Two different tripod-mounted metric cameras being used in the field: (left) Wild P31 5 × 4 metric camera; (right) UMK 300 5 × 7 metric camera.

to eliminate any film plane distortion. A fixed focus lens with minimal distortion is calibrated at a precise focal length to within 0.01 mm. The images are taken under even diffuse illumination, and recorded together with survey dates and an exact architectural plan. The accuracy is at a standard 0.18 mm line width, which equates for 1:50 output scale to 9 mm in reality, or for 1:20 output scale to 4 mm in reality, or for 1:10 output scale to 2 mm in reality.[1] Examples of specialised metric cameras being used on site are shown in Figure 14.2.

Rectified photography. Levelled, non-distorted photographs are taken under even illumination. Defined targets in the photos, together with the survey data, enable the distortion to be rectified. Rectified images are suitable for inherently 2D objects such as walls, wall paintings and stained glass windows. The accuracy depends on the imaging scale. See Chapter 5 for a detailed discussion.

Conservation photography. The majority of photography is used in conjunction with other work, such as restoration. The metric or rectified images produced by the photographer form the base for mapping and graphical documentation. In many cases, a professional photographer is brought on location at the beginning and the end of the project to record the before-and-after state of conservation. Typically large and medium format images are taken with different lighting techniques to reveal the details of artefacts such as wall paintings. Images at all scales may be taken, according to the required content and purpose. Different types of illumination are used to reveal (analyse) the material properties of the artwork, e.g. raking light and UV/IR. The scale should be sufficient to enable a view of 1:1. Documentation of the imaging features should be sufficient to enable another image being captured in the future from exactly the same viewpoint and with the same exposure characteristics. Such repeatability is essential

for imaging studies of changes in physical condition over time, e.g. weathering, fading, erosion, etc.

14.3 Object Characteristics

The wide range of objects within the environment of historic buildings creates a challenge for the photographer. These may include, for example, stained glass windows, wall paintings and sculptures, with a wide variety of properties of the materials used, e.g. glass, metal, sand, textiles. Figure 14.3 shows five examples of objects encountered in the experience of the authors.

The size of the object being photographed may vary from large surfaces of several square metres down to tiny objects requiring a macro lens. The reproduction scale (dimensional ratio of image plane to object plane) varies from 1:50; 1:10; 1:5 to 1:1.

Film-based. For the standard architectural output scales of 1:50, 1:20 and 1:10, the minimum film (negative or positive) scales are:

- For 1:50 output scale, a minimum film scale of 1:200;
- For 1:20 output scale, a minimum film scale of 1:100;
- For 1:10 output scale, a minimum film scale of 1:50.

Where a particular project requires the use of film-based imagery with a different negative scale to those above, this will be noted in the project brief.

(a) (b) (c) (d) (e)

Figure 14.3

Objects encountered within historic buildings have a wide variety of surface properties: (a) Berlin, bronze, Adrian de Vries, Photograph by Kerstin Brendel; (b) Nuremberg, St. Sebaldus, stained glass window in reflected light, Photograph by P. van Treeck; (c) Schleissheim castle, fresco from Cosmas Damian Asam, raking light; (d) Studley Royal, St. Mary's Church, wall painting on a curved gilded background; (e) Oxford, Christchurch Cathedral, enamelled glass window in transmitted light.

Digital-based. Where digital photography is used, the selected image resolution must allow for an output resolution of at least 600 dpi and a pixel size that satisfies the following scales:

■ For 1:50 output scale, a maximum pixel size corresponding to 5 mm in reality;
■ For 1:20 output scale, a maximum pixel size corresponding to 2 mm in reality;
■ For 1:10 output scale, a maximum pixel size corresponding to 1 mm in reality.

14.4 Photographic Equipment

14.4.1 Analogue photography

The choice of the camera and film format is dependent on the size of the object, the available imaging distance, the required scale and therefore the required resolution.

Small-format. 35 mm reflex cameras with 24×36 mm imaging format are used for small cut-outs, details, and macro shots.

Medium-format. The imaging formats of 6×4.5, 6×6, 6×7, 6×8 and 6×9 cm provide high-resolution images in various convenient aspect ratios. Medium format cameras are selected for their ease of use, versatility, and the ability to swap from standard film to a digital back. The facility to change the format on some camera models can assist in getting the ideal frame.

Large-format. The choice of imaging formats 9×12, 13×18 and 18×24 cm, and the possibility to tilt, shift and swing the film and lens panels, make large-format cameras ideal for architectural imaging. Converging verticals, which are commonly encountered with other camera formats, can be corrected with these camera movements.

Panoramic cameras. With an imaging format of 6×12 or 6×17 cm, special 'panoramic cameras' enable panoramas to be captured in a single operation, rather than as a series of images that later need to be stitched together. Some models enable continuous image capture with varying resolutions around a full circle.

Digital camera backs. Replace the analogue film cassettes of medium-format (MF) cameras. The area of the silicon sensor is usually smaller than the original film format, and hence wider angle lenses must be used to compensate for this loss of field of view. The camera back may be linked directly to the host computer (Mac or PC) or the image saved to an on-board camera memory card. The manufacturers of digital backs provide their own software, sometimes with the capability for image manipulation.

14.4.2 Digital photography

Small-format analogue cameras tend not to be used for conservation photography because of their relatively low quality. The operational comfort of

compact digital reflex cameras is high and they are extremely simple to operate with most functions automated. In the latest digital cameras the CCD sensor covers the full film format, therefore the imaging frame remains the same. Thus the lenses retain the same focal length and have none of the disadvantages of needing to compensate with other lenses. Current CCD chips have sizes 30×30, 24×36, 37×37, and 36×48 mm. These cameras, especially with their high sensitivity and integrated flash illumination, make them suitable for providing additional imagery, e.g. a general survey at the first site visit, or the setup of equipment during the subsequent image capture.

The advantages of digital photography are that the equipment and methods need not be so different from conventional film photography. Once the digital back and the correct lens have been acquired, the photography is essentially the same. The great benefit is that images can be checked immediately on an integral camera display, or on a connected computer monitor. With most of the small-format digital cameras it is easy to capture a UV image, because the settings are similar to analogue photography. The relatively low sensitivity of some medium-format digital camera backs can be a problem, for example the Jenoptik *eyelike precision* M16 digital back is rated at only 32 ISO. The long exposure times, of several seconds in some cases, can be problematic if the camera is not mounted on firm ground, for example on a scaffold platform.

14.4.3 Lenses

Fixed focal length lenses are normally used in professional photography, because their optical quality is superior to zoom lenses, and it facilitates the repeatability necessary for documentation imagery. Most commonly used are the standard lenses of focal lengths 50 and 80 mm for small- and medium-format cameras respectively, which have minimal distortion characteristics. For metric photography a fixed focal length lens is permanently attached to the camera body (i.e. it is non-removable) and the lens–camera combination is calibrated. All photographs captured with the camera are supplied with a calibration certificate so that the photogrammetrists are able to compensate for the known distortion when they produce architectural drawings.

In many instances, the area of coverage required and the restrictions of the physical space of the building interior make it necessary to use wide-angle lenses for architectural photography. Panoramic photography also requires wide-angle lenses. In the field of conservation photography macro lenses enable image capture at a scale of 1:1 and greater.

A number of manufacturers now produce digital backs that can be fitted onto existing medium-format camera bodies (see also Chapter 5). When a digital

back is placed onto a standard camera body, in many cases the dimensions of the sensor are smaller than those of the image plane where the film would normally be located. The consequence is that the focal length of the lens is effectively extended. Thus, a standard 80 mm lens for a medium-format camera may behave as a small telephoto lens with an extension factor of about 1.7 and a correspondingly smaller angle of view. A wide-angle 50mm lens will likewise behave as a normal lens. This reduction of field of view (FOV) is a distinct disadvantage, especially for architectural photography.

As an example, the camera developed for use in the VITRA project consists of a Rollei 6008 AF medium-format body with a Jenoptik *eyelike precision M16* digital back. The square CCD sensor has 4096×4096 pixels and dimensions of 36.7×36.7 mm (pixel size of 9 μm), thus occupying only 61 per cent of the linear dimension or 37 per cent of the full 60×60 mm area of the image plane. The consequence is to reduce the effective field of view, i.e. to increase the effective focal length of the lens. Hence the area of wall that can be captured from a given operating distance is reduced, as shown in Table 14.1 for an object distance of 1 m for four commonly used medium-format lenses. At an object distance of 2 m, the dimensions of the area covered on the wall would be doubled and the resolution halved.

14.4.4 Film

Even with the increased quality of film produced for the amateur market, professional film stock should always be used because it gives a consistent quality of colour reproduction, especially if the film is from the same batch. The photographer can be assured that the film has been stored correctly and that the film emulsion has not been affected by heat or process inconsistencies. To achieve a high-quality result the film must also be developed in a professional laboratory, which has in place a recognised chemistry control system to ensure that the film is developed to the manufacturer's specifications.

Lens focal length (mm)	Lens FOV (deg) diagonal / side	Effective CCD FOV (deg)	Area covered on wall (cm)	Resolution (pixels/mm)
40 mm – extra-wide-angle	88 / 68	54 / 42	90×90	4.6
50 mm – wide-angle	75 / 57	46 / 35	70×70	5.9
80 mm – norman	52 / 38	32 / 23	42×42	9.8
120 mm – telephoto	36 / 26	22 / 16	29×29	14.1

Table 14.1

Effective field of view of a CCD of dimension 36.7×36.7 mm in a medium-format image plane of 60×60 mm, and the corresponding wall coverage at a distance of 1 m.

14.4.5 Filters

Filters are normally not used in record photography, because anything that adds an additional optical element in front of the lens will introduce distortion. There are occasional exceptions to this rule, however. An example would be photography in non-visible wavelengths, such as UV fluorescent and infra-red reflectography, which require cut-off filters.

14.4.6 Illumination

One of the most important aspects of all photography is the correct use of lighting. Reflective lighting is the standard method for documentation. Transmissive illumination can be used for transparent materials like stained glass windows. To get a true colour reproduction, flash lights are the preferred source. A professional flash light system provides constant colour temperature of about 560K over the entire intensity range. The short illumination time (only a few microseconds) prevents light-induced damage to the subject and, when combined with a short camera exposure time, is effectively able to eliminate from the image any ambient light that would affect colour balance and exposure.

Individual adjustment of two lights helps to create an even distribution of illumination. Tungsten lamps are not used, because although they can be daylight balanced with filtration the main concern is the heat they generate, which can damage objects and is dangerous for the historic environment. A 'hot lamp rule' on most sites also forbids the use of these units for health and safety reasons.

The shadows created under raking light emphasise the 3D relief of the surface, making visible paint layers, holes, flakes, etc. This is a very useful aid to documentation of the condition of an object, as shown in Figure 14.4. Depending on the object, the use of peripheral equipment such as reflectors, soft boxes can help to diffuse the light and to balance the intensity fall-off of the raking illumination or the rendering of difficult surfaces.

Figure 14.4

Different lighting techniques to render the fragile surface of medieval wall paintings at the former Dominican Church, Bamberg: (a) Diffuse even illumination over an area about 40 × 40 cm; (b) Raking light, emphasising the surface relief; (c) UV Illumination, making visible the different layers.

(a) (b) (c)

On either side of the visible spectrum are the ultra-violet (UV) and infra-red (IR) wavelengths, which provide useful tools in the fields of conservation and restoration. The long wave UVA (366 nm) rays stimulate some materials to fluoresce.[2] This produces a visible image which is valuable for assessment of materials, and for distinguishing between the 'original' and additional work of previous conservation treatments. Specific uses are:

- Separation of different layers;
- Visibility of reduced painting layers;
- Assessment of damage, moisture distribution, small cracks;
- Detection of conservation materials;
- Control of conservation treatments (e.g. reduction of a later coating);
- Control of microbiological growth (some bacteria fluoresce).

Most of these phenomena are also slightly visible in normal illumination, but under UV rays the contrast is enhanced (Figure 14.4(c)). Therefore it offers a very appropriate technique for mapping and documentation. UV rays do not penetrate into materials but react only on the surface. IR rays are able to penetrate through some thin paint layers, making them valuable for the detection of detail normally hidden from view, e.g. the under-drawings of pictures (see Chapter 8).

Within a German research programme (Bundesministerium für Forschung und Technik) for the conservation of wall paintings, a standard for UV fluorescent photography was established [3] to specify the characteristics of UV illumination, UV filters, camera and exposure times to be used for analogue photography. A source of UV illumination that conforms to the standard is the Philips high-pressure mercury *Black light HPW 125 W*. A suitable filter is the Schott *UV Filter MUC2* with transmission spectrum as shown in Figure 14.5.

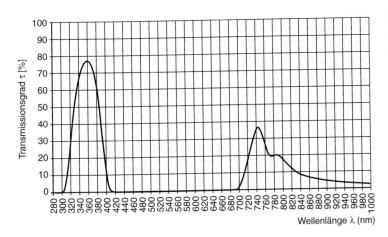

Figure 14.5

Spectral transmittance of the Schott UV filter MUC2. Note that the transmission is effectively zero throughout the visible spectrum 400–700 nm.

For balanced illumination of a large area, two lamps at a distance from 1 to 20 m are recommended. Normally a UV 'barrier' filter is also placed in front of the camera to exclude reflected ultraviolet light, thereby restricting the image to wavelengths in the visible spectrum. This standard is transferable to digital photography.

14.4.7 Exposure measurement

Incident and reflective light measurement are the two methods used to obtain an accurate exposure reading. Incident measurements record the illuminance (lux) of light onto the surface, and hence have the advantage to be independent of the surface properties. Reflective light measurements record the luminance emitted from a surface (cd/m^2), which for reflective objects are the product of the incident light and the surface reflectance factor. Direct reflective measurements are used by photographers only when the object is not accessible, for example a wall painting that is several metres above the ground. Care must be exercised because the light absorption characteristics of different surfaces, which may range from polished metal to dark matt woodwork, could give misleading readings.

In digital photography, the exposure measurement is checked by analysing the captured image through the graphic user interface of the host computer. The histogram or the preview display indicate tonal range and under- or over-exposed areas of the image. It is particularly important to set the white point correctly with a digital camera, because digital sensors do not have the over-exposure latitude of film: once the pixel in a sensor has reached its full charge level, no additional photons can be registered (see Section 7.4). If necessary, it is a simple matter to change the exposure setting and then capture another image. It should be noted that the display screen cannot be replied upon to give the correct exposure. Many factors can cause a false appearance, particularly incorrect screen colour calibration and external light falling onto the screen.

14.4.8 Support of camera

The standard method of supporting the camera is a professional tripod. The capability of the head to move in three dimensions – pan, tilt and yaw – enables optimal orientation of the camera to minimise distortion. The maximum height normally reachable by a tripod is 2.70 m. Higher positions can be reached by lifting the equipment using zip-up scaffolding towers (up to 12 m), scissor lifts (up to 15 m), telescopic masts (up to 18 m), and cherry pickers and cranes (up to 30 m). Height is limited only by the constraints of the building.

14.4.9 Calibration techniques

Standardised targets are used for calibrating the parameters in the image-capture system. These are normally reflective references printed on a sturdy card. They range from exposure control and colour calibration to resolution targets for lens systems. A dimensional scale should always be included within the picture, or some form of survey data should be associated with the image.

The simplest target for tonal control is a neutral grey card that reflects 18 per cent of the light falling upon it, and has a visual lightness of approximately 50 per cent (i.e. mid-way between perfect white and perfect black). This is used to give an accurate light meter reading, and may be particularly useful in photographing objects under difficult lighting conditions. A neutral grey-scale is often employed to establish the sensitometry of photographic materials. These scales are manufactured with specific reflectance densities against which reproduced positives can be compared.

Another important target is the colour checker chart, which should be positioned in the image capture area or recorded as metadata. The chart becomes a reference for colorimetric imaging, especially for colour printing. The MacBeth ColorChecker (Figure 14.6(b)) was originally devised for the photographic film process and has 24-colour reference patches. Six of these represent graduated steps of grey from black to white. The remaining 18 colour patches represent the full reflected gamut and include skin-tone colours used as a colour reference for portraiture. With the advent of digital photography, the GretagMacBeth DC colour chart was devised (Figure 11.10). With 237 patches it provides a larger data set to increase the accuracy needed for digital colour reproduction. It has a 12-step grey scale at the centre plus white, grey and black patches repeated all around the periphery to check uniformity of illumination across its surface area.

Although there are clear advantages to using colour charts for archival purposes, there can be practical hindrances. For example, the size of the chart may not match the size of the object being photographed, and may appear relatively very small or very large (see also Section 3.6). Its presence could interfere with the composition of the image. This may be overcome by taking two images

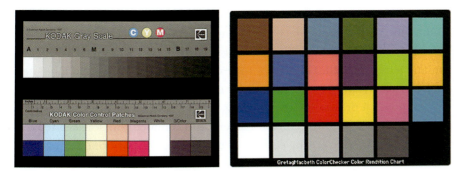

Figure 14.6

Two colour charts commonly used for conservation photography: (a) Kodak Q13 colour control patches and grey scale; (b) Macbeth ColorChecker chart.

with and without the reference chart, but this would double the volume of archival material. There may be very limited tolerances in positioning the angle of the reference chart relative to the light source, which could result in misleading variations in the light reflected from the chart. The colour patches will fade over a long period of time and so they need to be protected as much as possible from exposure to light and should be replaced when faded. The colour chart may need to be positioned in locations with difficult access, especially in high-up places out of reach. A special problem is the photography of stained glass windows *in situ*, where a transmissive reference is needed (see Section 15.4). Ideally the chart would need to be included as part of the window, which is usually impossible to achieve!

It often takes a little imagination to overcome these problems, but ultimately, reference charts are invaluable tools for accurate colour image capture and reproduction. Useful advice is provided by the UK Technical Advisory Service for Images (TASI).[4]

14.5 Setting the Scene

Essential preparation includes identifying the condition and nature of the subject and its surroundings. At the preliminary site visit the photographer should gather the requirements of the clients, such as conservators, archaeologists or architects. Bringing together the expertise of the different disciplines guarantees that the images created will serve a purpose and that the information will be useful to future conservators. The photographer can influence the style and technique of the required images. Above all the content of the photograph has to be arranged to show the subject as it exists at that moment in time.

The majority of historic monuments have been previously documented to varying degrees. These records and other information from the client help the photographer to clarify what is to be included within the brief. Architectural drawings can be used to plan the imaging programme. At this stage physical constraints can also be assessed such as access, power supply hazards and the need for scaffolding. Such forward planning and preparation supports a cost-effective working practice.

Positioning of the camera and lighting always presents a challenge in historic monuments. With documentary photography, evenly lit images are preferred. These are usually supplemented with other capture methods to show the object's form and surface detail. Guidelines for exposure usually cannot be tabulated because of the variety of materials under differing lighting situations. In practice there exists a proven standard setting, known as the *copy setting*, that establishes the initial positioning of the camera and illumination sources relative to the object. The basic setting consists of two flashlights, positioned equally on either side of the camera (Figure 14.7(a)).

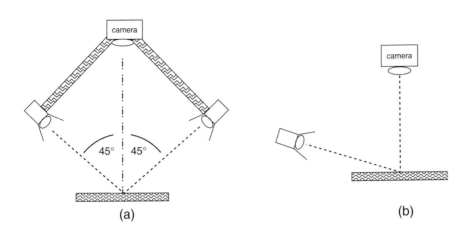

Figure 14.7
Two common methods of
illuminating the object:
(a) copy setting with two
lights positioned at 45° to
the surface; (b) a single
light source at a low
raking angle to highlight
surface relief.

The final adjustments are worked out during the imaging on site. The distance
from the camera to the object depends on the size of the image and the repro-
duction scale, i.e. whether it is an overview or detail image. The scale affects the
resolution of the image. The distance of the illumination is determined by
the size of the object and the position of the camera. The position and angle of
the illumination relative to the object are guided by the surface properties such as
matt, glossy or uneven. Raking light enables the surface texture to be visualised
(Figure 14.7(b)), for documentation of fabrication, layers and damages.

The two following case studies illustrate the range of settings in conservation
photography.

14.5.1 Case study: Dauntsey Doom Board

In October 1998, the Photogrammetric Unit of English Heritage was commis-
sioned to create a photographic record of the Doom Board, taken from St. James's
Great Church, Dauntsey, Chippenham, Wiltshire. Rectified images of the 25 frag-
ile single boards were to be produced. Some of the original boards were missing
and others had suffered physical loss, principally from around their edges. The
client requested that the final arrangement of the Doom Board should be proved
by a virtual montage of digital rectified photography before rehanging the actual
boards. This survey method is ideally suited to flat, non-three-dimensional
surfaces such as painted oak boards.

Setting
A small copy set-up was built in the conservator's workshop to photograph each
board separately. Two electronic flash units were used and fitted with soft boxes.
This provided the ability to control the intensity and angle of the light falling
onto the subject, reducing the chances of highlights reflecting off the shiny
varnish finish. Using a professional flash system also ensured a consistent colour

temperature of 5500K (Kelvin), approximating daylight. A standard Kodak colour chart was used as a reference. A medium-format 120 roll film camera, with a 90 mm lens, was used for the photography. Under the circumstances this was considered the most appropriate format for the project, given its increased flexibility over the larger 5 × 4-in. format. The enlargement factor, from negative up to the final 1:10 print scale, was also well within the capability of the arrangement allowing imagery without loss of definition. Each board was placed on a plain panel to be photographed on which six control targets of 1 cm diameter, were fixed (Figure 14.8). Simple trigonometry was used to determine the 2D co-ordinates for each of the six targets.

Rectification and digital manipulation

To digitise the images, each negative was scanned onto Kodak ProPhotoCD. Each image was digitally rectified with the Rolleimetric MSR software, as shown in Figure 14.9, and scaled to 1:10. Each of the rectified images was imported into *AutoCAD* for viewing and manipulation. The montaging was carried out in Adobe *Photoshop*, which was used for its ability to edit the background and leave it transparent, enabling several different layers of information to be manipulated. Each of the 25 Doom Boards was assigned its own layer, making it simple to rearrange and position them accurately to form the final montage shown in Figure 14.10.

14.5.2 *Case study: the former Dominican Church in Bamberg*

The building of the late Romanesque Hall church in Bamberg, Germany, started in 1310 and continued in the fourteenth, and fifteenth centuries. Throughout these centuries the story of the building and changes of decoration continued until 1803 when the church was secularised. In 1934, the large-scale wall paintings on the north and south walls of the side naves were uncovered. There are three layers of medieval age paintings, partially visible through defects in the

Figure 14.8

Plan of set-up for photography of individual painted boards.

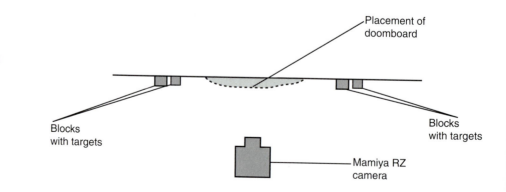

Placement of doomboard

Blocks with targets

Blocks with targets

Mamiya RZ camera

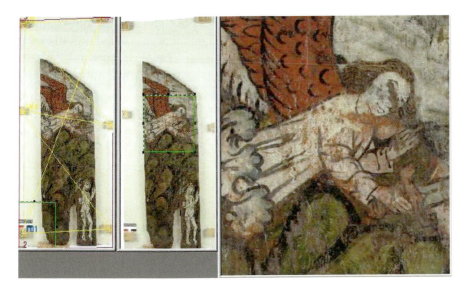

Figure 14.9
The digital rectification process using MSR software from Rolleimetric.

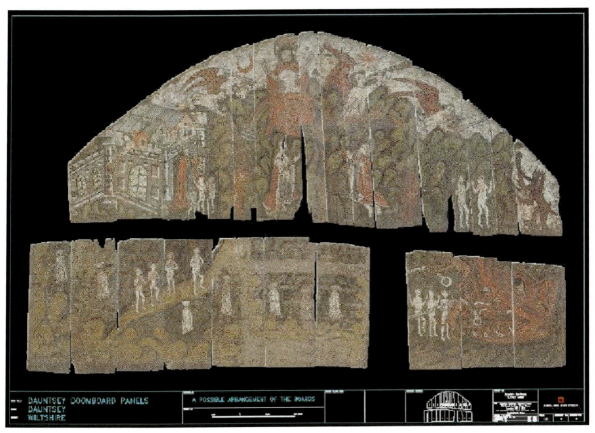

Figure 14.10
The final digital montage of the complete Doom Board.

overlaying layers. The paint layers are powder-like and flaking (a preliminary fixation was made in 2002). The wall paintings had been covered with thick wall hangings to make the room useable as a concert hall. In 1996 the plan for rebuilding started, to make the room usable as the main assembly hall of the University of Bamberg. With this new use the climatic situation will change, and monitoring of the progressive damage of the fragile paint layers is therefore necessary. A set of images was taken for documentation of the rebuilding phase, including the precious wall paintings.

Imaging

All wall and ceiling surfaces of the church were photographed in preparation for the conservation treatments in 2001. A survey of damage and material assessment of the wall paintings was also carried out with UV fluorescent and IR reflectography. The images have been used for documentation of the physical condition and a reference file for the monitoring. A stitched file of the scans of the black-and-white images serves as a base map for the building survey, and documentation of the 'examination openings'. The imagery of the wall paintings also enables material assessment of the different paint layers, damage assessment monitoring (with the changing use of the room), and a basis for planning of the rebuilding works. A virtual reconstruction of the different paint layers was produced for display on partition walls installed at a distance of 1.5 m in front of the wall paintings.

Setting

Two large-format cameras were used: *Linhof* 4 × 5, *Mamiya* 6 × 7, with lenses from Schneider and Rodenstock, of focal lengths 80 mm, 40 mm, 50 mm, 60 mm. Mercury vapour lamps were selected to give high intensity and good daylight colour rendering. The measurements and the images were taken by raising the photographer and camera on the platform of a cherry picker and 'scissor lift'. The camera-to-object imaging distance ranged from 2 to 7 m. After a first metric measurement (Tachymeter) of the building, a schedule for the recording was made. With the large-format camera 96 black-and-white images were taken on negative film (Figure 14.11). Additional colour slides were taken of just the areas with the wall paintings.

Image processing

The films were digitised, then rectified with the measurement data of the tachymeter, and stitched. Software used was AutoCAD 14, Image-Edit 4.1, AutoCAD-Tracer 4.1 and Photoshop 6. The stitched images (Figure 14.12) established the basis for material assessment for conservation, mapping of treatments, and preconsolidation of the paint layers. The mapping for the prints was carried out manually on the scaled prints (1:10, 1:20) on site from

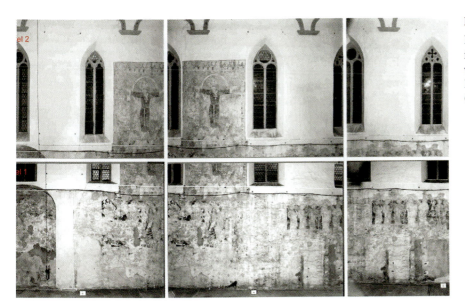

Figure 14.11
Plan of the single images for stitching, on the west wall of main nave. Photographer: Uwe Gaasch.

scaffolding and then transferred into the PC at the office. The images were stored on CDs at the University of Bamberg.

Documentation photography was undertaken by the restorers during work. About 250 small-format colour slides, up to a scale of 1:1, were taken during the survey and conservation works by the restorers. Figure 14.13 shows how different illumination geometries enable different features of the same surface to be rendered.

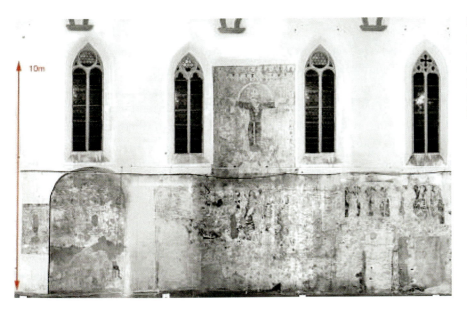

Figure 14.12
Image after stitching of the complete west wall of main nave. Photographer: Uwe Gaasch, Stitching Vera Lutz.

Figure 14.13
Wall painting before the consolidation of the flaking paint layer. (left) diffuse light, macro ring flash; (right) raking light, mercury vapour lamp.

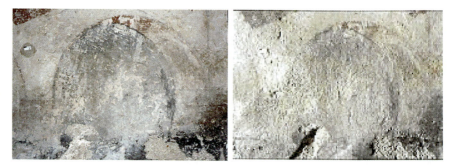

14.6 The VITRA Project

14.6.1 Overview

VITRA (*Veridical Imaging of Transmissive and Reflective Artefacts*) was a 30-month collaborative research project funded under the European Community's 5th Framework Programme (FP5-IST-2000-28008). It developed practical methods for the acquisition, storage and visualisation of high-quality digital images of architectural details in historic buildings.[5]

Its objectives were to investigate several tasks of 'digital heritage imaging':

- Construct a robotic carrier to reach up to 15 m without scaffolding;
- Adapt a high-resolution digital camera for remote control;
- Design illumination apparatus for transmissive and reflective surfaces;
- Enable veridical colour capture of reflective and transmissive artefacts;
- Develop image processing software for image stitching and removal of artefacts;
- Produce interactive software for viewing within a virtual environment.

Five main contractors were included in the consortium: the Colour & Imaging Institute of the University of Derby (UK), Cybernetix (France), Jenoptik (Germany), System Simulation Ltd. (UK) and the Bavarian State Department for Monument Restoration (BLfD, Germany). In addition there were four sub-contractors: English Heritage (UK), Wavecrest Ltd. (UK), CCD Videometrie (Germany) and the University of Padua (Italy). English Heritage and BLfD, as the user organisations in the project, defined the requirements and carried out the practical site evaluation of the imaging system.

14.6.2 Robotic carrier

Cybernetix designed a unique robotic carrier (Figure 14.14) to position a digital camera and illumination to sub-millimetre accuracy with six degrees of freedom at heights of up to 15 m above floor level. It uses a pneumatic telescopic mast

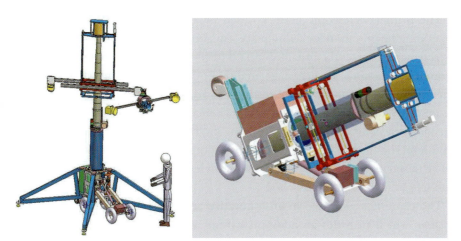

Figure 14.14
CAD drawing showing the design concept of the VITRA robotic carrier: (left) the carriage mounted on the top of the telescopic mast; (right) the carrier folded down for transport.

to carry the camera and flash lighting into locations which would be very difficult to reach by any other means.

The mobile components of the robotic carrier, i.e. the components dedicated to the acquisition systems, were designed to be tele-operated, via an easy-to-use man–machine interface. The MMI provides the operator with means to preview the scene being captured by the camera, to steer the digital camera, to zoom in and out, and to control all other settings. Joystick control enables remote control of height, pan, tilt, yaw and rotation. Stabilisation legs serve to steady and level the mast. It also provides real-time information on the camera's relative position and status of the whole system (power supply, communication, etc.).

The engineering approach to develop a light high-reach robotic carrier with easy erection and placement was first to fix the payload and then to design from top (positioning system) to bottom (moveable carrier) a light, stable, rigid and accurate architecture. Components off-the-shelf (COTS) were employed wherever possible, including the mast telescope. The carrier has rubber wheels in order to be moveable on a flat floor surface and through a standard doorway. When erected it is fitted with stabiliser legs with manual levelling to ensure safety of operation.

The main design characteristics of the VITRA robotic carrier are:

- Vertical reach of 15 m maximum height
- Stabilised legs (with safety interlocks) on floor
- Wheels to move carrier and pass small obstacles
- Less than 2.5 m high in homing position
- Payload of 25 kg for camera and lights
- Maximum payload around 100 kg for principal mast
- Powered elevation system (electric air compressor)
- Total weight 200 kg for integrated carrier.

The primary telescopic mast is raised by air pressure to the approximate operating height, then locked in place. An additional precision carriage on top of the mast provides the fine movements to give the necessary accuracy for positioning the camera. This carriage enables horizontal excursions of ±1 m, using an equilibrated counterweight, in order to reach over any floor obstacle such as an altar, tomb, statue, seating, etc.). The carriage provides three degrees of freedom for X, Y, Z coordinate positioning in 3D. Stabilisation legs help to steady and level the mast. The short legs have a footprint of 1.5 m² allowing the mast to be raised up to 7 m. The long stabilisation legs with 2.5 m² footprint allow the full height of 15 m to be reached.

The camera is mounted in an innovative accurate Pan, Tilt and Yaw (PTY) system, which provides an additional three axes of rotation to orientate the camera in a suitable range to face the scene. A mechanical interface on the PTY system allows it to be positioned in three different configurations: (1) camera horizontal (in central position) facing the wall; (2) camera vertical upwards (to picture ceiling for example); (3) camera vertical downwards (to picture floor). For cylindrical panoramas the camera can also be mounted on the central axis of the mast to rotate around a full 360°.

The functional positioning range of the camera when perpendicularly facing a wall at a height of 13.5 m, and a width of 2 m over a depth of 190 mm (Figure 14.15). The normal camera-to-wall operating distance for photography

Figure 14.15

Geometry of camera motion enabled by the robotic carrier.

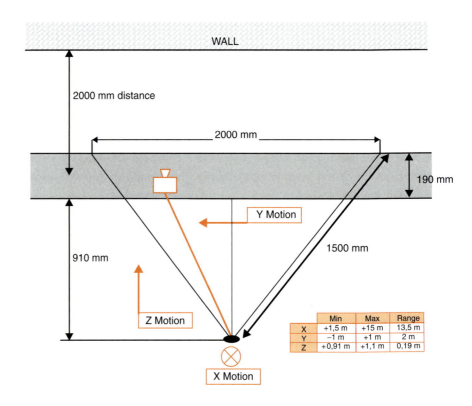

	Min	Max	Range
X	+1,5 m	+15 m	13,5 m
Y	−1 m	+1 m	2 m
Z	+0,91 m	+1,1 m	0,19 m

is in the range 1–2 m. All co-ordinate information is available on the embedded host computer as positioning data references. All orientation movements of the carrier are controlled manually by the operator through the MMI. Laser positioning beams shown on the screen permit the specified operating distance to be set precisely.

14.6.3 Digital camera

Jenoptik developed a new high-resolution digital back, called the *eyelike precision M16*, based on a Kodak 4K × 4K CCD sensor (see Section 7.3.4). It is fitted to an auto-focus Rollei medium-format camera body with an 80 mm AF Schneider lens. This enables high-quality images to be captured with full remote-control over all camera functions.

The Rollei 6008AF, which was developed concurrently during the VITRA project, contains all the functionality of a professional SLR camera such as integrated TTL-exposure measurement and a precise and flexible AF-system. This functionality is necessary in order to work with the camera under full remote control. The digital back is mounted onto the camera instead of the standard film cassette, and connects to the camera's micro-controller through an RS-232 serial interface.

To facilitate constant daylight balanced illumination, a Balcar Nexus A3200 Flash system with two lightweight pencil heads was selected. These had soft boxes fitted to diffuse the light, and were mounted on a bar at the camera head in a copy setting at a distance of 1 m on either side of the camera (Figure 14.16). On matt surfaces this gives an even balanced illumination. For raking light, a separate mast, to bring the flash close to the surface at a great distance, is required. For transmitted light, a lightweight crane from the film industry can be used to position a flash lamp with a soft box on the outer side of a window from outside. Synchronisation is possible with radio remote-control trigger units.

Control of the camera system, all image acquisition, camera-related image processing, display and storage is from the application software on the Apple *Macintosh* G4 PowerBook host computer. Communication with the robot control unit synchronises robot movement with image capture. For selection of the desired surface area and rough control of exposure and focus, a slow video mode is available. More precise control of image quality is possible by image preview, with the help of a histogram function, user-adjustable exposure and flexible sharpness control. After the user agrees to the preview, the image is transferred to a gallery and the robot is informed that a new movement is allowed. Every image in the gallery is automatically related to the metadata, which describe the respective status of the robot, illumination and camera system at the time the image was taken, thus providing all information necessary to repeat image capture in the future. The *Twilight* function allows the operator to overlay the

Figure 14.16

VITRA imaging assembly, showing camera (Rollei 6008AF with 80 mm lens) and two Balcar Pencil lights with soft boxes in copy setting.

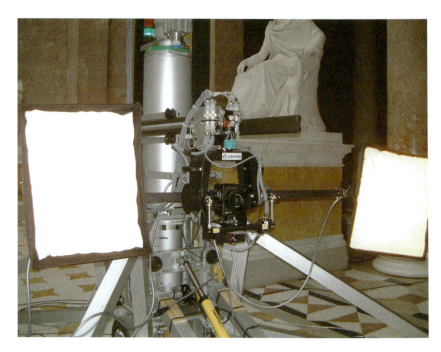

preview image over an existing image, to enable accurate positioning of the camera to repeat the shot (Figure 14.17).

Image processing within the Jenoptik application software compensates all camera and illumination-related characteristics and adapts to the photographic situation on site. Thus pixel defects of the CCD are corrected, electronic behaviour linearised, non-uniformity of the CCD and illumination

Figure 14.17

Screenshot of the Jenoptik graphic user interface on a Macintosh, showing the twilight function with overlaid images of the coffered ceiling at Walhalla.

flattened, RGB pixel data of the CCD interpolated, and colours converted from camera RGB signals to CIE *XYZ* values. The result after processing is a high-quality image of 96 MB (i.e. 16 million pixels in three colour components of 16 bits each). The fully processed image is stored after conversion into the CIE *L*a*b** colour space as a TIFF file. The raw (unprocessed) image file is also stored to enable the possibility of applying new and more specific algorithms to improve colour reproduction in future.

14.6.4 Image processing

To ensure veridical colour-balanced images the camera was calibrated to the prevailing light conditions. For the reflective mode, a standard GretagMacBeth *ColorChecker DC* colour target was used (Figure 14.18). The tone reproduction characteristics of the three channels of the camera were established by plotting the respective normalised *RGB* signal values against the CIE *XYZ* values measured for the thirteen grey patches at the centre of the DC chart. The non-uniformity of the illumination was compensated by constructing an illumination profile, based on an image of a uniform matte surface (white cardboard sheet) taken under the same condition. This white image was used to calculate a correction

Figure 14.18
Keith Findlater holding a GretagMacbeth DC colour chart in the Church of St. Mary, Studley Royal, for characterisation of the VITRA digital camera (left).

factor pixel by pixel. Tests showed that a good colour accuracy could be achieved, with a mean error (ΔE^*_{ab}) of only 2.36. Using the flash lights it was possible to calibrate once before a session with the camera and illumination assembly at ground level. The flash is powerful enough, combined with short exposure times, effectively to eliminate ambient light from the images.

Software was developed by the University of Derby to 'stitch' multiple images into a single large image. The image-stitching problem is to identify corresponding 'tie-points' in successive over-lapping image frames, and then to 'blend' the component images into a single large image on a common coordinate grid. Where the subject is non-planar, some suitable geometric transformations, or judicious 'rubber-sheet' stretching of images may be necessary to produce a seamless result (Figure 14.19). The problem for VITRA images is more complicated than for stitching images of planar objects such as paintings on canvas, because there may be small variations in camera orientation relative to the surface from one image to the next, and because the surface itself may be non-planar or inherently three-dimensional (see Section 15.8). The criteria of success are that: (1) the final image is a geometrically accurate representation of the original; and (2) no joins are visible between component images.

The VITRA stitching was developed as a plug-in to the Vasari Image Processing Software (VIPS), developed over the past 14 years at the National Gallery in London. VIPS contains an extensive image-processing library together with a graphical user interface *nip*. Compared with Adobe *PhotoShop*, VIPS has the

Figure 14.19

Images of eight panels of the painted ceiling of the choir in St. Mary's, Studley Royal, stitched together into a seamless image mosaic using the new software developed in VITRA.

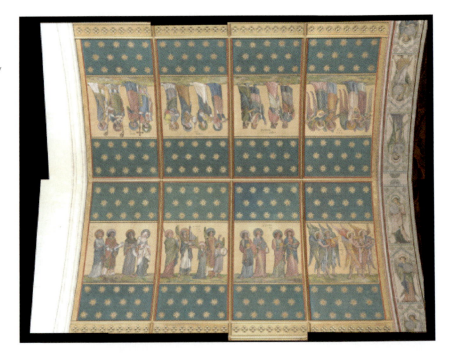

advantages that it is an open source software written in C++, it can deal with very large images (more than 2 GB, and the time consumption for large images is much less. A set of new image-processing functions was developed for images in the *L*a*b** colour space, including: (1) an orthorectification function for perspective correction, to make sure that parallel lines do not cross; (2) up right rotation to ensure that the vertical line is perpendicularly upright to the ground level; (3) multiple tie-points stitching, in which corresponding tie-points are matched to each other and the image is warped if necessary; (4) lightness balance of the luminance of two stitched images by remapping the original lightness of each pixel to the new value using linear interpolation.

14.7 Site Testing

14.7.1 Evaluation objectives

From February to July 2004, the VITRA system was evaluated at three selected sites in Bavaria and one site in England. These were Walhalla in Donaustauf, the former Dominican church in Bamberg, St. Sebaldus in Nuremberg, and St. Mary's Church at Studley Royal near Fountains Abbey. Sites of historical importance were chosen to cover a wide range of imaging requirements in the field of cultural heritage. The criteria on which the evaluation was based were related to five main concerns:

(a) Technical performance of the system and its individual hardware and software components. This included physical characteristics (such as the weight, payload acceptance and stability of a robot carrier; weight and output of a lighting system; recording resolution and colorimetric characteristics of a camera back) and functional features that could be tested under laboratory conditions before prototypes were subjected to field trials.

(b) Usability of the system and its hardware and software components under field conditions (measuring the degree to which they satisfy the user requirements). Criteria include both the degree to which components meet generic specifications (for instance system transportability and weatherproof qualities) and the success (or otherwise) of the system in meeting a particular type of heritage requirement in a real environment (such as photographing a tall stained glass window that has uneven natural illumination and difficult access).

(c) Robustness of the system (reliability and freedom from bugs) under realistic conditions of use.

(d) Quality of results achieved, including resolution and colour accuracy of individual images; accuracy of composite and rectified images (including consistency of colour and form); and the realism of virtual environments or presentations of 3D objects. Comparison was made with results of analogue photography, and image processing for image survey, conservation/restoration work and multimedia presentation.

Figure 14.20

(left) VITRA Robot operating at full height of 15 m in Walhalla to photograph the sloping empanelled ceiling; (top right) one panel in the ceiling; (lower right) detail shows clearly the corrosion of the metal.

(e) Perceived cost-effectiveness and ease of use of the VITRA system in comparison with existing image survey and photographic methods involving the use of scaffolding.

14.7.2 Test site 1 – Walhalla

Walhalla is the 'Hall of Fame', dedicated to the 'Genius of Great German Men'. It was built 1830–1841 by Leo von Klenze for King Ludwig I, and houses more than 250 marble busts of famous German kings, generals, poets, musicians and scientists 'of German tongue'. The interior is richly decorated with precious natural stone. The ceiling is a unique cast iron construction carrying a coffered ceiling made of bronze plates decorated with silver stars on a blue background. The 15 m high ceiling is decorated with painted bronze coffers. Due to condensation the paint layer is flaking. In preparation for a conservation/restoration campaign a photographic record of the ceiling was necessary.

In comparison with photography from scaffolding it was found to be easier and cheaper to take images with the VITRA system, which can easily be adapted to the varying heights of the ceiling. When the camera's auto-focus system worked well, the sharpness and resolution was sufficient for both material and damage assessment. Using flash the colours of images were veridical, and the subtly different colours within the coffers could be distinguished. In a demonstration of the VITRA system to the architects responsible for Walhalla, it was

shown that good images could be obtained of the joints of the later roof windows, which are leaking and need to be replaced. The images indicated, in high quality, the condition of the connections between the glass panels and the metal support bars, and even stains on the glass were visible.

14.7.3 Test site 2 – former Dominican church, Bamberg

The former Dominican church is described above as an example of the range of images encountered in record photography (see Figure 14.4). It was possible to produce high-resolution images from the middle section of the wall painting (Figure 14.21). At the close imaging distance of 1 m, the 4K × 4K image covered an area of approximately 40 × 40 cm on the wall, representing a resolution of 10 pixels per mm. The flaking of the paint is clearly visible. The stitched

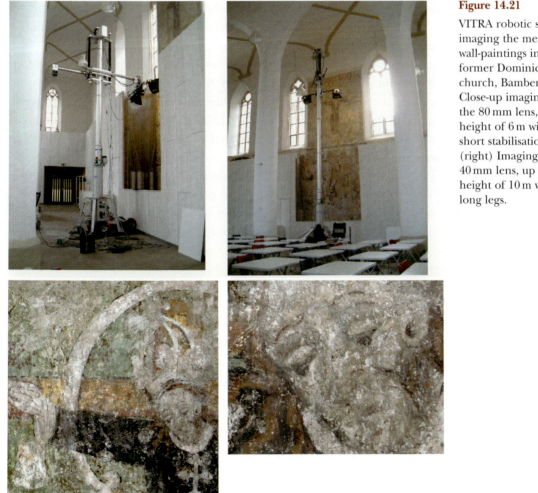

Figure 14.21
VITRA robotic system imaging the medieval wall-paintings in the former Dominican church, Bamberg: (left) Close-up imaging with the 80 mm lens, up to a height of 6 m with the short stabilisation legs; (right) Imaging with the 40 mm lens, up to a height of 10 m with the long legs.

images were used to create a database for planning the necessary conservation and restoration.

Imaging the wall painting, which is 10 m high and approximately 4 m wide, was quick and easy with the robotic system. The VITRA images achieved the high quality of previous analogue images, and the resolution was high enough to show the required detail of the painting. The two flash lights in copy setting gave constant even illumination. For visualising the different layers of wall painting and the damages, such as the flaking of the paint layer, raking light was necessary. The VITRA images with the flash illumination had a better colour rendition than digital images taken with daylight or film images taken with daylight.

14.7.4 Test site 3 – St. Sebaldus, Nuremberg

St. Sebaldus in Nuremberg was built in sandstone from 1230 to 1490 in the late Romanesque and Gothic styles. The medieval stained glass windows date from fourteenth to sixteenth century and were designed among others by Hans von Kulmbach and Albrecht Dürer. Deterioration of the glass and deposition of gypsum crusts on the outer surface caused by environmental pollution necessitated restoration in the first half of the twentieth century. The windows were removed for safe-keeping during World War II, and afterwards they were put back in place behind an outer glass shelter. Extensive restoration including the renewal of the glass shelters took place 1985–1990. Because of difficult damage symptoms a detailed record of the stained glass windows is necessary for monitoring the state of conservation.

The spacious Hallenchor of St. Sebaldus facilitated the positioning of the VITRA robotic carrier in front of the precious stained glass windows at a distance of 3 m (Figure 14.22). To detect damages in the paint layer reflective illumination was used. Ideally there would have been additional raking light. To capture the images the glass paintings were photographed with transmitted light, in this case natural daylight. Good images were obtained with external daylight, subject to the variability of colour temperature.

Stained glass has a wide dynamic range from the lightest highlights to the darkest shadows. As in analogue photography, digital imaging of stained glass windows ideally needs a sequence of exposures to acquire all the tonal information. Remote control of the VITRA camera, combined with the stability of the carrier, made this easy to achieve (Figure 14.24).

14.7.5 Test site 4 – St. Mary's, Studley Royal

St. Mary's Church at Studley Royal is the ecclesiastical masterpiece of William Burges, one of the most original and yet most characteristic of High

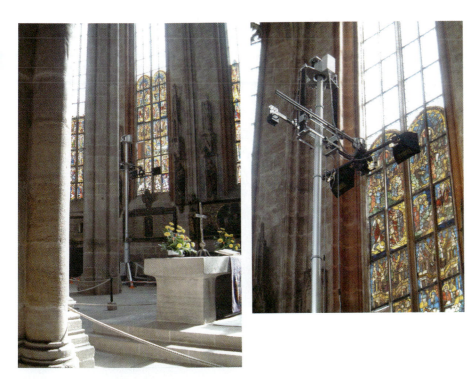

Figure 14.22
VITRA robotic system in operation in front of the stained glass windows in the choir of St. Sebaldus Nuremberg: (left) at a height of 9 m; (right) with the Balcar flash lights in copy setting at 14 m height.

Victorian architects. It was built by the Marchioness of Ripon in 1871–78. The interior gathers together a whole variety of different materials, including mosaics, gilding, wall painting and stained glass windows. The site is still in its original condition (i.e. it has never been restored) and needs regular monitoring for conservation purposes.

It proved possible to image the stained glass windows at St. Mary's with the Rollei 6008AF and the Jenoptik *eyelike precision* digital back in both transmitted and reflected light (Figure 14.24). Due to the low window height of about 2 m it was possible to position the flash with soft box from outside in front of the window.

The VITRA system was also tested at St. Mary's for creation of an interactive panoramic walkthrough. The VITRA camera with 40 mm lens was used on a ground-based tripod to capture 20 cylindrical panoramas at 5 exterior and 15 interior locations around the church. Each panorama was made up of 12 images taken at 30 deg rotational increments, converted to full resolution TIFF format, then stitched together to make cylindrical panoramas using *Realviz* software. The innovative viewer software from the University of Padova was applied for the interactive display of the panoramas (see Chapter 17).

Figure 14.23

Stained glass windows at St. Sebaldus: (a) digital stitched reconstruction of complete window light 15×2 m; (b) one image of 4K × 4K pixels, imaged at distance of 3.5 m with 80 mm lens, transmitted light; (c) detail showing the eponymous saint.

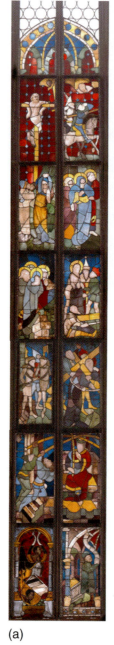

(a)

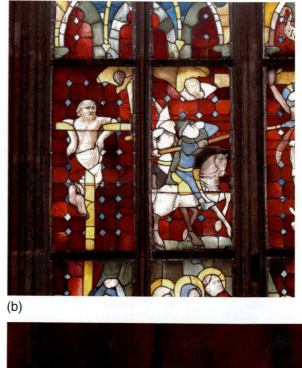

(b)

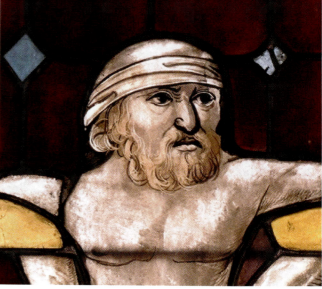

(c)

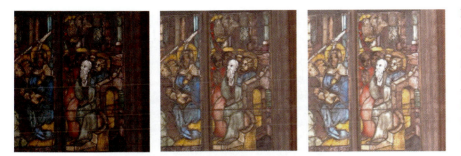

Figure 14.24
Digital image sequence (bracketing) of stained glass windows in St. Sebaldus Nuremberg, with different exposures in transmissive illumination permits optimum capture of highlights (left), mid-tones (centre) and shadows (right).

14.7.6 Observations from the VITRA test sites

From the on-site evaluations of the VITRA system, the following conclusions were reached:

- The accuracy of camera characterisation was good enough for recording colour in real scenes. Compensation for the non-uniform illumination was valuable for image colour correction.
- The digital images had sufficient resolution for the specified survey and conservation purposes.
- Users felt that they could achieve in a digital image a similar degree of definition and colour saturation as in film.
- The image database functioned very well and the performance of most of the functions was 'excellent'. The system and GUI were easy to use.
- The versatility of the digital system led users to believe that digital origination will replace film-based systems when archiving issues have been resolved.

The site tests showed that the VITRA robotic system is a good tool for imaging objects at high level, up to 15 m. Remote control from the ground makes the imaging easier and cheaper than hiring in the usual scaffold tower or hydraulic lift. Because of the precise control over the imaging conditions, such as distance, illumination and camera parameters, it is possible to stitch the single digital images together. The resolution of the digital back is sufficient to show details of damage, such as flakes and cracks, necessary for conservation purposes.

The high degree of repeatability is essential in historic documentation for monitoring the state of conservation of an object. The various image-capture parameters, including camera position, distance from object, lens, and lighting are automatically recorded as metadata in the digital format. This metadata eases the requirement of repeatability (refer to Chapter 10).

The physical realities of many sites, such as pillars and church furnishing, constrain the positioning of the equipment, however, making it necessary for

Figure 14.25

Stained glass window at St. Mary's, Studley Royal: (a) image taken by transmitted light with one Bowens flash diffused by a softbox from outside, after physical removal of the shelter grill; (b) same subject with shelter grill attached, producing shadows; (c) image taken with reflected illumination showing surface of glass and lead calmes.

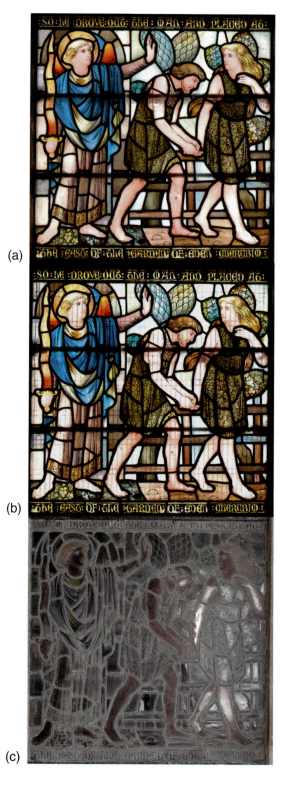

the photographer to adjust the setting on site. The great advantage of digital techniques is that if a large-sized object such as a wall painting cannot be imaged as a whole, then subsequent image manipulation and stitching can be used effectively.

14.8 Summary

This chapter has demonstrated the feasibility of achieving a high-quality image representation of a heritage object. With the different choices of equipment and setting, the requirements of clients can mostly be fulfilled. Deviations due to location constraints may force the photographer to adjust the basic setting, therefore it is impractical to give a fixed formula. Techniques used for traditional analogue photography can be migrated to digital photography with a few modifications. The use of digital imaging has real advantages over the traditional wet analogue process in having the ability to see the image immediately on site. This possibility of proofing the quality of the image and the required content saves time. If the client is also on site the images can be approved immediately by inspection.

The highly accomplished standards of traditional architectural photography encompass over 150 years of photographic expertise. Whilst it is easily possible to use digital image processing to make corrections to captured images, this should not be thought of as a tool for correcting badly taken images. Careful initial planning and setting up of the shot are indispensable.

Digital imaging is a relatively new medium that currently complements but does not yet supersede film photography. There are advantages and disadvantages to both systems depending on application, required resolution, cost, archival stability, portability and accessibility. Novel systems such as the VITRA robotic carrier make new forms of site photography possible. It is likely that further advances will be made in the forthcoming years that will improve the capability of direct digital capture.

14.9 Acknowledgements

The authors would like to thank their colleagues in connection with the location photography in Germany and England. Further thanks are due to Prof. Rainer Drewello and Dr. Ursula Drewello, who kindly provided images of the former Dominican Church in Bamberg.

14.10 References

1. English Heritage, *Metric Survey Specifications*, 2000, product code XH20155, ISBN 1873592574 EPL Access, Barford Road, St. Neots, Cambs., PE19 6WB Linhof, Image circle, München. 2002, p.28

2. Mairinger, Franz, Strahlenuntersuchung an Kunstwerken, Leipzig 2003
3. Authenried P., Aldrovandie A. and Turek P. (1990). in Kunsttechnologie.
4. http://www.tasi.ac.uk/advice/creating/targets.htm/
5. A more complete account of the project may be found in the Final Report at www.vitra.org

14.11 Graphics

Cybernetix Deliverable D10, p. 60

Schott catalogue of interference and special filters, Mainz.

Except where noted all illustrations used in this article were taken by Nick Beckett (English Heritage) and Barbara Schick (BLfD)

14.12 Registered Trademarks

ABC – Products GmbH & Co KG

Adobe – Photoshop image retouching software

Apple Computer – Macintosh

Apple Computer – QuicktimeVR panoramic image editor and display

Arri – lighting

Autodesk – AutoCAD computer-aided design software

Balcar – Nexus flash system

Bowens – Traveller flash system

Cybernetix – robotics manufacturer

Jenoptik – eyelike precision digital camera back

Kodak – ProPhotoCD digital image recording system

Realviz – image stitching software

Rollei – medium-format camera systems

Imaging of Stained Glass Windows

Lindsay MacDonald, Keith Findlater, Richard Tao Song,
Alfredo Giani and Shanmugalingam Suganthan

15.1 Introduction

Stained glass has been an important medium for the illustration of European culture and history for over 1500 years. Stained glass windows originally served an architectural purpose, being designed to admit light to the interior of the building through openings within the structural masonry. The medieval window comprised panels, lancets and traceries, each anchored into the surrounding masonry by iron ferramenta or saddle bars. As time passed, designers recognised the potential of this unique translucent medium and construction techniques became more sophisticated and the ambition of benefactors grew ever greater. The range of colours expanded and the H-shaped strips of lead, or calmes, which held together the separate pieces of glass became incorporated into the designs. In the great church architecture of the fourteenth and fifteenth centuries, stained glass became an essential part of the medieval multimedia experience.[1]

Strictly speaking, the term 'stained glass' refers to a specific glass-painting technique from the early fourteenth century, in which yellow stain was applied to clear glass. In practice, the term is widely used today to mean any leaded windows of coloured or painted glass. Several factors affect the body colour of glass, including the chemical composition of the raw materials, melting times and temperatures, and how the glass was cooled from the molten 'pot-metal' state.[2]

Glass has the paradoxical qualities of being both brittle and highly durable, able to survive for many centuries. Glazed artwork resists fading and weathering, and in general it is likely that original stained glass will out-survive any of its reproduced archival images. Yet, because glass is so fragile, it takes only a moment for it to be cracked or broken. Typical threats include damage from stone projectiles, birds, fire, weathering, acidic atmosphere, and condensation. It is therefore important to have visual records for historical and restoration purposes.

Although stained glass windows are robust enough to survive *in situ* for many hundreds of years, they may become very fragile when removed. The component

panels and traceries may be very heavy, especially with the weight of the lead work, and can also lack rigidity because of the matrix of the separate pieces of glass held together by flexible lead. Some panels from the eighteenth century were painted with enamels on very thin glass, making it now almost impossible to move and work on them without damage.

15.2 Survey of Stained Glass Studios

The role of the stained glass conservator is primarily to preserve and maintain existing glass. The role of the restorer is to repair damaged glass by cleaning, stabilising, repainting and (only when unavoidable) replacing with new materials and artwork, generally carried out off-site in a workshop.

A survey in 2001 investigated the imaging requirements of stained glass conservators and restorers across the UK and Europe.[3] A questionnaire was sent to a range of stained glass studios accredited by the UK Institute for Conservation (UKIC). The following figures are based on an analysis of 27 responses received. It was found that more stained glass is restored from the nineteenth century than any other, although medieval stained glass (fifteenth century and earlier) accounts for approximately 25 per cent of work (Figure 15.1).

Questions about the width and height of panels produced the distributions shown in Figure 15.2. The results indicate that the majority of panel widths are in the range of 50 to 70 cm (20 to 28 inches). Such dimensions are typical of the spacing between the stone mullions in multi-panel church windows. In the case of panel heights, the majority are in the range 60 to 100 cm (24 to 40 inches).

With regard to window features captured in the photographic image, the resolution of painted detail was rated most important. Visibility of the glass itself and attributes such as surface corrosion were regarded as important, while indications of the condition of leads, makers' marks, and sorting marks were said to be very desirable.

Figure 15.1

Century of origin of stained glass restored in studios.

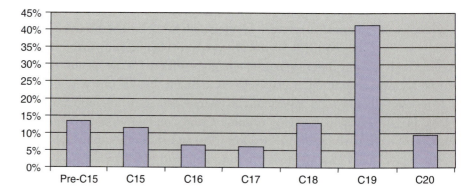

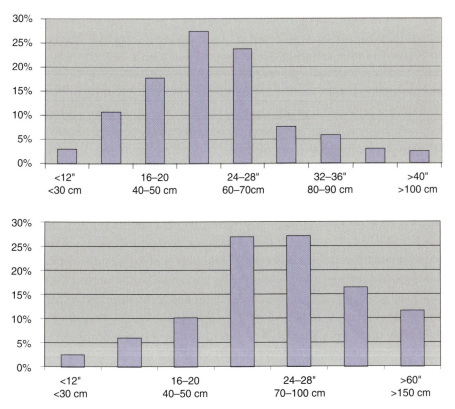

Figure 15.2
Distribution of widths (top) and heights (bottom) of stained glass panels restored in studios.

Another question asked about is the type of lighting used for the illumination of stained glass panels. The responses showed that approximately one-third of studios use daylight only, a further third use light boxes only, and the remainder use a variety of sources including tungsten and flash light. Various lighting set-ups were described, depending on the facilities and imaging requirements needed. In general, the techniques were simple with daylight and artificial light sources such as light boxes or tungsten lamps.

For the photography of panels over 60 per cent of studios used specific guidelines, such as those from the Council for the Care of Churches (CCC). The main uses for photographs in conservation/restoration were described as illustrating the state of the window throughout the process of restoration: before to record the existing condition/damage; during to show the treatments applied, including occasional microscopic images; and after to document the final condition. Other reasons for photography were:

- To make a conservation record with before/after images and written details of the condition and work done;
- To prepare archival images, including details of the glass painting, etc.;
- To create a visual record, especially for monitoring degradation over time.

The majority of respondents claimed to spend 5–10 per cent of their time on photography. Approximately 80 per cent were using 35 mm SLR film cameras and 20 per cent were using digital cameras, although since 2001 the balance has probably changed substantially because of the rapid development of the latter. Most respondents were positive about the potential for digital photography to speed up the restoration process and to facilitate the illustrating of documentation and reports. It was considered to be especially promising for site survey in the preparation of contract proposals.

15.3 Photography of Stained Glass

A stained glass workshop usually has horizontal light tables on which the glass panels can be laid out to enable the conservator to see clearly details of the glass and paint work. For the purposes of photography, a tilting or near-vertical light box may be more convenient, with a strong horizontal bar to support the weight of the panels. Figure 15.3 shows a custom light box constructed by Verivide Ltd. for experimental work at the University of Derby. The design was influenced by a light table used at the York Glaziers Trust.[4] The objective of the new design was to accommodate the majority of panel sizes determined from the survey of stained glass practitioners, with uniform diffuse illumination over the full working area of 1 metre square. Ten fluorescent tubes simulating D65 daylight were employed, giving a high luminance level of approximately 3400 cd/m². High-frequency electronic ballasts were used to prevent flicker.

The contrast range of stained glass, from clear to the darkest blues and purples may be in excess of 5000:1, greater than the sensitivity range of most photographic film and digital sensors. Photography of the transmitted image is therefore a challenge, and some compromises usually have to be made, sacrificing

Figure 15.3

Using a Rollei/eyelike digital camera to photograph two stained glass test panels on a custom-made light box.

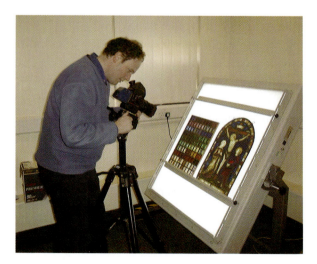

detail in either the highlight or shadow regions. For a complete record, it may be necessary to take multiple images of the same subject, bracketing the exposure above and below the midtone setting to capture the full density range.

Front lighting is used to illuminate surface details of the glass and (for pictorial purposes) to illuminate opaque regions such as the lead calmes and masonry. The reflective image complements the transmissive image by providing additional information of value to the conservator. The angle and directionality of the lighting determines the length of surface shadows and the emphasis of surface relief.

Stained glass windows in their normal architectural setting are usually illuminated from both outside (by daylight) and inside (by interior lighting and ambient illumination), and hence images of the windows normally contain both transmitted and reflected components. The proportions vary according to the time of day, so that in bright sunshine, the transmitted light will be dominant, whereas at dusk the reflected interior light may be more prominent. The daylight components are continuously variable in direction, intensity and colour temperature. Factors that affect the imaging of stained glass in daylight include the position and orientation of the window within the building, weather conditions, colour of the sky, and position of the sun at different times of the day and year, including background foliage.

In order to standardise the illumination, a 'black-box' technique was used for photographing the stained glass windows at Fairford Church in Gloucestershire.[5] The aim was to eliminate daylight and use only controlled artificial illumination. The camera was set at a fixed distance from the window and a 'tunnel' constructed from a pyramidal frame covered in black cloth was used to eliminate flare and ambient daylight from inside the building. On the exterior, a light source consisting of a 500-watt tungsten-halogen floodlight with a softbox diffuser was pressed up against the window. This provided a controlled and uniform source of illumination for imaging by eliminating the effect of daylight.[6]

Stained glass windows in many cases are large in surface area and also contain a wealth of artistic detail in the painted areas. The image should ideally resolve the finest spatial detail, equivalent to the width of one hair of the glass-painter's brush.[7] The consequence of capturing a digital image of a full-size window at such a level of detail is that very large image files are created. For example, a single panel of dimensions 40×40 cm captured at 10 pixels/mm (sufficient to resolve 5 lines/mm) would produce a file of 4000×4000 pixels, which for three colour channels of 16 bits each would have a size of 96 Mb. To cover a four-lancet window of height 5 m, typical of the windows in many parish churches, would require 50 such images, requiring nearly 5 Gb of storage.

In planning the image acquisition, a compromise must always be made between resolution, number of images, window size and file size. Resolution on

the surface of the glass is dependent on magnification, which is determined by the subject-to-camera working distance and the focal length of the lens. These also determine the area of stained glass being photographed. The actual resolution achieved by a digital camera depends on the dimensions of the CCD pixel array, the physical size of the sensor, the modulation transfer function (MTF) of the camera lens and other factors such as electronic noise and quantisation.[8,9]

15.4 Camera Characterisation

It is highly desirable when using digital photography to capture the true colours of the stained glass, meaning the colours that would be seen by a standard human observer in standard illumination and viewing conditions. Such an image is termed colorimetric, and is usually referenced to the CIE standards (see Chapter 20). For a transmissive object, such as a window with stained glass, the light source and the camera are located on opposite sides. The light passes through the target and is partially absorbed by it before reaching the observer or camera.

To achieve colorimetric image capture, a characterisation model is needed to convert from the Red-Green-Blue (*RGB*) colour signals generated by the camera and a device-independent colour space such as CIE tristimulus values (*XYZ*). Generally speaking, the colour gamut for transmissive objects is larger than for reflective objects. In other words, the glass colours may be more saturated and have higher densities than for reflective surfaces, which will affect the performance of the characterisation model.

15.4.1 Polynomial model

It is possible to measure the spectral sensitivity of the camera channels directly with the aid of a calibrated monochromatic light source, but this is a time-consuming procedure best performed in the laboratory.[10] Instead polynomial models based on the least squares error minimisation method are widely used for characterising digital cameras because they can be applied without knowledge of the spectral sensitivity of the camera's sensors. Polynomials of different degrees give different accuracy of characterisation. According to previous studies [11], a third-order polynomial should usually be sufficient. Fourth or higher orders may actually worsen the model performance because the high-order terms tend to amplify the image noise and give poor predictions for extrapolation outside the range of the training data set. The characterisation model can be represented in a simple form as a product of two matrices:

$$\mathbf{H} = \mathbf{MR} \tag{15.1}$$

where:

\mathbf{H} is matrix $[X_i\ Y_i\ Z_i]^\mathrm{T}$, $i = 1, 2, \ldots n$, where n is the number of samples;

M is a $3 \times m$ matrix of coefficients, where m is the number of terms in the polynomial;

R is matrix $[R_i^j G_i^k B_i^l]^T$ where $0 \leq j + k + l \leq h$, $i = 1, 2, \ldots n$, where h is the degree of the polynomial.

By the well-known regression method for solving a system of equations to minimise the sum of the squares of the errors, the solution **M** of Eq. 15.1 is given by:

$$\mathbf{M} = \mathbf{HR}^T (\mathbf{RRT})^{-1} \qquad (15.2)$$

In this study, a third-order polynomial equation with 20 terms per colour channel was used, in the following form:

$$R = [R\,G\,B\,R^2G^2B^2RG\,RB\,GB\,R^3G^3B^3GR^2\,RG^2\,RB^2\,BR^2\,BG^2\,GB^2\,RGB\,1]^T$$

15.4.2 Glass test panels

Two glass test panels, with 50 stained glass tiles each, were constructed as characterisation targets as shown in Figure 15.4. The glass tiles were 1.3 by 1.8 inches

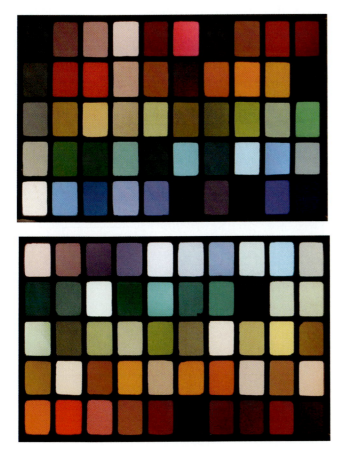

Figure 15.4

Two stained glass panels custom-made for camera characterisation: (top) training panel with grey scale on the left; (bottom) test panel with rows organised in hue order.

(3.4 by 4.6 cm) in size, arranged in 5 rows by 10 columns, to give an overall panel dimension of approximately 16 by 10 inches (40 by 25 cm). Before they were leaded together, the glass tiles were measured individually using a Macbeth *Color-Eye 7000A* spectrophotometer to determine their transmission spectra.

The glass tiles were chosen from over one thousand workshop samples with the help of an expert stained glass window restorer, Keith Barley of Barley Studios in York. The selection criteria were:

- The training set should contain enough neutral or near-neutral colours to form a 'tone scale' from transparent (white) through grey to near opaque (black);
- Colours should be typical of those found in real stained glass windows;
- The colour gamut should be as large as possible, including very saturated dark colours;
- The glass should be uniform (no bubbles inside, no texture, colour looks uniform);
- The training set and test set should be made of physically different colours.

The *XYZ* values of each glass piece were calculated from its measured spectral transmittance distribution and the spectral power distribution of the flash lamp, using the CIE 2-degree standard observer. Figure 15.5 shows how the colours of the selected glass pieces are distributed in the CIE 1931 *x-y* chromaticity diagram. Some of the colours, particularly deep red and deep blue, are very close to the spectral boundary, indicating a high degree of colour saturation.

Figure 15.5
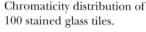
Chromaticity distribution of 100 stained glass tiles.

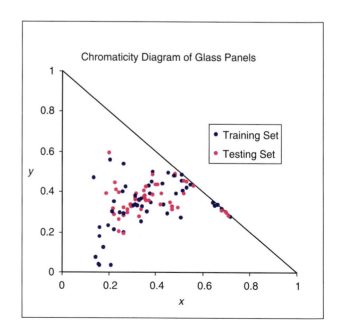

15.4.3 *Photographic setting*

The illumination of a real stained glass window is critical for photography. The simplest means is to use natural daylight as the source, but because daylight changes from minute to minute and varies across a wide range at different times of a day, weather and seasons, the appearance of the stained glass window under such illumination may also change greatly. One solution to this problem is to use a standard light source that has a constant spectral power distribution. A studio flash lamp with a softbox diffuser provides an ideal source for this purpose, when held against the outside of the window. Some additional advantages of this method of illumination are:

■ There is no shadow caused by trees or other structures outside the window;
■ It is economical and consistent because flash is standard photographic equipment for taking pictures of reflective objects;
■ The flash intensity is easily controlled;
■ Flash is synchronised and has a very short duration, which means that the camera exposure speed has minimal effect on the appearance of the illuminated glass.

Therefore in the experiment, a flash lamp with a softbox was employed as the light source. The glass panel was placed directly in front of the diffuser of the softbox, with the camera approximately one metre distant. An 80 mm auto-focus lens was used on the Rollei 6008 AF camera with Jenoptik M16 digital back. The lens aperture was set to $f18$ and a check made to ensure that there were no over-exposed regions within the image. The exposure speed was set to $1/1000$ s so that ambient light was effectively eliminated.

Although in the softbox two layers of woven diffuser material were applied to smooth the distribution of the flash light, the illuminating surface was still not uniform. Figure 15.6 shows the luminance distribution over the illuminated area, based on analysis of a 'white image' without the glass panel, showing that the luminance was higher in the centre and lower around the edges. In fact the maximum luminance in the centre was over double the minimum luminance in the corners. Deriving the colour transform matrix without correcting for such non-uniformity would give a false result.

The average pixel values for an area within each glass tile were corrected by dividing by the corresponding relative luminance value. The illumination profile can be applied in two ways: either to the CIE *XYZ* values or to the camera *RGB* values. For the former, the *XYZ* tristimulus values of the glass tiles are adjusted so that the modified values represent what would be seen in the actual scene. For the latter, the output image is normalised as if it were illuminated by uniform lighting.

Figure 15.6

Non-uniformity of the illuminating surface, showing the maximum intensity near the centre and fall-off towards the corners.

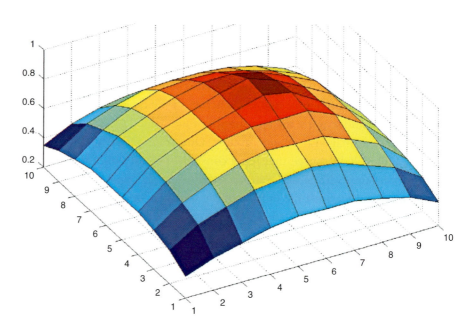

15.4.4 Model performance

The performance (expressed in colour difference units of ΔE^*_{ab}) of a cubic polynomial model with 20 terms, when applied to the *XYZ* image data, was a mean error of 2.8 for the training set and 3.9 for the test set, with a maximum error of 17. The performance when applied to the *RGB* image data was a mean error of 3.3 for the training set and 3.6 for the test set, with the maximum error reduced to 13 for the test set. This indicates that the correction of *RGB* values produced slightly more consistent results. The large errors occurred for colours close to the edge of the spectral locus (the outer horseshoe shape in Figure 15.5). Such colours are very saturated and may easily fall outside the colour gamut of a digital camera.

Figure 15.7 plots the errors in the CIELAB colour space between measurement and prediction against measured lightness, chroma and hue respectively. Large errors (greater than 9) occur for dark (*L** less than 25) and colourful (*C** more than 40) glass tiles. There is no obvious relationship between the error and hue angle. Such a finding confirms that substantial errors in modelling camera response may arise because of the large colour gamut of stained glass.

15.5 Removing Shadows from Images of Stained Glass

Because glass is translucent, images of stained glass windows taken with external illumination very often contain shadows cast by external structures, as shown in Figure 14.25(b) and Figure 15.8. These fall into two main types: protective wire

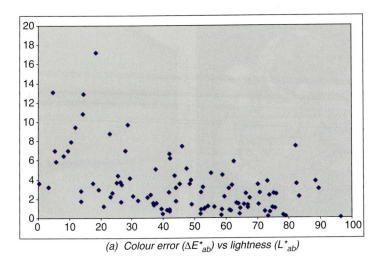

*(a) Colour error (ΔE^*_{ab}) vs lightness (L^*_{ab})*

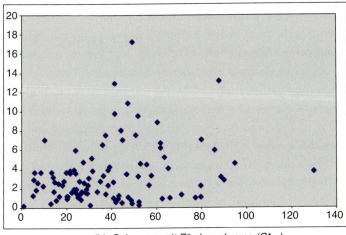

*(b) Colour error (ΔE^*_{ab}) vs chroma (C^*_{ab})*

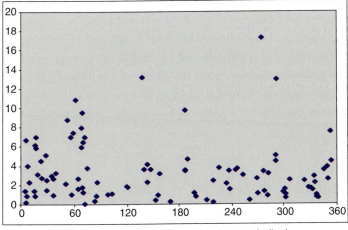

*(c) Colour error (ΔE^*_{ab}) vs hue angle (h_{ab})*

Figure 15.7

Distribution of colour errors (ΔE^*_{ab}) between predicted and measured values of colours of glass tiles in CIELAB.

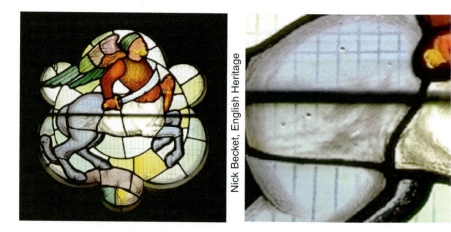

Figure 15.8

Shadows of a horizontal support bar and wire mesh grille in a stained glass window. The detail (right) shows both the transmitted image of the grille and its shadow cast by the sunlight. The window is in the chancel of the Church of St. Mary, Studley Royal, Yorkshire, UK.

Nick Becket, English Heritage

grilles and iron support bars (ferramenta). Such shadowing objects are generally irremovable for the purposes of photography, either because they are difficult to access, or because they constitute integral structural elements of the window. Image processing can help to remove, or at least to minimise the visual impact of, unwanted shadows from the window images.[12]

The observed image, as captured by the camera, may be modelled mathematically as a combination of a 'true stained glass image' and a 'grille/bar shadow image'. If this mixture can be separated into its original components, then it should be possible to remove the unwanted shadow component from the captured image to produce the desired image of the stained glass without the shadows.

A shadow is produced when a surface element (grille/bar) acts as a blocker of some of the light emitted by another surface element (light source). The blocker stops some of the radiant energy along its path. The energy is then absorbed or redirected. Because there is usually a gap between the grille/bar and the window, the shadowed region of the glass still receives partial illumination from the non-point source of the sun's disc at the edges (penumbra) and from the diffused skylight overall. This suggests that the response of the camera in the shadowed region should be related to the response in the neighbouring unshadowed region. Since the effect of the blocker is to reduce the amount of illumination, there is a multiplicative relationship between the pixel value P_S corresponding to a grille line and its closest non-shadowed pixel value P_{NS}:

$$P_S = \alpha(\cdot)P_{NS} \quad \alpha(\cdot) \in [0,1] \tag{15.3}$$

We assume that the 'shadow factor' α depends on parameters such as the distance between the blocker and the glass, the thickness of the blocker and the type of glass. An opalescent glass will tend to scatter light, therefore yielding values of α closer to unity. On the other hand, a very transparent glass will produce a more distinct and possibly darker shadow, therefore yielding

values of α closer to zero. The observed image intensity $I_o(x,y)$ can then be modelled as:

$$I_o(x, y) = \alpha(x, y) \cdot I(x, y) \quad \text{for } \alpha(x, y) \in [0,1] \qquad (15.4)$$

where: x, y are image co-ordinates in pixels; I_o is the observed image; I is the true image; α is the grille/bar shadow image; and $\alpha(x,y) \in [0,1]$ if x, y lies on a bar line, else $\alpha(x,y)=1$.

15.5.1 Removing bar shadows

A prerequisite for the development of physically based shadow computation is knowledge about the distribution of light in a scene from each of the illuminating sources. Figure 15.9 illustrates the concept of an illuminating hemisphere.

The illuminating hemisphere is a notational device for describing the illumination 'events' above or below a surface. These events, produced by light sources or other reflecting surfaces, are projected onto the hemisphere. A solid angle specifies the amount of the hemisphere covered by the projection of the illumination. A differential solid angle is defined as a projected differential surface element on the hemisphere divided by the square of the radius of the hemisphere. The solid angle of an illumination event is determined by integrating the differential solid angle over the bounds of the projection of the event.

Physical models can explain the formation of 'simple' shadows. The most powerful tool for analysing this problem is to think about *what a source looks like from the surface*. This technique enables a qualitative description of 'brightness'. An idealised form is the Wall-Bar model, where a bar of infinite length casts a shadow onto an infinite surface (wall) illuminated by a perfectly diffused light source (overcast sky) with the geometry shown in Figure 15.10.

The solid angle of the bar is determined by projecting it onto the illuminating hemisphere above the surface and integrating the area of the projection. Figure 15.11 sketches the appearance of the infinitely long bar at two points A and B on the infinite wall. The bar projected onto the illuminating hemisphere looks rather like a segment of an orange, converging to a polar point at either end as the bar recedes to infinity. All points on a given horizontal line on the wall 'see' the same input hemisphere, and so must have the same 'brightness', but points along a vertical line see different amounts of the input hemisphere (Figure 15.12).

Based on this technique, Figure 15.13 shows the typical shadow profile predicted by the simple model, plotting brightness as a function of vertical position on the wall, with bar diameter as a parameter. Figure 15.14 shows a family of actual shadow profiles extracted from the pixel values of a photograph of a real window.

Figure 15.9

The illuminating hemisphere.

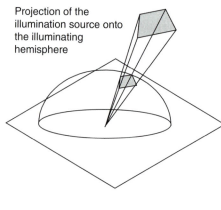

Projection of the illumination source onto the illuminating hemisphere

Figure 15.10

Brightness of the shadow cast by an infinitely long bar onto an infinitely long wall, under a uniformly overcast sky.

Infinite wall

Overcast sky

Infinitely long bar

Figure 15.11

Projection of the bar onto the illuminating hemisphere.

A

B

Figure 15.12

Projected outline of the bar.

β

A

y

$d/2$

0

D

d

a

Figure 15.13
Physical model prediction.

The resulting shadow profile is a bell-shaped curve. In order to determine the shape of the curve, it is necessary to know the diameter of the bar and its distance from the wall. This simple model provides a useful first approximation, but for a more sophisticated model of transmissive media one should consider other effects, like multiple reflections within the glass, scattering of light by impurities, and the homogeneity of the glass itself. Other extensions could include the restriction of the illuminating hemisphere to the upper half (sky), and the dual illumination of direct sunlight (yellowish) and skylight (bluish).

An idealised test image was created by using a high-resolution digital camera to photograph a stained glass panel on a large light table (see Figures 15.4 and 15.23), with a thick metal bar positioned between the glass and the light table to produce a shadow. A detail from the Red-Green-Blue (*RGB*) test image was cropped to 600 × 600 pixels, then transformed into Hue-Saturation-Value (*HSV*) components, using the standard computer graphics model.[18] Figure 15.15 shows the resulting image components. It is clear that the shadow affects mainly the *V* channel rather than the *H* or *S* channels.

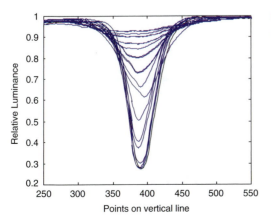

Figure 15.14
Measured profile on a sample window (under controlled illumination).

Figure 15.15

Test image:
(a) *RGB* original;
(b) *H* component;
(c) *S* component;
(d) *V* component.

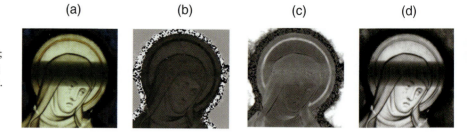

(a) (b) (c) (d)

In the case of a shadow produced by a bar across the window, if the position and diameter of the bar are roughly known, then the model can be used to predict the shadow profile. Most images of stained glass windows are photographed in diffuse lighting environments rather than direct light. Here the transmittance through the glass is assumed to reduce the photonic flux by the same amount over all parts of the glass. The intensity of illumination arriving on the exterior surface of the window is computed. Using the multiplicative wall bar model, the α value is estimated and then I is recovered, with the result shown in Figure 15.16.

The result indicates that the wall-bar model is a good initial step but that it is over-simplistic. At the centre line of the bar the model gives encouraging results. The shadow is mostly removed, and the features of the glass hidden by the shadow are fully restored. Note the texture of the glass and the paintwork. The periphery of the shadow, however, shows that the model does not fit so well with the actual image profile. The result is an over-compensation of the data, meaning that the actual image was brighter than predicted by the model, possibly due to the lateral scattering of light within the glass. Another problem may be the uncertainty with which the diameter and distance of the bars were determined. Further investigation is needed to determine whether the model parameters can be fitted to the actual shadow edge profile observed in the image, or whether a more sophisticated blending model should be used.[13]

Figure 15.16

Result of shadow removal algorithm (right) compared to the original shadowed image (left).

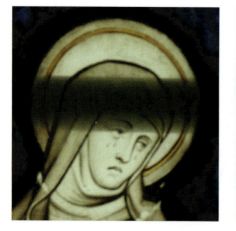
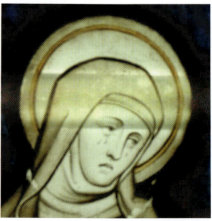

15.5.2 Removing the grille shadows

Removing the shadow cast by the protective wire grille presents a set of challenges somewhat different from the removal of a bar shadow. Grilles are typically constructed from a regular mesh of small-diameter iron or copper wire fixed to a frame 10–15 cm away from the glass. The scattering of light produces a soft shadow that is not completely black, but in fact inherits some chromaticity from the glass onto which the shadow is cast. Thus the shadow line in the image is 'dark greenish' where the interposed glass is green, 'dark bluish' where the interposed glass is blue, etc. Although exceptions might be found, this can be considered as the general behaviour in typical illumination conditions.

Another characteristic of this kind of shadow is derived directly from the typical periodic structure of a grille. The pattern of horizontal and vertical lines repeats across the window, although its tint changes across the different glass tiles. Figure 15.17 shows the test image, in which we focus our attention on a horizontal line of 1 pixel width, as indicated by the two arrows, just below the belly of the centaur. The luminance profile for pixels on this horizontal line is shown in Figure 15.18. The grille shadow profile is approximately V-shaped, and its periodicity is clearly evident.

An algorithm was developed using two convolution windows in correspondence with the vertical and horizontal grille lines. The vertical convolution window computes the average of column j over the averages of the neighbouring columns. The quantities are defined on a region of 5×5 pixels as shown in Figure 15.19.

The algorithm was applied to the test image and the resulting 'grille maps' for the vertical and horizontal orientations are shown in Figure 15.20. The grille has been successfully detected, but unfortunately this approach fails because

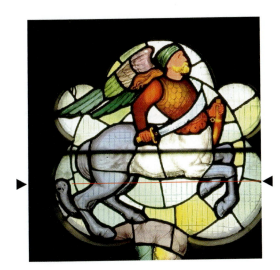

Figure 15.17
Test image and horizontal sampling line.

Figure 15.18

Luminance profile of pixels in horizontal line.

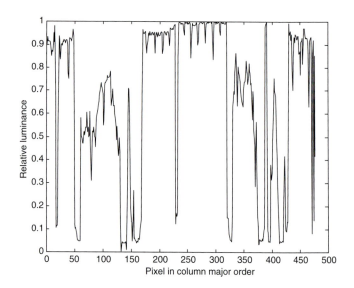

Figure 15.19

Vertical (left) and horizontal (right) convolution windows of size 5×5 pixels, centred on pixel (i, j).

Figure 15.20

Detected vertical grille map (left), and horizontal grille map (right).

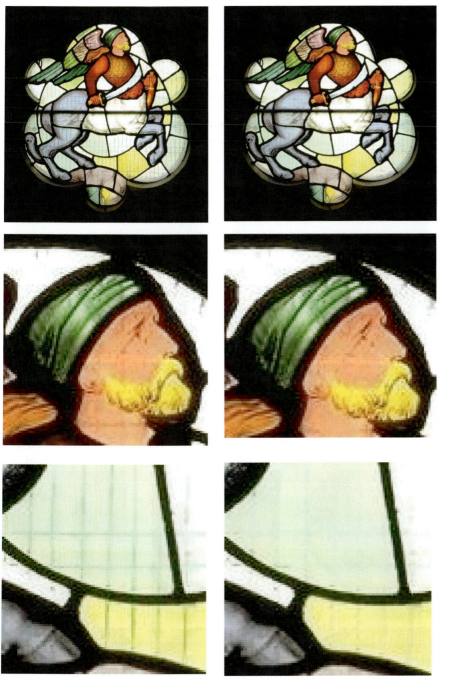

Figure 15.21
Comparison between the original image (left) and the results of the basic algorithm (right).

there are other features in the image which have similar characteristics to the shadow, namely the lead calmes and painted details. Figure 15.21 shows that the algorithm does succeed in substantially reducing the grille shadow but also removes some detail, for example in the centaur's beard. To solve this problem

it is necessary to discriminate the window features (to be retained in the image) from the grille shadows (to be removed).

Extensions to the basic algorithm enable its performance to be improved by using knowledge about the structure of stained glass:

1. The lead calmes have a linear form and where they are vertical or horizontal may look similar to the grille shadows. In the image, however, the calmes have a lower luminance level, close to black, and can therefore be discriminated by introducing a lower bound on luminance.
2. The painted features cover a wide range of spatial frequencies, whereas the typical grille structure is periodic (i.e. the pattern of horizontal and vertical lines repeats across the window). Template matching techniques enable detection of the lines in order to correct the grille map then estimate the α value.
3. Remaining shadow artefacts can be further reduced in two ways: first to increase the convolution window size; second to use multiple iterations. In the current implementation, the user sets the number of iterations, although it would be easy to implement other termination criteria.

The resulting algorithm is fast because it usually converges in 3 to 5 iterations and each iteration calculates the α value on a grille region only and not on the entire image. The results of successive iterations are shown in Figure 15.22.

Figure 15.22

Results of applying the shadow-removal algorithm with multiple iterations.

Original

After 1 iteration

After 2 iterations

After 3 iterations

After 4 iterations

After 5 iterations

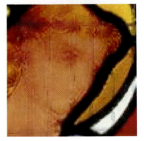

In general, the more information there is available about a given image processing problem, the easier it is to solve by modelling the characteristics of the wanted and unwanted image features. Removal of shadows is no exception, but getting the necessary information is not always easy. If the bar and grille structures were perfectly regular geometrically and the windows were always illuminated by a perfectly diffused uniform backlight, the problem would be easy. In practice, real stained glass windows are non-planar and the bars and grilles are distorted, corroded and dirty. Illumination varies with weather conditions and time of day, and is affected by reflections and occlusions from nearby masonry, vegetation, trees and buildings. Ultimately it is the user who must decide how the images of the windows are to be reproduced and therefore how (un)acceptable the visibility of shadows will be.

15.6 Image Segmentation

Image processing is a potent tool to assist conservators in the analysis and restoration of stained glass panels, by enabling visualisation of the effects of repainting and reconstruction before physically undertaking the work.[14] Stained glass windows present peculiar challenges for image processing. Their structure is characterised by irregular tiles of coloured glass, with rather arbitrary shapes but a limited number of transmissive body colours, and the linear pattern of the opaque calmes. The paint work has a higher level of detail but minimal colour variation (typically dark grey or brown) compared with the glass.

One useful technique is morphological analysis of the structure of the calmes, with a view to segmentation of the panels into their constituent pieces of glass.[15] The process is complicated by the dark painted lines and textured areas on the glass. In a purely transmissive image, these may easily be confused with the contours of the calmes, which are opaque and therefore appear black. In practice, the metallic lead also reflects some of the ambient light, rendering it off-black (dark grey, brown or blue) in the image.

In order to segment the structure in transmissive light, several image processing strategies suggest themselves: the glass tiles clearly define bounded clusters of relatively high values of saturation and luminosity, while the calmes present a very low level of luminosity, with a bluish, desaturated tint given by the typically weak ambient light reflected from the surface of the lead. Therefore, a thresholding procedure [16] in some suitable colour space may prove sufficient to segment the calmes from the glass background.

This approach suffers from major limitations. It is overly simplistic to treat the glass tiles as areas of uniform colour, when in fact the corrosion and deposition of opaque elements weakens the transmitted light and spreads the distribution of the pixel lightness values to overlap those of the calmes. On the other hand,

scattering phenomena and diffuse illumination could cause the calme tint to drift far from the expected value, especially at the boundary with a bright region. Paint-work represents the other major limitation of this approach, since the values belonging to the painted areas in the chosen colour space might not be separable from those of the calmes.

Figure 15.23 shows the three components of a test image captured by a high-resolution digital camera, the Rollei 6008i with a Jenoptik *eyelike MF* digital back.[17] The subject was a Victorian (c.1860) stained glass panel placed on a specially constructed light table, as shown in Figure 15.3. The *RGB* digital image was cropped and reduced in size to 640 × 480 pixels, then transformed into Hue-Saturation-Value (*HSV*) components, using the standard computer graphics model.[18] The pixels were manually classified as belonging to the calmes (*object* pixels), to the glass (*background* pixels) or to the boundary of the two areas (*edge* pixels), producing the classification mask shown in Figure 15.23(d). Comparing the object and background histograms for the three channels, as shown in Figure 15.24, it is clear that the problem of separation by means of three independent thresholds is ill-conditioned, since the object and background histograms overlap strongly and is not possible to identify a set of simple threshold values that achieve a satisfactory result. It is therefore necessary to devise a more robust solution.

One possibility is offered by the application of neural network techniques, specifically the *multi-layer perceptron* (MLP).[19] MLP allows arbitrary functional mappings (i.e. segmentation functions) to be defined in the colour space, and therefore multi-dimensional thresholding profiles of arbitrary shape and complexity. In order to train the MLP, the test image was classified using the manual classification mask depicted in Figure 15.23(d). The edge pixels (depicted in grey) were excluded from the training process, since it was difficult to determine whether they belong to the object or to the background. In the test image the object (the calme structure) represents only 12 per cent of the pixels. Causes of errors are mainly the paintwork and the darkening of the glass near the boundary with the calmes, in which areas the glass tiles yield pixel values similar to those of the calmes.

15.6.1 Template matching

Regardless of the effectiveness of segmentation by a neural network, it is unrealistic to suppose that every image could be completely separable. The cluster of object vectors in the input space will unavoidably overlap with the cluster of background vectors. The input space alone is insufficient to define a separable problem. It is therefore necessary to include more information to discriminate object from background. One possible solution is to increase the dimensionality of the input space by considering local neighbourhoods of pixels (sampling)

Figure 15.23

Test image and its derived *HSV* components:
(top left) *V* component;
(top right) *H* component;
(bottom left) *S* component;
(bottom right) Segmentation mask. The panel is Victorian *c.*1860 from Armley Castle, courtesy of the Glaziers' Trust, York.

Figure 15.24

Object calmes and
background glass
histograms of the image
in Figure 15.23:
(a) *H* component;
(b) *S* component;
(c) *V* component.
The vertical axis
represents the relative
occurrence as a
probability density.

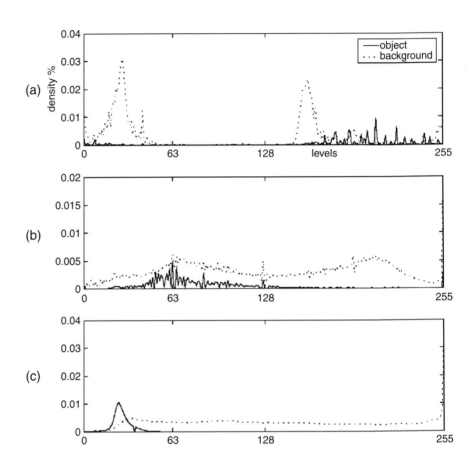

and calculating local statistics such as mean and variance. This approach, known as *feature extraction*, has the drawback that as the dimensionality increases so does the computational complexity, to a level that might prove infeasible.

One of the main characteristics of the calmes is that for a given window, they generally have a constant width. This information can be exploited, knowing that this width is not generally found in the areas of glass that overlap the calmes in the colour space. Template Matching (TM) techniques provide a simple method to identify and segment structures of given width.[20] A binary template mask represents the elementary calme pattern (width and orientation) in a properly sized window, and the image is successively convolved with this mask. It is necessary to define as many template masks as the number of orientations one wishes to detect. Figure 15.25 shows eight template masks of size 50×50 pixels, with feature width equal to 20 (the approximate calme width in Figure 15.23), representing eight possible calme orientations.

Template matching has an intuitive relationship with the goal of segmentation. It is also computationally convenient when the mask is binary (two-valued), as in Figure 15.25, since the convolution integral can be simplified into a summation of the pixel values corresponding to the non-zero mask values. From a

Figure 15.25
Template masks.
(a) $\theta=0°$ (b) $\theta=22.5°$
(c) $\theta=45°$ (d) $\theta=67.5°$
(e) $\theta=90°$ (f) $\theta=112.5°$
(g) $\theta=135°$
(h) $\theta=157.5°$

more analytical point of view, however, TM may not offer enough flexibility, in the sense that the spectrum of spatial frequencies is unequivocally determined by the feature size.

Gabor Filters (GF) represent a more effective way to extract spatial information from the image.[21] Unlike the TM masks illustrated above, Gabor filters can be tuned in both space and frequency. They have been widely applied to texture analysis.[22] Of relevance for the segmentation of stained glass is their application to fingerprint ridge structures.[23]

15.6.2 Results

Figure 15.26 shows the results obtained by applying the TM and GF methods to the thresholded images output by the neural network. Despite the preponderance of background pixels, the MLP neural network produced satisfactory results on the calmes as well as on the glass. There are few gaps and holes in the calme areas, and the connectivity of the calmes is well preserved. The TM and GF methods were successively applied to remove thin lines and fill gaps and holes in the calmes, with eight TM masks as shown in Figure 15.25. The eight results were combined by taking the maximum output value for each pixel, and setting the optimal threshold to binarise the image.

It is evident that the application of the Gabor filter produced a visually improved segmentation compared to template matching. In general, Gabor filters show superior performance due to their ability to tune the filter by determining both the frequency and spatial spread according to the feature characteristics in the image, an ability not afforded by the simpler TM filter.

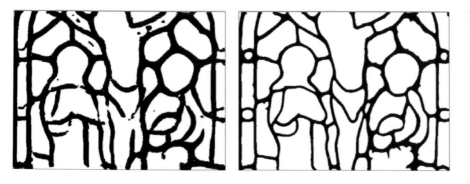

Figure 15.26
Classification output of neural network followed by two filtering techniques: (left) Template matching (TM); (right) Gabor filter (GF).

Figure 15.27

Junctions may be detected by using a set of 3×3 convolution windows.

0	1	0
0	1	0
0	1	0

Not junction

0	0	1
1	1	0
0	0	0

Not junction

0	0	1
0	1	0
1	0	0

Not junction

1	0	1
0	1	0
0	0	0

Not junction

0	1	0
0	1	1
1	0	0

Junction

0	1	0
1	1	0
1	0	0

Junction

1	0	1
0	1	0
0	1	0

Junction

0	1	0
1	1	1
0	1	0

Junction

15.7 Feature Extraction

Feature extraction is the process of identification of structures, patterns, and textures in an image. By this means, a topological description of an image of a stained glass window may be constructed in terms of junctions (crossing points between individual calmes) and connections. In the binary image in Figure 15.26 (right) the black contours represent the lead calmes and the white regions represent the glass pieces. It is evident that there is some noise, which may be removed by means of a feature extraction process. First, a thinning algorithm is applied to reduce each calme to a minimal contour of one pixel in width.

Junctions of the calmes may be detected using a set of binary 3×3 convolution windows, as shown in Figure 15.27, which define what is and what is not a junction, using the criterion of whether or not the summation of the convolved elements is greater than 3. A description of the thinned image may then be extracted in terms of its minutiae, or significant points, namely junctions and connections, as shown in Figure 15.28.

Feature extraction and image segmentation provide useful tools for information-based retrieval from large image databases (see Chapters 4 and 10). The user

Figure 15.28

Results of detecting junctions. The circles represent minutiae (significant junction points) in the pattern.

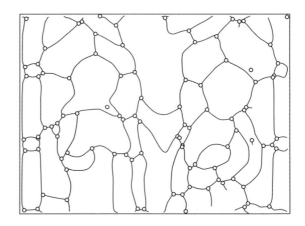

can input a single image that is successively segmented, against which the database processor compares the stored images and retrieves any occurrence, based on a similarity measure involving both the spatial pattern and the substrate colour set. The very process of catalogue display could be simplified by segmentation. The database initially would provide the user with a simplified version generated from the segmented image, so that rapid access to a large number of images would be possible (especially in remote applications, where segmentation would result in an effective compression technique). The database server would provide the original picture once the user had made a choice.

Other applications of feature extraction include the detection and measurement of cracks in windows, frescoes and other surfaces. This has been effectively demonstrated for canvas paintings.[24] More general feature extraction could provide useful information for the conservator, for example the identification of the glass substrate (body) colours in a stained glass window. This would require the segmentation of each individual piece of glass and the discrimination of substrate colour beneath the paint colour.[15]

15.8 Image Mosaicing

Mosaicing, also called 'stitching', is the composition of partial views of a single subject in order to produce a larger composite image. The remarkable dimensions of many windows found in churches and cathedrals, together with the image resolution required to resolve the brush-scale detail of the original, make mosaicing a vital tool for the high-resolution photography of stained glass. The window is partitioned into a set of regions small enough to be photographed individually at the required resolution. The corresponding images are then successively stitched together to form a single high-resolution image of the whole window. Stained glass windows imaging is one important application of mosaicing, but it could also be used for any large surface, such as a wall-painting, tapestry, ceiling, etc.

The image processing problem is to identify corresponding 'tie-points' in successive overlapping frames, and then to 'stitch' the component images into a single large image on a common coordinate grid. Where the images are non-planar, some suitable geometric transformations, or judicious 'rubber-sheet' stretching of images, may be necessary to produce a seamless result. The problem for stitching images of stained glass windows is more complicated than for planar objects such as paintings on canvas, because there may be small variations in camera and orientation relative to the surface from one image to the next, and the surface itself may be non-planar or inherently three-dimensional. The criteria of success are: (1) that the final image is a geometrically accurate representation of the original, and (2) that no joins are visible between the component images.

The problem of stitching together pictures of a wall painting or stained glass window has many peculiar aspects that must be considered in order to achieve a satisfactory result. These include the characteristic geometry of the original surface and its architectural context. Intuitively, the image areas can be modelled as purely planar surfaces. This produces a great simplification of the stitching problem, once the camera has been calibrated and its motion is known.[25] In the case of a genuinely planar surface, images can be registered using simple 3D linear algebra (affine transformations).[26] More importantly, it is not necessary to know the 3D location of the points in the plane. On the other hand, any attempt to extend the planar model to include proper 3D structures leads to a very different order of problem. In this case it is necessary to have explicit knowledge of the 3D co-ordinates of points in the image. In the context of churches and cathedrals, the crucial factor is the presence of 3D structures like stonework, pillars, and mullions. An intermediate problem is represented by 'quasi 3D' structures, such as the metal frame of a stained glass window, the lead calmes and local deformation of the glass tiles.

A previous attempt at mosaicing images of stained glass windows used the Vasari Image Processing Software (VIPS), an open-source image processing software package which allows the management of very large image files and can easily be extended by developers.[27] The mosaicing of three large stained glass windows in Christ Church Cathedral (Oxford, UK) was investigated.[28] The VIPS algorithm, originally developed for stitching images of canvas paintings, follows a semi-automatic approach where the user provides the software with matching points (landmarks or tie-points) in the two images and the software successively finds the best match by rotating the images using the tie-points as pivots. It is assumed that there is some overlap between the pictures, and the algorithm estimates by correlation the planar motion in terms of linear rotation and translation. The exact location of the tie-point is also optimised by searching for the best match within 10 pixels from the initial landmark. The complete mosaic is produced by merging images in a one-to-one fashion, firstly in rows and then in columns.

Because the VIPS mosaicing algorithm is purely two-dimensional, it does not compensate for any 3D motion of the camera. In other words, this strategy provides satisfactory results when: (a) the camera is fully calibrated (so that camera distortion can be compensated); (b) the camera motion is limited to roto-translation on a plane parallel to the window plane; and (c) the window does not contain significant 3D structures. An example where these assumptions were found to be valid is the window shown in Figure 15.29, which is approximately planar, being constructed from a rectangular grid of enamelled glass tiles. At the time the pictures were acquired there was enough room in the location to allow precise control over the camera motion.

In the presence of 3D structures or inaccurate camera positioning, the problem of mosaicing can be critically ill-posed if no information is available on the

(a) (b) (c)

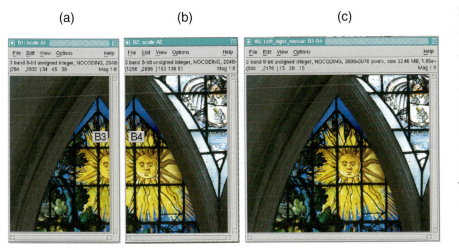

Figure 15.29

Stitching two sections of the Jonah window using VIPS: (a) Left image with tie-point (indicated as B3); (b) Right image with the matching tie-point (indicated as B4); (c) The resulting mosaic. The window, depicting the prophet Jonah at Nineveh, was constructed by Abraham van Linge in 1631, and is in the nave of Christchurch Cathedral, Oxford. See also the extended image on the back cover.

geometry of the scene. Applying the simple VIPS stitching algorithm, based on the identification of 2D landmarks, cannot account for the complex transformation of the image. Because linear 2D roto-translation cannot model this situation, some sort of an estimate of the 3D structure is necessary. The estimation strategies can be divided into four classes:

1. Determination of an approximate model from the depth map obtained from the two pictures. This automatic (unsupervised) approach typically requires the extraction of some significant geometrical features (e.g. straight lines, abundant in architectural photography) from the two images to be stitched, followed by estimation of the correspondences between matching lines in the mosaic to create a depth map.

2. 'Rubber sheet' non-linear warping of images using multiple tie-points, [29] which may either be specified by the user or be detected automatically. The user provides a set of tie-points, between which a 2D plane is 'stretched' in each region. This may provide sub-optimal solutions if there are no major occlusions in the image. The stretching should be compared to a set of geometric primitives, and the solution constrained to produce a realistic outcome.

3. User-assisted interactive 3D modelling, in which the user provides a simple description of the scene in terms of simple geometric primitives, such as cylinders, domes, cuboids, etc.

4. Determination of a precise geometrical model of the subject obtained through range imaging equipment (e.g. a laser scanner).

An alternative is a multi-resolution approach, where a reference image such as a picture of the entire area, is used to guide the stitching process. Each tile of the mosaic is located on the overview image using several tie-points, followed by a proper deformation (warping). Alternatively, the entire mosaic could be

compared post-stitching to the full picture to permit more precise local adjustment. In order to provide a valid basis for comparison, the mosaic tiles must be rescaled (down-sampled) to match the (much lower) resolution of the full image, as shown in Figure 15.30.

As a first approximation we can model the motion of the camera as a linear roto-translation. Feature-based estimation has a major role in this process. Stained glass windows contain a series of characteristic features that constitute natural alignment landmarks, most obviously the complex network of linear features created by the calmes. By describing these features in terms of geometric

Figure 15.30

Multi-resolution stitching based on an overview image of the whole window as a reference map. The high resolution target image is down-sampled in order to match the reference resolution (top). A corresponding area in the overview image (bottom) is used to determine the warp parameters. The window, depicting the legend of St. Frideswide, was designed by Edward Burne-Jones and fabricated by Powell's in 1859. It is in the Latin Chapel of Christchurch Cathedral, Oxford.

parameters (nodal points and local curvatures) it may be possible to produce more accurate estimates.

Another problem arises from the over-simplification of considering the window as a 2D planar structure. In fact, many windows have visible bowing, sagging or irregularity produced by age. In older windows, the glass pieces themselves are not perfectly planar due to the manual glass-making processes of the time. The lead calmes are also three-dimensional with a surface raised above the glass. Above a certain resolution, therefore, both calmes and glass tiles may reveal their true 3D nature and interfere with the simple planar hypothesis of the rubber-sheet minimisation algorithm.

The major concern is the presence of 'true' 3D artefacts, elements of the scene that appear as 3D at any resolution. An example is the stone mullions that typically divide large windows geometrically into separate lancets or tracery regions, as depicted in Figure 15.31. These structures represent a real problem for mosaicing, because the relative motion of each element depends on its depth, resulting in a local non-linear 'stretching' of the image. The 3D structure of such artefacts is usually simple enough in cross-section to be described as an assembly of regular geometric shapes such as rectangles, semicircles, ellipses, etc., for which an accurate match may be obtained with minimal user supervision.

15.9 Conclusions

This chapter has shown how digital photography and image processing may be applied to stained glass windows. By using controlled lighting and a digital camera of known colour sensitivity, colorimetric images may be captured directly from the windows without the use of film. These images are of significant value for conservation because they can provide a precise record of the colour and the spatial detail of the originals. By image processing techniques they may be segmented into the individual pieces of glass and lead, or combined into mosaics

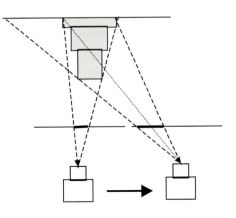

Figure 15.31

(Left) a typical tracery window constructed within a frame of mullions; (Right) the 3D effect of the planar motion of the camera: the apparent width of the mullion (dashed) increases from left to right, while the corresponding planar distance (dotted) decreases.

of arbitrary size. Image processing also enables the images to be filtered to remove shadows cast onto the glass by external structures.

There are many further challenges for image processing in the investigation of stained glass. Some engaging research questions are as follows:

- Can colorimetric images of stained glass windows be captured in arbitrary daylight? Although it is possible to produce colorimetric images of panels on a light table with known illumination in a studio, as described in Section 15.4, the situation is much more difficult when the backlight is not controlled. One solution would be to place a diffuse source, such as a flash lamp in a softbox, on the outside of the window. But for practical application, there is a need to be able to work without special illumination in the existing daylight.

- Can background be effectively removed from images of stained glass? Glass is translucent and the image captured is a combination of the glass itself and the scene behind the window. In typical church environments, the latter may include sky, foliage, other buildings, etc. The methods of Section 15.5 could be extended to the general case of an arbitrary background, but it is not easy to obtain an image of the 'unwanted' background from the camera viewpoint.

- Can full-scale reproductions of stained glass windows be printed onto translucent substrates that are good enough visually to be used as surrogates? There are numerous applications for such surrogates, for example in museum collections when a panel is temporarily removed for conservation or sent away for exhibition. Another example would be in a church when a window is removed for restoration, in order to maintain the interior appearance.

- Can flat-panel displays reproduce the full tonal and colour range of stained glass? High-dynamic-range (HDR) imaging could be used to enhance the colorimetric accuracy of dark and high-chroma colours, by using image processing to combine multiple images taken with different exposures to produce a single image that represents the full density range of the glass, from the palest highlights to the darkest shadows.

- Can multi-modal imaging assist conservators in the inspection and interpretation of windows? Multiple images of the same area could be taken, for example, under different illumination conditions, from inside and outside, and with visible and infra-red photography. These could be placed in register, using the mosaicing algorithms described in Section 15.8, and information extracted through correlation techniques.

- Can the appearance of stained glass windows in a church be modelled accurately enough to permit computer graphic rendering of the interior scene with a high degree of realism? Such a model would have to include the changing intensity and direction of the sunlight, the scattering of light by inhomogeneities in the glass, the geometry and illumination of the interior, and the mesopic adaptation of the observer. This is indeed a challenge.

15.10 References

1. MacDonald, L. W. (1997). Stained Glass: The Medieval Multimedia Experience, *Proc. Electronic Imaging & the Visual Arts Conf. (EVA)*, Paris, September 1997.

2. Brown, S. (1995). *Stained Glass – An Illustrated History*. Bracken Books.

3. Findlater, K. D. M. and MacDonald, L. W. (2001). Photographic Practices, Report #2, AHRB project *Direct Digital Image Capture of Stained Glass*, University of Derby, March 2001.

4. Buchanan, T. (1984). Recording Stained Glass. *British Journal of Photography*, **2**, 230–233, March 1984.

5. Brown, S. and MacDonald, L. W. (eds.) (1997). *Life, Death and Art: The Medieval Stained Glass of Fairford Parish Church*. Appendix 3, pp. 142–148, Sutton Publishing, Stroud UK.

6. MacDonald, L. W., and Oldfield, J. (1996). Image Capture and Restoration of Medieval Stained Glass, *Proc. 4th IS&T/SID Color Imaging Conf.*, Scottsdale AZ, November 1996, pp. 44–49.

7. MacDonald, L. W. (1997) Digitization of Stained Glass, Conf. on Very High Resolution and Quality Imaging, San Jose, *Proc. SPIE*, **3025**, January 1997, pp. 40–48.

8. Bouzit, S. and MacDonald, L. W. (2002). Modelling the Modulation Transfer Function of Various Imaging Devices, *Proc. IS&T PICS Conf.*, Portland, April 2002, pp. 130–135.

9. MacDonald, L. W., Ji, W., Bouzit, S., and Findlater, K. D. M. (2002). Characterisation of a Digital Camera for Heritage Photography, *Proc. Intl. Congress of Imaging Science (ICIS)*, Tokyo, May 2002, pp. 345–346.

10. MacDonald, L. W. and Ji, W. (2002). Colour Characterisation of a High-Resolution Digital Camera, *Proc. Colour in Graphics, Imaging and Vision (CGIV)*, University of Poitiers, France, April 2002, pp. 433–437.

11. Hong, G., Luo, M. R. and Rhodes, P. A. (2001). A Study of Digital Camera Colorimetric Characterisation Based on Polynomial Modelling. *Color Research and Application*, **26**(1), February 2001, pp.76–84.

12. Suganthan, S. and MacDonald, L. W. (2004). Removing Shadows from Images of Stained Glass Windows, *Proc. IS&T/SID 12th Color Imaging Conf.*, Scottsdale.

13. Giani, A. and MacDonald, L. W. (2003). Blending Images of Stained Glass Windows, *Proc. IS&T/SID 11th Color Imaging Conf.*, Scottsdale.

14. Makau, A. (1996). Digital Imaging and Stained Glass Conservation, *V&A Conservation Journal*, (**19**), April 1996, pp. 8–12.

15. Giani, A., MacDonald, L. W., Machy, C. and Suganthan S. (2003). Image segmentation of stained glass, Conf. on Color Imaging VIII: Processing, Hardcopy, and Applications, Santa Clara, *Proc. SPIE*, **5008**, January 2003, pp. 150–158.

16. Petrou, M. and Bosdogianni, P. (1999). *Image Processing – the Fundamentals*. John Wiley & Sons.

17. MacDonald, L. W. and Giani, A. (2003). Image Processing in the VITRA Project, *Proc. Electronic Imaging in the Visual Arts Conf. (EVA)*, Florence, June 2003.

18. Foley, J. D., van Dam, A., Feiner, S. K. and Hughes, J. F. (1990). *Computer Graphics – Principles and Practice*, 2nd edn., pp. 590–592, Addison-Wesley.

19. Bishop, C. M. (1995). *Neural Networks for Pattern Recognition*. Oxford University Press.

20. Jain, R., Kasturi, R. and Schunck, B. G. (1995). *Machine Vision*. McGraw-Hill International.

21. D. Dunn, W. E. Higgins, J. Wakeley (1994). Texture segmentation using 2-D Gabor Elementary Functions. *IEEE Trans. Pattern Analysis and Machine Intelligence*, **16**, pp. 130–149.

22. Weldon, T. P., Higgins, W. E. and Dunn, D. F. (1996). Efficient Gabor filter design for texture segmentation, *Pattern Recognition*, **29**(12), pp. 2005–2015.

23. Ross, A., Jain, A. K. and Reisman, J. (2002). A Hybrid Fingerprint Matcher, *Proc. International Conference on Pattern Recognition (ICPR)*, Quebec City, Canada, August 2002.

24. Abas, F. S. and Martinez, K. (2002). Craquelure Analysis for Content-Based Retrieval, *Proc. IEEE 14th International Conference on Digital Signal Processing*, July 2002, pp. 111–114.

25. Gruen, A., and Huang, T. S. (eds.) (2001). *Calibration and Orientation of Cameras in Computer Vision*, Springer-Verlag.

26. Wolberg, G. (1999). *Digital Image Warping*. IEEE Computer Society Press.

27. The VIPS software can be downloaded from: http://www.vips.ecs.soton.ac.uk/

28. Findlater, K. D. M. and MacDonald, L. W. (2002). Fieldwork at Christchurch Cathedral, Oxford, Report #4, AHRB project *Direct Digital Image Capture of Stained Glass*, University of Derby, Appendix by John Cupitt, pp. 37–39.

29. Arad, N. and Reisfeld, D. (1995). Image warping using few anchor points and radial functions, *Computer Graphics Forum*, **14**, pp. 35–46.

Making Online Monuments more Accessible through Interface Design

Cristiano Bianchi

Different parts of the Ocean contained different sort of stories and as all the stories that had ever been told and many that were still in the process of being invented could be found here, the Ocean of the Streams of Story was in fact the biggest library in the universe. And because the stories were held here in fluid form, they retained the ability to change, to become new versions of themselves, to join up with other stories and so become yet other stories.[1]

16.1 Introduction to Interface Design

16.1.1 *Adaptation – person versus technology*

Think of one of the simplest devices you encounter every day: a light switch. When you flick it on, all you care about and expect to happen is that the light turns on, and that if you flick it again, it goes off. That's really all that matters.

Beneath the surface, your simple flicking starts a rather complex chain of events, which involves the property of copper to conduct electricity, the light speed of electrons, the colour attributes of a tungsten filament, Planck's law of a black radiator body and incandescence and probably much more.

Of course, you do not need to know the exact order of events and all the implications of this process in order to turn the light on, as someone has thought it through for you. You can simply go home and read your favourite novel without thinking about how to illuminate your book.

The extraordinarily complex process of turning on a light has been made simple by the clever people who created an *analogue* interface between your finite human body and a continuous chain of events. This interface has developed and refined over many years since the first electrical light was introduced, so that we can now also control the intensity of the light with the simple rotation of a knob. The focus of the technical development is to enhance the usability of complex

devices by adapting them to the needs of the human body and mind. It is a slow process.

Things are different in the digital world, which is still in its experimental infancy. If we compare today's computer interfaces to the simplicity of a light switch, it would be as if the act of turning a light on would require us to solder some wires to a piece of metal manually. Today, the simple operation of connecting a computer to the internet still requires us to deal with obscure protocols like TCP/IP, PPP and HTTP. Even if we manage this, the interface to the information we seek is in many cases far from as intuitive as the light switch. For example, the movie section of a well known newspaper [2] website does not allow us to search simultaneously for a movie title and a cinema location. Instead, we have to scan all cinemas in a neighbourhood manually, in order to find out whether the film we want to watch is being shown.

It would seem, then, that at this early stage, interactive designers and programmers are taught that the most flexible component of a user interface is, in fact, the user.

16.1.2 Evolution – the need for interfaces in computer technology

Interfaces have always existed in the form of a *no-mans-land* between different entities. The definition has been around since 1880, so it should not be surprising that its general definition has little to do with interactive digital design. A well-known encyclopaedia of Internet concepts defines an interface as:

> A boundary across which two independent systems meet and act on or communicate with each other. [3]

A more general source describes an interface as:

> [...] 2. A point at which independent systems or diverse groups interact [...] 3. Computer Science a. The point of interaction or communication between a computer and any other entity, such as a printer or human operator. b. The layout of an application's graphic or textual controls in conjunction with the way the application responds to user activity. [4]

Realising that human operators and printers have fairly different needs, the industry has started to refer to *user* interfaces (or *graphic* user interfaces – GUI) as a metaphorical way to represent and organise data for the use of people.

Everyone using a contemporary computer is now familiar with the idea of *filing documents inside folders.* In terms of computer systems, each electronically produced document or folder is nothing more than a series of polarised magnetic fields on the computer hard disk. The filing metaphor makes our interface with

the information easier and more immediate by moving the technology closer to our way of thinking, because we are familiar with cardboard folders and paper documents. When Alan Kay and his team of researchers at the Xerox PARC developed the original Doug Engelbart idea of a metaphorical desktop into a fully functional prototype, the world of computers was presented with the revelation that technology could be humanised.[5]

Up until the last decade of the twentieth century, computers used to be specialist tools for trained individuals in a research context. Interfacing to computers did not require design, and principles like usability and accessibility were mainly ignored.

In the span of a few years, computers have become *personal,* with people expecting the same ease of use of their typewriter initially and then, with the advent of the World Wide Web, of their television sets. The World Wide Web has popularised computer culture, shifting the perception of computers to the status of domestic appliances.

Terms like 'usability', 'accessibility' and 'ease of use' have become mainstream, because they were lacking in computer interfaces. No one would ever talk about the usability of a door handle, let alone think of a user manual for it. The sudden metamorphosis of computers from pure research and professional tools to mainstream consumer appliances has caught designers unprepared. The technology might have been ready, but not the mindset.

16.1.3 *Form and function – the role of design*

It is useless to convince someone that a technology is important. No technology is important – it's the use of it that's important.[6]

We have already seen how the role of user interface is to simplify a complex task. In software design, in particular, user interface design has the very important task of mediating between *atoms* (people) and *bits* (computer information).[7] This involves a two-way communication between a human understanding of the world and a series of digital signals. Following this interpretation, the role of user interfaces, and ultimately of interface *design,* is to humanise the technology and empower people.

The purpose of design in user interface is to establish the best way for people to access information and to create suitable narratives. As there is not a single way to present information, a good interface should consider content, context and audiences as the fundamental factors in the creation of suitable metaphors. The process to develop a successful user interface varies, but it normally involves [8]:

■ *Information architecture.* The general organisational structure of the content to be represented, which includes how users understand and access information as well

as cross-links and references between individual portions of content. Information architecture is often confused with a site map, which is really only one of the outcomes of a good site architecture, especially in the context of dynamic content, where information changes and gets updated regularly. The purpose of information architecture is to define the relationships between pieces of content in a context.

- *Target audience.* Information is only sensible when it is relevant to specific individuals, because different audiences have different requirements. Given the fact that content is fixed, the context can become variable depending on user needs. Museum curators accessing a heritage website will look for different information than pupils in formal education. When combined with information architecture, paying attention to the needs of different audiences should generate multiple possibilities for browsing and searching for information.

- *Sensory design.* After the information has been structured and aimed at the intended audiences, it must become visible, and eventually even audible and touchable. In dealing with the digital representation of information, content usually appears on a computer screen. The feel of the content will derive from the information architecture and will be articulated through a combination of product and graphic design techniques that will convert abstract concepts and connections into a visual layout that conveys one or multiple narratives.

Having discussed an abstract theory of interface design, the next step is to see how these principles apply to the field of digital cultural heritage.

16.2 Digital Cultural Heritage

16.2.1 What is digital cultural heritage

Culture is a system of representations. Representations create or constitute a meaning and do not merely obtain meaning in virtue of their correspondence with reality.[9]

Digital cultural heritage is a relatively new discipline, sharing and expanding the objectives of traditional cultural heritage, which aims to preserve the past and increase possibilities for public awareness and interpretation.

Digital Cultural Heritage (sometimes called also Virtual Heritage when it deals with three-dimensional synthetic recreation of real environments) has recently been defined, in a somewhat clumsy way, as:

[…] the use of computer based interactive technologies to record, preserve or recreate artefacts, sites and actors of historic, artistic and cultural significance and to deliver the result openly to a global audience in such a way to provide formative educational experiences through electronic manipulation of time and space.[10]

This definition intends to be as broad as possible, yet it falls short in several respects. The conveyed experiences must not necessarily aim at strict educational

or formative purposes, as virtual reconstruction of historical sites can be entertaining in their own right. Moreover, the issue of open global access depends on factors often beyond the control of content creators (like copyright and bandwidth, to name just two) and accessibility has to be defined in more rigorous terms (see below).

We can define as Digital Cultural Heritage the entire series of productions that aspire to enhance, complement or substitute the experience of a site or object of historical and/or cultural significance, by making active use of digital computer technologies. The range of applications is very broad and includes (from simple to complex):

- Digital cataloguing for online or offline accession;
- Website and CD-ROMs, including images and descriptions of sites and objects;
- Three-dimensional reconstructions of remote or destroyed objects, delivered via a number of different platforms;
- Augmented reality systems, in which real images and movies are combined with synthetic data in order to put computer simulation into a natural context.

See Section 16.4 for a more detailed discussion of the possibilities outlined above.

16.2.2 Why we Need Digital Heritage

Accessibility and preservation

As the history of humanity progresses, there seems to be a continually growing interest in preserving the cultural heritage transmitted to us from the historic past. Museums are not just crowded with visitors, but also with growing collections. An increasing number of cultural objects are considered worth cataloguing and preserving, which has led Jean Clair to talk of the ever increasing *museification* of the contemporary world (the 'eco-museum').

In addition, the increasingly scientific approach to conservation and restoration as well as the need to document the history of each object, often makes costs to preserve the growing cultural patrimony prohibitive.

Furthermore, ongoing wars and lack of concern in developing countries can lead to the opposite extreme, the careless loss of extremely important objects and monuments. These are lost forever, not so much as the result of a country that is 'uncivilised', but because of a ruthless political or religious regime.[11]

Other issues to be considered include:

- Fragile monuments and the dangers of mass tourism, which has damaged objects in the past by allowing uncontrolled access to visitors;
- The cost of running facilities (especially in remote areas);
- Accessibility to people with various mobility problems.

Time and space constraints

Most people are either not permitted to remain at a site long enough to see the whole thing, or simply do not have the energy to take it all during one visit. As a consequence, many would welcome the opportunity to continue their visit virtually from home. In addition, visitors and educators might wish to plan a visit ahead of time, and might seek detailed information on a site before they are actually there.

In spite of the increasing opportunities for easy and affordable travel, many children, students, scholars and teachers still struggle to learn from a past that seems to have remained difficult to access and to see it as a living asset. Old and disabled people, often with free time on their hands, may not be able to enjoy the living memories of our collective past because they have trouble travelling to or even accessing a site.

Digital access to cultural objects from a remote location can open the doors to these various audiences.

16.3 Audiences

In developing a virtual experience, it is extremely important to consider not only what we are trying to achieve, but also whose attention we are seeking. It would seem bizarre to talk about audiences before describing the actual object of Digital Cultural Heritage.

A digital representation of a physical object, be it a painting or a building, is an *interpretation* of the physical object. When visitors experience a real site, they already have an idea of what to expect.

In dealing with representation, we are actually talking about the problem of interpretation, for however accurate the images or reconstructions are, they will never be able to match and substitute the experience of the original. As a result, knowing our audiences and their needs is crucial, for it allows us to cater to the broadest possible group of people and deliver the experience they are most likely to want.

> *Representations create or constitute meaning and not do merely obtain meaning by virtue of their correspondence with reality. Reality does not exist outside the process of representation.*[12]

Whether or not we agree with this extreme view, the fact remains that any digital or analogue representation of a physical object constitutes an interpretation of reality and gives visitors a *mediated and biased* experience, obviously different from *the real thing*. The success of the digital experience depends on how well the team of designers and conservators has met the unpredictable expectations of a varied audience.

16.3.1 Learn from the real world

In the real world, some museum goers take the narrated headset tour and don't wander off the path, others browse through galleries randomly, and others head to the research library to find exactly what they are after. How can we accommodate all these experiences online?[13]

As the audience to a heritage site varies enormously and is difficult to predict, it is fundamental to know *for whom* the digital interpretation is intended. Johnson (above) simplifies an extremely complex problem for which convincing answers have yet to be established.

Complicating matters, online visitors expect more narrative possibilities than they might do in a physical site, because objects can be continuously re-arranged to accommodate a dynamic contextual environment. In an actual museum or site, the location and context of objects changes relatively rarely. But a digital collection can be browsed according to varying criteria, such as time, geography, influences, keywords and more. To get an idea of what this would involve, imagine the possibility of re-arranging objects in a museum at the click of a button, so that you see all of them according to a time sequence, regardless of geographical or social classifications. This allows comparisons of parallel developments amongst different cultures. So, a digital environment makes possible what cannot be done in a physical one – but also adds a layer of complexity to the design and fruition of a visit. We explore these ideas more in Section 16.4.

Creating a flexible and coherent digital display is not an easy task to accomplish. Most online museums are still nothing more than image catalogues, which lack any sense of narrative and storytelling and do very little to stimulate and foster the curiosity of virtual visitors.

16.3.2 Know your audience

Audiences can be categorised according to multiple criteria.[14]

- Age groupings can be effective, but should be combined with other criteria: it might be relatively easy to provide content to pre-school children, but it is much more difficult to predict tastes and needs of teenagers, and even more problematic to understand how to hold the attention of grown-ups.
- Geographic criteria can offer a means of analysing visitors. For example, people who live near a monument will be looking for completely different information about it than visitors from farther away.
- If and when available, knowing the aims and reasons for which visitors access digital versions of cultural objects can be extremely valuable. For example, school pupils conducting research will look to meet requirements set out by the national curriculum. While a digital environment should fulfil this main goal, ideally it will

also stimulate visitors' curiosity beyond the limits of the requirements of the curriculum.

16.3.3 Know yourself – marketing heritage

What do you want from an online museum? Is it to attract visitors onsite (commercial purposes) or to promote culture and education (government or academic agenda)? Is an on-site visit possible and recommended, or is the digital interpretation the only way to explore a destroyed or lost object? Can the digital assets enhance a visitor's experience by showing aspects of monuments that are impossible to see on site?

These questions call for specific answers, which will differ from situation to situation.

16.4 The Experience of Digital Cultural Heritage

16.4.1 Content and context

When we explore a historical site or immerse ourselves in a museum or gallery, we are bound to a fixed context, in which the sequence of the display and connections between objects have been established for us, either by professional curators or by architects of the past. The experience we have during a visit depends largely on our route through a finite set of *contents* within a fixed *context*.

On the other hand, digital collections, be they images or three-dimensional simulations, have the potential to increase our freedom of movement and capacity for understanding by at least one degree. While the content is fixed, like in the physical environment, the context may be made dynamic.

One example will serve to clarify this idea. A painting by Paul Cézanne might be included in the post-Impressionist area of a museum, where it is likely to be next to a Pissarro and, say, a Degas. This arrangement provides a context for the story of French painting. Although if we are particularly interested in the unique style of Cézanne, might want to look at paintings of Gustave Courbet, whose works are, in this scenario, in a different section of the museum, probably in the rooms labelled 'Realism'.

The same happens for buildings. Inigo Jones' architecture was heavily influenced by Andrea Palladio, whose style in turn was based on his studies of Roman ruins. Each one of their physical buildings provides visitors a powerful yet self-contained experience. Digital media could allow comparisons and enhanced understanding by providing a dynamic means of comparing entire buildings or parts of them.

Many digital representation of objects and buildings fail in at least one aspect of their presentation, because they lack contextual information. Many of the

websites showing museums' collections simply display a series of pictures, with no sense of elementary contextual information such as the scale of a painting.

16.4.2 Guided tours, stories, narratives – types of digital experiences

Digital content can be organised in different ways, from simple catalogues to complete guided tours. Each type of experience offers the possibility for visitors to follow their own interests and create highly personalised visits of the digital content, which can grow and change over time.

We can identify at least five methods of organising and presenting digital cultural heritage.

Step 1 – The Standard Catalogue
A series of images following a free or pre-arranged search on a subject. Visitors can browse digital objects and explore detailed information about any single work, building, or part of it.

- Drawback: Lack of any narrative
- Useful for: Scholars, researchers, visitors who are looking for a specific work, especially if not on display.

Step 2 – The cross references
Each object is categorised in multiple ways. Detailed information includes links to relevant objects that can be defined by means of key concepts (e.g. keywords, time and geography).

- Drawback: The narrative is still very bland, but it opens new possibilities.
- Useful for: Cultured visitors, non-professional learners, who know their subject to some extent and are looking to find out more.

Step 3 – Tours
Tours are created either by users or by curators. They are a simple and effective way to build a simple narrative, simply by collecting objects during a browsing session and adding a brief introduction. Tours can be automatically combined with cross references.

- Drawback: Linear narrative, fixed context.
- Useful for: Teachers, presenters, guides, who want to create an organised tour of the museums.

Step 4 – Stories
Similar to tours, stories have an introduction, but also a more detailed explanation of each individual artwork. This is the digital analogy to the traditional

guided tour, where the visitor is introduced to a subject and accompanied through it; in the case of digital cultural heritage, though, visitors can leave the tour and start their own at any moment.

- Drawback: The narrative is more complex, but still linear.
- Useful for: Formal and informal learners.

Step 5 – Multiple dimensions
Any of the ways outlined above can become the starting point for different directions, allowing visitors to:

- Divert from a path
- Create and store their own visit
- Restart a visit at a later stage
- Share a visit with others.

This way of exploring cultural heritage digitally is by far the most complex and offers the most new possibilities, leading to a true extension of the visit to the physical site.

16.4.3 The role of curators

Many curators underestimate their role when it comes to Digital Heritage. The infancy of the media means that most curatorial professionals tend either to dismiss the role of digital collections or to apply the same rules that govern the physical world.

We have seen from the examples above that digital cultural heritage may offer new possibilities for interpretation (dynamic context) and learning (creation of completely personal experiences using multiple dimensions in the narrative of the visit to a digital site).

Rules for curating digital 'spaces' have not been established yet, but a few resources are already available.[15]

16.4.4 Exactness versus convincing experience

Ultimately, the demand for interesting and exciting public presentation may dictate the look and content of the virtual experience. Here, the demand for realism can result in taking creative license during the interpretation of historic data. The need to have fully detailed re-creations may result in the addition of features than might be incongruous with the archaeological reconstruction. In these cases, virtual constructs might take a life of their own, potentially misrepresenting the history and content of a site to future generations. [...] With the need to solicit public

support for preservation and archaeological investigations, some artistic license may be important to create a complete and credible 3D reconstruction of a site.[16]

The idea set out in this quotation goes back to the issue of narrative and storytelling. The question of exactness and scientific nature is particularly relevant when attempting the reconstruction of a site in the absence of a complete dataset. In this case, the role of interpretation is fully exploited and curators and designers assume an active role in attempting to establish a necessarily partial result, in line with the best tradition of scientific research, where results are always partial and destined to be overcome by successive discoveries.

The topic of artistic license is also relevant when aiming to provide a convincing user experience, where it is more important to provide an effective narrative plot than to concentrate on excessive detail.

Again, the focus of the interpretation depends on the needs of the audience. In some cases, this is on educating and entertaining (laymen and general public), while in others, it is on exact representation (scholars).

16.5 Access to Digital Cultural Heritage

Let us imagine we have by now collected all of the assets needed to create a great online digital representation of a physical collection of objects or of a site.

We have all the digital images, movies, sounds and virtual reality environments; a curator has been appointed, provided with world-class expertise in dealing with digital media and creating multi-contextual narrative paths; we have spent time thinking about our audience, their purposes and aspirations (we have also contacted user groups and run experiments with them, in order to appraise the viability of the approach chosen); finally our best-of-breed developers and producers have created a stunning website/CD-ROM/kiosk which is likely to win a handful of industry awards.

We are ready to go.

In order to get to this point, we had to take some crucial decisions to shape the *accessibility* of the digital content, in order to fulfil the desires and needs of our projected audience. We will leave aside for the moment technical issues, discussed in the next section. Such decisions have established the kind of *intellectual* and *physical* access we are offering.[17]

We will have made assumptions concerning the nationality, ethnicity and race, language, religious and belief systems, gender and sexual orientations of out intended audience. While some people have automatically been included, unfortunately others have out of necessity been excluded. While regrettable, this is inevitable and we are probably better off knowing the consequences of our decisions at the outset.

Not all developers of applications in the digital domain plan ahead, analysing their audience carefully and consciously in such detail. Nevertheless, even unconscious decisions will have a fundamental impact on the accessibility.

Let us take language as a simple example. If we make an online resource available only in English, this will exclude all of those people who cannot understand the language.

Furthermore, even within the minority who understand English and could potentially use the site, the *style* of the language chosen might further exclude some of the remaining potential audience, who are not comfortable with an academic or technical wording if that is being used. Some people might have attention disorders and cannot follow a long story without self-contained subsections and paragraphs. If a larger audience had been desired, we ought to have planned more carefully. For example, by writing the content in a more popular style, we could have taken into account subcultures and minorities.

Every decision we make shapes the accessibility of our resource.

16.5.1 Intellectual access

The concept of intellectual access concerns the informational representation of things. Do the representations accurately reflect what they're supposed to be representing? What exactly is being represented? And more importantly, do the representations elicit the appropriate or intended response from those receiving them; that is, how are they being interpreted? If there is not some kind of meeting of the minds regarding a representation, then intellectual access has not been achieved.[18]

The meeting of minds is the key concept in this statement, though a difficult one to achieve, given the little information we have available about our potential audience.

When *architecting* (the word, although unattractive, is accurate, because the process of *building* a digital experience involves a similar approach to the one employed in the construction industry) a digital representation and experience of a physical object or site (such as a museum or a monument), all of these variables ought to be considered.

The creators of intellectually accessible digital experiences will have thought very carefully about the scope and intent of their content, and aimed it at a well-defined target audience. They know that it is impossible for everything to be accessible and interesting to everyone and try to bring across a meaning in a well-defined, self-explanatory way.

16.5.2 Physical access

Physical access, as the phrase implies, concerns whether people can actually get hold of the information they need or desire. In general, the control and delivery of information is a function of power relations.

There may be diverse and conflicting agenda that influence whether or not something should be made accessible. Barriers to physical access are not necessarily immediate and direct, but can also be indirect, as are economic impediments. [19]

Let us draw an analogy with the issue of physical accessibility in buildings. The current tendency is to classify a building's accessibility in binary terms – it is either accessible or not accessible. The latter is usually the case when one or more steps are required in order to enter, which means that a person on a wheelchair cannot access it. Usually, little or no information is given about the barrier itself.

This approach fails to take into account a few variables (and we name just a few here).

- Disabled people are not only the ones needing a wheelchair: a blind person can perfectly well climb stairs if they are designed to provide an audible feedback to the ticking of a stick.
- Disability is not necessarily a permanent state: a pregnant woman or someone with a broken leg are temporarily less able to move in a *normal* way.
- The severity of disability varies from person to person: the intended target of the disability message, the person on the wheelchair, might, on a sunny day, feel stronger than usual and willing to climb the odd one or two steps required to enter the building. She is able to do this if she has been informed of the nature of the barrier, not just confronted with the binary flag accessible/not accessible.[20]

In a perfect world, all physical accessibilities would be removed, but for now, the least we can do is to let people know what they will have to deal with.

On the technical side, physical accessibility is nearly always the result of proper use of resources, testing and quality control. Using today's technologies, it is perfectly possible to create fully accessible applications on every device.

16.6 Technology

Alongside the cultural questions concerned with intellectual and physical access, technology offers different and more immediate challenges to accessibility.

Although computers and digital information have now existed for a number of decades, the fundamental requirement of allowing *normal* people (i.e. people with no specific technical knowledge about computing) to access information easily and effectively, is still far from being accomplished. It will take a few more years before people use computing equipment with the same confidence and ease that they use a television set or a telephone. Improvements are needed at both technical and interface levels.

The rapid development of the Internet is championing new ways for people to access information in digital format, using a variety of platforms, including

computers, interactive television sets, game consoles, personal digital assistants (PDAs) and mobile telephones.

Although the Internet is becoming ubiquitous, there are as yet no universally agreed standards that developers use to create and distribute content.

In order to understand what this means in practical terms, it may be useful to make a comparison with the television industry. In order for the television to become a widespread appliance, technical specifications had to be agreed between all players, so that what was encoded and transmitted from one side (TV studios) could be received and decoded on the other (people's homes). PAL, NTSC and SECAM won the battle among the many experimental formats in the early days of television and became the leading (and only) standards for broadcasted signals. No matter what brand of television you use to receive the signal or what transmitting equipment the studio purchased to generate it, the two are compatible as long as you are in the right part of the world.

Setting a standard for television was relatively simple (compared to the Internet), as the only thing to agree upon is the encoding and transmission mechanisms. Such consensus on transmission standards is already in place for the Internet as well – TCP/IP regulates all the transmission protocols between computers connected over the Internet.

In the case of the Internet transmission, protocols are only one part of the equation, and not even the biggest one. The trouble starts with *content encoding* standards, which is the way information is structured in order to reach an audience meaningfully. A variety of technologies are available to accomplish this, ranging from the original HTML (Hyper Text Markup Language, which exists in different versions) to Macromedia Flash, passing via XML (eXtensible Markup Language), XHTML (eXtensible HTML) and many more.

This situation is exacerbated by the varying degree of support provided by the different browser vendors. As a result, content developed specifically for one browser can perform in completely differently, if accessed using another. If this was the case in television, for example, it would mean that a certain TV set might decide to display colours in a way different from the rest, or even change the voice of the actors.

A detailed discussion of these technologies is outside the scope of this chapter. It is enough to know in this context that each one of these standards has strengths and weaknesses, as well as advocates and detractors. This situation is a double-edged sword. On the one hand, it offers content creators an extensive range of possibilities, but on the other, it results a certain degree of confusion among final users.

16.6.1 Accessibility: technology and design

Accessibility for interactive digital content is often determined by sets of rules or industry-wide guidelines developed by non-commercial organisations, such

as the World Wide Web Consortium. [21] These guidelines define various degrees of accessibility. For example, they dictate that for content to be accessible by visually impaired people, each image should be accompanied by a relevant textual description. This allows specially designed browsers to read the page aloud, including both the text and the description of each image. This straightforward, deterministic approach constitutes the minimum requirement for making digital content accessible to disabled people.

Unfortunately, there are not really any specific guidelines for creating content accessible to *all* users. How do we create digital experiences that not only allow access to disabled people, but also do not let other users *feel* disabled, because of bad design? Borrowing another example from architecture, it might be a good idea to create a ramp alongside a series of steps at the entrance of a building, but we should not forget the door to actually *enter* the building.

Bad navigational metaphors, use of wrong colours and text sizes, inconsistent information architecture, lack of design taste – all of these factors are impossible to dictate according to guidelines, as they rely entirely on good system, visual and experience design.

Bad technical implementation is not mentioned here, as the technology is now so sophisticated that a technically non-working interactive application is simply unacceptable.

16.6.2 Open and industry standard, open source

One way to make content more accessible is to rely on standards – open and industry standards, created and distributed using commercial or open source software.

There seems to be a great degree of mystification about the use of these terms. They mean completely different things, yet they are often confused with one another.

Open and industry standards

> *Open standards are publicly available specifications for enhancing compatibility between various hardware and software components. Open standards allow everybody with the technical know-how and necessary equipment to implement solutions which work together with those of other vendors.[22]*

An obvious examples of an open standard is HTML and its derivatives. A less obvious example is the Macromedia SWF format. Although the main content creation tool is a piece of proprietary software (Flash, by Macromedia), the files produced by it are in a free format (SWF). This way other people can, if they want, create alternative tools to produce the same format, enhancing its distribution and acceptance.

There are a considerable number of *de facto* or attempted open standard projects,[23] but for these to become valuable they need to accepted by a large number of people and organisations, becoming *industry standards*.

At the other end of the scale, a standard can be widely accepted even without necessarily being open. Oracle, for instance, is one of the reference formats for database servers, although its technology is proprietary.

The issue here is acceptance for reasons of sustainability. The more widespread a technology is, the more chance it has of surviving.

Open source

> *Open source refers generally to any computer software whose source code is either in the public domain or, more commonly, is copyrighted by one/more persons/entities and distributed under an open source license.[24]*

An example of an open source product is the web server Apache. Everyone can access the Apache code and modify it freely for their own purposes. This differs from the example of Macromedia Flash, described above, because while the distribution format (SWF) is open to everyone, the Flash application is not, as Macromedia sells it for a profit.

16.6.3 Sustainability

The discussion about open standards and open source is fundamental to the issue of *sustainability*. How do we guarantee that the digital versions of object collections and sites we create today will be operational in a few years time?

The issue is a huge one, ranging from the format of physical media (are CD-ROMs already obsolete?) to delivery technologies. The trouble is that, with digital technology, future development often lacks concern for backward compatibility (what happened to all files stored on 5 1/4″ floppy disks?).

Similarly, new versions of software or standards offer huge advantages over old versions, but often at the expense of compatibility. If we created a great interactive application a few years ago using Macromedia Flash version 4, for how long will it be supported by current version, in their strive to become lighter and lighter to download? Moreover, new versions of standards may change radically the way information is structured, so that older version are not compatible and not even easily converted.

In 2002, UNESCO launched a new initiative on 'Preserving Our Digital Heritage', which has culminated in 2003 in a 'Draft Charter On The Preservation Of The Digital Heritage'[25] There is clearly a paradox here, in that we run the risk of having to preserve the very materials we intend to use for preservation purposes.

There is no one simple answer. Standards which have gained industry-wide acceptance are more likely to guarantee the longevity of the digital content. They are not always 'open' standards.

The Digital Object Chain – technical sustainability

A fundamental concept is emerging through these ideas about sustainability and the use of technology: the life of digital objects. While we are familiar with the 'life cycle of a physical object, from creation to disposal and the actors involved',[26] this concept is not yet widely recognised in relation to digital objects. Erpanet [27] is a European community project with the aim of establishing preservation criteria for digital objects. It starts from the recognition that digital objects have a life cycle of their own, and that as such, they need a maintenance program.

16.7 Review of European Funded Projects in the Field of Digital Heritage

Many European funded projects on the IST website address issues related to Digital Heritage.[28] However, judging from the material available online and from direct experience with some of them, the vast majority pay very little attention to the role of the user interface design as a means to increase usability, accessibility and the enhancement of the overall user experience. It seems that many projects start by addressing a technical problem, and all the time and energy is spent on solving that problem, with little attention to real users' needs.

Surprisingly, browsing through the European Community project directory reveals how many of these projects are dedicated to developing new technologies in order to facilitate access and content creation, but how few are dedicated to the user perspective on cultural heritage. It would be as if all the designers in the car industry were working on fantastic engines, but no one was developing the design of the body and the controlling ergonomics, such as the steering wheel or the gear stick or the pedals.

The key words are all very laudable. Projects describe themselves in terms of 'open', 'collaborative', 'community-based', but almost none address the needs of the audience for digital cultural objects. The conclusion seems to be that digital technologies are now indispensible for archiving and managing cultural collections, but little time has been spent on the expectations of virtual visitors. The following projects are examples:

16.7.1 European projects

3D Murale – http://www.brunel.ac.uk/project/murale/
Developing and using 3D Multimedia tools to measure, reconstruct and visualise archaeological ruins in virtual reality using as a test case the ancient city of Sagalassos in Turkey.

Archeoguide – http://archeoguide.intranet.gr/
'ARCHEOGUIDE will build a system providing new ways of information access at cultural heritage sites in a compelling, user-friendly way through the use of

advanced IT including augmented reality, 3D-visualisation, mobile computing, and multi-modal interaction'.

Arco – www.arco-web.org

'ARCO is a research project, funded by the European Union, aimed at developing technology for museums to create 3D Virtual Exhibitions on the Web. Virtual exhibitions are created by digitising museum objects, which are then transformed into Virtual Representations, which can be X3D or VRML models or scenes'.

A very interesting technology with an unfortunate approach (or lack of) to interface design, both in terms of content creation and fruition for end users. A typical example of underestimating the role of interactive design and digital curating.

CHIOS – Cultural Heritage Interchange Ontology Standardisation – http://cidoc.ics.forth.gr/

'The CIDOC Conceptual Reference Model (CRM) provides definitions and a formal structure for describing the implicit and explicit concepts and relationships used in cultural heritage documentation. The CIDOC CRM is intended to promote a shared understanding of cultural heritage information by providing a common and extensible semantic framework that any cultural heritage information can be mapped to. It is intended to be a common language for domain experts and implementers to formulate requirements for information systems and to serve as a guide for good practice of conceptual modelling. In this way, it can provide the "semantic glue" needed to mediate between different sources of cultural heritage information, such as that published by museums, libraries and archives'.

This addresses a very important issue of cultural heritage: standardisation of information. In fact, while technologies have reached a level where they can be easily integrated, Cultural institutions are often left on their own and have to invent archive methodologies that are different from one another. There definitely is a need for a 'semantic glue'. This outlines both the advantages and the ambiguities of standardisation. In fact, most information depends on the context of the application and cannot be separated and made available in every situation.

Cipher – Open University – http://cipherweb.open.ac.uk/

A user browsing through objects will need a different presentation style to someone who wishes to be led through the data. Not all Forums will have the same requirements for the way in which they are presented. In order to deal with the differing needs of domains and usage modes, CIPHER will build on web-based presentation technologies to develop different presentation templates.

A similar effort to Chios, based on communities. See also the Dublin Core (http://dublincore.org).

**COINE – Cultural Objects in Networked Environments –
http://www.uoc.edu/in3/coine/**

'The idea behind the COINE Research and Development Project is to enable people to tell their own stories. New levels of interactivity will be possible for museums, libraries and other cultural bodies – visitors will be able not just to use "exhibits" created for them, but to create their own. Children will be able to use pictures, texts and objects to record and share their family history. Older people might use oral history, photographs, video and images of written documents to tell the story of their lives. Each story can then be shared, and authors can make links with other people's stories'.

This is one example in which the contribution by visitors becomes crucial and they themselves are not merely spectators to be entertained, but rather content creators. It develops from communities where many people participate to discuss issues and present personal stories.

The Museum of Pure Form – http://www.pureform.org/

'The Museum of Pure Form aims at exploring new paradigms of interaction with sculptural pieces of arts. The Museum of Pure Form is a Virtual Gallery with digitised sculptures from European and worldwide museums, where the visitor can interact, through the senses of touch and sight, with 3D art forms and sculptures. The use of innovative technologies allows users to perceive suitable tactile stimuli and feel the physical contact with the digital model of statues'.

Although the premise, to put 3D scanning of sculptures in a virtual environment, is attractive, its interface is so poor as to disappoint. No information is provided about the objects exhibited, the navigation is far from being clear, ranging from user movement to the supposedly informative panels, which carry no information at all.

**Valhalla – Virtual Access to Landscapes and Historic Gardens at Linked
Locations – http://environment.uwe.ac.uk/valhalla/**

'The Valhalla project is developing this prototype web based digital comparison between two historic gardens, based on real-time video capture and conferencing between experts'.

Although defined as 'web based' it carries 90 Mb videos – with no streaming capability.

**VIHAP3D: Virtual Heritage: High-Quality 3D Acquisition and Presentation –
http://www.vihap3d.org/**

'The ViHAP3D project aims at preserving, presenting, accessing, and promoting cultural heritage by means of interactive, high-quality 3D graphics'.

Links to the 3D models do not seem to work. The interface and site navigation is poor.

16.8 Conclusions

It is Sunday and a sunny day in London (so rare in this summer of 2004) and we are about to go visit the area of Temple, with its courtyards, secluded gardens and beautiful buildings, which are usually excluded from tourist sightseeing, by short-sighted guides.

We are likely to walk around for a while, at our own pace, sit down under a big magnolia tree in one of the central courtyards, have a quiet conversation about nothing in particular, and listen to our own thoughts, while surrounded by beauty and peace in the centre of one of the busiest cities in the world. Later we might cross the millennium bridge and pop in at Tate Modern for the latest display in the stunning turbine hall. Surely enough, we will have coffee, or a pint of beer (more likely) at one of the many pubs along the river, before coming back home, probably feeling enriched, as well as happy and entertained, by what we had the chance to *live*.

We are lucky, we live in London and can easily do all of this. For others (as well as for ourselves in regards to other places), such pleasures might be less achievable.

Digital cultural heritage can augment and enhance our lives by offering the chance to connect our busy selves with our overlooked past, present and future. That is, if the story is convincing and it can hold our attention.

I was going to conclude this chapter writing about principles and rules, but I'm not convinced there are any to talk about. Good interface design for online heritage, as well as good design in general, is not about rules. Good design is providing a convincing answer to a specific situation or problem. It does not always completely solve a problem (what does it mean to 'solve a problem'?) or tell the truth (what is the truth?), but in all cases it informs, perhaps not perfectly but always convincingly.

I have highlighted a few questions we should address when dealing with creating online digital interpretations of cultural phenomena; I also tried to hint at a few ideas about how to approach such problems, bearing in mind the needs of conservators, curators and the general public.

A few convincing results have strengthened the feasibility of creating good online interpretations, which do not attempt to replace *the real thing*, but rather to augment its perception, allowing conservators and visitors alike to create new connections. The best results are achieved when digital interpretations *extend* the context of objects and collections beyond the physical boundaries of museums and archaeological sites, for them to become everyday realities. In this sense, digital cultural heritage may be seen as a branch of architecture, with the agenda of creating new *virtual* spaces for museums and sites limited by their physical boundaries.

These are spaces where objects may be displayed in continuously changing contexts, according to the personal tastes and needs of visitors and curators, who will be able to create their own stories.

The art of storytelling has always involved shuffling old materials to create new narrative possibilities. It will never cease to fascinate us.

16.9 References

1. Rushdie, S. (1991). *Haroun and the Sea of Stories.* Penguin Books/Granta, London, ISBN 0140140352.
2. http://film.guardian.co.uk (Accessed on 15 June 2003).
3. http://www.webopedia.com (Accessed on 15 June 2003).
4. The American Heritage Dictionary of the English Language (2000). HMCO, In *American Heritage Dictionaries* (Mifflin, H., ed.) ISBN 0395825172.
5. Johnson, S. A. (1991). *Interface Culture: How New Technology Transforms the Way We Create and Communicate.* Basic Books, ISBN 0465036805.
6. Pesce, M. (2000). *The Playful World.* Ballantine Books, New York, ISBN 0345439430.
7. For a thorough discussion of aspects of digital culture see: Negroponte, N. (1996). *Being Digital.* Coronet, ISBN 0340649305.
8. Due to the context of this publication this is a very broad and abstract classification. For a more detailed discussion of user interface design please see: Garrett, J. J. (2003). *The Elements of User Experience.* New Riders ISBN 0735712026.
9. Hall, S. (ed.) (1997). *Representation: Cultural Representations and Signifying Practices.* Sage Publications Ltd, London, ISBN 0761954325.
10. Stone, R. and Ojika, T. (2000). Virtual heritage: What's next?. *IEEE Multimedia,* April/June 2000, vol. 7, no.2, pp. 73–74.
11. The destruction of statues of the Buddha by the Taliban regime in Afghanistan is well known (http://www.cnn.com/2001/WORLD/asiapcf/central/03/18/afghan.buddhas/, accessed on 15 June 2003), but also the massive bombing of the Iraqi capital city Baghdad by western civilised armies should be noted (http://www.heraldonline.com/iraq/iraqss/story/2352338p-2196245c.html, accessed on 15 June 2003).
12. Hall, S. (1997) cit.
13. Johnson, B. Disintermediation and the museum web experience: database or documentary – which way should we go? *Proceeding of Museum and the Web 2003* (http://www.archimuse.com/mw2003/papers/johnsonbrad/johnsonbrad.html, accessed 15 June 2003).
14. In a recent tender by the Museum of River and Rowing (Henley on Thames, United Kingdom), museum curators had observed the way their visitors engaged with computer interactive programmes. They elaborated a simple yet sophisticated metaphor to divide and classify their audiences in *Paddlers* (visitors of all ages who 'taste the water', whose attention is very difficult to be kept alive), *Swimmers* (who know their way but also would like to wander around and be entertained) and *Divers* (research kind, who go straight to their destination and don't look for distractions). The museum had also devised a strategic plan: concentrate on *Paddlers* to get them to become *Swimmers.*
15. Grout, C. et al., *Creating Digital Resources for the Visual Arts: Standards and Good Practice,* Visual Art Data Services. (Online at http://vads.ahds.ac.uk/guides/creating_ guide/contents.html, accessed on 18 June 2003).
16. Levy, R. M. Ph.D. (2001). Temple site at Phimai: Modelling for the scholar and the tourist, *Proceeding of the Seventh international Conference on Virtual Systems and Multimedia (VSMM'01)* (www.ieee.org, accessed on 15 June 2003).

17. For a really thorough analysis of issues of representation, accessibility and control please see Access to American Cultural Heritages: A Study Guide to Issues of Representation, Delivery and Control (http://sunsite.berkeley.edu/American Cultures/guide.html, accessed on 18 July 2004).

18. ibid.

19. ibid.

20. I have seen disable toilets in restaurants whose only way of access is a twenty-step stair.

21. http://www.w3.org

22. http://encyclopedia.thefreedictionary.com/Open+standard (Accessed on 18 July 2004).

23. A good source is http://openstandards.org/

24. http://encyclopedia.thefreedictionary.com/Open+source (Accessed on 18 July 2004).

25. http://unesdoc.unesco.org/images/0013/001311/131178e.pdf. (Accessed on 18 July 2004).

26. Erpanet, Principles of digital preservation, draft 4.1, 30 October 2002.

27. www.erpanet.org

28. www.cordis.lu/ist

Visualisation of Panoramic Images over the Internet

Francesco Aru, Pietro Zanuttigh and Guido M. Cortelazzo

17.1 Introduction

In the early 1990s, panoramic photography made its appearance in the literature of computer graphics, digital image processing and computer vision communities already with a long tradition [1] of its own.

In computer graphics, the idea of rendering novel views from suitable collections of images (called image-based rendering) rather than from 3D models (called model-based rendering) attracted a lot of attention because of its potential of bypassing the difficulties of both 3D modelling real objects and of rendering photorealistic scene illuminations.[2–6] Within the image-based rendering framework, panoramic images became a very popular tool for representing complex real environments, i.e. for obtaining 'environment map' to use in virtual tours of building, cities and the like. In this connection, the work of [7] deserves a special mention as it led to a commercial product called Quick-Time VR, which was very successful and which was the first of a series of many authoring tools for panoramic images.

The issue of panoramic images appeared in the image processing and computer vision literature as special instance of the more general problem of 'image mosaicing', i.e. the composition of images covering portions of a scene into a larger image representing the scene. In the technical literature, the issue of mosaicing is considered together with the automatic estimation of planar projective transformations. Indeed, it is well known that, if the scene's geometry is planar or if the camera's nodal point is held fixed while taking the images, the images are related by 2D projective transformations characterised by 8 parameters (typically called homographies in the computer vision literature). In this respect, the general issue of automatically estimating projective transformations from the images, bears strong ties with the issue of automatic image mosaicing and of automatic construction of panoramic images.[3,7–13] Although panoramic images in principle can be supported by any type of surface,[13] the surfaces' interiors used in practice are cylinders, spheres and cubes. This chapter will concentrate on cylindrical panoramas which are the most popular ones, owing

to the ease of their taking. Indeed cylindrical panoramas can be built from a series of photographs taken with a camera on a levelled tripod.

The construction of a cylindrical panorama or 'stitching' within this framework requires to solve two basic problems: the automatic estimate of the projective transformation between adjacent pairs of images from their overlap (the images must be taken holding the camera's nodal point fixed); the redistribution of the registration error between the whole series of images in order to compensate for error propagation and to make the last image to perfectly fit onto the first one. This second issue is rather relevant especially for high-resolution imagery.[13–16]

It is fair to say that the theoretical problems and solutions behind stitching are well understood (for a comprehensive account, see [13]). Nevertheless fully automatic stitching with high-quality results, in practice is rather difficult. Current commercial products typically combine automatic passes with manual adjustments. Geometrical stitching artefacts may easily go unnoticed if the panoramic images are shown at small scale. This is typically the case of the panoramic images currently used in the Internet in order to avoid transmission delays. However large size panoramas require proper stitching.

Another practically relevant issue which must be overcome in the stitching process concerns the photometric imbalances between adjacent images due to nonuniform illumination and vignetting. Such colorimetric border artefacts can be overcome in many ways. A simple solution called 'feathering' in [13] consists in blending the colours according to convex weights proportional to the distance of the pixels from the image's border. More complex multiresolution blending algorithms can be found in [17,18]. The issue of stitching images within prescribed colorimetric tolerances has not received much attention yet.

It may be worth mentioning that panoramic images can also be obtained by dedicated hardware such as panoramic cameras (typically equipped with special rotating optics featuring a shutter of linear rather than circular shape), fisheye lenses,[19] pyramidal or parabolic mirrors, capable of directly conveying to the optics 360° fields of views.[20] These last solutions have the advantage of avoiding the need for stitching. Moreover they have the drawback of not exploiting the camera's full resolution. They are the popular choice in current omni-directional robotics applications.[21,22]

While the construction of panoramic images indisputably received a fair amount of attention in the technical literature, the issue of local or remote visualisation of panoramic images did not receive comparable consideration. The original paradigm [7] of visualising panoramic images essentially by a procedure dual to stitching (i.e. by sectioning the panorama into a number of slices, converting the slice selected by the user from cylindrical to Cartesian coordinate and displaying it) was generally adopted in both academic prototypes and commercial products. Minor conceptual variations concerned programming languages (e.g. the use of Java) or the compression of panoramic images by schemes such as JPEG or IPIX, in order to improve the transmission efficiency.

In light of the rendering performance of graphic cards and of their current diffusion it seems sensible to explore visualisation solutions for panoramic images which can take advantage of their presence. Exploiting graphic cards for various tasks is a growing trend also in computer vision.[23] Such an approach would have made little sense in the mid-1990s, when the visualisation of panoramic images was first approached, considering the limited capabilities and diffusion of the graphic cards of the time. In the subsequent sections, we will present a visualisation scheme for panoramic images which treats them as 3D objects enabling the use of the graphic hardware.

Another important issue is the remote visualisation of large size panoramic images. In the market, recently, appeared image zooming applications based on the use of video-servers (see Section 4.7). Within this scheme a very high-resolution image resides in the server. When a user, at client's side, selects an image's portion of any size, the graphic interface sends the server its position and size. The server computes in real-time the required image and sends it back to the client. In this way, image zooming becomes a video-on-demand operation relying on a dedicated server. A positive aspect of this solution is the continuous range of high-quality enlargements it can give (provided that the server can perform complex interpolation algorithms in real-time). A first disadvantage is that a dedicated server is required, i.e. a server must be purchased, maintained in operation 24 hours a day 7 days a week, its computation/memory resources must be adequate to serve the expected number of clients, when a peak of demand occurs the quality of service will be degraded, etc. A second disadvantage currently exhibited by the commercial products based on this technology is that they only support small sized visualisation windows, which make it hard to locate the detail within the whole scene. Image-zooming based on dedicated video-servers can also be implemented within viewers of panoramic images.

This chapter discusses an alternative solution for the remote visualisation of panoramic images based on the use of current progressive compression standards. Practical experimentation of such a possibility shows that it allows remote display and zoom of panoramic images in large sized visualisation windows in a very effective way. It is well known that JPEG2000 is intrinsically more efficient than JPEG and that it is scalable in image resolution and quality (see Section 12.3). Therefore, not only it can speed up the transmission of panoramic data with respect to JPEG, but, perhaps more importantly, it allows for a size/quality scalable delivery without data retransmission as would be the case with JPEG. There are, of course, many ways of incorporating progressive compression within a viewer of panoramic images. We will present a solution that is very effective within our novel visualisation scheme.

This chapter is organised in five sections. Section 17.2 reviews basic geometry of panoramic image construction and visualisation. Section 17.3 introduces the proposed rendering scheme where panoramas are treated as interiors of textured cylinders. Section 17.4 presents a way to incorporate JPEG2000 within such

a scheme in order to obtain progressive remote visualisation of zoomable panoramic images. Section 17.5 has the conclusions.

17.2 The Geometry of Panoramic Images

Cylindrical panoramas are supposed to show what a person could see if he were only allowed to rotate his head around a vertical and a horizontal axis as long as the rotation centre remained fixed. The vertical rotation is assumed to be confined within a maximum (and minimum) vertical angle. Indeed such a person could not tell the difference between a still scene surrounding him and the interior of a cylinder textured with the same scene, as long as the cylinder's axis coincided with the head's rotation axis and the cylinder's height corresponded to the maximum vertical viewing angle.

Cylindrical panoramas are the result of a pinhole camera model [24], where the scene is not imaged onto the customary plane, but onto the interior of a cylinder with axis through the centre of projection and parallel to the imaging plane. Figure 17.1(a) exemplifies the formation of an image onto a planar patch (of width $2l$ and height $2h$) by central projection. The projection centre is at the origin of the world coordinates system (WCS) with axes labelled (X, Y, Z). The image plane is orthogonal to the Z axis and has its origin at $(0, 0, f)$, where f is the camera's focal length. The image coordinates are labelled (x_p, y_p). By triangle similarity (see Figure 17.1), it is straightforward to determine that the image coordinates (x_p, y_p) of point $P = (X, Y, Z)$ are

$$\begin{cases} x_p = f \dfrac{X}{Z} \\ y_p = f \dfrac{Y}{Z} \end{cases} \tag{17.1}$$

Figure 17.1 also shows the formation of an image on a cylindrical surface of radius $r = \sqrt{f^2 + l^2}$, with axis coinciding with the Y axis of the WCS. The image is formed on a patch of the cylindrical surface subtended by the above-considered planar patch of width $2l$ and height $2h$.

Let us call (x, y) the coordinates of point $P = (X, Y, Z)$ on the cylindrical surface (see Figure 17.1). By observing that $\tan(\theta) = X/Z$ and that $x = \theta \cdot r$, it is straightforward to see that

$$\begin{cases} x = r \tan^{-1}\left(\dfrac{X}{Z} \right) \\ y = r \dfrac{Y}{\sqrt{X^2 + Z^2}} \end{cases} \tag{17.2}$$

The last equation derives from the similarity of the triangles.

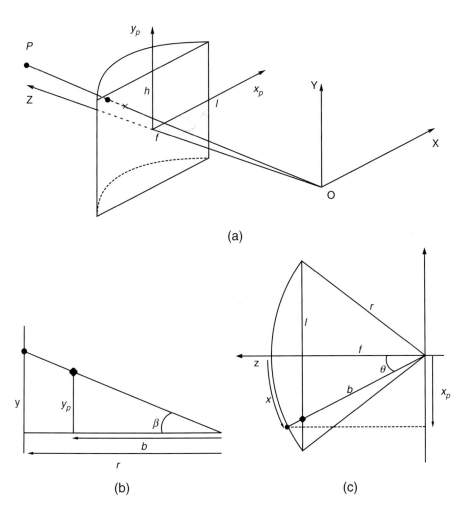

Figure 17.1
(a) Central projection
of point *P* onto a planar
and a cylindrical imaging
surface; (b) side view;
(c) top view.

(a)

(b) (c)

Direct relationships between (x, y) *and* (x_p, y_p) are most useful. Indeed the stitching procedure requires the mapping of regular images formed on a planar surface, onto a cylindrical patch of the type shown in Figure 17.1. Panorama visualisation requires instead to remap into planar surfaces the images positioned on cylindrical surfaces. By comparing the first equations of (17.1) and (17.2) and by eliminating from them the term X/Z (or by direct inspection of Figure 17.1b if one prefers) it can be easily seen that

$$x_p = f \tan \theta = f \tan \left(\frac{x}{r} \right) \qquad (17.3)$$

Figure 17.1(a) and (b) show that since $b = f \cos \theta$ the relationship $y_p/b = y/f$ can be written as

$$y_p = y \frac{f}{r} \frac{1}{\cos \left(\dfrac{x}{r} \right)} \qquad (17.4)$$

Figure 17.2

(a) An example image from
a panoramic sequence taken in
the nave of St. Mary's Church,
Studley Royal, UK, and (b) its
projection on a cylindrical
surface by Eq. (17.5) displayed
on a plane.

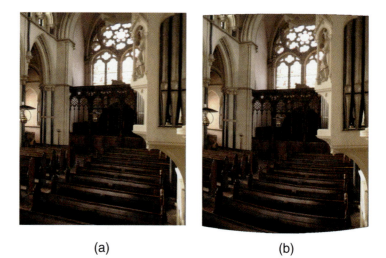

(a) (b)

From Eqs. (17.3) and (17.4) one obtains

$$
\begin{cases}
x = r \arctan\left(\dfrac{x_p}{f}\right) \\[2ex]
y = y_p \dfrac{r}{f} \cos\left(\dfrac{x}{r}\right)
\end{cases}
\tag{17.5}
$$

The computation of Eq. (17.5) requires first the evaluation of the expression
concerning coordinates x and x_p.

It is worth observing that when images projected onto a cylindrical surface are
displayed on a planar surface (such as a monitor or a paper sheet), horizontal
lines exhibit a characteristic curvilinear distortion, as shown in Figure 17.2.

17.3 Rendering Panoramic Images as 3D Objects

Cylindrical panoramas, as shown in the previous section, are images projected
onto cylindrical surfaces. Standard visualisation procedures essentially reproject
the portion of panorama of the viewer's interest onto a planar surface via Eqs.
(17.3) and (17.4). We propose instead to consider directly the panoramas as
interiors of textured cylindrical surfaces. In this way, panoramic images may be
treated as 3D objects and graphic accelerators, ubiquitous in current comput-
ers, may be deployed in their visualisation.

This solution requires development of a special graphic engine tailored to the
visualisation of cylindrical panoramics, i.e. complying with a number of constraints.
A first constraint is that the user has only one viewpoint, located at the mid-
point of the main axis of the cylinder supporting the panorama. Furthermore,
since what one sees with cylindrical panoramas emulates the limited horizontal

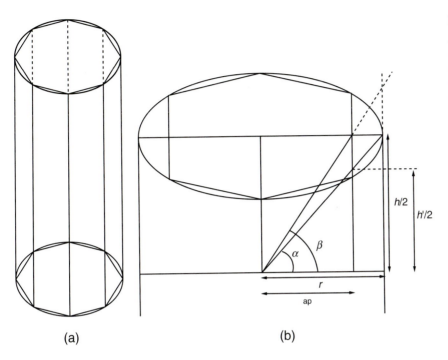

Figure 17.3

Approximation of a cylinder by a regular (osculatory) prism (a) general view; (b) detail.

(a) (b)

and vertical rotation of the head from a fixed centre, the graphic engine must only allow for lateral panning motion and vertical rotation (within a given angle) around the centre. Other constraints on the graphic engine come from the fact that in computer graphics it is customary to approximate cylinders with osculatory prisms having regular polygonal basis, as shown in Figure 17.3.

The term osculatory means that the prism's edges are tangential to the cylinder's interior. Clearly the higher the number N of the polygon's sides the better is the approximation. For sensible choices of N it is worth examining the texture's warping from a cylinder to its prism approximation. It is worth recalling that the perimeter of a regular N sided polygon inscribed in a circle of radius r is

$$P = 2 N r \sin\left(\frac{\pi}{N}\right) \qquad (17.6)$$

and that the minimum distance from the border to the polygon's centre, called apotheme (see Figure 17.4), is

$$a = r \cos\left(\frac{\pi}{N}\right) \qquad (17.7)$$

Therefore the image obtained by mapping a panoramic image supported by a cylinder of radius r, i.e. of width $2\pi r$, onto an osculatory prism inscribed in the cylinder will have width P given by Eq. (17.6). If the original panoramic

Figure 17.4
The apotheme of a hexagon.

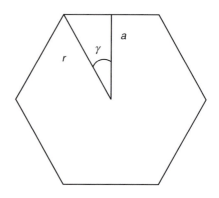

image has height H the image warped on the prism will need to be adjusted to have maximum height h_M given by

$$h_M = H \frac{P}{2\pi r} = \frac{HN}{\pi} \sin\left(\frac{\pi}{N}\right) \tag{17.8}$$

in order to keep its original proportions. Furthermore, since the distance from the cylinder of the points on each prism's side varies from zero (for the points on the prism's edges which are tangent to the cylinder) to a maximum of $r - a$ (for the points exactly at the middle of each prism's side), the height of the image mapped on the prism varies from the maximum value h_M given by Eq. (17.8) to the minimum value h_m given by

$$h_m = h_M \frac{a}{r} = \frac{HN}{\pi} \sin\left(\frac{\pi}{N}\right) \cos\left(\frac{\pi}{N}\right) \tag{17.9}$$

Figure 17.5 shows the section of a panoramic image mapped onto an osculatory prism with $N = 9$ sides (for clarity sake we choose a low value of N in order to emphasise the vertical border effects of the prism's projection).

Since the approximation of the cylinder by the prism improves with N, the white region will decrease as N increases. Reasonable choices for N can be determined by examining the behaviour of ratio $h_m/h_M = \cos(\pi/N)$ versus N. Figure 17.6 and Table 17.1 show that N values greater than or equal to 16 allow one to see at least 98 per cent of the original image's height. It is not recommended to use N less than 16.

This characteristic of the mapped image implies a further constraint on the graphic engine, namely that it will have to limit its vertical viewing angle to image sections of size h_m in order to avoid showing the white regions of the top and bottom parts. More specifically, if β is the vertical viewing angle of the visualisation window, assumed to be centred at angle α, as shown in Figure 17.7(a) and Figure 17.7(b), the graphic engine must ensure that

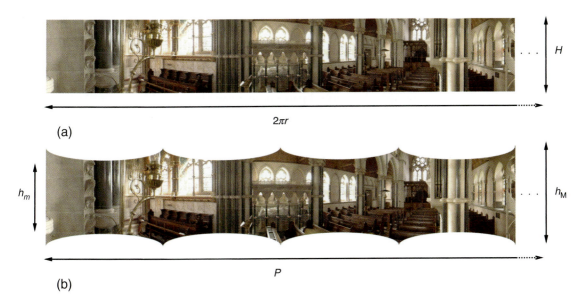

(a)

$2\pi r$

h_m

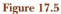

(b)

P

h_M

Figure 17.5

(a) Horizontal section of panoramic image; (b) its mapping onto an osculatory prism with $N = 9$.

$$\alpha + \frac{\beta}{2} \leq \tan^{-1}\left(\frac{h_m}{2}\right) \qquad (17.10)$$

It is worth recalling that the vertical angle constraints affect also the maximum horizontal viewing angle φ, which must satisfy

$$\varphi \leq \frac{V_\omega}{V_h} \tan^{-1}\left(\frac{h_m}{2}\right) \qquad (17.11)$$

where V_ω and V_h denote the visualisation window width and height respectively.

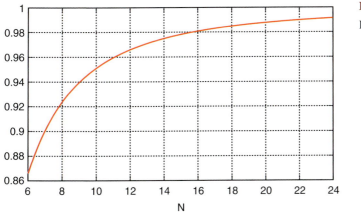

Figure 17.6

Ratio h_m/h_M versus N.

The panoramic image warped onto the prism's interior gives the texture to be mapped on each rendered view. Given the fact that most graphic cards supporting OpenGL cannot handle single textures exceeding 2048 × 2048 pixels and that the width of a panoramic image can easily be 2048 pixels, it is convenient to subdivide the warped panoramic image into N subimages and to use them as textures for each side of the prism. Owing to the interpolation needed to texture each view, it is advisable to use for each side textures slightly wider than the side width, as exemplified in Figure 17.8. The texture's extensions should include as many pixels as needed by the interpolation filter at the side's edge. Such a provision eliminates border effects at the prism's edge in views covering regions between sides.

The inclusion of a zoom-in and zoom-out feature in a viewer of panoramic images cannot be implemented as in standard graphic engines, i.e. by moving the view-point closer to or farther from the area of interest, since in a graphic engine specialised for rendering panoramic images the view-point is constrained to remain fix. In such a view the zoom-in (zoom-out) effect can be obtained by narrowing (enlarging) the field of view. The perceptual result approximates rather nicely the moving closer or farther of the actual view-point.

A practical way of handling field of view's variations is by partitioning the panoramic's texture into subregions, see Figure 17.9. Their number and size will depend on the panorama's dimensions. Some examples are reported in Table 17.2. We will describe a mechanism capable of effectively handling several resolution levels. For clarity of presentation, we will focus on the case of a basic resolution level and two enlargement levels, called zoom 1 and zoom 2, each one at twice the resolution of the previous level. Such a situation is adequate for most practical situations, however it is straightforward to extend the proposed scheme to handle an arbitrary number of zoom levels.

Figure 17.7

Visualisation window and vertical viewing angles:
(a) perspective view;
(b) side view.

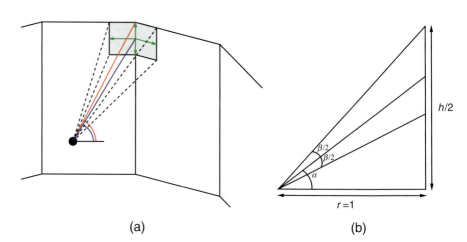

(a) (b)

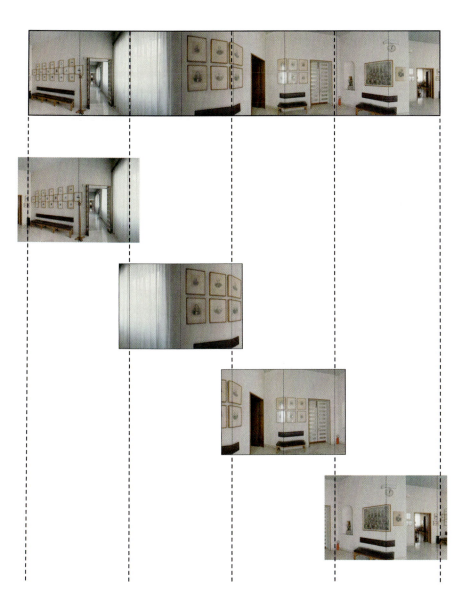

Figure 17.8
Examples of textures of the prism's side.

Figure 17.9
Example of panorama's subdivision.

Table 17.2

Examples of texture
partitioning for
panoramic images.

	Texture subdivision (rows–columns)	Basic resolution	Zoom level 1	Zoom level 2
St. Mary's Church	3–6	6912 × 768	6912 × 768	13824 × 1536
Sant'Orsola's Fresco	2–8	1536 × 512	3072 × 1024	6144 × 2048
Gardena Pass	2–5	1728 × 160	3456 × 320	—
Giau Pass	2–4	768 × 128	1536 × 256	—

The graphic engine besides the N static texture areas reserved for each prism's side, reserves one dynamic texture area for each zoom level. Zoom level 1 is supported by a dynamic texture area encompassing a region of 3×3 basic subregions of double resolution with respect to the basic level. When the user's navigation calls for a close-up view at twice the resolution of the basic level, the graphic engine loads into the dynamic area reserved for zoom level 1 the double resolution textures of the central subregion required by the user and of the 8 subregions surrounding it (see Figure 17.10). Once such a texture area is loaded, the graphic engine takes the texture from it. The dimensions of the 3×3 subregions are chosen in order to fill the visualisation window, so that no regions at different resolution may fall into it and a single resolution scene is always displayed. Resolution levels between the basic level and zoom level 1 are filled in by interpolation.

Zoom level 2 is supported by a dedicated dynamic texture area encompassing a region of 2×2 basic subregions at resolution double that of zoom level 1 (and quadruple that of the basic level). The zoom level 1 subregions are subdivided in four regular areas of type left top, right top, left bottom and right bottom. When the user's navigation calls for a close-up view at twice the resolution of zoom level 1, the quadruple resolution textures of four suitable subregions are loaded into the dynamic texture area reserved for zoom level 2. The subregions are selected so that the area of the subregion targetted by the zoom occupies

Figure 17.10

Enabling zoom level 1.
The Memorial Chapel
in the south aisle of
St. Mary's Church
contains the marble
effigies of the Marquess
and Marchioness of
Ripon.

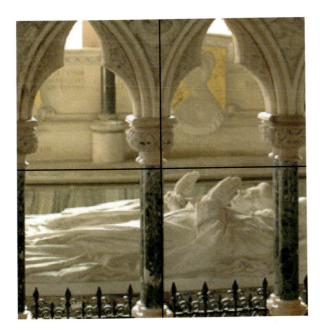

Figure 17.11
Enabling zoom level 2.

the central position. For instance if the viewing direction aims at the right bottom tile, the graphic engine will load the subregions located at the right and at the bottom of the subregion originally inspected (see Figure 17.11). Resolutions intermediate between zoom levels 1 and 2 are handled by interpolation. Clearly such an operational scheme can be arbitrarily iterated.

Higher resolution textures can be locally handled with relative ease. Their availability and handling become much more delicate in a remote visualisation context where they have to be transmitted. Caching in this scenario becomes an essential texture management tool. Practical transmission and caching of zoomed data requires to take image compression into account. Therefore the description of the zooming provision will be completed in the next section, after the introduction of image compression.

17.4 Progressive Compression of Zoomable Panoramic Images

Current signal compression algorithms are able to organise the compressed data stream into levels of increasingly higher detail. Such a characteristic is recognised to be most useful for the remote visualisation of images over narrow band channels as it allows the user to rapidly receive a coarse version of the image, which over time can become rich in details.

The major standardisation effort in such a direction is represented by JPEG2000, produced by the JPEG and JBIG committees under the auspices of

ISO/IEC JTC 1/SC29/WG1, i.e. of working Group 1 of Study Committee 29 of Joint Technical Committee 1 of ISO/IEC [25,26]. A first recognised characteristic of JPEG2000 is a typical compression improvement over JPEG of 20 per cent without appreciable loss in image quality. A second important characteristic is that it allows for scalability with respect to both image resolution and image quality. This means that a suitable organisation of the code-stream allows one to obtain versions of the same image of different visual quality and of different resolution steps (each one of resolution double that of the previous step). Any of the above possibilities would require full data retransmission with JPEG. For a description of standard JPEG2000, which is rather articulated and rich with possibilities, the reader is referred to Chapter 12. In the literature [27] is recommended as a rather comprehensive and clear source.

It may be worth recalling where the above-mentioned scalability characteristics of the JPEG2000 come from. In this connection, JPEG2000 can be considered as a two-step procedure featuring a first step concerning wavelet-based signal filtering and a second step concerning coefficient quantisation (see Section 12.2). The wavelet transform, at its simplest conceptual level, operates a subband partition, i.e. it subdivides the Fourier representation of an image into four separate subbands typically denoted as LL, HL, LH and HH, as shown in Figure 17.12(a), from the type of their frequency content. Letters 'L' and 'H' in this context denotes low-or high-frequency content. Code 'LL' indicates that the subband contains the low horizontal and vertical frequency content of the considered image, 'HL' that the subband contains the high vertical and low horizontal frequency content, etc. By iterating such a subdivision in the LL band one obtains the pyramidal decomposition shown in Figure 17.12(b). Clearly such a procedure can be iterated as many times as required, leading to the spectral decompositions typical of the wavelet transform. A five level wavelet decomposition is rather typical for image compression (though clearly for small size images not as many decomposition levels are used).

The data associated with band LL_2 pertain to the low horizontal and vertical frequencies of the image and give a low resolution version of the image, as shown by Figure 17.12(c). The data associated with the other subbands of level 2, namely with subbands LH_2, HL_2 and HH_2 contain the higher frequency detail which needs to be added to LL_2 in order to obtain LL_1, i.e. an image version of resolution double that of associated with LL_2. By adding the image associated with LL_1, to the data associated with LH_1, HL_1 and HH_1, one obtains the maximum resolution image for the decomposition represented in Figure 17.12. This example explains how wavelet decomposition enables scalability in resolution.

Coefficient quantisation, which is the second basic ingredient of JPEG2000 is also performed in a progressive way. The mechanisms behind coefficient

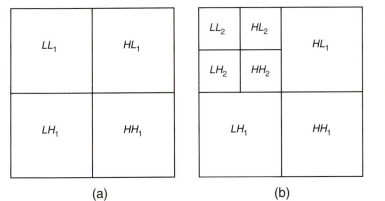

(a) (b)

Figure 17.12

(a) Subband partition;
(b) wavelet decomposition;
(c) an example of transformed data.

(c)

quantisation are rather complicated and it is not possible to attempt any description without introducing considerable technical detail. For the purposes of this chapter it will suffice to say that the precision of coefficients is progressively organised into 'quality layers', so called because each is associated with a visual quality level. The more quality layers are jointly used for the coefficients, the better the image quality will be.

Both types of scalability can be very useful for transmitting images over narrow band channels such as current modem connections to the Internet, particularly for the transmission of large size images, as is typically the case with panoramic images. Indeed the compressed data can be organised in such a way that a low-resolution low-quality version of the image is first transmitted; the visual quality can be subsequently improved in one or more steps by the transmission of further packets of data. Once the full image quality of a given resolution is obtained, the resolution can be doubled and the quality of the double resolution image can be subsequently improved in various steps. Such a procedure, in principle, can be iterated as many times as wanted. In practice, it is worth breaking the codestream into a number of resolution/quality contributions suited to the channel bandwidth. For instance, a reasonable trade-off for current Internet transmission over modems with at most 56 kb/s transmission rate is given by codestream slots not greater than a few hundred kilobytes. Data packets of such a size can avoid the user from excessive waiting without noticing any variation in the transmitted image.

In the previous section, it was pointed out that in order to enable zooming of a picture it is convenient to treat panoramic images not as single pictures but as sets of subimages. Such a position is the only practical way to handle the transmission of panoramic images of several megabytes (for example, consider that a panoramic image of 13824×1415 pixels occupies about 60 MB in uncompressed form and typically 2 or 3 MB when compressed by JPEG2000 with reasonable quality). Indeed, the transmission of a few megabytes of data, even when broken into a suitable number of packets of hundreds of kilobytes, would require a long time. Furthermore, the memory management of the uncompressed data on the user's part would also require proper care. JPEG2000 provides special structures for handling image partitioning and regions of interest. JPEG2000's concept of 'tile' applies to image subdivisions into regular non-overlapping regions such as those introduced in Section 17.3 in connection with zooming. For a formal treatment of this concept the reader is referred to Chapter 11 in reference [27]. Here it will suffice to recall that an image can be treated as a collection of separate subimages, called tiles, and each tile can be independently coded. Quality and resolution scalability can be independently applied on each tile. Each tile can be transmitted independently of the others when needed.

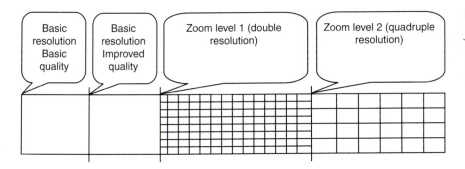

Figure 17.13

JPEG2000-based progressive compression scheme for 3 resolution levels.

Zooming at three resolution levels, as discussed in Section 3, can be supported within a JPEG2000 framework by the tile-based scheme shown in Figure 17.13. Such a scheme has a first basic resolution/basic quality level for the whole image (all the tiles) followed by an improved quality level for the whole image. Zoom levels 1 and 2, when activated, provide the transmission of a further resolution layer each for the requested tiles only.

All transmitted tiles once used are stored in the cache in compressed form. When the user's navigation prompts a zooming request, the graphic engine at first checks whether the requested tiles are already in the user's cache. In case they are, they are decompressed at run-time and placed in the proper dynamic texture area; in case they are not, the graphic engine requests their transmission from the server. Caching the tiles in compressed form solves possible memory management problems since it may require at most a few megabytes of random access memory (RAM). Caching the tiles in uncompressed form would not be equally straightforward if they occupied several tens of megabytes as might be the case with large size panoramas.

Table 17.3 presents some examples of compressed partitioned panoramic images of various sizes. The largest panorama concerns an interior view of St. Mary's Church, Studley Royal. It has dimensions 13824×1536 pixel. It could be compressed with JPEG2000 down to 2.073 MB maintaining acceptable image quality. The layers relative to basic resolution and basic quality (3456×384 pixel) occupy 118 kB, therefore a low-quality version of this image could be transmitted relatively fast also on a 56 kb/s modem line. The image quality can be substantially improved by the transmission of a further 297 kB. If a close-up was needed, on navigation the user's demand, nine tiles of zoom level 1 will first be transmitted. It can be seen that doubling the basic resolution for the whole panorama, i.e. the direct use of a panorama of 6912×768 pixel would require the transmission of about 1 MB of further data, namely of 973 kB.

The double resolution panorama is divided into 324 tiles of size 128×128 pixels, each of which occupies around 3 kB of data. The exact memory occupancy of each tile depends on its specific characteristics (level of detail, etc.). The transmission of the data concerning zoom level 1 of just 9 tiles, i.e. what is strictly

Table 17.3

Examples of
compressed
partitioned
panoramas.

	Panorama's dimension	Uncompressed ARGB 32 bit/pixel (MB)	Uncompressed RGB 24 bit/pixel (MB)	JPEG2000 compressed (MB)
St. Mary's Church	13844 × 1536	85	60	2.07
Sant'Orsola's Fresco	6144 × 2048	50.33	37.75	1.2
Gardena Pass	3456 × 320	4.42	3.32	0.3
Giau Pass	1536 × 256	1.6	1.2	0.096

	Basic resolution basic quality (kB)	Basic resolution improved quality (kB)	Zoom level 1 total memory (kB)	Zoom level 1 single tile (kB)	Zoom level 2 total memory (kB)	Zoom level 2 single tile (kB)
St. Mary's Church	118	297	973	3	685	2.11
Sant'Orsola's Fresco	25.4	92.1	452	2.35	658	3.43
Gardena Pass	20	101	170	1.21	–	–
Giau Pass	7.3	31.6	57	0.6	–	–

necessary for a close-up at zoom level 1 would require only the transmission of approximately 27 kB. Therefore it can be performed very fast. The direct use of the whole full resolution panorama of 13844 × 1533 pixels would require only the transmission of a further 685 kB of data, which is a rather sizable amount. However, since the image is split into 324 tiles of 256 × 256 pixels, a further zoom up to the second zoom level can be accomplished by just the transmission of the data relative to zoom level 2 of 4 tiles of this type. Since they occupy about 2 kB each, visualisation at zoom level 2 can be obtained by transmission of a further 8–9 kB. Table 17.3 reports other data relative to the partitioning of panoramic images of different size and characteristics.

17.5 Conclusions

This chapter has presented an innovative scheme for the visualisation of cylindrical panoramas which is very effective for remote use. There are several conceptual and practical points of interest of the proposed method.

A conceptual novelty of the proposed visualisation scheme is that it does not consider cylindrical panoramas as warped 2D images as typically assumed by

current viewers (which consistently approach the visualisation of panoramic images as a 2D warping task). Cylindrical panoramas are instead considered as 3D objects, namely as interiors of textured cylinders (with axis coinciding with the panorama's photographic axis). Such a conceptual position allows the visualisation of a cylindrical panorama to be treated as a rendering issue for dedicated graphic engine. The graphic engine must indeed satisfy the constraints required by the inspection of a panoramic image, notably, it can only allow for horizontal panning (and a limited vertical rotation) around one central viewpoint. This fact has several consequences for implementation, as explained in Section 17.3, such as the fact that zooming in (or out) must be dealt as a viewing angle reduction (or enlargement) and not as a motion of the viewing position closer (or further) to the textured cylinder.

Treating panoramic images as 3D objects and deploying a graphic engine for their visualisation gives the ability to exploit graphic cards for visualising panoramas. Graphic cards, rather powerful and ubiquitous in current computers, enable large window size visualisation and zooming of panoramic images at quality clearly superior to that of merely software-supported visualisation. Graphic cards can indeed implement effective real-time linear and nonlinear texture processing operations beyond the reach of software implementations.

Another important novelty of the proposed visualisation scheme is that it incorporates progressive compression based on JPEG2000 in order to handle the remote visualisation of panoramas most effectively.

The performance of the proposed scheme for visualising panoramas is demonstrated by a prototype [28] implemented within the VITRA project. The current viewer's implementation is in Java 3D, which is an extension of Java enabled to access graphic accelerators (standard Java cannot use graphic cards). Java 3D has the portability features typical of Java, but it requires an addition to the libraries of the standard Java virtual machine.

As the standard scheme for panorama visualisation based on image warping from cylindrical to cartesian coordinates has been implemented in many versions with different languages and various compression algorithms, one can envision a similar activity also for the panorama visualisation method presented in this chapter. In this connection, implementation tests certainly worth considering are represented by GL4Java and by Shout3D which are specialised graphic libraries in the Java language giving access to graphic hardware facilities. A better performing implementation of the viewer can be obtained by plug-ins tailored to specific system characteristics.

It is also worth recalling that the structures of JPEG2000 and in general of current progressive compression algorithms offer many possibilities of integration within remote viewers of panoramic images in order to support zooming and visualisation window enlargements. There is relatively little research in this area at this time and further investigation will certainly be beneficial.

17.6 Acknowledgements

We would like to acknowledge EC project *VITRA* which supported in part this work and various people involved in it for their help. Keith Findlater of the Colour & Imaging Institute of the University of Derby provided the panoramic image of St. Mary's Church, Studley Royal. Cristiano Bianchi pointed out to us the usefulness of GL4Java and Shout3D for implementing the proposed viewer. Alfredo Giani acted as a contact person between our group and the Colour & Imaging Institute, often providing us with stimulating discussions.

17.7 Bibliography

1. Malde, H. E. (1983). Panoramic Photographs. *American Scientist,* **71**(2), 132–140.
2. Chen, S. and Williams, L. (1993). View interpolation for image synthesis, *Computer Graphics (SIGGRAPH'93),* pp. 279–288.
3. McMillan, L. and Bishop, G. (1995). Plenoptic modeling: an image based rendering system, *Computer Graphics (SIGGRAPH'95),* pp. 39–46.
4. Gortler, S. J., Grzeszczuk, R., Szeliski, R. and Cohen, M. F. (1996). The Lumigraph, *Computer Graphics Proceedings, Annual Conference Series, Proc. SIGGRAPH'96.* New Orleans, ACM SIGGRAPH, pp. 43–54.
5. Levoy, M. and Hanrahan, P. (1996). Light field rendering, *Computer Graphics Proceedings, Annual Conference Series, Proc. SIGGRAPH'96. New Orleans,* ACM *SIGGRAPH,* pp. 31–42.
6. Kang, S. B. (1997). A survey of image-based rendering techniques. Technical Report 97/4, Digital Equipment Corporation, Cambridge Research Lab.
7. Chen, S. E. (1995). Quicktime VR, an image-based approach to virtual environment navigation, *Computer Graphics (SIGGRAPH'95),* pp. 29–38.
8. Mann, S. and Picard, R. W. (1994). Virtual bellows: constructing high-quality images from video, *First IEEE International Conference on Image Processing (ICIP'94),* Austin, Texas, pp. 363–367.
9. Szeliski, R. Image mosaicing for tele-reality applications, *IEEE Workshop on Applications of Computer Vision (WACV'94), IEEE Computer Society, Sarasota, Florida,* pp. 44–533.
10. Irani, M., Anandan, P. and Hsu, S. (1995). Mosaic based representations of video sequences and their applications, *Fifth International Conference on Computer Vision (ICCV'95),* Cambridge, Massachusetts, pp. 606–611.
11. Szeliski. R. (1996). Video mosaics for virtual environments. *IEEE Computer Graphics and Applications,* **16**(2), 22–30.
12. Cortelazzo, G. M. and Lucchese, L. (1999). A new method of image mosaicking and its application to cultural heritage representation, *Computer Graphics Forum,* **18**(3), C265–C275.
13. Shum, H.-Y. and Szeliski, R. (2000). System and experiment paper: Construction of panoramic image mosaics with global and local alignment. *International Journal of Computer Vision,* **36**(2), 101–130.
14. Szeliski, R. and Shum, H.-Y. (1997). Creating full view panoramic image mosaics and texture-mapped models, *Computer Graphics (SIGGRAPH'97),* pp. 251–258.
15. Kang, S. B. and Weiss, R. (1997). Characterization of errors in compositing panoramic images. *IEEE Computer Society Conference on Computer Vision and Pattern Recognition (CVPR'97),* San Juan, Puerto Rico, pp. 103–109.

16. Hasler, D., Sbaiz, L., Ayer, S. and Vetterli, M. (1999). From local to global parameter estimation in panoramic photographic reconstruction, *Proc. of IEEE International Conference on Image Processing*, pp. 113–117.

17. Burt, P. J. and Adelson, E. H. (1983). A multiresolution spline with application to image mosaics, *ACM Transactions on Graphics*, October 1983 **2**(4), 217–236.

18. Hsu, C.-T. and Wu, J.-L. (1996). Multiresolution mosaic, *Proc. of ICIP'96*, vol. 3, Switzerland, September 1996, pp. 743–746.

19. Xiong, Y. and Turkowski, K. (1997). Creating image-based VR using a self-calibrating fisheye lens. *IEEE Computer Society Conference on Computer Vision and Pattern Recognition (CVPR'97)*, San Juan, Puerto Rico, pp. 237–243.

20. Nayar, S. (1997). Catadioptric omnidirectional camera, *IEEE Computer Society Conference on Computer Vision and Pattern Recognition (CVPR'97)*, San Juan, Puerto Rico, pp. 482–488.

21. Benosman, R. and Kang, S. B. (eds.) (2001). *Panoramic Vision: Sensors, Theory and Applications*. Springer-Verlag, May 2001.

22. Omnivis 2003: Workshop on Omnidirectional Vision and Camera, *IEEE Computer Society Conference on Computer Vision and Pattern Recognition (CVPR'03)*, Madison, Wisconsin, June 2003.

23. Yang, R. and Pollefeys, M. (2003). Multi-resolution real-time stereo on commodity graphics hardware, *IEEE Computer Society Conference on Computer Vision and Pattern Recognition (CVPR'03)*, IEEE Computer Society, Madison, Wisconsin, June 2003, pp. I211–I217.

24. Hartley, R. I. and Zisserman, A. (2000). *Multiple View Geometry in Computer Vision*. Cambridge University Press.

25. New work item proposal: JPEG2000 image coding system. (1996). Technical ReportN390, ISO/IEC JTC1/SC29/WG1, June 1996.

26. JPEG2000 Part 1 defect report. (2001). Technical Report N1980, ISO/IEC JTC1/SC29/WG1, January 2001.

27. Taubman, D. and Marcellin, M. (2001). *JPEG2000: Image Compression Fundamentals, Standards and Practice*. Kluwer Academic Publishers, Boston, November 2001.

28. http://lttm.dei.unipd.it/vitra-final

3D Virtual Restoration of Polychrome Sculpture

Angela Geary

18.1 Introduction

The practice of physically restoring the appearance of damaged and aged artefacts is long established in the field of conservation. It is still widely considered to be an essential aspect of the conservator's role and indispensable to our appreciation of cultural heritage, particularly in the domain of pictorial art. However, the imposition of one view of the possible original appearance of an object, albeit 'well informed', can give rise to significant subjective approximation or complete invention. The author's research into the application of digital imaging technology in conservation has explored the viability of providing an alternative means of visualising the past appearances of artefacts. Virtual restoration could come to displace the aesthetically motivated physical restoration of objects by offering an alternative means of conveying original appearance in the context of museum display.

Damaged and degraded three-dimensional (3D) painted surfaces present a particular problems, especially in cases where physical restoration is unfeasible because of extensive damage or where the basis for a particular restoration outcome is uncertain due to lack of knowledge, historical precedent or other factor. In contemporary conservation practice, full restoration of such degradation is usually considered neither a practicable nor an ethical option. Digital imaging technology offers a means of recreating the original appearance of such objects through virtual restoration. Existing accessible technologies can be utilised in the reconstruction of the possible original appearances of artefacts to achieve realistic full-colour 3D visualisation in the fields of conservation or cultural heritage. This chapter presents a comprehensive overview of the processes, technologies and skills involved in advanced visualisation for conservation and heritage applications with accompanying case studies.

For 3D visualisation, a method is required for the development of accurate, full-colour content representing the object. The process can be broken down into several stages, each of which engages with different technologies and requires a particular set of skills. These include: 3D digitisation, converting the raw scanned data to a 3D digital model, mapping colour and texture to the model, manipulating the model's appearance using 3D and 2D visualisation software and, finally, rendering images for static or dynamic presentations of the visualisations.

18.2 3D Digitisation

Technologies for the 3D scanning or digitisation of physical objects have been available since the 1980s. The National Research Council of Canada (NRCC) was among the first to apply laser scanning technology to heritage recording,[1] and added to this the possibility of accurate 3D colorimetric[1] capture in the 1990s, when they developed an RGB[2] scanner.[2] This was tested in association with the Canadian Museum of Civilisation and other Canadian collections and several full colour models were acquired.[3] In the early 1990s, the 3D fax project in 3D digitisation was begun by the Computer Science Department of Stanford University.[4] This evolved into a repository of high-resolution data, subsequently made available for general research applications[3]. More recently, a research challenge for digitising heritage objects has been the high-resolution capture of large objects. Levoy,[5] as part of the Digital Michelangelo project, has captured data sets from a selection of the sculptor's major pieces. However, it is only relatively recently that 3D scanning devices offering sufficiently high resolution and accuracy have become more accessible and affordable. In addition to visualisation applications, 3D scanning can provide a complete and informative method of museum documentation including arbitrary virtual viewing positions, volumetric and surface measurement information, the possibility of facsimile reproduction and, using tri-colour laser systems, precise colour data (see also Chapter 6).

18.2.1 Options for 3D scanning

For the case studies presented later in this chapter, a variety of digitisation methods was considered. Laser range scanners offer a very efficient means of

[1]Colorimetric information is calculated from the intensity of the R, G, B components of the laser reflectance in three-colour laser scanning. The measurement results in X, Y, Z values in the Commission Internationale de l'Éclairage (CIE) colour space.

[2]A red, green and blue laser emission, incident on the surface, returns range and amplitude data simultaneously to the camera.

[3]http://www-graphics.stanford.edu/data/3Dscanrep/.

remotely sensing objects, allowing accurate, high-resolution 3D capture at real-time processing speeds. Theoretically, passive photogrammetric systems[4] can match laser scanners in accuracy and resolution (see Section 6.3.3). In practice, however, the time and labour involved in achieving this with currently available software is prohibitive. Photogrammetric software calculates surface shape mathematically from stereo images of a scene. Velios [6] provides a detailed investigation of this method for the digitisation of fragmented museum artefacts. Photogrammetry is usually more appropriate to situations where sparse data is sufficient, such as geographical imaging and other survey applications. The method is found not to be practicable for capturing the dense coordinate point data required for accurate visualisation.

Active, close-range photogrammetric (CRP) systems that combine the photogrammetric method with patterned light projection have been developed. The Tricorder[5] *Visage*™ CRP device used in the research, projects a random light pattern onto the subject to collect 3D data. To achieve this, four digital video cameras are mounted in a fixed position and record images from the subject while it is illuminated by the light pattern. The cameras record four sets (two horizontal and two vertical) of stereo-pair images from the subject. The random light pattern provides the multiple point correspondences needed for fast and reliable digitisation. This proprietary capture system, described by the company as *Digital Surface Photogrammetry* (DSP), reconstructs geometry from the stereo images by matching the light pattern between them. The illumination and camera are precisely synchronised allowing rapid capture (every 2 milliseconds). This facilitates the digitisation of animate subjects, such as human beings, because small movements will not affect the acquisition process. It is also possible to capture 3D data over time using DSP[6]. These features are particularly useful in the field of medical imaging and have been applied in maxillofacial surgery[7], for example. Traditional photogrammetry matches common surface features between images to reconstruct geometry. It can be slow, painstaking and relatively inaccurate to reference points manually. Automatic matching of surface points by computer, although more precise, can also be slow and processor intensive. Thousands of points must be identified iteratively and their coordinates calculated. If dense cloud data is needed, as in

[4]It is considered a passive method when the capture process does not modify the view of the subject.

[5]Tricorder Plc. became TCT International Ltd. in 1999. The *Visage*™ system evolved to become *tcti FACE*™. The same technology of capture was used in *Visage*™ as is now implemented in the 3dMD company's current range of scanning hardware. http://www.3dMD.com

[6]The DSP approach differs from the more common active CRP devices, which use structured, rather than random light projection.

[7]Surgeons at the Queen Victoria Hospital in East Grinstead use a TCTi DSP system to acquire 3D data from patients. This is used in facial reconstruction plans. Measurements are also extracted allowing the assessment of the effects of surgery and other treatments. http://www.queenvic.demon.co.uk

digitisation for detailed surface reconstruction, then many thousands of features must be matched. This becomes problematic if the surfaces do not have sufficient features or suitable surface texture information. *Visage*™ and other CRP systems overcome this by projecting a pattern of light onto the scan subject to provide the necessary diffuse feature matching data needed for simultaneous capture of multiple points.

Laser scanners provide an appropriate digitisation solution for both visualisation requirements and the particular constraints of scanning museum objects. Laser scanners, or range finders, pass a laser beam over the object's surface and the reflectance of this is sensed by a camera device (see Section 6.4). Typically, laser scanners use a single laser source, usually in the red range of the spectrum. The position of the laser emitter and the sensor are fixed and known, therefore it is possible to calculate the changes in surface shape from the varying angles of reflectance (Figure 18.1) Positional information about the laser emission reflectance is optically recorded and these values are used to determine depth by a trigonometric triangulation calculation. To build 3D data from a continuous surface it is necessary to take measurements from many location points. This is achieved rapidly when the laser beam is passed through a diverging lens to create a stripe of light, which is then swept back and forward at high speed by an internal tilting. In this way, many coordinates are recorded simultaneously resulting in a dense set of points known as a 'point cloud' (Figure 18.2). The scanning device itself is steered manually or automatically over the subject to capture its entire surface area. Manual sweeping is common and, in the case of bench top scanners, automatic translation can be achieved by calibrated turntable rotation. Due to recent advances in technology this is no longer true. A fixed photodetector of some kind is needed to sense the laser reflectance that provides the values used in the triangulation calculation. Standard digital video cameras, with suitable optics, are adequate for this purpose and usually two or more cameras are used.

The Konica-Minolta VI-700™ laser scanner (Figure 18.3) was used to digitise the *St. Christopher* sculpture (see Section 18.6). It is a single-position system and determines range data from one fixed viewpoint. If multiple views are needed to create a complete model, either the scan object must be moved relative to the scanner or the scanner must be moved and re-calibrated for each position. For each method, the scan sessions should overlap and the resulting multiple scan 'shells' must be processed by registration software in order to match them and resolve a continuous surface. The narrow field of view of the scanner limits the area of capture and correspondingly increases the number of scan shells needed. This in turn requires more software-based registration, increasing the opportunity for error[8]. Realistically, such a scanner used without an accurate mechanical positional

[8]Error is also introduced for each calibration instance if the scanner is moved relative to the object.

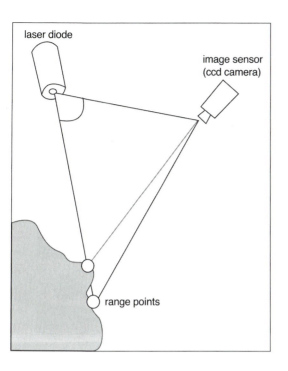

Figure 18.1

Diagram showing a typical laser scanner system using the triangulation calculation method.

system (a motorised turntable or easel for example) has limited function. However, the accuracy of registration and alignment algorithms is now extremely good, provided sufficient overlap data is present in the shells to be registered.

Portable, handheld scanners are particularly well suited to heritage applications since they can be moved relative to the subject, minimising the need to handle and move objects and facilitating *in situ* scanning. This requires some form of 3D global positioning system that accommodates the automatic alignment of multiple scans is present. However, the technology used to

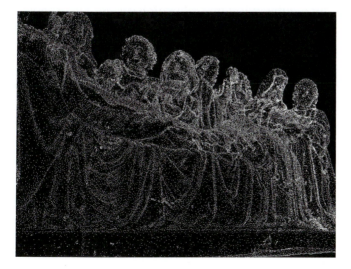

Figure 18.2

A section of The *Dormition* point cloud.

Figure 18.3

The Konica-Minolta VI-700™ scanner being tested in during the research.

achieve this can impose limitations. Magnetic tracking devices, for example, can be affected by the presence of metals, leading to distortion in the acquired points. The appropriateness of the physical range of a system must be considered in relation to the scale of the subject. The *ModelMaker*™ product from 3D Scanners[9] is an example of a hand-guided device used in the project (Figure 18.4). The *ModelMaker*™ scanning head is attached to a mechanical, articulated multi-axis arm[10]. One end of this is fixed in a static position, the origin, which defines the common coordinate system to which the scanning head is calibrated. Problems of inequality can arise between the accuracy of the laser scanner and the precision of the tracker or other positional calibration system. The scanner is more accurate and points are collected to an accuracy of up to 25 µm, but the mechanical positional referencing is only precise to about 90 µm (0.09 mm). Therefore, there is a registration or alignment discrepancy to be solved by the software. Distortion in the optics and mirrors can also cause inaccuracies – making it difficult to match the points in overlapping scans. However, these problems can be significantly reduced by additional calibration procedures. The *ModelMaker*™ calibration includes test scanning a cube of dimensions known to the scanner calibration software. This extra calibration routine reduces the

[9]3D Scanners UK Ltd. http://www.3dscanners.com/.

[10]FARO technologies Ltd. Produce a range of precision arms which are used with laser scanning devices.

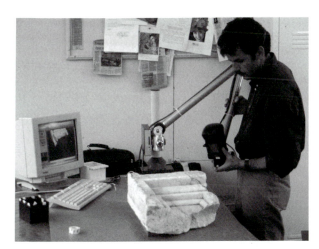

Figure 18.4

The *ModelMaker*™ scanning system. Photograph by Athanasios Velios.

results of scanning the cube are used to calculate such distortions during data collection.

18.2.2 Registration and integration

The registration and integration of multiple scan data segments and the scanning process are not merely related, but are mutually dependent activities. Registration is the processes of aligning two-point sets such that corresponding features are matched. During integration, overlapping and erroneous points are discarded. The outcome of this phase is a resolved point set ready for refinement and surface reconstruction. The importance of registration, alignment and integration cannot be over-stressed. If this step in the surface reconstruction process is imprecise then the fidelity of the data will be compromised, irrespective of the accuracy of acquisition. Usually, in a handheld device, alignment of multiple sweeps of the scan head will be automatically registered by the driver software, based on a reference coordinate system – a particularly desirable feature when many passes of the scanner are needed to capture a complex surface. The *ModelMaker*™ scanner fulfils this requirement, provided the subject's dimensions lie within the physical reach of the articulated arm. When the object to be captured has dimensions that do not fall within this range, it is necessary to capture from multiple calibration orientations. Such an approach was used when scanning the large *Dormition* sculpture (see Section 18.7). To facilitate the integration of the scan shells, the *ModelMaker*™ uses a referencing system of calibration blocks that are adhered to the floor or platform around the subject. They were used each time the *Faroarm* was moved to provide a reference to the previous calibration position. When such global referencing

options are lacking, as with *Visage* or VI-700™, alignment and integration can be achieved by a combination of manual positioning and automatic refinement, using feature-matching algorithms. Scanning software environments often implement such algorithms to achieve a precise convergence after a crude manual alignment. At least three surface features are selected by the operator in overlapping regions of the shells. The software uses a system of proximity point matching to achieve a more precise registration. An example is the iterative closest points algorithm [7], which calculates correspondences between the points of two datasets. Based on these correspondences, a transformation matrix is calculated which will bring the points more closely into alignment. Transformations are applied until satisfactory convergence is reached (Figure 18.5).

Of the scanners used, it was found that laser range finders provide the most appropriate solution in terms of accuracy, expediency and flexibility. An essential aspect of scanner suitability is the presence of a 3D positioning system that will accommodate the automatic alignment of multiple scanned elements. The appropriateness of the physical range of this system must be considered in relation to the scale of the subject. The technology used is also significant as it can impose serious limitations in some instances. Magnetic devices, for example, are affected by the presence of metals, leading to distortions in the acquired points. 3D scanning technology is an active area of international research and development, and the range of products continues to grow. The new Konica-Minolta V-9i laser scanner (replacing the VI-700 model), includes a photogrammetric marker-based system to facilitate calibration across multiple scanner positions, which is particularly useful when capturing large-scale objects. RGB laser systems are now commercially available, although costs are still very high. The simultaneous capture of accurate colour data in addition to form is an ideal solution for visualisation and other applications. The advanced photogrammetric technology of 'space carving',[8] may have potential for the capture of museum objects. This method applies the 'space carving' algorithm to reconstruct surfaces from a set of calibrated multiple position photographic images of a scene. This method currently is lower in accuracy than laser scanning but does offer a means of capturing colour maps and 3D data simultaneously. It may prove to be particularly useful in the capture of larger objects, such as archaeological sites.

Figure 18.5

A two-dimensional representation of iterative closest point matching.

18.3 Creating the 3D Model

18.3.1 Mesh generation

Once scanning is complete, a significant step remains before a 3D model of the object is created: mesh generation. 3D digitisation produces a dense, disordered point cloud. The task of creating a model from this is like a giant 'join-the-dots' problem, where the points must be connected to create a polygonal mesh (Figure 18.6). Fortunately, there is a range of software applications designed to perform this process, known as triangulation, automatically. Several of these 'surfacing' applications have emerged from other fields such as car manufacture and human body imaging. A selection of commercially available products[11] was used to process the point clouds captured from sculptures in this study.

Ideally, the captured point cloud can be triangulated directly, retaining the resolution quality of the original scan data. However, this process must be matched to the computational power available. The point cloud obtained when scanning the *Dormition* sculpture was in excess of 30 000 000 points. To use the entire data set would have far exceeded the processing capabilities of the available computer. The best capture resolution was much greater than actually needed for many purposes. In such instances, it is best to proceed using simplified data that achieves a compromise between satisfactory resolution and a manageable file size. Surfacing software will usually offer one or more point sampling functions, which can be applied to discard points in a manner that retains the integrity of the data. The original high-resolution file remains

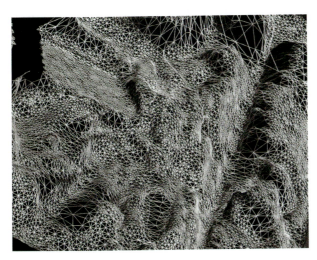

Figure 18.6

A triangulated polygonal mesh from the *Dormition* point cloud.

[11]Examples of mesh generating software include Paraform's Points2Polys™[13], Raindrop Geomagic's Wrap™[13] and Alias Systems Eval Viewer™[13](a component of Studio tools™).

a permanent archival record, accessible for future reconstruction, should the need arise and the resources become available to process it.

Noise reduction and the removal of extraneous points are other concerns during this phase. During laser scanning, the digital camera's sensor can pick up erroneous reflective data from the surface of the scan object, particularly in regions of high reflectance (specular highlights). Unwanted data from surfaces adjacent to the target object, tabletops and so on, can also be removed. This can be done using automatic filters for reducing or eliminating noise or points isolated from the main body of data. It can also be achieved manually, and sometimes more reliably, by interactive selection and deletion.

After triangulation, the polygonal mesh can have various defects, such as missing triangles or holes. Despite accurate and comprehensive scanning, data may still be missing from the surface. This may be unavoidable due to an unachievable line of sight for the scanner's laser beam or sensor in under-cut regions of the subject. Bad or ambiguous data can also be the cause of this. Hole filling functions are provided in most surfacing software as an automated means of making a 'best guess' gap fill in the mesh. Other hazards include inverted normals[12], where the triangles are, literally, inside out. Noise and patterned noise in the points, which can cause a false texture in the surface. Fortunately, these post-triangulation vices can often be corrected, or refined to some extent, by the software.

A polygonal mesh, irrespective of its resolution, remains an approximation of the original physical object from which it is derived. In reality, surfaces are continuous, not faceted. Most of today's 3D modelling applications can render an acceptable surface from polygonal models. However, for the demands of realistic visualisation smooth non-faceted models can yield results that are more convincing. These can be generated by fitting a uniform grid, or patch, of curves closely outlining the original, irregular mesh (Figure 18.7). The curves, called splines[13], are mathematically defined and different rules may be applied to their construction. The NURBS[14] (Figure 18.8) patch is used extensively in surface modelling applications and is particularly well adapted for generating accurate, close-fitting surfaces from irregular geometry. Spline patch surfaces carry additional advantages for optimisation because, allowing multiple resolution models to be generated rapidly, simply by varying the density of the grid.

[12]A normal vector projects perpendicularly to the tangent plane of a triangle face. If it is directed inwards, the face will appear to be back facing. This leads to difficulties in the texture mapping process.

[13]The term spline is thought to originate from shipbuilding where flexible lengths of wood or metal were held in a curved formation by the restraining control 'ducks'.

[14]A non-uniform rational B-spline curve.

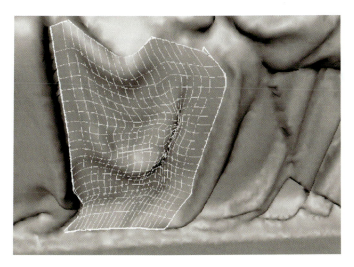

Figure 18.7
A NURBS patch surface applied to a section of the *Dormition* model.

18.3.2 Mapping colour and texture to the model

The colour and surface texture information for the scanned object has to be applied in a separate process, to the resulting 3D model. To achieve this, 2D digital colour images are assigned, or mapped, to the surface of the model. While the VI-700™ and other scanner models capture a digital 2D colour image simultaneously with dimensional data, the resolution of these images is often too low to be useful. High-resolution images can be acquired by digitising existing colour transparencies or by digital photography. Noticeable distortion or positional inconsistencies may occur when standard image mapping techniques are used to project a map onto the entire model of a captured complex object. In order to achieve exact mapping and a convincing impression of realism, the geometry can be segmented into components to be mapped individually. The use of NURBS surfaces offers benefits in this respect, as they can be partitioned with smooth boundaries, unlike polygonal meshes that display a jagged edge when divided.

Image-based mapping techniques rely on projection systems following geometric rules for positioning (Figure 18.9). Cylindrical and spherical projection, for example are most effective when applied to geometry that broadly

Figure 18.8
A simple NURBS patch.

Figure 18.9

Standard geometric image mapping systems for 3D Models. Each of the projection methods imperfectly maps the image to the teapot. The spherical and cylindrical methods display typical 'seams' where the map edges do not meet. In the planar example, the map is mirrored on either side of the geometry. Scaling, rotation and translation can be used to adjust the position in all cases, but this alone seldom completely resolves the image fitting alignment.

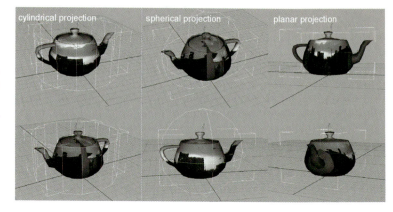

matches these forms. An orange, for example, would be best approximated by spherical projection and a wine bottle by cylindrical. In planar projection, the image is projected as a flat single or tiled plane across the model, similar to a slide projector image falling on a screen. Planar mapping is more adaptable in many instances, but where there are sharp changes in plane or marked curvature, distortions will occur. To overcome this, models are, assigned with an individual planar projection and image map. However, misalignment of the intersecting maps at the boundaries of the segments must be avoided. It is possible to achieve reasonable results using planar projection for simple objects with low curvature and a single planar aspect to be mapped. However, greater precision can be achieved using a more flexible mapping method called UV[15] mapping. In UV mapping the mesh is unwrapped to form a 2D net, defined in a 2D coordinate system, with U and V axes (Figure 18.10). Pixels in the image can be matched precisely to geometric features in the model using this

Figure 18.10

The texture UV coordinate system: A simple two-dimensional map of a plane is shown, where U and V are the local equivalents of the x and y axes. The convention is that the coordinate 0,0 will always be at the lower left corner. The position of the 2D '✿' image map is defined by one U and one V coordinate, each having a value between 0 and 1.

15UV is the local equivalent of the x and y coordinate axes. UV is used to avoid confusion between local and global Cartesian space.

method. In the process, the original 2D image is distorted to some extent to accommodate the geometry, in the same way as a sheet of rubber might be if it is stretched and pinned to fit a surface. The UV coordinate information is stored in the 3D model and consequently, when the resulting image is imported for mapping, it is correctly positioned.

18.3.3 Manipulating colour in the image maps

Advanced work in precise digital colour imaging, using specialist systems, for canvas paintings has been carried out by Saunders and Cupitt.[7] as presented in Chapter 19. The methods applied in the case studies described in this chapter used Adobe *Photoshop®*, a standard image-editing software package, and the computer graphics native RGB (Red, Green and Blue channel) colour space. The colour manipulation for original appearance was achieved by the *Curves* modification tool (Figure 18.11).

Linear and non-linear mathematical transformations can be applied to the colour values of pixels in selected regions, based on values referenced from within the image or from another source, such as cross section images or undamaged regions of the polychromy. This approach requires care to avoid data loss or 'pixel clipping' and consequent degradation in image quality (Figure 18.12). In mathematically linear transformations, such as the multiplicative transform applied in Figure 18.12, there is a risk of losing data and degrading the image. This can be monitored via a histogram of the image area of interest. A histogram gives a graphical representation of the number of pixels with a given intensity value (ranging from 0 to 255). In a normal well-exposed photographic image a Gaussian distribution of values would be expected,

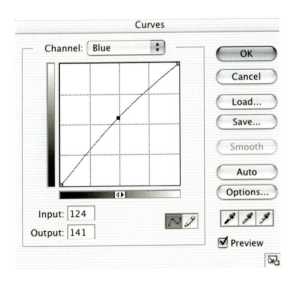

Figure 18.11

The *Curves* dialogue in Adobe *Photoshop®*

Figure 18.12

In this example of a linear RGB curves transformation, tonal variation is lost in the highlight range, when the original pixels are 'clipped' to a maximum intensity value of 255 (white).

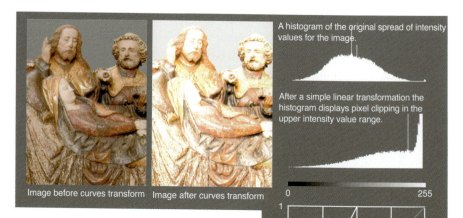

A histogram of the original spread of intensity values for the image.

After a simple linear transformation the histogram displays pixel clipping in the upper intensity value range.

Image before curves transform Image after curves transform

where the majority of the pixels fall in the mid-range and progressively fewer in the extreme dark or light values. By interpreting the histogram for a given selection within the image, it is possible to select an appropriate transformation that will avoid or minimise pixel clipping. This may be more successful when transformations are applied selectively to individual colour channels. Making an image less blue, for example, need not involve any change in the red or green channels. Figure 18.13 gives an example of a selective transformation. Each channel is adjusted by an individual multiplicative transformation to achieve the desired match with the reference region of original azurite blue. The histograms illustrate how it is possible to use simple multiplication in this case, as the selected pixel falls within a safe range of intensity values (82–107), unaffected by clipping. A paler area of the image with higher values would require a different transformation approach. *Photoshop*® allows the user to save the transformation parameters and, which is helpful in maintaining consistency in the image-editing process.

18.4 Simulating Surfaces in 3D

18.4.1 Surface shading

Real materials display a complex interplay with light and achieving a high level of realism in visualisation requires a sophisticated approach. 3D software

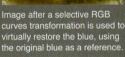

Figure 18.13

A selective RGB curves transformation showing the virtual restoration of an area of azurite blue from the *Dormition*.

Image of discoloured blue surrounding an area of preserved blue.

Image after a selective RGB curves transformation is used to virtually restore the blue, using the original blue as a reference.

Care is taken to ensure no clipping occurs as a result of the transformation. To achieve the transformation in the selected colour area, each channel has been multiplied individually. The histogram illustrates that all selected pixels fall into an intensity range unaffected by the pixel clipping caused by this calculation (from 82 to 107).

environments implement a range of mathematical models developed to approximate phenomena such as illumination shading and surface gloss. While many 3D visualisation tools are excellent for simulating real appearances, none of them is perfect. Systems based on ideal mathematical models of nature cannot replicate reality in all its complexity. Consequently, it may be more effective to address aspects of human perception. Careful attention to the additional 'cues' that convince us of the reality of scenes in everyday life can considerably enhance visual credibility. Relationships of scale, imperfections such as dirt, scratches and flaws, subtle changes in texture and the preconceptions that the viewer may have about a particular setting all play a part in a convincing visualisation.

Creating convincing interplay with light is a crucial aspect of imparting realism to a modelled surface. The image mapping and texturing tools available in most advanced 3D graphics environments have a complex array of features. The model's surface qualities are assigned by generic 'shaders' (Figure 18.14). The Gouraud[16] and Phong[17] shading algorithms were the first to be developed for computer graphics.[10] The Phong illumination model offers a significantly

[16]Developed by H. Gouraud in 1971, also called 'intensity interpolation shading' or 'colour interpolation shading'.

[17]Developed by Bui-Toung Phong in 1975, also known as 'normal-vector interpolation shading'.

Figure 18.14

Four commonly used computer-graphic models for surface illumination shading. On the right, a Strauss shader has been used to create a metallic gold effect.

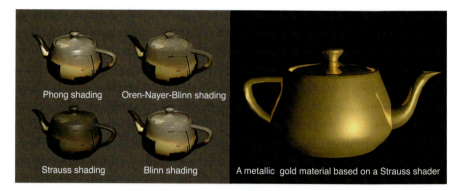

Phong shading Oren-Nayer-Blinn shading

Strauss shading Blinn shading

A metallic gold material based on a Strauss shader

improved realism over Gouraud, but the latter remains widely applied because of the lower computational overheads. Both shaders use a local[18] reflection model to compute the shading of a surface, meaning that the reflective qualities of a light form rely on the localised values for three reflection parameters: perfect specular reflection, imperfect specular reflection and perfect diffuse reflection (Figure 18.15).

A method is needed to calculate a value for the reflected light when rendering a pixel for any given vertex. Gouraud and Phong are both interpolating models, meaning that reflectance values are blended smoothly across each polygon. They supersede the 'flat' shading method which uses only a single face normal to assign a constant shade to the entire triangle. The resulting faceted appearance is contradictory to realism, although much easier to compute.

Figure 18.15

Perfect specular reflection (top) corresponds to light incident on a perfectly smooth mirror – no divergence of the beam occurs. If the specularity is imperfect (middle) there will be some divergence or scattering of light due to surface roughness. In a perfectly diffuse or matte surface (bottom) light is reflected equally in all directions. For surface modelling, each of these factors can be varied to affect the apparent surface qualities of the object.

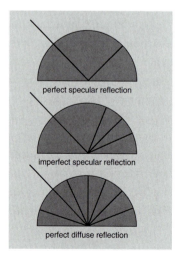

perfect specular reflection

imperfect specular reflection

perfect diffuse reflection

[18]Local reflection models consider only direct illumination. Global models such as radiosity shaders also consider one or more reflected light sources.

Gouraud, Phong and variants such as Strauss[19] use the orientation of a plane in relation to a single light source and in conjunction with information about the properties of the surface. Values from the three reflectance types are combined in order to arrive at the final pixel shade. Gouraud shading interpolates between intensity values and is appropriate for evenly diffuse surfaces but is less successful in the representation of highlights. Additionally, in Gouraud shading some unevenness in the surface blending can arise – colour values are sometimes more intense at the polygon edge, causing a slightly faceted appearance. The Phong method addresses these failings by interpolating between the vertex normals themselves yielding a calculated normal and specific intensity for each projected pixel of the polygon. The method facilitates genuinely smooth gradation and copes better with specular highlights. A further improvement on the representation of highlights was made with the introduction of the Blinn[20] model in 1978 which adapted the specular component of the Phong shader.

Several shaders are often grouped to simulate a specific 'material' such as glass, steel or marble. Each material has multiple layers, affecting different characteristics and each of these may have independent image maps, colour values or other sub-material (Figure 18.14). The diffuse colour layer is normally the base layer, where the principal image map is assigned. It defines colour and appearance for matte interaction with light. 'Specular', 'opacity' and 'bump' are also important layers. Gloss or shine characteristics are set in the specular layer. The decorative surface finishes of polychrome sculptures can vary considerably in this respect, for example high specularity values are needed to recreate gilded and glazed regions. Opacity maps allow a level of transparency to be set for a material. Even where the substrate of the model is opaque, transparency layers can still be useful. In cases where a section of extraneous geometry cannot be eliminated at the point of surface reconstruction, it can be made invisible (Figure 18.16). A complex intermixing of layered shading affects can be used to visualise objects with several different surface qualities and transparency settings can be applied to restrict a material to the desired region on the model. Bump mapping differs from the other layers, as it effects a change in the topographical appearance of the surface. An illusion of surface texture or roughness is created by manipulating the object's vertex normals (Figure 18.17). The bump features may be controlled by a greyscale image map or by explicit parameter settings. In 3D imaging, bump mapping can be of value in terms of reducing computational expense, since maintaining a fine local texture in the geometry requires a dense mesh. Realism demands some degree of surface

[19]An adaptation of the Phong and Blinn shading algorithms for metallic material was developed by Paul Strauss of Silicon Graphics Inc. in 1990.

[20]Developed by Blinn in 1978 and further adapted by Cook and Torrance in 1982.

Figure 18.16

On the far left, the *St. Christopher* model's gilded regions are mapped selectively using transparency mapping. In the centre image a map has been applied to the entire model, which includes the backing board on to which the sculpture was attached when it was scanned. In the right-hand image, a transparency alpha

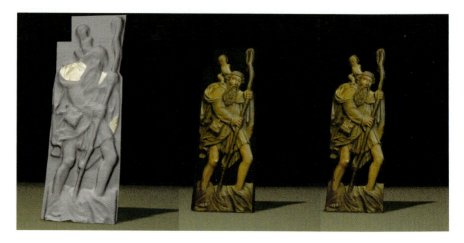

channel image map has been used to render this unwanted geometry invisible.

roughness and dust, even in apparently smooth objects. A fine 3D 'noise' can be used to recreate such fine surface qualities.

18.4.2 Lighting

The lighting of the models is significant to the realism and authenticity of visualisation. CIE Standard Illuminants[21] were used in the research as a reference

Figure 18.17

Bump mapping was used on the *St. Christopher* model to recreate the *pressbrocaat* texture. The greyscale image, tiled across the model to achieve this effect, is shown in Figure 18.23.

[21]The Commission Internationale de l'Eclairage standard. A series of spectral data sets describing the spectral power distribution of different light sources.

for the simulation of natural and artificial lighting. The colorimetric $L*a*b*$[22] values from the CIE standards were converted to RGB values so that they could be approximated in the graphics software environment. The *St. Christopher* case study visualisations have diffuse lighting equivalent to natural daylight[23] intended to correlate with optimal examination conditions in a conservation studio under 'artificial' 'daylight' fluorescent light. The main objective was the clear imaging of the sculpture and polychromy, so it was inappropriate to assign lighting for any other purpose. When necessary the lights were offset in position in order to be sympathetic to the lighting set up in the original photographs.

18.4.3 Recent developments in image rendering techniques

Simple surfaces, such as plastics, are successfully mimicked by the Phong and Blinn models. Complex materials can also be approximated by the skilful use of shading models and placement of light sources in the virtual scene. However, local shading systems, based on idealised mathematical formulae are intrinsically limited in function. In reality, the interaction of light with matter is rather more complex. Visual appearance is affected by both the surface properties of the materials and the nature of the illumination. Alternatives to traditional shading models have been explored by recent research into physically based methods.[11] Techniques have emerged which use illumination information recorded from a real environment. In effect, this allows synthetic objects in a virtual scene to be illuminated with a recording of real light, in real space (see Section 19.2.2).

Special photographic techniques are used to capture the information needed about all the direct and indirect sources of light in an environment. Normal photography, whether film or digital, captures only a narrow dynamic range (the ratio between light and dark in an image) of a real scene. High dynamic range photography overcomes this by taking a series of images at different exposure settings, to gather information across a wider dynamic range of illumination. In addition, omnidirectional illumination information may be gathered by photographing a mirrored sphere[24]. The resulting images contain both pixel colour data and directional illumination data for a wide angle around a single point of view[25]. These High Dynamic Range (HDR) images can then be applied directly in the virtual 3D scene to create extremely realistic illumination. HDR image technology has been integrated into many 3D graphics applications.

[22]CIELAB (CIE $L*a*b*$) is a mathematical derivative of CIE *XYZ* (1931) that describes colours using three synthetic primaries: $L*$ (which indicates Lightness), $a*$ (which indicates redness–greenness), and $b*$ (which indicates yellowness–blueness). See also Chapter 11.

[23]CIE standard daylight D65: 6500K.

[24]The reflective ball, known as a light probe, facilitates a very wide angle of view. A similar result can be achieved with a fisheye lens.

[25]This data is stored as a radiance map.

18.5 Visualising Polychrome Sculpture

18.5.1 *Late Gothic polychromy*

Polychrome sculpture from the late Gothic[26] period was intended to be opulently and realistically coloured in finishes that closely resembled flesh, rich textured fabrics and metals such as gold and silver. In their interaction with light, dramatic and subtle contrasts played across these varied surfaces. Historically, the principal purpose of applying colour and texture to the surface of the sculpture was to impart lifelike qualities that could not be conveyed by form alone. As objects of worship, these sculptures as part of altarpieces or as solitary devotional figures conveyed religious narratives, serving to inspire and awe. The richness and spectacular presence of some examples exceeded convincing realism, to convey an enhanced and transcendent impression. The painters of the polychromy, usually specialist craftsmen governed by their own trade guilds,[12] went to considerable lengths to achieve the intention of recreating the surface qualities – matte, reflective and textured – of all aspects of the composition. The polychromy was applied with skilled intent. The use of contrasting surface qualities – strong colours juxtaposed with gilding, for example – assisted the interpretation of the complex drapery and folds, which emulated dress fashions typical of the late medieval period. Spatial relationships in the sculpture could be subtly modulated using the interaction of light with the surfaces.

The late Gothic period is one of remarkable accomplishment in the history of German polychrome sculpture. The work of masters such as Niclaus Gerhaert[27], active in Strasbourg and, later, Tilman Riemenschneider[28] of Würzburg are often used to define and exemplify the movement as a whole.[13] In the fourteenth century sculptors practised in workshops attached to, and administered by, the churches they served. The fifteenth century trend toward masters establishing smaller independent workshops,[13] controlled and regulated by town guilds, allowed a departure from the stiffer, less expressive Gothic tradition toward an increased naturalism. Growing commercial competition also served to advance technical achievement. The practice of structured apprenticeship in the workshop tradition also fostered a progression of skill and vision.[14] In the final decades of the fifteenth century, these and other socio-political factors marked

[26]The period of transition from the Gothic to the more advanced, classical Renaissance style is often described as Late Gothic. The Renaissance was established in Italy by the late early fifteenth century. However, the late Gothic style persisted rather longer in Northern Europe and was still in evidence in Germany in the early sixteenth century.

[27]Niclaus Gerhaert had a significant role in developing the florid style. He was active in Strasbourg between 1460 and 1467.

[28]Tilman Riemenschneider 1460–1531, active in Würzburg, 1483–*c*.1531.

the beginning of a rapid evolution and flowering of the style, characterised by heightened realism and observation of material detail.

These artefacts present a good case for virtual restoration. The skilful, flamboyant intricacy of late Gothic carving and the lifelike vibrancy of the painted surfaces are often no longer apparent due to significant changes in appearance. Degradation wrought by time, accidental or deliberate damage and previous restoration can significantly detract from the interpretative value and visual experience of these, once functional, religious icons. It is not unusual for a sculpture to have been completely stripped of its original polychromy in the past, resulting in radical changes in colour and surface quality. Stripping was, in some cases, the result of iconoclastic practices during the Protestant Reformation. Iconoclasm also took the form of defacement by local damage – removal of facial features for example. Sculptures with damaged polychromy may also have been stripped out of ignorance or as misguided restoration. In the conservation of polychrome sculpture, varying degrees of intervention and restoration have been considered ethically appropriate at different times in history and in different cultures. In Scandinavian practice, for example, less intervention and restoration has been a consistent feature.[15] At this time British conservation also tends toward a minimal approach, whereas, in the nineteenth and early twentieth centuries, extensive, and often highly subjective, reconstruction of damage and loss was considered acceptable.[16]

18.5.2 Case studies

Two case studies of 3D digitisation, visualisation and virtual restoration of sixteenth century polychrome sculpture from the Victoria and Albert Museum collections are presented in this chapter. These were carried out as part of a doctoral study,[17] within the Royal College of Art/Victoria and Albert Museum Conservation Programme.

Ideally, museum conservation is supported by extensive technical analysis and historical evidence and takes place within an ethical framework. Thus, it was considered imperative that the practice of visualising an artefact's earlier appearances virtually should be scholarly and fully informed by all technical, analytical and historical data available. The approach to recreating original appearance in the following case studies is based to the greatest extent possible on analytically proven fact and historical understanding pertaining to the materials and techniques of polychromy. The techniques used in painting sculpture were allied to those of panel painting, as described in documentary sources, such as the *Strasbourg Manuscript*,[18] and Cennino Cennini's *A Craftsman's Handbook*.[19] Analytical and observational findings made by conservation specialists also provide supporting evidence. There is also an element of informed subjectivity in this process. For example, where no physical colour reference exists, but the

technique or pigment is known then that information can be used to create a physical sample as a reference. Additionally, it was possible to take referencing information from more intact examples of a similar style and period. Compiled expertise relating to the subject is the background to making final selections for the pigments or techniques to apply. Natural and synthetic pigments are not consistent in hue. For instance, rose madder can vary according to the method of manufacture [20], natural variations in the harvested root and the base onto which the extracted dye is struck. Authenticity was the guiding principle and choices about this and other pigments were made with an awareness and scholarly interpretation of all the influencing factors.

The visualisation techniques applied in the case studies were created using two-dimensional image editing techniques in Adobe *Photoshop®*, as previously described. None of the techniques applied is beyond the scope of non-specialist implementation, although some may be considered advanced. The images were acquired by digitising existing colour transparencies and from digital photography. These images were subsequently applied to 3D models of the sculptures, derived from laser scanning.

18.6 St. Christopher

St. Christopher (Figure 18.18 and front cover), a carved relief polychrome sculpture, was the primary test subject for the study. The carving was considered a good example for exploring virtual restoration techniques, not only because of the extent of its disfigurement but also because of the range of effects it would have once displayed. The sculpture depicts the Saint fording a river, while bearing the infant Christ, and is thought to date from the late fifteenth or early sixteenth century. The acquisition notes for the piece indicate that it may have been removed from a church in the Tyrol, Austria[29]. The notes mention a similarity to the style of Adam Kraft, a Nürnberg-based stone carver who worked predominantly in relief.[13] Stylistically similar works, also mentioned, include Veit Stoss's[30] *Death of the Virgin* (*c.* 1477–89) and *The Mourning Virgin*[31], by Hans Leinberger[32], *c.* 1520. The sculpture is carved from a single piece of limewood. The infant Christ's arms have been lost, but it is otherwise structurally intact. The polychromy is in a regional style typical of the period and, although now significantly damaged and discoloured, would once have been vibrant in

[29]Acquisition notes, Victoria and Albert Museum Sculpture Department.

[30]Veit Stoss is thought to have been born in Neckar, Swabia *c.* 1440. He was an established master in Nuremberg and Cracow.

[31]*c.* 1520 now in the Bayerisches National museum, Munich. Was originally in Stadtpfarrkirche, Dingolfing, Lower Bavaria.

[32]Hans Leinberger of Lower Bavaria (?), active in Moosburg 1513.

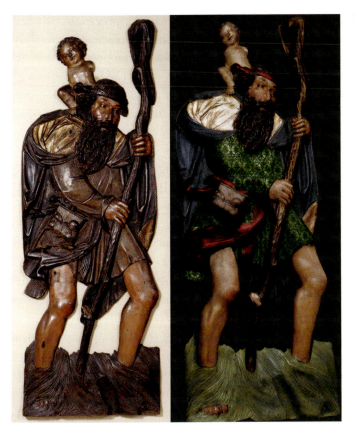

Figure 18.18

St. Christopher (Victoria and Albert Museum 1304–1872, dimensions 1220 × 450 × 54 mm). The sculpture in its current state (left) and a virtual reconstruction of its possible original appearance (right). The left-hand image appears by kind permission of the Victoria and Albert Museum.

colour and opulently decorated. Each region of *St. Christopher's* polychromy represents a different technique and use of materials. The artists of the time strove to represent surfaces in as realistic a manner as possible and intended to impress the viewer with the lifelike appearance. This is apparent in areas such as the flesh of St. Christopher where bluish veins are visible below the semi-translucent upper layers of paint. All the areas of *St. Christopher's* decoration have since been significantly changed in appearance by discoloured varnish layers and wax coatings. In several regions, the paint and decorative layers have themselves either discoloured or faded. Extensive flaking in the paint was consolidated during conservation treatment in 1989, in addition to the structural restoration of a damaged area of the right knee. The conservation record documents that it was not possible to remove the discoloured varnish due to the sensitivity of the original surfaces.

Prior to treatment of St. Christopher in 1989, a thorough chemical and technical analysis[33] was carried out to determine the materials used in the polychromy.

[33]Darrah, J., Technical analysis, conservation report, Victoria and Albert Museum sculpture conservation section, June 1993.

Analytical information is a valuable asset in the process of visualising original appearance and its availability was a significant factor in selecting the object for study. Numerous samples were taken from the polychromy in all regions of the composition. These samples were prepared as cross sections giving visual information about the layer structure of the paint. Dispersion samples[34] were used for the optical identification of the pigments. As mentioned in the description above, the polychromy had changed markedly in appearance through damage and deterioration. The process of deducing a likely original appearance relied on several sources of information: colour data from the cross sections, the known appearance of the identified pigments and colour references from undamaged regions of paint on the sculpture itself. A wing of the *Boppard Retable*[35], a slightly later example, was being treated in the Victoria and Albert Museum sculpture conservation studio during the research and provided a useful additional reference.

The flesh tones were identified by chemical analysis as vermilion[36], together with red and brown earth pigments, mixed in varying proportions with lead white[37]. The paint is well preserved other than minor local lacunae and abrasions, but the darkened varnish and wax coatings are particularly disfiguring. Discolouration of natural resin varnishes is a common dilemma in the conservation of decorative and pictorial art. Varnish removal treatments using organic solvents can be effective, but may cause varying degrees of damage to the original paint layers. Even if damage is not immediately obvious, solvent exposure can increase vulnerability of the paint to future cleaning campaigns by weakening the matrix of the paint. To visualise a possible original appearance of the flesh digital RGB[38] colour reference data was used in the application of computed colour transformations (as described in the previous section), altering the contrast and colour balance of the apparently brownish flesh. Virtual restoration of the paint losses was carried out first, using local referencing from undamaged areas. The supporting colour references for the transformations were derived from the digitised cross-sectional images and known colour values for the pigments, vermilion and lead white. In the extremely darkened areas, colour values from the brown varnish were used to calculate subtractive transformations.

[34]A sample is powdered and mounted, in a medium of known refractive index, in preparation for microscopic identification.

[35]*Winged Retable*, upper Rhenish (Strasbourg?) *c.* 1510–20, carved in limewood and polychromed. Museum no. 125-1873.

[36]A manufactured red mercuric sulphide. Also occurs naturally as the mineral cinnabar.

[37]A white, densely covering, manufactured pigment. Chemically a basic lead carbonate.

[38]Red, green and blue digital colour intensity values.

An alternative surface restoration to the restored knee was also visualised using the same references and a photograph of the sculpture taken prior to the loss.

The Saint's cloak was predominantly brilliant azurite blue with contrasting regions of gold leaf water gilding in the hood and red lake[39] glazed over silver leaf on the inside folds. Azurite does not have attractive optical properties in oil due to the deadening effect it imparts. Traditionally, it was predominantly applied in the matte media of egg or glue tempera,[21] which retained the vibrancy of the colour. The approach is consistently evident in examples of north European polychromy, where azurite is present.[22] The cloak's azurite is, for the most part, now dark and dull because of the non-original varnish and wax coatings. The apexes of the folds are extremely worn and the wood substrate is now exposed (Figure 18.19). The inappropriate application of varnishes and other coatings in earlier restoration practice are an unfortunate legacy for contemporary conservation. Fortunately, in some protected undercut areas of the carving, islands of relatively well-preserved pigment remain (Figure 18.19). It was possible to use digital RGB references from these regions, derived from digital photography, in the virtual restoration of the blue sections.

The most complex layer structure of the sampled regions was the *pressbrocaat* decorated tunic. *Pressbrocaat* or wax appliqué is a relief decoration technique

Figure 18.19

A worn, discoloured azurite blue region from *St. Christopher* with a small area of preserved pigment visible.

[39]Red lake is the term applied to transparent red pigments made from dyes derived from various natural sources.

used to create repeat patterns emulating textured fabrics. There are several variations to the technique. In this case, tin foil was pressed into a carved wooden mould and filled from the reverse with putty made of various constituents which may have included wax.[23] Once dried, cut and decorated the foil was adhered to the sculpture. The tunic is now a substantially altered region. Colour references from the cross-sectional images provided useful evidence of the original colour, revealing undeteriorated green copper resinate[40] below the brown surface layer (Figure 18.20). The extremely damaged *pressbrocaat*[41] was more problematic because so little survived and it was impracticable to reconstruct the pattern. Two virtual restoration alternatives were explored. Simple colour reinstatement of the transparent green over gold leaf, without any attempt to restore the deteriorated brocade texture was the first route. It gave a convincing general impression of the possible original colours and was considered appropriate since reliable visual evidence was used. In order to give some kind of impression of the texture as it might have been, a well-preserved brocade texture was referenced from the *Herlin Altarpiece*, a well-documented sculpture of a similar period and origin,[16] and mapped to the model at an appropriate scale (Figure 18.21).

The water around the Saint's feet now appears almost completely brown but traces of a greenish blue layer were identified. There was little evidence in the sampled cross sections or on the sculpture for reference. A greenish[42] azurite layer consistent with the materials of the time, supported by the confirmed use of azurite in the cloak, was reconstructed for the river. A painted sample was made and additional references were taken from the water of the Boppard *St. Christopher* panel, where similar materials had been identified.

In the badly deteriorated regions of the girdle and head band the samples showed silver leaf with red lake glazes. These layers are indiscernible on visual inspection of the sculpture due to the fading of the glaze, oxidation of the silver leaf and the discoloured varnish. Silvering was a popular technique, often used in the polychromy of armour and weapons. It was also applied in areas

Figure 18.20

Copper resinate cross section from the tunic of *St. Christopher*. The original strong green is visible in places below the brownish discoloured upper layer. The image appears by kind permission of the Victoria and Albert Museum.

[40]Copper resinate is a solution of green copper acetate (verdigris) in resin, usually Venice turpentine.

[41]This technique is also known as wax appliqué and press brocade.

[42]Azurite occurred in a range of hues, some tending more toward green than blue.

Figure 18.21
The *pressbrocaat* pattern from the *Herlin Altarpiece* used in the reconstruction.

of cloth and costume, providing a useful contrast in optical quality to gold and, glazed with a yellow varnish, was sometimes used as a less expensive alternative to gilding. Transparent glazing of the leaf, often in green or red, was common – the opalescent effect benefitting from the reflective qualities of the silver. Glazing also afforded some protection against tarnishing. Silver is prone to oxidation, turning black in consequence. It is now rare to find an uncorroded example and it is made even more unlikely by the misinterpretation of the appearance of corroded silver in the past often resulting in its 'restoration' with black over-paint. To recreate a possible appearance for these regions (Figure 18.22), references were taken from a reconstructed sample, emulating the materials of the layers evident in the cross section. Unfortunately, an exact identification of the red lake was not determined in the analysis. There are several possibilities as a variety of

Figure 18.22
Details showing virtually restored regions of the St. Christopher poly-chromy including the red glazed, silver leaf belt and the *pressbrocaat* green tunic. On the left, the virtual restoration is overlaid with the current condition of the surface.

red lakes was available at that time. The example of rose madder[43] was chosen for each area of the composition.

18.7 The Dormition

The *Dormition* (Figure 18.23) is a polychrome sculpture from the early fifteenth century (c.1420–30) originating from South Germany. The main objective for the visualisation of the Dormition was the virtual reversal of a disfiguring earlier restoration of a damaged area of carving.

 The *Dormition* was acquired for the Victoria and Albert Museum collection in 1896. The group is carved in walnut wood and is entirely painted and gilded across the front face. The *Dormition*'s subject is the death of the Virgin Mary, surrounded by the disciples and Jesus. St. John is the kneeling figure at the feet of the virgin. Originally, the *Dormition* would have been a component of a larger altarpiece, either as part of the predella or corpus[44] with accompanying complementary religious scenes. The scale of the sculpture makes it more likely to have been the main element of a corpus. The sculpture consists of three blocks of walnut timber, one smaller and two larger similar sized sections. It is probable that the two larger blocks came from the same tree trunk – their dimensions and growth ring patterns are very similar. The reverse of the sculpture is evenly hollowed and there are clearly visible vertically worked adze[45] tool markings.

Figure 18.23

The *Dormition* (Victoria and Albert Museum 1881–1896, dimensions: 810×1690×290 mm). This image appears by kind permission of the Victoria and Albert Museum.

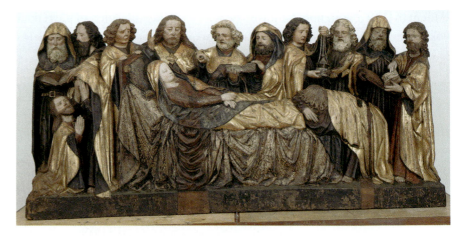

[43]Rose madder or madder lake is prepared from the dye extracted from madder root (*Rubia tinctorium*), cultivated widely across Europe.

[44]The predella is the base of an altarpiece and the corpus is the main body. Normally there are two or more wings attached.

[45]The adze is an axe-like tool, with a horizontal edge. It was used in the preliminary roughing out stages of carving and for hollowing.

Four non-original, cut out alterations are present, each with two holes placed horizontally. The broad, rounded chisel work around them is perpendicular in direction to the original tool marks. There are several substantial structural restorations – the most obvious and disturbing is a block inset in the drapery beneath the dying virgin's bed. The crudely executed carving attempts to match the adjoining drapery. During conservation[46] it was found that the repair, as well as filling a region badly affected by insect damage, was executed partly to stabilise structural weakness. Another stabilising structural repair is the narrow vertical inset that travels through the grieving St. John. The remaining structural additions are aesthetic interventions. Half of the book and a thumb on the right side of the sculpture have been replaced. On the left side a single toe has been restored. The structural repairs were not re-painted to match the surrounding polychromy, but were instead stained to a dark tone. All the repairs were carved in walnut timber.

The visible paint layers of the polychromy are, for the most part, unoriginal. Conservation test cleaning patches exposing the primary layer show that the later over-paint was applied in correspondence with the original decorative scheme. There are now only a few original painted areas left exposed. These include, the robes on the first, fourth and fifth standing figures. An azurite blue lining is present on the far right figure. The drapery on the bed also displays primary polychromy, but it is severely deteriorated. The silvered and glazed ornamental pattern has oxidised to black and there is now little indication to the design of the pattern, due to the degree of damage.

The original gilding remains. It is burnished water gilding over a light red bole[47]. The polychromy had two added surface coatings – animal glue and a wax layer. Both were removed during recent conservation treatment (Sundström 2002). There are traces of punch work, a common decorative technique, visible in the border of St. John's gilded cloak.

The main objectives for the visualisation of the *Dormition* – over and above the achievement of a highly accurate and convincing virtual model – differed from those of the *St. Christopher*. Rather than set out to virtually restore the polychromy, prompted by concerns that arose during the recent conservation, the visualisation focussed on exploring a strategy for the reversal of the disfiguring structural restoration (Figure 18.24). Possible approaches were being considered by conservation and curatorial staff for reducing the impact of the disfiguring structural additions. Some cleaning tests removing the wood stain were carried out to determine whether it would help the appearance of the structural repairs. The

[46]Sundström, R. 2000, Conservation Report, Victoria and Albert Museum Conservation Department, September.

[47]Bole is a clay, which is often red, but varies in colour. It is bound in animal glue and used as an under-layer for water gilding.

Figure 18.24

The current state and alternative visualisations of the *Dormition's* crude structural restoration. On the left, the walnut restoration in its current state, stained dark brown. In the centre, a virtual reconstruction of the lost carving in a style more

sympathetic to the original. On the right, the restoration is depicted as it might appear if the stain were removed.

result was only of limited value in terms of visual assessment since the test area was restricted. Computer visualisation offered a way of previewing a number of viable options for the entire restored surface. In addition, beyond the scope of the treatment being considered, it was possible to recreate more convincing stylistically faithful carving in the poorly matched insets and to reinstate the surface polychromy virtually, based on referencing its current state. In the end, the conservation treatment decision was that no alteration provided an improvement significant enough to justify reversal of the current restoration. A choice influenced, to some extent, by the visualisations produced. It was evident that there was no aesthetic advantage in removing the stain to reveal the pale wood – it did not serve to diminish the impact of the poor restorations. However, the visualisations produced in the study, represent the only alternative means of viewing the sculpture without the distraction of the old repairs, illustrating the considerable potential of conservation informed virtual reconstruction for museum display.

18.8 References

1. Boulanger, P. *et al.* (1987). Applications of a laser scanner to the recording and replication of museum objects, *ICOM-CC Preprints 8th Triennial Meeting Sydney, Australia, Scientific Examination of Works of Art,* ICOM-CC, Paris.
2. Rioux, M. (1994). Digital 3-D imaging theory and applications, *SPIE Proceedings – Videometrics III, International Symposium on Photonic and Sensors and Controls for Commercial Applications,* vol. 2350, Boston, MA, pp. 2–15.
3. Baribeau, R. *et al.* (1996). Colour three-dimensional modelling of museum objects, *Imaging the Past, Electronic Imaging and Computer Graphics in Museum and Archaeology,* British Museum, London, Occasional Paper Number 114, pp. 199–209.
4. Curless, B. and Levoy, M. (1996). A Volumetric Method for Building Complex Models from Range Images, *SIGGRAPH Proceedings,* ACM, New York.
5. Levoy, M. (1999). The digital Michelangelo project: Creating a three-dimensional archive of his sculptures using laser scanning, *Proceedings of Electronic Imaging and the Visual Arts,* Florence, Italy.

6. Velios, A., Harrison, J. and Cummings, A. (2003). Digital Reconstruction of Fragmented artefact: *Improved Methods for Data Capture, The Conservator,* UKIC, issue 27, pp. 81–94.

7. Besl, J. P. and McKay, N. D. (1992). A Method for Registration of 3-D Shapes, *IEEE Transactions on Pattern Analysis and Machine Intelligence,* vol. 14, no. 2, pp. 239–256.

8. Kutulakos, K. N. and Seitz, S. M. (2000). A theory of Space Carving, *International Journal of Computer Vision,* **38**(3), Kluwer, Netherlands, 199–219.

9. Saunders, D. and Cupitt, J. (1993). Image processing at the national gallery: The VASARI Project, *National Gallery Technical Bulletin,* vol. 14, National Gallery Publications, London.

10. Watt, A. (1989). *Fundamentals of Three-Dimensional Computer Graphics.* p. 171, Addison-Wesley, Wokingham.

11. Debevec, P. (1998). Rendering synthetic objects into real scenes: Bridging traditional and image-based graphics with global illumination and high dynamic range photography, *SIGGRAPH Proceedings,* ACM, New York.

12. Marcinola, M. and Chapius, J. (eds.). (2000). The surfaces of Riemenschneider, In *Tilman Riemenschneider Master sculptor of the late Middle Ages,* p. 101, Yale University Press, NGA Washington.

13. Baxandall, M. (1980). *The Limewood Sculptors of Renaissance Germany.* Yale University Press, Newhaven and London.

14. Williamson, P. (1996). *European Sculpture at the Victoria and Albert Museum.* p. 70, Victoria and Albert Museum, London.

15. Kollandsrud, K. (1994). Krusifiks fra Haug kirke. In *Undersøkelser og behandling,* (Varia 27), p. 178. Oslo.

16. Bachmann, K. W., Oellerman, E. and Taubert, J. (1970). The conservation and techniques of the Herlin altarpiec, In *Studies in Conservation,* vol. 15, p. 330.

17. Geary, A. (2001). *Computer Imaging in Conservation: The Visualisation in Three Dimensions of the Original and Present Appearances of European Polychrome Sculpture Using Laser Scan Data, Presented in Virtual and Enhanced Reality Environments.* Ph.D. Thesis, Royal College of Art, London.

18. Borradaile, V. and R. (trans.), (1966). *The Strasbourg Manuscript.* Tiranti, London.

19. Thomson, D. V. (trans.) (1969). Cennino d'Andrea Cennini, In *The Craftsman's Handbook.* Dover, New York.

20. Harley, R. D. (1982). *Artist's Pigments c.1600–1835.* Butterworths, London, p. 141.

21. Thomson, D. V. (1962). *The Practice of Tempera Painting.* Dover, New York.

22. Ballestrem, A. (1970). Cleaning of polychrome sculpture, *Conservation of Wooden Objects,* IIC conference papers, vol. 2. New York, p. 69.

23. Frinta, M. (1963), The use of wax for appliqué relief brocade on wooden statuary, *Studies in Conservation,* vol. 8, no. 4, pp. 136–149.

Albrecht, E. and von Bonsdorff, J. (eds.) (1994). *Figur und Raum, Mittelalterliche Holzbildwerke im historischen und kunstgeographischen kontext.* Reimer-Verlag, Berlin.

Fowler, V. J. (1985). Laser scanning techniques, *Laser Scanning and Recording,* SPIE proceedings, vol. 378, p. 38.

Kollandsrud, K. (1996). Teknikk og malemåte/Technique and Painting Methods, *Norske frontaler fra middelalderen i Bergen Museum/Norwegian Altar Frontals in Bergen Museum,* Bergen, pp. 13–15, 23–25.

Krishnamurthy, V. and Levoy, M. (1996). Fitting smooth surfaces to dense polygonal meshes, *SIGGRAPH proceedings,* ACM, New York, pp. 313–324.

Wilson, J. and Hawkes, J. F. B. (1987). *Lasers. principles and applications.* Prentice Hall, New York.

Digital Imaging for Easel Paintings

David Saunders, John Cupitt and Joseph Padfield

19.1 Introduction

In the same way that many museums and galleries were very early to see the potential of photography for documenting objects for the future and for making representations of great works more widely available, so they have been closely involved with the development and use of digital imaging and printing technologies.

Digital imaging of easel paintings, i.e. paintings on movable supports as opposed to those applied or attached to building structures, can be divided into two principal categories. First, images are being made to assist the technical study and documentation of paintings, including visible imaging to measure and monitor changes, infrared reflectography to examine underdrawing and *pentimenti*, X-radiography to examine compositional changes and painting structure, and raking light (illumination from a low angle) to study the surface texture of paintings. Second, imaging technologies are being used for general documentation of paintings, to build image libraries that can be used for specialist consultation in museums, galleries or universities, as a basis for public-access systems, and as primary resources for the reproduction of images, for example in books, catalogues and posters.

19.2 Imaging for Technical Examination

There are now digital imaging analogues of most of the traditional photographic techniques used to document and examine paintings. But in the late 1970s and early 1980s, when digital imaging was first used in museums and galleries, its application aimed to take advantage of two particular properties of digital images that offered distinct advantages over photography. First, the images that were produced by digitising the signal from television cameras (these applications date to before the introduction of solid state digital cameras) offered greater accuracy and reproducibility than photographs. Monochrome cameras with a known spectral response were used in conjunction with a set of colour

separation filters and a controlled lighting system to produce calibrated colour images to monitor long-term changes in paintings.[1,2] This technique replaced a photographic method in which monochrome images were made through colour separation filters, but which suffered (like all photographic processes) from variations between film stocks and the vagaries of the processing chemistry.

The second great advantage of digital images to be exploited by early applications was the ability to manipulate, or process, the digitised data once it had been captured; although photographs could be manipulated in the darkroom, digital methods offered a means of applying reproducible changes rapidly. Such techniques had been used in astronomy and geological mapping (and of course by the military) and there was great excitement about the possibility of enhancing images to show hitherto invisible features. The processing of X-radiographs and images made using infrared radiation yielded some promising results.[3,4] Unfortunately, like many image processing exercises, the old adage of 'rubbish in – rubbish out' applied to some other studies, particularly since those with the expertise in image processing were often not in a position to gain access to higher quality images of paintings on which to employ their algorithms.

Except in the case of infrared reflectography (see Chapter 8) where no photographic equivalent exists, direct electronic imaging of paintings has been a more recent development; most research on paintings has been conducted using photographic transparencies digitised on a drum or flat-bed scanner. Because so much effort has been put into developing reliable, high-resolution colour photographic film over many years, digital equivalents of large-format colour photography with similar spatial resolution have only recently become technologically possible, and at the time of writing, are still relatively expensive. Even with these new cameras, the images are not sufficiently accurate for some scientific applications, particularly that of detecting long-term colour changes in paintings, one of the original applications of digital imaging in museums.

19.2.1 Visible imaging to measure and monitor changes

Imaging in the visible region of the spectrum has been used to measure and monitor gradual colour and structural changes in paintings. The equipment required to make sufficiently colour-accurate high-resolution images for these purposes was developed in the late 1980s in a European research project named VASARI, (Visual Arts: Systems for Archiving and Retrieval of Images).[5]

During the project, two similar imaging systems were produced in London and Munich, which were capable of reproducibly capturing images with a resolution of up to 20 pixels per millimetre across a one metre square painting. This resolution is sufficient to allow detailed examination of brushstrokes and craquelure and to detect any changes occurring with time; a lower resolution

(5 to 10 pixels per millimetre) can be used for more general imaging for documentation. The high resolution of the VASARI systems was achieved by mounting a Kontron Progres 3000 monochrome digital camera (which produced an image of 3000×2320 pixels by piezo micro-positioning) on a computer-controlled x-y positioning stage. This stage was used to move the camera parallel to the picture plane in a reproducible fashion, allowing the capture of many lower resolution images, which could subsequently be combined together to produce a complete higher resolution image.

Where required, accurate colour information about the paintings was produced by capturing a number of images of the same small area of the painting while it was illuminated with light transmitted through one of a series of broad-band interference filters; initially seven bands, from 400 (violet) to 700 nm (red) were used, but subsequent modification of the London system has increased this to ten bands.[6]

To allow the colour images to be calibrated so they could be stored in a standard format, three calibration targets were also imaged using each of the filters, a process repeated before each painting was examined. The three targets were a uniform matt white PTFE (Teflon) sheet used to correct for inhomogeneity of the illumination, a target to allow correction for optical scatter and a MacBeth Color Checker Chart, for which the 24 colour patches had previously been measured spectrophotometrically. Each of the seven images for a portion of the painting was automatically corrected using the data acquired from the white and scatter targets and the colour in the CIELAB colour space was reconstructed using a transform calculated from the images of the Color Checker, minimising the average or maximum colour error (expressed in ΔE^*_{ab} units) in the 24 colours in this chart.[7] The VASARI scanner at the National Gallery, London, is shown in Figure 19.1.

The corrected images were then assembled and the spectral bands combined to produce high-resolution colorimetric images which initially had a colour accuracy between original and image of around 2.3 ΔE^*_{ab} units (approximately one ΔE^*_{ab} unit corresponds to a just-visible difference).[7] Refinements in the equipment (including the use of a 12-bit rather than 8-bit camera) and in the calibration process over recent years, have reduced this colour difference to around 1.1 ΔE^*_{ab} units. The completed systems have since been used to capture single images to document paintings, and also to capture a sequence of images over time that can be compared to look for changes in colour or condition, particularly when paintings are moved between venues for loan exhibitions.[8,9]

In all cases where images are to be compared, be they images that are made at different times, or images made in different spectral ranges, one of the most important, and difficult, operations is to bring the images to be compared into exact superposition. This registration process involves correcting one of the images for any geometric distortion relative to the other image. When a painting

Figure 19.1

The VASARI scanner at the National Gallery, London during image acquisition under light centred at 450 nm.

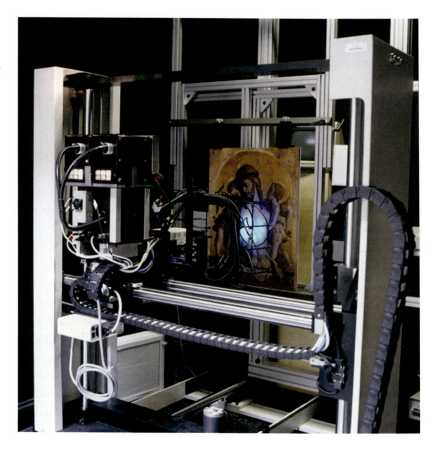

is placed on an easel, taken off and then replaced, it is very difficult to ensure that it is in exactly the same position and that the plane of the painting is again perpendicular to the focal axis of the imaging device. Errors in repositioning can be corrected by applying a perspective transformation to one of the images.[9] Once the images coincide, the colour difference between individual pixels can be determined, or the differences at the edge of the painting or in the craquelure pattern examined for signs of damage during transportation. Alternatively, the two images can be presented in a dynamic display that allows the viewer to 'fade' from one image to another – a technique that is particularly useful for examining images of the same painting made in different spectral ranges. For example, Figure 19.2 shows a blend of the X-ray, visible and infrared images of *The Holy Family with a Shepherd* by Titian (National Gallery, London No. 4). To the left, changes to Mary's face can be seen in the infrared image while to the right, one of the diagonal stretcher braces is visible.

The resampling of one image with respect to another encounters problems when large-scale structural change has occurred between making two images, for example if a painting has been subjected to extremes of relative humidity, or has had an unsuitable, restrictive cradle removed as part of a conservation

Figure 19.2

From left to right; extracts from the infrared reflectogram, visible light image and X-radiograph for *The Holy Family with a Shepherd* by Titian (National Gallery, London, No. 4).

treatment. Registration is still possible, using more complex 'rubber sheeting' algorithms, but as this process corrects the distortions, information about how the structure of the painting has changed is lost.

19.2.2 *Imaging surface texture and distortion*

Traditionally, structural features of paintings, such as distortion of the canvas or panel and raised paint, have been revealed using raking light photography.[10] A raking light photograph is made by illuminating the surface of a painting at a very low angle, to accentuate any texture or irregularities. The depth of the shadows cast by surface details can be altered by changing the angle of illumination. A digital version of this technique is easily realised by substituting a digital camera for the large-format plate camera generally used in museum or gallery studios. While this process works well for documenting specific features or structural problems in a painting, a single direction of illumination is of limited use when the aim is to document the entire surface of a painting or to compare the state of the painting before and after treatment. It is possible to make a set of images with different lighting positions, to highlight various features of the painting, but it remains extremely difficult to replicate the lighting conditions for comparative imaging.

Three-dimensional imaging techniques, described elsewhere in this book in Chapters 6 and 18, can be applied to paintings, but the results are often poor, as most paintings have very low relief.[11] A relatively new technique, polynomial

texture mapping (PTM), which was developed for rendering applications in computer graphics,[12] has also been used to image low-relief sculptures and incised tablets. Polynomial texture maps are a compact representation of the appearance of a surface under varying lighting conditions and can be rendered in real time, allowing the viewer to observe the effect of lighting an object from any direction. Recently, the technique has been applied to easel paintings at the National and Tate Galleries in London.

The prototype system used to make images of paintings comprises a wooden 'dome' supporting 24 lights in three tiers of eight. The eight lights in each tier are distributed around the circumference of a circle at 45° intervals and the three tiers are positioned to provide light from angles of *c.* 2, 30 and 60°. A digital camera fixed at the apex of the dome is used to make a set of 24 images, one with each of the lights switched on, Figure 19.3. The images are corrected for differences in exposure and passed to the PTM generator along with a file containing information about the location of each light source with respect to the centre of the painting. The PTM viewer software allows the user to select a lighting position and thus see the result of illuminating the painting from any direction and angle.

While the full three-dimensional information about the object can only be viewed using the PTM, images that show particular features to good effect can

Figure 19.3

The lighting 'dome' constructed at the National Gallery, London to record images for polynomial texture mapping.

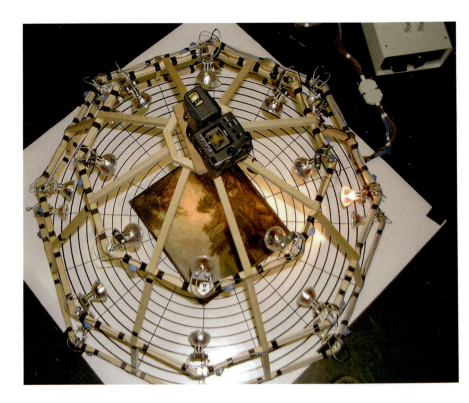

be rendered in two dimensions for documentation. Figure 19.4 shows a rendering from the PTM of the *Portrait of Jean de la Chambre at the Age of 33* by Frans Hals (National Gallery, London, No. 6411). The painting is shown as if lit by raking light from the left, which accentuates the texture of the underlying panel and the passages of thick white paint in the sitter's ruff.

Although its application to paintings is relatively new, the PTM technique has proved to be a useful tool for the documentation of the surface texture and structure of paintings and for examining the materials and techniques used in the execution of the painting, from the carpentry of the panel to the application of the paint layers. PTM visualisation is useful for showing features that result from the ageing of the painting, for example craquelure and distortion of the support; fine details such as signatures and small retouchings (repaints) can also be seen.

The dome described here can only accommodate paintings of a limited size (no larger than approximately 40 × 40 cm). To examine larger paintings, the

Figure 19.4

Rendering of the *Portrait of Jean de la Chambre at the Age of 33* by Frans Hals (National Gallery, London, No. 6411) from the PTM, showing the painting lit as though by raking light from the left.

painting can be positioned on a standard easel and a single photographic light moved between each exposure to acquire the set of images required by the PTM software. However, it would be necessary to measure the position of the light accurately prior to each exposure, which is time consuming and prone to error. At the time of writing, a lighting system is under development to allow larger paintings to be imaged; this system will use flash, rather than continuous, illumination, in order to improve image quality and to reduce the overall light exposure during imaging.

19.2.3 Visualising changes in paintings

Digital images of works of art have been used as the basis for reconstructing the colour of paintings that have changed with time. In most cases, it is extremely difficult to produce an image that accurately reflects the original appearance, as there are few clues to the colour before deterioration. However, if part of a work of art has been hidden from light, the original colour may simply be reapplied to the areas that have been damaged. This has been shown to work very well for tapestries, since the reverse side of the tapestry is often undamaged by light exposure. A very clear example of this has been presented recently.[13] The front and reverse of a light-damaged tapestry were imaged, a set of masks that isolated each thread colour in the front image made, and the colour of the damaged threads replaced by the corresponding colour measured from the reverse of the same section of tapestry. The result is a visually correct reconstruction of the unfaded colour of the object. This technique works well for two main reasons: first, as observed above, there is always a light-protected version of every colour. Secondly, there is no mixing of pigments in the way one finds in easel paintings, since in a tapestry each area of colour is made from a single thread.

However, in most paintings the degree of change of vulnerable pigments, and hence the original colour, cannot be assessed so easily, making it impossible to produce a definitive reconstruction of the colour of the original. In addition, there will be subtle changes over the whole surface of the painting that cannot be modelled. However, combining digital images and information from pigment analysis can provide an impression of how a painting might have appeared. For example, Pedro Campaña's *The Conversion of the Magdalen*, National Gallery, London No. 1241, depicts many figures, originally in brightly coloured draperies, most of which have faded or deteriorated to different shades of brown. As the original colour cannot be guessed, and can only be deduced by scientific analysis of the pigments, this painting is a particularly suitable candidate for colour reconstruction on a digital image. An accurate colour image of the painting, made using a MARC II camera (see below), was segmented and the colours of the deteriorated regions were adjusted using information from colour measurements on

paint cross sections from the painting or on samples intended to simulate the paint layer structures found in it. A number of techniques were used to control the amount of colour reintroduced into faded areas, and many of the colours were based on data from studies of light-induced colour change for samples of pigments prepared using traditional recipes. Several areas show dramatic change, including the very faded pink robes of the figure of Christ and His blue cloak that had become brown with time, due to alteration of the blue cobalt-glass pigment smalt. Several robes in the painting that had been painted with mixtures of smalt and red had deteriorated to indistinguishable browns and their reconstruction reintroducing a striking variety of purple tones, from deep violet to burgundy and maroon, see Figures 19.5(a) and (b).[14]

Another good example of such a reconstruction was conducted on Hendrick ter Brugghen's *The Evangelist Luke* from the Museum *De Waag* in Deventer in

(a)

(b)

Figure 19.5

(a) Digital image of *The Conversion of the Magdalen* by Pedro Campaña (National Gallery, London, No. 1241); (a) before and (b) after the reconstruction of the colour in deteriorated areas.

the Netherlands. The blue pigment smalt had been used extensively, notably in St Luke's robe, which, as in the Campaña, had deteriorated to brown. In this case, the reconstruction (Figure 19.6) was made without taking samples from the paint films, by using neutron-activated radiography to map the original distribution of the blue pigment. After the painting had been exposed to a neutron source, photographic plates were placed in contact with the painting to record the distribution of X-rays emitted by the nuclei of the different elements present in the pigments, which decay at different rates. Arsenic is a common impurity in smalt, and its distribution was used to reconstruct the area painted with smalt in the original painting, by assuming that the lightness corresponded to the concentration of arsenic at that point and by applying a constant hue measured from samples of smalt prepared by traditional methods.[15,16] The reconstruction of one half of St Luke's robe can be seen in Figure 19.6.

19.2.4 Infrared examination

Moving from the visible region, paintings are routinely imaged using cameras sensitive to infrared radiation. This topic is covered in more detail in Chapter 8, but its application to easel paintings generally centres on its ability to reveal preparatory drawings and *pentimenti*. In museums, imaging in the infrared can be divided into three categories, infrared photography, infrared reflectography and thermal imaging, although the last of these is not widely used and will not be discussed here.

Infrared photography has been in use since the 1930s.[17] The technique relies on the ability of radiation with wavelengths in the 700–900 nm region to

Figure 19.6

Image of *The Evangelist Luke* by Hendrick ter Brugghen (Museum *De Waag*, Deventer) showing the reconstruction of one-half of St Luke's robe. Photo Joris Dik.

penetrate the upper paint layers, revealing the preliminary drawings beneath. A digital imaging analogue of infrared photography is easily realised by removing the infrared blocking filter from a standard silicon CCD camera and replacing it with a filter that blocks visible light. It is also possible to convert a standard camcorder to make images or videos in the very near infrared using one of a number of widely available conversion kits.

However, many pigments only become transparent when radiation of a longer wavelength is used. Imaging in this 700–2000 nm (0.7–2.0 micron) region is generally termed infrared reflectography. Traditionally, a tube camera based on a lead sulphide detector has been used, and many museums continue to use such vidicon cameras for infrared examination of paintings (the tubes are normally manufactured by Hamamatsu in Japan and housed in either Hamamatsu or Grundig camera bodies). Because the widely used infrared vidicon tube produces an ephemeral TV image, a permanent record is often still made by photographing the image on the TV using standard black and white film stock. More recently, the signal from the vidicon has been digitised and the images stored on computer. Nevertheless, these cameras have certain drawbacks; they are rather low resolution, they are subject to image distortion, and as the tube heats up, the contrast, brightness and gamma of the images alter. As a result, museums and galleries have been investigating alternative solid-state cameras to make infrared reflectograms of paintings: again, more details are given in Chapter 8.

However, very good results have been obtained from the tube cameras by careful control of the acquisition conditions,[18] and by correcting the images for radiometric and geometric distortion.[9] The low resolution of the images from the tube camera (and indeed from most digital infrared cameras) means that only a small region of the painting can be imaged at a sufficiently high resolution to resolve the detail needed to interpret the underdrawing. As a result, a series of images is made, moving the camera between successive acquisitions and the resulting images assembled to form a mosaic covering a larger portion, or all, of the painting.[19,20] Refinements in these mosaic assembly programs have allowed museums to produce images comprising many sub-images in which the joins between the individual frames are scarcely visible. For example, Figure 19.7 shows the infrared reflectogram of Altdorfer's *Christ taking Leave of his Mother* (National Gallery, London, No. 6463), which despite comprising more than 100 individual images, is free from obvious image joins. The underdrawing shows the mountains sketched in the background that were never realised and the outlines of even more improbably large feet for the woman supporting the Virgin than were finally painted.[21, pp. 159–161]

A further refinement of the process, which takes advantage of the availability of digital images in both the visible and infrared regions, is the 'colourising' of infrared images to make the differences between the preliminary drawings and the finished painting more apparent. Such images are produced by first

Figure 19.7

Infrared reflectogram mosaic of *Christ taking Leave of his Mother* by Albrecht Altdorfer (National Gallery, London, No. 6463).

resampling one of the images (usually that made in the visible region, which generally has a higher resolution) so that the two areas of interest coincide, then 'bleeding' colour from the visible image into the reflectograms.[22] An example from *Saints Christina and Ottilia* by Lucas Cranach the Elder (National Gallery, London, No. 6511) is given in Figure 19.8. In the centre is the infrared reflectogram of St Christina's head and to its left the visible image of the corresponding region after resampling. The image to the right is the 'colourised' reflectogram, which makes clearer the relationship between the drawn and painted facial features, particularly the eyes, which were drawn looking more to the right rather than at the viewer as finally painted.[21, p. 146]

This superposition of images can be taken a step further when the images are examined 'live' on a computer, allowing the user to control the blending of the visible and infrared (or other) images. A good example of this can be found on

Figure 19.8

Saints Christina and Ottilia by Lucas Cranach the Elder (National Gallery, London, No. 6511): visible image (left), infrared reflectogram mosaic (centre), 'colourised' reflectogram (right).

the web site entitled 'Investigating the Renaissance', produced by the Straus Center for Conservation, Harvard University Art Museums.[23]

Although most infrared reflectography studies have concentrated on Old Master paintings, the technique is increasingly being used to examine works from the twentieth century. At the Museum of Modern Art in New York, a lead sulphide vidicon camera, and more recently a platinum silicide solid state camera, have been used to study works by a wide range of artists including Max Ernst, Joan Miro, Andy Warhol, Jackson Pollock, and Jasper Johns.[24] Figures 19.9(a) and (b) show an example of the results from this programme of study. Infrared examination of the centre 'bull's-eye' region of Jasper John's collage

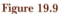

Figure 19.9

Green Target by Jasper Johns (Museum of Modern Art, New York): (a) black and white visible image and (b) infrared reflectogram. Photos Jim Coddington.

(a) (b)

Green Target (1955) reveals that beneath a uniform coloured paint layer Johns had pasted pages from K. Langer's *Philosophy in a New Key* from 1942. From the infrared image (Figure 9(b)), the text has been identified as a passage from a chapter that begins 'What distinguishes a work of art from a "mere" artifact?', a statement that accords with Johns' own philosophy.[24, pp. 43,44]

19.2.5 X-radiography

X-radiography has been used to examine paintings for many years, becoming almost a standard technique soon after the discovery of X-rays by Wilhelm Röntgen in 1895. X-ray examination yields information related to the entire three-dimensional structure of a painting, including the structure of wooden supports, canvas weave and areas of paint loss. In addition, the build up of the paint layers can be seen, allowing different artists' hands to be distinguished, and previous compositions beneath the surface to be revealed.

While there have been considerable developments in the use of X-radiography for medical and industrial imaging, for example in tomographic imaging, the procedure for making X-radiographs of paintings has changed little over the last hundred years. In most cases, X-radiographs are made by placing an X-ray sensitive film in contact with the surface of the painting and exposing it to that X-radiation transmitted by the painting structure; few, if any, museums are using digital X-radiography equipment to examine paintings routinely. Typically, each X-ray plate is approximately 300×400 mm, so a mosaic of individually exposed plates is made to cover the painting surface. To avoid the need to make multiple exposures, a number of museums have used large-format roll film up to 1.37 m wide.[25,26] Large film can be cumbersome to handle or digitise and most museums have large archives of X-ray plates that are often of historical importance. Increasingly, these plates are being digitised, to preserve the information they hold and to make the images more easily accessible and manipulable.

Because the X-ray film has a high density range and is slightly larger than the closest standard paper size (A3), digitising X-radiographs presents some technical problems. In the early 1990s, the Centre de Recherche et de Restauration des Musées de France (C2RMF) developed a scanner specifically for digitising X-ray films and have gone on to digitise over 100 000 individual plates.[27,28] As the performance of reasonably priced, commercially available scanners has improved, these have become a viable alternative to purpose-built digitisation equipment, and many museums now use good quality flat bed scanners to digitise X-radiographs.

For medical and industrial imaging, several systems have been developed that do not use film as an intermediate. One such system exposes re-usable phosphorescent plates that are then digitised, while other systems replace the X-ray film with a digital detector, commonly a scintillator that converts the X-radiation

to light that is then detected using a standard silicon photodiode sensor. Although recent advances in the latter technology make it a viable alternative to traditional X-ray plates in terms of image resolution, the set up costs are very high. Against this, the time required to make digitised images is much reduced, and the success of an exposure can be judged quickly, without the need to process the photographic intermediate.

However, all these systems produce digitised images of only part of the painting, rather than of the whole. To give an image of the entire panting that can be used alongside the original, or compared to images made in other spectral regions, the individual images need to be joined in a mosaic – in the same way that the mosaics are made for infrared reflectograms. The main difficulty to be overcome when making a mosaic of an X-radiograph is that because the two-dimensional image represents a three-dimensional object, care is needed in selecting the tie points that are used to join images.[29]

Once a mosaic image of the whole painting has been assembled, the digital image can be further processed to enhance details of interest or to remove the parts of the image due to secondary structures such as stretchers or cradles.[29] The example given in Figures 19.10(a) and (b) shows the effect of processing an X-ray image of *The Judgement of Paris* by Rubens (National Gallery, London No. 194) to suppress the visual impact of the cradle, improving the readability of the image of the surface paint layers.

19.2.6 *Multispectral imaging of paintings*

Multispectral imaging of paintings (i.e. using imaging systems with more than three colour-separation bands) has been interesting to researchers since at least the late 1980s. Multispectral imaging is attractive for two reasons: first because a higher colour accuracy is attainable than with a trichromatic system (this was the reason for the development of the multispectral VASARI system to measure colour changes). Second, it is possible to estimate the spectral reflectance of the surface of the object under examination.

In a trichromatic imaging system, high colour accuracy requires that the three filters be a linear recombination of the CIE XYZ curves. Filters with this property are very difficult to manufacture, so a simpler approach is to use a multispectral method and to derive the XYZ curves from a combination of the extra bands. Many studies have been conducted to determine the best combination of theoretical (and real) filters for this purpose, and the minimum number of filters that are required for a given accuracy.

Estimating spectral reflectance is a more difficult problem, but potentially opens up interesting areas for painting conservation. Three-band images are set for a particular observer and illuminant, whereas a multispectral image can estimate the colour for any combination of observer and illuminant, reducing

Figure 19.10

(a) *The Judgement of Paris*
by Rubens (National
Gallery, London, No. 194):
(a) computer-assembled
X-ray mosaic image and
(b) histogram-matched
radiograph derived from
the computer-assembled
X-ray mosaic image.

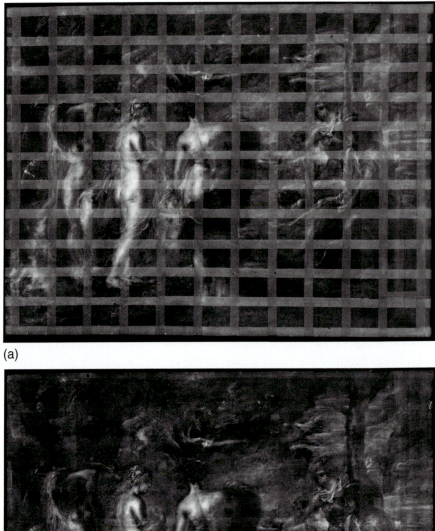

(a)

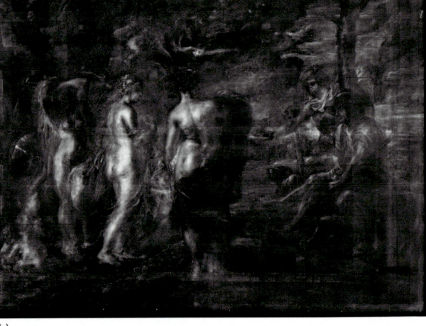

(b)

the metamerism between object and image experienced with three-colour systems. Problems such as simulated varnish removal can only be accurately attacked spectrally. In combination with other techniques, reflectance spectra can be used to aid pigment identification.

For example, a multispectral examination of Pontormo's *La strage degli undicimila martiri*, from the Galleria Palatina, Pitti Palace, Florence used a lead sulphide–lead oxide vidicon detector and a set of 29 narrow band filters with peak transmissions between 400 and 1550 nm.[30] The resulting multi-band image was used to help identify the distribution of two yellow pigments used in the composition; yellow ochre (an iron oxide) and lead–tin yellow. The authors measured the reflectance spectrum of the pigments independently and then used differences in the curvature of the spectra in the 440–600 and 800–1000 nm regions to produce images showing the distribution of the two pigments in the yellow cuirass worn by one of the soldiers; Figures 19.11(a–c). Because radiation at 800–1000 nm penetrates deeper into the paint layers, the distribution maps for the two wavelength ranges differ. The map for 440–600 shows the distribution at the surface of the painting, while that for 800–1000 nm shows the greater use of lead tin yellow in the underpaint, a pattern confirmed by inspection of the paint film under the microscope.

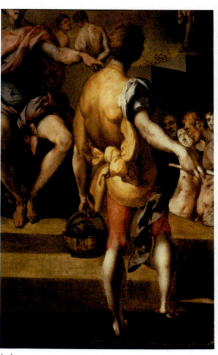

(b)

(a)

(c)

Figure 19.11

La strage degli undicimila martiri by Pontormo (Galleria Palatina, Pitti Palace, Florence): (a) visible image of soldier's yellow cuirass, (b) image of equivalent area in the 440–600 nm region, and (c) 800–1000 nm region. Photos Andrea Casini.

Following the development of the VASARI multispectral scanner described above, very few systems have been developed with the express aim of examining paintings or other works of art.[31] For some time, Art Innovation in the Netherlands have been producing a camera (MuSIS) that can image seven broad bands from the ultraviolet to near infrared, using a silicon CCD and an image intensifier to extend the infrared range to *c.* 1550 nm; this camera serves as a very useful replacement for a whole series of photographic techniques used in conservation.[32,33]

However, at the time of writing, three further systems are at various stages of development. At Rochester Institute of Technology, Berns is working on a multispectral imaging system for museum use. This is currently based on a monochrome camera and a tunable LCD filter. Although still at the design and testing stage, the results have been encouraging and the images have been of sufficient quality to be used in experiments in multispectral printing.[34] The Foundation for Research and Technology Hellas (F.O.R.T.H.) has recently announced the development of a multispectral camera capable of recording a series of images at 3 nm intervals from 380 to 1000 nm. The device has already been used to differentiate between the original and altered script on an eleventh-century palimpsest and to examine the red pigments in a historiated letter in a twelfth-century manuscript.[35]

Finally, the EU-funded CRISATEL project is developing a successor to the VASARI scanner – a 13-band multispectral camera for museum applications. The camera uses a 12 000-element line CCD sensor scanned mechanically to up to 30,000 positions. The 13 interference filters that span the visible and near infrared are mounted on a rotating drum just in front of the sensor. The camera has additional hardware to refocus the optical system between scans and to move the camera to maintain pixel superposition. Software calculates estimated reflectance spectra for each point on the painting.[36,37] To reduce the light exposure during imaging, a specialised lighting system has been developed which illuminates only the portion of the surface that is being imaged as the sensor scans across the painting, Figure 19.12.

19.3 Imaging for Publication and Conservation Documentation

While the absolute colour accuracy of photographic transparencies is not particularly good, their spatial resolution can be extremely high. In contrast, digital cameras have, until recently, been capable of making only much lower resolution images, although they are theoretically capable of greater colour accuracy than transparencies, given appropriate calibration. Understandably, the overwhelming majority of digital images for documentation and publication have hitherto been made by scanning existing large-format transparencies

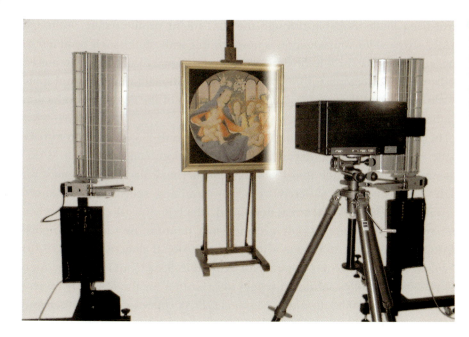

Figure 19.12

The CRISATEL camera (foreground) in use to image a painting in conjunction with the specialised *Jumbolux* lighting system.

using the high-end scanners that have been in use in the reprographic sector for many years.

It is, however, the potential to replace photographic transparencies by accurate high-resolution digital images as the principal record of a painting for publishing, documentation and distribution that is one of the most exciting facets of these digital technologies.

19.3.1 Publication

The first colour-matched digital art publishing system was developed in the EU-funded MARC project (1992–1995).[38] The project built a very high resolution, colorimetric digital camera,[39] and a corresponding colorimetric press calibration package.[40] One of the project outcomes was an art catalogue of Flemish Baroque painting produced using the process. The 80 plates in the book are facsimiles with a high degree of colour accuracy, although there were some issues with the handling of dark colours due to problems with black point calibration. *Flämische Barockmalerei* was thus the first colour-managed art catalogue in which all the images were produced from digital files, with no intervening photographic stage.[41]

In the last 10 years, direct digital capture of paintings has become more widespread. Large-format studio digital cameras are now commonly available, and their introduction in galleries is usually limited by funding rather than technical constraints. Similarly, the colour management aspects of the MARC project

have been made available through the ICC colour profile system. Although MARC-style colour reproduction is now possible with off-the-shelf commercial packages, it is rare for it to be done well. Studio digital cameras are often used as drop-in replacements for film cameras in a traditional print chain and some of the advantages that could come from a revamp of the colour reproduction methodology are missed.

The National Gallery, London, is currently the only major museum to have made direct colorimetric digital records of its entire collection. The MARC camera developed in the mid-1990s was not mechanically robust enough for high-volume use, and suffered from slow scanning speeds. An enhanced version of the MARC camera was developed, which is physically much tougher, and reduces scan time to only two-and-a-half minutes. As with the original MARC camera, each shot made with the new MARC II camera (Figure 19.13) is colour calibrated to an accuracy of around 2–3 ΔE^*_{ab} units. A new user-interface and colour calibration system were written for the MARC II camera and from 1999 to 2002, the entire National Gallery collection was digitised and stored on a high capacity server.[42]

This set of scans forms the basis for making reproductions of the National Gallery's paintings. Derivatives of these images are used in visitor information systems, websites, and in the future will be used in all printed publications. One print application launched at the time of writing is the Print on Demand kiosk in the gallery shop. Visitors can select any painting on a touchscreen and have

Figure 19.13
MARC II high-resolution visible camera used at the National Gallery, London.

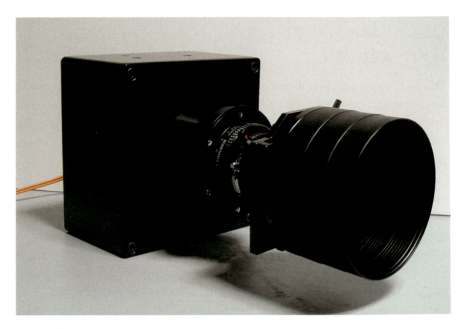

a colour facsimile printed on a large format inkjet printer while they wait. Other museums, notably the National Portrait Gallery, London and Museum of Modern Art in New York, have also offered print on demand services, but these have been based on digitised photographic transparencies.

Many institutions are looking at adding high-resolution images of their works to their websites. While it is clearly good for visitors to be able to see details of objects, most galleries are concerned about losing control of copyrighted images. The usual solution is to embed watermarks or to offer only a partial view of the image, so that in order to copy an image, the user would have to make many screen captures. Some research packages and many commercial image-viewing systems are available that offer these facilities (Flashpix, ImagePump, etc.). Web colour standards are still rather vague, so these systems seldom attempt accurate colour reproduction.[43]

19.3.2 Conservation documentation

The purpose of conservation documentation is to record the condition of a work of art at a particular point in its history and the details of any treatments carried out. The intention is that these documents will serve as permanent, yet accessible records for future consultation and comparison. Traditionally, conservators store written details of the state of a painting, complemented by photographs that illustrate the condition of the object and the effects of treatment. These records are easily accessible at their point of storage, but are sometimes the only copy of a written or photographic record and are therefore, susceptible to loss or deterioration. The photographic images, even when made using the highest quality stock, will degrade over time, especially colour photographs.

Digital documentation offers a method of storing both text and image in a way that is both accessible and permanent, although suitable precautions must be taken to ensure the integrity of the files and to back up and maintain parallel archives. Through network access, the records can be made available throughout a museum and, if appropriate, to a wider audience through the web. If hard copies are required, these can be produced without fear of loss of the original data and can thus be used without regard to their long-term preservation – they can for example be drawn on or cut up.

Digitised records can be organised and linked in ways that are not possible with traditional text and photographic material. For example, a database that contains a text description of an X-ray image can automatically associate it with the digital image and produce a printable report from predefined templates. Searching for particular text and images is also possible once the records are in digital form. Text searching is well advanced, including searching for images by means of associated text or metadata. While image-based image searching is not at such an

advanced stage, image recognition from target images or sub-images has shown promising results.[44]

When using traditional documentation techniques for very complex conservation projects, keeping track of all of the information being generated can become very difficult. The conservation of The Westminster Retable, part of an English mediaeval altarpiece,[45] carried out at the Hamilton Kerr Institute, UK, provides a clear example of such a problem (the Retable comprises over 3500 separate parts), and how it can be tackled more effectively by using a database that links text and images to present material and spatial relationships.[46]

Once digitised, images can be presented in ways that are not possible with photographic records, for example to make image comparisons or overlays. Examples include the comparison of images made in different regions of the spectrum to correlate features. The combination of images in the visible and infrared was described earlier, but it is also possible to compare any combination of X-radiographs, ultraviolet, visible, raking light or infrared images. For example, subtraction of the visible image from the infrared image has displayed pentimenti and overpainted areas with greater clarity,[47] while a comparison of the curf marks (seen in the X-radiograph) with the craquelure pattern, which is most visible in the infrared reflectogram of *The Dead Christ supported by Two Angels* by Carlo Crivelli (National Gallery, London, No. 602) shows the influence of the tooling of the panel on the development of the crack pattern as the painting aged, Figure 19.14.

Comparisons can be made between different versions of the same paintings, or related works by the same artist, to show how closely parts of the composition match (or differ), and shed light on the use of models or cartoons within artists' studios. For example, a painting of *Salome* by Giampietrino (National Gallery, London, No. 3930) shows Salome holding the head of John the Baptist on a platter. Superposition of this figure with that of Cleopatra in another painting by Giampietrino, now in the Louvre, Figure 19.15, showed that the

Figure 19.14

The Dead Christ supported by Two Angels by Carlo Crivelli (National Gallery, London, No. 602); detail of angel's head: infrared reflectogram (left), visible image (centre), and X-radiograph (right). The curf marks seen in the X-radiograph can be related to the craquelure patterns seen in the visible and infrared images.

Figure 19.15

Superposition of an image of *Salome* by Giampietrino (National Gallery, London, No. 3930) over an image of *Cleopatra* by the same artist (Musée du Louvre, Paris).

same drawing of the principal figure must have been used for both paintings; even the hand, although shifted, is in the same posture.[48]

Another advantage of digital images is that the colour accuracy can be sufficiently high to make meaningful comparisons, if calibration procedures are used for both images, Figure 19.16.

As mentioned in previous sections, it is very difficult to control colour in traditional photography. When the photographs are taken in different institutions, years apart, using different film types, it makes any comparison almost irrelevant. However, if appropriate calibration processes are followed during the acquisition of colour digital images, even using fairly standard commercially available CCD cameras, it is possible to produce permanent images of good colour accuracy,

Figure 19.16

Results from the long-term study of
colour change. Two images of the *Pietá*
attributed to the workshop of Rogier
van der Weyden (National Gallery,
London, No. 6265) made using the
VASARI system at an interval of
six years and resampled to allow
comparison (top and bottom). The
central image is a colour difference
map; the differences have been
exaggerated to increase visibility, but
show only the edges between dark and
light regions where resampling of the
second image has not produced exact
superposition.

thus allowing images to be compared and cross-referenced, even when they have been taken with different cameras and at different times.[49] For example, small paint samples (cross-sections), are commonly photographed through microscopes. These photographs are used in various types of publications, but the colours cannot be confidently compared with similar photographs taken in other institutions. Correctly colour-calibrated digital images of these samples would allow direct comparisons to be made with confidence.

19.4 Acknowledgements

The authors are grateful to present and past colleagues at the National Gallery for their contributions included in this survey, particularly, Clare Richardson and Tiarna Doherty. We owe a great debt to our long-term collaborators at the Doerner Institut in Munich, Andreas Burmester and Lars Raffelt. Jim Coddington, Andrea Casini, Joris Dik, and Felix Horn generously allowed us to present synopses of their work in the sections above. The following allowed us to reproduce images of paintings or the technical images created in their laboratories: The National Gallery, London; Museum of Modern Art, New York; The Soprintendenza per i Beni Artistici e Storici, Florence; The Galleria Palatina, Florence; the Museum *De Waag*, Deventer. Finally, the authors would like to thank the European Commission and Hewlett Packard for their continuing support of imaging projects at the National Gallery London, many of which are described in this chapter.

19.5 References

1. Thomson, G. and Staniforth, S. (1982). Identification and Measurement of Change in Appearance by Image Processing. In *Science and Technology in the Service of Conservation* (N. S. Brommelle and G. Thomson, eds), pp. 159–161, International Institute for Conservation.

2. Saunders, D. (1988). Colour change measurement by digital image processing. *National Gallery Technical Bulletin*, **12**, 66–77.

3. Heitz, F., Maitre, H. and de Couessin, C. (1987). Applications of autoregressive models to fine arts painting analysis. *Signal Processing*, **13**, 1–14.

4. Druzik, J. R., Glackin, D. L., Lynn, D. L. and Quiros, R. (1982). The use of digital image processing to clarify the radiography of underpainting. *Journal of the American Institute for Conservation*, **22**, 49–55.

5. Burmester, A., Cupitt, J., Derrien, H., Dessipris, N., Hamber, A., Martinez, K., Müller, M. and Saunders, D. (1992). The examination of paintings by digital image analysis. *3rd International Conference on Non-Destructive Testing, Microanalytical Methods and Environmental Evaluation for Study and Conservation of Works of Art*, Viterbo, pp. 201–214.

6. Ribés, A., Brettel, H., Schmitt, F., Liang, H., Cupitt, J. and Saunders, D. (2003). Color and Multispectral Imaging with the CRISATEL Multispectral System. *Proceedings of the PICS conference May 13–16, 2003*, The Society for Imaging Science and Technology, pp. 215–219.

7. Saunders, D. and Cupitt, J. (1993). Image processing at the National Gallery: The VASARI project. *National Gallery Technical Bulletin*, **14**, 72–85.

8. Burmester, A. and Müller, M. (1992). The registration of transportation damages using digital image processing. *Zeitschrift für Kunsttechnologie und Konservierung*, **6**, 335–345.

9. Saunders, D., Raffelt, L., Cupitt, J. and Burmester, A. (2000). Recent applications of digital imaging in painting conservation: transportation, colour change and infrared reflectographic studies. In *Tradition and Innovation: Advances in Conservation* (A. Roy and P. Smith, eds), pp. 170–176, International Institute for Conservation.

10. Hours, M. (1976). *Analyse scientifique et conservation des peintures.* Office du livre, 123–128.

11. Guidi, G., Atzeni, C., Seracini, M. and Lazzari, S. (2004). Painting survey by 3D optical scanning: the case of Adoration of the Magi by Leonardo da Vinci. *Studies in Conservation*, **49**, 1–12.

12. Malzbender, T., Gelb, D. and Wolters, H. (2001). Polynomial texture maps. *Computer Graphics. Proceedings of ACM Siggraph*, pp. 519–528.

13. Horn, F. (2003). *Digitale Bildverarbeitung als ein Werkzeug der präventiven Konservierung.* Ph.D. thesis, Technical University of Munich. ISBN 3-935643-06-3.

14. Richardson, C., Saunders, D. and Spring, M. (2001). Reconstructing altered colours by image processing: The Conversion of the Magdalen by Pedro Campaña. *Zeitschrift fur Kunsttechnologie und Konservierung*, **15**, 338–346.

15. Dik, J. (2003). *Scientific Analysis of Historical Paint and the Implications for Art History and Art Conservation.* Ph.D. thesis, chapter 6, University of Amsterdam.

16. Dik, J., den Leeuw, M., Verbakel, W., Peschar, R., Schillermans, R. and Schenk, H. (2002). The reconstruction of a smalt discoloured painting by Hendrick Ter Brugghen. *Zeitschrift fur Kunsttechnologie und Konservierung*, **16**, 130–146.

17. Rawlins, F. I. G. (1943). Beneath the surface of old pictures. *Journal of the Royal Society of Arts*, **41**, 150–154.

18. Burmester, A. and Bayerer, F. (1993). Towards improved infrared-reflectograms. *Studies in Conservation*, **38**, 145–154.

19. Wecksung, G., Evans, R., Walker, J., Ainsworth, M., Brealey, J. and Carriveau, G. W. (1987). Assembly of infra-red reflectograms by digital processing using a portable data collecting system. *ICOM Committee for Conservation, 8th Triennial Meeting, Sydney, Australia*, vol. 1, pp. 107–110.

20. Billinge, R., Cupitt, J., Dessipris, N. and Saunders, D. (1993). A note on an improved procedure for the rapid assembly of infrared reflectogram mosaics. *Studies in Conservation*, **38**, 92–98.

21. Bomford, D. (ed.) (2002). *Art in the Making: Underdrawings in Renaissance Paintings*, National Gallery Publications.

22. Saunders, D. and Cupitt, J. (1995). Elucidating reflectograms by superimposing infra-red and colour Images. *National Gallery Technical Bulletin*, **16**, 61–65.

23. Spronk, R. (1996). More than meets the eye: An introduction to technical examination of early Netherlandish paintings at the Fogg Art Museum. *Harvard University Art Museums Bulletin*, **1** (http://www.artmuseums.harvard.edu/Renaissance).

24. Coddington, J. and Siano, S. (2000). Infrared imaging of twentieth-century works of art. In *Tradition and Innovation: Advances in Conservation* (A. Roy and P. Smith, eds), pp. 39–44, International Institute for Conservation.

25. Van de Voorde, G. (1973/4). Het gebruik van de Cronaflex-film voor de radiografie van schilderen. *Institut Royal du Patrimoine Artistique Bulletin*, **XIV**, 34–38.

26. Aldrovandi, A. and Ciappi, O. (1995). La radiografia di grande formato: problemi e soluzioni tecniche. *Rivista dell'Opificio delle Pietre Dure e Laboratori di Restauro di Firenze*, **7**, 163–168.

27. Lahanier, C. (1995). L'Analyse d'image en très haute définition dans le cadre des musées: le projet NARCISSE. In *Analyses et conservation d'œuvres d'art monumentales*, pp. 113–123, Laboratoire de conservation de la Pierre.

28. Lahanier, C., Aitken, G. and Aubert, M. (1995). NARCISSE: une bonne résolution pour l'étude des peintures. *Techne*, **2**, 178–190.

29. Casini, A., Lotti, F., Picollo, M., Stefani, L. and Buzzegoli, E. (1999). Image spectroscopy mapping technique for non-invasive analysis of paintings. *Studies in Conservation*, **44**, 39–48.

30. Padfield, J., Saunders, D., Cupitt, J. and Atkinson, R. (2002). Recent improvements in the acquisition and processing of X-ray images of paintings. *National Gallery Technical Bulletin*, **23**, 62–75.

31. Maître, H., Schmitt, F. J. M., Crettez, J. P., Wu, Y. and Hardeberg, J. Y. (1996). Spectrophotometric Image Analysis of Fine Arts Paintings. *4th Colour Imaging Conference, IS &T-SID*, 6), pp. 50–53.

32. Kautek, W., Pentzien, S., Müller-Hess, D., Troschke, K. and Teule, R. (2001). Probing the limits of paper and parchment laser cleaning by multi-spectral imaging. *Proceedings of SPIE*, **4402**, 130–138.

33. Havermans, J., Aziz, H. A. and Scholten, H. (2003). Non destructive detection of iron gall inks by means of multispectral imaging. *Restaurator*, **24**, 55–60.

34. Day, E. A., Berns, R. S., Taplin, L. and Imai, F. (2003). A Psychophysical Experiment Evaluating the Colour Accuracy of Several Multispectral Image Capture Techniques. *Proc of the PICS conference May 13–16,2003*, The Society for Imaging Science and Technology, pp. 199–204.

35. Balas, C., Papadakis, V., Papakadis, N., Papakadis, A., Vazgiouraki, E. and Themelis, G. (2003). A novel hyper-spectral imaging apparatus for the non-destructive analysis of objects of historic and artistic value. *Journal of Cultural Heritage*, **4**, 330–337.

36. Cotte, P. and Dupouy, M. (2003). CRISATEL High Resolution Multispectral System. *Proc of the PICS conference May 13–16, 2003*, The Society for Imaging Science and Technology, pp. 161–165.

37. Liang, H., Saunders, D., Cupitt, J. and Benchouika, M. (2004). A new multi-spectral imaging system for examining paintings. *IS&T's Second Conference on Color in Graphics, Imaging and Vision (CGIV 2004)*, pp. 229–234.

38. Cupitt, J., Martinez, K. and Saunders, D. (1996). A Methodology for Art Reproduction in Colour: the MARC project. *Computers and the History of Art*, **6**, 1–20.

39. Lenz, R., Beutelhauser, R. and Lenz, U. (1994). A microscan/macroscan 3×12 bit digital color CCD camera with programmable resolution up to $20,992 \times 20,480$ picture elements. *Proceedings of the Commission V Symposium: Close range techniques and machine vision*, Melbourne, Australia, *International Archives of Photogrammetry and Remote Sensing*, **30**.

40. MacDonald, L. W. (1993). Image representation and colour separation in the MARC Project. *Proc of the Electronic Imaging and the Visual Arts Conference*.

41. Burmester, A., Raffelt, L., Renger, K., Robinson, G. and Wagini, S. (1996). *Flämische Barockmalerei: Meisterwerke der Alten Pinakothek München; Flemish Baroque Painting: Masterpieces of the Alte Pinakothek München*. Hirmer Verlag.

42. Saunders, D., Cupitt, J., White, C. and Holt, S. (2002). The MARC II camera and the scanning initiative at the National Gallery. *National Gallery Technical Bulletin*, **23**, 76–82.

43. Martinez, K., Cupitt, J. and Perry, S. (1998). High resolution colorimetric image browsing on the Web. *7th International World Wide Web Conference.*

44. Chan, S., Martinez, K., Lewis, P., Lahanier, C. and Stevenson, J. (2001). Handling sub-image queries in content-based retrieval of high resolution art images. *Proc of the International Cultural Heritage Informatics Meeting 2* (D. Bearman and F. Garzotto, eds), pp. 157–163.

45. Binski, P. (1987). What was the Westminster Retable. *Journal of the British Archaeological Association, 3rd series,* **140**, 152–174.

46. Bucklow, S. (2002). Using digital images for conservation documentation. In *Digital Imaging for the Paintings' Conservator, Preprints for a conference held in the Starr Auditorium at Tate Modern on Friday 6th December 2002,* pp. 53–59, UKIC Paintings Section.

47. Spezzani, P. (1984). Infra-red and visible image processing. In *Riflettoscopia all'Infrarosso Computerizzata,* Quaderni della Soprintendeza ai Beni Artistici e Storici di Venezia, **6**.

48. Keith, L. and Roy, A. (1996). Giampietrino, Boltraffio and the influence of Leonardo. *National Gallery Technical Bulletin,* **17**, 4–19.

49. Cupitt, J. (2001). Using a budget digital camera in a museum. Presentation to the Museum Computer Group, 7 June. http://cima.ng-london.org.uk/~john/mcg/title.shtmls

20

Research Policy and Directions

Tom Evans

20.1 Introduction

As recently as 1990, digital image capture, asset management and display for cultural heritage were almost entirely unknown. Interactive multimedia technologies were the subject of laboratory research and the Internet was unused for heritage data exchange (let alone display). Today, they are pervasive in 'memory institutions' and the conservation industry. The development and application of digital technologies have been achieved only by a substantial research effort, accompanied by a cultural revolution in the heritage sector.

The pattern of development is the product of a complex interplay of different forces. These include the increase in performance and availability of new technologies; public policy and the consequent availability of funding for projects in public institutions; and the perception within the memory institutions themselves of the needs (and opportunities) for ways of delivering services in a better or more cost-effective way. The development and availability of improved technologies for cultural heritage is itself the result of a similar set of factors, and is heavily influenced by the direction of public policy. By definition, the heritage sector is dealing with some of the most beautiful, profound and valuable products of humanity, which stretch the capacity of digital technologies to the limit and beyond. As previous chapters have shown, the requirements are particularly demanding in terms of quality of data capture image definition and colour accuracy), the required persistence of information, tools for its interpretation and sharing, its transmission over the Web, and the quality of its display. However, the cultural heritage sector does not undertake basic scientific research and very rarely develops new technologies. Instead, it is typically involved in applications research and the development of new tools, applications and services that are based on technologies developed elsewhere for other purposes. Museums, memory institutions and heritage organisations are dependent on research policy decisions, which underpin both the development of basic imaging, knowledge, network and display technologies as well as their applications for cultural purposes.

Technology foresight is a very imprecise art, and particularly prone to error in the area of applications where scientific, policy, economic and social forces influence the outcome. It is nonetheless essential, not only to policy makers but also for research centres, museums and heritage bodies, which variously wish to plan the work, undertake it, shape its direction to useful ends, and employ the results.

20.2 Background to Research Policy for Digital Culture and Heritage

Every country in Europe has its own policies for heritage conservation and technological research, which are themselves culturally determined: there are significant differences between the approach to artefacts in the Southern European countries where ancient heritage is superabundant and Nordic countries where it is sparse. However, regional differences of policy approach to digital heritage research are becoming less important as European policy and funding develop in magnitude and influence. It is on the common strands of European activity that we should therefore focus, rather than the particularities of individual nations.

Current European research policy for digital heritage, expressed in the European Commission's 'DigiCult' actions in the Information Society Technologies Programme, grows from work in the Digital Libraries sector in the late 1980s. This was carried out before multimedia was established as a concept or image computing became a widely available and affordable technology. While there have been a number of stand-alone projects in various programmes at different times, at the European level, policy development for digital libraries and heritage effectively started in 1984, when the European Parliament drew attention to the importance of libraries to the Community and the 'Schwencke Resolution' called for action by the European Commission.[1] This resulted in a policy resolution by the Council of Ministers with responsibility for cultural affairs, adopted on 17 September 1985, calling for 'Collaboration between libraries in the field of data processing'. Libraries were seen both as a major force in the emergent information market and as intermediaries to knowledge and culture. (Collaboration for knowledge, for the benefit of citizens across countries and languages is also one of the least contentious areas of European action.) The Council invited the European Commission, as the administrative branch responsible for policy proposal and execution to prepare a work programme in collaboration with those responsible for libraries in the Member States. An exploratory phase started in 1985, resulting in a discussion document that described a possible plan of action. Following consultations, the draft Action Plan for Libraries became the basis for a series of preparatory activities started in 1989–1990. These included more in-depth consultations and investigations as well as a small number of test-bed pilot. Eventually, a Libraries programme was established, as part of the

Telematics Programmes within the Third Framework Programme (1991–1994), and continued under the Fourth Framework Programme (1994–1998). As a result, 51 projects with grants totalling 25 million ECU were co-funded under the Third Framework in 1991–94. In the Fourth Framework, the Telematics for Libraries Programme emphasised the role of libraries in the development of an electronic information infrastructure. The work plan recognised that information was increasingly created, distributed, accessed and used entirely in electronic form and libraries might have an important role in managing these flows of electronic information. Special attention was given to the dependency between individual libraries and the 'wider European information infrastructure'. Ironically, while the Telematics Application programme (TAP for short) identified the growing importance of electronic networks, the Internet explosion was not foreseen (and the Internet was not mentioned in the work programme documentation). All of that was to change in 1994 with the launch of the World Wide Web Consortium, as a result of which the concepts of the Web, universal access to the Internet, and multimedia online data replaced closed, sectoral data networks.

As the PriceWaterhouseCoopers study remarked 'In these years, the Web has changed from an environment for scientists and networking specialists to a mass medium. It now forms a common platform for user-oriented services – and the Libraries Programme has managed to follow suit'. In other words, some very rapid adjustment was needed to redirect a policy-driven programme and maintain any sort of relevance in the face of a potentially disruptive technology. So, rather than looking at network structures for document exchange, the libraries concentrated efforts on searching and indexing services and the use of metadata, notably through the initiatives of the Dublin Core group.

In keeping with the libraries' focus on textual data and metadata, there were only a few, small-scale experiments with digitisation and image-based work. This mainly concentrated on digitising rare materials from original documents, describing and providing access to image-based materials. However, quite a lot of effort was devoted to the development of appropriate user interfaces and tools to support the retrieval, browsing and selection of images.

The development of technology to help cultural imaging *per se*, and of image-rich multimedia services for museums and libraries, was happening elsewhere. Basic research was typically located in the ESPRIT programme (European Strategic Programme for Information Technology). The VASARI project [2] (1989–92) was unusual in conducting research directly aimed at 'an important niche market of the 1990s: the visual arts image-processing market', which was designed to demonstrate 'the feasibility and benefits of high-resolution and high-quality digital image processing techniques'. VASARI was an unusually successful and influential project: the technology has continued to be developed and the VASARI scanner in the National Gallery London remains in use to provide very high-quality digital scans direct from paintings.

Its successor project MARC (1992–95) aimed to extend VASARI's results to the publishing world by developing 'an integrated system for the digital acquisition, storage and handling of colorimetric high-definition images of paintings for printing purposes'. ACOHIR (1997–2000) aimed to develop tools to acquire more detailed images (3k×2k pixel) from 3D objects than was then possible with QuickTime VR software to view them seamlessly.

Most museums lack the resources and skills to take part in technological research, although they are increasingly interested in using the results to deliver better services for conservation, scholarly study and public display. They often make close links with University or other research centres, and specialist companies working with digital media technologies. In the early 1990s, the European Commission made a substantial effort to encourage the museum sector to experiment with digital imaging and multimedia publishing in the IMPACT2 programme. This was not meant to foster research, but to encourage the development of innovative products based on the multimedia technologies using digital optical disks that were beginning to emerge in the market. In practice, as we shall explore shortly, the element of technical development (as opposed to digital production, publishing and marketing) was much larger and closer to research than many had anticipated.

The various strands of what were ESPRIT, TAP and IMPACT were largely woven together in the Information Society Technologies Programme in the Fifth Framework (1998–2002). Underlying the policy goals of both the Fifth Framework (and its successor the Sixth) is a technical vision of 'Ambient Intelligence', which was articulated in 1999 by the Information Society Technologies Advisory Group (ISTAG) in a report on 'Orientations for the Workprogramme 2000 and beyond'.[3] ISTAG summarised its advice in a headline note:

> *Start creating an ambient intelligence landscape (for seamless delivery of services and applications) in Europe relying also upon testbeds and open source software, develop user-friendliness, and develop and converge the networking infrastructure in Europe to world-class.*

The concept of 'Ambient Intelligence' refers to a future in which people are surrounded by invisible microprocessors, embedded in everyday objects within the environment and linked by imperceptible, very high bandwidth networks, so as to provide information and services in ways that require no particular skills from the user. This environment should respond seamlessly and automatically to each individual, adapting 'intelligently' to their needs. The idea of ambient intelligence arises from the convergence of three technological concepts: 'Ubiquitous Computing', 'Ubiquitous Communication', and 'Intelligent User-Friendly Interfaces'. The idea of Ubiquitous Computing has a long history. It was discussed at the Hakone Forum in 1992,[4] and was the subject of a first set of experiments at Xerox Parc in 1992–95 (the ParcTab Project led by Mark Weiser).

In essence, Ubiquitous Computing proposes the disappearance of the computer. As processor power becomes cheaper, so processors with advanced functionality are invisibly embedded in an ever-greater range of everyday devices and arte-facts in the environment.[5] Ubiquitous Communication is the twin concept, for technologies that link any set – or all – of these devices together in a seam-less mesh, accessible by anyone, anywhere. Intelligent User-Friendly Interfaces are the glue that holds the whole thing together and makes it usable by anyone. There is a growing realisation that most interfaces require a lot of learning and a lot of effort by determined users. For ubiquity and invisibility to work, a much easier approach, with little or no learning curve, was deemed essential. In the ISTAG jargon, ambient intelligence proposed a laid-back mode of dialogue with an integrated service infrastructure in which the everyday surroundings become the interface.

In the Framework 5 Information Society Technologies Programme, support for research and development for libraries and cultural heritage were both included within a broader 'Key Action' for 'Multimedia Content and Tools'. By now we were 'propelled by an ever-present and ever-expanding internet', under whose influence 'the world is undergoing a rapid transformation from an industrial to an information-based society'.[6] Multimedia content and tools would be central to the revolution of the information society, living in an envi-ronment of ubiquitous multimedia. In the confident days before the dotcom bubble burst, 9/11 and the War on Terror, the European Council of Ministers declared the aim at the Lisbon European Council of 2000 *'To become the most competitive and dynamic knowledge-based economy in the world, capable of sustainable economic growth with more and better jobs and greater social cohesion'*.[7] Research and development in multimedia technologies under Key Action 3 (KA3) would combine applied research, especially in the area of digital publishing, e-culture and e-learning, with generic technology development to support more intelligent and user-friendly provision, access and management of content.

In the cultural sector, this should mean improving 'access for citizens and professionals to Europe's expanding repositories of cultural and scientific knowl-edge, while contributing to the creation of a sustainable European cultural land-scape.[8] Libraries continued to be well to the fore (reflecting the continuity of well-established interests) with an emphasis on 'advanced digital library appli-cations' but there was also a reflection of the needs for museums for research into tools for the sharing and interactive use of internationally distributed and culturally significant collections and 'novel ways of creating, manipulating, managing and presenting new classes of intelligent, dynamically adaptive and self-aware digital cultural objects'. This would certainly be pushing the enve-lope: the concept of an intelligent and self-aware cultural object (digital or not) is intriguing to say the least and, in the strict sense, certainly impossible with any foreseeable technologies. However, this is really a byproduct of compressed

drafting: we do not believe the authors intended that digital cultural objects should pass the 'Turing test' or possess some form of consciousness. The intention (which is still extremely challenging) was, rather, that future digital representations or recreations of objects should possess realistic behavioural characteristics and automatic associations to relevant information (be it positional, contextual, historic, or whatever).

It is hard to pinpoint what all of this has been worth in terms of money and projects, since the basis of comparison changes. The following table and graph show the increase in number and value of projects from Framework 3 Telematics for Libraries to Framework 5 Key Action 3 'DigiCult' projects. The totals include various types of support and demonstration actions, in addition to the research and development projects that make up the bulk. The growth needs interpretation, since the Framework 5 'DigiCult' activities include classes of multimedia and conservation research that were not previously specifically identified and funded, or would have been funded under basic technologies development in ESPRIT. (Note also that the close dates for each programme do not refer to the end of projects, but the last year on which new funded projects were launched.)

In the succeeding Framework Programme 6 (2003–06), the stated 'mission' for Digital Culture was to support research and development that can lead to

Value (Million €)	25	29	90
Projects	51	49	110
Programme	FP3 TAP Telematics for libraries 1991–94	FP4 TAP Telematics for libraries 1994–98	FP5 KA3 DigiCult actions 1998–2002

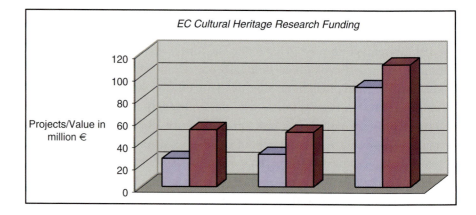

new technologies for making archives, museums and libraries 'accessible to everyone, everywhere and at any time.' Research and prototype application development should enable automated digitisation, and digital restoration and preservation techniques, as well as the creation of large-scale interactive networks of cultural resources and new environments for intelligent heritage and tourism, and community memory. These advanced systems and services should improve access to Europe's knowledge and educational resources and generate new forms of cultural and learning experiences.

Framework 6 was designed not to support research as such but to restructure the way in which Europe carries out research, building a 'European Research Area' with more formal and durable partnerships. In consequence, it has set out to fund fewer, larger projects. It is still too early to determine the impact on the Digital Heritage sector, either in the value of research funding or its outcomes in terms of projects.

20.3 Case Study: The Introduction of Digital Imaging and Multimedia to a Museum

The implementation of visions of seamless access to all digital culture, or ambient tools for scholarship will require considerably more than technological research and the investment of large sums of money. They need the support and conviction of museums and the wider cultural community, which must be convinced that the new technologies support their goals and can be genuinely useful. Experience on the ground teaches that the introduction of advanced technologies into cultural institutions is not a straightforward process. Many institutions, in the early 1990s, had little or no IT capacity and real fears that new technologies might reduce visitor numbers, dilute the authenticity of the public experience of the collections, and pose a threat to real scholarship.

Journeys through Victorian London was conceived in 1992 as an experimental multimedia production for the Museum of London, and an initial limited pilot project was undertaken in the first half of 1993 in response to a call for proposals from the European Commission's IMPACT2 programme. The Museum of London, as its name suggests, is the chief repository of and authority on all kinds of artefacts relating to London and its history. It is the largest museum of urban history in the world and its nineteenth-century collection is exceptional in the range, quality and variety of material in contains. Items in the collection include not only every conceivable type of artwork, book, manuscript, and object of daily domestic or industrial use: the nineteenth-century collections were the first period to include photographs, sound recordings and film. The IMPACT2 call was designed to encourage memory institutions to work with publishers to

develop digital interactive multimedia products at a period when there were no large-scale digitisation programmes, interactive multimedia was in its infancy and potential costs were uncertain. Most home computers lacked multimedia capacity and video replay was limited to a small window (often with a severely reduced frame-rate). The only low-end device capable of playing full-screen full-motion video was an enhanced version of Philips's CD-i system, which itself was only launched in 1992, with a plug-in MPEG accelerator cartridge. The Web and web-based multimedia did not exist at all. Although the first digital multimedia CD-ROMs and CD-i were appearing, there was no real market as such. However, there was an opportunity for Museums to learn about the emerging digital technologies and the hope of advantages for early adopters.

The Museum's main partner in the project was Valkieser Multimedia (NL), (now known as Valkieser Capital Images [9]), which provided services for multimedia production using state-of-the-art production and post-production facilities. A pioneer in CD-i technology and full-motion digital video, Valkieser was designated as the title's producer. They were accompanied initially by a start-up multimedia publisher, Round One Media and a management partner specialising in European projects (CITE [10]).

The Museum and Valkieser understood that it should be possible to build a database of multimedia files, which could then be navigated in different ways according to the interests of the user. The general public should be offered an entertaining, coherent experience, but also be able to make their own explorations. The more expert user (including museum professionals) should be able to drill down into the data to get more detailed information about any artefact. The user must be able to construct meaningful narratives from the mass of data, which had to have curatorial authority and be presented with full 'televisual' production quality.

Most of the aims could be achieved through the metaphor of a journey, which provides a narrative structure with a choice of routes, and the opportunity to stop along the way or take diversions. To quote the original contract:

The user will be able to take personal journeys, which could start at the newly developed docks and leave via one of the major railway terminuses. En route, the traveller may explore the topography, architecture, society and occupations of the city, and select from a range of key events to access specialised data in more depth. The user may also 'be' an object on a carrier's cart, an item at various stages of its manufacture, etc.

Choice of the nineteenth century allows the use of the widest possible range of material from the Museum's collection, including historic photographs; maps; paintings, prints and drawings; panoramas; objects; printed texts and ephemera. These will be supported by music (of the period), voice-over, rostrum-camera work, and special effects for the recreation of specific events.

The project is aimed at the consumer market, but will also have markets in the educational and art-historical sectors.

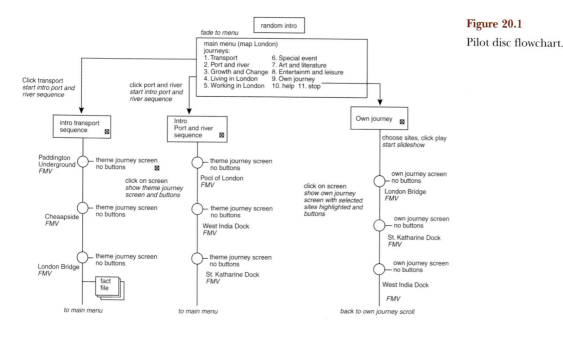

Figure 20.1

Pilot disc flowchart.

If the concept worked, further titles would be produced for other periods. CD-i was selected as the format, as the only technology platform theoretically capable of delivering the full-motion full-screen video needed to show some of the first films ever made. (At that time, full-screen video was still under development and no title had yet been released that used it, but Valkieser was confident of its ability to deliver.) The pilot phase was due to take six months, until the end of June 1993: if it succeeded, a further bid would be made to produce the complete disk.

The title was to have eight themed journeys, with a facility for the user to build their own journey from the basic building blocks consisting of detailed material about specific 'sites', with linked in-depth fact files. The initial pilot Demonstrator tested the complete structure and functionality of the final concept, but only implemented two 'journeys' with a sample data set.

The pilot was encouraging: visitors to evaluation sessions at the Museum had responded positively (as well as giving useful feedback on the design) and in March 1994 the project entered an 'Implementation Phase' that lasted until September 1995. At this point, differences of opinion developed between the Museum and the publisher. The publisher was anxious to maximise its chances of a commercial return and wanted the Museum not only to publish the title cross-platform, but also to license a wide range of rights in possible future titles and ancillary products. The Museum was only prepared to commit itself to the CD-i under the IMPACT2 contract, although it was willing to consider further activities if this undertaking were a success. The differences proved irreconcilable and eventually a newly formed division of the Valkieser Group took over the publishing task.

The Museum and Valkieser took a long, hard look at the project. They changed the title for the disk (to *Journeys through Victorian London*); re-wrote some of the scripts; and re-designed the graphics and interactivity. They decided to stick with CD-i, despite the limitations of the market, to allow full-motion video and provide a televisual quality that was still impossible on CD-ROM.

The Museum of London had set up a team of eight people to author the content and to prepare a structural specification for the title. Using this as a guide, they acquired and digitised the assets, carried out the content research, compiled a database, and created the storyboard and scripts.

The basic building block of the title was the 'site visit'. As well as forming an element of a themed journey each site gave access to additional levels of information, going down to the 'fact files', which formed the bedrock of the disk. The sites and fact files were inter-related both by the journey and by sub-themes, which raised complex questions of historical relationship (as well as programming problems). During the initial design stage, the research team [11] drew up the fact file information under a set of thematic headings. The fact files also included related and detailed image suggestions as well as the interactive hotspot locations for each key image.

The Museum provided the necessary images to create the content of the title using both its own collections and also a number of external sources. A great deal of effort was put into the picture research of what were in many cases un-catalogued collections, and the selected pictures were then photographed onto large-format transparency or negative film for digital transfer onto Photo CD disks. A chance phone call to the museum early on in the process also revealed for the first time the existence of film material on London from the Lumière brothers dating from 1896. The clips had a crucial influence on the developing visual style of the title. The Museum also contracted a scriptwriter to work with the images and information that it had assembled. Early in 1995, Valkieser hired a specialist multimedia author, who played a major role in the re-definition of the title content and the final versions of the scripts. All the scripts were verified for accuracy and publishing concept by the Museum.

Copyright was a major issue: rights for optical media were becoming very expensive and commercial picture libraries were charging extremely high fees, as well as stipulating edition size and production plans. Fortunately the Museum owned most of the necessary material. Its status and extensive connections with other archives also made it possible to acquire rights to assets at favourable prices and in some cases free of charge under *quid pro quo* agreements.

Valkieser executed the production using the Group's high-level digital facilities, working very closely with the Museum. Unlike any previous project undertaken by Valkieser, the majority of assets were available from the beginning of the production period. The partners originally expected to use recordings of nineteenth-century music to accompany the visual images. However, the costs of performing rights were prohibitive, and the writing and recording of new

music in appropriate style made it possible to tailor the music track very precisely to image sequences for the maximum atmospheric effect. The chosen composer, Robert Jan Stips, was asked to combine contemporary feels with nineteenth-century echoes, in a score that contributed emotionally to the content.

The human touch was enhanced by a selection of 'Encounters' with famous Londoners and visitors to the city (Dickens, Van Gogh, Mayhew, Marx, etc). Music hall artistes Dan Leno (on record) and Little Titch (on film) were later added for a lighter note and Gustave Doré and Paul Martin for their engravings and photographs, respectively. All the voice-overs were recorded in Valkieser's studios, using actors whose voices were carefully selected for timbre and accent related to their roles.

The interaction design of the disk evolved considerably, to reflect trends in multimedia. In the CD-i version, the viewer saw a kaleidoscopic (or zootropic) impression of its contents, with historic film, maps and graphics overlaid to indicate the wealth of material. The main interface screen was a scrolling collage of elements of London life and architecture. Pointing and clicking took the user direct to locations, slide shows and film clips. Moving the cursor to the bottom of the screen revealed a pop-up scroll bar that gave thematic access to locations, maps, time-line, fact files, commentaries by famous figures and help. The interface was designed for intuitive use, and contains some surprises.

The original Contract specified a first pressing of 1000 disks. As a consequence of the delays, the project got no further than internal testing and evaluation, leading to the preparation of the final digital master. All of this had been much more arduous, and expensive, than initially planned. Worse was to follow with the collapse of the CD-i market and withdrawal of Philips from consumer multimedia. The Museum and Valkieser were left with no platform, no product and no evident possibility of either recouping their investment or issuing the title on another platform (since CD-ROM was still incapable of delivering, either technically or financially).

Normally that would have been the end of the story and a fairly typical outcome of a high-risk, high technology development project. But this was not the case. In 1997, the Museum started a major re-organisation, which would lead to the opening of a new 'World City Gallery' covering the period 1789–1914. By the late 1990s, the Web was a popular phenomenon, all personal computers were 'multimedia capable', and digital technology was becoming established in museums. There was an opportunity to re-configure *Journeys through Victorian London* as a CD-ROM both for in-gallery display and public sale.

The Museum went back to Valkieser, to agree to a new scheme, which would re-use the original material as directly as possible but in a simpler form. Further evaluation by the Museum had led it to conclude that the scrolling 'zoetrope' introduction screen was too complicated for use in a museum-based display. The user interface must be extremely simple, direct and foolproof (and resist

Figure 20.2

Home screen.

children's attempts to crash the system in the Museum gallery), there should be no keyboards to get damaged, and the graphic image should also reflect the Museum's new corporate style. In the intervening years, the Web had become a part of daily life and the public had become used to mouse-based 'click through' interfaces with simple 'forward', 'back' and 'play' commands.

The revised design accordingly reflects a more page-based than TV-programme metaphor and the thematic 'Journeys' are no longer explicitly available. Instead, the disk is divided into four main sections: People, Places, London on Film (the very early film clips – a star attraction that everyone goes to), and 'Images of London' (a searchable access to *all* of the images, with their associated text files). The 'People' files employ the same audiovisual sequences as the original 'Encounters', with a navigation bar that allows the user to stop, go forward or back, call up detailed information about this image, or go home again. The following sequence of screen shots shows the 'People' main screen and a sample from the sequence on the photographer Paul Martin (Figure 20.3(a–d)).

The 'Sites' are the same, core building blocks with their detailed research. Each location is a slide show, with a similar navigation to the 'People' section. This time, though, stopping the show to ask for 'more info' produces a curatorial 'fact file' text in addition to the photo reference. The fact file text is shown as a scrollable overlay to the picture (Figure 20.4(a–d)).

'London on Film' provides a selector screen, which then plays the clip chosen. When the film stops, an information screen comes up with the caption and catalogue information (Figure 20.5).

Figure 20.3

(a) People; (b) Paul Martin intro; (c) Paul Martin slideshow; (d) Paul Martin 'More Info'.

The Wold City Gallery opened on 7 December 2001; *Journeys* was incorporated as a culminating 'micro gallery' interactive display and the CD-ROM went on sale in the Museum shop. The first pressing of 1000 copies sold out and was re-pressed in 2004. In the words of the Museum's web site [12]:

These spacious galleries – by far the largest in the Museum–show how London became the world's first metropolis.

In little more than one hundred years, the city's population increased sevenfold – from one million to around seven million. Hundreds of artefacts, film-clips, sound archives and the Victorian Walk of original shop fronts and interiors bring this fascinating period to life.

Follow the stories of individuals – Lord Shaftesbury, Elizabeth Fry, Queen Victoria, Wellington, Mary Seacole – or study more general themes such as working life, education, rail travel, the Great Exhibition, music-hall entertainment or the Suffragette movement. Visit the website.

Figure 20.4

(a) Places; (b) Site visit, St Katharine's with scrolling fact file; (c) London on Film; (d) Information, W. G. Grace.

Before you leave, use one of the interactive computers to take a more detailed look at 19th-century life through film sequences, over 500 images, and the descriptions of contemporary commentators. This multimedia experience is also on sale in the shop as a CD-ROM Journeys through Victorian London.

The project has given the Museum a familiarity with multimedia publishing and the whole process of digital image storage and production. At the outset, it had little concept of the potential of the digital revolution: now it has gained valuable insights into ways in which its collections can be made available to a wide audience. The experience of the authoring and publishing teams has been diffused throughout the Museum, and the use of digital sound and image is an everyday part of its work.

Figure 20.5
Alex Werner and the
*Journeys through Victorian
London* installation.

20.4 Attitudes and Uses: Implications for Research

One of the problems in formulating research policy and making sensible research proposals is the great variety of viewpoint. Scientists, technologists, curators, historians, critics, artists and general public have different needs, desires and criteria; none of them constitutes a homogenous group. In terms of imaging, heritage and photography, the problems and disagreements are as old as photography itself. In 1859, in his attack on the pretensions of photography to be a form of art, Charles Baudelaire wrote of the medium:

> *Qu'elle enrichisse rapidement l'album du voyageur et rend à ses yeux la précision qui manquerait à sa mémoire, qu'elle orne la bibliothèque du naturaliste, exagère les animaux microscopiques, fortifie même de quelques renseignements les hypothèses de l'astronome; qu'elle soit enfin la secrétaire et le garde-note de quiconque a besoin dans sa profession d'une absolue exactitude matérielle, jusque-là rien de mieux. Qu'elle sauve de l'oubli les ruines pendantes, les livres, les estampes et les manuscrits que le temps dévore, les choses précieuses dont la forme va disparaître et qui demandent une place dans les archives de notre mémoire, elle sera remerciée et applaudie.[13]*

Baudelaire, as a poet, sees no need to define the 'absolute exactitude' required by the scientists, and nearly 150 years later the VITRA project demonstrated how difficult it still is for photography to provide even a verisimilitude of appearance.

His advocacy of the use of photography as a means of preserving the image of crumbling monuments, books, prints and manuscripts illustrates a popular misconception. For while photography is, indeed, a very useful recording tool, in the conservation arena the photograph is by its nature more fragile and fugitive than most of the objects that it is used to record. Digital images are even more impermanent than photochemical ones, since not only are their storage media (optical disk, hard drive or magnetic tape) short-lived but their encoding formats and reading devices also. Even in output terms, silver gelatine photographic prints are currently more permanent than the best archival ink-jet prints of digital images. As Paul Conway points out, throughout history the longevity of storage media has decreased as their information storage capacity has increased (compare for example a printed book with a stone tablet). And

> During the twentieth century, the permanence, durability, and stamina of newer recording media have continued to decline, with the exception of microfilm (Sebera 1990). Magnetic tape may be unreadable just thirty years after manufacture (Van Bogart 1995). The newest recording medium – optical disk – may indeed have a longer life than the digital recording surfaces that have gone before. It is likely, however, that today's optical storage media may long outlast the life of the computer system that created the information in the first place. This is the ultimate irony of recorded history. In order to achieve the kind of information density that is common today, we must depend on machines that rapidly reach obsolescence to create information and then make it readable and intelligible (Dollar 1992).[14]

At this point, we may consider an example (historic photograph of a monument) to discover what current digital cultural resources have to say about it, what other things we would like to know but cannot discover, and what the postulated future 'digital self-awareness' or ambient intelligence might add, were they to exist.

The physical object itself is an un-mounted, original photographic print 285 mm high × 235 mm wide ($11\frac{1}{4}'' \times 9\frac{1}{4}''$) on thin, slightly glossy paper. The highlights are a pale creamy yellow; the mid-tones and shadows are purplish. The paper, surface and colour are typical of an albumen print that has been toned with gold chloride, a process that was widely used from 1850–1900. The glass plate from which the print was taken has been damaged, resulting in a black segment in the top right-hand corner. There has been some crazing of the emulsion on the lower left-hand edge, possibly as a result of thermal damage when the negative was processed, and there is slight foxing to the right of the print. The photograph is signed in the negative 'Bourne' with an identifying number 1223.

The image itself shows part of an octagonal marble pavilion with decorative tracery and inlay in Mughal style. There is considerable depth of field, with sharp focus in the extreme foreground through to the detail of the furthest

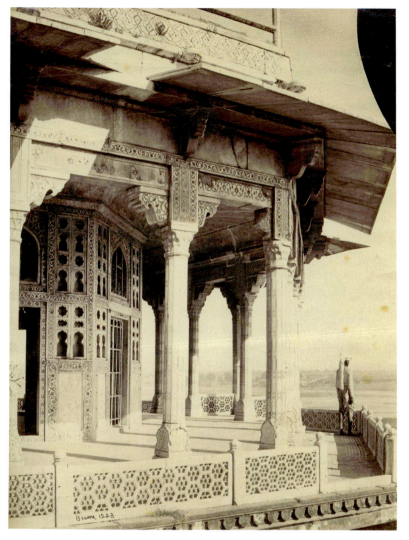

Figure 20.6
Photograph by Samuel Bourne.

columns: this would have required a small aperture and a fairly long exposure, probably in the region of ten seconds with the wet collodion plates used by Bourne at that period. Technically and creatively, this is a very accomplished piece of work, with a carefully chosen viewpoint and a balanced composition. It combines very high information content about the form and decoration of the building with a suggestion of surroundings and atmosphere. The posed figure gives scale to the architecture and a sense of human presence. It is probable that he was one of Bourne's numerous entourage: a similar figure, similarly dressed, can be seen in other photographs.

The name of the photographer, inscribed on the plate, is of course a give-away. Samuel Bourne was probably the most celebrated photographer of British

India, active there between 1863 when he established himself in business with Charles Shepherd in Shimla until his return to England in 1870. During this time, he made two famous photographic expeditions to the Himalayas (in 1863 and 1866) and another to Kashmir (in 1864). There are mentions of Samuel Bourne in all the standard photographic histories: tracking down this picture, dating it and identifying the exact subject should be an easy task for the web. In practice, it was rather more difficult than that. There are numerous web references to Bourne, and at least one very thorough biographic summary. However, at the time of searching (May 2004), nobody had put the 1860s Bourne and Shepherd catalogue onto the web. A search for this particular image, by photographer name and number, also drew a blank. Various searches, through Google, of images by Samuel Bourne threw up the adjacent photograph ('Bourne 1222') in a collection at the Brown University Library, showing the Diwan-i-Khas at Agra Fort and dated 1865. Searches for information about the Agra Fort eventually identified the precise subject of 'Bourne 1223' as the 'Muthamman Burj' in Agra Fort, looking over the Yamuna River. The Muthamman Burj is a decorative octagonal marble tower, built as part of the royal residence where the main wall of the fort takes a turn towards the east. Shah Jehan demolished the previous palaces and erected this marble tower, inlaid with precious stones, between 1631–40 for his wife Mumtaz Mahal. Shah Jehan is reputed to have died in the Muthamman Burj, gazing across the river at the Taj Mahal.

While the photograph would certainly have 'enriched the album of the traveller' (whether a real voyager or an armchair one only) as a topographical record, it has now entered the museum and gallery as a work of photographic art. Having identified the exact site of the photograph, a link from a biographical article on Samuel Bourne led to the Smithsonian Institute web site, where, in *India through the lens: Photography 1840–1911* in an extensive section devoted to Bourne, there was my picture, described as 'The Fort, Exterior of the Zenana (Agra)' with its Bourne and Shepherd catalogue number and an ascribed date of 1865–66.[15] The title, from the Bourne and Shepherd record, is correct even if it does not precisely the subject as the Muthamman Burj.

The trail of investigation, which spread across several days, shows that the Web in 2004 offered considerable information relevant to images of cultural objects (in this case, both the photograph and the building), but that the data may be very hard to find. Let us try to imagine how this might be different in a brave new world that is on the way to self-aware digital objects, ambient intelligence and a seamless web.

The first point is that the information sought was particular: another searcher could start from the same photograph, wanting to get to quite different places or results. That aside, what should one expect in an environment that gives access to 'Europe's knowledge'? First of all, one ought to be able to enter either descriptive text (photograph 'Bourne 1223') or a digital scan of the print (either from

my own desktop or a public access space). This should produce an immediate identification of the photograph, with its title, date, and physical description of the original (size, medium) and the locations of other original prints. One should be offered a wide range of associated contextual information related to the original object (the photograph) such as biographical information about the photographer; the Bourne catalogue; the articles Bourne wrote for the British Journal of Photography describing his work; critical articles; and other photographs by Samuel Bourne, starting with those closest in place and time to 1223 and also grouped by subject or location of originals. It is almost inevitable that the system would produce commercial information such as the value, and places to buy or sell the print or others like it.

At a more general level, the image's 'self-awareness' would connect to information about photographic techniques (wet collodion plates, albumen printing-out paper, gold chloride toning), paper and camera types, the history of photography in British India, topographic photography in the nineteenth century and so on in ever widening circles.

So far, this has just dealt with the photograph as an object. There would be a similar trail based on the photograph as an image, and the elements within it: the Muthamman Burj, Yamuna river and the standing figure. The architecture is the easiest part, particularly as we are dealing with a masterpiece. In addition to historic or cultural information, fanning out, to the Muthamman Burj, Agra Fort, the Taj, Shah Jahan, Mughal culture and history etc., there should be more images. These might show other views of the Muthamman and its details, and of the Agra Fort, the countryside and the Taj Mahal. For such a famous site, the user would expect a 3D navigable model or 'fly through', which would make it possible to see exactly where the photograph was taken from. It should eventually be possible to extract and download a reconstructed model of a considerable part of the Muthamman (or any other building shown), derived from the image. As for the enigmatic figure in the corner, it should eventually be possible to find every other one of Bourne's photographs in which he (or a figure like him) appears: in this case, one would not expect to discover anything much more about him, but in the case of a famous figure, the associative potential would be almost without limit in volume, richness or complexity.

20.5 The Future of Digital Heritage Research: The State-of-the-Art and Scenario Building

The direction of research plans is largely shaped by momentum from the past. Anything other than linear continuity based on direct extrapolation and 'please give us more money to keep the team together and do the next stage of the job' requires serious thought about the current big picture and possible

mid- to long-term future. At this point, policy makers turn to expert advisory groups and scenario builders. This is complicated in the area of Digital Culture by the cleavages between basic science, technology applications and cultural goals. The divide between 'two cultures' [16] is still visible and effective in the digital heritage arena, where many cultural humanists respect but feel incompetent in the presence of scientists, and *vice versa*. Many curators, who are clear about the job they need to do, are indifferent to the technological means (provided the technology performs) while most technologists are keen to offer tools, which others may apply to what they will.

One exercise in mapping tasks, research domains and technologies was carried out in 2003 by a European group (CACHE [17]) co-ordinated by the Dublin Institute of Technology, which contained a large group of experts with wide experience in European digital heritage research.[18] This 'CACHE technology matrix' went through several iterations before achieving the following form, in which critical hardware and software technologies are mapped onto the three principal stages of Content Acquisition, Construction and Storage; Content Access and Manipulation; Presentation, Display, Publishing and Distribution. The 'CACHE Matrix' considers a broad spectrum of technologies for imaging and virtual reality, interface building, spatial location, knowledge description and presentation, information retrieval, personalisation and interpretation. It has also taken into account the different perspectives and requirements of the various 'heritage professionals' on the one hand and 'access for all' on the other. The result is an unusually clear picture of the current mesh of relationships between advanced technology domains and cultural activities.

The above-mentioned technologies will be the critical technologies for the next stages. Policy, and to some extent project planning requires a longer view, with scenarios for a ten-year timescale (or longer in the case of basic technologies). This is the job of Foresight Groups, which, in the case of the European research programmes means ISTAG. ISTAG in 2001 published *Scenarios For Ambient Intelligence in 2010*,[19] which set out a series of possible futures in which the vision of an ambient intelligent environment had been realised, and analysed the steps required to achieve these ends. As the introduction emphasised:

> *Scenarios are not traditional extrapolations from the present, but offer provocative glimpses of futures that can (but need not) be realised. Each scenario has a script that is used to work out the key developments in technologies, society, economy, and markets necessary to arrive at the scenario.*

Scenarios are therefore tools to stimulate thinking rather than predictions of outcome. Their quality and usefulness depend on the knowledge and imagination of the authors: at their best, they can enable researchers and policy makers to see beyond the horizons of their current work. In the case of ISTAG, the four scenarios represented a considerable effort of informed imagination, but none

Technologies	Content Acquisition, Construction and Storage	Content Access and Manipulation	Presentation, Display, Publishing and Distribution
Interface Technologies	Multisensor, interactive services with ambient intelligence Multimodal interfaces to support artefact analysis and curatorial decisions	Augmented reality Multimodal interfaces to support virtual experience of rare artefacts	User-customised virtual galleries Pre-built 'template' virtual galleries Multilingual and non-visual interfaces Intuitive multimodal exploration using, for example, natural language. Embedded media narratives Integration into end-user systems (e.g. interfaces to enable the 'movement' of artefacts between systems)
Capture Technologies	Stereo, panoramic, aerial, multispectral and multi-view photography. Use of captured material to support curatorial decisions Indexing and retrieval techniques Metadata acquisition Born digital objects 'User facing' capture technologies	Radiometric, colorimetric and goniometric surface measurement Are there issues here for born digital artefacts? Multi-view rendering of 3D objects and scenes Montage, composite views Cross-media reproduction	
Location-Based and Spatial Technologies	Remote monitoring of CH objects Mobile hand-held device data collecting Geo-context sensitive hanging Geo-multimedia guidance management	Augmented reality Location-sensitive information to support the understanding of inaccessible places	Physical navigation through Cultural Heritage Situation-aware publishing on demand Location-aware task management
Knowledge Technologies	Annotation and ontology development Visitor collection tools Knowledge level description of curatorial narratives for single and pan-institutional exhibitions Semantic description of artefact and domain Professional interpretation of artefacts	Reasoning using incomplete and inconsistent data to support reconstruction of heritage events, scenes and artefacts	Support for semantic search, exploration and retrieval. High-level semantic structures for content presentation and personalisation Content-based retrieval Personalised and context sensitive presentation
Visualisation and Display Technologies	Advanced workspaces for artefact creating, collecting and organising Digital preservation and manipulation of rare artefacts	VR design of physical exhibitions Design of virtual exhibitions Augmented reality	Scene and object recognition Intelligent, immersive, multisensory and inter-active environments Virtual exhibitions Augmented reality

of them specifically addressed the cultural domain. As part of its development activity, the CACHE group commissioned Dr Patricia Donlon to fill the gap with a scenario that could complement its technology matrix and extend its planning into the future. The scenario imagines a family, with three generations, experiencing ambient intelligent culture in the daily lives in Dublin on Bloomsday, June 16, 2010. The following extract [20] sets the scene and covers just the morning (where the original continues to bedtime):

The 'Bloomsday 2010' scenario reflects Dr Donlon's varied experience in the cultural heritage sector as a scholar, curator, manager and policy-maker.[21] This scenario reflects the central role of the user at a time when 'user pull' is becoming increasingly important in defining research requirements: one of the central tenets of ambient intelligence is that the 'environment should be aware of the specific characteristics of human presence and personalities; adapt to the needs of users; be capable of responding intelligently to spoken or gestured indications of desire; and even result in systems that are capable of engaging in intelligent dialogue'.[22]

Daily life, the individual experience, social interaction and the physical object retain their primacy over the digital or the technological in this vision. Digital technologies exist to enhance reality (whether by helping to remove the mildew

Dramatis Personae

Sinéad Bright – a Forty-something home keeper, wife, mother and share time Cyber Docent.

Brian Bright – Fifty-year-old husband, father and Professor of Interactivity at DIT, the leading centre for Applied Arts in Ireland.

Cian Bright – 8-month-old baby of family

James and Rebecca Bright – 9-year-old twins

Laura May O'Brien - Sinéad's 80 year old mother, wheel-chair bound, yet determined to lead a full life.

6.30 a.m. Light streaming through the curtains wakes the Bright Family. Music, wafts from each bedroom about the house as the first sounds of the new day trigger everybody's favourite pieces.

7.30 a.m. The day's plans emerge over a noisy breakfast. Brian is going to lead his students and colleagues, scattered around the world, on the James Joyce trail. Sinéad, the Cyber Docent, dressed in her great-grand aunt's outfit is taking part in the Annual Bloomsday Celebrations. At the National Library Joyce Reading, she will interact with tourists from around the world who are linked to the readings.

Sinéad must prepare for the event. She uses the Digital Access Window to visit the Reading Room just as Leopold Bloom is reading a back issue of *The Kilkenny People*. Almost over his shoulder she can read the same issue of the paper; the language and advertisements are very different. To really put her in the mood she takes a quick tour of the sights and sounds of Dublin on that

Continued

fateful day in 1904. Horses and carriages, seagulls on Dollymount Strand, cobblestone and voices, Sinéad really felt that she had been there at that time.
8.30 a.m. The twins are off to school! With their "Compuvests", Sinéad can keep an eye on them during the day wondering how parents managed before the "Compuvest" became available.

Today is the day when the twins must hand up their project on the Romans. The twins (and the entire family) have made several visits to the British Museum, to Bath and even as far as the Forum in Rome. It is finally all done and the class's work will be presented and filed in hypertext. In truth, James was the one more involved as Rebecca regularly slipped away to take an e-class from her Piano Tutor. It was odd really how much she preferred these classes to those formal classes in the Academy – with the Tutor she could listen back to her playing and really hear those wrong notes and never feel stupid or backward. Pleased with her progress today, the tutor suggests that she try a new piece and plays it for her. Delighted Rebecca promises to tackle it for their next class. She loved the impersonal, patient advice from the Tutor. Now Miss McGarry at the Institute was something else....

9.30 a.m. Sinéad goes to dress and to her horror discovers that Great-grand Aunt's gown has developed mildew. Through the Digital Access Window, Sinéad explains her problem to the Curator at the Textile Conservation Laboratory who, with the aid of virtual gown, explains how to treat the mildew. Would Sinéad like to sign up for an interactive class in textile preservation at the Conservation Laboratory given by their team of virtual conservators? Even Sinéad, who adores this kind of class, is still a little uneasy with avatars. To Granny they are little more than "witchcraft"!

10.30 a.m. Already late, Sinead checks on the whereabouts of the LUAS line, and for once she is grateful that it is running behind schedule. There is time to settle Granny, drop Cian off at the Stimulation Centre, and secure her seat with her smart badge before the train's arrival. She rolls up her portable screen through which she will both access materials and artefacts and communicate with her cyber tourists and sets off.

Meanwhile, Granny is going to visit the Museum of Folk Life in Mayo. Since her confinement to a wheelchair she really looks forwards to these outings. So settling herself comfortably by the Digital Window in her room, she meets and is greeted by the Curator - who is to be their guide today and is introduced to the other visitors from around the world. During the morning they will go on a tour through the collection, stopping when something catches their eye, ask questions and share stories – with real time translation for the non-English speakers. When lunchtime arrives, the Curator talks to them about today's menu (delivered earlier this morning, and now waiting in the microwave to be activated via the gesture pendant which Granny wears constantly) – it is a traditional meal from the last century Coddle. In amongst mouthfuls, they swap memories of other favourite meals no longer fashionable. During a short break in activities Granny Bright checks in on screen with the Home Nurse, who commenting on her high colour decides to check her blood pressure.

Continued

> The afternoon session is spent with the Curator asking them for help in identifying objects, photographs and sharing their memories of everyday life at the end of the Second World War. Although just a young girl at the time, Granny regales them with stories of the 'glimmer man' and ration books. Before they finish the Guide tells them that next month's outing will be to the Lascaux Caves in France – long closed to the public – and suggests links they might like to explore before their outing.
>
> **12.00 noon** Brian and his students join the bevy of good humoured tourists on the walking tour of Joyce's Dublin – they have synchronised their palm guides with different groups opting for a range of varying aspects of the tour. The students look forward to their afternoon class when they will talk with groups in Trieste and Philadelphia. In Philadelphia they will be in time for the Bloomsday breakfast at the Rosenbach where they will examine and "hold" the original manuscript of *Ulysses*, before sharing their project. They have been working on one chapter of *Ulysses* and have integrated music, maps, photographs of the period together with original art work illustrating part of the text and a clip from their dramatized version of the excerpt. This will be followed by a discussion and critique of the work from the group in Trieste and Philadelphia, and if it is judged of merit it will become part of the expanding multi-media Joyce archive at the Rosenbach Library.

from Great-Aunt's dress or by tracking the twins with the 'Compuvest') and support the social interaction on which all culture depends. Above all, it is a *democratic* vision, in which technologies are not tools for the specialist that exclude everyman, but means for every man, woman and child to achieve a fuller experience of cultural heritage in their own times and on their own terms. Herein lies the key to future research policy for Digital Heritage. The humanising aspect, rather than a focus on any one technology or group of technologies, is where policy should be directed.

20.6 Picture Credits

All illustrations from *Journeys through Victorian London* are © The Museum of London and Valkieser Content Ventures, They are reproduced by permission of the Museum of London

Photograph of Alex Werner and the *Journeys through Victorian London* installation © Tom Evans 2004

The Muthaman Burj, Agra Fort by Samuel Bourne 1865, from the collection of Tom Evans. This print came to the author from the collection of Rodney Grey.

20.7 References

1. Information on the development of the 'Telematics for Libraries' is mainly based on the report *Impact of the Telematics for Libraries Programme under the Fourth Framework Programme* prepared by PriceWaterhouseCoopers for the European Commission, DG INFSO, Luxembourg 1998.

2. The VASARI project is well referenced on the Web, for example at the University of Southampton site at http://www.ecs.soton.ac.uk/~km/projs/vasari/

3. Edited by Claus Weyrich, ISTAG, September 1999.

4. The Hakone Forum, Japan, was a 'convergence summit' organised by Satjiv Chahil (then at Apple). It brought together a wide range of leading experts from business and academia, representing the major interests in computing, publishing, film and television to set the multimedia technology agenda.

5. Ubiquitous Computing is widely documented on the web. See for example a lecture presentation Ubiquitous Computing by Steve Czerwinski and Mehul Shah 5/24/98 of the University of Berkeley, Computer Science, archived at http://www.cs.berkeley.edu/~adj/cs294-1.s98/Ubicomp/

6. From the European Commission's web site promoting 'Key Action 3, Multimedia Content and Tools' of the Information Society Technologies Programme in the Fifth Framework, archived at http://www.cordis.lu/ist/ka3/

7. Quoted for example in the Work Programme for 2002 of the Information Society Technologies Programme, European Commission, 2001.

8. From the EC IST Work Programme 2000, Key Action 3. description of action *III. 1 Interactive publishing, digital content and cultural heritage*

9. http://www.valkieser.com

10. The present author was formerly Director of CITE and Project Manager for the *Journeys through* contracts with the IMPACT2 programme. This case study is based on his records of the funded project and subsequent discussions with Alex Werner at the Museum of London.

11. Led by Alex Werner, who was at the time nineteenth-century curator and one of the two CD-i project managers within the Museum, working closely with Mike Seaborne, curator of photography and the other CD-i project manager.

12. http://www.museumoflondon.org.uk/MOLsite/learning/features_facts/world_city.html

13. From *Salon de 1859: II Le Public moderne at la photographie*. This may be translated as follows: 'Let it [photography] rapidly enrich the traveller's album and give his eyes the sharpness that his memory lacks, let it illustrate the naturalist's library, enlarge microscopic animals, even provide evidence for the astronomer's hypotheses, let it be the secretary and record-keeper of whomever has a professional need for absolute material exactitude – and thus far all is for the best. Let it save from oblivion the hanging ruins, the books, prints and manuscripts that time is devouring, those precious things whose form is about to disappear and which demand a place in the archives of our memory – then it will be thanked and praised'.

14. From *Preservation in the Digital World* by Conway, Head, Preservation Department, Yale University Library, March 1996.

15. The Smithsonian Institution copy is from the Howard and Jane Ricketts Collection, Smithsonian catalogue number ELS2000.6.49. In May 2004 another copy was offered for sale on the Internet. This last example was later print, probably made in the 1880s, identifiable as such by the inscription in white on the print 'Zenana in

Fort Agra 1223'. Whereas Bourne inscribed many of his plates (including this) by scratching into the negative emulsion (making dark text), the number and title were added later by writing onto the plate (giving white lettering on the print) in more formal capitals. It is thought that Shepherd added these inscriptions some time after Bourne's return to England in 1870. The firm of Bourne and Shepherd still exists and is now based in Calcutta at 141 S.N. Banerjee Road in what is now a listed building.

16. *The Two Cultures and the Scientific Revolution*, C.P Snow 1959.
17. CACHE (Communities of Ambient Culture and Heritage) brought together 74 of Europe's research institutes, community memory institutes and industries from 12 countries to prepare the platform for a Framework 6 IST Network of Excellence for digital culture and Community Memory
18. With representatives from the FP5 IST DigiCult projects CIPHER, ACTIVATE, COINE, CHIMER, VITRA, and CULTIVATE.
19. By K. Ducatel, M. Bogdanowicz, F. Scapolo, J. Leijten and J.-C. Burgelman, published by the European Commission DG INFSO, February 2001.
20. Quoted with kind permission of Dr Patricia Donlon and the Faculty of Applied Arts, Dublin Institute of Technology.
21. Dr Donlon was an Arnold Graves Fellow at the Dublin Institute of Technology 2000–2004. She was Director of the Irish National Library, 1989–97 and before that Curator and Trustee of the Chester Beatty Gallery and Library of Oriental Art. She was Burns Scholar at Boston College, 2000–2001 and has been a member of many heritage panels and policy groups at European and National levels, including the Heritage Council of Ireland.
22. *Ambient Intelligence: from vision to reality*, ISTAG draft report, 2003.

INDEX